Olaf Schmidt
Wood and Tree Fungi
Biology, Damage, Protection, and Use

Olaf Schmidt

Wood and Tree Fungi

Biology, Damage, Protection, and Use

With 74 Figures, 12 in Colors, and 49 Tables

 Springer

Professor Dr. Olaf Schmidt
Universität Hamburg
Zentrum Holzwirtschaft
Abteilung Holzbiologie
Leuschnerstraße 91
21031 Hamburg
Germany

o.schmidt@holz.uni-hamburg.de

Cover: Fruit body of *serpula lacrymans* and electrophoresis gel demontstrating species-specific priming PCR.

Library of Congress Control Number: 2006920787

ISBN-10 3-540-32138-1 Springer Berlin Heidelberg New York
ISBN-13 978-3-540-32138-5 Springer Berlin Heidelberg New York

Springer is a part of Springer Science + Business Media
springer.com

© Springer-Verlag Berlin Heidelberg 2006
Printed in Germany

The use of general descriptive names, registered names, trademarks, etc. in this publication does not imply, even in the absence of a specific statement, that such names are exempt from the relevant protective laws and regulations and therefore free for general use.

Editor: Dr. Dieter Czeschlik, Heidelberg, Germany
Desk editor: Dr. Andrea Schlitzberger, Heidelberg, Germany
Cover design: *design & production*, Heidelberg, Germany
Typesetting and production: LE-TEX Jelonek, Schmidt & Vöckler GbR, Leipzig, Germany
31/3100/YL – 5 4 3 2 1 0 – Printed on acid-free paper

Foreword

Wood, as a raw material and a renewable biomass, has had great importance for thousands of years. Under suitable conditions, however, it is also easily degradable as part of the biological cycle. The processes of decomposition by fungi, and measures for protection against them, have been studied for quite a long time. The resulting knowledge on the causes and effects of wood degradation can hardly be overlooked.

For more than 30 years, Olaf Schmidt has investigated the causes and effects of wood degradation by fungi and bacteria. Pioneering contributions have also been made in several fields, such as wood-inhabiting bacteria and molecular methods for fungal identification. Laboratory work is accompanied by teaching the field of wood deterioration by microorganisms, thus contributing to the broad spectrum of information accumulated.

"Wood and Tree Fungi" by Olaf Schmidt presents the most comprehensive treatise on the fundamentals, causes, and consequences of decomposition of wood as well as measures for its prevention. The 1,400 references give an overlook of the vast amount of information evaluated. For a long time to come this book will be the competent source of knowledge about the fascinating interactions between wood and microorganisms.

Walter Liese

Preface

This book is the updated revision of the German edition "Holz- und Baumpilze" from 1994. Errors were corrected and new results were included. Particularly the chapter "Identification" was supplemented by molecular techniques. I realize that a one-author book on a relatively broad topic must include errors and also may have ignored recent literature. Strictly speaking, one should only write about things that they have experienced themselves, in the case of point this only concerns some aspects of bacteria and those fungi which inhabit the xylem of dead wood. Thus, current "secondary literature" was used for those chapters that are "on the edge" of my own research interest.

For better readability, the authors of fungal names are not mentioned in the text, but summarized in an appendix. Fungal synonyms are also not given. These are available from Index Fungorum (www.indexfungorum.org/names/names.asp). Fungal names cited from (older) publications were transferred to the current version.

Thanks for general advice go to Prof. Dr. Dr. h.c. mult. Walter Liese, for critical reading to Prof. Dr. Dirk Dujesiefken (Chap. 8.2), Dr. Hubert Willeitner, and Dr. Peter Jüngel (Chap. 7.4), to Mrs. Ute Moreth for providing experimental data, Dr. Tobias Huckfeldt for several photographs, many colleagues for permission to use their photographs, Mrs. Christina Waitkus for transferring many pictures in an electronic version, to Springer-Verlag, particularly Mrs. Ursula Gramm and Dr. D. Czeschlik, for co-operation, to Mr. Jardi Mullinax for making my English understandable, and to Mrs. Cornelia Gründer for careful printing.

Hamburg, December 2005 *Olaf Schmidt*

Contents

1 Introduction

Wood is damaged by various agents (Table 1.1).

This book addresses wood damage caused by microorganisms (fungi and bacteria). Wood damage by fungi has also been called "wood diseases" ("Holz-krankheiten") and "wood pathology" ("Holzpathologie"). Because it concerns the substrate "tree" in the majority of dead cells, because all parenchyma cells in the wood of felled trees are dead after a few weeks, and, thus, because a dead tissue cannot fall ill, distance was taken to these terms. With regard to the microbial decomposition of biomass, in the English language there is a well-describing differentiation between "biodeterioration", which means unwanted biological destruction, and "biodegradation", which means controlled degradation by microorganisms or their enzymes and degrading agents. Biodeterioration corresponds to the German "Holzzerstörung" and "Holzzersetzung", and the latter positive aspect of wood biodegradation ("Holzabbau") belongs to the area of "biotechnology of lignocelluloses" (Bruce and Palfreyman 1998; Chap. 9).

In the following text, the microbial damage to the xylem (wood) of the tree is mainly addressed. Since leaves, bark, and roots are entrance gates for parasites into the living tree that can lead to reduced tree growth and to lesser wood quality, some aspects of the area of "forest pathology" are included (Butin 1995; Chaps. 5 and 8.1–8.3). The mechanisms of the decomposition of solid

Table 1.1. Agents for wood damages

- mankind: e.g., paper production, fire for cooking
- conflagrations for agriculture
- weathering, UV light
- acids, bases, corrosion by salts, gases, discoloration by metals
- wood insects: xylophagous beetles, termites, wasps, breeding ambrosia beetles, wood-colonizing ants
- marine borers
- bacteria: wetwood, discoloration, pit degradation, decay by erosion, tunneling, cavity bacteria
- fungi:
 wood discoloration by molds, blue-stain fungi, red-streaking fungi
 wood decay by brown, soft, and white-rot fungi

wood apply essentially also to wood-based composites (plywood, fiberboard, particleboard, orientated strand board) (e.g., Chung et al. 1999) and to wood-plastic composites (Simonson et al. 2004). Sutter (2003) and Unger et al. (2001) report on damages, conservation, and restoration of wood artifacts. Bacterial and soft-rot attack of archaeological wood is described by Blanchette (1995), Nelson et al. (1995), and Singh et al. (2003).

The decomposition of biomass, which concerns wood and other lignocelluloses (annual plants), is a necessary part of the natural material cycle: during photosynthesis, wood and O_2 are formed from CO_2 and H_2O by means of light. In counterpart, the wood becomes degraded by fungi and bacteria to CO_2, H_2O and energy for microbial metabolism.

In the forests of the earth, about 400 billion t of CO_2 are bound. Without microbial degradation (or burning) of the biomass, the CO_2 supply of the atmosphere necessary for photosynthesis would be used up in 20–30 years (Schlegel 1992), photosynthesis would grind to a halt, and the earth would be overfilled with non-decaying biomass.

Humans retard wood degradation by microorganisms for economic reasons by wood protection measures (Willeitner and Liese 1992; Goodell et al. 2003; Müller 2005; Chap. 7.4) in order to prolong the use of the raw material wood. Thus, for example, the service life of a beech sleeper, which would amount to about 3 years without any protection, extends to about 45 years after impregnation with coal tar oil.

Until around 1800, rot was considered punishment from God, and fruit bodies as eczemas. Still, in 1850, v. Liebig attributed decay to a "slow burning". In 1874, Robert Hartig recognized the causality between pest and damage and is thus considered the father of forest and wood pathology (Merrill et al. 1975). The first pure culture of a wood-degrading fungus was succeeded to Brefeld (1881).

Research on wood deterioration is done worldwide. The global network for cooperation in forest and forest products research is the International Union of Forest Research Organizations (IUFRO), which was created in Eberswalde, Germany, in 1892, and has 15,000 scientists in almost 700 member organizations in over 110 countries. Current research results on wood damages, protection, and investigation methods are introduced at the annual symposia of the International Research Group on Wood Preservation (IRG). Edible mushrooms cultured on wood are discussed at the meetings of the International Mycological Society. A recent comprehensive treatise on the various aspects of fungi is "The Mycota" (Esser 1994 et seq.).

2 Biology

2.1
Cytology and Morphology

"Wood fungi" are eukaryotic and carbon-heterotrophic (free from chlorophyll) organisms with chitin in the cell wall, reproduce asexually and/or sexually by non-flagellate spores, filamentous, immovable and mostly land inhabiting. Damage to wood in water by fungi is described by Jones and Irvine (1971), Jones (1982) and Kim and Singh (2000). Soft-rot fungi belonging to the Ascomycetes and Deuteromycetes (Chap. 7.3) destroy wood with high moisture content in water or soil (e.g., Findlay and Savory 1954; Liese 1955). Fungi associated with leaf litter in a woodland stream were treated by Suberkropp (1997).

In this book, a fungal cell, the hypha, is defined as one individual cell of mostly tubular shape that consists of a cell wall, contains a protoplasm with a nucleus and other organelles, and is in the "higher fungi" separated from its one or two neighbors by a transverse wall, the septum (Fig. 2.1). In analogy to the "higher plants", where nearly every living cell is connected to its neighbors by cytoplasmic channels, the plasmodesmata, which pass through the intervening cell walls, also the protoplasms of neighbored hyphae are connected with each other through the pore or dolipore system (Fig. 2.2). This basic hypha is termed "vegetative hypha" in this book. This definition contrasts to others where one hypha, also termed generative hypha, is a more or less long filament consisting of several hyphal "compartments", a definition that is hazy because the transition to the next higher unit, the mycelium, is flowing. The mycelium is thus the filamentous lining up of hyphae, consisting in young mycelia of only a few vegetative hyphae and in older ones of several and branched hyphae. Figure 2.1 shows septate hyphae as they occur in the wood-inhabiting Deuteromycetes, Ascomycetes, and Basidiomycetes.

The diameter of hyphae reaches from 0.1–0.4 µm for the microhyphae of *Phellinus pini* (Liese and Schmid 1966) to 60 µm for the vessel hyphae in the mycelial strand (cord) of the True dry rot fungus, *Serpula lacrymans*, with an average for vegetative hyphae of about 2–7 µm (*S. lacrymans*: 3 µm: Seehann and v. Riebesell 1988). Their length reaches from about 5 µm for round/oval cells (spores) up to several micrometers. The size of many bacteria is between 0.4 and 5 µm.

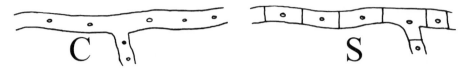

Fig. 2.1. Vegetative hyphae. *C* coenocytic hyphae, *S* septate hyphae

Due to the smallness of the individual hypha and the use of microscopic and microbiological methods, fungi are microorganisms. This attachment does not contrast to the fact that fungi can form large and firm structures such as fruit bodies of decimeters in size like in the Tinder fungus, *Fomes fomentarius* (see Fig. 8.15). Those fruit bodies are, however, also composed of single hyphae. The main argument is, however, that the "actual fungus" is the vegetative hyphal system that can grow unlimited by simple mitotic reproduction without ever fruiting if fresh nutrients (wood, soil, agar) are available, and if growth in a certain biotope is not inhibited by the own or foreign metabolic products.

Fungi are scientifically examined in microbiological or medical institutes (predominantly Deuteromycetes and Ascomycetes) and often in botanical institutes. They do, however, no longer rank among the plants. In multi-kingdom systems (Whittaker 1969), the "higher fungi" (Ascomycetes, Basidiomycetes) form the distinct group of fungi beside the Prokaryotes (Bacteria), Protista (eukaryotic single-celled organisms: slime fungi and "lower fungi"), plants, and animals (Müller and Loeffler 1992). Based on rDNA sequences, Woese and Fox (1977) divided the Prokaryotes into the kingdoms Eubacteria and Archaebacteria and later emphasized three domains, which were renamed Bacteria, Archaea, and Eucarya (see Fig. 5.1).

The hyphal wall defines the shape of the hypha and provides the mechanical strength to resist the internal turgor pressure. The wall consists of various carbohydrates. Some yeast has mannan-β-glucans, while Ascomycetes, Deuteromycetes, and Basidiomycetes possess chitin-β-glucans, never cellulose. Chitin [poly–β(1-4)-*N*-acetoamido-2-deoxy-D-glucopyranose], which occurs except in fungi also in the exoskeleton of arthropods and crustaceans, and in some mollusks, is a macromolecule made of β-1,4-glycosidically linked *N*-acetylglucosamine units. Chitin synthases (CHS; EC 2.4.1.16) catalyze the formation of chitin from the precursor UDP-*N*-acetylglucosamine. In the yeast *Saccharomyces cerevisiae*, CHS I acts as a repair enzyme and is involved in the chitin synthesis at the point where the daughter and mother cells separate. CHS II participates in septa formation and CHS III in chitin synthesis of the cell wall (Robson 1999). Ascomycetes have two-layered cell walls, while walls of Basidiomycetes are multilamellar. The entire structure of the cell wall including extracellular layers is complex (Toft 1992; Robson 1999): The wall of filamentous fungi may consist for example of an inner wall of about 10–20 nm composed of chitin microfibrils and an outer wall composed of a protein layer (about

10 nm), a layer of glycoprotein (about 50 nm), and a slime layer, also termed mucilage layer, sheath, extracellular matrix or mycofibrils (about 75–100 nm).

Slime layers are common to fungi and have been found in blue stain, white, brown, and soft-rot fungi. They are composed of protein, lipid and carbohydrate containing material (α-glucan, β-1,3 and β-1,6-glucan) or of crystalline to membranous and fibrillar structures (Liese and Schmid 1963; Schmid and Liese 1965; Schmid and Baldermann 1967; Holdenrieder 1982; Green et al. 1989). Various functions have been suggested for the slime layer (Schmid and Liese 1966; Sutter et al. 1984; Green et al. 1991b; Kim 1991; Abu Ali et al. 1997; Messner et al. 2003; Table 2.1). In *Phanerochaete chrysosporium*, the slime layer is composed of equal amounts of carbohydrates, lipids, and proteins, including five fractions with molecular weights between 30 and 200 kDa (cf. Messner et al. 2003). Production of the slime layer was influenced by iron, manganese and nitrogen concentration, temperature, and pH value (Jellison et al. 1997).

Hyphae may be encrusted and covered with resinous material, oil drops, and calcium oxalate crystals (e.g., Holdenrieder 1982).

The hyphal wall encloses the cytoplasm with its outer boundary, the plasmalemma. In the majority of fungi, ergosterol is the chief sterol in the plasma membrane and is used for fungal quantification (Chap. 2.4). Some antifungals like polyene and triazole act on this ergosterol (Robson 1999). The cytoplasm principally resembles that one of plants. There is one too many relatively small nuclei. Plastides are absent. Growing hyphae of Ascomycetes and Basidiomycetes show at the hyphal apex a mass of small vesicles, the "Spitzenkörper". The tonoplast encloses a vacuolar system. Carbon is stored in glycogen vesicles and lipid vacuoles. Nitrogen is deposited as amino acids in the vacuolar system or as protein. Phosphorus is condensed as polyphosphate in volutin grana, often in vacuoles. Some yeast contains starch.

Table 2.1. Possible functions for fungal slime layers

- substrate recognition
- adhesion to and establishing contact
- covering the S_3 layer of the wood cell wall during decay process
- conditioning of the substrate for decay
- modification of the extracellular ionic environment and pH-value
- transport vector for low-molecular decay agents and enzymes to the wood (see Fig. 7.3)
- transport vector for degradation products to the hypha
- storage, concentration and retention of decay agents
- regulation of the decay process, e.g., by controlling the glucose level
- microenvironment for H_2O_2 maintenance needed for lignin degradation
- storage of nutrients
- permitting a film of liquid water to surround the wood cell wall
- protection of the mycelium against dehydration and adverse environmental conditions
- increase of surface area for aerobic respiration
- storage of copper or CCA from attack of impregnated wood

The solutes in the cytoplasm and vacuolar system have a certain osmotic potential. If the potential is lower than that of the substrate, water is adsorbed across the membranes, increasing the volume of the cytoplasm (Jennings and Lysek 1999). An internal turgor needs to be generated for the elongation of the hyphal apex that is that water uptake and wall growth are in balance.

Mycelium is the filamentous, partly branched, and in the wood-inhabiting Basidiomycetes usually whitish network made from some to numerous, in the light microscope hyaline to light yellow and in the case of blue-stain fungi brownish (melanin) hyphae. In Deuteromycetes, the pigmentation of the culture is manifold due to the various pigments of the conidia, whose color depends on the species. Mycelium forms the macroscopically visible thallus, the undifferentiated form of vegetative growth of fungi (thallobionts), which is not differentiated as it is the kormus of the "higher plants" into the organs, shoot axis, leaf, and root. Mycelium is the actual fungus with nourishing function and thus with wood decay ability. Under sufficient nutrient offer, mycelium is theoretically growable for an unlimited period. Sexuality with fruit body formation is not necessary for survival. For example, mycelium of an isolate of the Asian edible mushroom Shiitake, *Lentinula edodes*, is now maintained since about 1940 exclusively on agar in the refrigerator without ever fructifying, but would immediately develop fruit bodies (Fig. 9.1) when favorable environmental conditions are provided (Schmidt 1990). The largest and longest-living wood fungi are *Armillaria* species. A clone of *A. gallica* in a Michigan forest covered 15 ha and was estimated at an age of about 1,500 years and a total biomass of 1,000 t (Smith et al. 1992). A clone of *A. ostoyae* estimated at 400–1,000 years covered an area of 6 km^2 in the Rocky Mountains (Anonymous 1992a). In Oregon, an *A. ostoyae* clone of 2,400 years stretched over an area of about 9 km^2 of forest soil (Schwarze and Ferner 2003).

Deutero- and Ascomycetes have in the septum a central simple pore. Wood-inhabiting Basidiomycetes (Homobasidiomycetes) contain the more complicated dolipore septum with a parenthesome on both sides (Fig. 2.2).

The protoplasts of neighboring hyphae are connected through pores in the septa for the longitudinal migration of organelles and even nuclei, and for the transport of solutes (translocation; Chap. 3.1). Woronin bodies, which are composed of protein, block the pore when a hypha becomes injured.

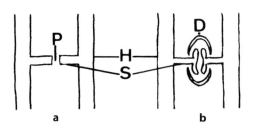

Fig. 2.2. Septa (*S*) of Ascomycetes (**a**) and Basidiomycetes (**b**). *P* simple pore septum, *D* dolipore septum, *H* hyphae

The hyphal system expands by extension of individual hyphae that exhibit apical growth and by branching (Fig. 2.3).

Different zones occur in the growing hypha (Fig. 2.4), which correspond to different ages and developmental stages (Huckfeldt 2003).

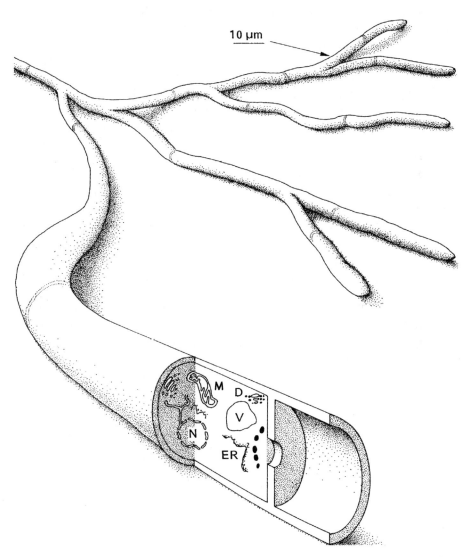

Fig. 2.3. Apical growth and hyphal branching system. One branch is sectioned to show the septum and some features of the protoplasm. *N* nucleus, *ER* endoplasmic reticulum, *D* dictyosome, *V* vacuole, *M* mitochondrion, Woronin bodies (*dark*) [reproduction with permission, from Jennings DH, Lysek G (1999) Fungal Biology, 2nd edn. Bios, Oxford, Fig. 1.1. page 6]

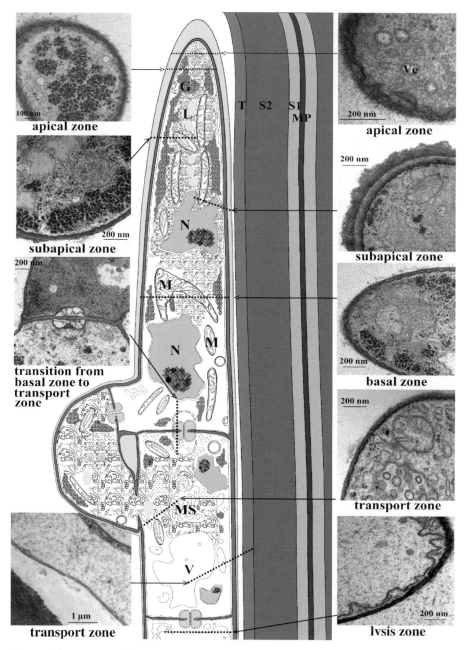

Fig. 2.4. Ultrastructural features and zonation of growing hyphae of a house-rot fungus in woody tissue (*MP, S1, S2* and *T* wood cell wall layers). *G* glycogen, *N* nucleus, *L* lipid drops, *Mi* mitochondrion, *MS* multivesicles structure, *V* vacuole, *Ve* vesicle (from Huckfeldt 2003)

Due to the apical growth, the hyphal tip is the most sensitive part of the mycelium and gets the first contact with the substrate wood. Wood preservatives, unfavorable temperatures, shortage of nutrients, and moisture affect the tip. The tip contains different vesicles and membranous structures for cell wall synthesis and transport processes as well as enzymes for nutrient metabolism (Robson 1999). Like in other Basidiomycetes, the tip in *Serpula lacrymans* (Fig. 2.4) consists of three zones:

In the apical zone, material for the structure of the cell wall, slime layer, and plasmalemma is concentrated and incorporated in the growing mycelium. Vesicles from the Spitzenkörper merge with the plasmalemma and deliver cell wall components. In the subapical zone, compartments and ribosomes are involved in the synthesis of cell wall material and secretion products. The basal zone contains the nucleus, or in the case of dikaryons, two nuclei. Vacuoles are involved in internal recycling processes, detoxification, storage, upkeep of turgor pressure, control of ionic strength as well as metabolization of compartments and macromolecules. The cytoskeleton, which consists of actin filaments and microtubuli, serves together with motor proteins to the upkeep of the zonation of the hyphal tip by changing the position of the compartments. Thus, the compartments continuously follow the growing tip to maintain the density of organelles in the subapical zone. Jennings and Lysek (1999) differentiated the apical growth zone with the extending hyphal tip, the absorption zone where there is uptake of nutrients, the storage zone in which nutrients are stored as reserve substances, and the senescence zone where dark pigments and lysis may occur.

The hyphal system produces a loose network of filaments (aerial mycelium on the wood surface, substrate mycelium within wood and soil) or solid, morphologically differentiated units such as the strands of house-rot fungi and the rhizomorphs of *Armillaria* species (Chap. 2.2.1), and the fruit bodies.

The mycelia of wood fungi differ considerably in their growth rate. Table 2.2 shows the growth rate of some house-rot fungi.

The growth rate serves as a characteristic for species identification in keys. Growth rate is also used as a hint of the age of the fungal infestation time of a building, e.g., in the case of damage by *Serpula lacrymans* (Chap. 8.5.3.4). However, mycelial extension depends on environmental conditions like temperature and nutrients, which differ between stable and favorable laboratory conditions and fluctuations in buildings. Furthermore, different isolates of a species commonly differ in growth rate ("strain variation"). In addition, dikaryons and monokaryons may differ in growth. For example, dikaryons of *Lentinula edodes* (Schmidt and Kebernik 1987), *Serpula lacrymans* (Schmidt and Moreth-Kebernik 1991a), and *Stereum hirsutum* (Rayner and Boddy 1988) grew faster than the monokaryons. Nevertheless, there are so-called "fast-growing" wood fungi like the Cellar fungus, *Coniophora puteana*, with up to

Table 2.2. Growth rate of house-rot fungi at optimum temperature (from Schmidt and Huckfeldt 2005)

Group	Species	Number of investigated isolates	Maximum radial increase on agar per day (mm)
Dry-rot fungi	*Serpula lacrymans*	2	4.0–5.1
	S. himantioides	2	7.0–11.0
	Leucogyrophana mollusca	6	1.0–3.3
	L. pinastri	4	2.4–4.2
	Meruliporia incrassata	2	2.8–3.2
Cellar fungi	*Coniophora puteana*	27	2.5–11.3
	C. marmorata	2	9.7–12.3
	C. arida	1	4.7
	C. olivacea	5	3.7–9.0
White polypores	*Antrodia vaillantii*	12	4.3–7.7
	A. sinuosa	4	4.0–8.0
	A. xantha	3	5.5–8.2
	A. serialis	3	3.5–3.9
	Oligoporus placenta	4	4.2–9.8
Gill polypores	*Gloeophyllum abietinum*	5	3.8–5.5
	G. sepiarium	4	6.8–8.3
	G. trabeum	5	7.1–9.1
Oak polypore	*Donkioporia expansa*	1	5.1

11 mm radial increment per day on 2% malt extract agar at 23 °C and "slow-growing" species like *S. lacrymans* with up to 5 mm at 19 °C.

Mycelium of wood-decay fungi predominantly grows as substrate mycelium inside of the substrates wood (or soil) and is often not visibly on the outside, thus, wood rot, particularly at incipient decay, is frequently not recognizable outwardly. By means of surface mycelium, growth additionally or predominantly occurs on the substrate surface, e.g., on nutrient agar or in the case of molds that grow superficially on timber and masonry. Aerial mycelium, e.g., in the white polypores in buildings (*Antrodia* spp.), is an intensively developed surface mycelium. The texture of the mycelial mat is manifold, e.g., flat on the substrate, crusty, woolly, felty, or zonate (Stalpers 1978).

2.2
Growth and Spreading

2.2.1
Vegetative Growth

Simplistically, wood fungi live through two functionally different phases: the vegetative stage for mycelial spread and the reproductive stage for the elaboration of spore-producing structures. Rayner et al. (1985) extended the de-

velopment of a fungus in arrival, establishment, exploitation, and exit. The vegetative, asexual stage consists in wood fungi of vegetative hyphae with some specialized forms. The reproductive stage can both occur asexually or sexually (Schwantes 1996; Table 2.3).

Functional specialization of the mycelium occurs during the vegetative stage: germination, infection, spread, and survival. These functions are correlated with different "fungal organs". Spores (conidia, chlamydospores, also the sexually derived asco- and basidiospores) germinate under suitable conditions (moisture, temperature). The young germ hypha first shows some nuclei before the young mycelium grows with septation in the monokaryotic condition.

Mycelial growth takes place via mitoses and synthesis of hyphal biomass. Infection and colonization of new substrates occurs by spores, hyphae, mycelium, and special forms like bore-hyphae, transpressoria, strands, and rhizomorphs. Prerequisites for the colonization of a substrate are suitable humidity and nutrient availability in the substrate or, like in *Serpula lacrymans*, the ability of a fungus to transport nutrients and water and last, whether and by which organisms the substrate is already occupied (Rayner and Boddy 1988). Boring microhyphae of 0.1–0.4 µm diameter develop e.g., in *Phellinus pini* at the hyphal tip without recognizable septum and produce boreholes of 0.3–3.3 µm diameter probably by enzyme action (Schmid and Liese 1966). The appressorium is a hypha for the mechanical fixation to the substrate (Fig. 2.5a). The transpressorium (Fig. 2.5b) of the blue-stain fungi (Chap. 6.2) is a specialized boring hypha (Liese 1970); it is still unknown whether the penetration of the woody cell wall is by mechanical and/or enzymatic action. Transpressoria have also been found in the white-rot fungus *Phellinus pini* (Liese and Schmid 1966).

Table 2.3. Functional and morphological differentiation of wood fungi (modified after Müller and Loeffler 1992)

Developmental stage	Function	"Organ"
Vegetative/asexual	Germination	Germ hypha
	Infection,	Hypha, mycelium,
	spread	boring hypha,
		appressorium, transpressorium,
		strand, rhizomorph
	Survival	Chlamydospore, arthrospore,
		mycelia with resistance to
		dryness and heat
Reproductive/asexual	Anamorphic	Fruit body, conidiophore,
	reproduction	conidium
Reproductive/sexual	Teleomorphic	Fruit body,
	reproduction	ascus, basidium
		ascospore, basidiospore

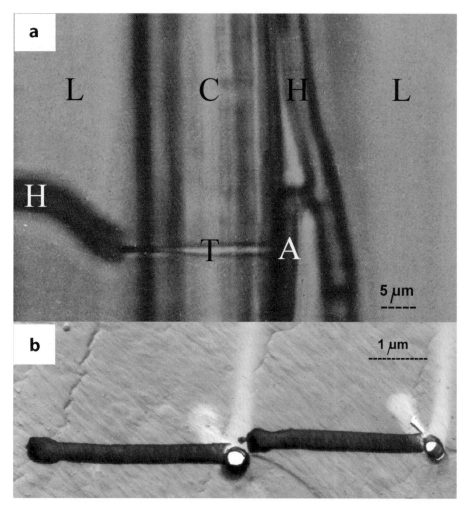

Fig. 2.5. Appressorium and transpressoria of blue-stain fungi in wood. **a** Hyphae (*H*) of *Ophiostoma piceae* in the luminina (*L*) of a pine tracheid. *A* appressorium, *T* boring canal through the activity of a transpressorium, *C* wood cell wall. (LM, from Liese and Schmid 1962); **b** Two transpressoria (EM, from Liese and Schmid 1966)

Strands (cords) (Fig. 2.6) develop in a number of house-rot fungi and usually consist of three hyphal types, vegetative hyphae, thin fiber (skeletal) hyphae with mostly thick walls for strengthening, and broad vessel hyphae for nutrient transport (Nuss et al. 1991). These hyphae form a distinct mycelium in the longitudinal direction, which is, however, not so well organized like the tissue-like structure of the rhizomorphs. Also in contrast to rhizomorphs, strands develop behind the mycelial growth front. Particularly *Serpula lacrymans* overgrows larger distances of non-woody substrates and penetrates through masonry

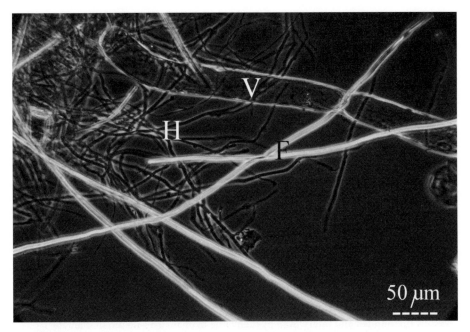

Fig. 2.6. Hyphae within a strand of *Serpula lacrymans*. *H* vegetative hyphae, *V* vessel hypha, *F* fiber hyphae (dark-field photo W. Liese)

(only through the joints) between bricks or through old, crumbly bricks, and insulation materials. In the laboratory, some house-rot fungi overgrew by means of strands agar that contained wood preservatives (Liese and Schmidt 1976) as well the fungal partner in dual culture.

In the literature, there is however not always a uniform use of the terms "strands (= cords)" and "rhizomorphs". For example, the strands of the American dry rot fungus, *Meruliporia incrassata*, have been termed rhizomorphs and were described as consisting of more or less parallel hyphae, outer (cortical) hyphae thick-walled and uniform in size (author: = fibers), inner (medullary) thin-walled hyphae, variable in size, and some differentiated into large conducting tubes (author: = vessels) (Palmer and Eslyn 1980). According to Burdsall (1991) "these two (*S. lacrymans*, *M. incrassata*) being similar and unique in forming large water-conducting rhizomorphs".

By means of his strand diagnosis, Falck (1912) was able to differentiate some house-rot fungi like *S. lacrymans*, *Coniophora puteana*, and *Antrodia vaillantii* macroscopically and microscopically. Table 2.4 shows an updated version for the above tree species based on recent measurements of mycelia in buildings and on agar cultures of genetically verified isolates.

As strand morphology is, after fruit body structure, a main feature to identify fungi growing indoors or an construction wood, an identification key for about

Table 2.4. Strand diagnosis for some common house-rot fungi (modified from Huckfeldt and Schmidt 2004, 2006)

Serpula lacrymans

Strands white, silver-grey to brown, more than 5 mm to 3 cm diameter, separable, with flabby mycelium in between, thick strands when dry breaking with clearly audible cracking (strands with mold contamination often not cracking any more), often in masonry; (*S. himantioides*: strands thinner than 2 mm and fibers 2–3.5 µm in diameter)

Vegetative hyphae hyaline, partly yellowish, with large clamp connections, 2–4 µm in diameter

Vessels at least partly numerous (in groups), 5–60 µm in diameter, not or rarely branched, with bar thickening up to 13 µm high

Fibers refractive, 3–5 µm diameter, straight-lined, stiff, septa not visible, no clamps, lumens often visible

Coniophora puteana, C. marmorata

Strands first bright, then brown to black, up to 2 mm wide, to 1 mm thick, root-like, hardly removable (not so in *C. marmorata*), when removed usually fragile, partly with brighter center, underlying wood becoming black, also in masonry

Vegetative hyphae usually without clamps, rarely multiple clamps (often indistinct when branched), 2–6 µm in diameter

Vessels surrounded and interwoven by many fine hyphae (0.5–1.5 µm in diameter), difficult to isolate (preparation with KOH solution); drop-shaped, hyaline to brownish secretions (1–5 µm in diameter) often on hyphae; vessels due to preparation irregularly formed or distorted, up to 30 µm in diameter, thin-walled (slightly thick-walled with *C. marmorata*), without bars, with septa

Fibers pale to dark brown, 2–4 µm in diameter, somewhat thick-walled, with relatively broad, usually visible lumen, some also branched, to be confused with generative hyphae

Antrodia vaillantii, A. serialis, A. sinuosa, A. xantha

Strands white to cream, partly somewhat yellowing or infected by molds, also ice flower-like, flexible also when dry, up to 7 mm in diameter, possibly also within masonry

Vegetative hyphae with few clamps, 2–4 µm in diameter, often somewhat thick-walled; in KOH somewhat swelling

Vessels not rare but in old strands difficult to isolate, up to 25 µm in diameter, thick-walled with middle lumen, without bars

Fibers hyaline (in *Antrodia xantha* partly somewhat yellowish), numerous, 2–4 µm in diameter, hyphal tips with tapering ending cell walls, straight-lined, mostly unbranched, insoluble in KOH, but partly somewhat swelling, then with "blown up" hyphal segments

20 strand-forming wood decay fungi based on Huckfeldt and Schmidt (2004, 2006) is given in Appendix 1.

The rhizomorphs of *Armillaria mellea* (Fig. 2.7) are tissue-like mycelial bundles with apical growth and consist of a black, gelatinous bark layer, followed by a pseudoparenchyma, and a central, loosely interwoven pith with vessel and

Fig. 2.7. Rhizomorph of *Armillaria mellea*. *Left*: Apex with hair-like microhyphae (*A*), cortex (*B*) and pith (*C*). (from Hartig 1882); *right*: cross section (LM; from Schmid and Liese 1970)

fiber hyphae (Hartig 1882). By means of rhizomorphs, *Armillaria* species grow in the soil and infect the roots of living trees (Chap. 8.3.1).

Under unfavorable conditions, resistance stages are formed. Spores are more resistant to heat, dryness, and wood preservatives than their mycelium. The hyphal cell water content is reduced, nutrients are concentrated, parts of the protoplasts or storage substances of neighboring cells are translocated in resting cells, and enzyme activity decreases ("latent life"). Chlamydospores (Fig. 2.8) are thick-walled spores with a brown cell wall, which occur in many blue-stain fungi.

Formerly, it was believed that the vegetative mycelium of some wood-decay fungi is also resistant to dryness (Chap. 3.3) and heat (Chap. 3.4). Recent results show that this must not be true: When cultured on agar at about 28 °C, the dikaryotic hyphae of *Serpula lacrymans* tend to revert to the monokaryotic condition, which regularly shows abundant arthrospores (Schmidt and Moreth-Kebernik 1990). In wood samples that were slowly dried or warmed, the substrate mycelium of *S. lacrymans*, *C. puteana*, *Donkioporia expansa*, and *Gloeophyllum trabeum* also formed arthrospores (Huckfeldt 2003). It was therefore assumed that these arthrospores are the agents for resistance against drying and heat.

2.2.2
Reproduction of Deuteromycetes

Fungi that reproduce asexually (anamorphic fungi) are either yeasts or Deuteromycetes. The term "yeast" is descriptive and stands for any fungus that reproduces by budding.

Deuteromycetes (Fungi imperfecti, colloquially: molds) is an artificial assemblage of fungi that reproduce asexually by conidia (conidiospores), either as the only form for propagation (imperfect fungi) or additionally (anamorph) to a sexual reproduction (teleomorph). When both the anamorph and the teleomorph are known, the fungus is called a holomorph (the whole fungus). The teleomorph may have one (mono-anamorphic) or many (pleo-anamorphic) asexual stages. In other words: Deuteromycetes are the conidia-producing forms of a fungus and may or may not be associated with a teleomorph. Many Deuteromycetes are supposed to have a teleomorph in the Ascomycetes, but they may also have basidiomycetous affinity. Also in the wood-inhabiting Deuteromycetes, the teleomorph often is of ascomycetous affinity as in the blue stain and soft-rot fungi, but some are anamorphs of Basidiomycetes like in the Root-rot fungus, *Heterobasidion annosum* [anamorph: *Spiniger meineckellus* (A.J. Olson) Stalp.; e.g., Holdenrieder 1989]. In the absence of a teleomorph, taxonomic affinity can be detected by the ultrastructure of the cell wall: Ascomycetes have two-layered walls, while the walls of Basidiomycetes are multilamellar. In terms of strict nomenclature, the teleomorph name takes precedence over the anamorph but in practice, a species is often identified according to the form in which it was found (Eaton and Hale 1993), like in the case of the wood-inhabiting molds *Aspergillus* and *Penicillium*.

The Deuteromycetes are usually divided in Coelomycetes and Hyphomycetes. Coelomycetes develop conidiophores within fruit bodies (conidiomata). In Hyphomycetes (or Moniliales), conidia develop on simple or aggregated hyphae. Conidium formation and conidiophore morphology are criteria to classify Deuteromycetes (Chap. 2.5). A simplified differentiation for wood-inhabiting Deuteromycetes (Fig. 2.8) distinguishes between conidiospore (free cell fragmentation at the hyphal tip or a branch) and sporangiospore (development in a sporangium).

Conidia of wood-inhabiting Deuteromycetes can be defined as mitotically developed (mitospores), immovable, mononuclear to more-nuclear, unicellular to more-celled, pigmentless (hyaline) to white, yellow, orange, red, green, brown, blue, or black colored (depending on the species) spores of different development, size, shape and surface (Fig. 2.9; Reiß 1997; Kiffer and Morelet 2000). The variety of the spore pigments causes that molded substrates may be colorful.

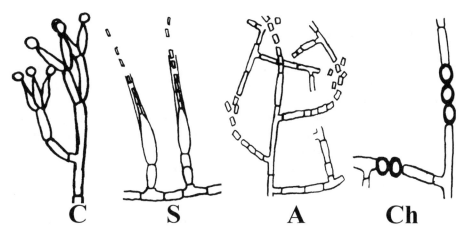

Fig. 2.8. Generalized view of conidia according to their development. *C* conidia, *S* sporangiospores, *A* arthrospores, *Ch* chlamydospores

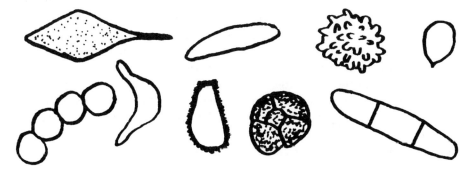

Fig. 2.9. Conidia. Example of the manifold shapes and structures

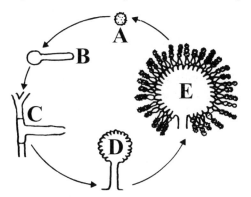

Fig. 2.10. Developmental cycle of a deuteromycete. *A* conidium, *B* germ hypha, *C* development of conidiophore, *D* development of vesicle, *E* vesicle with conidia

The series of spore germination, hyphal growth, and conidia production represents the asexual reproduction cycle of a deuteromycete fungus, illustrated in Fig. 2.10 by an *Aspergillus* species.

The biological advantage of the conidia production to the Deuteromycetes (and anamorphs of Asco- and Basidiomycetes) is that these fungi can exit from an exploited substrate to arrive fresh nutrients by spores (mitospores) in huge numbers without the need of preceding sexuality. Distributed randomly by and through the air or by adhering to the surface of animals, spores are present everywhere. Disadvantageous is that without (para)sexuality clones of an original hypha are distributed. Conidia can develop independently from the karyotic stage of the hypha that is anamorphs can occur both on haploid and dikaryotic mycelium.

2.2.3
Sexual Reproduction

A specific feature of the sexual reproduction of Ascomycetes and Basidiomycetes is that plasmogamy of haploid cells and karyogamy of two nuclei (n) to form a diploid nucleus (2n) are separated from each other temporally as well spatially by the dikaryophase (two-nuclei phase, dikaryon, n + n, ===) (Fig. 2.11). A dikaryotic hypha is one with two nuclei that derive from two haploid hyphae, but in which the nuclei are not yet fused by karyogamy.

Particularly in Basidiomycetes, the dikaryotic phase is considerably extended. By conjugated division of the two nuclei (conjugated mitosis), by division of the dikaryotic hypha, and by means of a special nucleus migration connected with clamp formation both daughter cells become again dikaryotic.

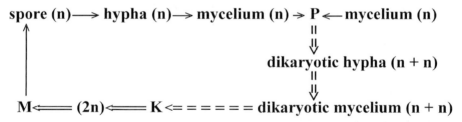

Fig. 2.11. Generalized scheme of nuclear condition of haplo-dikaryotic Ascomycetes and Basidiomycetes. → haploid (n), ===> dikaryotic (n + n), => diploid (2n), *P* plasmogamy, *K* karyogamy, *M* meiosis

2.2.3.1
Ascomycetes

The life cycle of a typical ascomycete is shown in Fig. 2.12 (also Müller and Loeffler 1992; Eaton and Hale 1993; Schwantes 1996; Jennings and Lysek 1999).

Haploid (n) spores (A, ascospores or conidia from an anamorph) germinate to haploid hyphae and after mitoses to haploid mycelium (B), which is

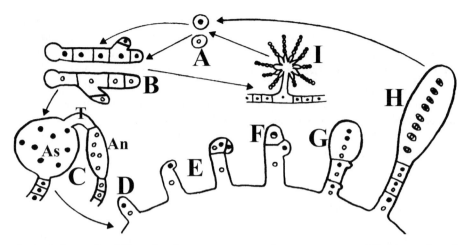

Fig. 2.12. Generalized life cycle of an euascomycete. *A* ascospores or conidia, *B* germinated monokaryons, *C* plasmogamy of ascogonium (*As*)-trichogyne (*T*) and antheridium (*An*), *D–G* section of ascogonium after incorporation of "male" nuclei, *D* ascogenous hypha, *E* hook formation, *F* karyogamy in the tip hypha, *G* dikaryon and ascus after meiosis, *H* ascus after mitosis with eight ascospores, *I* anamorph with conidia

the essential ascomycete with nutrition function and theoretically unlimited growth. Conidia may develop at the haploid mycelium as anamorph (I).

Within the fruit body, hyphae develop to gametangia ("sexual organs", C) connected with mitosis. The trichogyne (T, "copulation hypha"), which derives from the ascogonium (As, "female gametangium"), fuses (plasmogamy, gametangiogamy) with the antheridium (An, "male gametangium"). The nuclei from the antheridium migrate (therefore: male) through the trichogyne into the ascogonium. There may be various modifications of the generalized scheme: Antheridia are absent, and mono-nuclear spermatia (from an anamorph) fuse with the trichogyne (deuterogamy). Somatogamy of "normal" hyphae takes place (see Chap. 2.2.3.2). One sex is missing or not functional, and fertilization occurs between two nuclei of the same sex (automixis).

In the hymenial Ascomycetes (Ascohymeniales, wood-inhabiting Ascomycetes), the fruit bodies (ascocarps, ascomata) develop after the fertilization of the ascogonium from basal cells of the gametangia, and thus the fruit bodies predominantly consist of haploid hyphae (Fig. 2.13).

From the "pollinated" ascogonium, ascogenous hyphae develop, into which migrates each one pair of two genetically different (compatible) nuclei. In Ascomycetes, the dikaryotic phase is limited and without nutrition function. By means of hook formation (Fig. 2.12E) the short-lived hook mycelium and the ascus (meiosporangium) develop, in which karyogamy and meiosis occur. Before ascospore formation, there is commonly an additional mitosis, which brings the number of ascospores (meiospores) in the ascus to eight. The mature

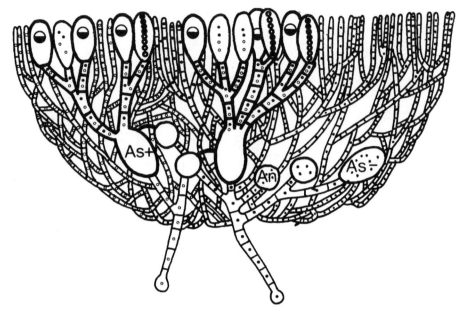

Fig. 2.13. Structure of a fruit body (apothecium) of an ascomycete predominantly consisting of haploid hyphae (*thin lines*, one nucleus), some dikaryotic hyphae (*thick lines*, two nuclei) and differently matured asci within the hymenium. *As-, An* ascogonium and antheridium before gametangiogamy, *As+* fertilized ascogonium

ascus is usually tube-shaped ("tube fungi"). The non-flagellate ascospores disper after disintegration of the ascus or via different opening mechanisms. The ascospores are mono-nuclear or after further mitosis multi-nuclear. They can be septate and show similar conidia characteristics of size, shape, color and wall sculpturing.

The relatively small fruit bodies (less than 1 mm in diameter) of the wood-inhabiting Ascohymeniales are the spherically closed cleistothecium, the pear-

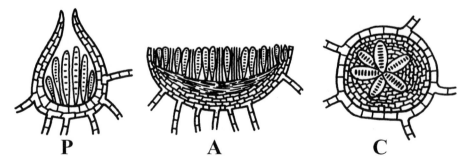

Fig. 2.14. Fruit body types of Ascomycetes. *P* perithecium, *A* apothecium, *C* cleistothecium

shaped perithecium, e.g., in several blue-stain fungi, or the disk-shaped apothecium (Fig. 2.14).

2.2.3.2
Basidiomycetes

The life cycle of a typical basidiomycete is schematically represented in Fig. 2.15.

The haploid basidiospore or conidium (A) germinates to the n-mycelium (B, monokaryon, primary mycelium). There are also asexual anamorphs in Basidiomycetes. According to Müller and Loeffler (1992), asexual anamorphs are supposed to occur almost just as frequently as in Ascomycetes: "they are named however only rarely with an own name, therefore hardly considered in the system of the Deuteromycetes and would be more frequent in the dikaryotic phase". A known example among the wood-decay Basidiomycetes is *Heterobasidion annosum* with its anamorph *Spiniger meineckellus*.

In the laboratory, monokaryons are capable of indefinite growth if they are regularly subcultured on fresh medium. In nature, characteristically the dikaryon or secondary mycelium develops. Basidiomycetes do not form sexual organs for plasmogamy, but monokaryotic hyphae come into contact one with another and fuse by somatogamy (C). If the nuclei are compatible, the dikaryon develops (D). This long-lived mycelium (Schwantes 1996) represents the essential basidiomycete that penetrates the substratum and absorbs nourishment, in the case of wood fungi with wood-decay function (D–G). In about half of the Basidiomycetes, the dikaryon grows by clamp connections (clamp mycelium):

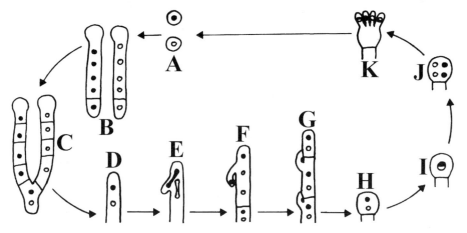

Fig. 2.15. Generalized life cycle of a homobasidiomycete. *A* basidiospores or conidia, *B* monokaryons after germination, *C* somatogamy, *D* dikaryon, *E–G* clamp formation, *H–K* basidium development, *I* karyogamy, *J* meiosis, *K* basidium with four basidiospores located in sterigmata

A short branch arises on the side of the apical hypha and bends over. After synchronous ("conjugate") division of the two nuclei (E), two daughter nuclei remain in the apical cell, one nucleus migrates into the branch (F), the branch end fuses with the subapical cell, and by septum formation, two dikaryotic hyphae have developed (G). Repeated conjugate divisions accompanied by septum formation result in an extensive dikaryotic mycelium (Jennings and Lysek 1999). Sometimes there are double or multiple (whorl) clamps (maximally eight) around one septum, e.g., in *Coniophora puteana* (four clamps). In a second method of dikaryotization, there is a division of the nuclei in the binucleate hypha followed by a migration of the daughter nuclei into the primary mycelium of the opposite mating type. The foreign nucleus in each mycelium divides and its progeny migrate from hypha to hypha through the septal pores until both parent mycelia have been dikaryotized (Alexopolus and Mims 1979).

Depending on external factors, like season (temperature, air humidity), nutrients and light, large fruit bodies (tertiary mycelium, basidiocarp, basidioma) develop on the secondary mycelium (Fig. 2.16).

In the fruit body of the hymenomycetes, the hymenium (fertile layer) develops (Fig. 2.16), in which the formation of basidia occurs (Fig. 2.15H–K). For

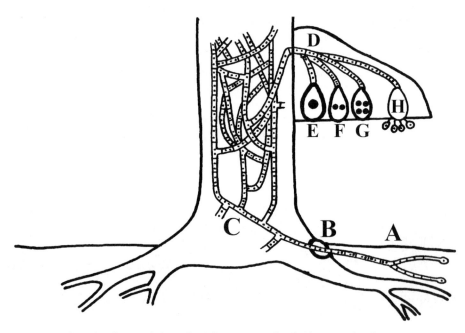

Fig. 2.16. Life cycle of a wood-decay basidiomycete. *A* haploid spores, hyphae, somatogamy and dikaryotic growth in the soil, *B* infection of the tree through a wound, *C* tree deterioration by the dikaryon, *D* fruit body formation (bracket); in the hymenium: *E* karyogamy, *F, G* meiosis, *H* mature basidium with four basidiospores

surface enlargement the hymenium may be e.g., net-like arranged (merulioid, *S. lacrymans*), warted (*C. puteana*), porous (*A. vaillantii*), or lamellate (*Armillaria mellea*). In the young basidium (Fig. 2.15H), karyogamy (I) and meiosis (J) occur. Four haploid nuclei migrate into outgrowths (sterigmata) at the top of the basidium (K) and are discharged as basidiospores.

The spore size (5–20 µm), shape (globose, cylindric, ellipsoid etc.), surface sculpturing ("ornamentation": warted, crested, etc.), wall-thickness (thin-walled, double wall) (Ryvarden and Gilbertson 1993) and color (colorless or pigmented: white, yellow, orange, ochre, pink, brown, green, violet, black) are taxonomic characteristics. In the microscope, spores appear frequently bright to colorless (hyaline), e.g., in *Daedalea quercina*, *Fomes fomentarius*, *H. annosum*, *Laetiporus sulphureus*, *Piptoporus betulinus* and *Trametes versicolor*. Brownish spores separate e.g., the genus *Serpula* from other fungi with merulioid hymenium (Pegler 1991). Further characteristics are the violet-staining of amyloid spores (e.g., *Stereum sanguinolentum*) and the brown-red staining of dextrinoid spores by JJK as well as the blue-staining of cyanophilic spores (*C. puteana*, *H. annosum*, *Oligoporus placenta*) by aniline blue (e.g., Erb and Matheis 1983).

For the differentiation of the various fruit body types serve, e.g., the occurrence of sterile cells (cystidia) between the basidia (e.g., *Antrodia* spp. and *Gloeophyllum* spp.) and the construction of basidiocarps consisting of vegetative hyphae (monomitic), additionally of either skeletal or binding hyphae (dimitic) or of all three hyphal types (trimitic). Monomitic genera are *Coniophora*, *Meripilus* and *Phaeolus*, dimitic are *Antrodia*, *Heterobasidion*, *Hirschioporus*, *Laetiporus* and *Phellinus*, and trimitic are *Daedalea*, *Fomes* and *Trametes*.

Most wood-inhabiting Basidiomycetes belong to the Homobasidiomycetes (formerly Holobasidiomycetes: single-celled basidium) and there to the Aphyllophorales with gymnocarpous (hymenium exposed while spores are still im-

Fig. 2.17. Common types of fruit bodies of wood-inhabiting Basidiomycetes. **a** Pileate with central stipe (*Lentinula edodes* cultured on wood by J. Liese in 1935). **b** Bracket-like (*Piptoporus betulinus* on a birch tree, photo T. Huckfeldt). **c** Resupinate (*Serpula lacrymans* in a building)

mature) and non-lamellate fruit bodies. The Aphyllophorales show a number of different types of fruit bodies whose attachment to the substrate may also be rather distinctive: stalked, coral-like, club-like, bracket-like, resupinate, etc. (Ryvarden and Gilbertson 1993, 1994; Schwantes 1996). Simplistically, fruit bodies may be grouped into pileate with central stipe, bracket-like, and resupinate (Fig. 2.17). Fruit bodies may be annual (passing after spore discharge), biannual or perennial (every year new hymenial layers laid on the preceding ones).

2.2.4
Fruit Body Formation

Fruit body initiation and development that occurs usually outside of the substrate are affected by various exogenous factors: humidity, temperature, light, nutrition, force of gravity, composition of air, and interactions with other organisms (Schwantes 1996). Endogenous factors cover the participation of phenol oxidases and other enzymes, cyclic adenosine monophosphate (AMP) and genes. Fruit body formation is often promoted by conditions, e.g., warmth in *S. lacrymans*, which are unfavorable for the vegetative development.

In fungi that are not tolerant to dryness, like *Pholiota* and *Pleurotus* species, the fruit bodies frequently have a fleshy consistency and lose when drying their function irreversibly, so that in the northern hemisphere many forest fungi with annual fruit bodies preferentially fructify in damp-cool weather in the autumn. Dry-tolerant fruit bodies, like in *Schizophyllum commune*, continue spore production under humid conditions after dryness for many years. Others reduce the evaporation by hairy or "varnished" surfaces, like *Inonotus* and *Ganoderma* species. The concentric zonation of the pileus surface (rough and smooth in the change) of *Trametes versicolor* is influenced by humidity variation and the different colors of the individual zones by light and dark phases (Williams et al. 1981). In *Coprinus comatus,* fruit body primordia do not develop further without light (Jennings and Lysek 1999). Short-wave light (UV, blue) may influence fruit body development (Schwantes 1996). The Oyster fungus, *Pleurotus ostreatus,* only fruits below 16 °C (Chap. 9.2), and the less tasty subspecies *P. ostreatus* ssp. *florida* at a higher temperature. Fruit bodies of the Winter fungus, *Flammulina velutipes,* appear also after snowfall. *Serpula lacrymans* fruits in the laboratory after a stimulating pretreatment of the mycelium for 3 – 4 weeks at the submaximal temperature of 25 °C (Schmidt and Moreth-Kebernik 1991b; Chap. 3.4). *Lentinula edodes* is stimulated during its cultivation on wood in Asia by a cooling treatment. *Schizophyllum commune* fruits already on simple nutrient agar at room temperature. *Gloeophyllum trabeum* (Croan and Highley 1992a) and *L. edodes* (Leatham 1983) fructified on defined growth media. AMP was suitable for a *Coprinus* species (Uno

and Ishikawa 1973). Yeast extract, vitamin B$_1$, traumatic influences through physical distortions to the mycelium, and the presence of another fungus or its mycelial extract or culture filtrate may be favorable (Stahl and Esser 1976; Leslie and Leonard 1979; Matsuo et al. 1992; Kawchuk et al. 1993). In *S. commune*, the development of a fruit-body-inducing substance (FIS) is genetically controlled (Leslie and Leonard 1979). In a *Polyporus* species, there are fi+ genes (fruiting initiation) (Stahl and Esser 1976; Esser 1989). The force of gravity determines that the yearly hymenial layers in the bracket-like, perennial fruit bodies of *Fomes fomentarius* also point to the earth center if the host tree is lying on the ground (Chap. 3.6).

2.2.5
Production, Dispersal and Germination of Spores

Spores represent in the life cycle of a fungus a state of rest (low water content, high nutrient content; "latent life") between the active phase of spore dispersal and start of new growth.

Serpula lacrymans produces 300,000 (Falck 1912) to 360,000 (Rypáček 1966) and *Piptoporus betulinus* 31,000,000 (Kramer 1982) spores per hour and cm^2 of hymenium. Many forest mycorrhizal fungi fruit at higher air moisture content and lower temperature in the autumn. Among the tree parasites, *Heterobasidion annosum* disperse spores almost over the whole year, *Laetiporus sulphureus* in the autumn.

Many Basidiomycetes disperse their spores actively for 0.1–0.2 mm (ballistospores) so that the spores more easily reach the open air (Schwantes 1996). In *Schizophyllum commune*, a liquid drop at the sterigma becomes larger and hurls the spore into the airflow (Müller and Loeffler 1992). Möykkynen (1997), using a wind tunnel, measured for the conidia of *Heterobasidion annosum* that a threshold speed of an airflow of 1.8 m/s liberates the spores.

Falck (1912) calculated the mass of a spore of *S. lacrymans* as 171×10^{-12} g. Fungal spores exhibit a density of 1.1 d$_p$. In standing air, spores sink with sedimentation speeds of 0.03–0.55 cm/s (Reiß 1997). A continuously colonized area can expand 50 km over the year. In an appropriate air stream, spores can be transported up to 1,000 km (Burnett 1976). Furthermore, spores are spread by rain and snow. Animals distribute spores that are attached by the spore surface sculpturing (see Fig. 2.9) or remain indigested. Assumably by international trade, the causal agent of the Dutch Elm disease, *Ophiostoma ulmi*, was imported from Asia to Europe in 1918 (Chap. 8.1.2.1).

The spore content in air is subject to characteristic rhythms. In Central Europe, it is higher in the summer at warm temperatures and low relative air humidity than in the winter. Basidiospores and ascospores are numerous in the air in spring and in autumn. Conidia have a maximum from June

to September. In cities in temperate regions, the spore concentration of *Cladosporium*, mainly *C. herbarum*, often rises up to $10,000-15,000$ spores/m^3 air with peaks of more than 50,000 spores/m^3 (Nolard 2004). Air turbulence during stable areas of high pressure may result in daily rhythms, the concentration rising during the midday (Reiß 1997). Interiors with high dust content (e.g., the wood-processing industry) may exhibit increased spore contents. The lifespan of spores in free air is affected by temperature, air humidity, and sun exposure. As unpigmented spores are sensitive to UV light, pigmented spores predominate in the air. Exogenously dormant spores only germinate when the environmental conditions (nutrients, temperature, pH value) become favorable. Endogenously dormant spores fail to germinate even under favorable conditions, which is due to factors within the spore such as nutrient impermeability or the presence of endogenous inhibitors. Dormancy within these spores is broken by ageing when nutrients begin to enter or the inhibitors leach out (Robson 1999).

Prior to the emergence of one or more germ tubes, spores undergo a process of swelling during which they increase in diameter due to the uptake of water. The metabolic activity, production of protein, DNA and RNA all increase.

The percentage of germinating spores depends on fungal species, spore age, temperature, available moisture, and substrate. In *Serpula lacrymans*, only 30% of sampled spores germinated in vitro (Hegarty et al. 1987). For the conidia of *Heterobasidion annosum*, the thermal cardinal points were 0 °C minimum, between 12 and 28 °C optimum and 34 °C maximum (Courtois 1972). Depending on the species, the duration of the germination ability reaches from a few days or weeks, like in *Stereum* species, to several years in *Chaetomium globosum*, and can reach up to about 20 years in *S. lacrymans* (Grosser et al. 2003).

Germination of spores of wood fungi is favored by high air humidity, warmth, and pH values of 4–6. In *Serpula lacrymans*, citric acid (Hegarty et al. 1987) and vitamin B$_1$ (Czaja and Pommer 1959) stimulated germination. Heartwood compounds may inhibit.

2.3
Sexuality

The wood-inhabiting Ascomycetes and Basidiomycetes are either homothallic or heterothallic (Ryvarden and Gilbertson 1993).

Homothallic fungi are self-fertile, that is no second mating type is required for sexual reproduction. Fertilization takes place at the same mycelium. Many Ascomycetes and about 10% of the Basidiomycetes belong to this type.

Heterothallism includes both bipolar and tetrapolar fungi. In bipolar (unifactorial) species, incompatibility is controlled by a series of multiple alleles at one locus. Any dikaryon has two alleles that segregate at meiosis so that half

the basidiospores have one allele and half the other. Compatible matings occur between monokaryons with different mating type factors. The inbreeding level is 50%. The outbreeding level in populations of bipolar polypores is over 90%.

In tetrapolar (bifactorial) species, incompatibility is controlled by two series of multiple alleles at two loci on different chromosomes. The two pairs segregate independently at meiosis. Four different mating types rise from one dikaryon. In a fruit body of an isolate, basidiospores of the mating type A_xB_x, A_xB_y, A_yB_x and A_yB_y develop. These spores germinate to monokaryons. Fully compatible matings of monokaryons (+ in Table 2.5) occur when both factors are heterozygous (A#B#): A_xB_x and A_yB_y as well as A_xB_y and A_yB_x. In addition, there are hemicompatible matings, in which only one factor is different: A_xB_x and A_xB_y as well as A_yB_y and A_xB_y.

The inbreeding level is 25%. The outbreeding level is very high. In *Schizophyllum commune* 450 A factors and 90 B factors can combine to over 40,000 mating types (Raper and Miles 1958). Many Ascomycetes and about 25% of the examined Basidiomycetes are bipolar heterothallic (e.g., *Oligoporus placenta*). About 65% Basidiomycetes are tetrapolar (Raper 1966). Bipolar mating predominates among brown-rot fungi and tetrapolar mating among white-rot fungi (Rayner and Boddy 1988). Of 25 investigated brown-rot polypores, 17 were bipolar, three were tetrapolar, three were heterothallic with type of mating system undetermined, one was homothallic, and one was reported by different authors as bipolar and tetrapolar (Ryvarden and Gilbertson 1993). The biological significance of heterothallism is that inbreeding is limited and outbreeding is enhanced, promoting gene flow between populations and decreasing the rate of speciation.

Combination and recombination of the genetic material with plasmogamy, karyogamy, and haploidization, but without sexual organs, gamets and changes of generations, can take place by parasexuality, particularly in Deuteromycetes (Jennings and Lysek 1999). Nuclei of a hypha migrate by anastomosis into another hypha and multiply and spread there. In the case of a heterokaryon,

Table 2.5. Mating scheme of tetrapolar heterothallic fungi

	A_xB_x	A_xB_y	A_yB_x	A_yB_y
A_xB_x	–	A	B	+
A_xB_y	A	–	+	B
A_yB_x	B	+	–	A
A_yB_y	+	B	A	–

– incompatible (A=B=), + compatible (A#B#)
A common-A heterokaryon (A=B#): conjugate nuclear division and clamp formation blocked, variable nucleus content per hypha,
B common-B heterokaryon (A#B=): nuclear migration and clamp cell fusion blocked ("false clamps")

some nuclear fusions and after haploidization new combinations occur. Usually, the diploid nuclei are unstable, and their ploidy number is regulated to the haploid stage by elimination of chromosomes or discharge of sections (Müller and Loeffler 1992).

Illustrated by the tetrapolar heterothallic *Serpula lacrymans*, interstock mating of ten isolates is demonstrated in Table 2.6 (Schmidt and Moreth-Kebernik 1991c). First, the four different mating type monokaryons of each isolate were obtained after fruit body stimulation (Schmidt and Moreth-Kebernik 1991b) and subsequent inbreeding according to Table 2.5. Then the 10×4 monokaryons were paired one with another in all possible combinations on agar. As in *S. lacrymans*, like in many Basidiomycetes, only the dikaryon forms clamps, it can be detected in the light microscope. In contrast, only the monokaryons of the fungus show abundant arthrospores. The heterokaryons of the type A=B# and the "false clamps" mycelia (A# B=) can be recognized from the mating diagram by calculation or by further pairings. The mating types of the isolate monokaryons are shown in the upper table part.

The mycelium of the F_1-dikaryons of *S. lacrymans* grew faster at about 20 °C than that of the two parental monokaryons (Schmidt and Moreth-Kebernik 1991a), like this applies also to *Lentinula edodes* (Schmidt and Kebernik 1987) and *Stereum hirsutum* (Rayner and Boddy 1988). Thus, dikaryotic mycelium, which grows out from compatible monokaryons, looks like a bow tie (Fig. 2.18), that is, dikaryons can usually be detected macroscopically.

In a sample of ten isolates, theoretically 20 different A and B factors can occur. In the *S. lacrymans* sample, there were however only four A and five B factors. This limited number of mating alleles contrasts with the regular observation of a high number of mating alleles in other Basidiomycetes (May et al. 1999) and indicated that *S. lacrymans* has a narrow genetic base.

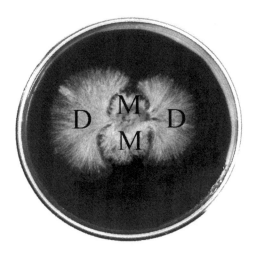

Fig. 2.18. Bow tie-like outgrowth of the faster growing dikaryon (*D*) of *Serpula lacrymans* from the slowly growing monokaryons (*M*)

Table 2.6. Pairings among the four mating types of ten isolates of *Serpula lacrymans* (from Schmidt and Moreth 1991b)

Isolate	16	5	11	12	14	2	3	27	28
Mating type	A A A A	A A A A	A A A A	A A A A	A A A A	A A A A	A A A A	A A A A	A A A A
	2 3 2 3	3 4 3 4	1 1 4 4	1 1 2 2	4 3 4 3	1 1 3 3	2 1 2 1	4 3 4 3	3 2 3 2
	B B B B	B B B B	B B B B	B B B B	B B B B	B B B B	B B B B	B B B B	B B B B
	3 3 1 1	1 1 4 4	4 2 4 2	2 5 2 5	1 1 4 4	4 2 4 2	4 4 3 3	1 1 2 2	1 1 3 3
7 A1B1	+ + B B	B B + +	A A + +	A A + +	B B + +	A A + +	+ A + A	B B + +	B B + +
A1B2	+ + + +	+ + + +	A - + B	- A B +	+ + + +	A - + B	+ A + A	+ + B B	+ + + +
A2B1	A + - B	B B + +	+ + + +	+ + A A	B B + +	+ + + +	A + A +	B B + +	B - + A
A2B2	A + A +	+ + + +	+ B + B	B + - A	+ + + +	+ B + B	A + A +	+ + B B	+ A + A
16 A2B3		+ + + +	+ + + +	+ + A A	+ + + +	+ + + +	A + - B	+ + + +	+ A B -
A3B3		A + A +	+ + + +	+ + + +	+ A + A	+ + B A	+ + B B	+ A + A	A + - B
A2B1		B B + +	+ + + +	+ + A A	B B + +	+ + + +	A + A +	B B + +	B - + A
A3B1		- B A +	+ + + +	+ + + +	B - + A	+ + A A	+ + + +	B - + A	- B A +
5 A3B1			+ + + +	+ + + +	B - + A	+ + A A	+ + + +	B - + A	- B A +
A4B1			+ + A A	+ + + +	- B A +	+ + + +	+ + + +	- B A +	B B + +
A3B4			B + B +	+ + + +	+ A B -	B + - A	B B + +	+ A + A	A + A +
A4B4			B + - A	+ + + +	A + - B	B + B +	B B + +	A + A +	+ + + +
11 A1B4				A A + +	+ + B B	- A B +	B - + A	+ + + +	+ + + +
A1B2				- A B +	+ + + +	A - + B	+ A + A	+ + B B	+ + + +
A4B4				+ + + +	A + - B	B + B +	B B + +	A + A +	+ + + +
A4B2				B + B +	A + A +	+ B + B	+ + + +	A + - B	+ + + +
12 A1B2					+ + + +	A - + B	+ A + A	+ + B B	+ + + +
A1B5					+ + + +	A A + +	+ A + A	+ + + +	+ + + +
A2B2					+ + + +	+ B + B	A + A +	+ + B B	+ A + A
A2B5					+ + + +	+ + + +	A + A +	+ + + +	+ A + A
14 A4B1						+ + + +	+ + + +	- B A +	B B + +
A3B1						+ + A A	+ + + +	B - + A	- B A +
A4B4						B + B +	B B + +	A + A +	+ + + +
A3B4						B + - A	B B + +	+ A + A	A + A +
2 A1B4							B - + A	+ + + +	+ + + +
A1B2							+ A + A	+ + B B	+ + + +
A3B4							B B + +	+ A + A	A + A +
A3B2							+ + + +	+ A B -	A + A +
3 A2B4								+ + + +	+ A + A
A1B4								+ + + +	+ + + +
A2B3								+ + + +	+ A B -
A1B3								+ + + +	+ + B B
27 A4B1									B B + +
A3B1									- B A +
A4B2									+ + + +
A3B2									A + A +

Within each isolate, dikaryons develop between 1st/4th and 2nd/3rd monokaryons, respectively.

+ dikaryon formation with clamps requiring A#B#

− no dikaryon formation caused by A=B=

A common-A heterokaryon (A=B#)

B common-B heterokaryon (A#B=)

The matings in *S. lacrymans* have also shown some physiological differences between the mycelia of the different nuclear types. However, there was also consistency over the generations (parents as well as F_1 and F_2 generation), namely with regard to the growth rate, wood decay ability, as well as temperature and preservative tolerance (Chap. 8.5.3.4).

Interfertility/intersterility tests are a useful criterion for the identification of unknown isolates and for separation of very similar species. Mating of

a haploid mycelium with defined tester strains whose species affiliation is known only results in a dikaryotic/diploid mycelium if the isolate belongs to the same species. Mating is also possible between dikaryotic/diploid mycelium and monokaryotic/haploid mycelium (Buller phenomenon) in this way that one nucleus of the dikaryon enters a monokaryon of the same species. Complete absence of interfertility between monokaryons of the True dry rot fungus, *S. lacrymans,* and the Wild dry rot fungus, *Serpula himantioides,* (Harmsen et al. 1958) showed that both fungi are independent species. That is the True dry rot fungus should no more described as domestic variant of the wild species adapted to buildings, which was later confirmed by DNA techniques (Chap. 2.4.2.2).

Intersterility must be approached cautiously, however, because intersterile populations (intersterility groups, ecotypes) occur that cannot be separated morphologically. For example, in *Heterobasidion annosum* (Chase and Ullrich 1990), monokaryons isolated from fruit bodies sampled in pine forests (P-isolates) did not pair with isolates from spruce trees (S-isolates) (Korhonen 1978a), and F-isolates were specialized for fir (Capretti et al. 1990). The different groups have been recently attributed to three distinct species (Niemelä and Korhonen 1998). Comparably, the five intersterility groups A, B, C, D, E within the annulate *Armillaria mellea* complex (Korhonen 1978b) were assigned to five biological species (Guillaumin et al. 1993). For edible mushrooms of the *Pleurotus* species, three North American, eight European, and five Asian intersterility groups have been found (Bao et al. 2004a).

Another genetic system referred to as somatic or vegetative incompatibility restricts plasmogamy between genetically different heterokaryotic dikaryons. In 1929, *Fomitopsis pinicola* was the first basidiomycete to be studied by means of somatic incompatibility (cf. Högberg et al. 1999). The somatic incompatibility system can be defined as the rejection of nonself mycelia following hyphal anastomosis (Worrall 1997), thus assuring the isolation of unrelated individuals in nature. Cultures of the same genotype form a common mycelium, while cultures of different genotypes of a species or of different species separate themselves by a demarcation zone. Two isolates are incompatible if they carry different alleles at one or more *vic* loci. Self/nonself recognition is normally related to genetic uniqueness (Hansen and Hamelin 1999). Thus, there is a correspondence between the delimitation of genets by DNA fingerprints and vegetative compatibility tests. In some Basidiomycetes, however, vegetatively compatible isolates are not necessarily genetically identical or similar individuals, clones or genets, but closely related genets by chance may share similar vegetative compatibility alleles and do not recognize self from nonself. Kauserud (2004) grouped the European isolates of *S. lacrymans* into five widespread vegetative compatibility groups (VCGs). Due to low genetic variation of the fungus, the VCGs may not represent clones or inbred lineages, but rather different genets by chance share similar *vic* alleles (Kauserud et al. 2004a).

In addition to the pairing of compatible monokaryons to insert genetic material in a fungus from another isolate, fusion of fungal protoplasts can be performed. Protoplast fusion can be used to make hybrids between cells of the same mating type, as well as of dikaryotic cells or even between species and genera. Spheroplasts (cell wall partially removed by lysing enzymes) or protoplasts (cell wall completely removed) fuse by electric influence or through osmotic active substances (polyethylene glycol) and some of them regenerate to new hyphae. Protoplast fusion is used for genetic studies as well as for isolate improvement. Experiments on wood fungi comprise, e.g., *Auricularia polytricha, Gloeophyllum trabeum, Heterobasidion annosum, Lentinula edodes, Oligoporus placenta, Ophiostoma piceae, O. ulmi, Phanerochaete chrysosporium, Pleurotus ostreatus, Trametes versicolor,* and *Trichoderma* spp. (Nutsubidze et al. 1990; Trojanowski and Hüttermann 1984; Royer et al. 1991; Sunagawa et al. 1992; Rui and Morrell 1993; Richards 1994; Tokimoto et al. 1998; Bartholomew et al. 2001; Xiao and Morrell 2004). Interspecific fusions (Toyomasu and Mori 1989; Eguchi and Higaki 1992) and intergeneric fusions (Liang and Chang 1989) were reported. With increasing genetic distance of the fusion partners, however, the hybrids are instable, do no fruit, die, or the obtained fruit bodies correspond to one of the parents, that is, obviously one of the two nuclei has been eliminated before.

Protoplasts have been produced from *O. piceae* with the aim of subsequently inserting genetic material capable of producing fluorescent proteins to allow visualization of hyphae of that species in wood by using fluorescence microscopy (Xiao and Morrell 2004).

2.4
Identification

2.4.1
Traditional Methods

Determination keys and descriptions for Deuteromycetes are based on morphology, color, and development (conidiogenesis) of conidia and conidiogenous cells (Figs. 2.8–2.10) (Carmichael et al. 1980; Domsch et al. 1980; v. Arx 1981; Wang 1990; Hoog and Guarro 1995; Schwantes 1996; Kiffer and Morelet 2000; Samson et al. 2004).

The fruit bodies of Ascomycetes and Basidiomycetes serve to identify species on the basis of macro- and microscopic characteristics using keys or illustrated books: Kreisel 1961; Domański 1972; Domański et al. 1973; Breitenbach and Kränzlin 1981, 1986, 1991, 1995; Moser 1983; Jülich 1984; Hanlin 1990; Jahn 1990; Wang and Zabel 1990; Ryvarden and Gilbertson 1993, 1994; Huckfeldt and Schmidt 2005; yeasts: Barnett et al. 1990). There are identification kits

for yeasts that employ assimilation tests of carbohydrates with a specifically adapted database, and also growth tests on carbon sources that are bound to a tetrazolium dye (Mikluscak and Dawson-Andoh 2005). An illustrated key for wood-decay fungi is in the Internet (Huckfeldt 2002).

For wood-inhabiting Basidiomycetes, of which only mycelium is present, keys are based on microscopic characteristics of the hyphae and on growth parameters (Davidson et al. 1942; Nobles 1965; Stalpers 1978; Rayner and Boddy 1988; Lombard and Chamuris 1990). Among the physiological characteristics, the Bavendamm test for the differentiation of brown- and white-rot fungi is based on the presence/absence of the phenol oxidase laccase (Bavendamm 1928; Davidson et al. 1938; Käärik 1965; Niku Paavola et al. 1990; Tamai and Miura 1991; Chap. 4.5). Specific reactions to temperature (Chap. 3.4) provide further information. However, keys for mycelia are unable to differentiate closely related fungi such as the various *Antrodia* and *Coniophora* species. The strand diagnosis of Falck (1912; Table 2.4, Figs. 8.19–8.21) differentiates few indoor decay fungi like *Serpula lacrymans*, *Coniophora puteana* and *Antrodia vaillantii*. As house-rot fungi are the economically most important wood fungi by destroying wood during its final use within buildings and as not all indoor fungi fruit, a key including about 20 strand-forming indoor wood decay fungi (Huckfeldt and Schmidt 2004, 2005, 2006) is given in Appendix 1.

In addition, there are monographs and descriptions of important tree pathogens (e.g., *Ceratocystis* and *Ophiostoma* species: Upadhyay 1981; Wingfield et al. 1999; *Armillaria* species: Shaw and Kile 1991; *Heterobasidion annosum*: Woodward et al. 1998) and of wood-degrading Basidiomycetes (Cockcroft 1981; Ginns 1982) with data to taxonomy, morphology, ecology, growth behavior, and wood degradation in the laboratory and outside. A further possibility for identification is by national institutions against fee (Table 2.7).

A list of collections and institutions with strain collections, compiled by German Collection of Microorganisms and Cell Cultures, is in the Internet (www.dsmz.de/species/abbrev.htm). Sixty-one culture collections in 22 European countries are united in the European Culture Collections' Organisation (ECCO; www.eccosite.org). The World Federation of Culture Collections (WFCC; www.wfcc.info/index.html) is a worldwide database on culture resources comprising 499 culture collections from 65 countries.

Table 2.7. Examples of institutions for identification, deposition, and purchasing of microorganisms

German Collection of Microorganisms and Cell Cultures (DSMZ), Braunschweig
Centraalbureau voor Schimmelcultures (CBS), Baarn, Netherlands
International Mycological Institute (IMI), Kew, UK
Belgian Coordinated Collections of Microorganisms (BCCM), Gent
American Type Culture Collection (ATCC), Rockville

2.4.2
Molecular Methods

Molecular methods to characterize, identify, and classify organisms do not depend on the subjective judgment of a human being as it might occur using classical methods, but are based on the objective information (molecules) deriving from the target organism. Thus, molecular methods are increasingly used to identify organisms and for taxonomy research (molecular systematic). In the 1980s, molecular methods were established for wood-decay and staining fungi. Mainly, the fungal proteins (enzymes) and nucleic acids are used. It is outside the intention of this book to describe all molecular techniques that are currently used in the field of biology. The following overview comprises only some methods and results that are related to the characterization, identification, and phylogeny of wood-inhabiting fungi, particularly wood-decay fungi. Genome sequencing (meanwhile over 100 genomes are sequenced), molecular engineering, cloning, etc. are briefly addressed in other chapters. As an example of the latter, Lee et al. (2002) transformed the wild-type and the albino strain of the blue-stain fungus *Ophiostoma piliferum* with a green fluorescent protein (GFP) to microscopically differentiate the GPF-expressing fungi from other fungi in wood.

2.4.2.1
Protein-Based Techniques

SDS polyacrylamide gel electrophoresis (SDS-PAGE)
In SDS-PAGE, the whole cell protein is extracted from fungal tissue, denatured, and negatively charged with mercaptoethanol and sodium dodecyl sulfate (SDS). The proteins are separated according to size on acrylamide gels and visualized by Coomassie blue, amido black, fast green, imidazole-zinc or silver staining. The banding pattern obtained discriminates at the species level and slightly below.

SDS-PAGE was used for wood-inhabiting Ascomycetes and Deuteromycetes like the Cancer stain disease fungus of plane, *Ceratocystis fimbriata* f. *platani*, (Granata et al. 1992) and *Trichoderma* species (Wallace et al. 1992).

The technique also differentiated a number of wood-decay fungi (Schmidt and Kebernik 1989; Vigrow et al. 1989, 1991a; Schmidt and Moreth-Kebernik 1991a, 1993; Palfreyman et al. 1991; McDowell et al. 1992; Schmidt and Moreth 1995). For example, the closely related *Serpula lacrymans*, *S. himantioides* and the "American dry rot fungus", *Meruliporia incrassata*, were distinguished (Schmidt and Moreth-Kebernik 1989a). Figure 2.19 shows that the technique also detected a misnamed isolate of *S. lacrymans*.

In addition, monokaryons and F_1 dikaryons of *S. lacrymans* exhibited the typical species profile (Schmidt and Moreth-Kebernik 1990). There was no need

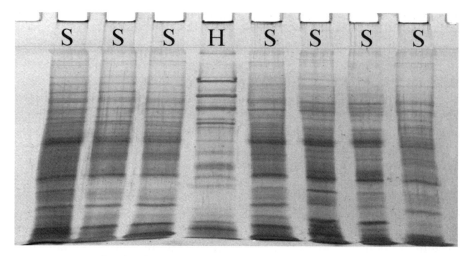

Fig. 2.19. Protein bands of *Serpula lacrymans* isolates (*S*) after SDS polyacrylamide gel electrophoresis. *H* false naming later identified as *S. himantioides* (from Schmidt 2000)

to extrapolate on a possible influence of culture age or medium composition (Schmidt and Kebernik 1989).

SDS-PAGE is fast when the sample originates from a pure culture and can be performed within 1 day. Reproducible homemade gels require accuracy and precautions, as acrylamide is carcinogenic in the unpolymerized form. Prefabricated gels are expensive. At least regarding wood-decay fungi, the method did not reach a practical application.

Isozyme analyses

Isozyme analyses have been used to distinguish similar and closely related species and forms, for investigations on the genetical variability and on the spread of pathogens (e.g., Blaich and Esser 1975; Prillinger and Molitoris 1981; Micales et al. 1992). Being functional proteins, isozymes are investigated by native electrophoresis or isoelectric focusing. There are a number of investigations on mycorrhizal fungi, e.g., *Pisolithus* and *Scleroderma* species (Sims et al. 1999) and on tree parasites, like *Armillaria* species (Bragaloni et al. 1997) and *Heterobasidion annosum* (Karlsson and Stenlid 1991).

Two-dimensional gel electrophoresis, comprising isoelectric focusing and subsequent SDS-PAGE, is able to separate a sample of a large number of proteins.

Immunological methods

Wood fungi can be also detected and identified by immunological (serological) methods. Immunological assays use polyclonal antisera or monoclonal

antibodies. Antisera produced by animals like mice and rabbits as answer to the injection of mycelial fragments, extracts or culture filtrates are investigated by Western blotting, enzyme-linked immunosorbent assay (ELISA) or immunofluorescence (Clausen 2003). However, the experiments often exhibit cross-reactions with non-target organisms, even when monoclonal antibodies after fusion with myeloma cells (hybridomas) are used. Investigations were performed with e.g., *Armillaria* spp., *Coniophora puteana*, *Gloeophyllum trabeum*, *Lentinula edodes*, *Lentinus lepideus*, *Oligoporus placenta*, *Phellinus pini*, *S. lacrymans*, *Trametes versicolor* and with wood-stain fungi (Jellison and Goodell 1988; Palfreyman et al. 1988; Breuil et al. 1988; Glancy et al. 1990; Burdsall et al. 1990; Vigrow et al. 1991b, 1991c; Clausen et al. 1991, 1993; Kim et al. 1991a, 1991b, 1993; Toft 1992, 1993; McDowell et al. 1992; Clausen 1997a; Breuil and Seifert 1999; Hunt et al. 1999).

The diagnostic potential lies in the identification of species without the need of preceding isolation and pure culturing and in the detection of fungi at early stages of decay (Clausen and Kartal 2003). The methods may become applicable when the producing techniques for hybridomas and diagnostic kits have been established.

Immunological methods were also used to visualize the distribution of enzymes of wood-degrading fungi within and around the hypha and in woody tissue (e.g., Kim 1991; Kim et al. 1991a, 1993; Chap. 4).

2.4.2.2
DNA-Based Techniques

Southern blotting of restriction fragments (RFLPs)
In the RFLP technique, nuclear, mitochondrial or chloroplast DNA is treated with endonucleases, which each have a short nucleotide recognition site on the DNA target, and which cut the DNA into fragments. The fragments are separated on agarose gels and transferred by Southern blotting on nitrocellulose or nylon membranes. The addition of a special nucleotide probe, which hybridizes with a fragment, selects fragments from the present bulk ("smear") of fragments. The probe may be radioactively labeled (^{32}P or ^{35}S) showing the hybridized fragment by autoradiography. Biotin, dioxigenin, or fluorescein probes visualize the fragment colorimetrically or as chemoluminescence. The different fragment pattern (restriction fragment length polymorphisms, RFLPs) differentiate species, intersterility groups and isolates, like as it was used e.g., for *Armillaria* spp. (Schulze et al. 1995, 1997).

The technique is exact, but needs time and is methodically longwinded.

Methods using the polymerase chain reaction (PCR)
The procedure of PCR multiplies a part of DNA by a repeated (25–40 times) three-stage temperature cycle (amplification): the double strand is split into its

single strands at about 94 °C (denaturation), two nucleotide primers (15–30 bases) attach to the complementary nucleic acid region at 35–60 °C (annealing), and a thermostable polymerase synthesizes two new single strands at about 72 °C (extension) by starting at the primers and using the four nucleotides present in the reaction mixture (Mullis 1990), that is the target DNA is doubled with each cycle.

In real-time PCR techniques, the accumulation of PCR product is detected in each amplification cycle either by using a dye or a fluorescently labeled probe. Hietala et al. (2003) quantified *Heterobasidion annosum* colonization in different Norway spruce clones using multiplex real-time PCR. Eikenes et al. (2005) monitored *Trametes versicolor* colonization of birch wood samples. The technique of PCR-DGGE was used for arbuscular mycorrhizal fungi. A nested PCR of variable regions of the 18S rDNA was combined with subsequent separation of the amplicons using denaturing gradient gel electrophoresis (DGGE), and the method is intended to be used to discriminate closely related *Glomus* species (Vanhoutte et al. 2005). Vainio and Hantula (2000) performed DGGE analysis of fungal samples collected from spruce stumps.

Randomly amplified polymorphic DNA (RAPD)-analysis

RAPD analysis is based on PCR, but uses only one, short (about ten bases) and randomly chosen primer, which anneals as reverted repeats to the complementary sites in the genome. The DNA between the two opposite sites with the primers as starting and end points is amplified. The PCR products are separated on agarose gels, and the banding patterns distinguish organisms according to the presence/absence of bands (polymorphism). It is a peculiarity of RAPD analyses that they discriminate at different taxonomical level, viz. isolates and species, depending on the fungus investigated and the primer used (Annamalai et al. 1995).

RAPD was used for tree parasites, such as *Armillaria ostoyae* (Schulze et al. 1997) and *H. annosum* (Fabritius and Karjalainen 1993; Karjalainen 1996), mycorrhizal fungi (Jacobson et al. 1993; Tommerup et al. 1995) and edible mushrooms (*Lentinula edodes*: Sunagawa et al. 1995). Regarding wood decay fungi, Theodore et al. (1995) showed for *S. lacrymans* polymorphism among eight isolates. Another RAPD analysis exhibited similarity within *S. lacrymans*, which may be attributed to the low genetic variation of the species, but "normal" polymorphism in *S. himantioides* and *Coniophora puteana* (Schmidt and Moreth 1998).

The German isolate Eberswalde 15 of *C. puteana* is obligatory test fungus for wood preservatives according to EN 113. The isolate is known for its variable behavior in wood decay tests. RAPD analysis was able to show that some alleged Ebw. 15 cultures held in different test laboratories are in reality subcultures from the British facultative test isolate FPRL 11e (Göller and Rudolph (2003), which explains the varying test results.

RAPD analysis does not require information of the target DNA and is fast when starting from pure cultures. However, at least four primers should be used to avoid spurious results, because the short primers imply a great sensitivity to contamination. In addition, the technique is unsuitable for the identification of unknown samples by comparison, because other not yet investigated fungi by chance may share a similar banding pattern.

Use of ribosomal DNA

The investigation of the ribosomal DNA (rDNA) has become popular, because the rRNA genes and spacers are assumed to evolve cohesively within a single species, to exhibit only very little sequence divergence between rDNA copies within single individuals, but to show normal levels of sequence divergence between species. The repetitive units of the nuclear rDNA of Eukaryotes consists of the conserved coding domains 18S and 28S rDNA. The conserved domains are interrupted by the non-coding variable internal transcribed spacer ITS I (between 18S and 5.8S) and ITS II (between 5.8S and 28S) which are informative for differentiation. The intergenic spacer IGS is located between the 28S and the 18S of the next rDNA unit. In the case of a present 5S rRNA gene, the IGS consists of two parts, IGS I and IGS II (Fig. 2.20). The conserved regions are preferentially used for phylogenetic analyses of genera, families, and orders. The rapidly evolving ITS spacers have become a popular choice for closely related species and at the subspecies level. After amplification by PCR, the amplicons are either restricted by endonucleases providing restriction fragments (RFLPs) which are subsequently separated according to size using agarose or polyacrylamide gel electrophoresis, or the DNA sequence is determined ("sequencing").

In addition to the nuclear rDNA, also mitochondrial rDNA was used for Basidiomycetes, e.g., by Bao et al. (2005a) in view of phylogenetic relationships among closely related *Pleurotus* species.

Restriction fragment length polymorphism (RFLP) of rDNA

RFLP analysis based on the rDNA was also called amplified ribosomal DNA restriction analysis (ARDRA). Depending on the intension, the RNA genes or the spacers are used. For RFLP analysis of the ITS, the ITS is first amplified, often using the "universal primers" ITS 1 and ITS 4 (White et al. 1990), which anneal to the evolutionary stable 18S and 28S rRNA genes. This attachment

Fig. 2.20. Schematic diagram of one rDNA unit. The number in the boxes is the size in base pairs for *Serpula lacrymans* (supplemented from Moreth and Schmidt 2005)

to conserved rDNA regions allows the ITS amplification from fungi without prior knowledge of their ITS sequence. The PCR products are then digested either as single or as double digest by restriction endonucleases, of which some hundreds of different enzymes are known and each having an own recognition site on the DNA.

Jonsson et al. (1999) identified mycorrhizal fungi in a spruce forest by ITS-RFLP comparison to reference material. Similarly, Johannesson and Stenlid (1998) identified tree parasites like *Armillaria borealis* and *Heterobasidion annosum* from bore core samples or mycelia isolated from wood. Regarding wood-decay Basidiomycetes, Zaremski et al. (1999) differentiated single isolates of *C. puteana*, *Gloeophyllum trabeum* and *Oligoporus placenta* by ITS-RFLPs. Various isolates of the closely related *S. lacrymans* and *S. himantioides* exhibited a distinct fragment profile for both fungi after digestion with *Hae*III/*Taq*I (Schmidt and Moreth 1999). Restriction with *Taq*I differentiated *S. lacrymans*; *S. himantioides*, *D. expansa*, *C. puteana*, *A. vaillantii*, *O. placenta* and *Gloeophyllum sepiarium* by specific fragments (Fig. 2.21).

Obviously, ITS-RFLP analysis is able to separate various wood decay fungi. It also detected misnamed isolates assumed to be *S. lacrymans* (Horisawa et al. 2004; also Fig. 2.21) and identified unknown samples. The method is currently to be intended as a database for the identification of wood decay and associated fungi (Zaremski et al. 1999; Adair et al. 2002; Diehl et al. 2004; Råberg et al. 2004).

Advantageous is that the technique is fast and inexpensive. Limitations are: First, the use of universal primers implies sensitivity to contamination. Second,

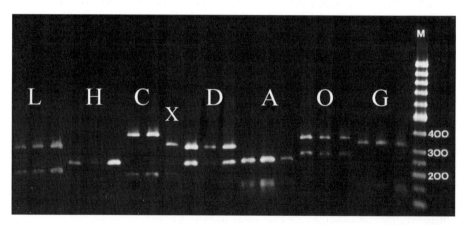

Fig. 2.21. Species-specific ITS-RFLP pattern of isolates of *Serpula lacrymans (L)*, *S. himantioides (H)*, *Coniophora puteana (C)*, *Donkioporia expansa (D)*, *Antrodia vaillantii (A)*, *Oligoporus placenta (O)*, and *Gloeophyllum sepiarium (G)* generated by *Taq*I. *M* marker (50–1,000 bp). The culture *X* had been assumed to be *C. puteana* and was later identified by sequencing as *C. olivacea*

in view of a data collection to be used for identification by fragment length comparison, the limited ITS size of only 600–700 bases prevents a separation of all relevant fungi in a certain biotope by specific digest pattern. Third, the great number of possible fungi in a biotope is much greater than the few fragment patterns that would be present in data collections, that is, a not yet analyzed species may feign another fungus by exhibiting identical fragments.

RFLP analysis of a 5.8S rDNA/ITS II/28S rDNA fragment was used to characterize five species of the *Phellinus igniarius* group (Fischer 1995) and 13 species of the *Phellinus pini* group (Fischer 1996). Corresponding DNA digestion of 52 lignicolous European species with *Hpa*II resulted in 44 distinct phenotypes and additional application of *Hin*6 I and *Hin*f I in 48 species-specific and two genera-specific phenotypes (Fischer and Wagner 1999). RFLP patterns obtained from seven restriction enzymes assigned 34 *Pleurotus* strains to 11 RFLP types, of which ten corresponded to biological species (Bao et al. 2004b).

The intergenic spacer, either the IGS I alone or both IGS parts, has often been used for RFLP studies of *Armillaria* species (e.g., Harrington and Wingfield 1995; Frontz et al. 1998; White et al. 1998; Terashima et al. 1998a; Kim et al. 2001). IGS I-RFLPs were also used to assign isolates of *Heterobasidion annosum* to intersterility groups (Kasuga and Mitchelson 2000) and to investigate the population structure of five Fennoscandian geographic populations of *Phellinus nigrolimitatus* (Kauserud and Schumacher 2002).

rDNA Sequencing

PCR-amplification and subsequent sequencing of parts of the ribosomal DNA avoid the main limitations of RFLPs because the whole information of hundreds of nucleotides of the target DNA is used. rDNA sequences may be used for diagnosis and for phylogenetic analyses (dendrograms) on relationships among fungi. Sequencing is nowadays the most important tool for molecular systematics and led to taxonomic rearrangements and changes in nomenclature.

The ITS sequences of a great number of wood fungi are known, e.g., from mycorrhizal fungi like *Hebeloma velutipes* (Aanen et al. 2001), from parasites like *Armillaria* species (Chillali et al. 1998) and *Laetiporus sulphureus* (Rogers et al. 1999), and from the red streaks producing *Trichaptum abietinum* (Kauserud and Schumacher 2003). Regarding wood decay fungi, a data set of rDNA-ITS sequences of 18 house-rot fungi is shown in Table 2.8 (Schmidt and Moreth 2002/2003) complemented by the 18S and 28S rDNA sequences of some important species (Moreth and Schmidt 2005). The ITS of some brown-rot and white-rot fungi was sequenced by Jellison et al. (2003).

It is normal to deposit sequences in the international electronic databases for everyone's use (European Molecular Biology Laboratory EMBL: www.ebi.ac.uk/embl; American GenBank: www.ncbi.nlm.nih.gov/genbank; DNA Data Bank of Japan DDBJ: www.ddbj.nig.ac.jp).

Table 2.8. Sequenced and deposited rDNA regions of indoor wood decay fungi. *Grey sequence known, 1–28* number of sequenced isolates, *six-digit number* EMBL database accession number (supplemented from Schmidt and Moreth 2002/2003 and Moreth and Schmidt 2005)

Species \ rDNA	18S	ITS I	5.8S	ITS II	28S	IGS I	5S	IGS II
Serpula lacrymans	3 440945 440946		7 245948 249268 419907 419908 419909 419910		3 440939 440940 440941	3	3	1
Serpula himantioides	3 440947 440948		12 245949 419911		3 440942 440943 440944	3	3	
Meruliporia incrassata			2 419912 419913					
Leucogyrophana mollusca			6 419914 419915			2	2	
Leucogyrophana pinastri			4 419916 419917					
Coniophora puteana	1 488581		28 249502 249503 344109 344110		1 583426	2	2	
Coniophora marmorata	2 540306		4 518879 518880		1 583427	2	2	
Coniophora arida	1 488582		3 345007 344113					
Coniophora olivacea	1 488905		5 344112 345009					
Antrodia vaillantii	1 488583		12 249266 344140 421007 421008		1 583429	1 842965		
Antrodia sinuosa	1 488906		5 345011 416068					
Antrodia serialis			8 344139 345010					
Antrodia xantha	1 488584		6 345012 415569		1 583430			
Oligoporus placenta			8 249267 416069					
Gloeophyllum abietinum	2 560802		5 420947 420948		1 583431			
Gloeophyllum sepiarium	2 540308		5 344141 420946		1 583432			
Gloeophyllum trabeum			6 420949 420950					
Donkioporia expansa	2 540307		2 249500 249501		1 583428			

Sequences of the ITS region (and the 18S and 28S rDNA) may be used to identify unknown fungal samples through sequence comparison by Basic local alignment search tool (BLAST) (e.g., www.ncbi.nlm.nih.gov/blast/bast.cgi). BLAST revealed ITS-sequence identity of a "wild" *S. lacrymans* isolate from the Himalayas with indoor isolates (White et al. 2001), identified misnamed isolates of *S. lacrymans* (Horisawa et al. 2004), identified *Antrodia* spp. and *Serpula* spp. isolations from fruit bodies and wood samples (Högberg and Land 2004), and confirmed *Coniophora puteana* isolates (Råberg et al. 2004). Kim et al. (2005) used a part of the 28S rDNA for identification of a number of basidiomycete fungi from playground wood products by BLAST. Partial 18S rDNA sequence of *Sirococcus conigenus* isolated from Norway spruce cankers was used by Lilja et al. (2005) to confirm the identification of the fungus. The whole IGS was sequenced to investigate intraspecific variation of mycorrhizal fungi like *Laccaria bicolor* (Martin et al. 1999). IGS I sequence analysis was used for *Hebeloma cylindrosporum* (Guidot et al. 1999) and *Xerocomus pruinatus* (Haese and Rothe 2003). IGS I analysis suggested that three different morphotypes/genotypes of an ectomycorrhizal fungus present in Kenya represent separate biological species (Martin et al. 1998). The IGS I region grouped isolates of *Armillaria mellea* s.s. in Asian, western North American, eastern North American and European populations (Coetzee et al. 2000).

Sequences are used to construct phylogenetic trees (dendrograms) for phylogenetic analyses (molecular systematics). It is not unusual for those intentions to complement own data with sequences downloaded from the databases.

For closely related fungi, like *Armillaria* species, IGS sequences were used for phylogenetic analysis (e.g., Terashima et al. 1998b). Also, ITS sequences may be applied to phylogenetic trees. An example of *S. lacrymans* and *S. himantioides* is shown in Fig. 2.22. The tree shows that isolates of *S. lacrymans* collected in nature in Czechoslovakia, India, Pakistan and Russia group in the branch of indoor isolates ("Domesticus group") but differ from wild Californian isolates ("Shastensis group") (Kauserud et al. 2004b; also White et al. 2001; Palfreyman et al. 2003), suggesting a North American link between the anthropogenic isolates and the wild relative *S. himantioides*. Yao et al. (1999) applied ITS sequences to a phylogenetic study of *Tyromyces* s.l.

For phylogenetic analyses of higher groups, genera, families and orders, often the conserved 18S and 28S rDNA are used. Bresinsky et al. (1999) and Jarosch and Besl (2001) sequenced 900 bases of the 28S rDNA of *S. lacrymans*, *S. himantioides*, *Meruliporia incrassata* and of *Coniophora* and *Leucogyrophana* species. Although it is not necessary to sequence the whole rRNA genes to construct trees, complete 18S and 28S rDNA sequences of a number of important wood-decay fungi are already known (Table 2.8).

Nuclear and mitochondrial genes have different inheritance. Selosse et al. (1998) showed intraspecific polymorphism of the large subunit of mitochondrial rDNA in *Laccaria bicolor*. A sequence database of several ectomycorrhizal

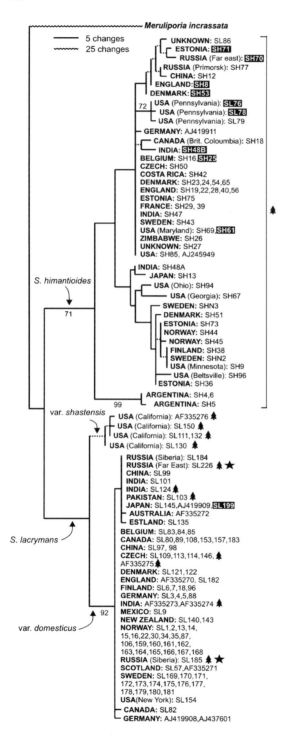

Fig. 2.22. Phylogeny of *Serpula lacrymans* and *Serpula himantioides* ITS-rDNA sequences using maximum parsimony and *Meruliporia incrassata* as outgroup. Sequences are labeled with geographical origin of the isolate, followed by the isolate or collection name. Bootstrap support values (≥50%) are shown below the nodes. *Stripped lines* indicate nodes that collapsed in the strict consensus tree. *Tree symbols* indicate specimens derived from nature (otherwise from buildings), and *star symbols* pinpoint sequences derived from two newly discovered localities in Russia. *Black squares* indicate specimens having double character nucleotides in one or several positions, reflecting a heterozygous state (from Kauserud et al. 2004b)

basidiomycetes based on a portion of the large subunit of mitochondrial rDNA was assembled in view of identification (Bruns et al. 1998).

rDNA sequencing yields a comprehensive pool of information, but is tedious and expensive. Further costs emerge if the PCR products are previously cloned. An automatic sequencer is too expensive for small laboratories. However, specialized sequencing services are meanwhile inexpensive, providing a sequence of about 800 bp length for about € 10.

Species-specific priming PCR (SSPP)

As an advantage of the sequence divergence among fungi, oligonucleotide sequences may be used to design species-specific primers for PCR. At first sight, SSPP seems to be a powerful molecular identification tool for fungi. Subsequent restriction of the amplicon as well as the use of pure fungal cultures, axenically obtained samples, and precautions to exclude DNA from the laboratory or from contaminated field material are not required. Jasalavich et al. (1998) used primers that detect any basidiomycete fungus present, but not a particular species. Specific PCR primers were able to detect the aggressive biotypes 2 and 4 of *Trichoderma harzianum* (*T. aggressivum* f. *europaeum* and f. *aggressivum*), which are strong parasites in the mushroom production of agarics, Shii-take, and *Pleurotus* species (Albert 2003). With regard to the tree-inhabiting Basidiomycetes, special ITS-primers were used for *Heterobasidion annosum* and *Armillaria ostoyae* (Garbelloto et al. 1996; Schulze and Bahnweg 1998). Specific primers distinguished *A. mellea* from the other four annulate European *Armillaria* species (Potyralska et al. 2002) and detected *Phlebia brevispora* (Suhara et al. 2005).

To identify indoor wood decay fungi, specific oligonucleotide sequences that are located in the ITS II region of seven fungi and were previously tested for possible cross-reaction (Moreth and Schmidt 2000; Schmidt 2000) are suitable as primers for SSPP (Table 2.9).

To make subsequent sample recognition easier, different distances of the DNA target region to the ITS 1 primer were considered, that is the amplified ITS regions exhibit a DNA fragment for each fungus of distinct and predictable length on the agarose gel, ranging from about 385 to 625 bp (Fig. 2.23).

Oh et al. (2003) immobilized specific ITS oligonucleotides of some wood-inhabiting fungi onto membrane filters for subsequent hybridization of DNA from field samples and detected e.g., *Chaetomium globosum*.

A specific primer pair targeting the β-tubulin gene was able to distinguish between the mutant strain of *Ophiostoma piliferum* used for biocontrol of woodstain and the European and New Zealand wildtype isolates (Schröder et al. 2000).

SSPP is precise and fast. The technique is already used in Germany for commercial fungal diagnosis. However, SSPP does not work with all fungi. The

Table 2.9. Species-specific ITS-PCR primers (reverse) with target area (bp) in the ITS II if the ITS 1 primer of White et al. (1990) is used as forward primer (complemented from Moreth and Schmidt 2000)

Species	Specific primer (5′ → 3′)							Target area (bp)
Serpula lacrymans	ATG	TTT	CTT	GCG	ACA	ACG	AC	567–587
	CAG	AGG	AGC	CGA	TGA	ACA	AG	459–478
Serpula himantioides	TCC	CAC	AAC	CGA	AAC	AAA	TC	410–429
Coniophora puteana	AGT	AGC	AAG	TAA	GGC	ATA	GA	614–633
Antrodia vaillantii	CAC	CGA	TAA	GCC	GAC	TCA	TT	498–517
	ACT	GAC	TAC	AAA	ATG	GCG	CG	445–464
Oligoporus placenta	TTA	CAA	GCC	AGC	ATA	AAC	CT	431–450
Donkioporia expansa	TCG	CCA	AAA	CGC	TTC	ACG	GT	525–544
Gloeophyllum sepiarium	GTT	AAT	AAA	AAC	CGG	GTG	AG	379–398

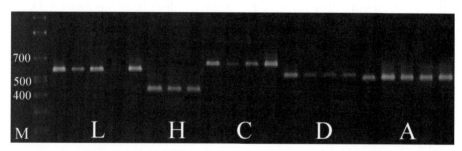

Fig. 2.23. Electrophoresis gel demonstrating species-specific priming PCR. *L–A* codes of specific primers which detected isolates of *Serpula lacrymans (L)*, *S. himantioides (H)*, *Coniophora puteana (C)*, *Donkioporia expansa (D)*, and *Antrodia vaillantii (A)*. M marker (200–900 bp) (from Moreth and Schmidt 2000)

closely related annulate European *Armillaria* species *A. borealis, A. cepistipes, A. gallica,* and *A. ostoyae,* exhibited rather similar ITS sequences and also intraspecific variation, that is a specific primer was only obtained for *A. mellea* (Potyralska et al. 2002; also Chillali et al. 1998). In addition, intraspecific variation may also occur with regard to the geographic origin of isolates (Kauserud et al. 2004b). The main limitation is, however, comparable to ITS-RFLPs, that the limited ITS size of only 600–700 nucleotides prevents the design of a specific primer for all relevant fungi of a certain biotope. In a practical view, also the technical effort becomes big on that score that a great number of specific primer has to be used for the diagnosis of an unknown sample.

Microsatellites

Microsatellites or simple sequence repeats (SSR) are hypervariable genomic regions characterized by short tandem repeat sequences of up to seven nu-

cleotide units that are distributed throughout the genomes of most Eukaryotes (Powell et al. 1996). The variability of the number of repeat units at a particular locus and the conservation of the sequences flanking the repeat make microsatellites valuable genetic markers. They provide information for identification and on genetic diversity and relationships among genotypes. For example, DNA fingerprinting with multilocus microsatellite probes suggested that Cape Town isolates of *Armillaria mellea* s.s. were introduced from Europe more than 300 years ago (Coetzee et al. 2001).

Amplified fragment length polymorphism (AFLP)
AFLP is a powerful tool for DNA fingerprinting and is based on (1) total genomic restriction, (2) ligation of primer adapters, and (3) unselective followed by selective PCR amplification of anonymous DNA fragments from the entire genome (Vos et al. 1995). AFLP markers are recognized as more reproducible compared to RAPD analyses and inter-simple sequence repeats (ISSRs), and are also able to give a higher resolution. AFLP analysis by Kauserud et al. (2004a) of European isolates of *Serpula lacrymans* belonging to five somatic incompatibility groups indicated that the species in Europe is genetically extremely homogenous by observing that only five out of 308 scored AFLP fragments were polymorphic. In contrast, *S. himantioides* as the closest relative to *S. lacrymans* possessed 31.3% polymorphic fragments.

2.4.2.3
Further Molecular Methods

DNA-Arrays
DNA-arrays (DNA-chips, microarrays) are tools in medical, pharmaceutical, and biological diagnosis of pathogens (genotyping, pathotyping) (Beier et al. 2002; Wiehlmann et al. 2004). Basis is the increasing availability of sequence information of various viruses and bacteria. One chip can carry up to 10,000 different DNA probes (e.g., oligonucleotides), which are raster-like bound on its surface. Nucleic acid molecules of the sample hybridize specifically with the corresponding DNA probe, and the hybridized chip areas are detected colorimetrically. Compared to PCR techniques, the sensitivity of the chip technology is lower than with species-specific PCR, and the chip techniques need experienced staff and expensive laboratory equipment. The great miniaturization and automation, however, allow the analyses of a great number of samples in a short time. Specific oligonucleotides to be used for arrays are already commercially available for several pathogenic bacteria and yeasts. A possible future use for wood fungi using specific oligonucleotides from rDNA sequences (Table 2.8) could be a new technique for fungal diagnosis.

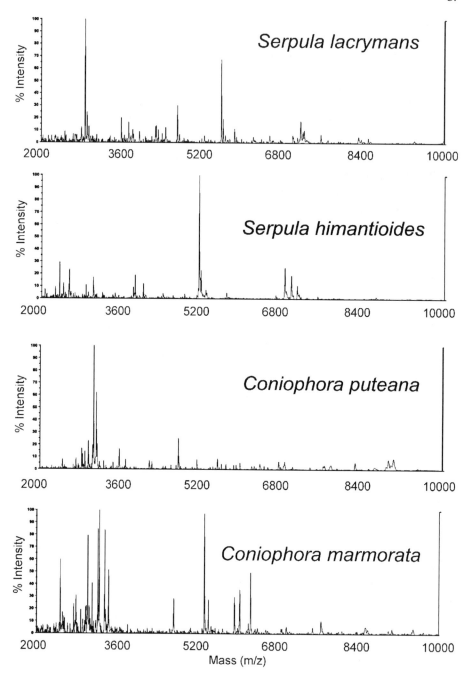

Fig. 2.24. MALDI-TOF mass spectra of mycelia of each two closely related *Serpula* and *Coniophora* species (from Schmidt and Kallow 2005)

Fatty acid profiles

Microorganisms synthesize over 200 different fatty acids. The presence of specific acids and their relative amounts are constant for a particular species. Since the 1960s, bacteria and fungi are identified by gas chromatographic analysis of fatty acids, which were previously derivatized to methyl esters. The technique has also been used to identify wood-decay fungi like *Phanerochaete chrysosporium*, *P. sordaria*, *Trametes versicolor*, *T. hirsuta*, and *T. pubescens* (Diehl et al. 2003).

MALDI-TOF mass spectrometry

The technique of matrix-assisted laser desorption/ionization time-of-flight mass spectrometry (MALDI-TOF MS) was developed in the 1980s, and was used in many fields for peptide, protein, and nucleic acid analyses (Jürgens 2004; Welker et al. 2004). The method was suitable to differentiate and identify viruses, bacteria, and fungi (yeasts and Deuteromycetes) (e.g., Fenselau and Demirev 2001). In MALDI-TOF MS, biomolecules and even whole cells are embedded in a crystal of matrix molecules, which absorb the energy of a laser. The sample is ionized by means of the matrix, and both the matrix and the analyte are transferred to the gas phase. The ions are accelerated in an electric field, and their time of flight is determined in a detector. After calibration of the instrument with molecules of known mass, the flight time of the analyte ions is converted to mass-to-charge ratios (m/z). Organism-specific signal patterns ("fingerprints") in the mass range 2,000–20,000 Da were obtained. Figure 2.24 shows the first MALDI-TOF MS fingerprints of Basidiomycetes, namely the closely related sister taxa *Serpula lacrymans*, *S. himantioides* and *Coniophora puteana*, *C. marmorata* (Schmidt and Kallow 2005). The obtained spectra may be used for subsequent diagnosis of unknown fungal samples by comparison.

2.5
Classification

Approximately 120,000 fungal species are described. If the numerical ratio between vascular plants and fungi of 1:6 in botanically well-examined regions, like Great Britain, however, is transferred to a global scale of 270,000 vascular plants, 1.6 million fungi might exist. That is, so far only about 10% of the actual fungal species are described (Anonymous 1992b). Robson (1999) even estimated 3 million fungal species.

Nomenclature regulates the constitution of names, their validity, legitimacy and priority or synonymy, and maintains a single correct name for each taxon (International Code of Botanical Nomenclature, St. Louis Code 2000). In view of the author names for fungi, these have to be only abbreviated when more than two letters are saved. Names are always abbreviated between a conso-

nant and a vowel. The abbreviation should not cause confusion with other names. Contractions by omission of letters are avoided. Sanctioned names are indicated with "Fr." or "Pers." after the author of the first valid publication. An example might be shown by *Trametes versicolor* (L.: Fr.) Pilát (Table 2.10) (Jahn 1990). "(L.: Fr.) Pilát" means that Linné (L.) described the fungus with the name *Boletus versicolor* in "Species plantarum" in 1753. Fries (Fr.) included it as *Polyporus versicolor* in "Systema mycologicum" in 1821 that is the epithet "versicolor" was protected (sanctioned). Pilát placed it in the genus *Trametes* in 1939. Particularly French mycologists prefer *Coriolus versicolor* (L.: Fr.) Quélet, because the French author included the fungus in this genus in 1886. In the various national colloquial languages and even within a state, different names are used.

For the classification of fungi, there are different attempts of artificial and natural systems. The various groups of fungi have little in common, except the heterotrophy for carbon, that they are Eukaryotes, possess a slightly differentiated tissue, and exhibit in at least one period of life cell walls as well as spores as resting and distributing forms. Only for practical reasons they are nevertheless united. Multi-kingdom systems (Whittacker 1969) consider the polyphyletic origin of the fungi by attaching the slime fungi and "lower fungi" to the Protista and the "higher fungi" to the Fungi, but break thereby the traditional biological and ecological term fungus. A generally recognized fungal classification system does not exist, and it was ironically argued that there might be as many systems as there are systematists. Due to new knowledge, and depending on the priority, which is attached to a certain characteristic, taxonomic revisions occur in the classification system as well as changes of fungal naming (names of wood fungi: e.g., Larsen and Rentmeester 1992; Rune and Koch 1992). Current names are shown in Appendix 2. The coarse grouping in Table 2.11 is based on Müller and Loeffler (1992).

About 2,000 described Protista group into six divisions that are independent from each other as well as from the "higher fungi". The "higher fungi"

Table 2.10. Naming of fungi, illustrated by *Trametes versicolor* (L.: Fr.) Pilát

L.: Linné 1753 "Species Plantarum": *Boletus versicolor*
Fr.: Fries 1821 "Systema mycologicum": *Polyporus versicolor*:
→ sanctioning of the epithet "*versicolor*",
Pilát: Pilát 1939: placement in the genus *Trametes*
Synonymous especially in France:
Coriolus versicolor (L.: Fr.) Quélet (1886)
Vernacular names:
Germany: Schmetterlingsporling, Bunte Tramete,
UK: Many-zoned polypore,
France: Tramète chatoyant

with about 120,000 species may be grouped into three divisions and a form division: Zygomycota, Ascomycota with the classes Endomycetes (yeasts) and Ascomycetes, Basidiomycota including the Basidiomycetes, and Deuteromycota (Deuteromycetes).

The important fungi that inhabit or destroy wood belong to the Ascomycetes, Basidiomycetes, or Deuteromycetes. Ascomycetes and Basidiomycetes have in common a dikaryotic phase and a haploid phase as mycelium, which does not sprout yeast-like.

About 30,000 Ascomycetes (additionally about 16,000 lichen fungi) are characterized by the development of the meiospores in asci, the restriction of the dikaryon to the ascogenic hyphae in the fruit body, and the predominant gametangiogamy. In the Basidiomycetes (about 30,000 species), the mature meiospores are located in the sterigmata, and after somatogamy the dikaryotic phase is extended to the mycelium.

As the third artificial group, the Deuteromycetes (30,000 species) are added whose vegetative characteristics correspond to the Ascomycetes or Basidiomycetes, in which, however, a teleomorph is not yet known or is either temporarily or generally not present.

The term "microfungi" covers the Deuteromycetes and some Ascomycetes with microscopic structures. "Macrofungi (macromycetes)" means Basidiomycetes and Ascomycetes with large fruit bodies.

There are different classifications of the Ascomycetes. A traditional way considers the appearance of the fruit bodies (ascomata): Hemiascomycetes (Protoascomycetes) do not form fruit bodies, Plectomycetes have protothecia or cleistothecia, Discomycetes show apothecia, Pyrenomycetes own perithecia, and Loculoascomycetes form pseudothecia (Schwantes 1996; Fig. 2.14). Another differentiation groups the Ascomycetes according to the time of development of the fruit bodies in the two groups, euascohymenial Euascomycetes and ascolocular Loculoascomycetes. In the first, the fruit body develops after the gametangiogamy, and in the latter, the primordia develop before the gametangiogamy. With priorization of the wall structure of the ascus, the Lecanoromycetidae show ascohymenial ascomata and a primitive archaeascus, the Euascomycetidae comprise ascohymenial fungi with a prototunicate

Table 2.11. General classification of fungi

Protista (2,000 species): Six divisions (e.g., slime fungi and "lower fungi")
Fungi ("higher fungi"), 120,000, three divisions and one form division:
1. Zygomycota
2. Ascomycota: yeasts and Ascomycetes, 46,000 (lichens included)
3. Basidiomycota: rust fungi, smut fungi and Basidiomycetes, 30,000
Deuteromycota: Deuteromycetes (imperfect fungi), 30,000
with relevance to wood: Ascomycetes, Basidiomycetes, Deuteromycetes

or unitunicate ascus wall, the Loculoascomycetidae have ascolocular ascomata development and mostly a bitunicate ascus wall, and the Laboulbeniomycetidae are ascohymenial fungi with prototunicate or unitunicate ascus wall. The separate group of the Taphrinomycetidae (Taphrinales) does not form ascomata, but the asci develop between the epidermis cells of the host plant. Classifications are shown in Kreisel (1969), Breitenbach and Kränzlin (1984), Müller and Loeffler (1992), Zabel and Morrell (1992), Schwantes (1996), and Hansen et al. (2000). However, a uniform and generally accepted classification does not exist. Thus, the Ascomycetes treated in this book are only classified by their orders (Tables 8.1–8.3).

The traditional differentiation of the Basidiomycetes is based on two different principles. Practically to apply is the use of the morphology of the basidium. Holobasidiomycetes have unicellular basidia, and Phragmobasidiomycetes show septate basidia. To consider natural relationships better, a differentiation that is based on the kind of spore germination seems favorable (Müller and Loeffler 1992). The basidiospores of Homobasidiomycetes germinate by germ hyphae. Heterobasidiomycetes show repetitive germination. All Homobasidiomycetes possess a holobasidium. The Heterobasidiomycetes contain orders with phragmobasidia, but initial more primitive orders have holobasidia (Schwantes 1996). Based on the principle type of the fruit body, the Homobasidiomycetes may be grouped in Hymenomycetes, which have the hymenium exposed on basidiomata surface, and Gasteromycetes with the hymenium enclosed within basidiomata.

Due to overlapping among the groups, lack of clarity, and different opinions among systematists, some authors (Müller and Löeffler 1992) abstain from uniting the orders into subclasses.

The former subgrouping of the Homobasidiomycetes into Aphyllophorales, Agaricales, and Gasteromycetales did only consider the fruit body type. Schwantes (1996) differentiates four order groups: Apphyllophoranae (six orders), Agaricanae (three orders), Gasteromycetanae (nine orders), and Phallanae (one order). Apphyllophoranae and Agaricanae are almost in accordance with the term Hymenomycetes, and Gasteromycetanae and Phallanae with that one of Gasteromycetes. Numerous order and family-schemes especially for the polypores either use large and comprehensive groups like in Ryvarden and Gilbertson (1993, 1994) or numerous and small groups like in Hansen et al. (1992, 1997).

Some common wood-inhabiting Basidiomycetes treated in this book are grouped in Table 2.12 according to Breitenbach and Kränzlin (1986, 1991, 1995), except that the Coniophoraceae were placed in the Boletales.

A great number of Deuteromycetes occur on wood, like molds (*Aspergillus*, *Penicillium* and *Trichoderma* species), blue-stain fungi (e.g., *Aureobasidium pullulans*, *Cladosporium* species, *Discula pinicola*), and soft-rot fungi (e.g., *Paecilomyces variotii*).

Table 2.12. Classification of some wood-inhabiting basidiomycetous genera

Class	Order	Family	Genus
Heterobasidiomycetes	Auriculariales	Auriculariaceae	*Auricularia*
	Darcymycetales	Dacrymycetaceae	*Dacrymyces*
Homobasidiomycetes	Aphyllophorales	Sparassidaceae	*Sparassis*
		Corticiaceae s. lato	
		Phanerochaetaceae	*Phanerochaete*
			Phlebiopsis
		Phlebiaceae	*Resinicium*
		Stereaceae	*Amylostereum*
			Chondrostereum
			Stereum
		Hymenochaetaceae	*Asterostroma*
			Inonotus
			Phellinus
		Fistulinaceae	*Fistulina*
		Ganodermataceae	*Ganoderma*
		Polyporaceae s. lato	
		Polyporaceae s. stricto	*Lentinus*
			Pleurotus
			Polyporus
		Bjerkanderaceae	*Bjerkandera*
			Oligoporus
			Tyromyces
		Coriolaceae	*Antrodia*
			Diplomitoporus
			Donkioporia
			Trametes
			Trichaptum
		Daedaleaceae	*Daedalea*
			Daedaleopsis
		Fomitaceae	*Fomes*
		Fomitopsidaceae	*Fomitopsis*
		Gloeophyllaceae	*Gloeophyllum*
		Grifolaceae	*Grifola*
		Heterobasidiaceae	*Heterobasidion*
		Laetiporaceae	*Laetiporus*
		Meripilaceae	*Meripilus*
		Phaeolaceae	*Phaeolus*
		Piptoporaceae	*Piptoporus*
		Rigidoporaceae	*Physisporinus*
		Schizophyllaceae	*Schizophyllum*
	Agaricales	Tricholomataceae	*Armillaria*
			Flammulina
			Laccaria
		Coprinaceae	*Coprinus*
		Strophariaceae	*Kuehneromyces*
			Pholiota
	Boletales	Boletaceae	*Boletus*
		Coniophoraceae	*Coniophora*
			Leucogyrophana
			Meruliporia
			Serpula
		Paxillaceae	*Paxillus*

The Deuteromycetes are usually divided in Coelomycetes and Hyphomycetes. Coelomycetes develop conidiophores within fruit bodies (conidiomata), which are either spherical with an apical opening (pycnidium), or flat, cup-shaped (acervulus). Nearly all Coelomycetes are of ascomycetous affinity. In Hyphomycetes (Moniliales), fruit bodies are absent, and conidia develop on simple or aggregated hyphae. The "black yeasts" with melanized cell walls and nearly always with true mycelium (Chap. 6.2) are anamorphs of Dothideales and are therefore also included in the Hyphomycetes.

The main criterion to classify Deuteromycetes is based on their mode of conidium formation. In addition, the conidiogenous cell is used to identify and classify Deuteromycetes. The conidiogenous cells can be borne directly in or from a vegetative hypha or on differentiated supporting structures. The entire system of fertile hyphae is called the conidiophore. Conidia can be formed in acropetal chains, or by basipetal succession, viz. the youngest conidium is formed at the base, or by sympodial succession, where each newly formed conidium moves into terminal position so that a geniculate, elongate or condensed rachis develops. It is differentiated whether conidia result from fragmentation and demarcation of already existing hyphae (thalloconidia, arthroconidia) or by sprouting (blastoconidia), after the origin of their cell wall from the mother cell and whether only one conidium is formed (solitary) or several one behind the other in chains (catenulate) or as clusters (botryos). Criteria for the recognition of taxa are mostly different from the fundamental characters for biological classification. Instead, species are identified with artificial key features. Descriptions and classifications are by v. Arx (1981), Barnett and Hunter (1987), Wang (1990), Müller and Loeffler (1992), Hoog and Guarro (1995), Schwantes (1996), Reiß (1997), Jennings and Lysek (1999), Kiffer and Morelet (2000) and Samson et al. (2004).

3 Physiology

The wood-inhabiting fungi as well as their colonization and damaging of wood are influenced by various physical/chemical and biological influences (Table 3.1).

Physical/chemical factors comprise nutrients, water, air, temperature, pH value, light, and the force of gravity. Biological influences arise because of reciprocal effects between different organisms as antagonism, synergism, and symbiosis (e.g., Rypáček 1966; Käärik 1975; Rayner and Boddy 1988). When investigating the various factors, laboratory methods do not reflect the situation under natural conditions. Often it is difficult to vary a parameter without affecting the others. The individual factors in nature do not work isolated, but strengthen or weaken themselves mutually.

Table 3.1. Influences on fungal activity

physical/chemical:
nutrients, water, air, temperature, pH-value, light, force of gravity
biological:
antagonism, synergism, symbiosis

3.1 Nutrients

Fungi consist of about 90% water and 10% dry matter (chemical composition: Bötticher 1974). This dry matter has to be synthesized in the course of each hyphal division so that nutrients must be assimilated. Regarding the source of carbon, wood fungi are heterotrophic by using carbon from organic material, which derives from the autotrophic trees. In view of the biochemical way of nutrition, wood fungi are chemo-organotrophic. These fungi use organic compounds as hydrogen suppliers to produce energy from organic substances. This energy production is created by reduction-oxidation reactions (Schlegel 1992). Wood fungi are either parasites, which affect living tree tissue, or saprobes, which grow on dead wood. Both forms can be obligatory or facultative, as a saprobe may become a weakness or wound parasite with weakening or

wounding a tree. A parasite may remain active as a saprobe for some time after tree cutting. Schmiedeknecht (1991) differentiated five main groups of the heterotrophic way of life: parasites, nekrophytes, which affect living hosts either as weakness parasites or kill them by toxic effect, sarkophytes, which prepare freshly died tissue for saprobes, saprobes, and symbionts (also Rayner and Boddy 1988).

In view of the use of wood nutrients (Table 3.2), wood-inhabiting microorganisms use carbon only from enzymatically easily accessible and digestible substrates, like simply constructed sugars, peptides, or fats, or from the storage material starch in the parenchyma cells. The wood decay fungi use carbon additionally from the complex, main components of the woody cell wall, cellulose, hemicelluloses, and lignin.

The cell wall components can be degraded either directly within the wood cell wall or only as a pure component after isolation from the cell wall (Table 4.3). In the laboratory, sugars such as glucose, maltose (in malt extract), and saccharose are suitable C-sources for most wood fungi. The wood-inhabiting fungi [yeasts (Chap. 9.5), molds, blue-stain fungi, red-streaking fungi in the early stage (Chap. 6)] and the wood-decay fungi during initial decay nourish predominantly of sugars and other components in the wood parenchyma cells. The quantity of these primary metabolites is usually below 10% related to the wood dry weight, and these metabolites occur usually only in living or just died sapwood parenchyma cells. For example, soluble nutrients in wood increased its susceptibility to soft-rot fungi and bacteria in ground contact (Terziew and Nilsson 1999). In *Pinus contorta* wood samples, triglycerides were consumed and mannose was the most depleted sugar by several blue-stain fungi (Fleet et al. 2001). The wood-degrading brown, white and soft-rot fungi (Chap. 7) use carbon additionally from the macromolecular cell wall components cellulose, hemicelluloses and lignin (the latter only with the white-rot fungi) (Chap. 4).

Wood-inhabiting bacteria (Chap. 5.2) consume sugars and peptides of the parenchyma cells and affect non-lignified cell tissue (parenchyma cells, epithelial cells of the resin channels, sapwood bordered pits). Under natural

Table 3.2. Grouping of wood microorganisms according to nourishment and damages

wood inhabitants:
bacteria, slime fungi, yeasts,
staining fungi (molds, blue-stain fungi, red-streaking fungi at an early stage):
growth on the surface and/or in the outer wood area,
nutrition from the contents of parenchyma cells and sawwood capillary liquid
wood decayers:
brown-rot, white-rot, soft-rot fungi:
wood rot as a result of nourishment from the polymeric components
(cellulose, hemicelluloses, lignin) of the lignified cell wall

conditions in the soil, in lakes, and marine environments, mixed bacterial populations of the erosion, cavitation and tunneling bacteria can degrade wood (Schmidt and Liese 1994; Daniel and Nilsson 1998; Kim and Singh 2000). Even a bacterial pure culture attacked woody cell walls (Schmidt et al. 1995) (Fig. 5.3c).

Whereas the fungal cell wall with openings up to 10 nm hardly limits the uptake of water and small molecules, the plasma membrane is a selectively permeable barrier for the uptake and secretion of solutes. Water, non-polar and small uncharged polar molecules, like glycerol and CO_2, can diffuse freely. Larger polar molecules and ions pass the membrane by means of diffusion or active transport (Rayner and Boddy 1988; Jennings and Lysek 1999). The uptake occurs mainly at the hyphal tips (Figs. 2.3, 2.4). Three main classes of nutrient uptake and transport occur in fungi, facilitated diffusion, active transport, and ion channels (Robson 1999). A constitutive low affinity transport system of facilitated diffusion allows the energy-independent accumulation of solutes like sugars and amino acids when present at a high concentration outside of the hypha, but not against a concentration gradient. When the solute concentration is low, carrier proteins are induced that have a higher affinity for the solute and mediate the energy-dependent uptake of solutes against a concentration gradient at the expense of ATP. During this process, fungi create an electrochemical proton gradient by pumping out hydrogen ions from the hyphae at the expense of ATP via proton pumping ATPases in the plasma membrane. The proton gradient provides the electrochemical gradient that drives nutrient uptake as hydrogen ions flow back down the gradient. A number of ion channels that are highly regulated pores in the membrane and allow influx of specific ions into the cell when open have been found in fungi. Ca^{2+} stimulated K^+ channels carry an inward flux of K^+ ions and are thought to be involved in regulating the turgor pressure of the hypha. A mechanosensitive or stretch-activated Ca^{2+} channel is opened when the membrane is under mechanical stress like during the generation of the high calcium gradient at the hyphal tip.

During early growth, nutrients surrounding the young mycelium are in excess. As the mycelium develops further, nutrients in the center are increasingly utilized, nutrient depletion and accumulation of metabolic products occur beneath the colony center. Therefore, growth becomes restricted to the periphery. Different parts of the colony are at different physiological ages, with the youngest hyphae at the edge of the colony and the oldest, non-growing mycelium at the center (Robson 1999).

The movement of the nutrient over short distances from a food source on to the regions devoid of the nutrient or nutrients required for growth can occur by diffusion within the aqueous phase of the cytoplasm (Jennings and Lysek 1999). As mycelial extension proceeds, nutrients are shifted from the site of absorption to another part of the mycelium by translocation (Jennings

1987, 1991). Translocation of nutrients is predominantly by water flow. Water flow is generated by the uptake of nutrients, particularly carbohydrates, by the mycelium such that the hyphae have a lower water potential than the substrate. In consequence, water flows into the hyphae and the hydrostatic pressure so generated drives a flow of solution towards the mycelial growth front. The volume flow is dissipated at the growth front by the increase in volume of the hyphae and the production of droplets at the hyphal apices. The droplets have a lower osmotic potential than the hyphae or that of the substrate from which the mycelium grows. This means that the water leaves the cytoplasm ultrafiltered by the plasmalemma of many of the nutrients in the translocation stream. Pressure-driven flow of solution has been studied particularly in *Serpula lacrymans* (Jennings 1991). It must occur in a wide range of fungi because droplets (guttation) are common among fungi. Guttation often occurs in white-rot fungi, like during growth of *Donkioporia expansa* in buildings and in the edible mushrooms *Lentinula edodes* and *Pleurotus ostreatus* when the colonization phase of the substrate is completed and the fungi start fruiting. In *S. lacrymans*, the droplets at the hyphal tips are slightly acidic (pH 3–4), which was related to the ability of the fungus to colonize alkaline substrates (Bech-Andersen 1987a).

The dry weight of fungal mycelium consists of about 5% of nitrogen (% N of the Kjeldahl method ×4.4 corresponds to the protein content of fungi. Additional nitrogen is included, e.g., in the chitin). Wood typically has a very low nitrogen content. The average nitrogen for healthy hardwoods and softwoods was 0.09% of the dry weight of wood and reached to about 0.2% N (Rayner and Boddy 1988; Fengel and Wegener 1989; Reading et al. 2003) with an average carbon to nitrogen ration of 500 to 600:1. Nitrogen content changes over the wood cross section and is lower in wounded or decayed tissue. With regard to lignocelluloses, it has to be considered, however, that the majority of carbon is present as a cell wall component and thus enzymatically difficulty accessible, while the nitrogen compounds are more easily degradable. Altogether nitrogen, however, is a limiting factor. Fungi do not fix atmospheric nitrogen, how this some bacteria are able to do. Instead, fungi use nitrogen rationally, as nitrogen compounds are translocated to the growth front at the hyphal tips due to different turgor pressure in the mycelium (Watkinson et al. 1981; Jennings 1987). Protein-rich woods, e.g., *Pycnanthus angolensis*, are colonized by bacteria after felling and during the drying process, which leads to undesirable discolorations (Chap. 5.2) (Bauch et al. 1985). For wood fungi, ammonium is a suitable inorganic source of nitrogen in vitro, while nitrate is usually not used. Organic nitrogen from amino acid mixtures in pepton or malt extract results in good growth on agar.

There are several minerals in wood. The main inorganic components found in wood ash are K, Ca, Mg, Na, Fe, silica, phosphate, chloride, and carbonate (e.g., Fengel and Wegener 1989; also Ważny and Ważny 1964). By SEM-EDXA,

Al, S, and Zn were detected (Rodriguez et al. 2003). Particle induced X-ray emission (PIXE) quantified P, S, K, Ca, Ti, Mn, Fe, Ni, Cu, Zn, Pb, Sr, Rb, Ba and F (Saarela et al. 2002). Inductively coupled plasma emission (ICP) showed a content of 50–100 ppm of manganese in Scots pine sapwood (Schmidt et al. 1997a). Inorganic compounds comprise 0.1–0.5%, oxide basis, of total wood components in temperate zones and up to 4% in tropical woods. Mineral elements enter the living tree predominantly through the root, which is frequently helped by mycorrhizae fungi. The wood-inhabiting fungi use metals present in wood for their growth and to degrade it (Chap. 4). Several metals are necessary to fungi, e.g., for wood degradation. Enzymes that participate in lignin degradation contain iron (lignin- and manganese peroxidases, cellobiose dehydrogenase) or copper (laccases) (Rodriguez et al. 2003). Iron, manganese, and copper are involved in the generation of hydroxy radicals or other oxidizing agents, which, in turn, attack wood (Henry 2003).

Elements present in forest and other soils can also be a nutrient source for fungi, enhancing fungal capacity to degrade wood. The wood nitrogen content can be increased by ground contact or by means of translocation through the mycelium. Nitrogen can be taken up, e.g., by *Serpula lacrymans* mycelium from the soil under houses and transported in the strands to the place of wood degradation within buildings (Doi and Togashi 1989).

Some wood-degrading Basidiomycetes are heterotrophic for vitamin B_1 (thiamine). *Heterobasidion annosum* is auxoheterotrophic regarding the pyrimidine half of thiamine, can however synthesize the thiazole part of the vitamin (Schwantes et al. 1976). Some wood-decay fungi additionally need vitamin H (biotin). Suitable vitamin sources in vitro are yeast and malt extract.

Thiamine is decomposed in hot alkaline medium. Therefore in the USA, poles had been treated with ammonium gas under high temperature ("dethiaminization") to destroy the vitamin and, thus, to protect the wood against decay fungi. The poles, however, were for all that attacked by fungi, as thiamine from soil bacteria (Henningsson 1967) diffused into the poles during service (treatment of cut timber: Narayanamurti and Ananthanarayanan 1969).

In addition to cell wall components, primary metabolites and storage material, wood contains a broad spectrum of extractable substances (extractives, accessory compounds, secondary metabolites) like waxes, fats, fatty acids and alcohols, steroids and resins (Fengel and Wegener 1989; Obst 1998). More than 10,000 compounds were reported to occur in plants (Duchesne et al. 1992). Depending on the wood species, the type, quantity, and distribution of the extractives can vary considerably. They are particularly located in the heartwood, and after wounding and microbial infection also in the sapwood as wound reaction (Chap. 8.2.1). Heartwood is a dark-colored zone in the central part of the stems of most tree species and is physiologically formed from sapwood, followed by decreased moisture content, the death of parenchyma cells, and increased extractive content. Inhibiting extractives, which cause the natural

durability of many heartwood species develop during heartwood formation from starch and soluble carbohydrates (Magel 2000) and are mainly phenols, like terpenoids, flavonoids, stilbenes, and tannins (Fengel and Wegener 1989; Obst 1998; Roffael and Schäfer 1998; Imai et al. 2005). For example, pinosylvins inhibited brown-rot fungi (Celimene et al. 1999), flavonoids inhibited *Gloeophyllum trabeum* and *Trametes versicolor* (Reyes-Chilpa et al. 1998). While the extractives during the obligatory formation of a colored heartwood penetrate in the cell walls, those that develop by exogenous influences (facultatively colored heartwood), like wound reactions, do not impregnate cell walls (Koch 2004).

Omnivors are the only less specialized molds (Chap. 6.1), which can grow on wood, paper, wallpaper, books and leather, and dissolve even minerals from glass by acid production (Kerner-Gang and Schneider 1969). The "polyphage" *H. annosum* has a broad host spectrum of over 200 wood species (Heydeck 2000). As a specialized parasite, *Piptoporus betulinus* attacks only birch trees (host spectrum: Jahn 1990; Ryvarden and Gilbertson 1993).

Nutrient media to isolate, enrich, purify, and cultivate wood-inhabiting fungi are malt extract agar and potato dextrose agar of about pH 5.5. Bacterial isolates from wood grow on nutrient media like peptone/meat extract/yeast extract of about pH 7 (Schmidt and Liese 1994). For special microorganisms, selective media are commercially available, or standard agar is enriched with selecting compounds. If bacteria have to be eliminated during fungal isolations, the substrate can be acidified by lactic or malic acid or an antibiotic is added. Orthophenylphenol selects on white-rot fungi. Benomyl inhibits molds like *Penicillium* and *Trichoderma* species.

3.2
Air

As aerobic organisms, wood fungi produce CO_2, water, and energy by respiration and need therefore air oxygen (Table 3.3).

The energy production from wood, if only cellulose is consumed, is shown in Table 3.4. Aerobes, however, do not respire carbohydrates totally, but use intermediates for their metabolism.

Fungal activity is affected by the composition of the gaseous phase. Usually wood decay decreases at low O_2 and high CO_2 content, respectively. The O_2

Table 3.3. Aerobic degradation of wood to CO_2, water and energy

cellulose, hemicellulose, lignin from wood – (ectoenzymes) →
sugars, lignin derivates – (uptake, intracellular enzymes) → CO_2 + 2(H)
2(H) + 1/2O_2 – (respiratory chain) → H_2O + energy (ATP)

Table 3.4. Energy production from wood cellulose

Assuming that 1 kg dry wood contains 48.6% cellulose:
1 mol glucose (180 g) yields 2,835 kJ, 180 g glucose correspond to 162 g cellulose [162 + 18; (1 mol H_2O used for hydrolysis)], 3 × 162 = 486, 486 g cellulose yield 8,505 kJ (2,025 kcal)

content in the wood of living oak trees varied season-dependently from 1–4% and the CO_2-content from 15–20% (Jensen 1969).

There are various reactions occurring in wood fungi that require oxygen, such as degradation of lignin, oxidative polymerization of phenols, and melanin synthesis in blue-stain fungi and other fungi. With the onset of differentiation, there is also an increased oxygen demand. When the reproduction is initiated, there is a high requirement for protein and nucleic acid synthesis, which energetically involves a higher demand on the fungal metabolism and, thus, increased oxygen utilization (Jennings and Lysek 1999). This reason as well as access to air currents for spore dispersal explain why most fungi form their fruit bodies at or near the substrate surface.

A lack of oxygen can limit wood decay. Saprobes usually react more sensitively to O_2 lack than parasites living within the heartwood: The saprobes *Serpula lacrymans* and *Coniophora puteana* survived without oxygen 2 and 7 days, respectively (Bavendamm 1936), the parasitic heartwood destroyer *Laetiporus sulphureus* more than 2 years (Scheffer 1986). In *Heterobasidion annosum*, mycelial growth hardly decreased at 0.1% O_2 content compared to 20% (Lindberg 1992). The conidia of some blue-stain fungi still germinated at 0.25% O_2 content, some Mucoraceae (molds) even in a pure N-atmosphere (Reiß 1997).

The yeasts, which are able to get energy also facultatively anaerobically by fermentation, form an exception of the aerobic way of life among the fungi. During the alcoholic fermentation of the hexose sugars (Saddler and Gregg 1998) in coniferous wood sulphite spent liquors which was performed in former times e.g., in Switzerland, the produced hydrogen is not transferred to atmospheric oxygen, but to the organic H-acceptor acetaldehyde: $2(H) + CH_3CHO \rightarrow CH_3CH_2OH$ (ethanol). At low oxygen content, anaerobic metabolites like ethanol, methanol, acetic acid, lactic acid, and propionic acid have been found also in Basidiomycetes (Hintikka 1982).

In the course of wood degradation, the CO_2 concentration may increase. Some wood-degrading Basidiomycetes, particularly heartwood destroyer, are tolerant of a high CO_2 content, since they grew well at 70% CO_2 and even at 100% (Hintikka 1982), while forest-litter decomposing fungi were inhibited

at more than 20% CO_2. *Chaetomium globosum* and *Schizophyllum commune* can fix CO_2 into organic acids of the citric acid cycle (Müller and Loeffler 1992). An increasing CO_2 content inhibits the growth of many Deuteromycetes, which then partly change the metabolism to fermentation and also alter their filamentous growth manner to a yeast-like appearance (Reiß 1997; Jennings and Lysek 1999).

The minimum air volume in wood for degradation by fungi is between 10 and 20%: 10% in *H. annosum*, 20% in *S. commune* (Rypáček 1966).

Reduction of the O_2 content in wood effects a protection against fungal (and insect) decay. Such protection is performed by wet storage of wind-thrown wood by dipping and floating in water or sprinkling of piled wood. From 17.6 million m^3 of windfalls after the storm in north Germany in 1972, 1.4 million were protected by watering and were sold until 1976 nearly without any quality loss (Liese and Peek 1987; Groß et al. 1991; Bues 1993). In 1990, 15 million m^3 of round timber were stored by sprinkling in Germany. At the density of about $0.5\,g/cm^3$ of spruce and pine wood, the 20% critical air volume is obtained through a wood moisture content of 120% u, so that alternating sprinkling is sufficient. With new methods, logs are wrapped by plastic foil and stored in an atmosphere of CO_2 and/or N_2 (Mahler 1992).

The soft-rot fungi are an exception among the wood decay fungi. They exhibit lower a requirement for oxygen and can also live in water-filled wood tissue like in sprinkled cooling-tower wood with about 200% u moisture content, because the cooling-tower water is enriched with the necessary O_2 by the spraying effect of the dripping water (Chap. 7.3). Among the Basidiomycetes, *Armillaria mellea* s.l. showed a strange behavior, as it caused in sprinkled Norway spruce logs tubes in the water-saturated sapwood, through which necessary oxygen for wood decay invaded the wood (Metzler 1994).

In addition, (facultatively) anaerobic bacteria degrade the non-lignified sapwood bordered pits in sprinkled and ponded wood, so that wood permeability increases and the wood shows later the unwanted, because uneven, excessive uptake of wood preservatives or pigments (Willeitner 1971).

3.3
Wood Moisture Content

As wood degradation by fungi involves enzymes, which are active in aqueous environment, and because hyphae consist of up to 90% of water, wood fungi need water. Water is also used for the uptake of nutrients, the transport within the mycelium and as solvent for metabolism. Without water, the metabolism rests. The resting phase occurs by means of spores, in wood fungi particularly by chlamydospores. Regarding the so-called dryness resistance of wood decay fungi (Theden 1972) it was however not proven if vegetative hyphae or spores

survived. Water is taken up from the substrate wood, the soil, and from masonry etc. Altogether the moisture content of wood is the most important factor for wood degradation by fungi and thus also for wood protection. Moisture in wood exists in two different forms: Bound or hygroscopic water occurs within the cell wall by means of hydrogen bounds at the hydroxyl groups mainly in the cellulose and hemicelluloses and to smaller extent in the lignin. Free or capillary water in liquid form is located in the cell lumen as well as in other holes and cavities of the wood tissue (e.g., Siau 1984; Smith and Shortle 1991).

There are several methods of measuring wood moisture content (Vermaas 1996): oven-drying method, microwave drying Danko (1994), distillation, Karl Fischer-titration, moisture meters based on electrical and dielectrical properties, continuous moisture meters, capacity admittance moisture meters, and hygrometric methods. Determination of the moisture content without destruction is done electrically by means of resistance measurement (Skaar 1988; Du et al. 1991a, 1991b; Böhner et al. 1993; Chap. 8.2.4). With increasing moisture content of wood from the oven-dry phase to the fiber saturation range (about 30% u) the electrical resistance decreases approximately by the factor $1:10^6$. Moisture can be rapidly determined in practice using an indelible pencil that is the pencil line runs if the fiber saturation point is exceeded.

The proportional wood moisture (% u) is determined gravimetrically by the wood mass before and after drying a wood sample at $103 \pm 2\,^\circ$C: u (%) = [(MW – MD) : MD] × 100 (MW = mass of wet wood, MD = mass of dry wood).

If heat-implied changes in the wood samples shall be excluded to take care of wood extractives and cell wall components for subsequent microbial/enzymatic degradation experiments or chemical analyses, drying of the wood specimens can be performed in an evacuated desiccator over silicagel or P_2O_5. Wood samples may be also conditioned to specific relative humidity conditions prior to and after decay, e.g., at $20 \pm 2\,^\circ$C and $65 \pm 5\%$ relative air humidity. With the latter method, the theoretical dry weight (MDt) of a sample results from: MDt = (100 × MC) : (100 + u) (MC = mass after conditioning, u = % wood moisture after air conditioning). However, weight loss methods using moisture-conditioned wood samples instead of oven-dry blocks are influenced by changes in hygroscopicity: For brown-rot, mass loss is slightly overestimated, for white rot, no difference occurs, while for soft rot, mass loss is slightly underestimated using the moisture-condition method (Anagnost and Smith 1997).

To quantify the moisture content of fungal nutrient substrates, including wood, only the proportional water content of the substrate was considered in previous investigations. At the disposal to microorganisms, however, not the whole water content of the substrate is available, but only that part of the total water, which is not bound by solved substances (salts, sugars, etc.). The relative vapor pressure of a substrate (water activity aw, 0–1) results from the quotient

of the water vapor pressure in the substrate (p) and the pressure of pure water (p_0) (aw = p/p_0) (Siau 1984; Rayner and Boddy 1988; Reiß 1997; Table 3.5).

The minimum water activity (Table 3.5) is for most bacteria with 0.98 aw higher than for many molds, which grow still at 0.80 aw. The minimum for growth of wood-decay Basidiomycetes on agar is 0.97 aw. Xerotolerant and xerophilic molds like some *Aspergillus* species still grow at 0.62 aw. Those fungi grow in solutions of sodium chloride around 5–6 M (Jennings and Lysek 1999) and tolerate an 80% saccharose solution (Schlegel 1992; Reiß 1997), generating the appropriate osmotic pressure within their protoplasm e.g., by the synthesis of glycerol. Below 0.6 aw usually no microbial growth occurs.

The situation of high salt concentrations (sodium chloride) applies also to marine fungi. Various "lower fungi", Deuteromycetes, Ascomycetes, and a few Basidiomycetes colonize wood in the sea (Kohlmeyer 1959; Volkmann-Kohlmeyer and Kohlmeyer 1993). As in marine fungi vacuoles constitute no more than about 20% of the volume of the protoplasm, there is no preferential accumulation of sodium chloride in the vacuoles. Marine fungi synthesize glycerol and other polyols (mannitol, arabitol) which contribute to their osmotic potential (Jennings and Lysek 1999).

For growth and wood degradation by fungi, particularly at low water contents, the water potential (MPa) is the most important factor for water availability. It is defined as free energy of water in a system relative to pure water, and because in the relevant range all values are negative, it can be defined as that negative pressure ("subpressure"), which is necessary to extract water from the substrate (Griffin 1977). The water potential is affected by different factors (Siau 1984; Jennings 1991). These are particularly the size and form of the boundary surfaces both between water and firm matrix and between water and air (matrix potential), and the osmotic potential due to the occurrence of solved substances. The influence of the water potential on growth of wood fungi was first examined with simple substrates, like agar plates in Petri dishes, in controlled air humidity (Bavendamm and Reichelt 1938). The observed values of mycelial growth still at −14.5 MPa (aw 0.9), however, were later classified as too low. Instead, as lower limit about −4 MPa were determined (Griffin 1977; Griffith and Boddy 1991; Table 3.5). *Serpula lacrymans* did not grow on agar below −0.6 MPa (Clarke et al. 1980).

Due to the occurrence of pores of different size (porosity of wood: Kollmann 1987), the special significance of the matrix potential becomes obvious with increasing drying of wood tissue. In water-saturated wood, all cavities are filled, and a neglectably small pressure difference is sufficient for dehydration. With progressive drying, increasingly smaller openings become free from water (Table 3.5). Large openings in wood tissue with radii over 5 µm like all cell lumens are free from water, if the matrix potential amounts to less than about −0.03 MPa. Between −0.03 and −14.5 MPa, pores from 5–0.01 µm radius become empty (pits, boreholes by microhyphae). Below about −14 MPa,

Table 3.5. Correlations between water activity (aw, relative vapor pressure p/p0), water potential (MPa), maximum water-retaining pore radius (μm) within wood at 25 °C, wood emptiness class and microbial activity (compiled from Griffin 1977; Clarke et al. 1980; Siau 1984; Rayner and Boddy 1988; Viitanen and Ritschkoff 1991; Schlegel 1992; Reiß 1997)

Water activity (aw, p/p0)	Water potential (MPa)	Pore radius (μm)	Wood emptiness class	Microbial activity
1.0000	0	(free water)		
0.9999	−0.014	10.5	cell lumens, large openings after decay	wood degradation and staining
0.9998	−0.028	5.2		
0.9993	−0.10	1.5	fiber saturation area, pits and small openings	minimum for most wood fungi
0.9990	−0.14	1.1		
0.9975	−0.35	0.4		
0.9950	−0.69	0.2		
0.990	−1.4	0.1		half-maximum growth rate of wood-decay Basidiomycetes on agar
0.980	−2.8	0.05		minimum for most bacteria
0.970	−4.2	0.035		minimum for mycelial growth and wood decay of *Serpula lacrymans*
0.960	−5.6	0.026		optimum for growth and sporulation of *Aspergillus niger*
	−6.0			no growth of *S. lacrymans* on agar
0.920	−11.3	0.013		minimum for sporulation of *A. niger*
0.900	−14.5	0.01		
0.880		< 0.01	temporary or intermolecular openings in the cell wall	minimum for growth of *A. niger*
0.840				minimum for germination of *A. niger* and growth of *Paecilomyces variotii*
0.800				minimum for most molds
0.750				minimum for halophilic bacteria
0.650				minimum for *A. repens*
0.600				lower limit for microbial growth

intermolecular cavities in the cell wall dry (liquid movement in wood: Siau 1984; Skaar 1988).

From the view of a hypha, a low water availability begins to become critical, if free water is no more located in the cell lumen void space, but liquid water exclusively within the cell wall and only water vapor in the lumen, or in other words, if the cell walls are fully hydrated yet with no water contained in the cellular spaces. This condition is defined as fiber saturation point or range (Babiak and Kúdela 1995) and lies at about −0.1 MPa (0.9993 aw), according to 1.5 µm pore radius (Table 3.5) and about 30% u wood moisture for woods of the temperate zones. The lower limit for wood degradation by Basidiomycetes is about −4 MPa (0.97 aw).

Below fiber saturation, not only fungi are influenced by the moisture content, but also all technological properties of wood. With increasing moisture, e.g., elastic, strength, and insulation properties decrease.

Relative air humidity (RH), which is in equilibrium with a substrate, and water activity of a substrate stand in the relationship: RH(%) = aw × 100. For example, 99.93% RH correspond to 0.9993 aw and thus to fiber saturation, so that the critical range for Basidiomycetes of 0.97 aw (Table 3.5) is exceeded by condensation in buildings. The S-shaped sorption isotherms, which indicate the dependence of the wood moisture on the relative air humidity of the environment, are shown by Siau (1984) and Kollmann (1987). Wood is dry at the relative vapor pressure of 0, and fiber saturation is reached at 1 (100% RH). Spruce sapwood samples placed over a saturated solution of K_2SO_4, which results in 97% RH and 26.5% u, showed 4.5% mass loss after 3 months of incubation with S. lacrymans (Viitanen and Ritschkoff 1991a). Wood samples in 93% RH according to 23–24% wood moisture content were overgrown by S. lacrymans and Coniophora puteana (Savory 1964). For the initial colonization, 21% u was necessary (Huckfeldt et al. 2005; cf. Table 8.7). Coniophora puteana colonized wood samples of 18% moisture content when a moisture source was 20–30 cm away from the wood. Timber in buildings reached however till 45% humidity in the winter during night by condensation (Dirol and Vergnaud 1992).

According to Skaar (1988), the wood moisture content of living trees amounted to 83% u in hardwoods in the sapwood and to 81% in the heartwood (average of 34 species) and in conifers to 149% in the sapwood and to 55% in the heartwood (average of 27 species).

The moisture content in dead wood is determined by several factors:

– fungal decay: For example, the wood moistures of dry heartwood samples of different wood species increased during decay by Trametes versicolor in 84 days to 78–236% and by Oligoporus placenta to 108–286% (Smith and Shortle 1991). Regarding the sorptive capacity of wood (Cowling 1961; Anagnost and Smith 1997), Rawat et al. (1998) showed that the moisture content

of brown-rot decayed wood was more than that of undecayed samples at low relative humidities, but at higher humidities (about 37%) the situation was reversed. Absorptiveness also increased after pretreatment with blue-stain fungi (Fjutowski 2005).

- moisture uptake, which can occur by five ways: rainfall, absorption from air, capillary penetration of water into wood in ground contact or in buildings by condensation on wood surfaces, water transport by the mycelium, and water formation by fungal metabolism,
- loss of water: in wood with large pores by the force of gravity, furthermore by evaporation as a function of temperature, humidity, and matrix potential as well as by water transport via mycelium.

The cardinal points of the wood moisture content for some decay fungi are shown in Table 3.6, whereby the data vary, however, depending on the fungal isolate, the wood species, and the testing method. Laboratory findings and practice observations may also yield different results (Ammer 1964; Savory 1964; Cockcroft 1981; Thörnqvist et al. 1987; Viitanen and Ritschkoff 1991a; Huckfeldt et al. 2005).

Generally, it applies to wood fungi: The minimum for wood decay is near the fiber saturation point of about 30% u, however, commonly slightly above this range because only then there is free water in the lumen void space. Some house-rot fungi, however, could colonize wood in laboratory culture, whose moisture was significantly below fiber saturation (minimum 18% u) before the mycelium contacts the woody substrate, because these fungi transported water from a moisture source by means of mycelium. The minimum for decay of pine wood samples by these house-rot fungi was between 22 and 37% u (Huckfeldt and Schmidt 2005; cf. Table 8.7). The optimum differs depending on the fungal species and affects the occurrence of different fungi in differently moist biotopes: For example, the optimum is at 50–100% for tree-inhabiting blue-stain fungi and below 50% for lumber blue-stain fungi (Bavendamm

Table 3.6. Cardinal points of wood moisture content (% u) for some wood-decay fungi (literature data)

	Minimum	Optimum	Maximum
Antrodia spp.	30	35–55	60–90
Coniophora puteana	26–30	30–70	60–80
Daedalea quercina		40	
Gloeophyllum spp.	30	40–60	80–210
Heterobasidion annosum		45	
Lentinus lepideus		35–60	
Phlebiopsis gigantea		100–130	
Serpula lacrymans	26	30–60	55–225

1974). Wood fungi are inhibited as the cellular spaces of wood become fully saturated with water. The maximum wood moisture content allowing fungal growth is determined by the minimum air content within the wood cell.

A certain water amount originates from fungal metabolism (Ammer 1964; Savory 1964). The assertion that *S. lacrymans* gets the total water, which is necessary to moisten dry wood, from the respiration of wood cellulose (Table 3.3), however, is wrong: It has to be considered that cellulose is not completely degraded to CO_2 and 56% water. Intermediate metabolites for the synthesis of fungal biomass are necessary. According to Weigl and Ziegler (1960) about 40% of the consumed cellulose is used for those metabolites. Furthermore, water production from carbohydrates is the rule for all breathing organisms. Nevertheless, some fungi, particularly *S. lacrymans*, show intensive guttation, that is excretion of water in drop form.

In view of dry wood, in addition to spores also the mycelium of some fungi was said to be resistant to dryness (Table 3.7).

The duration of this so-called dryness resistance depended on air humidity and temperature. Resistance lasted e.g., longer at 60% RH and low temperature than at 90% RH and high temperature. For *S. lacrymans*, the duration was 8 years at 7.5 °C and 1 year at 20 °C (Theden 1972). Dryness-resistant are also *Coniophora* species, indoor polypores, *Gloeophyllum abietinum* (on window timber), *Lentinus lepideus* (on sleepers), *Paxillus panuoides*, *Schizophyllum commune*, *Stereum sanguinolentum*, the soft-rot fungi and to smaller extent *Heterobasidion annosum* and *Trichaptum abietinum*. To what extent fungi, however, are qualified for dryness resistance, exclusively in the form of hyphae or as resistant spores was not examined in detail.

Serpula lacrymans survived only in slowly drying wood samples. Own laboratory observations revealed that its dikaryons formed arthrospores in old, dry agar cultures, which points to monokaryotization. That is, the hyphae may have developed dryness-resistant resting stages if the substrate takes a long time to dry down, and the spores germinate again under sufficient moisture conditions. Thus, studies with wood samples that have been colonized by mycelium and subsequently slowly dried indicated that *S. lacrymans*, *C.*

Table 3.7. Resistance to dryness (after Theden 1972)

Years withstanding at °C	27	20	7.5
Antrodia vaillantii	≥ 7	9	≥ 6
Coniophora puteana	0	2	4
Coniophora marmorata	0	3	7
Gloeophyllum abietinum	5	7	≥ 7
Gloeophyllum trabeum	11	≥ 10	≥ 8
Lentinus lepideus	7	≥ 9	≥ 8
Oligoporus placenta	9	≥ 11	≥ 5
Serpula lacrymans	0.5	1	8

puteana, Gloeophyllum trabeum, and *Donkioporia expansa* may survive as arthrospores (Huckfeldt et al. 2005).

3.4
Temperature

With respect to the temperature, Table 3.8 shows the cardinal points for some wood fungi. A comprehensive investigation was completed in 1933 grouping the species into low-temperature (optimum 24 °C and below), intermediate-temperature (optimum between 24 and 32 °C), and high-temperature group (optimum above 32 °C) (Humphrey and Siggers 1933). For three species, e.g., *Gloeophyllum sepiarium,* minimum, and maximum temperatures were already determined (Lindgren 1933). It has to be considered, however, that considerable differences can exist between isolates of a species (Table 3.11).

Generally, it applies to wood fungi: The minimum is usually at 0 °C, because below the freezing point there is no liquid water available necessary for metabolism. Exceptions of growth below 0 °C are possible, if the freezing point is decreased, e.g., by trehalose and glycerol or other polyhydric alcohols as anti-freeze agents which prevent ice-crystal formation within the hypha (Jennings and Lysek 1999). In some blue-stain and mold fungi, the lower limit for mycelial growth is at −7 to −8 °C (Reiß 1997). Above the lower limit, the "reaction speed-temperature rule" begins to take effect, as in a certain temperature range, enzyme activity runs two to four times faster by increasing the temperature of about 10 °C (Q_{10} value). Frequently, the optimum lies, depending on the species (and isolate) between 20 and 40 °C. Psychrophilic fungi have their optimum below 20 °C, mesophilic species between 20 and 40 °C and thermophilic species over 40 °C. Thermotolerant fungi, e.g., *Phanerochaete chrysosporium* and other fungi growing in wood chip piles, prefer the mesophilic range, tolerate however still 50 °C. The maximum for mycelial growth and wood damage by most wood fungi is often at 40–50 °C, because then the protein (enzyme) denaturing by heat takes effect. Fungi, however, may exhibit a change in gene expression, which leads to the synthesis of "heat-shock proteins (hsp)". The hsps appear to prevent and repair general damage, denaturation and aggregation of other cellular proteins, as they are not only induced by heat, but also by heavy metals and oxidants (Jennings and Lysek 1999).

Serpula lacrymans possesses a characteristic, which can be used for identification. With the optimum of about 20 °C, slight growth still at 26–27 °C, and growth stop at 27–28 °C, the fungus differs from the other indoor wood decay fungi, like the Cellar fungus and the white polypores, as well as from other *Serpula* species, because, e.g., *S. himantioides* still grows at 31 °C. There are, however wild Himalayan isolates of *S. lacrymans* that showed slight growth at 32 °C (Palfreyman and Low 2002). In addition, in *S. lacrymans* also the

Table 3.8. Cardinal points of temperature (°C) for fungal growth and survival (mainly from Humphrey and Siggers 1933; Cartwright and Findlay 1958; Ammer 1964; Cockcroft 1981; Mirič and Willeitner 1984; Thörnqvist et al. 1987; Viitanen and Ritschkoff 1991; data of house-rot fungi from Schmidt and Huckfeldt 2005)

Species	lethal	minimum	optimum	maximum	lethal on agar in 2 weeks	lethal on agar (h)	lethal 4 h in wood
Armillaria mellea			25–26	33			
Aspergillus niger			35–37	45–47			
Aureobasidium pullulans			25	35			
Daedalea quercina		5	23–30	30–44			
Fomes fomentarius			27–30	34–38			
Heterobasidion annosum		2–4	22–25	30–34			
Laetiporus sulphureus			28–30	36			
Lentinus lepideus		3–8	25–33	37–40		60 (0.5)	
Paxillus panuoides		5	22–25	29			
Phellinus pini			20–27	30–35		55 (0.5)	
Piptoporus betulinus			26–30	32–36			
Polyporus squamosus			24–25	30–38		60 (0.5)	
Schizophyllum commune			28–36	44		60 (0.5)	
Stereum sanguinolentum		< 4	20–22				
Trametes versicolor			24–33	34–40		55 (0.5)	
Trichaptum abietinum			22–28	35–40			
Serpula lacrymans	−6	0–5	20	26–27	30	55 (3)	50–70
Serpula himantioides			25–27.5	32.5	> 35		65
Leucogyrophana mollusca			25–27.5	32.5	30 ≥ 35		75
Leucogyrophana pinastri			20–27.5	32.5	> 35		
Coniophora puteana	−20/−30	0–5	22.5–25	27.5 ≥ 37.5	32.5 ≥ 37.5	60 (3)	70–75
Coniophora marmorata			20–27.5	25 ≥ 37.5	35 ≥ 37.5		
Coniophora arida			25	27.5	35		
Coniophora olivacea			22.5–25	32.5–35	35 ≥ 37.5		
White polypores (old data)		3–5	25–31	35–38		80 (0.5)	
Antrodia vaillantii			27.5–31	35	37–40	65 (24)	> 80
Antrodia sinuosa			25–30	35	37–42.5	65 (3)	
Antrodia xantha		5	27.5–30	35	40–42.5		
Antrodia serialis			22.5–25	32.5–35	37.5–42.5		
Oligoporus placenta		3	25	35	40–45	65 (24)	> 80
Gloeophyllum abietinum		0–4	25–27.5	37.5–42.5	40–42.5		> 95
Gloeophyllum sepiarium		5	27.5–32.5	≥ 45	≥ 45	60 (3)	> 95
Gloeophyllum trabeum		5	30–37.5	≥ 45	≥ 45	80 (1)	> 95
Donkioporia expansa			28	34	> 40	65 (24)	> 95

monokaryons tolerated 28 °C (Schmidt and Moreth-Kebernik 1990), so that probably some data in the literature concerning growth of the fungus above 27 °C (Wälchli 1977) were based on monokaryons. Last, dikaryons of *S. lacrymans* (and some further fungi) can be reverted to the monokaryotic stage by cultivation at relatively high temperature and thus these cultures then also grew above 27 °C.

From the cultivation of edible mushrooms on wood (Chap. 9.2) it is known that the optimal temperature can be lower for fruit body formation than for

mycelial growth. Cultivation of *Lentinula edodes* in Asia involves a dipping of the colonized wood in cold water to stimulate fruit body development. On the other hand, *S. lacrymans* is stimulated to fruit in laboratory culture, if the mycelium is incubated first 3–4 weeks at 25 °C and then 2 weeks at about 20 °C (Fig. 3.1; Schmidt and Moreth-Kebernik 1991b). In some fungi, spore germination is activated by high temperature, in nature for example after forest fires.

The temperature curve of the mycelial growth rate must not correlate with that one of fungal activity. For example, the temperature range for growth may be broader than for wood degradation (Wälchli 1977). Furthermore, the temperature optima of enzymes isolated from fungi are often higher (50–60 °C) than those of mycelial growth of the respective fungus. Some wood fungi tolerate extreme values beyond minimum and maximum by resistance to cold and heat, respectively. However, there are significant differences with regard to the test method used. Results from cultures on agar revealed that *S. lacrymans* survived 1 h at 55 °C, *Coniophora puteana* 1 h at 60 °C, *Antrodia vaillantii* 3 h at 65 °C (Schmidt 1995a), and *Gloeophyllum trabeum* 1 h at 80 °C (Mirič and Willeitner 1984). In colonized wood samples that were slowly dried before heating, *S. lacrymans* survived 4 h at 65 °C, *C. puteana* 4 h at 70 °C, *A. vaillantii* 4 h at 80 °C and *G. trabeum* 4 h at 95 °C, assumably by developing resistant arthrospores (Huckfeldt et al. 2005). This great resistance of the fungi to heat challenges the use of a heat treatment procedure for the eradication of fungi in houses. In Denmark, whole houses are subjected to heat treatment against *S. lacrymans* (Koch 1991) (Chap. 8.5.4).

Vegetative cells (bacteria and fungal hyphae) are destroyed by heating at 80 °C (pasteurization). Exceptions with growth of up to 113 °C are bacteria (Archaea) in volcanic biotopes (geysers, black smokers). Spores are frequently

Fig. 3.1. Fruit body formation of *Serpula lacrymans* in laboratory culture stimulated by a warmth treatment; 25 mycelial growth at 25 °C, 20 growth increase at 20 °C, F fruit body

more thermotolerant than the corresponding mycelium. The basidiospores of
S. lacrymans were killed by 32 h at 60 °C or 1 h at 100 °C (Hegarty et al. 1986).
However, 4 h at 65 °C reduced the germination rate from 30 to 8% (Hegarty
et al. 1987). The heat resistance of basidiospores has also to be considered in
view of eradication of indoor wood-decay fungi by heat treatment.

As spore forming bacteria may survive 100 °C, nutrient media for labora-
tory experiments are sterilized at 121 °C and 210 kPa pressure in autoclaves.
Alternatively, fractionated sterilization at 100 °C (tyndallization) may be used
(heating at 100 °C on three successive days for 30 min to destroy vegetative
cells; between the three heat phases incubation at room temperature to allow
germination of survived spores). Heat-sensitive nutritives can by sterilized by
membrane filtration using filter membranes with a pore size of 0.1–0.45 µm.
Insensitive laboratory equipment like glass material becomes sterile by 1 h of
dry heat at 180 °C. Wood samples for decay experiments may be sterilized by
ethylene oxide in special devices.

In many fungi, spores and also mycelia are resistant to cold. Thus, fungal
cultures in international strain collections are conserved, except by lyophiliza-
tion, also in liquid nitrogen at −196 °C and not like it is usually done in small
laboratories in the refrigerator on agar (or also on small wood pieces: Delatour
1991).

3.5
pH Value and Acid Production by Fungi

The pH value influences germination of spores, mycelial growth, enzyme ac-
tivity (wood degradation), and fruit body formation. The optimum for wood
fungi is often in slightly acid environment of pH 5–6 and for wood bacteria at
pH 7. Basidiomycetes have an optimum range of pH 4–6 and a total span of
about 2.5–9 (Thörnqvist et al. 1987). Ascomycetes, particularly soft-rot fungi,
may tolerate more alkaline substrates to about pH 11. Thus, the pH values from
3.3–6.4 in the wood capillary water of living trees and in aqueous extracts of
wood and bark samples from trees of the temperate zones and from trading
timbers (Sandermann and Rothkamm 1959; Rayner and Boddy 1988; Fengel
and Wegener 1989; Landi and Staccioli 1992; Roffael et al. 1992a, 1992b) cor-
respond with the pH demands of wood fungi. Over the tree cross section, pH
differences can occur, that is for example the heartwood of oaks and Douglas
fir is more acid than the sapwood. Furthermore, an initial pH value can be
changed in the context of microbial succession, because bacteria may acidify
or alkalize the substrate by their metabolites (fatty acid production in acid
wetwood or methane or ammonia formation in alkaline wetwood; Chap. 5.2).
Outside about pH 2 and 12, respectively, microbial activity is commonly pre-
vented. The acid pH-extreme of *Aspergillus niger* is 1.5 (Reiß 1997). There

are however fungi that even grow at about pH 0 like a *Cephalosporium* species. Among the bacteria, the Archaea *Picrophilus oshimae* and *P. torridus* have their pH-optimum at pH 0.7 and even grow at pH −0.06 (Anonymous 1996).

Various wood fungi can change pH values near the extremes by means of pH regulation through their metabolic activity (Rypáček 1966; Humar et al. 2001). Alkaline substrates are acidified by the excretion of organic acids, particularly oxalic acid/oxalate (Jennings 1991). Oxalic acid is synthesized by oxaloacetase (EC 3.7.1.1) from oxalic acetate of the citric acid cycle (Micales 1992; Akamatsu et al. 1993a, 1993b) and can also derive from the glyoxylate cycle (Hayashi et al. 2000; Munir et al. 2001). Table 3.9 shows the amount of oxalic acid produced by some house-rot fungi in vitro and the resulting pH value.

Figure 3.2a shows the change of the pH value by *Schizophyllum commune* as an example of the pH-regulation curve of fungi. If there would not have been a pH-change caused by the fungus, the diagonal in Fig. 3.2a would have resulted. Nutrient liquids with acidic initial pH values become alkalized. For example, the initial pH of 4.2 changed stepwise to the final pH of 7.5. After 3–4 weeks of culture, a nearly straight plateau of pH 7.5 derived from the initial pH values 4.2, 5.1, 6.0 and 7.5. In contrast, the alkaline initial pH value of 7.5 was acidified in the first 2 weeks of culture (Schmidt and Liese 1978).

Aerobic bacteria alkalize their substrates by ammonia release from proteins and amino acids (Schmidt 1986) and anaerobic bacteria alkalize the wetwood in trees by methane formation (Ward and Zeikus 1980; Schink and Ward 1984). Is less intensively examined by which metabolic pathways fungi alkalize acid media. This may occur by the consumption of anions or by the formation of ammonia from nitrogen compounds (Schwantes et al. 1976).

While unbuffered laboratory nutrient media approach the natural habitat of wood fungi and show the physiologically produced pH value of a fungus, buffered media of different initial pH values results in that pH-range, within which a fungus can grow without adjusting the pH. The pH-optima received

Table 3.9. Content of oxalic acid (g/L) and pH-value in nutrient liquid after 2 months of incubation (from Schmidt 1995; Schmidt and Moreth 2003)

Species	Isolate	(g/L)	pH
Antrodia vaillantii	FPRL14	1.85	2.4
	R112	0.63	2.8
	BAM 65	0.65	2.8
	DFP 2375	1.20	2.4
Antrodia sinuosa	MAD 2538	1.10	2.6
Oligoporus placenta	FPRL 280	0.25	2.2
Coniophora puteana	Ebw. 15	0.04	4.2
Serpula lacrymans	BAM 133	1.85	2.4
Donkioporia expansa	MUCL 29391	0.16	4.6

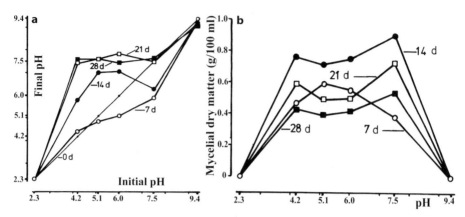

Fig. 3.2. pH value regulation by *Schizophyllum commune* (**a**) and mycelial dry matter after growth with different initial pH values (**b**) for 7–28 days (from Schmidt and Liese 1978)

in buffered and unbuffered media can differ. For example, *Schizophyllum commune* grew best on buffered agar at pH 4.7–5.1, but reached in unbuffered nutrient liquid the highest mycelial dry matter at pH 7.5 (Fig. 3.2b). Two pH-optima may occur (Fig. 3.2b). Frequently, the optimum pH value of enzyme activity of enzymes isolated from a fungus differs in vitro considerably from the pH value for the corresponding fungal growth.

Most brown-rot fungi accumulate oxalic acid (oxalate) in rather large quantities and acidify their microenvironment usually to a greater extent than do the white-rot fungi (Table 3.9: *Donkioporia expansa*). pH-reduction by brown-rot fungi was thought to favor the activity of some non-enzymatic systems hypothesized to be active in these fungi, as well as cellulolytic enzyme activity (Goodell 2003). In brown-rot fungi, oxalate serves as an acid catalyst for the hydrolytic breakdown of wood polysaccharides (Chap. 4). The acid attacked the hemicelluloses and the amorphous cellulose, thus increasing the porosity of the wood structure for hyphae, enzymes and low-molecular degrading substances (Green et al. 1991a; Shimada et al. 1991). The enzyme system to produce oxalate was also found in the white-rot fungi like *Trametes versicolor* (Mu et al. 1996). White-rot fungi accumulate smaller amounts of oxalate and use it in connection with the enzymatic lignin degradation by lignin peroxidase and manganese peroxidase. Under extracellular condition, the mediators, veratryl alcohol cation radicals and Mn^{3+}, produced by lignin and manganese peroxidase, respectively, catalyze the decomposition of oxalate to CO_2 (Shimada et al. 1994). During intercellular metabolism, oxalate is formed by oxalate decarboxylase (EC 4.1.1.2) to formate and CO_2, and the formate produced is converted to CO_2 by formate dehydrogenase (EC 1.2.1.2), yielding NADH (Watanabe et al. 2003). Oxalate may be also metabolized by oxalate oxidase (EC 1.2.3.4) to CO_2 and H_2O_2. There are, however, exceptions within both fun-

gal decay groups. *Gloeophyllum trabeum*, for example, degraded [14]C-labelled oxalic acid to CO_2 during cellulose degradation (Espoja and Agosin 1991), and only relatively slight acidification of nutrient liquids was observed for all indoor *Gloeophyllum* species (Schmidt et al. 2002a).

The intensive production of oxalic acid by *Serpula lacrymans*, which is reflected by an acidification of the growth medium to pH 2.4 (Schmidt 1995b, Table 3.9), has been discussed in connection with the preferential occurrence of the fungus within buildings. Excess oxalic acid is neutralized to Ca-oxalate by calcium from brickwork or by chelating with iron from metals, stonewool and nails (Bech-Andersen 1987b; Paajanen and Ritschkoff 1991, 1992; Paajanen 1993; Palfreyman et al. 1996).

The indoor polypores, especially *Antrodia vaillantii*, are resistant to copper mainly due to the formation of Cu-oxalate (Da Costa 1959; Sutter et al. 1983; Collett 1992a, 1992b; Schmidt 1995b; Chap. 8.5.3.2). Humar et al. (2002) showed that *A. vaillantii*, *Gloeophyllum trabeum* and *Trametes versicolor* transformed copper(II) sulfate in wood into non-soluble and therefore non-toxic copper oxalate. Hastrup et al. (2005) evaluated wood decay of samples impregnated with copper citrate and found 11 out of 12 isolates of *Serpula lacrymans* to be tolerant towards copper citrate. Table 3.10 shows the ability of some house-rot fungi to grow on copper-containing agar.

Table 3.10. Copper tolerance. Growth (±) of house-rot fungi on agar containing copper sulphate (from Schmidt 1995; Schmidt and Moreth 2003)

Species	Isolate	Molarity of copper				
		0.001	0.005	0.01	0.03	0.05
Antrodia vaillantii	FPRL 14	+	+	+	+	−
	FPRL 14a	+	+	+	−	−
	UK 14	+	+	+	(+)	−
	BAM 65	+	+	+	+	(+)
	BAM 486	+	+	+	−	−
	DFPG 6911	+	+	+	+	−
	DFP 2375	+	+	+	−	−
	Sweden R112	+	+	+	(+)	−
	Sweden R113	+	+	+	−	−
Antrodia sinuosa	MAD 2538	+	−	−	−	−
Oligoporus placenta	Ebw. 125	+	(+)	−	−	−
	FPRL 280	+	+	(+)	−	−
	Findlay 304A	+	(+)	−	−	−
Coniophora puteana	Ebw. 15	+	−	−	−	−
Serpula lacrymans	BAM 133	+	−	−	−	−
Serpula himantioides	MAD 213	+	−	−	−	−
Donkioporia expansa	MUCL 29391	+	−	−	−	−

(+) one of two duplicates

Antrodia vaillantii decreased the life-time of timber impregnated with chromated copper arsenate and borate, respectively. Chromium, which plays a role in the fixation reactions of the elements (Bull 2001; Bao et al. 2005b), and arsenate as well as borate became soluble by oxalic acid and were washed out by rain (bioleaching) (Göttsche and Borck 1990; Cooper and Ung 1992a). Copper is precipitated into the insoluble form of the oxalate, rendering the copper inert. This leaching effect was used for biological remediation (recycling) of CC-treated wood waste (Leithoff et al. 1995; Stephan et al. 1996; Samuel et al. 2003; Kartal and Imamura 2003). Arsenic and chromium free copper-organic, alternative preservatives which were recently developed in view of health and environmental aspects were also attacked (Humar et al. 2004; cf. Chap. 7.4). There are further possible candidates for bioremediation of CCA-treated wood such as *Laetiporus sulphureus* (Kartal et al. 2004).

3.6
Light and Force of Gravity

At first sight, light might have no significance for fungi, because fungi are carbon-heterotrophic. The vegetative mycelium including the rhizomorphs of *Armillaria* species and the strands of house-rot fungi grow in nature in the absence of light, namely in the soil and within trees or timber (substrate mycelium), or in buildings hidden behind wall coverings and in the subfloor area. The growth within the substrate might be rather due to hygro-, hydro-, geo- and chemotropisms than to negative phototropism (Müller and Loeffler 1992). Surface and aerial mycelia also grow in the dark like during the routine fungal culturing in the laboratory or at low light intensity like in the indoor polypores and *Serpula lacrymans* in buildings.

A requirement for light occurs particularly with respect to the initiation of reproduction and the ripening of the fruit bodies. Light is the signal that the mycelium has reached the (irradiated) surface, where there the spores can be produced in an environment suitable for spore release (Jennings and Lysek 1999). For fungi, light in the short wavelengths, blue light, is effective, while light with longer wavelengths is ineffective. The light acceptor of the photons hitting the mycelium is riboflavin, which then reduces a cytochrome. The required light quantities are low, below those of the full moonlight at a clear sky ($0.23\,\mu W\,cm^{-2}$).

During the cultivation of *Lentinula edodes* on wood (Chap. 9.2), the colonized wood substrate was exposed to light for 8–15 h/day (Schmidt 1990). In the dark, the primordia did not develop further or abnormal fruit bodies occurred. Particularly suitable are wavelengths from 370–420 nm and from 620–680 nm. *Daedalea quercina*, *Gloeophyllum abietinum*, *Lentinus lepideus*, *Paxillus panuoides* and some other fungi develop abnormal and frequently

sterile "dark fruit bodies" on mine timber. *Serpula lacrymans* fruits in buildings in twilight. In the laboratory, the daily light-dark cycles are suitable.

The Deuteromycetes *Aspergillus niger* and *Paecilomyces variotii* develop conidia both with light and in the dark, likewise the ascomycete *Chaetomium globosum* forms fertile cleistothecia. In other Ascomycetes, conidia formation is induced by light, while in darkness ascospores develop (Reiß 1997). Light-dark cycles lead to a rhythmic change of growth and reproduction of *Penicillium* species and other Deuteromycetes. When the hyphae are irradiated, their growth rate is reduced to differentiation into conidia. Concentric rings develop on agar plates from the inoculum in periodically repeated distances (Schwantes 1996; Reiß 1997; Jennings and Lysek 1999).

Some fungi can grow permanently on sites exposed to light, e.g., fungi growing on plant surfaces (leaves, phylloplane). Typical phylloplane fungi are *Alternaria, Aureobasidium* and *Cladosporium* species (Jennings and Lysek 1999). Some of them are potential parasites, but also effect blue stain of timber as saprobionts.

UV light, particularly 254 nm, has a lethal and mutagenic effect. Nucleic acids are damaged by UV-B of 260 nm by the photochemical induction of cyclobutan dimers, which prevents the correct transcription and reduplication of DNA (Panten et al. 1996). That is mycelium and colorless spores and bacteria can be damaged by sunlight. Microbial pigmentation, particularly black (conidia of *Aspergillus niger*) and yellow (e.g., bacterium *Micrococcus luteus*), is interpreted as a protection against the irradiance. UV is thus used in microbiological and molecular laboratories to reduce the amount of bacteria and fungi in the air, on laboratory surfaces and devices.

Fungi may also use the direction from which the light is coming to orientate themselves (Jennings and Lysek 1999). During the primordium growth of Basidiomycetes, the stipe grows towards the light source. In the *Pilobolus* species (Mucoraceae), there is a ring of yellow-orange carotenoids in the sporangiophore below the subsporangial bladder, which is shaded by the spore mass in the sporangium. If the light received by the ring is not at a minimum, the sporangial stalk bends until it is, which gives the direction in which the sporangium will be shot off, up to a distance of 40 cm (Jennings and Lysek 1999). The force of gravity takes effect immediately when the developing pileus shades the tip of the stipe (Schwantes 1996). This ensures that the pores and lamellae in the growing hymenium orientate to the earth's center (positive gravitropism, Nultsch 2001) that is, the mature basidiospores can sink to the soil. A known example of positive gravitropism may occur in the fruit body of *Fomes fomentarius*. The perennial, bracket fruit bodies are located at the stem of beech trees. When the white-rotten tree is wind-thrown, the fungus lives for a certain time as saprobiont in the laying stem. The new hymenia developing on the "old" fruit body orientate with a 90-degree change of direction again towards the earth's center. If there is by chance a further

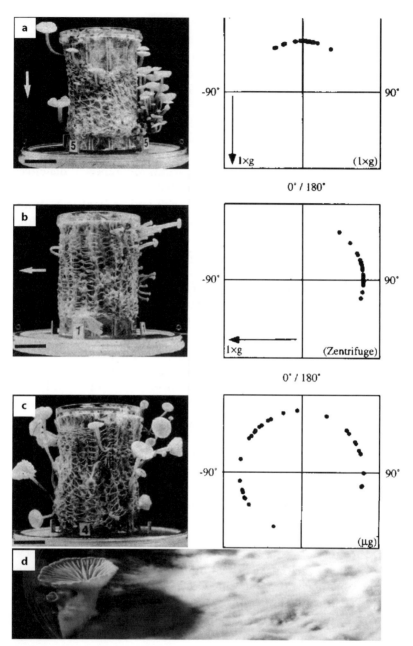

Fig. 3.3. Fruit body gravitropism of *Flammulina velutipes* growing **a** on wood chips in the laboratory, 5 days old, **b** during 1 × g conditions on a centrifuge in the orbit, 5 days old, **c** under micro-gravitation influence during the D2 Spacelab mission 1993, 7 days old. (from Kern and Hock 1996). **d** Fruit body of *Schizophyllum commune* grown during turning the dish upside down

change of the stem direction, the next hymenia again follow this change. An exception among the hymenia of following the gravity occurs in the re-supinate fruit bodies of house-rot fungi. The hymenium points upwards in fruit bodies growing on the floor, and orientates to the side in fruit bodies growing on a wall. The gravity perception in fungi was investigated by fruiting experiments with *Flammulina velutipes* under micro-gravitation condition during the German D-2 spacelab mission 1993 in the US space shuttle Columbia (Kern et al. 1991; Fig. 3.3). A positively gravitropic reaction can be simply demonstrated in the laboratory if a Petri dish with grown mycelium of a well-fruiting fungus like *Schizophyllum commune* is upside down for fruiting.

According to the statolithe theory, amyloplasts and the cytoskeleton in statocyte cells are involved in gravitropic reactions of plants. Fungi however do not possess statolithes. Gravity reaction of *F. velutipes* was hypothesized to occur as follows: In the case of correct negative gravitropic adjustment of the fruit body, a mycohormon that is produced in the lamellae is permanently transported into the upper pileus area. The hormone effects a length increase on all sides, mediated by the synthesis of vesicles and their following insert. Incorrect adjustment effects an unequal hormone distribution that influences vesicle formation and subsequent unilateral stretching growth (Kern 1994).

3.7
Restrictions of Physiological Data

Data in the literature with respect to the physiology of wood fungi like growth reactions to environmental factors should be valued with proviso. First, a fungus may be misnamed due to wrong identification. Thus, DNA-analyses of closely related house-rot fungi of the genera *Antrodia* and *Coniophora*, respectively, have shown that about 15% of all investigated isolates belonging to these genera and sampled from own and various other strain collections were wrongly identified. As extreme, an isolate named *A. serialis* revealed to be *Donkioporia expansa* (Schmidt and Moreth 2003). Second, due to changes in the taxonomy, there may be considerable confusion in older references, e.g., with respect to *Antrodia vaillantii* and *Oligoporus placenta*, because both had been termed *Poria vaporaria* (Domański 1972). Third, generalizing statements, like a fungus is faster growing than others, have to be restricted, because there is considerable strain variation within a species. Table 3.11, based on isolates that had been verified by rDNA-ITS sequencing, shows as an example for variation that there are isolates of the so-called "fast-growing" *Coniophora puteana* exhibiting a lower growth rate than isolates of the "medium-growing" *Antrodia vaillantii*. Fourth, comparisons between different fungi/authors/publications

are only valuable if the test methods used are comparable and appropriate. It is for example senseless to compare both species in Table 3.11 with respect to the growth rate, if the experiment did not consider the different temperature optima of the species.

Table 3.11. Examples for isolate variation within wood fungi (compiled from Schmidt et al. 2002; Schmidt and Moreth 2003)

Species	Isolate with origin and year of isolation	Temperature optimum (°C)	Maximum daily radial growth at optimum temperature (mm)
Antrodia vaillantii	FPRL 14, originally CBS	31	5.4
	FPRL 14a, fruit body, UK 1936	28–31	4.3
	UK 14, via Denmark and BAM Berlin	28	5.5
	DFPG 6911, New Zealand 1953	28	5.4
	DFP 2375, BAM	28	5.8
	Sweden R112, greenhouse, Stockholm ≈ 1952	28	5.1
	Sweden R113	28–31	5.6
	Ottawa 11740, USA?	28	5.1
	BAM 65	25–28	4.9
	BAM 486	28	6.1
Coniophora puteana	UK, FPRL 11e	22.5	2.5
	BK-C-50, Uppsala	25	6.3
	74453-2, Uppsala	22.5	5.0
	FORINTEK 9 0, fruit body, Ontario 1973	25	4.8
	Eberswalde 15, 'Normstamm I' 1930	25	7.0
	BAM 260, building, Berlin 1940	22.5	4.5
	Zycha, München 1963	25	3.5
	outdoor fruit body, Hamburg 1997	22.5	7.0
	G 61, fruit body, cherry-tree, Karlsruhe 1985	22.5–25	4.8
	G 98, building, Karlsruhe 1990	25	7.5
	G 100, building, Karlsruhe 1990	22.5	9.3
	G 107, building, Karlsruhe 1991	22.5	9.0
	G 125, building, Karlsruhe 1993	22.5	7.8
	G 135, building, Karlsruhe 1993	22.5	11.3
	G 156, building, Karlsruhe 1994	25	6.8
	G 219, building, Karlsruhe 1996	25	9.5
	G 220, building, Karlsruhe 1996	22.5–25	10.0
	fruit body, Ludwigslust Castle 1998	22.5	10.5

3.8
Competition and Interactions Between Organisms

Except for axenic laboratory cultures, there are only a few cases in which a natural substrate remains occupied by only one species. A known case is *Oudemansiella mucida* in standing, but dead trunks of *Fagus sylvatica* due to the production of the antifungal compound, mucidin. Instead, nearly every substrate accessible to fungi can support more than one species (Rayner and Boddy 1988), that is, various fungi and bacteria compete for space, nutrients, water, and air. Each fungus has its own strategy to withstand competition. Competition may occur between species and between mycelia of the same species. As a result of the latter, wood colonized by *Trametes versicolor* shows that the individual colonies form black barrier (demarcation) lines, where the different mycelia have interacted with each other to inhibit further movement of each mycelium in the region of contact. Different parts of the same mycelium and even adjacent hyphae may compete. For example, reproducing hyphae might consume more nutrients and thereby affect the vegetatively growing hyphae.

There are three main categories of the strategies or adaptations to ecological niches (Jennings and Lysek 1999). Through combative strategy, the fungus defends the substrate that has already been captured or attacks competitors occupying a substrate that is capable of capture (e.g., *O. mucida*). Through ruderal strategy, a substrate as yet unoccupied or only partly colonized is exploited. Those fungi do not attack potentially resistant substrates but degrade readily consumable or unusual compounds, like *Pholiota carbonica* (Europe, North America, Asia, North Africa) and *P. highlandensis* (USA), which both grow on former fire sites (Breitenbach and Kränzlin 1995). So these fungi occupy a substrate faster than possible competitors. Fungi concerned in the stress-tolerant strategy are adapted to environments that are too harsh for possible competitors. Examples for the latter are the soft-rot fungi growing in very wet timber of low air content.

3.8.1
Antagonisms, Synergisms, and Succession

Interactions (reciprocal effects) between wood fungi have been early investigated e.g., by Oppermann (1951) and Leslie et al. (1976), and were described in detail by Rayner and Boddy (1988).

Antagonism (competitive reciprocal effect), the mutual inhibition and in a broader sense the inhibition of one organism by others, is based on the production of toxic metabolites, on mycoparasitism, and on nutrient competition. Antagonisms are investigated as alternative to the chemical protection against

tree fungi ("biological forest protection") and against fungi on wood in service ("biological wood protection") (Wälchli 1982; Bruce 1992; Holdenrieder and Greig 1998; Phillips-Laing et al. 2003).

As early as 1934, Weindling showed the inhibiting effect of *Trichoderma* species on several fungi. *Bjerkandera adusta* and *Ganoderma* species were antagonistic against the causing agent of Plane canker stain disease (Grosclaude et al. 1990). Also, v. Aufseß (1976) examined mycelial interactions between *Heterobasidion annosum* and *Stereum sanguinolentum* and antagonistic fungi like *Phlebiopsis gigantea* and *Trichoderma viride* (also Holdenrieder 1984).

Root rot by *Heterobasidion annosum* (Chap. 8.3.2) is the classical target for biological forest protection and the only example of a successful biological control of a fungal forest disease. Based on the work of Rishbeth, stump treatment with *Phlebiopsis gigantea* was developed and successfully used in several countries. Originally in England, the spread of root rot in pine sites was diminished by the immediate coating of the fresh stump surface with an aqueous spore (asexual arthrospores) suspension of *P. gigantea* (Meredith 1959; Rishbeth 1963). The antagonist colonizes the stump, that is *H. annosum* cannot infect it by air-borne spores and thus an infection of neighboring trees via root grafts is prevented. The treatment of spruces yielded differently satisfactory results (Korhonen et al. 1994; Holdenrieder et al. 1997). Holdenrieder and Greig (1998) listed also several bacteria, which were antagonistic against *H. annosum*. Promising systems for the biological protection of growing trees have been studied against *Armillaria luteobubalina, Chondrostereum purpureum, Phellinus tremulae, P. weirii,* and *Ophiostoma ulmi* (Bruce 1998; also Palli and Retnakaran 1998).

There were many attempts for biological wood protection (Bruce 1998). To date, the application of biological control to prevent wood decay and discoloration has been successful in the laboratory, but was often inconsistent in its performance in the field (Dawson-Andoh and Morrell 1997; Mikluscak and Dawson-Andoh 2004b). Much work has been done in the Forest Products Laboratory, Madison. In the laboratory, a blue stain fungus was inhibited by antibiotic substances from *Coniophora puteana* (Croan and Highley 1990) and *Bjerkandera adusta* (Croan and Highley 1993). Bacteria were examined for their suitability to prevent of blue stain (Bernier et al. 1986; Seifert et al. 1987; Benko 1989; Florence and Sharma 1990; Kreber and Morrell 1993; Bjurman et al. 1998; Payne et al. 2000; Bruce et al. 2004). A bacterial mixed culture decreased staining and molding of pine wood samples as well as decay by *Trametes versicolor* and *Oligoporus placenta* (Benko and Highley 1990). *Streptomyces rimosus* Sobin, Finlay & Kane (Croan and Highley 1992b) and its culture filtrate (Croan and Highley 1992c) prevented spore germination of *Aspergillus niger, Penicillium* sp. and *Trichoderma* sp. as well as blue stain by *Aureobasidium pullulans. Trichoderma* species are extensively researched biological control agents for wood protection against decay fungi (Highley and Ricard 1988;

Murmanis et al. 1988; Morris et al. 1992; Doi and Yamada 1992; Bruce 1998; Phillips-Laing et al. 2003). Culture filtrates of *Chaetomium globosum*, *Penicillium* sp., *Sporotrichum pulverulentum* and *Trichoderma viride* decreased wood degradation by *T. versicolor* (Ananthapadmanabha et al. 1992).

Current attempts for biological wood protection use a colorless mutant of the blue-stain fungus *Ophiostoma piliferum*. Round wood and cut timber is treated with a spore suspension of the mutant to reduce or even prevent subsequent natural colonization of the wood by blue-stain fungi (Blanchette et al. 1994; Behrendt et al. 1995; Schmidt and Müller 1996; White-McDougall et al. 1998; Ernst et al. 2004). Corresponding experiments used *Gliocladium roseum* to protect green lumber from molds, stain, and decay (Yang et al. 2004a). Figure 3.4 demonstrates the inhibiting effect of *O. piliferum* against two blue-stain fungi in the laboratory.

Synergism (mutualistic reciprocal effect) means the mutual promotion and in the broader sense the promotion of one organism by others. To prepare the substrate, the pH value can be changed, vitamins can be excreted (Henningsson 1967), and inhibiting heartwood compounds can be degraded. The nitrogen content may be increased by N-fixing soil bacteria (Baines and Millbank 1976), and nutrients can become more available (also Levy 1975a; Hulme and Shields 1975). Neutralistic reciprocal effects, neither inhibition nor promotion, occur more rarely.

Fig. 3.4. Inhibition by a colorless mutant of *Ophiostoma piliferum* of blue-staining of wood samples by *Phoma exigua* and *Aureobasidium pullulans*. Wood samples *A* were previously dipped in a spore solution of *O. piliferum* and then all four samples were inoculated with the blue-stain fungi (from Müller and Schmidt 1995)

The various competition strategies and reciprocal effects influence the sequence (succession) of fungi and bacteria that are found at different stages in the degradation of a complex substrate like wood. Each species uses a different component of the substrate as it becomes available as a result of the degradation by the preceding species (Jennings and Lysek 1999). Primary colonists, bacteria and non-decay fungi (slime fungi, yeasts, molds), rely on relatively easy assimilable substrates such as simple sugars, starch and proteins and remain predominantly on the wood surface and within the outer wood parts, preparing the substrate for following organisms. There may occur a continued co-existence of non-decay organisms on the substrate. Or the primary colonists are followed by the decay fungi which are capable of degrading the relatively refractory wood cell wall components and which penetrate deeper into the wood such as staining fungi and the brown, soft and white-rot fungi (Levy 1975a; Käärik 1975; Rayner and Boddy 1988).

Schales (1992) found 15 wood-decay fungi on a wind-thrown beech tree and its stump. *Chondrostereum purpureum* and *Stereum hirsutum* occurred during the initial phase of 2 years. *Bjerkandera adusta* and *Trametes versicolor* were common in the following medium (optimum) phase of 5–7 years. *Kuehneromyces mutabilis* and *Kretzschmaria deusta* were observed in the final phase (also Jahn 1990; Röhrig 1991). Ten beech stumps showed within 4 years after tree felling 74 fungal species, 46 Basidiomycetes, 25 Ascomycetes and three Deuteromycetes (Andersson 1997a; also Willig and Schlechte 1995; Andersson 1997b; Blaschke and Helfer 1999). Those surveys indicate that a substrate is colonized by more species than commonly described in literature and that some fungi occur earlier than expected.

While most fungi colonizing wood use nutrients of the substrate, some are probably only passive occupants using the wood only as a support for fruit body formation.

Interrelationships between trees and the fungi that inhabit them have been treated by Rayner (1993).

3.8.2
Mycorrhiza and Lichens

Mycorrhiza ("fungal root") is the association of mutual benefit (mutualistic interaction) between a fungus and the root of a higher plant (Agerer et al. to 1986; Willenborg 1990; Allen 1991; Schwantes 1996; Smith and Read 1997; Varma and Hock 1999; Egli and Brunner 2002; v.d. Heijden and Sanders 2002; Peterson et al. 2004). About 80–95% of the higher plants are capable of mycorrhization (e.g., Bothe and Hildebrandt 2003).

Mycorrhizas are differently grouped. The grouping according to Hock and Bartunek (1984) in Fig. 3.5 distinguishes three major forms.

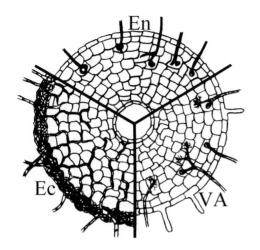

Fig. 3.5. Major forms of mycorrhizas. *Ek* ectotrophic, *En* endotrophic, *VA* vesicular-arbuscular (modified from Hock and Bartunek 1984)

The ectotrophic mycorrhiza (ectomycorrhiza) occurs predominantly on conifers and hardwoods of the boreal and temperate zone, particularly associated with Pinales, Fagales and Salicales. In many conifers and in beech and oak, the association is obligatory, and in other trees like elms it is facultative (Müller and Löffler 1992). The predominant part of the mycelium grows at the surface of side roots and forms a dense mycelial coat at the root tips. The hyphae penetrate between the cells of the outer root tissue by dissolving the middle lamellae, and coat the cells completely as "Hartig net" (Kottke and Oberwinkler 1986). The colonized roots do no longer possess root hairs; instead hyphae or rhizomorphs radiate into the soil.

In the endotrophic mycorrhiza (endomycorrhiza) of the orchids, only a loose hyphal net is formed around the root, and the hyphae settle inside the cells in the root bark area. As an intermediate, the ectendotrophic mycorrhiza is particularly present on roots of 1 to 3-year-old conifers, whereby the hyphae penetrating into the bark cells degenerate with ageing.

The most frequent form, the vesicular arbuscular mycorrhiza (VAM) occurs associated with over 200,000 wild and cultivated angiosperms, in addition, with *Ginkgo biloba*, *Taxus baccata* and *Sequoia gigantea* and *S. sempervirens* (Werner 1987), as well as predominant form in tropical forests. In the VAM, the unseptate hyphae extend inside the root cells bubble-shaped (vesicles) or branch out tree-shaped (arbuscules). The arbuscules develop by hyphal branching and become enclosed by the peri-arbuscular membranes from the plant (Bothe and Hildebrandt 2003).

The benefit for the trees is the improved nutrient (amino acids) and mineral (N, P, K, Mg, Cu, Zn, Fe) support and the better water supply (Smith and Read 1997) due to the larger absorption area. Soils with frequently occurring ectomycorrhiza are commonly characterized by a lower nutrient content, the trees growing there would not be competitive without mycorrhizas (Schönhar

1989). The soil quality (ventilation, water permeability, stabilization of soil particles) is increased. The trees are more resistant to drying stress. In addition, mycorrhizal fungi play a role in tree defense against fungal pathogens (Strobel and Sinclair 1992). The fungi benefit from the supply of photosynthates (carbohydrates) from the trees and from supplements, e.g., thiamine. As much as 30–35% of the photosynthate by a beech forest is metabolized by the mycorrhizal fungi (Jennings and Lysek 1999).

About one-third (2,000 species) of the "higher fungi" which grow in forests are mycorrhizal fungi (Egli and Brunner 2002). Among them there are many edible mushrooms (e.g., *Boletus edulis*, *Cantharellus cibarius*), but also poisonous species (e.g., *Amanita* species). Endotrophic mycorrhizal fungi are usually Ascomycetes. Ectotrophic fungi are usually Basidiomycetes such as *Amanita* species, *B. edulis* or the truffles (Ascomycetes). The about 150 VAM symbionts belong to the Zygomycetes, often to the genus *Glomus*.

Many trees, like beech, oak, spruce, chestnut, pine, larch and willow, become stunted in sterile culture and previous mycorrhizal inoculation of seedlings improved tree growth (Ortega et al. 2004). Several obligatory mycorrhizal fungi, like *B. edulis*, only fruit in association with roots, partly host-specifically or with a narrow host spectrum, like *Amanita caesarea* predominantly associated with oaks, usually however hardly host-specifically, like *A. muscaria* at birch, eucalypts, spruce and Douglas fir (Werner 1987). The trees are usually less specific: *Pinus sylvestris* forms mycorrhizas with at least 155 fungal species and *Picea abies* with 118 fungi (Korotaev 1991).

Artificial mycorrhization may de done in the tree nursery or during planting or by injection in the root area of old trees (Egli 2004; Evers and Pampe 2005). About 500,000 l mycorrhizal inoculum was produced worldwide in 2003 (Grotkass et al. 2004).

With regard to the significance of the mycorrhizas in view of the forest dieback by pollution (Flick and Lelley 1985), there is a trend that young trees already show a fungal community, which is typical for old trees. The changed mycorrhiza was rated as signal for tree damage: "The fungi disappear before the trees" (Cherfas 1991). A negative correlation was found between the frequency of fungal occurrence and the content of nitrogen and sulfur compounds as well as ozone in the atmosphere: 71 species of fungi were observed in a certain area of the Netherlands from 1912–1954 and only 38 species between 1973 and 1982. Also, the size of the fruit bodies decreased (Cherfas 1991). According to Schönhar (1989), the change of the mycorrhiza is particularly based on nitrogen imissions by fertilization. The possible role of mycorrhiza in forest ecosystems under CO_2-enriched atmosphere in view of the global atmospheric change was discussed (Quoreshi et al. 2003). Experimental drought investigated in view of the expected reduction in water in Mediterranean regions showed that drought treatment did not delay mushroom appearance, but reduced mushroom production by 62% (Ogoya and Peñuelas 2005).

Investigations have been performed to regenerate the decreased mycorrhizal occurrence and the species change in forest damage sites by artificial inoculation and thus to improve the health of these trees and also of trees on other problematic sites (Römmelt et al. 1987; Marx 1991; Schmitz 1991; Lelley 1992; Hilber and Wüstenhöfer 1992; Schmitz and Willenborg 1992; Göbl 1993; Kutscheidt and Dergham 1997). However, it has to be considered that thereby one intervenes only at the symptoms of the damage and not at its causes, that is, new inoculations without reduction of the emissions might be unsuccessful in the long run. To improve the isolate characteristics of mycorrhizal species, interstock matings have been done e.g., with *Paxillus involutus* (Strohmeyer 1992).

A further association of mutual benefit is lichens, a close and stable partnership between Ascomycetes (and rarely Basidiomycetes) with green algae or cyanobacteria (Kappen 1993). In the mutualistic form of lichens, the fungi receive organic nutrients and vitamins from the algae/bacteria and these get water and inorganic salts from the fungi. The association allows the pioneer settlement of inhospitable biotopes such as rocks with only traces of nutrients. In the antagonistic form, the fungi are parasitic to the algae, and the algae survive by increasing faster than they are destroyed by the fungi (Schubert 1991). With respect to classification, the lichens are placed in the fungal system as lichenized fungi.

Fungal associations with animals are the endosymbioses in the mycetomes of insects. Ectosymbioses occur in the "fungal gardens" of termites and in the cultivation of the ambrosia fungi in the drill ducts of bark beetles (Francke-Grosman 1958; Werner 1987). For example, *Ips typographus* is associated with ophiostomatoid fungi (Solheim 1999; Sallé et al. 2005). The fungi are transferred to the tree during the beetle attack and are considered important partners in beetle population establishment. In addition, fungi invade the host's phloem and sapwood, where the hyphae can cause blue stain. Recently, a symbiosis between three partners was found: leaf cutter ants in Panama and Ecuador are associated with a basidiomycete fungus, but additionally with a bacterium (*Streptomyces* sp.) which was shown to be antagonistic against a parasitic ascomycete that has a negative effect on the ant/basidiomycete interaction (Anonymous 1999). Aspects of the association of fungi and insects with the infected trees are described by Raffa and Klepzig (1992).

4 Wood Cell Wall Degradation

4.1
Enzymes and Low Molecular Agents

In view of the historical development of the research on wood degradation by fungi, this chapter starts with the enzymes involved in the decay of the woody cell wall, although it is now commonly accepted that non-enzymatic, low molecular weight metabolites are involved as precursors and/or co-agents with enzymatic cell wall degradation.

Under the conditions within microbial cells, namely an aqueous environment with pH values around 6 and temperatures of $1-50\,°C$, most reactions would run off only very slowly. Enzymes reduce the amount of the necessary activation energy as biocatalysts and control the reaction by substrate and effect specificity. More than 3,000 enzymes are described.

Comparable with the lock/key principle, enzymes possess an active center, into which the substrate must fit, and which thus controls the conversion of the correct substrate (substrate specificity). The protein portion of the enzyme decides on the way of the reaction (effect specificity). Enzymes may consist only of protein or contain additional cofactors (e.g., Mg^{2+}, Mn^{2+}) or coenzymes (e.g., vitamin B_1). Before the conversion of the substrate into a product, the enzyme substrate complex is formed: enzyme E + substrate S \rightarrow enzyme substrate complex ES \rightarrow enzyme E + product P.

Studies on fungal polysaccharide hydrolyzing enzymes have shown a structural design composed of two functional domains, a catalytic core responsible for the actual hydrolysis and a conserved cellulose-binding terminus, with an intervening, glycosylated hinge region. A large number of genes encoding cellulases, hemicellulases, glucanases, amylolytic enzymes, and those hydrolyzing various oligosaccharides have been cloned from fungi. The best-studied organisms are *Trichoderma reesei*, *Phanerochaete chrysosporium*, and *Agaricus bisporus* in respect of cellulases and hemicellulases, and several *Aspergillus* species in respect of amylolytic enzymes, pectinases and hemicellulases (reviews by Penttilä and Saloheimo 1999; Kenealy and Jeffries 2003). For example, papain cleavage of cellobiohydrolase (CHB) from *P. chrysosporium* separated the catalytic domain from the hinge and binding domains. Restriction mapping and sequence analysis of cosmid clones showed a cluster of three structural

related CHB genes. Within a conserved region, the deduced amino acid sequences of *P. chrysosporium cbh1-1* and *cbh1-2* were, respectively, 80 and 69% homologous to that of the *Trichoderma reesei* CBH I gene. Transcript levels of the three *P. chrysosporium* CHB genes varied, depending on culture conditions (review by Highley and Dashek 1998). Binding domains specific for xylan have also been identified (review by Kenealy and Jeffries 2003).

Because of their valuable protein character, constitutive enzymes always present in the cell are the exception. Usually, the biosynthesis of the inducible enzymes is induced, if its presence is necessary, by the substrate or other molecules. Some work was done with regard to the regulation of extracellularly acting enzymes in fungi. For example with white-rot fungi, cellulase synthesis is induced in vitro by cellulose and repressed by glucose. As the wood cell-wall macromolecules are degraded outside the hypha, the most generally accepted view of the induction process is that the fungi produce a basic level of constitutive amount of enzyme that produces soluble degradation products that function as inducers. In *Phanerochaete chrysosporium*, which has served as a model organism for white-rot degradation studies, cellobiose concentration, a product of cellulase action, is controlled in at least four ways, by β-glucosidase, transglucosylation reactions, and two oxidative enzymes. As with cellulases, simple sugars repressed the production of most hemicellulose-degrading enzymes by white-rot fungi (review by Highley and Dashek 1998).

For the naming of enzymes, particularly in former times "ase" was added to the name of the substrate (e.g., lignin, ligninase). Nowadays, the enzyme nomenclature indicates the enzymatic reaction. In accordance with the Nomenclature Committee of the International Union of Biochemistry and Molecular Biology (www.chem.qmul.ac.uk/iubmb/enzyme), enzymes are grouped according to their function into six classes and there into sub-groups: Oxidoreductases catalyze oxidation and reduction reactions by transferring hydrogen and/or electrons, transferases the transmission of different groups. Hydrolases hydrolyze glucosides, peptides etc., lyases catalyze non-hydrolytic cleavage, isomerases cause among other things reversible transformations of isomeric compounds, and ligases catalyze the covalent linkage of two molecules with simultaneous ATP cleavage. Each enzyme receives an EC number, which points out to its reaction. For daily use, the common, trivial names (ligninase, cellulase, xylanase), however, are still used.

Some general characteristics of enzymes and of those enzymes involved in wood degradation are summarized in Table 4.1.

The dry matter of wood consists of about 45% cellulose and, depending on wood species, of 20–30% hemicelluloses and 20–40% lignin. With exception of pectins in the middle lamella, which has significance to wood-inhabiting bacteria, further components such as the contents of parenchyma cells, resins, accessory compounds etc. are less considered in the following. Thus, relatively few enzymes are involved in the primary, extracellular enzymatic wood decay.

Table 4.1. Some characteristics of enzymes for wood degradation

altogether six classes of enzymes with subgroups:
1. oxidoreductases, 2. transferases, 3. hydrolases,
4. lyases, 5. isomerases, 6. ligases

lignin degradation by oxidoreductases:
lignin peroxidase EC 1.11.1.14
manganese-peroxidase EC 1.11.1.13
laccase EC 1.10.3.2
hemicellulose degradation by hydrolases:
endo-1,4-β-xylanase EC 3.2.1.8, xylan 1,4-β-xylosidase EC 3.2.1.37
mannan endo-1,4-β-mannosidase EC 3.2.1.78, β-mannosidase EC 3.2.1.25 etc.
cellulose degradation by hydrolases:
cellulase EC 3.2.1.4
β-glucosidase EC 3.2.1.21
cellulose 1,4-β-cellobiosidase EC 3.2.1.91 etc.

ectoenzymes:
extracellular degradation of macromolecules pectin, hemicellulose, cellulose, lignin
outside the hypha
[uptake of degradation products (carbohydrate oligomers, dimers, monomers,
lignin degradation products)]
intracellular enzymes:
metabolic transformation within the hypha to hyphal biomass, metabolites, energy
endoenzyme:
attack within the substrate, often randomly
exoenzyme:
attack at the non-reducing substrate end

enzyme activity:
in former times (but still used):
international unit: $1\,U = 1\,\mu mol/min$, $(1\,U = 16.67\,nkat)$
currently:
kat (katal, catalytic activity): $1\,kat = 1\,mol/s$

The enzymes for the degradation of the cellulose and hemicelluloses within the woody cell wall belong predominantly to the hydrolases, which cleave glucosidic bonds. Briefly (and thus not totally correctly), cellulose is hydrolyzed by cellulase, cellulose 1,4-β-cellobiosidase and β-glucosidase. The hemicelluloses xylan and mannan are degraded by endo-1,4-β-xylanase and mannan endo-1,4-β-mannosidase, respectively, followed by xylan 1,4-β-xylosidase and β-mannosidase and further enzymes for the side chains. Lignin is oxidatively degraded by the oxidoreductases lignin peroxidase and manganese peroxidase. Enzymatic wood degradation was summarized e.g., by Eriksson et al. 1990, Shimada 1993, Jennings and Lysek 1999, Goodell et al. 2003.

Cellulose, hemicellulose, and lignin are as macromolecules too large to be taken up into the hypha. Therefore, the molecules are first degraded by extra-

cellular enzymes (ectoenzymes) into smaller fragments, which are taken up and then metabolized by intracellular enzymes to energy and fungal biomass. Independent of this place of action, an exoenzyme attacks at the end of a macromolecular substrate, while an endoenzyme splits within the molecule. These four terms are sometimes mixed up.

Occurrence and distribution of enzymes and metabolites inside hyphae, in the hyphal slime layer, and within the attacked woody tissue were investigated by means of immunological methods and electron microscopy (Sprey 1988; Goodell et al. 1988; Srebotnik et al. 1988a; Blanchette et al. 1989, 1990; Daniel et al. 1989, 1990; Srebotnik and Messner 1990; Kim 1991; Green et al. 1991b; Kim et al. 1991a, 1991b, 1992, 1993; Lackner et al. 1991; Blanchette and Abad 1992). TEM of immunogold-labeled hyphae of *Trametes versicolor* grown on carboxymethylcellulose localized β-glucosidase on the plasmalemma, in the hyphal cell wall, and in the hyphal sheath (review by Highley and Dashek 1998).

Simple methods are used in screening tests to detect enzymes and to determine their activity. For example, a cellulose is added to a fungal culture, whose cellulolytic enzymes produce glucose. The glucose of the sampled culture filtrate reduces a test compound, which is added in oxidized form and changes its color by reduction. At a specific wavelength, the quantity of the converted test substance and thus of the developed glucose is measured and the activity of "cellulolytic enzymes" is calculated. Remazol brilliant blue, which binds to cellulose and hemicellulose by a microbially relatively inert linkage, may be mixed in agar. If cellulolytic or hemicellulolytic microorganisms or their enzymes are present, the still colored degradation products are released and clearing zones occur around the active colony, which can be also quantified (Schmidt and Kebernik 1988; Takahashi et al. 1992). For detailed investigations, various purification and enrichment steps may be used (chromatography, electrophoresis, etc.).

The current unit of enzyme activity is katal (catalytic activity, kat), although in practice the old definition U is still used (Table 4.1).

Microbial wood degradation is influenced by several major characteristics of the substrate wood (Table 4.2).

Accessory compounds in the heartwood as well as resin excretion and wound reactions after wounding inhibit the colonization and spread of microorganisms within the tree (Chap. 3.1).

The polymeric structure of the nutrients cellulose, hemicelluloses, and lignin requires that the degrading agents act outside the hypha. Cowling (1961) first stated that the known enzymes of the time were too large to penetrate into the interior of the wood cell wall and hypothesized a possible existence of a small mass enzyme. The molecular weights of cellulases range from 13–61 kDa (Fengel and Wegener 1989). A cellulase of 40 kDa can exhibit a thickness of about 4 nm and a length of 18 nm (Messner and Srebotnik 1989). Frequently, about an 8 nm size was measured (Reese 1977; Messner and Stachelberger

Table 4.2. Characteristics that make wood recalcitrant to fungi and bacteria

- accessory compounds in the heartwood
- resin excretion of softwoods, wound reactions of parenchyma cells in hardwoods
- polymeric structure of the cell wall components
- extracellular degradation of the nutrients
- small pore sizes within the cell wall
- complex structure of the woody cell wall
- partially crystalline nature of cellulose
- incrustation of the more easily degradable carbohydrates by lignin
- structure and non-water-solubility of lignin

1984; Murmanis et al. 1987). Thus, cellulases are too large for diffusing into the capillary areas of the cell wall from 0.5–4 nm pore size (average in spruce: 1 nm: Reese 1977; Kollmann 1987) (Keilisch et al. 1970; Flournoy et al. 1991). This pore size excludes compounds with kDa mass greater than 6. Bailey et al. (1968) postulated a "pre-cellulolytic phase". Meanwhile, so-called low molecular weight agents are known to be involved in the decay of the woody cell wall. As the different groups of wood decay fungi differ with regard to the participating low molecular agents, these aspects are treated separately in the chapters on cellulose and lignin degradation.

The complex ultrastructure of the woody cell wall (e.g., Booker and Sell 1998) affects its degradation (Liese 1970; Daniel 2003). A great part of the cellulose is bundled up by hydrogen bonds to larger, crystalline units ("crystalline cellulose", Fig. 4.3), the elementary fibrils. The crystalline nature of the cellulose prevents an attack of many microorganisms. Several elementary fibrils result by linkage with hemicelluloses in the next larger unit, the microfibril. At the surface of the microfibrils, hemicelluloses form a bridge to the incrusting lignin, as chemical bonds exist between lignin and hemicelluloses (lignin carbohydrate complex, Koshijima and Watanabe 2003; Fig. 4.1). Several models depicting this molecular arrangement have developed (e.g., Kerr and Goring 1975; Fengel and Wegener 1989) although there is no accepted model (Daniel 2003).

Principally, the carbohydrates cellulose and hemicelluloses are rather easily degradable, however, the lignin is resistant to most microorganisms due to its structure of phenylpropane units and the recalcitrant linkages between them. Thus, lignin incrustation of the carbohydrates inhibits the access to the consumable holocellulose. The hydrophobic nature of lignin further prevents a diffusion of the degrading enzymes inside the three-dimensional giant molecule.

The composition of the microbial enzyme apparatus and its regulation affect the type of rot. Lignin (Fig. 4.4) is effectively degraded only by white-rot fungi and acts for other microorganisms as a barrier against wood decay. Table 4.3

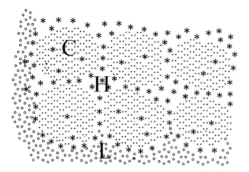

Fig. 4.1. Scheme of the association of cellulose (*C*), hemicelluloses (*H*) and lignin (*L*) within the woody cell wall

Table 4.3. Lignified cell wall as carbon source for microorganisms

Organism group	Degradation of			Degradation	
	hemicellulose	cellulose	lignin	of isolated components	within the cell wall
bacteria	+	+	−	+	−[a]
yeasts	−	−	−		
molds	+	+	−	+	−
blue-stain fungi	+	−	−	+	−
soft-rot fungi	+	+	−	+	+
brown-rot fungi	+	+	−	−(+)	+
white-rot fungi	+	+	+	+	+

[a]cf. Chap. 5.2

summarizes the behavior of the different groups of organisms against the nutritive "lignified cell wall". It is differentiated if the cell wall component is degraded within the native woody substrate or only as sole nutritive after isolation from the wood. Within the bacteria, yeasts, and molds, only a few species are able to degrade isolated cell wall components.

4.2
Pectin Degradation

Pectins comprise galacturans, galactans and arabinans as complex, branched polysaccharides of molecular weights of about 10^3 kDa. Galacturans are predominantly deposited in the middle lamella/primary wall (compound middle lamella) and in the tori of bordered pit membranes (Fengel and Wegener 1989). The content of galacturans in the wood is below 1%. They consist predominantly of α-1,4-linked galacturonic acid units and are split by hydrolases to

galacturonic acid. Further enzymes are needed for the other pectins and for side chains.

Various plant pathogenic fungi and bacteria and several soil (*Bacillus* spp.) and water bacteria (*Clostridium* spp.) are capable of degrading pectin (Schlegel 1992). Wood-inhabiting bacteria lead to the "overuptake" of wood preservatives and paints (Willeitner 1971) after the degradation of the bordered sapwood pits (Chap. 5.2) during wet storage of wood.

4.3
Degradation of Hemicelluloses

Hemicelluloses of wood are a complex combination of relatively short polymers made of xylose, arabinose, galactose, mannose, and glucose with acetyl and uronic side-groups. The major hemicellulose (polyose) of hardwoods is the *O*-Acetyl-(4-*O*-methylglucurono)-xylan, also named glucuronoxylan or briefly xylan. The xylan content in hardwoods ranges from 15 to 35%. For example, birch wood contains 22–30% xylan and 1–4% glucomannan, while pine wood contains 5–11% xylan and 14–20% glucomannan (Viikari et al. 1998). In monocotyledons, hemicelluloses may amount to 40% and exceed the cellulose portion. Beech wood xylan consists of about 200 β-1-4-linked xylose units (xylopyranose). About five to seven acetyl groups (linked to C-2 or C-3) and one 4-*O*-methylglucuronic acid residue (α-1-2) occur per ten xylose units (Timell 1967; Fengel and Wegener 1989; Eriksson et al. 1990; Puls 1992;

Fig. 4.2. Diagram of enzymatic xylan degradation. *x* xylose residue, *Ac* acetic acid residue, *4-O-Me-GA* 4-*O*-methylglucuronic acid residue

Saake et al. 2001). The enzymatic xylan degradation is shown as a diagram in Fig. 4.2.

The xylan backbone is degraded (\Uparrow) by the ectoenzyme endo-1,4-β-xylanase ("xylanase", systematic name: 1,4-β-D-xylan xylanohydrolase, EC 3.2.1.8) within the xylose chain (endohydrolysis) to xylo-oligomers, xylobiose and xylose (Eriksson 1990; Eriksson et al. 1990). Intracellular and/or membrane-bound xylan 1,4-β-xylosidase (1,4-β-D-xylan xylohydrolase, EC 3.2.1.37) removes successively D-xylose residues from the non-reducing termini (exoenzyme) of small oligosaccharides. The side-groups are split by accessory enzymes: Acetylesterase (acetic-ester acetylhydrolase, EC 3.1.1.6) removes the acetyl groups. Xylan α-1,2-glucuronidase (xylan α-D-1,2-(4-O-methyl)glucuronohydrolase, EC 3.2.1.131) hydrolyzes the α-D-1,2-(4-O-methyl)glucuronosyl links (Puls 1992). Arabinose side-groups in arabinoxylans are removed by α-arabinosidase. The structure of different xylans and their enzymatic degradation is described by Bastawde (1992).

The mannans (glucomannans, galactomannans, galactoglucomannans) of the conifers, consisting mainly of the hexose mannose, are similarly hydrolyzed by mannan endo-1,4-β-mannosidase ("mannanase", 1,4-β-D-mannan mannanohydrolase, EC 3.2.1.78), β-mannosidase (β-D-mannoside mannohydrolase, EC 3.2.1.25) and accessory enzymes like β-galactosidase, α-glucosidase, and esterase (Eriksson et al. 1990; Takahashi et al. 1992; Viikari et al. 1998).

There are hemicellulose hydrogen bonds to cellulose fibrils and also covalent links with lignin.

Oxalic acid of brown-rot fungi might be involved first in the degradation of the side chains of the hemicellulose, thus providing entrance to arabinose and galactose, and then depolymerize the main hemicellulose chain (and amorphous cellulose) (Green et al. 1991a; Bech-Andersen 1987b).

Hemicellulose degradation is common in wood fungi, but rarer in bacteria. The soft-rot fungus *Paecilomyces variotii* produced plenty of xylanase (Schmidt et al. 1979), and glucuronidase was excreted, e.g., by *Agaricus bisporus* (Puls et al. 1987; Bastawde 1992). In *Oligoporus placenta*, xylanases were located in the hyphal sheath (Green et al. 1991b).

Basidiomycetes, which prefer conifers in nature, degraded a spruce wood mannan more intensively than a birch xylan, and in reverse hardwood fungi showed greater activity against xylan (Lewis 1976). During incipient brown-rot decay, the hemicellulose components are degraded first. In southern pine, early strength loss up to 40% was associated with loss of arabinan and galactan components, and subsequent strength loss greater than 40% was associated with the loss of the mannan and xylan components. Since the cellulose microfibril is surrounded by a hemicellulose envelope, significant loss of cellulose was only detected at greater than 75% modulus of rupture loss (Curling et al. 2002).

4.4
Cellulose Degradation

In the biosphere about 2.7×10^{11} t of carbon are bound in living organisms. According to Schwarz (2003) about 4×10^{10} t cellulose are produced per year. Cellulose occurs in all land plants, is always fibrillarly constructed and consists of β-1,4-linked glucose anhydride units (glucopyranose). The substrate for cellulose biosynthesis is UDP-glucose which is polymerized by cellulose synthase (UDP-glucose: 1,4-β-D-glucan 4-β-D-glucosyltransferase, EC 2.4.1.12) to β-1,4 glucan chains. Depending on the wood species, the degree of polymerization (DP) of native cellulose ranges from 10,000 to 15,000 glucose anhydride units. In "native cellulose", hydrogen bridges exist between the OH groups of neighboring glucose units and neighboring cellulose molecules. Tidy (crystalline cellulose) regions and areas of lower order (amorphous, paracrystalline cellulose) alternate (Fengel and Wegener 1989; Fig. 4.3). In *Boehmeria nivea*, cellulose crystals of about 300 glucose residues are interrupted vertically to the longitudinal axis by an amorphous region of 4–5 glucose residues (Schwarz 2004). There are different models for the arrangement of the cellulose molecules in the fibrils.

Bacterial cellulose degradation including the cellulosome was treated by Schwarz (2003). There is still some uncertainty as how cellulose is degraded by fungi. Differences occur between the various groups of fungi, brown, white, and soft-rot fungi.

Fig. 4.3. Diagram of enzymatic cellulose degradation

Early workers investigating brown-rot fungi assumed that only cellulolytic enzymes were responsible for cellulose degradation. Cellulolytic activity was initially described using terminology of C_1-C_x (Reese et al. 1950): native (crystalline) cellulose is prepared by C_1 cellulase for the degradation by C_x cellulase, as C_1 cellulase loosens the crystalline areas by cleaving the hydrogen bridges for the following attack by C_x cellulase.

The C_1-C_x model was later refined to refer to the action of general classes of exoglucanases and endoglucanases, respectively. As methods were further refined more specific functionalities were defined and newly isolated enzymes were found in brown-rot fungi. Brown-rot fungi produce several endo-1,4-β-glucanases and β-glucosidases, but typically lack exo-1,4-β-glucanase activity. However, cellobiohydrolase and cellobiose dehydrogenase [cellobiose: (acceptor) 1-oxidoreductase, EC 1.1.99.18] have been isolated from *Coniophora puteana*. Brown-rot fungal wood degradation was recently reviewed by Goodell (2003). White-rot and soft-rot fungi produce the full cellulolytic enzyme system of endo- and exoglucanases, and β-glucosidase.

The enzymes produced are thought to act in concert with each other as well as with non-enzymatic systems. Attack occurs at the amorphous cellulose regions (C_x action) by cellulase ("endoclucanase", systematic name: 1,4-β-D-glucan 4-glucanohydrolase, EC 3.2.1.4), which endohydrolyzes 1,4-β-D-glucosidic linkages in cellulose and other β-D-glucans. A combined action takes place by cellulose 1,4-β-cellobiosidase (1,4-β-D-glucan cellobiohydrolase, EC 3.2.1.91), which hydrolyzes 1,4-β-D-glucosidic linkages in cellulose and cellotetraose, releasing cellobiose from the non-reducing ends (exoenzyme), and by glucan 1,4-β-glucosidase (1,4-β-D-glucan glucohydrolase, EC 3.2.1.74), which acts on 1,4-β-D-glucans and related oligosaccharides and exohydrolyzes successive glucose units from the ends. The final hydrolysis of oligosaccharides is mediated by β-glucosidase ("cellobiase", β-D-glucoside glucohydrolase, EC 3.2.1.21), which acts on terminal, non-reducing β-D-glucose residues with release of β-D-glucose. Cellobiose may be also attacked by cellobiose dehydrogenase [cellobiose:(acceptor) 1-oxidoreductase, EC 1.1.99.18] oxidizing cellobiose to cellobionolactone under reduction of O_2 to H_2O_2, and Fe^{3+} to Fe^{2+} (Kruså et al. 2005).

In the mold *Trichoderma viride* (*T. reesei*), three endoglucanases, two exoglucanases, and several β-glucosidases were found (Eriksson et al. 1990). In *Sporotrichum pulverulentum* Novobr. (anamorph of *Phanerochaete chrysosporium*), five endoglucanases, one exoglucanase and two β-gucosidases, which together with oxidizing enzymes (laccase and cellobiose: chinon oxidoreductase) caused a combined degradation of cellulose and lignin. Uemura et al. (1992) isolated six exoglucanases. In *P. chrysosporium*, cellulases have been classified into eight different families among the glycoside hydrolases (Samejima and Igarashi 2004). In addition, the importance of the cellobiose dehydrogenase (CDH) was shown, as this enzyme could participate in the extracellular

metabolism of cellobiose instead of β-glucosidase. The role of CDH for cellulose degradation was discussed (Hyde and Wood 1997; Kruså et al. 2005). It was hypothesized that CDH act as link between cellulolytic and ligninolytic pathways (Temp and Eggert 1999).

Insoluble, native cellulose is attacked comparatively slowly by a system of cellulolytic enzymes. A limited introduction of substituents into the cellulose molecule reduces the number of hydrogen bonds of cellulose chains in proportion to the degree of substitution (DS) and the pattern of occurrence along the cellulose chain. Depending on these features and the nature of the substituent, water solubility of cellulose derivatives may be obtained at DS values between 0.4 and 0.7, and cellulose loses its ordered structure and becomes enzymatically accessible. Cellulose acetates up to a DS of 1.4 were deacetylated by various enzyme preparations (Altaner et al. 2001).

For in vitro-degradation tests, carboxymethylcelluloses (CMC) are often used as soluble cellulose substrate (e.g., Schmidt and Liese 1980). The molecular structure of CMCs was characterized e.g., by Saake et al. (2000).

Pure crystalline cellulose substrates, like cotton or Avicel, are degraded by white and soft-rot fungi. Most brown-rot fungi hardly show enzyme activity against crystalline celluloses and attack only pre-treated cellulose derivatives (Highley 1988; Enoki et al. 1988), because brown-rot fungi do not possess the synergistic endo/exo glucanase system, but have only endoglucanases. Within the woody cell wall, brown-rot fungi, however, depolymerize cellulose rapidly. Thus, the presence of lignin, lignin breakdown products, hemicelluloses, or simple sugars was postulated.

Due to the limitation of enzyme accessibility to the woody cell wall by its pore sizes, the conceptions on cellulose degradation within wood by brown-rot fungi focused both on non-enzymatic procedures and enzymatic mechanisms (e.g., Eriksson et al. 1990; Highley and Illman 1991; Micales 1992; Ritschkoff et al. 1992; Goodell 2003). Bailey et al. (1968) postulated as preceeding non-enzymatic agent a "precellulolytic phase". Koenigs (1974) and others showed that cellulose was oxidatively degraded by Fenton reagents $[Fe(II) + H_2O_2 \rightarrow Fe(III) + OH^- + OH^0]$. Since ferrous iron is required in Fenton reactions, which is, however, absent in oxygenated wood decay processes, a search for a mechanism to reduce iron was made. H_2O_2 can also react with copper ions and some chromium, vanadium and nickel species to generate OH^0 (Halliwell 2003).

Numerous investigations stress the participation of oxalic acid (e.g., Green et al. 1991a, 1993; Micales 1992), as the acid reduces Fe^{3+} to Fe^{2+}, which forms from H_2O_2 the reactive hydoxylradical, which then depolymerizes the cellulose. In several brown-rot fungi, like Coniophora puteana, Serpula lacrymans and Oligoporus placenta, extracellular H_2O_2 was proven (Ritschkoff et al. 1990, 1992; Ritschkoff and Viikari 1991; Backa et al. 1992; Tanaka et al. 1992). Serpula lacrymans dissolved by means of oxalic acid iron from stonewool, which

promoted fungal growth and wood decay together with H_2O_2 (Paajanen and Ritschkoff 1992). In wood samples impregnated with chrome copper arsenic, in contact with rusting iron, probably iron ions diffusing into the wood increased wood decay (Morris 1992). Iron-sulfate reducing soil bacteria increased the iron content in wood samples as well as the mycelial growth rate of *Gloeophyllum trabeum* and *Oligoporus placenta* (Ruddick and Kundzewicz 1991). In contrast, inorganic chelating agents and iron-binding siderophores decreased growth and wood decay by brown-rot fungi (Viikari and Ritschkoff 1992). The potential function of oxalate as reducing agent of Fe^{3+} is, however, limited to the inside of woody substrates because this type of reaction shall occur only in the absence of light (Goodell 2003). The role of oxalate in brown-rot mechanisms may rather lie in a slow action on the hemicellulose matrix to help to open up the wood structure.

Since the early work on Fenton systems for hydroxyl radical production, several hypotheses have been developed explaining the function of low molecular weight metabolites, metals, and radicals, which initiate cell wall degradation by brown-rot fungi.

A compound, termed "glycopeptide", isolated from *Fomitopsis palustris*, with a molecular weight of 7.2 to 12 kDa reduced O_2 to OH^0 and catalyzed redox reaction between NADH as electron donor and O_2 to produce H_2O_2 and to reduce H_2O_2 to OH^0. The glycosylated peptide reduced Fe(III) to Fe(II) (Enoki et al. 2003). The glycopeptide may either diffuse as a deglycosylated "effector" form of lower molecular weight in the wood matrix or the shape of the glycopeptide is elongated allowing cell wall penetration or the glycopeptide generates longer-lived radicals such as superoxide which penetrate the wall microvoid spaces (Goodell 2003).

A cellobiose dehydrogenase enzyme system was proposed to occur in *Coniophora puteana* and to bind and reduce iron in the presence of oxalate, which the fungus employs to generate and maintain the low pH environment at least in the vicinity of the hypha, which is required to avoid autoxidation of the reduced valence state of iron (Hyde and Wood 1997; Goodell 2003).

"Low molecular weight fungal chelators" from *Gloeophyllum trabeum* ("Gt chelator") mediated the production of hydroxyl radicals within the wood cell wall, immunolocalized in the S_2 layer, and were termed as "chelator-mediated Fenton system" (CMFS). In CMFS, iron is reduced and then repeatedly "re-reduced", exceeding a 1:1 ratio for reduction of iron by catechol. Gt chelator in CMFS reactions reduced the cellulose crystallinity of wood and the molecular weight of Avicel crystalline cellulose (Goodell and Jellison 1998; Goodell 2003).

Shimokawa et al. (2004) provided evidence that *Serpula lacrymans* employs a Fenton reaction mediated by a quinone-type chelator, and preferentially degrades amorphous regions of cellulose in the non-enzymatic cellulose degradation.

The accessibility of the cellulose for cellulases can be improved by several pretreatments of wood (Chap. 9): for example, soaking increases the pore areas, and chemical pretreatments decrease the lignin content.

4.5
Lignin Degradation

Next to cellulose lignin is the most abundant polymeric organic substance in plants. Of about 10^{11} t of annual production of terrestrial biomass, about 2×10^{10} t are lignin (Jennings and Lysek 1999). Lignin is contrary to linear polysaccharides, like cellulose, a complex, stereoirregular, three-dimensional macromolecule (see Fig. 4.4, Nimz 1974; Higuchi 2002) in the range of 100 kDa (Abreu et al. 1999) and is highly hydrophobic reducing the hygroscopicity of wood. Lignin functions as a binding and encrusting material in the cell wall distributed with hemicelluloses in the spaces of inter-cellulose microfibrils in the cell wall. It acts as a cementing component to connect cells and harden

Fig. 4.4. Structural scheme of beech lignin (modified from Nimz 1974)

the cell walls of xylem tissues, which helps a smooth transportation of water through vessels and tracheids from roots to branches (Higuchi 2002). The incorporation of lignin into the cell wall gives trees with heights of 100 m the chance to remain upright. Lignin gives resistance against disease and wood decay by microorganisms. Lignin content amounts in softwoods to 26–39% (average 28%) (compression wood: 35–40%), in hardwoods of the temperate zone to 18–32% (average 22%) (tension wood: 15–20%) and in tropical hardwoods to 23–39% (Fengel and Wegener 1989).

The monolignols (p-hydroxycinnamyl alcohols), p-coumaryl, coniferyl, and sinapyl alcohol, are the primary precursors and building units of all lignins (Fengel and Wegener 1989; Fig. 4.5). The biosynthetic pathway of monolignols starts from glucose via shikimic acid over phenylalanine and tyrosine, respectively, to p-coumaric acid which yields via intermediates p-coumaryl alcohol. p-coumaric acid is converted via caffeic acid and ferulic acid to coniferyl alcohol. Ferulic acid is transformed via 5-hydroxyferulic acid and sinapic acid to sinapyl alcohol (Higuchi 2002).

For lignin polymerization (Li and Eriksson 2005), the monolignols are initially dehydrogenated by peroxidases and/or laccases to phenoxy radicals. The radicals then couple non-enzymatically to quinone methides as reactive intermediates. According to one proposal, dimeric quinone methides are converted into dilignols by water addition, or by intra-molecular nucleophilic attack by primary alcohol groups or quinone groups. Dilignols can also undergo enzymatic dehydrogenation to form the corresponding radicals, which in turn couple with phenoxy radicals to produce trilignols, etc. In a second mechanism, enzymatic dehydrogenation is restricted to monolignols. The polymerization evolves by successive non-radical addition of phenols to the quinone methides. In a third mechanism, the lignin polymer evolves from the polymerization of quinone methides.

Most softwood lignins are as guaiacyl lignins (G-lignins) polymers which are predominantly made of coniferyl alcohol (spruce: C : S : p-C = 94 : 1 : 5). Hardwood lignins are guaiacyl-syringyl lignins (GS lignins) and consist predominantly of C and S (beech: C : S : p-C = 56 : 40 : 4). Guaiacyl-syringyl-p-hydroxyphenyl lignins occur in grasses. Lignin quantity and composition

Fig. 4.5. Lignin building units. A p-coumaryl alcohol. B Coniferyl alcohol. C Sinapyl alcohol

vary also as with the tree age (Wadenbäck et al. 2004), between root and stem wood, heartwood and sapwood, xylem and bark, earlywood and latewood, and in different wood cells and cell wall layers. In the lignin molecule, the basic modules are linked with a variety of chemical bonds, ether and carbon-carbon linkages. Most bonds are covalent, of considerable variety and are equally in all three dimensions. The β-O-4 linkage (fat in Fig. 4.4) is the most frequent interunit linkage with about 50% (spruce) to 65% (beech) (Fengel and Wegener 1989; Abreu et al. 1999; Higuchi 2002).

Lignin forms an amorphic complex with hemicelluloses to encapsulate cellulose. As lignin represents a substance, which is hardly open to attack for most microorganisms, it protects within the woody cell wall the enzymatically more easily accessible carbohydrates against microbial degradation (Chap. 9, Table 4.3). There are different model conceptions with regard to the arrangement of the three components (see Fig. 4.1).

Causes for the resistance of lignin against microbial enzymes are: Aromatic rings are generally more difficulty degradable. The variety of the linkages between the building units and the hydrophobic nature require a breakdown system that is non-specific and, for the most part, nonhydrolytic as well as extracellular (Jennings and Lysek 1999; Reading et al. 2003).

Overviews on lignin degradation are e.g., by Umezawa (1988), Higuchi (1990), Schoemaker et al. (1991), Jeffries (1994), Cullen and Kersten (1996), Yoshida (1997) and Koshijima and Watanabe (2003).

An effective degradation of natural lignin (lignin within the woody cell wall) with respiration of the C-atoms from that aromatic ring exclusively occurs in white-rot fungi (Chap. 7.2). The residual lignin in wood degraded by brown-rot fungi is dealkylated, demethoxylated and demethylated, with some oxidation of the alkyl side chain. The aromatic ring is not attacked (Goodell 2003). Soft-rot fungi mainly cleave the methoxyl groups from the aromatic rings. Some bacteria demethylate or cleave within the alcoholic side chain, particularly in synthetic lignins with small molecular weights (dehydrogenation polymer, DHP) and in lignin model compounds (Fengel and Wegener 1989). For the "tunneling bacteria", lignin degradation was postulated within the woody cell wall (Chap. 5.2).

Many white-rot fungi produce extracellular phenol oxidases, which results in positive oxidase tests on nutrient agar with tannic and gallic acid. Only 40% of the white-rot fungi studied produced the combination of lignin peroxidase and manganese peroxidase, whereas the combination of manganese peroxidase and laccase was more common. In an extreme case, *Pycnoporus cinnabarinus* produced only laccase, lacking both lignin and manganese peroxidase (Eggert et al. 1996; Li 2003). The test by Bavendamm (1928) is used since that time for the rapid differentiation of white and brown-rot fungi in the laboratory and is in identification keys for wood fungi among the first distinguishing characters (Stalpers 1978). Malt agar is supplemented with a lignin

model compound (Davidson et al. 1938; Lyr 1958; Käärik 1965; Rösch and Liese 1970; Tamai and Miura 1991) and inoculated with the unknown fungus. If the fungus excretes the phenol oxidase laccase (benzenediol:oxygen oxidoreductase, EC 1.10.3.2), tannic acid, etc. are oxidized (brownish discoloration), and it usually concerns a white-rot fungus. By definition, laccases catalyze the oxidation of p-diphenols and the concurrent reduction of dioxygen to water, although the actual substrate specifities of laccases are often broad (Eggert et al. 1998). Most brown-rot fungi do not oxidize tannic acid, as they usually possess only intracellular tyrosinase (1,2-benzenediol:oxygen oxidoreductase EC 1.10.3.1). However, misinterpretation may occur because tyrosinase can be set free through injuring the mycelium, e.g., by the inoculation procedure, which feigns then a white-rot fungus (Rösch 1972). Furthermore, also some intensive lignin decomposer, e.g., *Phanerochaete chrysosporium*, may cause negative or only weak Bavendamm reaction (Eriksson et al. 1990). Laccase is also present in several Deuteromycetes and Ascomycetes (Butin and Kowalski 1992; also Luterek et al. 1998). Phenol oxidase (laccase) and one-electron oxidation activity was shown for the soft-rot Deuteromycetes *Cladorrhinum* sp., *Graphium* sp., *Scopulariopsis* sp., and *Sphaeropsis* sp. (Tanaka et al. 2000). Niku-Paavola et al. (1990) used 2, 2′-azino-di(3-ethylbenzothiazoline)-6-sulfonic acid as enzyme substrate, which is oxidized by laccase, while tyrosinase does not.

Due to the effect of the laccase in vitro, in former times, lignin degradation was assumed to occur exclusively by phenol oxidases. The main significance of the laccase is, however, seen in the polymerization of phenols. Lignin polymerization by laccase occurs through the formation of phenoxy radicals by abstraction of hydrogen followed by a series of radical polymerization reactions. Thus, laccase has also been used to obtain wood composites like particle and MDF boards that were bound mainly or even solely by lignin when polymerized in situ by this enzyme (Kharazipour and Hüttermann 1998). On the other hand, laccases are involved in lignin degradation by fungi, which was confirmed by "synergistic cellulose lignin degradation models" (Ander and Eriksson 1976). In connection with the cell wall degradation, the significance of the phenol oxidases might be rather an adjusting function for the carbohydrate degrading enzymes (Eriksson et al. 1990). In fungi, laccases are also involved in pigmentation, fruit body formation, sporulation, and pathogenesis (Rättö et al. 2004).

The isolation of the first ligninolytic enzyme was simultaneously obtained in two groups (Glenn et al. 1983; Tien and Kirk 1983) from culture filtrates of the white-rot fungus *Phanerochaete chrysosporium*. This fungus was well known as an intensive lignin decomposer, since it degraded [14]C labeled lignins to CO_2 as well as dehydropolymers and model compounds (Kirk 1988). The enzyme, diarylpropane peroxidase (lignin peroxidase, LiP, "ligninase I", diarylpropane: oxygen, hydrogen-peroxide oxidoreductase, EC 1.11.1.14) is a glucoprotein with a molecular weight of 42 kDa (also Srebotnik et al. 1988b), contains hem

(porphyrin with iron as central atom), needs extracellular H_2O_2, cleaves C-C bonds in a number of model compounds, and oxidizes benzyl alcohols to aldehydes or ketones.

The key reaction of the LiP is a one-electron-oxidation of various non-phenolic compounds to generate instable aryl radical cations, as the enzyme delivers two electrons to hydrogen peroxide, which the enzyme then takes back from each one-phenyl propenoid unit (Kirk 1985; Higuchi 1990). Phenolic and non-phenolic lignin substructures are attacked, but not the intact lignin molecule.

The radicals undergo subsequent non-enzymatic reactions to yield a variety of final products. The radical cations themselves act as oxidants. Thus, LiP initiates by means of different non-enzymatic reactions the cleavage of C_α-C_β bond in the side chain, β-O-4 bond between side chain and next ring, as well the aromatic ring (Eriksson et al. 1990; Schoemaker et al. 1991; Fig. 4.6). Also, veratryl alcohol, which is produced independently of lignin degradation, can be oxidized by LiP to the radical cation, which itself can oxidize lignin (Jennings and Lysek 1999).

The ligninolytic system of *Phanerochaete chrysosporium* is not induced by lignin but appears constitutively as cultures enter the secondary metabolism, that is, when primary growth ceases because of depletion of nutrients. Secondary metabolism was triggered by nitrogen, carbon, or sulphur limitation (review by Highley and Dashek 1998). Lignin cannot be used as only C source, but in cometabolism with cellulose or hemicellulose. A high O_2 concentration (100% more suitable than 21%) was favorable (Kirk 1988). The enzyme was excreted by old, autolytic hyphae, but not by arthrospores and chlamydospores (Lackner et al. 1991).

LiP has been found in several white-rot fungi, e.g., *Trametes versicolor*, *Phlebia radiata* (Dodson et al. 1987) and *Bjerkandera adusta* (Muheim et al. 1990). There are numerous isomers of LiP with molecular weights of 40 to 47 kDa, which differ in the carbohydrate portion of the protein (Evans 1991). The enzyme activity of LiP preparations is determined via C_α oxidation of

Fig. 4.6. Scheme of reactions initiated by lignin peroxidase. Cleavage of C_α-C_β bond in the side chain (*1*), β-O-4 bond between side chain and next ring (*2*), and aromatic ring (*3*)

veratryl alcohol (with presence of H_2O_2) to the aldehyde, whose amount is measured at 310 nm (Faison and Kirk 1985; Schoemaker et al. 1991).

The second enzyme involved in lignin degradation is manganese peroxidase (MnP) [Mn(II):hydrogen-peroxide oxidoreductase, EC 1.11.1.13], which needs free phenolic groups at the aromatic ring and does not oxidize veratryl alcohol. The hemoprotein enzyme was first detected in *P. chrysosporium* (Glenn and Gold 1985) and occurs e.g., in *Armillaria* species, *Lentinula edodes*, *Pleurotus ostreatus* and *T. versicolor*. It oxidizes in the presence of hydrogen peroxide Mn(II) to Mn(III), a strong oxidant, which oxidizes phenolic structures by single-electron-oxidation (Perez and Jeffries 1992; Kofugita et al. 1992; Robene Soustrade et al. 1992; Chatani et al. 1998; Kamitsuji et al. 1999). MnP polymerizes more extensively and depolymerizes less than lignin peroxidase (Tanaka et al. 1999). Treatment of water-insoluble ^{14}C-labeled milled wheat straw and milled straw lignin with MnP preparations from the white-rot fungus *Nematoloma frowardii* resulted in the direct release of $^{14}CO_2$ and in the formation of soluble ^{14}C-lignin fragments (Hofrichter et al. 1999). MnP also degraded polyethylene (Iiyoshi et al. 1998).

For the degradation of native lignin, a fungus must have enzymes, which attack both phenolic and non-phenolic lignin components (Martinez-Inigo and Kurek 1997). The lignin peroxidase is most likely responsible for the degradation of the non-phenolic components and the laccase as well manganese peroxidases for the oxidation of the phenolic parts (Evans 1991). All together, there is a variety of oxidative enzymes that may be utilized by white-rot fungi for lignin degradation (Highley and Dashek 1998). Various enzymes, low molecular weight agents, free-radical reactions, and metals have been proposed to participate in lignin degradation (Messner et al. 2003; Reading et al. 2003): Lignin peroxidase (LiP), manganese peroxidase (MnP), cellobiose dehydrogenase (CDH), laccases, oxalate, hydrogen peroxide, small molecule mediators, methyl transferases, and the plasma membrane redox potential are involved in the degradation systems. There is, however, still some uncertainty on their accurate participation in lignin degradation.

Progress has been made concerning the molecular genetics of lignin and cellulose biodegradation by white-rot fungi, primarily with *Phanerochaete chrysosporium*, but also with *Bjerkandera adusta*, *Phlebia radiata*, and *Trametes versicolor* (reviews by Highley and Dashek 1998 and Li 2003). Genes encoding Lip and MnP have been cloned and sequenced (e.g., Irie et al. 2000). The total genome sequence of *P. chrysosporium* has been disclosed by the DoE Joint Genome Institute in the USA, which has facilitated cDNA cloning of various cellulase genes from *P. chrysosporium* and successive production of recombinant proteins from them (Samejima and Igarashi 2004). The X-ray crystal structures of both LiP and MnP have also been elucidated. By means of recombinant DNA techniques, laccase catalysis has been studied, and the crystal structure of a T2-copper deleted laccase has been reported. In *Pycnoporus cinnabarinus*,

genes encoding two laccase isozymes have been cloned and sequenced (also Eggert et al. 1998). Glyoxal oxidase as a source of extracellular H_2O_2 was found to be encoded by a single gene.

Occurrence and distribution of lignin peroxidase inside hyphae and white-rotten wood were examined by immuno gold labeling (Srebotnik et al. 1988a; Blanchette et al. 1989; Daniel et al. 1989, 1990; Blanchette and Abad 1992; Kim et al. 1993). The enzyme is particularly found in the hypha and the extracellular sheath, and less so in the wood cell wall and then near the hypha. In the cell wall, it is only considerably present in late degradation stages. It was concluded from this distribution that the lignin peroxidase attacks rather lignin fragments that had been set free from the cell wall, than that it binds at the polymeric lignin inside the intact wall. The primary degradation would have then taken place by low-molecular compounds like the cation radical of veratrylalcohol, which diffuses into the wall, produces there lignin fragments, which are then degraded by ligninase (Evans 1991). It may also assumed that the limited cell wall degradation starting from the cell lumen in close neighborhood of a hypha occurs directly by the enzyme towards closely neighboring lignin. This would agree with the early results of the erosion-like cell wall degradation by white-rot fungi (Schmid and Liese 1964; Liese 1970; Fig. 7.2b).

There are many ways that a white-rot fungus could generate hydrogen peroxide required for LiP and MnP. Extracellular H_2O_2-producing enzymes are aryl-alcohol oxidase (EC 1.1.37), glyoxal oxidase, pyranose 2-oxidase (EC 1.1.3.10), and cellobiose dehydrogenase. Intracellular enzymes include glucose 1-oxidase (EC 1.1.3.4) (Leonowicz et al. 1999), pyranose 2-oxidase, and methanol oxidase (e.g., Daniel et al. 1994; Hyde and Wood 1997; Urzúa et al. 1998). OH^0 may be also formed via hydroquinone redox cycling involving semiquinones produced by peroxidase or laccase which reduce both Fe(III) and O_2 to provide the components for Fenton-type hydroxyl radical formation. It is not exactly known which enzyme plays the primary role in supplying H_2O_2 (Li 2003).

From the only slow microbial decomposition of lignin results its significance for the formation of humic substances (e.g., Haider 1988; Schlegel 1992) and also for the lastingness of archaeological woods (Chap. 5.2). The suitability of lignins as fertilizer and for soil improvement was described by Faix (1992). Mikulášová and Košíkowá (2002) indicated a potential application of lignin biopolymers as antimutagenic agents in chemoprevention.

There are some general prerequisites for the action of the degradative systems. As lignin is a highly oxidized polymer, reductive as well as oxidative reactions are required to effectively degrade it, both of which must occur aerobically. These reactions must be balanced or controlled to prevent redox cycling and free-radical-based polymerization of the degradation products. The oxidizing and reducing equivalents must be unique and continuously produced since extracellular regeneration would be improbable. Common biological compounds for reducing or oxidizing equivalents, such as NADH, which would

be difficult to regenerate once released extracellularly are precluded. In vitro, reduction of manganese dioxide was demonstrated for a ferrireductase system that includes NADPH-dependent ferrireductase and the iron-binding compound from *Phanerochaete sordida* (Hirai et al. 2003). Extracellularly formed free-radical species are able to diffuse away from their origin and mediate reactions with the insoluble lignin. The small, diffusible radicals and low-molecular agents achieve a greater area of reactivity than could be obtained by reactions catalyzed by enzymes or the fungi directly. The distance of the action from the hyphae also prevents self-inflicted damage to the fungus (Reading et al. 2003).

The following description of systems to generate low molecular agents is according to Messner et al. (2003).

In the "manganese peroxidase/Mn(II)/oxalate system", there are two one-electron reducing steps by Mn(II). The Mn(III) formed is chelated and released from the enzyme by the fungal metabolite oxalate. The relatively stable Mn(III) oxalate oxidizes phenolic lignin compounds and has been proposed to diffuse in the wood cell wall.

In the "manganese peroxidase/Mn(II)/oxalate/cellobiose dehydrogenase system", CDH is oxidized by O_2 and metal ions such as Fe(III) and Cu(II) yielding H_2O_2, and Fe(II) or Cu(I) which react with H_2O_2 to generate hydroxy radicals which in turn demethoxylate and hydroxylate non-phenolic lignin. The phenolic lignin formed is then attacked by MnP-generated Mn(III).

In the "manganese peroxidase/Mn(II)/oxalate/lipids system", lipids extend the oxidative potential of MnP. Mn(III) promotes peroxidation of unsaturated fatty acids resulting in the formation of peroxyl radicals which are diffusible, potentially ligninolytic agents. Mn(III) also abstracts hydrogen from fatty acids to form acyl radicals. The system depolymerized both phenolic and non-phenolic lignin (Katayama et al. 2000).

In the "lignin peroxidase/veratryl alcohol system", the veratryl alcohol radical, generated during turnover of LiP, was proposed to act as a charge transfer system in wood. However, its short lifetime may prevent a diffusion into deeper cell wall areas.

In the "laccase/mediator system", laccases are combined with low molecular weight charge transfer agents, so-called mediators. The system is used to bleach pulp and depolymerized non-phenolic guaiacyl lignin.

In the "glycopeptide system" (Enoki et al. 2003), low-molecular weight glycosylated peptides produce hydroxy radicals which modify lignin, resulting in new phenolic, benzyl radical, and cation radical substructures which are then attacked by LiP, MnP or laccase. The system also depolymerizes the wood carbohydrates (see Chap. 4.4).

In the "coordinated Cu/peroxide system" (Messner et al. 2003), either hydrogen peroxide or organic peroxides, is the agent involved at least in the initial lignin degradation. Cu(II) is reduced to Cu(I) by either H_2O_2 or reducing groups in wood. Cu(I) forms with H_2O_2 a reactive one-electron oxidant

that oxidizes phenolic and non-phenolic lignin. Cu(I) is reoxidized by lipid hydroperoxide.

For the preferential white-rot type without the intense damage of cellulose, Teranishi et al. (2003) showed that *Ceriporiopsis subvermispora* produced ceriporic acid, which strongly inhibited the Fenton reaction to suppress the formation of OH^0.

In summary, meanwhile many details on the degradation of the various components of the woody cell wall are known. It may be considered, however, that in view of lignin and cellulose degradation, many results derive from only one fungal species, *Phanerochaete chrysosporium* (anamorph: *Sporotrichum pulverulentum*), and that this fungus has nearly no relevance for wood, neither for trees nor for construction timber, only for chip piles.

5 Damages by Viruses and Bacteria

5.1
Viruses

Viruses are small particles (10–2,000 nm in size) that infect Eukaryotes as obligate intracellular parasites. They reproduce by invading and taking over other cells as they lack own metabolism and the machinery for self-reproduction (Nienhaus 1985a). Typically, they carry either DNA or RNA surrounded by a coat of protein or protein and lipid. Plant viruses penetrate the shoot, leaf tissue and root via wounds or they are transferred by vectors [aphids, cicadas, nematodes, among fungi: *Sphaerotheca lanestris* (Erysiphales) on oak]. Partial bleaching of chlorophyll results in angular, circular (mosaic) or diffuse chloroses. Leaf damage, dwarfing or growth inhibition, distorted growth, and necrotic areas or lesions can occur, that is, virus infection can reduce the tree growth. Over 1,000 virus diseases of plants are described for Europe. Virus diseases in forest trees have been summarized e.g., by Nienhaus and Castello (1989) and Cooper and Edwards (1996). Viruses occur in several gymnosperms (*Chamaecyparis, Cupressus, Larix, Picea* and *Pinus*), angiosperms (*Acer, Aesculus, Betula, Carpinus, Cormus, Corylus, Fagus, Fraxinus, Juglans, Populus, Prunus, Quercus, Rhamnus, Robinia, Salix, Sambucus, Sorbus* and *Ulmus*) (Nienhaus 1989; Brandte et al. 2002), in bamboos and palms. Twig increase in horse chestnut (Butin 1995), and witches'-broom on beech and robinia are probably likewise due to the participation of viruses. Viruses have been detected several times in forest dieback sites (Parameswaran and Liese 1988; Winter and Nienhaus 1989; Gasch et al. 1991).

Viroids are infectious agents that consist of a single-stranded RNA. Viroids are smaller than viruses, lack a protein cover and are the smallest causal agents of plant diseases, like discolorations, chloroses and distorted growth, e.g., in coconut, cucumber, hop, potato and tomato (Schlegel 1992; Butin 1995; Nienhaus and Kiewnick 1998). About 33 species of viroids have been identified.

5.2
Bacteria

"The Prokaryotes" (Dworkin et al. 2005) is a comprehensive reference on bacterial biology.

The term bacteria had been used for all Prokaryotes or for a major group of them. Based on the 16S rDNA sequence the Prokaryotes were divided into the kingdoms Eubacteria and Archaebacteria (Woese and Fox 1977). Later three domains, Bacteria, Archaea and Eucarya were renamed (Fig. 5.1) and confirmed by sequencing (Gray 1996).

Archaea differ from other Prokaryotes in their membrane composition, flagella development and the similarity of their transcription and translation to that one of Eukarya. Many Archaea are extremophiles and live in geysers and black smokers at 80–110 °C (*Pyrodictium* spp.), or in acid (about pH 0), alkaline, or saline (till 30% salt content) water like *Halobacterium* species. Methanogenic Archaea inhabit the digestive tracts of ruminants, humans, and termites, or soil, marshland and sewage etc. In trees, methanogenic Archaea are involved in the development of the alkaline wetwood (see below).

Bacteria cover a major group of Prokaryotes and are ubiquitous in soil, water, as symbionts, or pathogens. They lack cell nucleus, cytoskeleton, mitochondria, and chloroplasts. The genetic information is located on a circular DNA strand, which is not covered by a nuclear membrane. Many bacteria contain plasmids with extrachromosomal DNA. Ribosomes are made of the 70S type (Eukaryotes: 80S). Reproduction is asexual by cell division. Exchange of genetic material can occur by transformation, transduction, and conjugation.

About 10,000 species are identified, characterized, and deposited in culture collections, which might, however, represent only 10% of the actually existing species. Many bacteria are rod-shaped, sphere-shaped (cocci), helix-shaped (spirillum), or comma-shaped (vibrios). Common bacteria are minute, measuring 0.4–5 µm in size. They occur single, or double, or in chains or clusters.

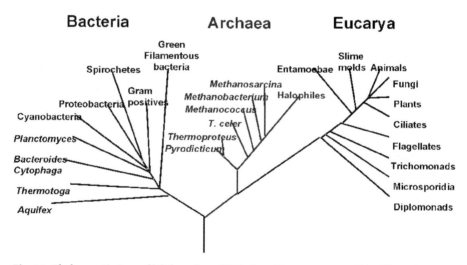

Fig. 5.1. Phylogenetic tree of life based on rDNA data (from www:en.wikipedia.org)

Gram staining divides Gram-positive and negative species according to their wall structure and the occurrence of pepitoglycan or lipids. With regard to oxygen, aerobes grow only in the presence of oxygen and anaerobes in its absence. The latter behavior may be either facultative or obligate. Many bacteria are motile, using either flagella, axial filaments, gliding, or changes in buoyancy. In some genera (*Bacillus*, *Clostridium*), the mother cell develops an endospore, which is rather resistant against heat, radiation and chemicals (Schlegel 1992).

Actinobacteria are bacteria, which often live in the soil. They play important roles in plant decomposition, humus formation, and degradation (Filip et al. 1998) and are found on timber in soil contact. Some form branching filaments, which resemble the fungal mycelium (in former times: Actinomycetes), whereby the cell diameter of about 1 μm is however smaller than that of most fungal hyphae. Some actinobacteria (e.g., *Streptomyces*) develop a plenty of air-borne spores.

There are various interactions between bacteria and plants, like increase of soil fertility by nutrient release, nitrogen fixation (*Azotobacter*), root symbioses (*Rhizobium*), decomposition and humification, and parasitism as causal agents of diseases.

The pathogenic bacteria of woody plants belong to the genera *Agrobacterium*, *Erwinia*, *Pseudomonas*, and *Xanthomonas* (Nienhaus and Kiewnick 1998). Bacteria cause the fire blight [*Erwinia amylovora* (Burrill) Winslow et al.] of many species of the rose family (Tattar 1978), canker of poplar [*Xanthomonas populi* ssp. *populi* (Ridé) Ridé & Ridé], willow (*X. populi* ssp. *salicis* de Kam) and ash (*Pseudomonas syringae* ssp. *savastanoi* pv. *fraxini* Janse) (Butin 1995). *Agrobacterium* species infect the roots of a wide range of dicotyledonous plants and some gymnosperms causing crown gall and hairy root diseases.

Since the late 1970s, *Agrobacterium*-mediated gene transfer is an important tool in genetic transformation of forest trees. During the disease process, a DNA segment of the bacterium (T-DNA) is integrated into the host plant genome. The T-DNA originates from a 200-kb plasmid (Ti plasmid) and foreign genes can be inserted into this DNA for transfer into the plant (Palli and Retnakaran 1998; Häggman and Aronen 1996), e.g., for gene-manipulated poplars and white spruce (Séguin et al. 1998). Kajita et al. (2004) transferred the gene for the enzyme feruloyl-CoA hydratase/lyase, which is involved in lignin (hydroxycinnamates) metabolism, from a bacterium into aspen by *Agrobacterium tumefaciens* (E.F. Smith & Townsend) Conn in view of producing trees with novel characteristics.

Rickettsia and Rickettsia-like organisms (RLOs) (Proteobacteria) (100–800 nm) are obligate intracellular, Gram-negative bacteria with reduced metabolic activity. They cannot be cultured in nutrient medium. RLOs in plants are transferred by arthropodes, particularly cicadas, and multiply in the vector

and in the phloem or xylem. They cause e.g., leaf necrosis in oak and planes and distorted growth of larch (Nienhaus 1985b; Linn 1990; Butin 1995).

Mycoplasmas (genus *Spiroplasma*) and phytoplasmas (in former times: MLOs; genus *Phytoplasma*) are the smallest (100–750 nm) independently growing bacteria. They are pleomorphic, sporeless, immovable, and filterable. *Spiroplasma* grows on nutrient medium, *Phytoplasma* does not. Plant pathogens are transferred by grafting, root grafts, vegetative propagation of infected material, *Cuscuta* species, and sucking insects, in which they multiply, into the phloem (Nienhaus and Kiewnick 1998). They cause a great number of yellow-type diseases, necroses, growth disturbances, or dying of rice, maize and sesame, vegetables, sugar cane, fruit trees, coconut palm, whitethorn, alder and ash, witches'-brooms on poplar, and sandal spike (Tattar 1978; Nienhaus 1985a, 1985b; Linn 1990; Sinclair et al. 1990; Lindner 1991; Lederer and Seemüller 1991; Raychaudhuri and Mitra 1993; Raychaudhuri and Maramorosch 1996).

Bacteria appear in trees and wood as both primary and secondary colonizers often in the context of succession together with fungi. They live on easily accessible nutrients and may prepare the substrate for fungi (Shigo 1967; Cosenza et al. 1970; Shigo and Hillis 1973; Shortle and Cowling 1978; Rayner and Boddy 1988). Soil bacteria may increase vitamin content (thiamine) of wood in ground contact, which promotes subsequent decay Basidiomycetes (Cartwright and Findlay 1958; Henningsson 1967).

Bacteria penetrate into the sapwood of a tree via wounds. In hardwood vessels that are not closed by tyloses or other wound reactions, they might spread with the capillary water over larger distances. In softwood samples, however, only a few tracheids were passed due to the small free spaces within the pit membrane (Liese and Schmidt 1986).

The wet heartwood (wetwood) of several tree species, particularly fir, hemlock, poplar, elm, also beech and oak, means any water-saturated and dead wood in living trees. Characteristics are the unpleasant smell of butyric acid and other acids, dark discolorations and gas escape from the heartwood if an increment borer has been used. The exact cause of wetwood formation, whether being due to bacteria or necrotic changes in the parenchyma cells, is not clarified. Wetwood develops in connection with mechanical wounds, branch breaking, decay, stem cracks, and insect attack. So-called acid wetwood, predominantly in conifers, contains several organic acids (butyric, acetic, propionic acid) produced by (facultative) anaerobe bacteria. Alkaline wetwood, mostly in hardwoods, develops with participation of obligate anaerobe methanogenic Archaea. These Prokaryotes attack the pits or cause their incrustation, give rise to discolorations, their metabolites may stress the tree, and the unpermeable wetwood tends to crack during drying (Carter 1945; Hartley et al. 1961; Wilcox and Oldham 1972; Bauch 1973; Knutson 1973; Bauch et al. 1975; Tiedemann et al. 1977; Ward and Pong 1980; Ward and Zeikus 1980; Schink et al. 1981; Mur-

doch and Campana 1983; Zimmermann 1983; Schink and Ward 1984; Kučera 1990; Klein 1991; Walter 1993; Xu et al. 2001).

Bacteria may be also associated with the development of false frost cracks in oak, ash, elm, poplar, and Silver fir. These radial shakes develop progressively from the stem interior, being initiated either from old cambial injuries or from pockets of fungal heart rot (Shigo 1972; Butin and Volger 1982). Occurrence, distribution, and enzyme activities of the bacteria isolated from pedunculate oak trees supported the assumption that bacteria may be involved in the weakening of the woody tissue in the area of the ray parenchyma cells so that mechanical factors like frost subsequently push the shake in the predamaged tissue (Schmidt et al. 2001).

Several bacteria isolated from wet-stored stem wood were able to degrade pectin, hemicelluloses, and cellulose when these cell wall components had been supplied as isolated compounds (Schmidt and Dietrichs 1976). With regard to lignin, lignin derivatives or DHPs up to 1 kDa were attacked (Vicuña 1988).

In view of bacterial wood degradation, bacteria attacked within partially lignified plant organs, like a shoot or a needle, only non-lignified tissue. The cell walls of the phloem cells of the vascular bundles were degraded, but those of the xylem part resisted. Inside woody tissue, bacteria preferentially feed soluble sugars, the content of parenchyma cells and attack non-lignified pit membranes (Liese 1970). In tension wood fibers, bacteria only consumed the cellulosic G-layer (Schmidt 1980). After a mild delignifying pretreatment of wood samples with sodium chlorite, however, bacteria caused mass loss up to 70% (Schmidt 1978), as the carbohydrates were now accessible. Figure 5.2

Fig. 5.2. Beech wood microtome sections with slightly reduced lignin content without (**a**) and after culture with *Cellulomonas flavigena* (**b**)

shows beech wood microtome sections whose lignin content have been reduced
from naturally (21%) to about 19% and which subsequently had been used as
the only carbon source for bacteria in liquid cultures. The microtome section in
Fig. 5.2a represents the non-inoculated control. The section in Fig. 5.2b shows
that only the highly lignified middle lamella primary wall region resisted to
the bacterium *Cellulomonas flavigena* Kellerman and McBeth. However, the
bacteria only consumed the carbohydrates of the pretreated wood. The lignin,
which was dissociated from the pretreated woody cell wall by the bacteria, was
not respired but was refound in the nutrient liquid, suggesting that lignin is
a "ballast" to these bacteria that inhibits the dissimilation of the wood carbo-
hydrates. The action of the chlorite pretreatment was assumed to result from
the "opening" of the close association between carbohydrates and lignin in the
woody cell wall so that the carbohydrates became accessible to the bacteria.
Decay may have not been due to the reduction of the lignin content, because
bacteria did not attack natural beech wood with 21% lignin content, but de-
graded pretreated Scots pine samples with a higher lignin content of about
23% (Schmidt and Bauch 1980).

Several bacteria were isolated from sawn *Liriodendron tulipifera* lumber al-
ready after 2 months of stacking (Mikluscak and Dawson-Andoh 2004a). After
longer wood exposition under natural conditions, like in soil, or lakes and
marine environment, the lignified cell wall was degraded by mixed popula-
tions and obviously the hurdle of the lignin barrier was cleared (Liese 1950;
Liese and Karnop 1968; Schmidt et al. 1987; Fig. 5.3a). Dependent on the de-
cay type within the wood cell wall, cavity, erosion, and tunneling bacteria
were distinguished (Singh and Butcher 1991; Nilsson et al. 1992; Singh et al.
1992; Daniel 2003). The two first types resemble the soft-rot types 1 and 2
(Chap. 7.3). The tunneling bacteria are qualified by means of slime sheats to
a gliding movement inside cell wall concavities created by themselves. The
aggregates of the tunneling bacteria subcultured from the woody samples con-
sisted of different bacterial species (Nilsson and Daniel 1992; Nilsson et al.
1992).

Aureobacterium luteolum Yokota et al. isolated from pond water caused ero-
sions in the secondary wall in microtome sections of pine sapwood as substrate
in 1 month of incubation, that is, bacterial wood degradation occurred obvi-
ously also by a pure culture under laboratory conditions (Schmidt et al. 1995;
Fig. 5.3c). The result was however not reproducible using another strain of *A.
luteolum* (Nilsson pers. comm.).

In contrast to the xylem of healthy trees, which was rather "sterile", wood
samples from forest dieback sites contained several bacteria (Schmidt 1985;
Schmidt et al. 1986). In view of the forest damage by pollution, bacteria (in-
cluding RLOs and MLOs) were however assumed to be no causal agents, but
rather, apart from other influences (emissions, climate, location), predisposing
factors, or secondary parasites of the weakened trees.

Fig. 5.3. Bacterial wood decay. **a** First photo (1944 by J. Liese) of wood cell walls degraded by bacteria showing destroyed pine wood tracheids within a foundation pile (from Liese 1950). **b** Degradation of a pine sapwood tracheid cell wall during 3 months of ponding in a lake (TEM, from Schmidt et al. 1987). **c** Degradation of a tracheid cell wall in the laboratory by *Aureobacterium luteolum* (TEM, from Schmidt et al. 1995). *B* bacterium, *E* erosion, *S* secondary wall, *MP* middle lamella/primary walls, *R* cell wall residues

In logs, which were stored for protection from decay fungi, staining and insect attack in the open (v. Aufseß 1986; Schmidt et al. 1986) or were sprinkled (sprayed) or water-stored (ponded) (Karnop 1972a, 1972b; Berndt and Liese 1973; Schmidt and Wahl 1987), bacteria degraded in situ within a few weeks the non-lignified margo fibrils of the sapwood bordered pits (Fig. 5.4). Several bacterial isolates were obtained (Schmidt and Dietrichs 1976). The increased wood porosity may cause wood cracks during artificial drying and an irregular over-uptake of preservative solutions, varnishes, stains, or paints resulting in uneven finishes (Willeitner 1971). Wood spots due to increased permeability and bad smell of bacterial metabolites are current problems when wet-stored wood is used for indoor wood paneling.

Timber in service is colonized by bacteria, if the wood is very wet and thus less suitable for fungi due to reduced oxygen content. Early reports (Liese 1950; see Fig. 5.3a) on bacterial degradation refer as to wood in long-lasting ground contact (Levy 1975b), as in foundation piles, sleepers, or to wood in water, like in cooling towers, harbor constructions and boats (Liese 1955). Cell wall degradation even occurred in chromium-copper-arsenic-treated piles and poles (Willoughby and Leightley 1984; Singh and Wakeling 1993). The bacteria dissolved the toxic components and thus favored wood degradation by soft-rot fungi (Daniel and Nilsson 1985). Wood samples impregnated with chromium-copper-arsenate and incubated with bacterial pure cultures showed increased wood mass loss during subsequent incubation with *Coniophora puteana* (Willeitner et al. 1977).

Bacteria are often found in archaeological woods from buried and water-logged environments (Blanchette 1995; Björdal et al. 1999; Kim and Singh 1999, 2000; Singh et al. 2003; Björdal et al. 2005; Schmitt et al. 2005). In those wet conditions, bacterial wood degradation is often associated with soft-rot fungi (Willoughby and Leightley 1984; Singh et al. 1991; Singh and Wakeling 1993).

Fig. 5.4. Destruction of a pine sapwood bordered pit showing the detachment of the torus (T) by bacterial (B) degradation of the margo fibrils. (REM, from Peek and Liese 1979)

Woods from Tertiary fossil forests after 20–60 million years of burial showed indications that nonbiological degradation was responsible for the changes in the cell walls (Blanchette et al. 1991).

Bacteria are also involved in wood discoloration. The wood of the light African Ilomba, *Pycnanthus angolensis*, is colonized after felling during storage and shipment of the round timber. The bacteria spread in the stem interior and cause reddish-brown discoloration. Further discoloration develops during air-drying of the boards in the area of the stacked wood (sticker stain). As causal bacteria e.g., *Pseudomonas fragi* (Eichholz) Gruber was isolated, which remained active in the damp wood parts (contact with stacked woods) and increased there the pH value from about 5.5 to 7.5–8.5 by producing ammonia from the protein of the protein-rich wood species. This alkalinity results in chemical reactions (phenol oxidation and polymerization) of accessory components in the parenchyma cells, which cause the brown discoloration (Bauch et al. 1985). The bacterium also discolored wood samples in vitro (Fig. 5.5). Bacterial discoloration of Ilomba wood during air-drying could be almost completely prevented by previous dipping the fresh boards in a solution of each 5% formic acid and propionic acid.

Several bacteria were isolated from beech trees that possessed an irregular stellar-shaped red heart (splash-heart). The bacteria caused also in vitro brown discoloration of light beech wood samples and wood capillary liquids by raising the pH value to over 7.3 (Schmidt and Mehringer 1989; also Mahler et al. 1986; Walter 1993).

Pseudomonas aeruginosa (Schroeter) Migula discolored Obeche, *Triplochiton scleroxylon* (Hansen 1988). In water-stored pine stems, bacteria produced flavonoids from flavone glycosides, which diffused to the wood surface during drying the sawn timber and caused there brown discolorations (Hedley and Meder 1992).

Bacteria were inhibited by chromium-copper wood preservatives and further preservation salts used against fungi. Concentrations used for fungi were mostly sufficient to prevent bacterial activity (Schmidt and Liese 1974, 1976; Liese and Schmidt 1975; Schmidt et al. 1975). Archaeological woods, like the Bremen Cog of 1380, are stabilized against further deterioration using polyethylene glycol (Hoffmann et al. 2004).

Fig. 5.5. Bacterial discoloration of Ilomba wood within 1 day by a pure culture of *Pseudomonas fragi* inoculated as a line on the light wood sample

Reviews on "bacteria and wood" are by Liese (1992), Schmidt and Liese (1994), Daniel and Nilsson (1998) and Kim and Singh (2000).

Several bacteria, like *Bacillus* spp., *Pseudomonas* spp. and *Streptomyces* spp., were investigated in view of antagonism (Chap. 3.8.1) against fungal parasites (*Armillaria* spp.: Dumas 1992), wood staining fungi (Bernier et al. 1986; Seifert et al. 1987; Benko 1989; Florence and Sharma 1990) and decay fungi (Benko and Highley 1990).

Bacteria are currently discussed in connection with the hygiene status of wood used for packing, transport, and preparation of foodstuffs. A study, which compared wooden and plastic boards used in kitchens, revealed that especially pine boards possess hygienic advantages due to its extractives compared to other woods and plastic (Milling et al. 2005).

Pretreatment of spruce wood chips with the actinobacterium *Streptomyces cyaneus* (Krasil'nikov) Waksman for mechanical pulping decreased the energy consumption during fiberizing of 24% and increased some strength properties of handsheets (Hernández et al. 2005).

To identify bacteria, predominantly on the basis of morphological and biochemical characteristics, "Bergey's Manual of Determinative Bacteriology" (Buchanan and Gibbons 1974) is suitable. "Bergey's Manual of Systematic Bacteriology" (Garrity 2001 et seq.) is the classic reference on bacterial taxonomy considering numerous rearrangements and changes in nomenclature, which are mainly due to molecular techniques notably sequencing of 16S rDNA and analysis of fatty acids.

6 Wood Discoloration

The damage of wood by fungi is essentially caused by the degradation of the cell wall by fungi, which decreases the mechanical wood properties and substantially reduces wood use. However, wood quality is also influenced by bacterial, algal and fungal discolorations (e.g., Grosser 1985; Zabel and Morrell 1992; Eaton and Hale 1993).

Discolorations in the wood of living trees, in round wood, timber and wood in service are long-known problems and are based on different biotic and abiotic causes (Bauch 1984, 1986; Kreber and Byrne 1994; Koch et al. 2002; Koch 2004; Table 6.1).

Discolorations in standing trees occur after wounding by wound reactions of the tree (Chap. 8.2) and by the colonization of the stemwood with bacteria and fungi as a result of microorganism-own pigments (e.g., melanin of blue-stain fungi, Zink and Fengel 1989) or of their metabolism (brown, white, and soft rot in trees, chemical reactions of accessory compounds after pH-change by wetwood bacteria and in the splash-heart of beech trees).

Algae like *Chlorococcum* sp. and *Hormidium* sp. soiled and discolored timber surfaces (Ohba and Tsujimoto 1996; also Krajewski and Ważny 1992a), whereby the green algae *Chlorhormidium flaccidum* (Kützing) Fot. and *Chlorococcum lobatum* (Kortschikoff) Fritsch & John caused even slight cell wall erosion (Krajewski and Ważny 1992b).

Table 6.1. Biotic and abiotic wood discolorations (completed after Bauch 1984; Butin 1995)

tree reactions on wounding
microbial discolorations
- staining by algae, molds, blue stain and red-streaking fungi
- grey stain of poplar wood by *Phialophora fastigiata*
- pink stain by *Arthrographis cuboidea*
- black streaking of beech wood by *Bispora monilioides*
- red spotting of beech wood by *Melanomma sanguinarum*
- "green rot" by *Chlorociboria* spp.
- wood rots
physiological reaction of living parenchyma cells ("Ersticken" of beech and oak)
biochemical reaction by wood-own enzymes ("Einlauf" of alder)
chemical reactions (iron-tannic acid reaction of oak, discoloration of hemlock by zinc)
combined reaction (brown discoloration of Ilomba by bacterial pH-increase and
 subsequent chemical reaction of phenols)

The wood-discoloring molds and staining fungi live on nutrients in the parenchyma cells of the sapwood. Conifers and hardwoods, round wood, lumber, finished wood and wood products can be colonized. Discoloring fungi do not cause any or only very little cell wall attack. Prioritization of the color damage depends on subsequent wood use.

Several Deuteromycetes and Ascomycetes stain woody substrates. *Phialophora fastigiata* (Hyphomycetes) causes a grey stain of poplar wood. *Arthrographis cuboides* (Hyphomycetes) produces a pink stain in several hardwoods and softwoods, and a naphthalenedione has been isolated from such wood (Golinski et al. 1995). Red alder wood used in the USA for furniture is stained reddish purple by *Ophiostoma piceae* if not rapidly processed after harvesting (Morrell 1987). Black streaking of beech logs occurs by *Bispora monilioides*. Red spotting of beech wood is effected by *Melanomma sanguinarum* (Dothideales). *Paecilomyces variotii* produces a yellow discoloration of oak wood during drying through its pH-change, which causes chemical reactions of the hydrolyzable gallotannins (Bauch et al. 1991).

So-called green rot is caused by species of the ascomycete *Chlorociboria* (Helotiales). *Chlorociboria aeruginascens* and *C. aeruginosa* discolor rotten and moist hardwood (and conifer) branches and other woody debris in the forest (Jahn 1990). The green wood has often been employed in marquetry and veneering and is a feature of the famous Tunbridge ware (Ellis 1976). The naphthoquinone pigment, xylindein, produced by the fungus is mainly deposited in the ray parenchyma cells as well as in vessels and fibers adjacent to the rays. The pigment is now since more than 500 years durable (Blanchette et al. 1992a; Michaelsen et al. 1992). In a recent reproduction of a violin from the 17th century, green stained wood was used for the ornaments (Fig. 6.1).

Fig. 6.1. "Green rot" caused by *Chlorociboria* species. **a** Green-rotten poplar wood. The missing section was used for the green intarsia **b** of the replica **c**, **d** by T. Schmitt in 1998 of a violin by J. Meyer from 1670 (photos **b–d**: T. Schmitt)

6.1
Molding

The term mold originates from daily life and is not a taxonomic name of a single systematic group (Reiß 1997; Kiffer and Morelet 2000). The Deuteromycetes (fungi imperfecti) constitute an artificial group and comprise a great variety of 20,000–30,000 species of 1,700 genera of Hyphomycetes and 700 genera of Coelomycetes. The different molds have a broad spectrum of physiological response with regard to temperature, water activity, pH value etc. and thus can colonize and damage very diverse materials (molding). Molds are significant in view of damages to foodstuffs, deterioration of natural materials (leather, books, textiles, wallpapers), with regard to human and animal health, and for biochemists and the manufacturers of antibiotics [772 of about 3,200 admitted antibiotics originate from fungi: Müller and Loeffler (1992)], organic acids [e.g., citronic acid, malic acid: Rehm (1980)], enzymes (e.g., amylase, protease, lipase, cellulase, pectinase), cheese (*Penicillium camemberti*, *P. roqueforti*), salami sausages (*P. nalgiovense*), and "country cured ham" (*Aspergillus* spp., *Penicillium* spp.) (Schwantes 1996; Reiß 1997). *Botrytis cinerea* causes the "noble rot" of sweet wines. *Fusarium oxysporum* ssp. *cannabis* is used as an herbicide for suppressing marijuana plants (Kiffer and Morelet 2000). Even synthetic floor coverings, airplane fuels, oils, glues, paints, optical glasses, and textiles can be overgrown with and damaged by molds.

With regard to lignocelluloses, seeds, seedlings, young tree roots (Schönhar 1989), standing trees (Schmidt 1985), stored and blocked wood (Wolf and Liese 1977; Bues 1993), piled wood chips (Feicht et al. 2002) of the pulp industry (Hajny 1966), stored annual plants, like sugarcane bagasse (Schmidt and Walter 1978), and books (Kerner-Gang and Nirenberg 1980) can be colonized by molds. *Paecilomyces variotii* (mold and soft-rot activity) is involved in the yellow discoloration of oak wood during storage and drying (Bauch et al. 1991). There are German and European standards and test methods to measure growth of molds on and resistance of substrates like electrotechnical products, plastics, textiles, optic apparatus, and timber (Kruse et al. 2004).

Frequently, molds are recognizable by their fast growth on the surface of substrates, on which conidia develop rapidly (Fig. 6.2a). Due to the species-specific color of the conidia, wood colonized by several mold species can make a multicolored impression, or it outweighs e.g., black due to *Aspergillus niger* or green after *Penicillium* spp. or *Trichoderma* spp. colonization.

Trichoderma species were the most frequent fungi on spruce roots from forest dieback sites (Schönhar 1992). Stored beech stems are frequently colonized by *Bispora monilioides*, which causes black, radially arranged, elliptical strips on the fresh trunk cross surface.

Molds develop on fresh cuts after tree felling, particularly on the moist sapwood, on inappropriately stored lumber, insufficiently dried and airtight

Fig. 6.2. Molding. **a** Substrate surface with various molds (REM, photo W. Kerner). **b** Molding of insufficiently dried and then plastic-covered paneling

sealed wood, like plastic-coated paneling (Fig. 6.2b), during sea transport of round timber and wood products under deck and in chip piles of pulp industry. Among 427 isolates from stacked yellow-poplar lumber, *Penicillium implicatum* and *Aspergillus versicolor* accounted for 29.7 and 14.5%, respectively (Mikluscak and Dawson-Andoh 2004b).

The hyphae penetrate the wood only a few millimeters and live on parenchyma cells (sugar, starch, protein). In the laboratory, some species degraded isolated pectin, hemicelluloses, and cellulose, but not lignified cell walls. Thus, wood strength properties remain unchanged.

Molded wood is, however, unmarketable. For decorative purpose, e.g., wall paneling (Fig. 6.2b), molded wood is unsuitable, as the color spots are not mechanically removable, but can be only masked by colored paints. Infected wood is not suitable for various hygienic requirements, e.g., packaging material. In addition, technological characteristics, for example the gluing of plywood, can be affected by molds (Wolf and Liese 1977).

Mold growth in buildings is increasingly becoming a problem. Molding in indoor environments (Thörnqvist et al. 1987) is favored by high substrate moisture (water activity 0.9–1.0), high air humidity around 95%, warmth and insufficient ventilation (Viitanen and Ritschkoff 1991b), like in cellars and bathrooms. According to the German standard DIN 4108 part 2, the relative air humidity on the indoor surfaces shall not amount to over 80% (Borsch-Laaks 2005). Moisture with following mold contamination can arise from condensation, flood, and various types of leaks. Excessive insulation after the petroleum crisis has markedly favored condensation areas (cold bridges), from cellars to attics, which rapidly become sites of mold growth. Accompanying lifestyle changes (frequent showers, new cooking methods, inadequate airing of bedrooms) have led increasingly to the production and accumulation of moisture in the home. A study in Belgium of isolated molds in homes of patients with allergic problems showed that more than 90% of those houses were contaminated by molds of the genera *Cladosporium*, *Penicillium* and *Aspergillus* (Nolard 2004). *Cladosporium sphaerospermum* infiltrated 60% of the homes and was responsible for high contaminations, particularly in bedrooms and bathrooms. *Aspergillus versicolor*, *Penicillium chrysogenum*, *P. aurantiogriseum*, *P. spinulosum*, *P. brevicompactum*, *Chaetomium globosum*, *Stachybotrys chartarum*, and *Alternaria alternata* are often found on the walls of bedrooms, living rooms, and kitchens. While *Cladosporium herbarum*, a phytopathogen, does not grow in houses, large numbers of spores enter through windows and doors mainly during the summer months.

Molds may cause health problems. About 200 fungal species produce various mycotoxins (about 100), of which some are highly toxic to humans and animals (mycotoxicoses) (Müller and Loeffler 1992; Schwantes 1996; Reiß 1997; Kiffer and Morelet 2000; Samson et al. 2004). The cancerogenic aflatoxins from *Aspergillus fumigatus* and *A. flavus* in food (agricultural crops, cereals etc, Meister and Springer 2004) are well known. Human health damage can further develop by mycoallergies through direct contact with a fungus or inhaled spores (molds in the living space). Five to 15% of the population suffering from respiratory allergy has been sensitized to one or several molds. Exposure of young children to molds and their metabolites may have a "stimulating" effect on the onset of later allergies (Nolard 2004). Mold allergies also occur in work environments. Woodworkers inhale spores of *Cryptostroma corticale* and *Alternaria* species (woodworker's lung). "Bagassosis" may develop during bagasse processing. "Suberosis" is due to *Penicillium glabrum* growing on cork

bark. Pulpwood handler's disease is caused by *Alternaria* species growing on paper pulp. Farmers inhale spores of *Aspergillus fumigatus* when damp hay is worked. Dustmen and compost makers may be exposed to molds when kitchen waste is stocked in closed containers for too long. Mushroom growers may be exposed to huge quantities of spores released by the basidiomycete they cultivate, and the culture substrate is sometimes contaminated by molds (mushroom grower's disease) (Nolard 2004).

Superficial mycoses occur on mucous membranes (fingernail bed, lips) and profound mycoses after wounding the skin or inner body (ear, eye, lung, blood vessels). Deuteromycetes are also significant in view of immunodepression in cases of transplants and of diminished defense mechanisms of AIDS sufferers.

With regard to indoor environments (Frössel 2003; Hankammer and Lorenz 2003) only a few molds are considered as producers of important toxic compounds which can be released in the environment and which may cause severe health problems (Samson and Hoekstra 2004). These are *Alternaria alternata*, *Aspergillus flavus*, *A. fumigatus*, *A. versicolor*, *Chaetomium globosum*, *Emericella nidulans*, *Memnoniella echinata*, and *Stachybotrys chartarum*, whereby the latter is considered the most important toxic fungus in buildings producing the cytotoxic satratoxins. A questionnaire study among U.S. homebuilders, new homeowners, and real estate agents indicated that overall, respondents did not have a strong understanding of how mold forms in new constructions. Ten percent of homeowners believed that mold was an issue in their neighborhoods while 35% of home builders and 19% of real estate agents believed that this was an issue in the homes they built (Vlosky and Shupe 2004). The aspect of molds on indoor piled chips was treated by Feicht et al. (2002). Air sampling is performed to quantify and identify contamination. Measurement of microbial volatile organic compounds (MVOCs) in houses serves as note for contamination, especially for hidden contaminations (Keller 2002). *Stachybotrys chartarum* and *Chaetomium globosum* emitted ketones and alcohols (Korpi et al. 1999). There are also dogs trained to detect molds by sniffing. For remediation, first of all the cause of the damage (dampness) has to be removed continuingly (Neubrand 2004). In view of allergies, the spores may be taken away. There are primers and paints with prophylactic anti-molding substances, like organic sulfur-nitrogen compounds (thiocarbamate) and organic tin compounds (tributyltin oxide). Yang et al. (2004b) proposed that incorporating tree bark (white spruce), which inhibited mold growth in vitro, into the production of composite boards may increase the resistance of panels to fungi.

Particularly several *Trichoderma* species are antagonistic against other organisms and also destroy (mycoparasitisms) fungal parasites and saprobionts (v. Aufseß 1976; Highley and Ricard 1988; Murmanis et al. 1988; Giron and Morrell 1989; Doi and Yamada 1991; Dumas and Boyonoski 1992; Phillips-Laing et al. 2003).

There are various textbooks and keys to identify molds (e.g., Wang 1990; Kiffer and Morelet 2000; Samson and Hoekstra 2004; Samson et al. 2004).

The attachment of a species to the molds is not always strict. There are over-lappings with blue-stain and soft-rot fungi since fungi traditionally implicated in wood discoloration can cause soft rot if the conditions are suitable (e.g., *Alternaria alternata*, *Cladosporium herbarum*, *Aspergillus fumigatus*) and many soft-rot fungi are highly melanized (e.g., *Phialophora* spp.). That is, a fungus all may show the typical superficial mold growth and is treated in textbooks on molds, but also effected blue stain, or produced weight loss in soft-rot tests (Seehann et al. 1975; Daniel 2003).

6.2
Blue Stain

Blue stain (synonymous sap stain) is a blue, grey or black, radially striped wood discoloration of sapwood, which can be caused by about 100 to 250 (Käärik 1980) fungi belonging to the Ascomycetes and Deuteromycetes. Seifert (1999) and others differentiated three groups of blue-stain fungi: – *Ceratocystis*, *Ophiostoma* and *Ceratocystiopsis* species (Upadhyay 1981; Perry 1991; Gibbs 1999), – black yeasts such as *Hormonema dematioides*, *Aureobasidium pullulans*, *Rhinocladiella atrovirens*, and *Phialophora* species, – dark molds such as *Alternaria alternata*, *Cladosporium sphaerospermum*, and *C. cladosporioides*. Yang (1999) differentiated dark staining fungi, such as *Ophiostoma piliferum* on jack pine, *Ceratocystis minor* on white pine, and *C. coerulescens* on white spruce, and light staining fungi, such as *O. piceae*, *C. adiposa* and *Leptographium* sp. Frequently, like in the *Ophiostoma* species, the teleomorph is a perithecium (Figs. 2.14, 6.3E). Blue stain occurs in conifers, particularly in pine, but also in spruce, fir, and larch, in hardwoods, like beech and birch, and in tropical woods. The stain may be superficial or penetrate deeply into the wood. In heartwood species, only the sapwood discolors, since blue-stain fungi live mainly on the content of the parenchyma cells. Figure 6.3 shows some details of blue stain.

The hyphae are brown colored due to melanin (Zink and Fengel 1989) and relatively thick (Fig. 6.3C). Some species like *A. pullulans* develop dark-brown, thick-walled chlamydospores (Fig. 6.3D). The blue-black color of the wood develops as optical effect due to refraction of light. Hyphae penetrate into stem wood from cross sections or radially through bark fissures and move via the medullary rays. Easily accessible nutrients (sugars, carbohydrates, starch, proteins, fats, extractives) are taken up from the ray parenchyma cells. Xylanase, mannanase, pectinase and amylase have been detected in several blue-stain fungi (Schirp et al. 2003a). From the rays, the hyphae penetrate into the longitudinal tracheids with mechanical pressure through the torus of the bordered

Fig. 6.3. Blue stain in wood. **A** Artificial bluing of pine boards by *Phoma exigua*. **B** Detail.
C Thick, brown hyphae of *P. exigua*. **D** Chlamydospores (photo G. Koch). **E** Perithecia (A,
B, C, E from Schmidt and Huckfeldt 2005), — 5 cm, - - - 5 mm

pits (thin hyphae through the margo) and grow there from cell to cell through
the pits. Because fungi colonize the sapwood tracheids and fibers, components
of the capillary liquid also might be used as nutrients. Although there are
special microhyphae, transpressoria (Fig. 2.5), which can break through the
wood cell wall, probably by physical pressure and/or enzymatic action (Schmid
and Liese 1966; Liese 1970), in most cases the strength properties of wood are
hardly affected. Thus, the occasionally used term "blue rot" is wrong. Some
species however caused some strength loss. Toughness was the property most
seriously affected (Seifert 1999; Schirp et al. 2003b). In most cases, however,
the damage to wood is mainly cosmetic. The damage however affects domestic
and export earnings for the forest industries. For example, *Pinus radiata* in
New Zealand is highly susceptible to blue stain with an estimated annual loss
in revenue of NZ$ 100 million per year (Thwaites et al. 2004).

Temperature minimum depends on the species, and is between 0 and −3 °C;
the optimum is between 18 and 29 °C and the maximum is between 28 and

40 °C. The moisture span reaches from fiber saturation close to u_{max}. In many species, the optimum is between 30 and 120% (Käärik 1980; Schumacher and Schulz 1992). For log colonization, moisture loss in the felled tree of 10–15% is sufficient. Blue stain occurs during seasoning or transportation of green lumber before the wood is dried and is enhanced at relative humidities above 90% (Seifert 1999).

Blue-stain fungi were arranged into different ecological groups (Butin 1995): In blue stain of stems (primary blue stain), spores of *Ophiostoma* species (moisture optimum 50–130%), particularly *Ophiostoma piceae* (Harrington et al. 2001) and also *Discula pinicola* are transferred by wind in bark wounds (forest work or wood transport) as well as by bark beetles particularly in un-debarked pine stems which are allowed to dry out slowly over weeks or months while lying in the forest (Neumüller and Brandstätter 1995). *Hormonema dematioides*, *A. pullulans*, and a *Leptographium* species were the most frequently isolated stain-fungi from bark and sapwood of living *Pinus banksiana* trees. There were indications that none of the well-known log-staining fungi was associated with healthy living jack pine trees, and it was deduced that prompt transportation of logs from forests to sawmills and sanitary treatment of log storage yards helps to reduce the severity of log staining before sawing (Yang 2004). The most aggressive sapstain species on fresh *Pinus contorta* logs was *Ceratocystis coerulescens*, followed consecutively by *Leptographium* spp., *C. minor*, *O. piliferum*, *O. piceae*, *O. setosum*, *C. pluriannulata*, and *A. pullulans* (Fleet et al. 2001). *Discula pinicola* is the main cause of the so-called internal blue stain, which is characterized by a central wood discoloration without any external staining. A comparison of the growth of several blue-stain fungi in freshly cut pine billets has been performed by Uzunović and Webber (1998). The blue-stain fungal composition on *Pinus radiata* logs harvested in New Zealand and shipped to Japan showed differences between summer and winter transport (Thwaites et al. 2004).

Blue stain of sawn timber (secondary blue stain) is caused e.g., by *Cladosporium* species (moisture optimum 50–100%) and *Strasseria geniculata* (Butin 1995) in sawn timber that is not completely dry or badly stacked in timber yards (Schumacher et al. 2003).

The classical distinction in primary and secondary blue-stain fungi was not confirmed however by the frequent occurrence of *D. pinicola* both in stored pine stems and in boards (Schumacher and Schulz 1992). Battens of Sitka spruce were stained by *O. piceae* when the surface moisture content in a stack was 22% or more (Payne et al. 1999).

Tertiary blue stain (moisture optimum 30–80%) results frequently from *A. pullulans* and *Sclerophoma pithyophila* on timber that has been converted into products, was painted and re-imbibe moisture while in service, like wooden façades, window frames, garage doors and garden furniture. Through damages of the coating in window wood e.g., by nails or due to inappropriate

window construction, water is taken up, distributes in the wood and cannot evaporate through the coat layer. Fungi start growing and their mycelia, spore masses or perithecia (Fig. 6.3E) cause the paint layer to flake off with further moisture increase (Sell 1968). Hyphae of *A. pullulans* were able to grow through alkyd paints (Sharpe and Dickinson 1992). Colonization of painted wood by blue-stain fungi was treated by Bardage (1997). Tertiary blue-stain fungi do not originate from infected stems or lumber, but are new infections. Colonized wood shows excessive uptake of solutions, so that spot-shaped color differences develop after painting, similarly like at the excessive uptake caused by bacteria. The isolate *A. pullulans* P 268 is test fungus in the standard EN 152.

Air-borne blue stain means the spread of blue-stain fungi by wind or rain, insect blue stain is due to fungi, which are associated with bark beetles (Solheim 1992).

There are different results in view of blue staining of wood that derives from forest dieback sites. Practical observations and fungal isolations (Schmidt 1985) showed that wood from polluted forest sites was more stained than that from healthy forests. Laboratory experiments however did not show these differences (Liese 1986; Saur et al. 1986). Klepzig et al. (1996) found different interactions of ecologically similar saprogenic fungi with healthy and abiotically stressed trees. Regarding the storage of spruce, pine and beech stems (v. Aufseß 1986; Göttsche-Kühn and Frühwald 1986; Schmidt et al. 1986; Schmidt and Wahl 1987; Nimmann and Knigge 1989) the wood from diseased trees first tended to faster discolorations due to fungal attack. However, after longer storage no relation was found between the state of health of the tree and the damage extent during storage. On the contrary, the stems of healthy trees were even more strongly discolored, since their longer lasting drying period provided for the fungi a longer time favorable growth conditions. Stored planks from damaged pine trees were also slightly less stained than wood from healthy trees (Schumacher and Schulz 1992). Altogether, there are no results justifying the occasionally used term "damage wood".

Incubation of fresh Scots pine sapwood samples with blue-stain fungi increased wood absorptiveness and the wood may show a greater ability to impregnation with water-based preservatives (Fojutowski 2005).

Stained wood is used due its color effects by Swedish woodworkers and was also used to produce attractive violins (Seifert 1999). Corresponding attempts to stain timber artificially did however not yield regular discoloration of the samples (Fig. 6.3A). It is possible to remove the stain from the wood using oxidizing agents such as sodium chlorite or hydrogen peroxide (Seifert 1999).

6.3
Red Streaking

Red-streaking discoloration (known as "Rotstreifigkeit" in Germany) is one of the most common and important damage in seasoning logs and sawn lumber, occurring only in conifers (spruce, pine, fir) and recognized as a distinct condition in continental Europe. The stripe-shaped to spotted yellow to reddish-brown discoloration extends in logs from both their bark-covered faces and from their cut ends (Butin 1995; Baum and Bariska 2002) (Fig. 6.4). Stems that are not debarked show a rather flat discoloration and debarked stems exhibit a streakier staining (v. Pechmann et al. 1967).

Causal agents are several white-rot Basidiomycetes, in spruce particularly *Stereum sanguinolentum* (Kleist and Seehann 1997) and *Amylostereum areolatum*. In south Germany, *Amylostereum chailettii* is common (Zycha and Knopf 1963; v. Pechmann et al. 1967). In pine, red streaking is mainly due to *Trichaptum abietinum* (Butin 1995). According to Kreisel (1961), *S. sanguinolentum* and *T. abietinum* occur often together in stored logs.

Red streaking develops if the wood remains in a semi-moist state over a long period, especially in the warmer season (v. Pechmann et al. 1967). The fungi gain access to the wood through the exposed cut ends and bark fissures. The mycelium reaches its greatest density in the medullary rays, where the fungus uses the primary storage compounds in the ray parenchyma cells. From there, the discoloration spreads axially deeply in the wood, penetrating the bordered pits and also by thin bore hyphae that perforate the tracheids cell wall (Kleist and Seehann 1997; Kleist 2001). Logs may be stained during overseas shipment, and red streaks producing fungi become again active in rewetted boards due to their ability to dryness resistance. The staining is mainly an oxidative process (Butin 1995). Kleist (2001) stated that the fungi involved excrete the pigments.

The moisture optimum of most species lies between 50 and 120% u. Red-streaking fungi are slowly growing white-rot fungi, so that initially no serious strength loss is connected with turning red. During longer colonization however an intensive white rot develops with substantial mass and strength loss, so that red streaking damage represents a transition from discoloration to decay (v. Pechmann et al. 1967; Peredo and Inzunza 1990).

Secondary infections by brown-rot fungi may occur. Red-streaked wood samples were degraded in the lab test more strongly by brown-rot fungi than controls without pre-infection. From reddish discolored fir wood, 26 Basidiomycetes (white and brown rot) and numerous blue-stain and mold fungi were isolated (v. Pechmann et al. 1967). From *Pinus radiata* wood, different molds, blue-stain fungi, *Stereum* sp. and the white-rot fungi *Ganoderma* sp., *Schizophyllum commune* and *Trametes versicolor* were isolated (Peredo and Inzunza 1990). Spruce wood samples from forest dieback sites contained more

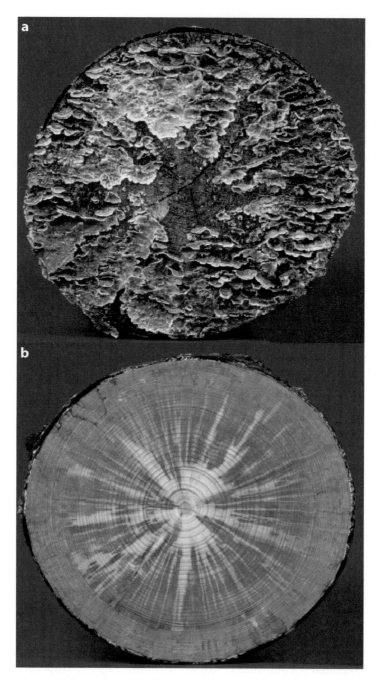

Fig. 6.4. Red-streaking discoloration of spruce wood by *Stereum sanguinolentum*. **a** Fruit bodies of *S. sanguinolentum* on the crosscut stem surface. **b** Wood discoloration some centimeters beneath the surface (photos G. Kleist)

often *A. areolatum* and *S. sanguinolentum* compared to samples from healthy forests (Schmidt et al. 1986).

Stereum sanguinolentum Bleeding Stereum
small, thin, resupinate to semipileate fruit body, soft-leathery-crusty, bowl-shaped, upper surface: felty, concentrically zonate, yellow-brown, whitish-wavy margin (Fig. 6.4a); bright to grey-brown hymenium blood-red after injury; dimitic (Breitenbach and Kränzlin 1986); amphithallic (Calderoni et al. 2003); apart from the saprobic way of life also parasitic after penetration through wounds and thus the most important species of "wound rot of spruce" (Butin 1995); stacked wood not attacked; genus *Stereum* with multiple clamps (Kreisel 1969).

Trichaptum abietinum Fir Polystictus
fruit body: annual, resupinate to semipileate and pileate, singly and roofing tile-like; upper surface: white-grey-brown, thin, felty, hirsute, zonate, leathery; pore surface: young net-shaped to porous, old: labyrinthine; young hymenium reddish with angular violet pores, later brown-violet; dimitic (Breitenbach and Kränzlin 1986); tetrapolar heterothallic (Nobles 1965); saprobic on stumps, stored logs and finished wood; severe white rot at high wood moisture; rarely on living trees (Kreisel 1961).

6.4
Protection

To avoid microbial wood discoloration, the generally suitable measures against fungi (e.g., Liese et al. 1973; Liese and Peek 1987; Groß et al. 1991; Yang and Beauregard 2001) are listed in Table 6.2.

Felling in the cold season and fast processing of the stems through well coordination between forestry and wood industry reduces microbial activity during storage of the stems in the forest. Cool, shady, and ventilated storage without ground contact and with unhurt bark to maintain high wood moisture content and to prevent lateral infections are favorable. Lumber discoloration can be prevented by prompt air-drying in well-ventilated stacks protected against rain by a roof, or by kiln-drying. Wet storage of stemwood by sprinkling or ponding protects against fungi and insects. Currently, stem storage

Table 6.2. Preventive measures to avoid microbial wood discolorations and decay

- felling in the cold season
- appropriate storage of fresh wood
- coordination between forestry and wood industry
- drying
- wet storage
- storage in N_2/CO_2 atmosphere
- chemical preservation

is performed in a N_2/CO_2 atmosphere (Mahler 1992; Bues and Weber 1998; Maier et al. 1999).

During wet storage, however, wood quality may become reduced by degradation of the pits by anaerobic bacteria (Willeitner 1971; Karnop 1972a, 1972b; Adolf et al. 1972; Fig. 5.4), by oxidative discolorations of phenolic compounds diffusing outward (Höster 1974), and by brown discoloration of the outer log parts through phenolics from the bark (Peek and Liese 1987; Bues 1993). Sprinkled stems were even colonized by *Armillaria mellea*, which "drilled" a borehole from the bark into the xylem to provide itself with air and subsequently decayed the wet wood (Metzler 1994).

Discoloring fungi and molds may be rather tolerant towards several fungicides, which inhibit decay fungi. Numerous protective agents were investigated for their effectiveness against mold and blue-stain fungi: e.g., Karstedt et al. (1971), Wolf and Liese (1977), Nunes et al. (1991), Laks et al. (1993), Wakeling et al. (1993), and Suzuki et al. (1996). Sodium pentachlorophenate (PCP-Na) had been used for dipping and spraying procedures against discoloration and decay (Willeitner et al. 1986). In view of the negative impact on humans, animals, plants, and the environment, utilization of PCP and import of PCP-treated woods are however restricted in Germany due to contaminations of PCP with polychlorinated dibenzodioxines and dibenzofuranes as well as due to the development and release of these compounds during burning of PCP containing woods. Dependent of material and intended purpose, e.g., boron compounds, quaternary ammonium compounds or dithiocarbamates may be used (Chap. 7.4). Solid wood, wood composites (Gardner et al. 2003), and gypsum wallboard treated with borate were tested for mold performance (Fogel and Lloyd 2002). Boron compounds were used against blue-stain in Norway spruce (Babuder et al. 2004) and rubber wood (Akhter 2005). Against discolorations of drying oakwood by *Paecilomyces variotii*, treatment of the fresh wood with 5–10% propionic acid was recommended (Bauch et al. 1991). Growth of molds and bacteria during the outdoor storage of sugarcane bagasse on Trinidad that is used there for the production of fiberboards was reduced by organic sulfur compounds and propionic acid (Liese and Walter 1980).

Although blue-stain fungi do not reduce wood quality significantly, discoloration is considered as substantial damage and is a perpetual problem of round wood and timber. Despite felling during the cold season as well as using ventilated stacking of the lumber, damage nevertheless occurs by blue-stain fungi. A two-year experiment with pine wood using different felling times and storage variations showed that damage of the round timber might be reduced and that rapid timber seasoning has the greatest influence (Schumacher and Schulz 1992).

Un unsolved problem is the discoloration of bright tropical woods, like *Pycnanthus*, *Virola*, *Aningeria* and *Pterygota* (Bauch et al. 1985), after felling and during shipment and drying of the sawn timber (Karstedt et al. 1971;

Fougerousse 1985). Discolorations result from oxidative reactions of accessory compounds with atmospheric oxygen and phenol oxidases (e.g., Neger 1911; Oldham and Wilcox 1981), from chemical reactions of wood contents with metals [iron, zinc: e.g., Bauch (1984)], or from microorganisms, particularly blue-stain fungi, and in some woods, like Ilomba, from "combined influences" [bacterial pH-change and subsequent chemical reactions (Bauch 1986; see Fig. 5.5, Table 6.1)]. The practical processing of wood preservation in the tropics against discolorations and decay is summarized by Willeitner and Liese (1992) (also Findlay 1985).

Comprehensive investigations on red streaks producing fungi, their reduction of wood quality and on suitable storage are described by v. Pechmann et al. (1967). Since fungal damage is usually only superficial in the first months, deeper discolorations can be limited to a practically insignificant extent, if the log does not remain in the forest in the warm season longer than some months. The wet to moist condition of the wood should rapidly run through either by suitable forest storage (no ground contact, ventilated, shady), or a high moisture content should be maintained in the sapwood by an unhurt bark.

Attempts of a "biological wood protection" by antagonism are described in Chap. 3.8.1.

To prevent enzyme-mediated, non-microbial sapwood discolorations such as sticker stain in ash or grey stain in oak, logs were treated with fumigants to kill living parenchyma cells (Amburgey et al. 1996; also Schmidt et al. 1997b; cf. Chap. 8.1.2.2).

7 Wood Rot

There are three types of fungal wood rot: brown, white, and soft rot (see Figs. 7.1–7.4). Further terms are either older names (e.g., destruction rot = brown rot), specifications (red rot = white rot by *Heterobasidion annosum*) or terms used in practice (marble rot = white rot with black demarcation lines) or false names (blue rot = blue stain). According to the classical school of thought a fungal species causes only one type of decay, and species causing different rots shall not be grouped in the same genus [e.g.: *Lentinus lepideus*: brown rot; *Lentinula* (in former times *Lentinus*) *edodes*: white rot].

Regarding the delineation between the three decay types, there are, however, exceptions: The brown-rot fungus *Coniophora puteana* produced cavities to be typical of soft-rot fungi and erosion and thinning of the cell wall to be characteristic of white-rot fungi (Kleist and Schmitt 2001; Lee et al. 2004). *Fistulina hepatica* revealed the soft-rot mode in cell walls rich in syringyl lignin, whereas brown rot was associated with cells rich in guaiacyl lignin (Schwarze et al. 2000). Several white-rot Basidiomycetes like *Phellinus pini* (Liese and Schmid 1966) as well as *Inonotus hispidus* and *Meripilus giganteus* caused cavities (Schwarze and Fink 1998; Schwarze et al. 1995a), which differed between the host trees, cell type, and location in the annual ring. Cavities in the secondary wall of fibers and tracheids were also found to be caused by two *Armillaria* species as well as by *Stereum sanguinolentum, Ganoderma applanatum,* and *Grifola frondosa* (Schwarze and Engels 1998). It was hypothesized that soft-rotting activity of white-rot Basidiomycetes may commonly precede white rotting when the fungus invades previously uninfected zones in the xylem, in which moisture content is high. Delignification of Norway spruce tracheids by *Stereum sanguinolentum* was associated with the presence of radial and concentric clefts containing cell wall entities in the secondary wall (Schwarze and Fink 1999) supporting observations of a radial and concentric arrangement of cell wall constituents within the S_2 (Sell and Zimmermann 1993).

7.1
Brown Rot

Brown rot is caused by Basidiomycetes, which metabolize the carbohydrates cellulose and hemicelluloses of the woody cell wall by non-enzymatic and

enzymatic action and leave the lignin almost unaltered (Fig. 7.1A; Chap. 4), whereby the brown color develops.

Brown-rot fungi do not produce lignin-degrading enzymes. There are however reports of lignin peroxidase and manganese peroxidase in some brown-rot fungi, and lignin loss or metabolization by brown-rot fungi have been reported. Particularly in later stages of decay, the highly lignified middle lamella/primary walls were observed to undergo attack. Also, the penetration of the wood cell wall by bore holes removes lignin in the process, all suggesting that low molecular weight lignin degrading agents and potentially even lignin degrading enzymes max occur in some brown-rot fungi, at least with localized activity (Goodell 2003). Laccase activity was also found in *Coniophora puteana* (Lee

Fig. 7.1. Brown rot. **A** Cubic crack. **B** Wood cell wall showing remaining lignin after carbohydrate degradation (TEM, photo W. Liese). **C** Brown cubical rot by *Oligoporus amarus*. *MP* middle lamella/primary walls, *S* secondary wall, *L* lumen

et al. 2004), and in *Gloeophyllum trabeum* and *Oligoporus placenta* (Goodell 2003). Non-enzymatic, low molecular agents produced by the brown-rot fungi are responsible for initial stages of cell wall attack (Goodell 2003; Chap. 4).

Of about 1,700 wood-degrading Basidiomycetes in North America, only 120 species (7%) caused brown rot, and of these 79 (65%) were polypores (Eriksson et al. 1990; Ryvarden and Gilbertson 1993). White-rot fungi distribute broader over the different basidiomycetous groups and some belong to the Ascomycetes (Rayner and Boddy 1988). Most brown-rot fungi affect conifers (Ryvarden and Gilbertson 1993), while white-rot fungi occur more frequently on hardwoods. Brown rot occurs in standing trees, felled and processed wood as well as in sapwood and heartwood. In the northern hemisphere, the majority of timber used in construction is from conifers. Thus, a large part of wood in outdoor and indoor service is destructed due to the action of brown-rot fungi. Brown rot is usually uniformly distributed over the substrate. A brown cubical pocket rot is caused by *Laurelia taxodii* in cypress and by *Oligoporus amarus* (Fig. 7.1C) in incense cedar. Decay pockets are localized and surrounded by firm wood (Zabel and Morrell 1992). A woody substrate both may show brown rot and white rot; a standing tree of *Picea engelmannii* exhibited "white pocket rot" by *Phellinus pini* in the heartwood (Chap. 8.3.8), and after wind throw the healthy areas became brown-rotten (Blanchette 1983). Brown-rot wood debris is extremely stable due to its content of slightly modified lignin and has remained unaltered in the soil for centuries. In conifers forests, this humic material may comprise up to 30 vol% in the upper layers (Swift 1982; Ryvarden and Gilbertson 1993). Table 7.1 lists some important brown rot.

Table 7.1. Some common brown-rot fungi

Fungus	Predominant occurrence				
	standing tree	timber outdoors	timber indoors	softwood	hardwood
Laetiporus sulphureus	×				×
Phaeolus schweinitzii	×			×	
Piptoporus betulinus	×				×
Sparassis crispa	×			×	
Gloeophyllum spp.		×		×	
Daedalea quercina		×			×
Lentinus lepideus		×		×	
Paxillus panuoides		×		×	
Antrodia spp.			×	×	
Coniophora spp.			×	×	
Serpula lacrymans			×	×	
Meruliporia incrassata			×	×	×

Brown-rot fungi colonize the wood via the rays and spread in the longitudinal tissue through pits and by means of microhyphae. They grow inside the cell lumina (Fig. 7.1B) and there in close contact with the tertiary wall. The low-molecular agents and/or the cellulolytic enzymes penetrate through the relatively resistant tertiary wall (high lignin content) and diffuse into the secondary wall, where they degrade the carbohydrates completely (Fig. 7.1). Typically, brown-rot fungi do not cause lysis zones around their hyphae, while this is characteristic of many white-rot fungi. The hyphae are surrounded by slime layers (Table 2.1).

In the early stages of decay, the carbohydrates are rapidly depolymerized. In *Serpula lacrymans*, the compression strength is decreased by 45% at only 10% mass loss (Liese and Stamer 1934). Hemicellulose degradation runs up to about 20% mass loss faster than the respiration of the cleaving products. The relative lignin content increases parallel to carbohydrate degradation, the absolute lignin content slightly decreases. Due to the rapid cellulose depolymerization, the dimensional stability particularly decreases. The wood breaks up into rectangular blocks if it shrinks by drying (Fig. 7.1A), which led to the former term "destruction rot". In some older literature, brown rot is falsely named as "red rot", which however means the typical white-rot caused by *Heterobasidion annosum*. In advanced decay, brown-rotten wood can be crushed with one's fingers to a brown powder ("lignin"). "House rot" means decay inside buildings, mostly by brown-rot fungi, particularly by *Serpula lacrymans*, *Meruliporia incrassata*, *Coniophora* species, *Antrodia* species, *Donkioporia expansa* (white rot) and *Gloeophyllum* species. There are further about 60 more rarely indoor occurring fungi (Table 8.6).

7.2
White Rot

White-rot research has been reviewed by Ericksson et al. (1990) and Messner et al. (2003). White rot means the degradation of cellulose, hemicelluloses, and lignin usually by Basidiomycetes and rarely by Ascomycetes, e.g., *Kretzschmaria deusta* and *Xylaria hypoxylon*. White rot has been classified by macroscopic characteristics into white-pocket, white-mottled, and white-stringy, the different types being affected by the fungal species, wood species, and ecological conditions. From microscopic and ultrastructural investigations, two main types of white rot have been distinguished (Liese 1970).

In the simultaneous white rot ("corrosion rot"), carbohydrates and lignin are almost uniformly degraded at the same time and at a similar rate during all decay stages. Typical fungi with simultaneous white rot are *Fomes fomentarius*, *Phellinus igniarius*, *Phellinus robustus*, and *Trametes versicolor* in standing trees and stored hardwoods (Blanchette 1984a). Wood decayed by *F. fomen-*

tarius, T. versicolor and some other fungi shows black demarcation lines (zone lines) (Fig. 7.2a), by which different species, or incompatible mycelia of the same species separate themselves from each other, or mycelia dissociate themselves from not yet colonized wood ("marble rot", in German: "Marmorfäule"). The lines result from fungal phenol oxidases, whereby fungal compounds or also host-own substances are transformed to melanin (Li 1981; Butin 1995). As a function of the moisture distribution in wood, or between different fungal species or incompatible genotypes, a compartmentalization of individual decay centers can result from black pseudosclerotic layers of firmly structured mycelium (Rayner and Boddy 1988; Eriksson et al. 1990).

Cell wall decay can start by microhyphae producing holes in the secondary wall (Schmid and Liese 1966), which flow together to larger wall openings with advancing decay. Usually, however, the hyphae grow inside the lumen with close contact to the tertiary wall. The hypha surrounded by a slime layer (Table 2.1) excretes the degrading agents, which are active only in direct proximity of the hypha. Thus, a lysis zone develops under the hypha, and the hypha produces grooves in the wall which is gradually reduced in thickness, like a river erodes the ground (Schmid and Liese 1964; Liese 1970; Fig. 7.2b).

Fig. 7.2. White rot. **a** Simultaneous white rot by *Trametes versicolor* in beech wood with black demarcation lines. **b** Clamped hypha of *T. versicolor* digging into the cell wall (TEM, from Schmid and Liese 1964). **c** Successive white rot by *Ganoderma adspersum* in the Chilean "palo podrido" (photo J. Grinbergs). **d** White pocket rot (photo W. Liese)

In the successive (sequential) white rot, e.g., by *Heterobasidion annosum* (root rot in spruce), *Xylobolus frustulatus* ("Rebhuhnfäule" in standing and felled oaks: Otjen and Blanchette 1984, 1985), or in the Chilean "palo podrido" (Fig. 7.2c), lignin and hemicelluloses degradation run faster at least in early stages of attack, so that first cellulose relatively enriches. Further fungi showing successive white rot are e.g., *Ceriporiopsis subvermispora*, *Dichomitus squalens*, *Inonotus dryophilus*, and *Merulius tremellosus*. Frequently, e.g., by *Phellinus pini* (Liese 1970) in the heartwood of living conifers as well as by *Bjerkandera adusta* and some other fungi (Blanchette 1984a; Otjen et al. 1987), there are small, elongated cavities within a wood tissue, where the lignin and also the hemicelluloses are "selectively" (preferentially) degraded ("selective white rot", "selective delignification", preferential white rot). The greatest part of the cellulose remains. These decayed regions are surrounded by tissue that appears sound (white pocket rot, honeycomb rot; Fig. 7.2d). With advancing decay, the wood becomes fibrous in texture by the decay of the more lignified middle lamella/primary wall area. Some *Ganoderma* species caused within a wood tissue as well white pocket rot as simultaneous rot, or, depending on the wood species, white pocket rot in birch and oak and simultaneous rot in poplar (Blanchette 1984a; Dill and Kraepelin 1986; Otjen and Blanchette 1986).

The terms "selective white rot" and "selective delignification" have been propagated in the period of biopulping research (Chap. 9.3) as these terms promise more experimental success than would do names like successive white rot. As in most cases of "selective white rot" and particularly in late stages of attack, cellulose is also degraded to some extent, the term "preferential delignification" should be used.

Many white-rot fungi, e.g., *Heterobasidion annosum* (Hartig 1874), *Fomes fomentarius*, *Ganoderma* species, and *Trametes versicolor* cause black spots of manganese dioxide deposits in the attacked wood (Blanchette 1984b; Erickson et al. 1990; Daniel and Bergman 1997). Manganese deposits may occur in connection with lignin degradation by manganese peroxidase. *Physisporinus vitreus*, isolated from cooling-tower wood (Schmidt et al. 1996) exhibited these manganese deposits predominantly in the slime layer and in the inner S_2 beneath a hypha shown by TEM/EDX spectra (Fig. 7.3B).

White-rot fungi attack predominantly hardwoods, either as pioneer organisms or later in the context of a succession. As conifers are the main timbers used in the northern hemisphere for constructions, white-rot fungi occur there rarely in buildings. In Table 7.2, some important white-rot fungi are specified.

In all white rot types, the wood strength properties are reduced to a lesser extent than in brown-rotten wood, since at the same mass loss, lesser cellulose is consumed, and it does not come to cracking or cubical rot. In a very late stage of attack, a wood mass loss of 97% has been measured.

Fig. 7.3. Manganese deposits occurring during decay of a Scots pine sapwood block by *Physisporinus vitreus*. **A** Wood sample with black manganese deposits after culture (from Schmidt et al. 1996). **B** TEM-micrograph showing electron-dense material in the hyphal slime layer (*c*) and the secondary wall (*b*). **C** TEM/EDX spectra of manganese and other elements in different areas of the attacked wood (see **B**). *a* control from a healthy area within the S₂, *b* spectrum from the S₂ beneath a hypha, *c* spectrum from dense deposit material within the hyphal slime layer. The copper peaks result from the metal grids. (from Schmidt et al. 1997a)

Table 7.2. Some common white-rot fungi

Fungus	Predominant occurrence			
	standing tree	timber outdoors	softwood	hardwood
Armillaria mellea	×		×	×
Donkioporia expansa		indoor	×	×
Fomes fomentarius	×			×
Heterobasidion annosum	×		×	
Meripilus giganteus	×			×
Phellinus pini	×		×	
Polyporus squamosus	×			×
Schizophyllum commune		×		×
Stereum sanguinolentum	×	×	×	
Trametes versicolor		×		×

7.3
Soft Rot

The term "soft rot" was originally used by Findlay and Savory (1954) to describe a specific type of wood decay caused by Ascomycetes and Deuteromycetes which typically produce chains of cavities within the S_2 layer of soft- and hardwoods in terrestrial and aquatic environments (Liese 1955), for example when the wood-fill (Fig. 7.4a) in cooling towers became destroyed despite water saturation, and when poles broke, although they were protected against Basidiomycetes. About 300 species (Seehann et al. 1975) to some 1,600 examples of ascomycete and deuteromycete fungi (Eaton and Hale 1993) cause soft rot, e.g., *Chaetomium globosum* (Takahashi 1978), *Humicola* spp., *Lecythophora hoffmannii*, *Monodictys putredinis*, *Paecilomyces* spp., and *Thielavia terrestris*.

Soft-rot fungi differ from brown-rot and white-rot Basidiomycetes by growing mainly inside the woody cell wall (Fig. 7.4b). The wood is colonized via the wood rays. In conifers, the fungi penetrate, starting from the tracheidal lumina, by means of thin perforation hyphae of less than 0.5 μm thickness into the tertiary wall and re-orientate then as thin hyphae after L-bending in one direction or after T-branching in both directions along the microfibrils in the secondary wall (soft rot type 1, Nilsson 1976).

In longitudinal wood sections, hyphal activity is recognizable in the polarized light by rhombus-shaped cavities in the secondary wall of different size and arrangement (Levy 1966; Butcher 1975), which may be lined up like a string of pearls (Fig. 7.4c): The thin hypha stops its growth and the cavity is then developed around the hypha by the release of enzymes (putatively endoglucanases) along what is described as the proboscis hypha. Within the cavity, hyphal thickness increases to about 5 μm. From the tip of the cavity, the next fine hypha starts its growth, which results in the next cavity, and continuous

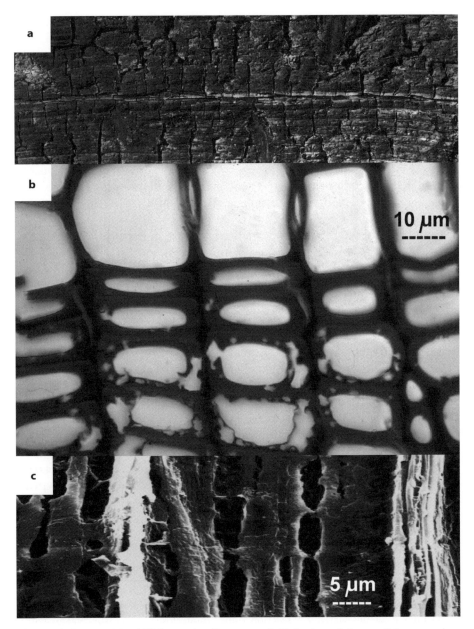

Fig. 7.4. Soft rot. a Woodfill from a cooling tower. **b** Hole-shaped decay of the secondary walls in latewood tracheids of pine sapwood (LM, photo M. Rütze). **c** Cavities inside a fiber (LM, photo by W. Liese)

enlargement of existing cavities and the formation of new cavities lead to total destruction of the S_2 layer (Eriksson et al. 1990; Daniel 2003). SEM and TEM showed that the hyphae are normally associated with a variety of granular and fibrillar materials including extracellular slime (Table 2.1), melanin and lignin breakdown products. In *Lecythophora mutabilis*, CCA was concentrated in the granular material (Daniel 2003). Several causes are discussed for oscillating hyphal growth and cavity formation (Table 7.3).

In cross sections, the cavities appear hole-shaped ("initial stage") and increase with advancing decay to larger wall openings (Fig. 7.4b). Finally, it comes to circular detaching of the tertiary wall ("advanced stage"). Because of their high lignin content, the tertiary and primary walls are attacked in the end ("late stage"). It remains an incomplete skeleton of middle lamella/primary walls ("destruction stage").

In the soft rot type 2, which particularly occurs in hardwood (Zabel et al. 1991), the hyphae erode particularly from the lumen the tertiary wall and penetrate till the middle lamella/primary wall. As rare variant, diffuse and irregular cavities in the secondary wall were described (Anagnost et al. 1994). Soft rot develops also in monocotyledons (bamboos: Liese 1959; Sulaiman and Murphy 1992). In a broader definition for soft rot, each significant fungal decay of the woody cell wall by non-basidiomycete fungi was suggested, which however contrasts to the white-rot causing Ascomycetes.

Since the tertiary and middle lamella/primary wall are resistant over longer time against fungal attack due to stronger lignification (Fig. 7.4b), wood with soft rot frequently first will not be recognized with the naked eye. Also with the "hammer test" it does not result in the hollow sound of decayed wood (Liese 1959), so that in former times during repair work of poles accidents arose several times by pole breaks due to the unawareness of the officials. Soft rot penetrates slowly from the outside to the wood center. Moist wood is dark colored and the surface is soft. Although softening of wet wood is typical, attacked CCA treated timber has shown degraded wood to be hard. The dry wood shows cubical rot with a fine-cracked, charcoal-like surface (Fig. 7.4a).

Table 7.3. Possible factors involved in cavity formation by soft-rot fungi

- chemical and morphological structure of the wood cell wall (Liese 1964)
- accumulation of toxic phenolic substances from lignin degradation (Liese 1970)
- oscillating cellulase activity as reaction to the produced sugars (Nilsson 1974)
- unequally distributed chemical factor of the carbohydrates in the cell wall (Nilsson 1982)
- composition and distribution of lignin in the cell wall
- nutrients obtained by cavity formation allowing only limited growth of a hypha
- small channel between two cavities due to intense enzyme production at the hyphal apex and less enzyme production at the hyphal basis (Eriksson et al. 1990)

Further infection symptoms are the blunt fracture and short-fibrous breaking out of splinters when puncturing.

Within the cell wall, soft-rot fungi degrade cellulose and hemicelluloses. Compared to the brown-rot fungi the cellulolytic agents diffuse, however, not so deep into the cell wall, but remain in direct proximity of the hyphae (Liese 1964). Lignin is not (or little) attacked at least in the initial stage, mainly by demethylation, so that soft rot with regard to the decay type resembles brown rot. Isolated lignins and DHP's are not demethylated. In lignin model compounds, the β-O4 linkage and the aromatic ring were cleaved (Eriksson et al. 1990; also Bauch et al. 1976).

The inhibiting effect of lignin was demonstrated by the result that a delignifying pretreatment promoted the carbohydrate degradation (Zainal 1976). Wood decay by soft-rot fungi is further affected by the quantity and type of the lignin: Lignin-rich softwood with lignin predominantly made of coniferyl units is more resistant than the lignin-poorer hardwood made of sinapyl-coniferyl units (Nilsson et al. 1988; Eriksson et al. 1990). In conifers, wood decay occurs preferentially in the late wood (Fig. 7.4b) with its relative low lignin and high cellulose content.

Due to the intensive carbohydrate degradation, soft-rot fungi, just like brown-rot fungi, already cause about 50% decrease of impact bending at only 5% mass loss, and cracks occur by the reduction of the dimensional stability.

Soft rot develops in trees, stored wood, and in outside used wood. Soft-rot fungi can decay wood under extreme ecological conditions, which are unsuitable for Basidiomycetes: constantly wet wood till almost water saturation, like in harbor constructions and ships, but not permanently submerged, as well as wood in soil contact, like poles, piles, sleepers (Liese 1959). Several soft-rot fungi were found on rotting branches (Butin and Kowalski 1992). Soft-rot fungi (and Basidiomycetes) under marine conditions were described by Kohlmeyer (1977), Leightley and Eaton (1980) and Troya et al. (1991). The wood moisture tolerance of the fungi reaches from dryness resistance to decay at almost water saturation. For example, *Chaetomium globosum* and *Paecilomyces* spp. did not show any inhibition of their decay ability in beech wood samples of 200% wood moisture content (Liese and Ammer 1964). With altogether relatively low oxygen demand, soft-rot fungi receive the necessary oxygen for the decay of water-saturated wood in cooling towers by the sprinkling effect of the water, which brings oxygen in solution. Thermophilic species and those with the ability of heat resistance destroy wood in the inner of wood chip piles (Hajny 1966; Smith 1975). *Chaetomium globosum* can start growing in nutrient solutions with initial pH values from 3 to 11. Some soft-rot fungi decay woods with high natural durability, like Bongossi or Teak. After 21 years of outdoor exposure in soil, the heartwood of several hardwoods exhibited soft rot in about three-quarters of all the samples, about one-quarter white rot and only 3% brown rot (Johnson and Thornton 1991). Soft-rot fungi are tolerant to chrome fluo-

rine salts, which inhibit brown and white-rot fungi, but are sensitive to copper (Chap. 7.4). Wood in soil contact must therefore be treated with a preservative that contains copper if coal tar oil is not applied. Large economic losses developed nevertheless in Australia when hundreds of thousands of eucalyptus poles, which were treated with chrome copper arsenic, prematurely failed by soft rot due to unequal preservative distribution in the wood (Dickinson et al. 1976; Liese and Peters 1977; Greaves and Nilsson 1982). Several soft-rot fungi were isolated from CCA treated (Zabel et al. 1991; Wong et al. 1992) and coal tar oil-impregnated poles (Lopez et al. 1990; Dickinson et al. 1992).

7.4
Protection

This chapter focuses on fundamentals upon prevention of wood damage by fungi, and protection and preservation of wood (e.g., Willeitner and Liese 1992; Eaton and Hale 1993; Palfreyman et al. 1996; Murphy and Dickinson 1997; Zujest 2003; Goodell et al. 2003; Müller 2005). Protection in the broader sense comprises non-chemical methods like organizational measures and measures by design, use of naturally durable woods, application of antagonisms, or wood modifications that do not affect the environment. Preservation predominantly stands for chemical measures.

Table 7.4 shows the conditions for the development of wood fungi and protection principles that can be deduced from them.

The principle of the wood protection consists of changing at least one of the three life prerequisites of fungi in wood in such a way that the development of fungi is impossible or at least inhibited. Fungal attack can be prevented

Table 7.4. Prerequisites for the development of wood fungi and principles of protection deduced from them (supplemented from Willeitner and Schwab 1981)

Prerequisite	Preventive measure	Protection principle
Suitable moisture	Reduce, keep away	Timber drying, constructional wood protection, wood modification
Suitable food	Make inedible	Use of durable wood, chemical wood preservation, wood modification, (use of antagonisms)
Sufficient oxygen	Keep away	Drying, wet storage, storage in CO_2/N_2 atmosphere, use below the water level

(Willeitner and Schwab 1981; Erler 2002; Willeitner 2000, 2003; Goodell et al. 2003; Böttcher 2005; Borsch-Laaks 2005; Schmidt 2005) by:

- organizational protection (e.g., short and appropriate wood storage),
- use of durable wood species (natural methods),
- keeping away water by structural wood protection measures by design: appropriate surface and weather protection, use of vapor barriers, avoidance of condensation due to thermal insulations, salient roof to protect timber from rain, drawing off of rain, barrier to avoid direct contact between wood and adjacent material, or inside the wall against raise of moisture from the ground,
- chemical wood preservation,
- wood modifications that increase dimensional stability of wood, reduce uptake of moisture, or make it hard to digest,
- use of antagonisms.

The moisture conditions in wood are of decisive importance for the development of wood fungi (Chap. 3.3). Table 7.5 shows the hazard classes of wood [to be replaced by "use classes" according to prEN 335-1 (2004) respectively ISO] that depend on wood use and timber moisture according to the German standard DIN 68800, parts 2 and 3 (1990, 1996), the corresponding potential application of durable timber, and the minimum requirements of chemical preservation measures.

Natural durability means the wood-own resistance against bacteria, wood-decay fungi, beetles, termites and marine borers, which will differ for a timber species against the various organisms. Wood durability is based on the presence of accessory compounds, whereby it concerns numerous compounds from different chemical classes (Fengel and Wegener 1989; Obst 1998). They are produced in the living tree during transition from the sapwood to the heartwood and are deposited in the heartwood (Taylor et al. 2002). Thus only the heartwood exhibits natural durability, while the sapwood of all wood species is only little or not durable. The European standard EN 350-2 (1994) uses a five-class system to group 128 timbers according to their durability against fungi. Wood with high durability against fungi (durability class 1, very durable) is e.g., greenheart (durable also against termites and marine organisms). European oak is durable (class 2), walnut is moderately durable (class 3), Norway spruce is slightly durable (class 4), and European beech not durable (class 5) (also Augusta and Rapp 2003, 2005; Willeitner 2005a). Natural durability of some bamboo species against four decay fungi was investigated by Remadevi et al. (2005).

The influence of the felling time on resistance is controversially discussed. It has to be considered that fresh winter-felled wood is less susceptible to damage due to other moisture, drying, and climatic conditions than wood felled in the summer. There are however no differences if the wood is carefully dried (Willeitner 2005a).

Table 7.5. Hazard classes of timber, conditions for wood use, resistant wood species, and chemical preservation measure

Hazard class	condition for wood use	durable wood	minimum preservative measure
0	indoors, if wood moisture ≤ 12%, timber open at 3 sides or coating against insects		none
1	indoors air humidity ≤ 70%, wood moisture < 20%	colored heartwoods sapwood proportion < 10%	prevention of insects
2	indoors: air humidity > 70% in wet areas: water-repellent coating outdoors: without weathering	colored heartwoods of durability class 1, 2 or 3	prevention of fungi and insects
3	outdoors: weathered without permanent ground or water contact indoors: wet rooms	colored heartwoods of durability class 1 and 2	prevention of fungi and insects, weatherproof
4	permanent ground or fresh water contact, special prerequisites for cooling towers and marine timber	colored heartwoods of durability class 1	prevention of fungi and insects, weatherproof, prevention of soft-rot fungi

There is still a worldwide spread superstition that wood properties like resistance against fungi depend on the moon. The wood of trees felled at a certain date related to the moon phase is thought not to swell nor shrink, to be incombustible, resistant to fungi and insects, and to become very hard. Those oscillating changes of the properties of the woody tissue, which mainly consists of dead fiber or tracheid cell walls, are biologically impossible. Thus, all specifications are in contradiction to scientifically based results (Ważny and Krajewski 1984; Seeling 2000; bamboo: Yamamoto et al. 2005). The positive effects of a certain felling date observed in the practice may be due to other influences: People which believe in lunar influences select in the forest well-grown trees, use appropriate drying, storage methods and wood design, that is, the wood, its processing and use are of high quality and thus the wood is more resistant to deterioration.

There are several standards to determine the resistance of untreated wood and wood-based composites against fungi and also to test the efficacy of

preservatives. In Europe, the standards are ruled by the European Committee for Standardization (Table 7.6; Willeitner 2005b).

Figure 7.5 shows a Kolle flask that is used according to the European standard EN 113 to determine the toxic values of wood preservatives against wood-destroying Basidiomycetes cultured on agar medium. The method can be also used to test the natural durability of timber species etc.

Chemical wood preservation is used, if structural-constructive measures, or natural durability, or wood modifications alone are insufficient for an increased wood endangering to meet the requirement of long-term use of wood. Not durable wood species or those of insufficient durability and the sapwood of all wood species can be made resistant for a long time against damage by treatment with appropriate wood preservatives, provided that the wood shows permeability. Prerequisite is, corresponding to the wood use, to bring effective formulations in sufficient amount deeply into the wood (Schoknecht and Bergmann 2000) using appropriate methods (Willeitner and Schwab 1981;

Table 7.6. European standards that deal with resistance and preservation of wood against fungi

EN 335 (1992/95) Durability of wood and wood-based products; Definition of hazard classes of biological attack (3 parts)

EN 350 (1994, 2 parts), EN 460 (1994) Durability of wood and wood-based products – Natural durability of solid wood

ENV 12038 (1996) Durability of wood and wood-based products – Wood-based panels

ENV 12404 (1997) Durability of wood and wood-based products – Assessment of the effectiveness of a masonry fungicide to prevent growth into wood of Dry rot *Serpula lacrymans* (Schumacher ex Fries) F.S. Grey

EN 113 (1996) Determination of toxic values of wood preservatives against wood destroying Basidiomycetes cultured on agar medium

EN 152 (1989) Test methods for wood preservatives; Laboratory method for determining the protective effectiveness of a preservative treatment against blue stain in service (2 parts)

EN 252 (1990) Field test method for determining the relative protective effectiveness of a wood preservative in ground contact

EN 330 (1993) Wood preservatives; Field test for determining the relative protective effectiveness of a wood preservative for use under a coating and exposed out of ground contact: L-joint method

ENV (prestandard) 807 (2001) Wood preservatives – Determination of the effectiveness against soft rotting micro-fungi and other soil-inhabiting micro-organisms

ENV 839 (2002) Wood preservatives – Determination of the effectiveness against wood destroying Basidiomycetes – Application by surface treatment

ENV 12037 (1996) Wood preservatives – Field test method for determining the relative protective effectiveness of a wood preservative exposed out of ground contact

Fig. 7.5. Kolle flask according to EN 113 to determine the toxic values of wood preservatives against wood-destroying Basidiomycetes cultured on agar medium. *a* Non-impregnated control. *b* Impregnated sample

Tables 7.9, 7.10). It is distinguished between "preventive wood preservation" (Kleist 2005) and "controlling wood preservation" after a damage (Sallmann 2005).

There are different national regulations with regard to testing, approval, application and toxicological aspects of chemical wood preservatives. Thus, the following only describes the German situation (Fischer 2005; Reifenstein 2005).

The official approval of wood preservatives used for load-bearing construction takes place by the "Deutsches Institut für Bautechnik (DIBt)", which evaluates the results of tests that had been performed in view of minimum requirements (efficacy, no unfavorable side effects). The Federal Institute for Risk Assessment (BfR) evaluates hygienic-toxicologic aspects of the preservative and the Federal Environmental Office (UBA) its ecotoxicologic behavior. Preservatives with approval obtain a general national approval by the DIBt. Important characteristics of a wood preservative are described by test ratings (Table 7.7).

About 95% of the mainly professionally used preservation salts possess the DIBt approval (23% share of the market), while only 10% of the predominantly solvent-based preservatives that are used by do-it-yourselfers have been previously proven by neutral boards.

Wood preservatives for non-load-bearing constructions can receive a quality mark by the RAL Quality Community of Wood Preservatives, including an evaluation by BfR and UBA.

For blue stain-preventing preservatives for timber outdoors without ground contact including windows and outside joinery, a registration process concern-

Table 7.7. Test ratings of wood preservatives in view of efficacy

P	prevention of fungi
Iv	prevention of insects
Ib	control of insects
W	for weathered wood without permanent soil or water contact
E	for wood in permanent soil or water contact or with dirt deposits in joints
M	prevention of *Serpula lacrymans* to grow through brickwork

ing efficacy and toxicology is possible by the German Association of Varnish Industry (VdL) on a voluntary basis.

All wood preservatives with DIBt approval, RAL quality mark, and the VdL-blue stain preventing preservatives are listed and specified by the active components in the annual wood preservative register (Deutsches Institut für Bautechnik 2005; Table 7.8). There is also a consumer guide on wood preservatives by the German Federal Ministry of Consumer Protection, Food and Agriculture (2003).

Water-based boron salts without chromate are only suitable for inside use due to their leachability (Peylo and Willeitner 1995, 2001). Wood preservatives based on protein borates greatly retarded the leaching of boron from treated timber (Thevenon et al. 1998). In chromate-containing salt mixtures, the biocides are fixed to the wood tissue (Bull 2001). By the fixation process, the hexavalent chromium (Cr^{VI}) is reduced by wood components to the trivalent less toxic Cr^{III}. This helps to stabilize the other preservative components in the wood (Bao et al. 2005b), in different degrees, e.g., copper is almost completely fixed. Therefore, those mixtures are also suitable for outside use. Chrome fluorine boron salts (CFB) are suitable for inside and outdoor use without ground or permanent water contact. Chrome copper salts (CC) are

Table 7.8. Major groups of wood preservatives for prevention and control of decay fungi and insects (based on Deutsches Institut für Bautechnik 2005)

DIBt approval-preservatives:
for prevention:
 water-based preservatives
 boron, CFB, CC, CCA, CCB, CCF salts
 quaternary ammonium compounds
 quaternary ammonium-boron compounds
 chromium-free copper compounds (Cu-HDO, Cu-quaternary ammonium, Cu-triazol)
 various other compounds
 solvent-based preservatives (e.g., Al-HDO, pyrethroides)
 solvent-based and water-soluble preservatives (only insects, carbamates)
 coal tar oil distillates (creosotes)
 special compounds for wood-based composites (only fungi, anorganic boron compounds, K-fluorides, K-HDO)
for control:
 water-based and solvent-based preservatives to control insects
 boron compounds, quaternary ammonium compounds, carbamates
 to prevent growth of *Serpula lacrymans* through masonry

RAL quality mark-preservatives to prevent blue stain, decay fungi, insects, and termites, to control insects, and to protect masonry against *S. lacrymans*

Blue stain preventing primers according to VdL instructions

allowed for indoor and outdoor wood, especially if it is exposed to leaching, and also for wood in ground contact, e.g., poles, exterior structures, such as decks and fences, mine timber (Narayanappa 2005), and wood in permanent water contact, such as cooling towers and marine works. Chrome copper salts with the addition of either boron (CCB) or fluorine (CCF) may be used indoors and outdoors.

Chrome copper arsenic salts (CCA) are restricted to outdoor use and certain application such as noise barriers (Commission Directive 2003/2/EC 2003). In the USA and Canada, industry registrants voluntary agreed to withdraw CCA treatment for use in such residential applications as decks, fences, and playground components effective as of 2004, although it is still registered for commercial/industrial products (Bao et al. 2005b). Component leaching from CCA-treated wood during above-ground exposure was affected by climatic variables like precipitation and temperature (Taylor and Cooper 2005). Bao et al. (2005b) showed for CCA, CCB and acid copper chromate (retention about 7 kg/m^3) fixation times of 8–32 days at 21 °C and between 12 and 48 h at 50 °C. Treatment of freshly impregnated wood with hot steam of 110 °C for 1 h was also suitable for sufficient fixation (Peek and Willeitner 1981, 1984; also Cooper and Ung 1992). Timber treated with water-based fixing salts should thus be protected from rain, depending on the type of preservative, to avoid leaching of the not yet fixed components, which would decrease the protection and pollute the environment. Cookson et al. (1998) evaluated the fungicidal effectiveness of water-repellent CCAs.

Molybdenum and tungsten have been studied as substitutes for arsenic in CC-salts (Cowan and Banerjee 2005). Schultz et al. (2005a) used a mixture of copper(II) and oxine copper for an outdoor ground-contact exposure.

Toxicological aspects have lead to an increased use of chromium-free preservatives that are just as fixing. These preservatives are based e.g., on ACQ (alkaline copper quaternary ammonium salts), copper HDO [bis-(N-cyclohexyl-diazeniumdioxy)-copper] and Cu-triazoles. Some of these products also include boron. Quaternary ammonium compounds are used as N-dimethylalkyl-benzylammoniumchloride, didecylpoly(ethox)ethylammoniumborate (polymeric Betain), and N,N-didecyl-N-methyl-poly-(oxethyl)-ammoniumpropionate. Zabielska-Matejuk et al. (2004) showed antifungal activity of bis-quaternary ammonium and bis-imidazolium chlorides (also Pernak et al. 1998). Didecyldimethylammoniumtetrafluoroborate inhibited mold and stain (Kartal et al. 2005a) and decay fungi (Kartal et al. 2005b). Copper(II) octanoate/ethanolamines were investigated by Humar et al. (2003). Mazela et al. (2005) used copper monoethanolamine complexes with quaternary ammonium compounds. The group of triazoles as wood preservatives was treated by Wüstenhöfer et al. (1993).

Solvent-based preservatives contain e.g., Al-HDO [tris (N-cyclohexyl-diazeniumdioxy)-aluminum] or triazoles (e.g., tebuconazole, propiconazole) as

fungicides and pyrethroides as insecticide. Pentachlorophenol is totally banned and γ-hexachlorocyclohexane (lindane) is not used any more. The addition of emulsifiers enables the use of various organic substances as emulsions in water-based systems.

Distillates of coal tar oil (creosote) are a complex mixture of some hundred compounds, mainly polycyclic aromatic hydrocarbons (Majcherczyk and Hüttermann 1998), and are allowed for outdoor use of timber in permanent ground and water contact that is not in contact with human beings. Preferably, creosotes are applied to wood that is exposed to leaching, e.g., railroad sleepers and telegraph poles. According to legislation, the content of benzo(a)pyren is limited to 50 ppm, classified by the Western-European Institute for Wood Preservation as type WEI B and C.

Boron compounds, quaternary ammonium compounds, and carbamates are suitable to prevent growth of *Serpula lacrymans* through masonry.

For the protective effect, the moisture content, the type of preservative (Table 7.8), the treatment process (Tables 7.9, 7.10), and the duration of treatment have to be considered. In addition, the timber species and part of the timber determine the permeability for preservatives. The treatability (EN 350-2) varies between completely permeable (class 1: easy to treat like the sapwood of *Quercus robur* and *Pinus sylvestris*) to extremely refractory (class 4: extremely

Table 7.9. Applicability of wood preservatives and treating processes depending upon the wood moisture content (modified from Willeitner and Liese 1992)

Moisture content	Wood preservative			Treating process
	water-based	creosote	organic solvent-based	
green much above fiber saturation	yes	no	no	sap-displacement (diffusion)
markedly above fiber saturation	yes	no	no	diffusion, long-term soaking
slightly above fiber saturation	yes	no	no	diffusion, long-term soaking, simple methods, OPM
below fiber saturation	yes	no	(yes)	soaking, simple methods, (diffusion), (pressure processes)
below fiber saturation	yes	yes	yes	pressure processes (except OPM), soaking, simple methods

underlined preferably recommended, *in brackets* possible but not recommended,
OPM oscillating pressure method

Table 7.10. Major groups of application procedures of wood preservatives (after Willeitner and Schwab 1981; Willeitner and Liese 1992)

Pressure processes, which use intervals of any difference of pressure until 0.8 N/mm^2 (including or excluding vacuum) and which follow different treatment schedules, dependent on preservative and timber, yield deep penetration and high retention.
In long-term procedures, the timber or the part of it to be treated is kept completely immersed (soaking) in the preservative, which slowly (some days) penetrates into the wood.
Short-term procedures (dipping, spraying, deluging, brushing) yield only little penetration (surface treatment) and low retention.
Special procedures preserve timber in use, like bored-holes in constructional timber, pilings or poles, and pastes or bandages used as a ground-line treatment for poles

difficult to treat like the heartwood of *Q. robur*). The role of bordered pits to the refractory nature of softwoods has been reviewed by Usta (2005).

The penetrability of refractory timbers like *Picea abies* (class 3–4) can be improved by using oscillating pressure methods (Breyne et al. 2000), by incising methods or by ponding. During the latter, bacteria attack the pits, but only irregularly and only in the sapwood. There were attempts to pretreat wood with chemicals (Militz and Homan 1992) and with enzymes to improve the permeability of conifers (Adolf 1975; Militz 1993) and hardwoods (Knigge 1985). Jagadeesh et al. (2005) improved penetration and retention of CCA in bamboo by using shockwaves.

There are different preconditions for chemical treatment of wood (Willeitner and Liese 1992): All wood must be debarked and free from phloem remainings ("white-peeled") before treatment. An exception is sap-displacement treatments (Boucherie process), where a water-based preservative is introduced under low pressure at the butt end of freshly felled trees replacing the sap of the sapwood by the preservative. Sap-displacement is out of use now for wood, but is applied to bamboo culms, whereby boron-salts are most commonly and successfully used (Liese and Kumar 2003). When the water content of wood is much above fiber saturation, a water-based preservative either of a high concentration or by long-term soaking in its solution can be used to distribute the chemicals into the timber by diffusion. Chemical treatment of seasoned wood with moisture content below fiber saturation requires penetration of a liquid into the capillary structure of the wood and subsequent distribution into the wooden tissue. Movement is effected either by externally applied pressure or by internal capillary forces.

Before treatment, working the timber like final cross cuttings, sawing, borings and shapings should be completed. Otherwise, the newly exposed part of the timber has to be treated once more, e.g., by brushing it several times. This applies also to later developing drying shakes if the wood was insufficiently dried before treatment.

Table 7.9 shows the applicability of wood preservatives and treating processes depending upon the wood moisture content.

For pressure treatments [full-cell process, empty-cell process (Lowry-process, Rüping-process), vacuum-process] and principally for creosote, the moisture content should be below fiber saturation. For short-term procedures (superficial treatments) and also for water-based preservatives, at least the wood surface must begin to dry. To bring the active substances into the wood, the procedures may be arranged into four major groups (Table 7.10).

In Germany, there are 234 pressure plants and 2,115 plants that use soaking (Quitt 2005). The necessary retention of a preservative depends on the endangerment of the wood, on the efficacy of the active ingredient, and the treatment procedure. The minimum quantities are shown in the respective DIBt approval. The preventing chemical preservation of wood-based composites is regulated in DIN 68800 part 5 (1978).

Wood plastic composites (WPCs) are a new material with plastic as a matrix and embedded wood particles and fibers as well as distinctive additives (Teischinger et al. 2005). The material is produced. e.g., by an extrusion process or injection molding process. Wood is added for better technical properties and for cost reduction. WPCs are increasingly used as a substitute for wooden decks especially in North America. Marketing of WPC products as "maintenance free" has been a key factor contributing to their success with the consumer. WPCs are nevertheless susceptible to fungal degradation despite the close association of wood with the plastic. Wood particles close to the surface of WPC products can attain moisture levels high enough to facilitate the onset of decay. Borates markedly reduced mass loss of WPC by *Gloeophyllum trabeum* in a soil block test (Simonsen et al. 2004). Mankowski et al. (2005) showed almost no mass loss by *G. trabeum* and *Trametes versicolor* in samples that had been treated with zinc borate.

The non-chemical protection and chemical preservation of bamboo are described by Liese (2002) and Liese and Kumar (2003).

Methods to determine the amount of active substances in the wood and to measure penetration depth are described by Petrowitz and Kottlors (1992), Schoknecht et al. (1998) and Schoknecht and Bergmann (2000). An overview is in the Internet (www.holzfragen.de/seiten/hsm_reagenzien.html). *N*-cyclo-hexyl-diazeniumdioxide in impregnated pine wood was measured by direct thermal desorption-gas chromatography-mass spectrometry (Jüngel et al. 2002).

Since about 1975 critical reports increase with regard of possible environmental impacts by chemical wood preservation, like by pentachlorophenol and chromate-containing preparations, the pollution of the soil by leached chemicals (Willeitner 1973; Willeitner et al. 1991; Leiße 1992; Hartford 1993) and due to problems arising from the disposal of treated timber (Marutzky 1990; Voß and Willeitner 1992). Pentachlorophenol (PCP) has protected wood since

1935 from staining and from decay by fungi and insects (Prewitt et al. 2003). The life expectancy of utility poles increased from approximately 7 years in an untreated pole to about 35 years in a treated pole, thereby saving utility companies millions of dollars in replacement costs. In the USA, 36 million PCP-treated poles have been estimated to be in service in 1990. In view of the negative impact on humans, animals, plants, and the environment, utilization of PCP and import of PCP treated woods are however restricted in Germany.

Disposal of spent treated wood has increasingly become a major concern. Popular methods, such as burning (incineration, combustion) and land filling, are costly or even impractical because of increasingly strict regulatory requirements. Recycling of the preserved wood and removal of the toxic preservatives from the treated wood is of great importance. Research in this area (Lin and Hse 2005) focus on direct recycling of preserved wood into composite manufacturing, CCA removal from spent CCA-treated wood performed by low-temperature pyrolysis, solvent extraction, hydrogen peroxide extraction (Kim et al. 2004), electrodialytic remediation (Christensen et al. 2005), biological remediation, and dual treatment processes involving biological remediation and chemical extraction. Li and Hse (2005) liquefied CCA-treated wood in polyethylene glycol and removed more than 90% of the metals by precipitation from aqueous solvents. Kartal and Imamura (2005) used chitin and chitosan for remediation of CCA-treated wood. Studies on bioremediation, particularly creosote, DDT, lindane and PCP, used several bacteria and fungi (review by Majcherczyk and Hüttermann 1998). Fungi which excrete high amounts of oxalic acid and are copper tolerant like *Antrodia vaillantii* (Collett 1992a, 1992b; Schmidt 1995b) have been used to bio-recycle CCA and CCB treated wood (Leithoff et al. 1995; Stephan et al. 1996; Kartal and Imamura 2003; Samuel et al. 2003; Humar et al. 2004; Kartal et al. 2004). Clausen (1997b) enhanced CCA removal from treated wood by *Bacillus licheniformis* (Weigmann) Chester.

There is a great bulk of investigations on new, alternative wood protection procedures that deal with the chemical and/or physical modification of wood (e.g., Militz and Krause 2003). Rapp and Müller (2005) grouped the recent wood protection procedures that are already used or are expected to be used into wood modification, wood hydrophobization, and supercritical fluid treatment.

Wood modification comprises various treatments that decrease the swelling of the woody cell wall and thus its accessibility for the fungal degradation agents.

Reactive organic compounds like acetic anhydride ("acetylation") are introduced in the wood (Hill et al. 1998), which react with the hydroxyl groups of the cell wall polymers and thus increase the dimensional stability of the wood as well as its resistance against decay and discoloring fungi. Acetylation with acetic anhydride results in covalently bonded acetyl groups ("plugging of hydroxyl groups") in the wood and acetic acid as a by-product. Acetylated wood is non-toxic and has no harmful impact on the environment, but may have an

unpleasant smell. Stake tests according to EN 252 with acetylated pine wood samples showed that the resistance of samples with an acetyl content of about 20% equals that of CCA treated wood with $10 \, kg/m^3$ retention (Larsson Brelid et al. 2000). Brown-rot decay became zero at a weight percent gain (WPG) of about 20% due to acetylation, and white-rot was prevented at a WPG of about 12% (Ohkoshi et al. 1999). As other anhydrides, propionic, butyric and hexanoic anhydrides were tested against brown, white and soft-rot fungi (Suttie et al. 1999; Papadopoulus 2004). Several carboxylic acid anhydrides were used for pine sapwood (Dawson et al. 1999).

Impregnation with melamine resins leads to a deposition of the resin in the cell wall (Rapp et al. 1999) and there to the "blockade of hydroxyl groups" without chemical linkage, which also improves the mechanical properties and durability of wood (Rapp and Peek 1996; Lukowsky et al. 1999).

Impregnation with 1,3-dimethylol-4,5-dihydroxyethylen urea (DMDHEU) effects the "linking-up of neighbored hydroxyl groups" by etherification with the N-methylol groups (Rapp and Müller 2005). There was no significant weight loss by *Trametes versicolor* of beech wood samples with 25% WPG of DMDHEU (Verma et al. 2005).

There are various methods to produce thermally modified timber ("thermal modification of wood") which leads to improved dimensional stability (Tjeerdsma et al. 1998) and biological resistance, but also partial wood degradation and discoloration. The processes have in common that the wood is subjected to temperatures between 160 and 260 °C in an atmosphere with low oxygen content (Leithoff and Peek 1998; Rapp 2001; Ewert and Scheiding 2005). Potentially toxic byproducts have been considered by Kamdem et al. (2000). In Europe, about 45,000 m^3 of thermally modified timber were produced in 2004. Four basic technologies have been established: the Finnish "Thermo wood", the Dutch "Plato wood", the French "Retification". Heat is transferred to the wood in the gas phase of air, exhaust fumes of combustion gases or nitrogen. The German "oil heat treatment" uses a vegetable oil (rape) for heat transfer, which additionally affects hydrophobization (Sailer et al. 2000; Bächle et al. 2004). The wood is used outdoors, e.g., for façade covering, noise barriers, and in gardens for decks, and indoors, e.g., for floorings. Four years lasting field tests of wood samples from the four European industrial heat treatment processes indicated that heat treated wood appears to be not suitable for in ground application, since only durability classes in the range from 2 (durable) to 4 (slightly durable) were achieved (Welzbacher and Rapp 2005). Thermal-hygro-mechanically densified wood showed reduced hygroscopy and improved mechanical performance, and resistance to fungal degradation (Schwarze and Spycher 2005).

Wood hydrophobization occurs by oils, waxes, paraffins, and silicons. Sailer (2001) and Rapp et al. (2005) used vegetable oils. The oil, which is deposited in the cell lumina, reduces water uptake without inhibiting vapor release. A wax-

type end coating of logs considerably reduced stain and checking (Linars-Hernandez and Wengert 1997). Hill et al. (2004) impregnated the wood cell wall with silane monomers, which polymerize in situ. Furuno and Imamura (1998) used sodium silicate-boron. The use of organic silicon compounds was reviewed by Mai and Militz (2004). Both hydrophobization and increased wood density were obtained in doubly modified wood samples when the wood was treated with reagents bearing isocyanate, carboxylic anhydride or oxirane functions to induce reactions with the OH groups and when the reagents also carried a polymerisable function by incorporating a monomer (styrene or methyl methacrylate) into the wood (Bach et al. 2005).

Supercritical fluid treatments use the principle that the preservative carrier e.g., CO_2 possesses at a certain pressure and temperature at the same time the properties of a gas and a liquid. The effective substance is similarly well soluble as in an organic solvent, but the penetration into the wood is deeper due to the minimal surface tension. At the end of the treatment, the carrier regains the gas phase by falling below the supercritical point that is the carrier loses the dissolving ability for the preservative, which remains deposited in the wood, and leaves the wood. Due to the minimal swelling of the wood, supercritical fluid treatment is particularly suitable for size-constant components like windows and doors (Rapp and Müller 2005). Morrell et al. (2005) impregnated wood-based composites with tebuconazole using supercritical carbon dioxide.

Chitosan, a linear copolymer of β(1-4)-linked 2-amino-2-deoxy-D-glucopyranose and 2-acetoamido-2-deoxy-D-glucopyranose residues, is produced commercially by alkaline deacetylation of chitin. Most chitosan is produced in India, Japan, Poland, Norway, and Australia, mainly based on crab and shrimps shells discarded by the canning industries in the USA and Japan. In contrast to chitin, which is highly crystalline and thus insoluble in water and most organic solvents, chitosan is soluble in diluted acids (Eikenes et al. 2005). It was tested against a brown-rot fungus (Lee et al. 1993), and blue-stain and mold fungi (Chittenden et al. 2003, Torr et al. 2005). Wood decay tests according to EN 113 showed that *Coniophora puteana* and *Gloeophyllum trabeum* were inhibited by about 6 kg chitosan/m^3, but *Oligoporus placenta* may be stimulated (Schmidt et al. 1995). Militz et al. (2005) showed a protecting effect against all three fungi. On the other hand, chitin and chitosan act as chelators for metal ions and enhanced removal of CCA components from treated sawdust in view of remediation of CCA-treated wood (Kartal and Imamura 2005).

Vanillin polymerized by laccase reduced the weight loss by *C. puteana* from 25 to 5% (Rättö et al. 2004). Proteinase inhibitors like hen egg white inhibited growth of *Ophiostoma piceae* in pine sapwood samples (Abraham et al. 1997). Antioxidants enhanced efficacy of organic biocides in decay tests (Schultz et al. 2005b). Chelators create metal limited conditions (Viikari and Ritschkoff 1992) or interact with enzymatic systems, like 2-hydroxypyridine-N-oxide (Mabicka et al. 2004). Cashew (*Anacardium occidentale*) nut shell liquid (CNSL), which

is a mixture of phenolics extracted from the shells of the cashew nut, reduced growth of some decay fungi (Pelayo et al. 2000). Venmalar and Nagaveni (2005) tested copperised CNSL and neem (*Azadirachta indica*) seed oil, containing azadirachtin, as preservatives. Alcoholic neem leaves extracts decreased wood mass loss by *Oligoporus placenta* and *Trametes versicolor* (Dhyani et al. 2005).

Recent research on the various aspects of modified wood was compiled at the Second European Conference on Wood Modification (2005).

There were (and are) many attempts at biological wood protection. To date, the application of microbiological control to prevent wood decay and discoloration has been successful in the laboratory, but inconsistent in its performance in the field (reviews by Bruce 1998; Bjurman et al. 1998; Chap. 3.8.1).

8 Habitat of Wood Fungi

Microbial damages to trees and wood can be differentiated into damage to the living tree, to felled and stored wood and in outside use, and to wood in indoor use.

Such grouping is however rather for didactical reasons. There are many overlappings: For example *Daedalea quercina* is occasionally found as wound parasite on living oaks, frequently on stumps, more rarely on timber in outdoor use, like sleepers or bridge timber, and sometimes also on buildings (half-timbering and windows). *Stereum sanguinolentum* causes as well the "wound rot" of spruce trees (Butin 1995) as the red streaking of stored coniferous wood (v. Pechmann et al. 1967).

8.1
Fungal Damage to Living Trees

This chapter belongs to the field of "forest pathology" and only gives an overview. For further reading see Tattar (1978), Schwerdtfeger (1981), Sinclair et al. (1987), Hartmann et al. (1988), Schönhar (1989), Butin (1995), Schwarze et al. (1997), and Nienhaus and Kiewnik (1998). Defense mechanisms of the trees are described by Blanchette and Biggs (1992) (also Chap. 8.2.1).

The tree can be already damaged on its flowers, seeds, and seedlings by fungi that belong to the Oomycetes, Deuteromycetes, or Ascomycetes. Among the more frequently occurring fungi on flowers or inflorescences are host specific *Taphrina* species that affect alder catkins, or female flowers of poplar, and *Thekopsora areolata* damaging spruce inflorescence (Butin 1995).

Seeds can be damaged by non-specific molds of the genera *Alternaria*, *Fusarium*, *Penicillium*, and *Trichothecium*. Among the specialists that can cause internal rotting of seeds are *Rhizoctonia solani* on beechnuts and *Ciboria batschiana* on acorns. Conedera et al. (2004) list several parasitic fungi that colonize chestnuts.

Heat damage in seedlings is often followed by secondary infections by *Alternaria*, *Fusarium*, and *Pestalotia* species. *Thelephora terrestris*, *Helicobasidium brebissonii*, *Rosellinia minor* and *R. aquila* can smother seedlings or young plants. Seedling rots are among the most common diseases in the forest nursery. Important fungi on conifer seedlings are *Phytium debaryanum*, *Phy-*

tophthora species, *Fusarium* species, *Rhizoctonia solani,* and *Macrophomina phaseolina.* The Shoot tip disease of conifer seedlings is caused by *Strasseria geniculata, Botrytis cinerea,* and *Sphaeropsis sapinea.* Sirococcus shoot dieback of spruce is caused by *Sirococcus strobilinus,* particularly on *Picea pungens* and *Pinus contorta. Meria laricis* causes the Meria needle-cast of young larch. The

Table 8.1. Some leaf diseases caused by fungi (compiled from Butin 1995)

Disease	Causal fungus	Classification
Needle-cast of Douglas fir	*Rhabdocline pseudotsugae* Sydow	Rhytismatales (A)
	Phaeocryptopus gauemannii (Rohde) Petrak	Dothideales (A)
Lophodermium needle blight of spruce	*Lirula macrospora* (R. Hartig) Darker	Rhytismatales (A)
Spruce needle reddening	*Lophodermium piceae* (Fuckel) Höhn.	Rhytismatales (A)
Spruce needle rust	*Chrysomyxa* species	Uredinales (B)
Rhizosphaera needle browning of spruce	*Rhizosphaera kalkhoffii* Bubák	Coelomycetes (D)
Lophodermium needle-cast of pine	*Lophodermium seditiosum* Minter, Staley & Millar	Rhytismatales (A)
Lophodermella pine needle-cast	*Lophodermella sulcigena* (E. Rostrup) Höhn.	Rhytismatales (A)
Naemacyclus needle-cast of pine	*Cyclaneusma minus* (Butin) DiCosmo, Peredo & Minter	Rhytismatales (A)
Dothistroma needle blight of pine	*Mycosphaerella pini* E. Rostrup ap. Munk	Dothideales (A)
Pine needle rust	*Coleosporium* species	Uredinales (B)
Larch needle-cast	*Mycosphaerella laricina* (R. Hartig) Neger	Dothideales (A)
Herpotrichia needle browning of Silver fir	*Herpotrichia parasitica* (R. Hartig) E. Rostrup	Dothideales (A)
Silver fir needle blight	*Hypodermella nervisequia* (DC.) Lagerb.	Rhytismatales (A)
Silver fir needle rust	*Pucciniastrum epilobii* (Pers.) Otth	Uredinales (B)
Black snow mold	*Herpotrichia juniperi* (Duby) Petrak	Dothideales (A)
White snow mold	*Phacidium infestans* P. Karsten s.l.	Helotiales (A)
Keithia disease of *Thuja*	*Didymascella thujina* (E. Durand) Maire	Rhytismatales (A)
Giant leaf-blotch of sycamore	*Pleuroceras pseudoplatani* (Tubeuf) Monod	Diaporthales (A)
Powdery mildew of maple	*Uncinula tulasnei* Fuckel, *Uncinula bicornis* (Wallr.) Lév.	Erysiphales (A)
Tar spot of maple	*Rhytisma acerinum* (Pers.) Fr.	Rhytismatales (A)
Cristulariella leaf spot of maple	*Cristulariella depraedans* (Cooke) Höhn.	Hyphomycetes (D)
Birch leaf rust	*Melampsoridium betulinum* (Pers.) Kleb.	Uredinales (B)
Beech leaf anthracnose	*Apiognomonia errabunda* (Roberge) Höhn.	Diaporthales (A)
Oak leaf browning	*Apiognomonia quercina* (Kleb.) Höhn.	Diaporthales (A)
Oak mildew	*Microsphaera alphitoides* Grif. & Maubl.	Erysiphales (A)
Taphrina gall of alder	*Taphrina tosquinetii* (Westend.) Magnus	Taphrinales (A)
Leaf browning of hornbeam	*Gnomoniella carpinea* (Fr.) Monod	Diaporthales (A)
	Asteroma carpini (Lib.) Sutton	Coelomycetes (D)
Apiognomonia leaf browning of lime	*Apiognomonia tiliae* (Rehm) Höhn.	Diaporthales (A)
Poplar leaf blister	*Taphrina populina* Fr.	Taphrinales (A)
Marssonia leaf-spot of poplar	*Drepanopeziza punctiformis* Gremmen	Helotiales (A)
Septotinia leaf blotch of poplar	*Septotinia populiperda* Waterman & Cash ex Sutton	Helotiales (A)
Poplar and willow leaf rust	*Melampsora* species	Uredinales (B)
Anthracnose of plane	*Apiognomonia veneta* (Sacc. & Speg.) Höhn.	Diaporthales (A)
Leaf blotch of Horse chestnut	*Guignardia aesculi* (Peck) Stew.	Dothideales (A)

A ascomycete, *B* basidiomycete, *D* deuteromycete

Table 8.2. Some fungal damages to buds, shoots, and branches (compiled from Butin 1995)

Disease	Causal fungus	Classification
Cucurbitaria bud blight of spruce	*Gemmamyces piceae* (Borthw.) Cassagrande	Dothideales (A)
Grey mold	*Botryotinia fuckeliana* (de Bary) Whetzel	Helotiales (A)
Sphaeropsis shoot-killing of pine	*Sphaeropsis sapinea* (Fr.) Dyko & Sutton	Coelomycetes (D)
Pine twisting rust	*Melampsora pinitorqua* E. Rostrup	Uredinales (B)
Brunchorstia dieback of conifers	*Gremmeniella abietina* (Lagerb.) Morelet	Coelomycetes (D)
Shoot shedding of pine	*Cenangium ferruginosum* Fr.	Helotiales (A)
Juniper rust	*Gymnosporangium sabinae* (Dickson) Winter	Uredinales (B)
Kabatina shoot killing of Cupressaceae	*Kabatina thujae* Schneider & Arx	Coelomycetes (D)
Pollaccia shoot blight of poplar	*Venturia macularis* (Fr.) E. Müller & Arx	Dothideales (A)
Myxosporium twig blight of birch	*Myxosporium devastans* E. Rostrup	Coelomycetes (D)
Marssonina leaf and shoot blight of willow	*Drepanopeziza sphaerioides* (Pers.) Höhn.	Helotiales (A)

A ascomycete, *B* basidiomycete, *D* deuteromycete

Beech seedling disease is due to *Phytophthora cactorum*. Other *Phytophthora* species attack chestnuts. *Rosellinia quercina, Cylindrocarpon destructans* and *Fusarium oxysporum* lead to root damage in young oaks.

Forest canopy fungi were investigated by Stone et al. (1996). A total of 344 different morphotaxa of endophytic fungi were isolated from leaves of *Theobromae cacao*. Most common were *Colletotrichum* sp., *Xylaria* sp. and *Nectria* sp. Inoculation of sterile leaves of young cocoa trees with these endophytes reduced subsequent damage by a parasitic *Phytophthora* sp. (Kull 2004).

Many species of fungi are capable of causing leaf diseases. Hardwood leaf diseases showing superficial fungal growth, or swollen, raised, or dead leaf areas, may be grouped simplistically into leaf spot, blotch, anthracnose, powdery mildew, leaf-blister, and shot-hole. Conifers may show needle spot, cast, blight, and rust (Tattar 1978; Stephan 1981; Butin and Kowalski 1989; Stephan et al. 1991). Table 8.1 only lists some fungi causing leaf diseases. Details on a specific disease may be read in Butin (1995).

Some fungal damages to buds, shoots, and branches are listed in Table 8.2.

8.1.1
Bark Diseases

Some bark diseases caused by fungi are listed in Table 8.3.

Three bark diseases are described in detail.

8.1.1.1
Beech Bark Disease

Beech bark disease (Fig. 8.1) has been known in Europe since about 1849 and was imported to North America (Shigo 1964; Parker 1974; Schütt and

Table 8.3. Some bark diseases (compiled from Butin 1995, supplemented from Jung and Blaschke 2005)

Disease	Causal fungus	Classification
Phacidium disease of conifers	*Phacidium coniferarum* (Hahn) DiCosmo	Helotiales (A)
Spruce bark disease	*Nectria fuckeliana* Booth	Hypocreales (A)
Crumenulopsis stem canker of pine	*Crumenulopsis soraria* (P. Karsten) Groves	Helotiales (A)
Pine stem rust (Resin-top disease)	*Cronartium flaccidum* (Alb. & Schwein.) Winter	Uredinales (B)
	Endocronartium pini (Pers.) Hiratsuka	Uredinales (B)
White pine blister rust	*Cronartium ribicola* J.C. Fischer	Uredinales (B)
Larch canker	*Lachnellula willkommii* (R. Hartig) Dennis	Helotiales (A)
Beech canker	*Nectria ditissima* Tul.	Hypocreales (A)
Beech bark disease	*Nectria* species	Hypocreales (A)
Black bark scab of beech	*Ascodichaena rugosa* Butin	Rhytismatales (A)
Fusicoccum bark canker of oak	*Fusicoccum quercus* Oudem.	Coelomycetes (D)
Chestnut blight	*Cryphonectria parasitica* (Murrill) Barr	Diaporthales (A)
Dothichiza bark necrosis and dieback of poplar	*Cryptodiaporthe populea* (Sacc.) Butin	Diaporthales (A)
Canker stain of plane	*Ceratocystis fimbriata* (Ellis & Halstead) Davidson f. *platani* Walter	Ophiostomatales (A)
Stereum canker rot of Red oak	*Stereum rugosum* (Pers.) Fr.	Aphyllophorales (B)
Pezicula canker of Red oak	*Pezicula cinnamomea* (DC.) Sacc.	Helotiales (A)
Coral spot	*Nectria cinnabarina* (Tode) Fr.	Hypocreales (A)
Sooty bark disease of sycamore	*Cryptostroma corticale* (Ell. & Ev.) Gregory & Waller	Hyphomycetes (D)
Sudden oak death	*Phytophthora ramarum* (Werres, De Cock & Man in't Veld)	Pythiales (O)

A ascomycete, *B* basidiomycete, *D* deuteromycete, *O* oomycete

Lang 1980; Eisenbarth et al. 2001). It develops particularly on trees older than 60 years of European *Fagus sylvatica* and American beech *F. grandifolia* by a disturbance of the water regime due to a abiotic/biotic factor complex: moist site, dry summer, participation of the Beech scale, *Cryptococcus fagisuga* (Lunderstädt 2002) and either one of two bark-killing Ascomycetes, in Europe *Nectria galligena* and in North America *N. coccinea* var. *faginata* (Mahoney et al. 1999), and possibly of mycoplasmas. Classical pathogenesis is an often short-lived mass reproduction of the Beech scale, which causes subcortical changes and subsequent infestation with *Nectria*. Xylem breeding *Trypodendron domesticum* and *Hylecoetus dermestoides* may follow. The larval galleries may be subsequently colonized by white-rot fungi. The susceptibility to the disease is biotically effected, whereby the physiological condition of the tree and its genetic potential determine the efficacy of the damaging agents (Beech scale, *Nectria* spp., beetles, white-rot fungi). The outbreak and/or healing can be controlled by the site conditions (Braun 1977; Lunderstädt 1992).

The fungus invades the bark that was previously altered by the feeding activity of the Beech scale. A red-brown to blackish (bark tannic substances) slimy liquid may ooze from the bark tissue (Wudtke 1991). Under the bark

Fig. 8.1. Beech bark disease. *a* tarry spots on the bark, *b* occluded bark lesions, *c* determination of extent of necrosis by scoring the bark with a timber scribe, *d* early stage of necrosis, *e* late stage with incipient white rot (from Butin 1995, by permission of Oxford University Press)

develop dark regions with dead cambium to over 1 m in extension. Small necroses with exposed wood may be closed by callus formation, which leads to a T-shaped fault in the xylem. Tylosis formation causes wilting. Massive invasions can result in tree dieback. Larger necroses form infestation gates for white-rot fungi (*Bjerkandera adusta*, *Fomes fomentarius*, *Fomitopsis pinicola*, *Hypoxylon* species, *Stereum hirsutum*) (Eisenbarth et al. 2001).

8.1.1.2
Chestnut Blight

The Chestnut blight (chestnut bark canker) (Fig. 8.2) is caused by the ascomycete *Cryphonectria parasitica* (Halmschlager 1966; Heiniger 1999). The pathogen was imported on Asian rootstock to New York in 1904 and caused lethal cankers on more than 3.5 billion susceptible American chestnut trees, *Castanea dentata*, across 9 million acres of the eastern US, being there at that

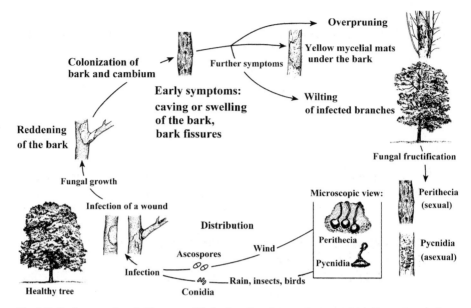

Fig. 8.2. Pathogenesis of Chestnut blight by *Cryphonectria parasitica* (translated from Heiniger 1999, with permission of Swiss Federal Institute for Forest, Snow and Landscape Research)

time the most important hardwood species. The disease appeared in Europe first in 1938 in Genoa in the European chestnut sites (*Castanea sativa*) of Italy, then in southern France, Spain, Switzerland (1948), Germany (1992), and Eastern Europe. The fungus penetrates as a spore by means of wind, rain, insects, or birds through wounds into the bark until the cambium. Then reddish-brown bark spots that break to longitudinal fissures, branch-surrounding necroses, wilt, and death of the affected branch or crown region occur. One- to 2-mm-large, orange-yellow-ochre pustules (conidiomata, ascomata) develop on the bark.

The disease in Europe does not run however as intensively as in the USA probably due to lesser aggressive fungal strains. The reduced pathogenicity is caused by *Cryphonectria*-hypovirus 1 that infests the fungus, that is, it becomes lesser virulent and only produces superficial cankers, which soon heal up. The virus is also found in the natural *C. parasitica* populations in Japan and China, but not in the North American populations. To limit the distribution of the fungus in non-infested countries, there are official regulations (European and Mediterranean Plant Protection Organization) (Heiniger 2003).

Breeding experiments are performed between *C. dentata* and resistant Asian species. There are also attempts on a biological control based on vegetative pairing of hypo-virulent fungal isolates with virulent strains. Infested sites are inoculated with hypo-virulent isolates that can transfer the virus in the

pathogen if both belong to the same vegetative compatibility group (Haller-Brem 2001). There are biotechnological attempts for transgenic chestnut trees (Gartland and Gartland 2004).

8.1.1.3
Plane Canker Stain Disease

The Plane canker stain disease (plane tree canker) (Fig. 8.3) is caused by the ascomycete *Ceratocystis fimbriata* f. sp. *platani* (Wulf 1995). The disease was for the first time observed on *Platanus* species in 1926 in the eastern USA and occurred in the 1940s in Europe [France, Italy, Spain, Switzerland, Turkey; Clerivet and El Modafar (1994)]. About 80% of the city-trees along motorways became destroyed until 1950 in the USA. Marseille lost over 1,500 100-year-old plane trees in 12 years. The fungus penetrates through wounds predominantly after pruning, more rarely by insects, into the bark of the stem and the branches and leads to cambium dying and elliptical bark necroses. Later, it colonizes the outer sapwood with bluish-brown discoloration. Excretion of toxins by the fungus and tyloses effect wilting of individual crown portions. Thus, the fungus both produces a bark and a wilt disease (Butin 1995). The trees die usually within 3–6 years. Reproduction organs are predominantly found on

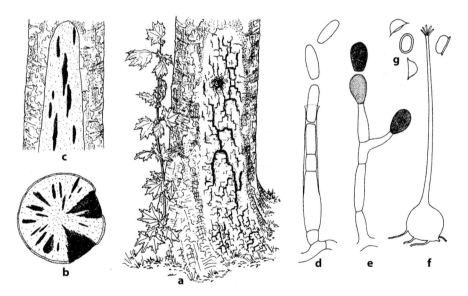

Fig. 8.3. Plane canker stain disease. *a* Symptoms on plane, *b* stem cross section showing stained wood, *c* tangential stem section showing the stain as streaks, *d* phialide with conidia of the *Chalara* anamorph, *e* conidiophore with chlamydospores, *f* perithecium, *g* ascospores (from Butin 1995, by permission of Oxford University Press)

cut sections of debranched or felled trees: perithecia with ascospores and three different anamorphs, e.g., *Chalara*. Necroses can by secondarily colonized by other fungi (*Chondrostereum purpureum*, *Schizophyllum commune*).

Transfer may be reduced by hygienic measures like removal of infested trees. National and EC regulations have to be considered.

8.1.2
Wilt Diseases

Diseases that affect the vascular system of a plant are called wilt diseases. A fungus causes moisture stress that leads to wilting, killing of large branches and even entire trees (Tattar 1978). Two important wilt diseases caused by fungi are Dutch elm disease and Oak wilt.

8.1.2.1
Dutch Elm Disease

Dutch elm disease ("elm dying") (Fig. 8.4) is caused by the ascomycetous fungus *Ophiostoma ulmi* s.l. (Gibbs 1974; Rütze and Heybroek 1987; Sinclair et al. 1987; Ouellette and Rioux 1992; Butin 1995; Harrington et al. 2001; Kirisits et al. 2001; Nierhaus-Wunderwald and Engesser 2003). The pathogen is composed of two separate species or three subgroups: the non-aggressive (NAG) subgroup, referred to as *O. ulmi*, and the two races, Eurasian (EAN) and North American (NAN), of the aggressive subgroup, referred to as *O. novo-ulmi* (Brasier 1999). The disease was probably imported from East Asia around 1917 over France into the Netherlands in 1919 (NAG), where 1920/21 the first comprehensive investigations took place, so that the disease was called Dutch elm disease. In 1923, it had arisen for the first time in England, 1930 via veneer wood in the USA, 1934 in almost all European countries and 1939 in the former Soviet Union (Heybroek 1982). Between 1940 and 1960 it receded, but again a new aggressive eastern race (EAN), probably from Romania/Ukraine, spread westward over the whole of Europe and eastward to middle Asia. Assumably after the import to North America, there the aggressive western race (NAN) shall have developed and imported to Great Britain (Röhrig 1996).

The wood loss in an economical view is very great. Altogether, hundreds of millions of decade- to centuries-old elm trees in Europe, North America, and in parts of Asia were destroyed. About 25 million elms died since the 1970s in England (Wörner 2005), and in Utrecht and Amsterdam, half of all the elms died.

Scolytid bark beetles are the principal agents of the long-distance transmission introducing the pathogen into healthy trees during adult feeding. In Europe, the principal vectors are *Scolytus scolytus* and *S. multistriatus*, but also

Swarming of infected beetles

Twig infection by young beetles

Plugging of vessels by mycelium and tyloses

Hyphae
Spores

Brown spots of plugged vessels

Tylosis

Fungal growth and infection of larvae, pupae, and young beetles

Female beetle

Wilting and discolouration

Infection of weakened or dying elms

Infection of freshly felled stems

Healthy elm

Teleomorph and anamorph

Larval galleries

Root graft transmission

Fig. 8.4. Pathogenesis of Dutch elm disease (translated from Nierhaus-Wunderwald and Engesser 2003, with permission of Swiss Federal Institute for Forest, Snow and Landscape Research)

other vector species are recognized (Wingfield et al. 1999). In North America, vectors are the imported *S. multistriatus* and the American elm bark beetle *Hylurgopinus rufipes*. The females select almost exclusively diseased, dying, or already dead elms for their breeding galleries. The larvae take up the pathogen, which is passed on alive via the pupa to the young beetle. The young beetles contaminated with spores (conidia or ascospores) infect healthy trees in twig crotches of small branches during maturation feeding. Since this bark is too thin for oviposition, the beetles leave the healthy tree and use the thick-barked parts of diseased elms for their breeding galleries. The change between the stem of infected elms and the branches of healthy trees makes the *Scolytus* beetles effective vectors (v. Keyserlingk 1982). Root graft transmission via connections from adjacent trees is the major cause of elm death in urban areas.

The principal reaction compounds developing in elms following invasion by the fungus are cadinane sesquiterpenoids [mansonones, elm phytoalex-

ins; e.g., Meier and Remphrey (1997)]. Barrier zones containing starch-filled parenchyma and swollen ray parenchyma have also been observed. During pathogenesis, the fungus develops within the xylem vessels with associated tyloses and vessel plugging, ultimately resulting in the wilt syndrome (Smalley et al. 1999), promoted by fungal toxins (cerato-ulmin) (Brasier et al. 1990). A branch cross section shows dark spots in the earlywood, which form brownish longitudinal strips in the tangential plane. An infection with a non-aggressive strain can be buried by new annual rings (chronic form); an aggressive strain grows through the annual ring borders (acute form), and the tree can die within 2 years.

The use of pheromones as an attractant does not cover all beetles. Fungal inhibitors such as benomyl only result in a dilatory effect. There were attempts of a biological control with the bacterium *Pseudomonas syringae* van Hall and with *Trichoderma* species (Aziz et al. 1993). Mansonones inhibited the growth of *O. ulmi* in *vitro*. Control measures are felling of infected or weakened trees as well as debarking and burning the bark and thicker branches in order to reduce the beetle population. In view of resistance to the pathogen, the major sources of genes for resistance are possessed by Asiatic elms. The responses of the European and North American elms vary depending on the individual subgroups of the pathogen. Classical breeding for resistance by selection of individuals from native populations have been made since the 20s, and hybrid elms have been bred, incorporating natural resistance from Asian elms. There are indications, which are based on DNA techniques, that most of the English elms, *Ulmus minor* var. *vulgaris*, are clones deriving from an Italian tree exported by the Roman agronomist Columella from Latium via Spain to England. That would explain the observed small genetic diversity within the English elms and thus their high susceptibility to the pathogen (Wörner 2005). Currently, two biotechnological approaches are pursued: Double-stranded RNA viruses, known as d-factors, may have the potential to reduce aggressivity if introduced into a fungal population at large in sufficient quantities to become established and spread through fungal populations. Transgenic *Ulmus procera* trees have been produced using *Agrobacterium rhizogenes* (Riker et al.) Conn and *A. tumefaciens* as mediator, demonstrating that a variety of exogenous genes can be expressed in regenerant elms (Gartland and Gartland 2004).

8.1.2.2
Oak Wilt Disease

The North American oak wilt (Fig. 8.5; Rütze and Liese 1980, 1985a; Sinclair et al. 1987) is a vascular disease that is endemic among oaks in the USA and caused by the ascomycete *Ceratocystis fagacearum*. It was recorded for the first time in Minnesota in 1928, Wisconsin in 1942, already in 1979 in 21 US states east of the Great Plains and is now also found in Texas and Tennessee. The

fungus can both infect red oaks (*Quercus falcata* var. *pagodaefolia, Q. rubra, Q. shumardii*) and white oaks (*Q. alba, Q. bicolor, Q. macrocarpa, Q. michauxii, Q. muehlenbergii*). Red oaks become systematically infected and die quickly, mostly within the year of first wilting symptoms and sometimes within a few weeks after infection. The economically more important white oaks are more resistant and show the damage often being restricted to just a few branches. The lower susceptibility of the white oak is attributed to smaller earlywood vessel diameter, more intensive tylosis formation resulting in a slower spread of the fungus in the tree and the ability to "bury" infected tissue by a new annual ring.

The infection usually occurs via root graft transmissions between the diseased and healthy trees (Fig. 8.5a), so that the distribution is low with 1 to 2 m (maximum 8 m) per year. Local spreading via root grafts can be inhibited by ditches. The fungus invades the vessels of the youngest two annual rings and stimulates the adjacent parenchyma cells to tylosis formation. Thus, wilt and defoliation occur in the undersupplied crown regions. Additionally, wilt toxins are produced. The leaves become flabby and discolor, are light green from the edge, and later bronze-brown in red oak and pale-light brown in white oak. After tree death, the hyphae grow inward in the sapwood as well as outward

Fig. 8.5. Transmission of the Oak wilt fungus, *Ceratocystis fagacearum*, via root-grafts (**a**), during maturation feeding of bark boring beetles (**b**), and from sporulating mat by sap feeding nitidulids (**c**) (from Rütze and Parameswaran 1984)

through the cambium under the bark. In the cambial layer particularly in red oak, 5 to 8-cm-large sporulation mats (usually conidia) develop from May to October, which cause bark detachment and fissure by means of pressure cushions.

There are two different ways for long-distance transmission by insects (about 100 m/year): First, oak bark beetles (*Pseudopityophthorus* spp.) breed in dying or dead oaks, and the young beetles transfer the pathogen during the maturation feeding on shoots and twigs of healthy oaks (Fig. 8.5b). Since asexual spores do not develop in the larval galleries, this transmission way has only less significance. Second, sap beetles, particularly Nitidulidae, are attracted by the smell of the sporulating mats and transmit infectious material to healthy trees into fresh wounds, attracted by their smell (Fig. 8.5c) (Appel et al. 1990). The nitidulids effect that the bipolar heterothallic fungus is dikaryotized and develops ascospores, if conidia with contrary mating factor were introduced from other sporulation mats. Since wounds are infectious only a few days in healthy oaks, this infection way has also less significance. Furthermore, the subcortical mats of *C. fagacearum* were observed to be rapidly overgrown by *Graphium pyrinum* Goid. (anamorph of *Ophiostoma piceae*). This colonization reduces the chance of contamination of the insect vectors with spores of the pathogen and is likely to contribute to the low efficacy of insect transmission (Rütze and Parameswaran 1984).

Since 1951, the import of unpeeled oak logs from North America to Germany was allowed according to a plant protection order, if the wood derives from healthy areas ("white counties"), in accordance with the plant protection department of the US Department of Agriculture. It had however to be considered that also the European oaks, although usually white oaks (*Quercus petraea* and *Q. robur*), are more susceptible from nature and that the European oak bark beetle *Scolytus intricatus* is more aggressive in its transmission behavior than the North American species. In order to prevent the import of the fungus (Gibbs et al. 1984), oak wood became subject to specific treatment requirements under Council Directive 77/93/EC including bark removal, kiln drying, etc. Since such wood cannot be converted to veneers, those measures would have equaled practically an import stop for oak logs and the endangerment of the European veneer industry. Thus, experiments were performed in a cooperative venture between the Federal Research Center for Forestry and Forest Products Hamburg and the Universities of Minnesota and West Virginia on log fumigation with bromomethane (methyl bromide) as a means of ensuring that the logs were free from *C. fagacearum* (Liese et al. 1981; Schmidt 1988). The European community permitted by EEC Plant protection guidelines of 1978 the import of unpeeled oak logs if they were disinfected before export with 240 g bromomethane per m^3 of wood for 3 days at a minimum temperature of 3 °C in plastic tents (Rütze and Liese 1983). The use of bromomethane has fallen off considerably since the Montreal Conference of 1997 because of its

destruction to the ozone layer. Log fumigation needs an exemption. In Europe, to monitor that sufficient bromomethane fumigation of the oaks has been carried out, the TTC test (Brunner and Ruf 2003) is suitable. The test is based on the fact that the gas kills not only the oak wilt fungus but also the living cells of oak sapwood. These cells would survive for several months in logs that are not treated with gas. Increment cores of the whole sapwood are treated with a 1% solution of 2,3,5-triphenyl-2H-tetrazolium chloride (colorless), which discolors dark red to triphenylformazan in contact with living cells by their dehydrogenase activity (Rütze and Liese 1985b).

Fumigation with bromomethane has also been applied to four pathogenic fungi in larch heartwood (Rhatigan et al. 1998). Due to the pending restrictions of bromomethane for phytosanitation in general, the potential substitution by sulfuryl fluoride and iodomethane was investigated (Schmidt et al. 1997c, Unger et al. 2001).

There are privileges of the import regulations for the fewer endangered white oak: no fumigation during winter months, however immediate debarking and burning of the bark as well as immediate wood processing. Since the wood of both oak groups is hardly or not at all to differentiate by appearance, a color test is suitable: When sprayed on the heartwood of any species of white oak a sodium nitrite solution produces a blue-black color within a few minutes, whereas the color is a reddish brown in red oak (Willeitner et al. 1982).

The possible oak wilt transmission to Europe was discussed several times in connection with the increasing illness of European oaks (Siwecki and Liese 1991). These damages develop however due to a complex effect of abiotic factors (dryness and pollutants as predisposing factors, severe winter frost as acute stressor) and biotic influences (leaf-eating insects, nematodes, phytoplasmas, and *Armillaria* spp. as weakness parasites, other *Ceratocystis* species, other fungi.) The literature on the role of pathogens in the present oak decline in Europe has been compiled by Donaubauer (1998).

8.2
Tree Wounds and Tree Care

8.2.1
Wounds and Defense Against Discoloration and Decay

Initiation for discolorations and decay are predominantly wounds that are frequently caused by animals chewing, branch breaking, pruning, mechanized wood harvest, construction injury, and motor traffic (Tattar 1978).

Rots in living trees might occur fast or result from processes of many years, which frequently remain hidden for a long time, until fruit bodies appear, or the tree is broken, thrown by the wind, or felled.

After wounding, tree-own discolorations (deposition of heartwood sub-stances) develop by living cells, followed by microbial stain and finally by wood rot (Shigo and Hillis 1973; Hillis 1977; Shortle and Cowling 1978; Bauch 1984; Rayner and Boddy 1988; Fig. 8.6).

Depending on the fungus and tree species, brown, white, or even soft-rot decay can develop in the tree. Sapwood and/or heartwood can be colonized. Fungi may be saprobionts of parasites. Development and spread of decay are influenced by the tree species, which can be susceptible, like birch or poplar, or exhibits natural durability in its heartwood due to inhibiting accessory compounds.

It has to be distinguished between passive mechanisms, which are already present before damage, and active defense mechanisms, which trees trained in the course of their phylogenetic development to limit wounds, infections, and senile damages (Blanchette 1992; Duchesne et al. 1992; Rayner 1993).

After the xylem is wounded, two defense functions have to be differentiated: First, the tree must avoid an interruption of the transpiration stream by air embolism, and second, limit the spread of invaded microorganisms (Liese and Dujesiefken 1996).

When a softwood tracheid is injured, its lumen is filled with air at ambient pressure. Thus, a pressure drop exists across the pit membranes of the water-containing neighboring tracheids. Their tori are therefore pulled against their pit borders, and the air-blocked tracheid is thus sealed off from the water-conducting tracheids (Zimmermann 1983). Conifers protect themselves from

Fig. 8.6. Model of successive changes in the stem wood after prior injury to the bark. *w* wound, *c* callus margin, *f* fruit body, *b* barrier zone, *r* rot, *m* microbial wood discoloration, *t* tree-own wood discoloration (after Shigo 1979)

wounds and penetrating microorganisms by phenolic compounds, terpenoids, and resin (Tippett and Shigo 1981).

In hardwoods, the defense reactions depend on physiologically active parenchyma cells. The water-conducting system is protected against damage by tyloses, plugs or membranes, and phenolic substances or suberin are deposited on the cell wall or in the lumen (Schmitt and Liese 1993).

For the graphic understanding of the spatial cut off within a tree, Shigo developed the CODIT model (Fig. 8.7; Shigo and Marx 1977; Shigo 1984), which stands for "compartmentalization of decay in trees". The model means that the tree protects itself from penetrating microorganisms by four inhibiting walls and that the spatial expansion of discoloration and decay is determined by the anatomical structure of the wood. The axial "walls 1" with the weakest partitioning effect are formed by the closure of the vessels and pits above and underneath a wound by gums and tyloses. The tangential "wall 2" stem-inward occurs by the annual ring borders and by the sapwood/hardwood boundary. The radial "walls 3" are caused by the lateral wood rays. The most effective compartmentalization is by "wall 4", also termed barrier zone, formed by the cambium after the injury with increased parenchyma content.

The CODIT model interprets the tree-own reactions as compartment formation against microorganisms. It seems, however, more biological that the tree protects itself first from penetrating air, particularly since wood fungi can only settle the tissue if air is present. With changed definition, the term CODIT has been expanded by Liese and Dujesiefken (1989, 1996): the D does not only stand for decay, but also for damage and covering desiccation as well as dysfunction.

The histological changes that occur in wood and bark as wound reactions in hardwoods are schematically shown in Fig. 8.8.

The parenchyma cells die at the surface of the damaged wood area. The tissue beneath the wound plane also dies, without mobilizing reserve materials,

Fig. 8.7. CODIT model with walls *1* to *4* (after Shigo 1979)

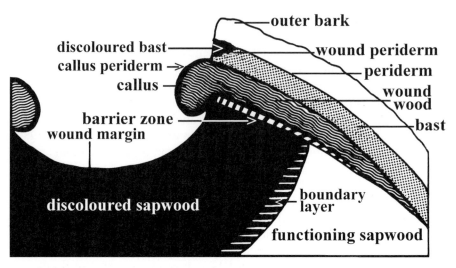

Fig. 8.8. Changes in the xylem and phloem of hardwoods after wounding (after Liese and Dujesiefken 1989)

since the defense reactions in the wood begin temporally retarded. In this bright zone of about 1 cm, the vessels remain open, and the lumina do not contain inclusions. With increasing distance to the wound, reserve material is mobilized, and the vessels are closed. In beech, the degeneration of the parenchyma is limited, as parenchyma cells in the wounded area are divided by transverse walls and limit the damage by suberization of the wound-near compartments (Schmitt and Liese 1993).

A closure by tyloses (Schmitt and Liese 1994) only takes place in tree species, which possess pit sizes of at least 8 µm. Trees without tyloses, like lime and maple, can prevent air embolism by blocking the vessels with plugs. In birch, the ladder-shaped vessel openings are closed on one side by membranes, and parenchyma cells excrete fibrillar material in neighboring vessels and fibers (Schmitt and Liese 1992a).

The tissue behind the wound area, which is discolored by means of accessory compounds and which contains died parenchyma cells and vessels out of function, had been termed protection wood. As it is colonized however frequently by fungi, it obviously does not possess increased durability. The healthy wood outside this area shows microscopically in an area of a few millimeters mobilization of reserve material and vessel closure, but no fungi, so that the actual protective layer obviously lies outside of the visible discoloration.

Also in the phloem the parenchyma dies at the wound surface and the tissue beneath is set out of function. A wavy-shaped wound periderm, which attaches the periderm of the young callus bark to the outer bark, develops in

the transition of the discolored to the functional phloem (Trockenbrodt and Liese 1991).

The cambium reacts to the damage at the wound margin with intensified cell formation (callus) to overwall the opened wood body (Stobbe et al. 2002a). The wound wood, which is later formed outside the callus, effectively limits discoloration and decay outward.

8.2.2
Pruning

Forest tress are pruned to produce high-class timber, trees in urban areas are pruned for safety reasons and along motorways and power-lines for clearance. Each cut causes a wound, which leads in the exposed wood to discoloration and decay (Fig. 8.9).

Until the 80s in Germany, the flush cut had been regarded as the correct method when removing a branch back at the stem. Studies on the pruning of hardwoods carried out by Shigo and staff (Shigo 1989) caused confusion. Comparing the effects of different cut locations of a total of 750 pruning wounds on 115 street and park trees led to the Hamburg Tree Pruning System (Dujesiefken and Stobbe 2002), which is integrated since 1992 into the German rules and regulations for tree care methods. The recommendations

Fig. 8.9. Discoloration reaching far into the stem of horse chestnut 9 years after flush cut pruning (a); reduced discoloration after a branch collar cut (b) (from Dujesiefken and Stobbe 2002)

for branches without branch collar are also part of the European Tree Pruning Guide. According to the branch attachment (branches with or without a collar), the cut has to be done outside the stem so that the branch bark ridge is not damaged. Flush cuts have to be avoided. When pruning dead branches, the distinctive swelling at branch base must remain at the stem. Regardless of the time of year and the tree species, radical tree pruning, e.g., a drastic removal of crown parts, should not be done. If possible, branches greater than 5 cm in diameter of weak compartmentalizing trees (e.g., *Aesculus, Betula, Malus, Populus, Prunus, Salix*), and greater than 10 cm of strong compartmentalizing trees (e.g., *Carpinus, Fagus, Quercus, Tilia*) should only be reduced partially rather than completely.

For organizational reasons and due to nature protection laws, pruning is usually done during the dormant season. However, wounding of maple, birch, beech, oak, ash, lime tree and spruce showed on the basis the intensity of the wood discolorations that injuries should be avoided in hardwoods during the dormant stage and in spruce from late summer to winter due to different wound reactions (Lenz and Oswald 1971; Armstrong et al. 1981; Dujesiefken et al. 1991; Schmitt and Liese 1992b).

8.2.3
Wound Treatment

In the 50s and 60s, large stem wounds were shaped out and filled with concrete. Since concrete and wood shrink and extend differently under weather influence, shakes develop, water penetrates and leads to rot. Since the 70s, the cleaned wounds were treated with wound dressings or with wood preservatives. Disinfection of the opened wood body with ethanol or alcoholic iodine solution before wound treatment did not led to a prevention of discoloration and decay in beech and ash (Dujesiefken and Seehann 1995). The use of wood preservatives was disputed for tree care measures, as they are not developed for the protection of tree wounds. The treatment of artificial wounds with wood preservatives resulted in beech in more intensive discolorations behind the wound area than at wounds, which were only treated with wound dressings. Wound dressings belong to the plant preservatives. In Germany, they must be tested according to efficacy and environmental compatibility to become licensed (Balder 1995).

Alternatively, cavities can be foamed with polyurethane (Dujesiefken and Kowol 1991). Figure 8.10 shows reduced discoloration in a beech tree after filling the wound with polyurethane.

Currently, traffic wounds on street trees are covered by black plastic wraps, which promote the development of a surface callus overgrowing the wound area (Fig. 8.11).

Fig. 8.10. Discoloration of beech at the control wound protected with wound dressing (**a**) and at the cavity filled with polyurethane (**b**) (from Dujesiefken and Kowol 1991)

8.2.4
Detection of Tree and Wood Damages

To investigate trees with regard to microbial damage, particularly to detect decay, discolorations, cavities, shakes and generally pathological changes, as well as to determine wood quality in felled timber, construction wood and wood-based composites, numerous methods are available. Inspection methods were described by McCarthy (1988, 1989), Zabel and Morrell (1992), Niemz et al. (1998), Londsdale (1999), Harris et al. (1999), Unger et al. (2001). Methods can be classified as destructive, nondestructive, or near-nondestructive. They reach from technically simple procedures like using increment bore tools to expensive equipment like computer tomography (Habermehl and Ridder 1993; Habermehl 1994) as well from subjective visual inspection to objective molecular techniques. In view of tree care, noninvasive or less destructive methods are preferable (Niemz et al. 1999; Kaestner and Niemz 2004). Modern techniques for nondestructive characterization and imaging of wood were reviewed by Bucur (2003) and comprise ionizing radiation computed tomography, thermal imaging, microwave imaging, ultrasonic imaging, nuclear magnetic resonance and neutron imaging. Some methods are preferentially used for trees, others for lumber, some may be used on the spot, others are pure laboratory tech-

Fig. 8.11. Use of a plastic wrap to improve the development of a surface callus. **a** Fresh, cleaned wound. **b** Wound covered with a black plastic wrap. **c** After 9 weeks nearly half of the wound covered with a bright surface callus tissue (from Stobbe et al. 2002b)

niques, and some of the latter are capable to identify the causal agent. Due to some overlapping in their use, the methods are listed together in Table 8.4. Limits of ultrasonic evaluation of wood defects have been shown by v. Dyk and Rice (2005). There is a great bulk of references on the various techniques; thus, only examples are given in Table 8.4.

The earliest nondestructive evaluation of trees is the visual inspection of the tree condition (growth, foliation, wilt) and occurrence of wounds, resin excretion, necrosis, canker, or fruit bodies. Visual inspection is also applied for lumber, poles, and wood in indoor use. Fruit bodies might serve to identify the causal agent. This visual inspection is by definition neither objective nor sure. Olfactory detection is done by the use of sniffer dogs that detect dry rot (Koch 1991), molds, or termites (Zabel and Morrell 1992).

Table 8.4. Inspection methods for fungal activity and wood quality in trees and timber

Method	Procedure	Advantage, disadvantage	Reference
Optical	Visual	Non-destructive, in situ, subjective	Janotta (1995)
	Endoscopy	Hidden spaces in buildings, bore holes may be required	Seufert et al. (1986)
	Rhizoscopy	Root system	Schwarze et al. (1997), Anagnost (1998)
	Light microscopy	Simple, destructive	Liese (1970), Daniel (2003)
	Electron microscopy	Accurate, photographic record, destructive	Körner et al. (1992), Schwanninger et al. (2004)
	IR/NIR/FTIR spectroscopy	Laboratory method, printed record	Koch and Kleist (2001)
	UV microspectrophotometry	Laboratory method, 3D wood topochemistry	Röder et al. (2004)
	Raman spectroscopy	Laboratory method, wood topochemistry	Keller (2002), Blei et al. (2005)
Spectrometrical	GC-MS	Laboratory method, MVOC's, mold and rot detection	Schmidt and Kallow (2005)
	MALDI-TOF MS	Laboratory method, fungal identification	Rust (2001), Niemz et al. (2002)
Acoustic	Speed of ultrasound (Impulse hammer)	Non-destructive, in situ, density of sound wood must be known	Noguchi et al. (1992)
	Acoustic emission	Non-destructive, in situ	Shigo et al. (1977), Kučera (1986)
Electrical	Electrical resistance, conductivity (Shigometer, Vitamat)	Less destructive, in situ, handy devices	Larsson et al. (2004)
	Nuclear magnetic resonance	Non-destructive, not transportable, expensive	Müller et al. (2002)
	Radar	Ground penetrating radar for root investigation, in situ	Barton and Montagu (2004)
	Microwaves	Non-destructive	Takemura and Taniguchi (2004)
Mechanical	Increment cores	Handy instruments, low cost, destructive	Niemz et al. (1998)
	Needle penetration (Pilodyn)	Handy instruments, low cost, nearly non-destructive	Niemz and Kučera (1999)
	Drill resistance (Resistograph)	Portable instruments, printed plots, destructive	Rinn (1994), Isik and Li (2003)
Thermographic	Heat radiation	Non-destructive, handy instruments, resolution insufficient	Niemz et al. (1998)
Radiographic	X-ray, γ-ray computed tomography	Non-destructive, in situ, expensive	Habermehl (1994)
Calorimetric	Isothermal microcalorimetry	Laboratory method, non-destructive	Xie et al. (1997)
Microbiological	Culturing to pure culture	Laboratory method, fungal identification	Kirk and Tien (1986)
Biochemical	CO_2	Laboratory method, fungal activity	McCarthy (1983), Bjurman (1992a)
	ATP	Laboratory method, fungal activity	Nilsson and Bjurman (1998)
	Chitin	Laboratory method, fungal quantification	Pasanen et al. (1999), Dawson-Andoh (2002)
	Ergosterol	Laboratory method, fungal quantification	Peek et al. (1980)
	pH-value	Non-destructive, fungal activity, brown/white rot differentiation	Koch (1991), Keller et al. (2004)
	Sniffer dogs	Non-destructive, detection of dry rot, molds	Schmidt and Kebernik (1989), Vigrow et al. (1989)
Molecular	Protein gel electrophoresis	Laboratory method, fungal identification	Vigrow et al. (1991a,b), Clausen (1997a)
	Immunology	Laboratory method, early decay, fungal identification	White et al. (2001), Schmidt (2000)
	DNA-based methods	Laboratory method, fungal identification, objective	

The type and intensity of a biological attack can be recognized by different macromorphologic changes of the wood tissue. Typical discolorations occur on and inside wood that is colonized by molds, blue stain, and red-streaking fungi. Brown- and soft-rotten woods differ in color and shape of the brown and soft-rotten cubes, and white-rotten wood between simultaneous and white pocket rot.

Various mechanical and physical wood changes occur when wood-inhabiting microorganisms colonize wood. Wood mass (weight) loss is a commonly used measure of decay capability. The basic calculation is: [(weight before − weight after): weight before] ×100%. The extent of decay in a specimen that was sampled from attacked wood can be determined the same way, if its dry weight is compared to that of a comparable healthy control: mass loss ML (%) = $[(DW_1 - DW_2) : DW_1] \times 100$ (DW_1 = dry weight of control, DW_2 = dry weight of decayed sample).

Mass loss of wood samples exposed to fungi is likewise used to determine the efficacy of wood preservatives and to examine the natural durability of wood species. There is a permanent discussion if fungal pure cultures or artificial mixed cultures should be used in laboratory tests (Kolle flask method, soil-block test, vermiculite method) or if soil contact decay tests are preferable. Laboratory tests are reproducible as they are based on defined test fungi. Field stake tests result in a severe exposure condition as the natural microbial composition may contain microorganisms that degrade wood, biodegrade organic wood preservatives or modify inorganic preservatives making them more susceptible to leaching (Nicholas and Crawford 2003). In Europe, the Kolle flasks method with malt extract agar and defined wood blocks of 5 × 2.5 × 1.5 cm in size from Scots pine sapwood and European beech is used for Basidiomycetes according to the standard EN 113 (Fig. 7.5; Table 7.6). In this method, specified isolates of certain fungal species, e.g., *Coniophora puteana* Ebw. 15, have to be used. The wood decay capacity of the test organisms is, however, erroneously named "virulence", although it concerns fungi and not viruses. Soft-rot fungi tests are performed in plastic containers with vermiculite (grainy substance of aluminum iron magnesium silicate) as moisture and nutrient depot. The standard soil block test AWPA E10 uses either 14-mm or 19-mm wood cubes that are exposed to white- and brown-rot fungi that were previously inoculated onto wood wafers on top of a sterile moist soil bed in a bottle. Soil bed testing based on the methodology described in the European Pre-standard ENV 807 uses $100 \, mm_{long} \times 10 \, mm_{rad} \times 5 \, mm_{tang}$ specimens that are exposed to the naturally soil-inhabiting microorganisms (v. Acker et al. 2003). Field stake tests use stakes or posts of the selected wood species that are half buried vertically in soil and inspected for decay at intervals. Wood assembly above-ground tests (post-rail, L-joint, lap-joint), all including some type of joint that effectively traps rainwater, simulate decking, door frames or joinery (Zabel and Morrell 1992; Nicholas and Crawford 2003).

The degree of wood decay can be quantified by changes in wood strength properties, modulus of rupture, work to maximal load in bending, maximal crushing strength, compression perpendicular to the grain, impact bending, tensile strength parallel to the grain, toughness, hardness, and shear strength (Wilcox 1978; Zabel and Morrell 1992; Nicholas and Crawford 2003).

Isothermal microcalorimetry has been used to determine the activity of fungi after exposure to high and low temperature, oxygen depletion, and drying (Xie et al. 1997).

Different stainings detect fungal hyphae and spores in woody tissue (Erb and Matheis 1983; Krahmer et al. 1986; Weiß et al. 2000). Treatment with safranine and astra blue stains lignified wood areas red and lignin-free parts blue, and thus differences between sound and decayed wood may become visible. Light-microscopic degradation patterns have been summarized (Schwarze et al. 1997). There is a key to identify wood decays based on light microscopic features (Anagnost 1998).

Transmission (TEM) and raster electron microscopy (REM) result in detailed views of the cell wall decay by the various groups of fungi (Liese 1970; Daniel 1994). UV microspectrophotometry (UMSP) characterizes lignin and phenolic compounds in situ, determines their content semiquantitatively in the various layers of the wood cell wall (Koch and Kleist 2001), and has also been applied to measure lignin content after microbial wood attack (Bauch et al. 1976; Schmidt and Bauch 1980; Kleist and Seehann 1997; Kleist and Schmitt 2001). General wood quality, microbial activity in wood, and composition in fossil specimens may be quantified by chemical analyses of the wood cell wall components, by UV and IR spectroscopy, and by gas chromatography/mass spectrometry of lignin components (Faix et al. 1990, 1991; Nicholas and Crawford 2003; Schwanninger et al. 2004; Uçar et al. 2005).

Biochemical methods to quantify microbial activity comprise assay of chitin as component of the fungal cell wall (Braid and Line 1981; Vignon et al. 1986; Jones and Worrall 1995; Nilsson and Bjurman 1998) and ergosterol as fungal membrane component (Nilsson and Bjurman 1990; Pasanen et al. 1999; Dawson-Andoh 2002).

Molecular methods to detect and identify fungi, like protein gel electrophoresis, immunology, and DNA-based techniques, are described in Chap. 2.4.2.

8.3
Tree Rots by Macrofungi

There is a broad spectrum of macrofungi (macromycetes) affecting trees. Most fungi belong to the Homobasidiomycetes (Table 2.12). About 20 species have greater economic importance. Among them, the Agaricales are represented

by *Armillaria*. The other important fungi belong to the Aphyllophorales and there predominantly to the Polyporaceae sensu lato ("polypores": Ryvarden and Gilbertson 1993, 1994). These polypores are summarized by the practical forester as "tree polypores" (Table 8.5; Seehann 1971). Fungi occurring on park and urban trees have been compiled e.g., by Seehann (1979), Wohlers et al. (2001), Wulf (2004) and Dujesiefken et al. (2005). Fungi affect predominantly older hardwoods and conifers of all climate zones. Infection occurs through wounds (wound parasites). Weakened trees may be more susceptible to fungi (weakness parasites). However, samples of dead wood from weakened spruces of different damage classes from forest dieback sites did not show differences in decay experiments with *Heterobasidion annosum*, *Trametes versicolor* (Schmidt et al. 1986), *Coniophora puteana*, *Gloeophyllum abietinum* and *Oligoporus placenta* (Liese 1986), compared to healthy trees.

Fungi either penetrate via the roots (root rots) or the stem (stem rots). Root-decay Basidiomycetes are e.g., *Armillaria* species, *Heterobasidion annosum*, *Meripilus giganteus*, *Phaeolus schweinitzii*, and *Sparassis crispa*. Among the Ascomycetes, *Rhizina undulata* (Pezizales) attacks the roots of spruce, pine and larch, and *Kretzschmaria deusta* (Xylariales) invades injured roots of beech, horse chestnut, elm, lime tree, maple, and plane causing white rot in the root and the stem (Butin 1995; Schwarze et al. 1995b; Baum 2001). Some common stem-decay Basidiomycetes in Europe (Butin 1995) and the USA (Zabel and Morrell 1992) are listed in Table 8.5. Most English names derive from Käärik (1978), Larsen and Rentmeester (1992) and Rune and Koch (1992).

Fungi may attack the heartwood (heart rots) and effect thus a considerable strength and volume reduction of the tree xylem. They cause either brown or white rot in a several years of development, whereby all combinations between hardwoods and conifers as well as brown rot and white rot occur. However, also a soft-rot decay pattern may develop in the standing tree. Tree decay fungi have great economical importance, since a great part of the wood body can be devaluated, and felling of infected trees may be necessary. After felling, windthrow, or death of the tree, some fungi continue growth as saprobes in the wood for several years, then however usually die, that is, typically they do not endanger structural timber. The variously sized fruit bodies (basidiocarps, basidiomata) are either pileate, shelf-shaped, bracket-like, coral-like, or resupinate (see Fig. 2.17). Shape and size of the pores are distinguishing features (Breitenbach and Kränzlin 1986; Ryvarden and Gilbertson 1993, 1994; Krieglsteiner 2000). Beside fungi with annual fruit bodies, species with perennial basidiomes produce new hymenial layers each year and may become very large, hard and woody (see Fig. 8.15a).

Daedalea quercina, *Fomes fomentarius*, *Phellinus igniarius*, *Laetiporus sulphureus*, *Piptoporus betulinus*, *Polyporus squamosus*, and *Meripilus giganteus* occur predominantly on hardwoods. *Heterobasidion annosum*, *Phaeolus*

Table 8.5. Some stem-decay Basidiomycetes

	Rot
Amylostereum areolatum (Chaill.: Fr.) Boidin	white
Armillaria mellea (Vahl: Fr.) Kummer, Honey fungus, and further *Armillaria* species	white
Bjerkandera adusta (Willd: Fr.) P. Karsten, Smokey polypore	white
Chondrostereum purpureum (Pers.: Fr.) Pouzar, Silver-leaf fungus	white
Climacocystis borealis (Fr.: Fr.) Kotl. & Pouzar	white
Coniophora arida (Fr.: Fr.) P. Karsten	brown
Coniophora olivacea (Fr. Fr.) P. Karsten	brown
Daedalea quercina (L.: Fr.) Fr., Maze-gill	brown
Daedaleopsis confragosa (Bolton: Fr.) J. Schröter	white
Fistulina hepatica (Schaeffer: Fr.) Fr., Beef-steak fungus	brown
Fomes fomentarius (L.: Fr.) Kickx, Tinder fungus	white
Fomitopsis pinicola (Sw.: Fr.) P. Karsten, Red-belted polypore	brown
Ganoderma adspersum (S. Schulzer) Donk,	white
Ganoderma applanatum (Pers.) Pat.	white
Ganoderma lipsiense (Batsch) G.F. Atk., Artist's conk	white
Ganoderma lucidum (Curtis: Fr.) P. Karsten	white
Grifola frondosa (Dicks.: Fr.) S.F. Gray	white
Heterobasidion annosum (Fr.: Fr.) Bref., Root rot fungus	white
Inonotus dryadeus (Pers.: Fr.) Murr.	white
Inonotus hispidus (Bull.: Fr.) P. Karsten	white
Laetiporus sulphureus (Bull.: Fr.) Murr., Sulphur polypore	brown
Meripilus giganteus (Pers.: Fr.) P. Karsten, Giant polypore	white
Oligoporus stipticus (Pers.: Fr.) Kotl. & Pouzar	brown
Onnia tomentosa (Fr.: Fr.) P. Karsten	white
Phaeolus schweinitzii (Fr.: Fr.) Pat., Dye polypore	brown
Phellinus chrysoloma (Fr.) Donk	white
Phellinus hartigii (Allesch. & Schnabl) Pat.	white
Phellinus igniarius (L.: Fr.) Quélet, False tinder fungus	white
Phellinus pini (Brot.: Fr.) A. Ames, Ochre-orange hoof polypore	white
Phellinus pomaceus (Pers.: Fr.) Maire	white
Phellinus robustus (P. Karsten) Bourdot & Galzin	white
Pholiota squarrosa (Pers.: Fr.) Kummer	white
Piptoporus betulinus (Bull.: Fr.) P. Karsten, Birch polypore	brown
Pleurotus ostreatus (Jacq.) Kummer, Oyster mushroom	white
Polyporus squamosus (Hudson: Fr.) Fr., Scaly polypore	white
Resinicium bicolor (Alb. & Schwein.: Fr.) Parm.	white
Schizophyllum commune Fr.: Fr., Split-gill	white
Sparassis crispa Wulfen: Fr.	brown
Stereum rugosum (Pers: Fr.) Fr.	white
Stereum sanguinolentum (Alb. & Schwein.: Fr.) Fr., Bleeding Stereum	white
Trametes hirsuta (Wulfen: Fr.) Pilát	white
Tyromyces caesius (Schrader: Fr.) Murr., Blue cheese polypore	brown
Tyromyces stipticus (Pers.: Fr.) Kotl. & Pouzar	brown
Xylobolus frustulatus (Pers.: Fr.) Boidin, Ceramic parchment	white

schweinitzii, Phellinus pini, and *Sparassis crispa* inhabit softwoods. Species of *Armillaria* attack both tree groups.

In the following, some common tree fungi are described, mostly in note form. For details see Seehann (1971, 1979) and textbooks e.g., by Butin (1995), Breitenbach and Kränzlin (1986, 1991), Rayner and Boddy (1988), Jahn (1990), Ryvarden and Gilbertson (1993, 1994), Krieglsteiner (2000), and Schwarze et al. (2004).

8.3.1
Armillaria Species, Honey Fungi

The genus *Armillaria* (Fr.: Fr) Staude comprises worldwide about 40 species. The rather similar fungi form rhizomorphs in the soil and beneath the tree bark, the mycelium shines in the dark, the secondary mycelium is diploid and normally clampless (Marxmüller and Holdenrieder 2000). There are ex-annulate and annulate species (Shaw and Kile 1991; Guillamin et al. 1993). In Europe, five intersterility groups that had been referred to as A, B, C, D, E (Korhonen 1978b) within the annulate *Armillaria mellea* complex were assumed until the 1980s to be polymorphic members of the species *Armillaria mellea* ("*Armillaria mellea* complex"). In the 90s, the groups were assigned to five biological species (Guillaumin et al. 1993; Nierhaus-Wunderwald 1994; Holdenrieder 1996):

A = **Armillaria borealis** Nordic honey fungus,
B = **Armillaria cepistipes,**
C = **Armillaria ostoyae** Dark honey fungus,
D = **Armillaria mellea** s.s. Honey fungus,
E = **Armillaria gallica** Marxm. & Romagn.

Based on the verification of isolates by mating tests between monospore cultures, between diplonts and haplonts (Buller phenomenon), and by somatic compatibility tests, morphological variation of the fruit bodies of the five annulate European species was recently shown in color plates with suitable characters for species identification (Marxmüller and Holdenrieder 2000). In North America, nine annulate species are known (Anderson and Ullrich 1979; Anderson et al. 1980; Bruhn et al. 2000). The six species in Australasia (Kile and Watling 1983) are incompatible with European and North American species. In Africa, a subspecies of *A. mellea* was found (Agustian et al. 1994).

Occurrence: The *Armillaria* species differ in host preference, pathogenicity (primary parasite, opportunist attacking weakened plants, destructive agent of non living tissue resulting in heart wood rot), geographical distribution, type and frequency of rhizomorphs, and in cultural characteristics such as mat morphology and optimum temperature (Rishbeth 1985, 1991; Shaw and Kile 1991; Guillaumin et al. 1993; Marxmüller and Holdenrieder 2000; Schwarze

and Ferner 2003; Prospero et al. 2003). The damage, *Armillaria* root disease (Hartig 1874, 1882), occurs in conifers and hardwoods, particularly spruce, pine, maple, poplar, oak, in plantations of fruit, vine, flowers, ornamentals, and tropical cash crops (Seehann 1969; Schönhar 2002a; Schwarze and Ferner 2003). The fungi occur also on stumps, piles, etc., and even in sprinkled wood (Metzler 1994).

Physiology: Parasite, saprobe, white rot; slow growth in the laboratory;

Characteristics: in pine and spruce, resin excretion; white, fan-like mycelial mats and brown-black, inside white rhizomorphs (0.25–4 mm; Schmid and Liese 1970; see Fig. 2.7) between bark and wood (Hartig 1874; Fig. 8.12a); wood colonized by living mycelium shining in the dark; clampless;

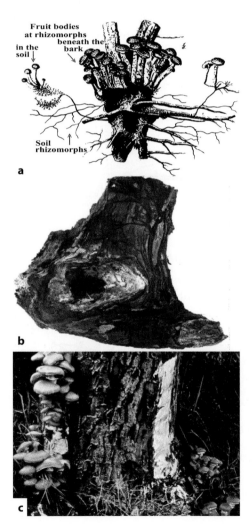

Fig. 8.12. *Armillaria mellea.* **a** Fruit bodies and rhizomorphs (translated from Hartig 1874); **b** White-rotten stump with rhizomorphs after removing the bark. **c** Fruit bodies and white mycelial sheet beneath the bark (photo W. Liese)

Fruit body (Fig. 8.12c): central stipe (to 15 cm), cap 5–15 cm in diameter; annual, in groups on stumps and at the root collar in late autumn; upper surface (*A. mellea*): small, yellow-brown scales on honey-yellow ground (Honey fungus); gill surface: cream-white to brownish-red gills; monomitic; clamps only at the basidium basis; pileus with white ring; young edible, danger of sickness when insufficiently cooked or overmatured;

Significance: The *Armillaria* fungi, which are feared by the foresters, belong to the most important and cosmopolitan pathogens inside and outside the forest. They can attack almost all species of hardwoods and conifers of all ages (Hartig 1874; Schönhar 1989; Livingston 1990; Klein-Gebbinck and Blenis 1991; Gibbs et al. 2002). They live as saprobes in the soil on dead wood remainders and on stumps. The transition to the parasitic phase occurs, if the tree is weakened by stress (other parasites, wetness, dryness, pollution), so that forest damage sites showed increased occurrence of *Armillaria*. The infection occurs by rhizomorphs (Fig. 8.13). Solla et al. (2002) showed that *A. mellea*

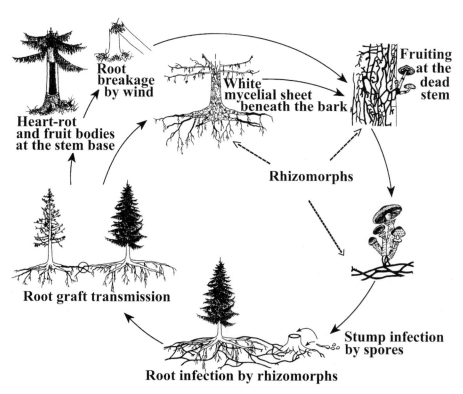

Fig. 8.13. Development and transmission of *Armillaria* root disease (translated from Nierhaus-Wunderwald 1994, with permission of Swiss Federal Institute for Forest, Snow and Landscape Research)

and *A. ostoyae* penetrated *Picea sitchensis* root bark without prior wounding, but neither species formed rhizomorphs. The rhizomorphs grow in the soil from tree to tree and serve for nutrient translocation and infection. If the tree does not succeed in defending the fungus by histological or chemical barriers (Woodward 1992a; Wahlström and Johansson 1992), the fungus spreads between bark and xylem in the cambial region. The sap stream is interrupted, and toxic metabolites are excreted by the fungus. If the whole cambium is colonized around the stem, the tree dies rapidly ("cabium killer"). Beside the parasitic way of life, the fungus can spread via the wood rays in the heartwood of the root and stem basis (butt rot). *Armillaria* species and *Heterobasidion annosum* showed an increased occurrence in forest dieback sites (Kehr and Wulf 1993).

A direct control of *Armillaria* spp. (e.g., Fox 1990) is practically impossible, particularly since the fungus occurs almost everywhere in the soil. In Oregon, the upper ground layer was colonized over an area of about 9 km^2 by only one mycelial clone of *A. ostoyae*, whose age was supposed to be 2,400 years. In England, a clone of *A. gallica* of about 500 years of age covered an area of 9 ha. In France and Germany, clone diameter reached about 200 m in diameter (Marxmüller and Holdenrieder 2000).

Armillaria is more frequent on soils with balanced microclimate and high air humidity at ground level as well as on nutrient-rich soils of about pH 5. Since young conifers are particularly susceptible on former hardwood soils, old stumps and roots should be rooted out before planting conifers to limit the vitality of the fungus, which, during its saprobic phase, depends on easily degradable nutrients (Butin 1995). Isolation of infected tree groups by 30 to 50-cm-deep ditches is usually unsuccessful. *Armillaria*-infected plants in gardens and parks should be promptly removed. The resistance of the plant hosts can be increased by suitable soil preparation, good planting, and tree care. Douglas fir, Sitka spruce, fir and larch are lesser susceptible species. The application of chemicals within the root range is strenuous and therefore only suitable for valuable garden and park trees (Schönhar 1989).

Pinosylvin from *Pinus strobus* inhibited mycelial growth of *A. ostoyae* (Mwangi et al. 1990). Growth rate, spread and survival of rhizomorphs decreased by several bacteria, particularly *Pseudomonas fluorescens* Migula (Dumas 1992), *Trichoderma* species (Dumas and Boyonoski 1992), wood-inhabiting Basidiomycetes (Pearce 1990) and mycorrhizal fungi (Kutscheidt 1992).

8.3.2
Heterobasidion annosum s.l. Root Rot Fungus, Fomes Butt Rot

From the Root rot fungus, several intersterility groups have been distinguished, which differ in relation to distribution, fruit body morphology and host tree (Korhonen 1978a). In Europe, three groups have been referred to as P-group

(pine), S-group (spruce), and F-group (fir) (Holdenrieder 1989; Siepmann 1989; Capretti et al. 1990; Stenlid and Karlsson 1991; Korhonen et al. 1992). In North America occur the P- and S-type. The Asian forms are lesser characterized (e.g., Dai and Korhonen 1999). The three European forms show significant differences in their distribution and host preference and have been attributed to three distinct species (Niemelä and Korhonen 1998; Korhonen and Holdenrieder 2005):

Heterobasidion annosum s.s. corresponds to the European P-type of *H. annosum* s.l. and may named pine root rot fungus, as it typically occurs in pine forests. In addition, the fungus attacks *Juniperus communis*, *Picea abies*, *P. sitchensis*, *Pseudotsuga menziesii*, *Larix decidua*, *L. x eurolepsis*, and *L. kaempferi*. The distribution area covers the whole of Europe except for the most northern forests and possibly the great parts of Siberia.

Heterobasidion parviporum (European S-type of *H. annosum* s.l.; Spruce root rot fungus) occurs in Europe nearly exclusively on *Picea abies*, but as it seems, it is not found in Western Europe. In Russia, it attacks also *Abies sibirica* and in East Asia further *Picea* and *Abies* species.

Heterobasidion abietinum (European F-type of *H. annosum* s.l.; Fir root rot fungus) occurs in fir forests from the Pyrenees to South Polonia and the Caucasus, particularly on *Abies alba*, but also on *A. borisii-regis*, *A. cephalonica* and *A. nordmanniana*.

The three closely related species can be differentiated by cultural studies, mating tests and DNA techniques. The hymenium of *H. parviporum* has small pores (up to 5 pores/mm) and the upper side shows short hairs, while *H. annosum* s.s. has bigger pores and a bald upper side. The features of *H. abietinum* often overlap with those of the two former species, but its occurrence on firs is a suitable clue (Korhonen and Holdenrieder 2005). Hybridization of the species occurs in the laboratory. A natural hybrid between S- and P-type has been found in North America, but generally, hybrids occur more easily between forms from different continents. Regarding the evolution of *H. annosum* s.l., the origin of *H. parviporum* and *H. abietinum* seems to be East Asia, as there occurs a form that showed high compatibility with all three species. Assumably, *H. annosum* s.l. spread from the eastern Himalayas and has thereby increasingly differentiated via different routes: *H. abietinum* arrived in Europe via the South Asian conifer forests, *H. parviporum* via northern Asia, and the American S-type reached North America over the Bering Strait. Not much is known on the P-types (Korhonen and Holdenrieder 2005). Molecular analyses have shown a close relation of the genus *Heterobasidion* to the Russulales.

The following description concerns *H. annosum* s.l.

Occurrence: common in Europe, North America; predominantly conifers; in heartwood and rootwood of spruce, larch and Douglas fir; in pine restricted to the root area due to greater resin content; broad host range of over 200 woody plants (Heydeck 2000); largest diameter of a genet smaller than 30 m, only in

single cases up to 55 m; maximum age of an individual genet around 200 years (Queloz and Holdenrieder 2005);

Physiology: white rot, root rot, butt rot, so-called red rot due to reddish discoloration of the wood; at initial decay preferential lignin degradation, later simultaneous white rot (Peek and Liese 1976); parasite and saprobe;

Characteristics: anamorph *Spiniger meineckellus* (A.J. Olson) Stalp. (Fig. 8.14C) on agar and fresh wood samples at high relative humidity: club-shaped thickened conidiophore after spore dispersal like a morning star ("Brefeld conidia" as identification feature: Brefeld 1889); flask-shaped increase of the stem basis of spruce by cambial irritation; resin excretion;

Fruit body (Fig. 8.14A): annual to enduring crusty brackets in autumn, often resupinate (1 cm thick, 3–20 cm wide) in rows and roofing tile-similar, usually fused, at the stem basis and on flat-running roots, frequently covered by needle litter; yearly a new pore layer; fresh: tough, old: hard and woody; upper surface: bumpy-wrinkled, brown, often zonate, leathery-crusty, white-yellowish margin; pore surface: white-cream with circular-angular pores (4–5/mm); dimitic; bipolar.

Significance: The fungus is one of the most important pathogens in coniferous forests of temperate regions (Hartig 1874, 1878; Rishbeth 1950, 1951; Zycha et al. 1976; Hallaksela 1984; Tamminen 1985; Benizry et al. 1988; Schönhar 1990; Woodward 1992a, 1992b; LaFlamme 1994; Woodward et al. 1998; Heydeck 2000; Greig et al. 2001; Gibbs et al. 2002; Korhonen and Holdenrieder 2005), which causes substantial damage particularly in older forests. The infection occurs by germinating spores or by mycelium that is already present in roots or soil. Several infection ways are possible: by basidiospores (also conidia) via stump infection (Redfern et al. 1997), by mycelial growth through root graft transmission from diseased to healthy roots (Hartig 1878; Schönhar 2001), or via spores [germinable about 1 year: Brefeld (1889)], which are washed into the soil by rain and germinate on the roots. The fungus penetrates into older roots through wounds and into young uninjured roots through the thin bark (Rishbeth 1951; Peek et al. 1972a, 1972b; Lindberg and Johansson 1991; Lindberg 1992; Solla et al. 2002). The hyphae penetrate into sound spruce roots via the pit channels of the thick-walled stone cork cells. The walls of the following thin-walled stone cork cells and the sponge cork cells are degraded. The fungus colonizes the tracheids from the bark rays via the wood rays. The tracheids are degraded by enzymes and perforated by microhyphae (Peek and Liese 1976). Embryos of *Pinus* spp. showed three days after artificial inoculation intercellular penetration of hyphae through the epidermis and into the cortex (Nsolomo and Woodward 1997). Infection of spruce seeds of 4–7 days of age showed that infective structures on the root surfaces were evident 24 h after inoculation. Internal colonization of cortical tissues started after 24–48 h and reached the endodermis within 72 h. Severe destruction of stelar cells occurred 12–15 days postinfection (Asiegbu et al. 1993). Infection of nonsuberized and

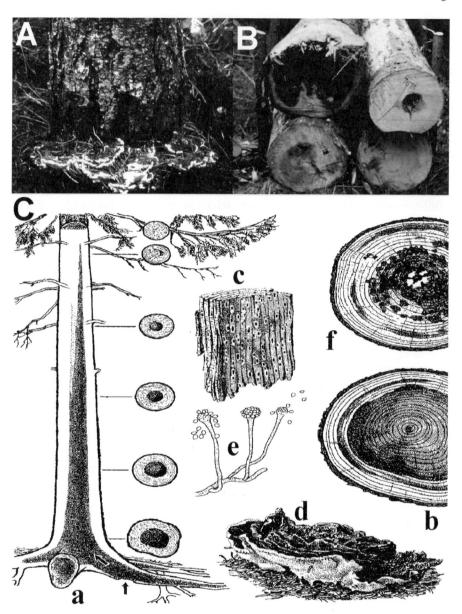

Fig. 8.14. Fomes root rot by *Heterobasidion annosum*. **A** Fruit bodies at the stem basis. **B** Sequent sections of a stem showing the different color and decay zones (photos W. Liese); **C** Pathogenesis, *a* longitudinal section through a spruce with heart rot, with stem cross sections, *b* cross section through a stem at an early stage of disease, *c* a late stage in the wood decay, *d* fruit bodies, *e* Brefeld conidiophores with conidia, *f* a heart rot caused by *Armillaria* sp. shown for comparison (from Butin 1995, by permission of Oxford University Press)

young suberized roots of spruce seedlings showed host reaction to delimit the infection by the formation of a necrotic ring barrier in the outer cortex. In cases where the inner cortex became infected, hyphae accumulated just before the endodermis, which acted as a new barrier. Only in nonsuberized roots, the stele was almost completely digested within 3 days after inoculation (Heneen et al. 1994a). In woody roots 2–4 mm in diameter, fungal infection was restricted to the remnant cortex cells and the rhytidome after an incubation period of 20 days; accumulation of granular materials prevailed in the infected periderm cells, which enclosed degenerated hyphae, both leading to the conclusion that the rhytidome acts as a successful barrier to infection of the inner parts of the root for at least 20 days following inoculation (Heneen et al. 1994b). Stem infections are rare and limited to wounds at the root collar (Schönhar 1990). Main infection is by airborne basidiospores that germinate on fresh stump surfaces. Infection of neighboring trees occurs by vegetative mycelia via root contacts. Once established in the root system, the fungus can remain active for about 60 years. The fungus spreads into trees of the next generation from infected stumps (Vasiliauskas and Stenlid 1998).

The significance of the fungus is not only based on its parasitic capability to kill living roots, but it is at the same time causal agent of "red rot", which ascends in the heartwood (heart rot) of the stem and is economically usually more serious. In Europe, on average, a 10% stem wood devaluation is counted for spruce by "red rot". In Scotland, the fungus is responsible for 90% of losses due to rot (Blanchette and Biggs 1992). The yearly damage in Germany amounts to € 56 million (Dimitri and Tomiczek 1998) and in the EU countries to about € 500 million (Woodward et al. 1998). "Red rot" increased in forest dieback sites.

The parasitic phase of the fungus develops first as root rot. In pine, the fungus predominantly grows stemwards in the root cambium area, until it is stopped by resin formation and a bark wound periderm. Large root parts die off. In the less resinous spruce, fir, larch and Douglas fir, fungal activity shifts, as soon as the mycelium reaches roots of more than 2 cm in diameter, into the root interior, that is, side roots and thus also the infected tree remain alive. Only if all roots are colonized, the mycelium also grows into the cambium and kills the tree.

The saprobic phase begins with penetration in the heartwood. Sapwood colonization occurs only after felling due to reduction of moisture content and particularly due to inhibition by the living sapwood (Shain and Hillis 1971). The effects of heartwood colonization depend on the tree species. In pine, the fungus spreads usually only insignificantly in the stem, but the tree dies due to the root damage. In larch, the mycelium grows in the heartwood/sapwood area and reaches likewise only low stem height. In spruce, the fungus climbs up in the stem 25–40 cm/year (Stenlid and Redfern 1998). Likewise, the Douglas fir stem can be colonized. The infected wood shows first a "1. color zone" (grey-

violet striping), then a "bright hard rot" (light brownish, wood still firm), later a "dark hard rot" (brownish-red, only wood structure remaining) and finally a "soft rot" (Fig. 8.14B; Zycha 1964), where the wood is fibrously dissolved and interspersed with small, white spindle-like nests with a black center of manganese deposits (Fig. 8.14C) (Hartig 1978; see Chap. 7.2).

Imperiled for *H. annosum* are first plantings on formerly agriculturally used pasture soils and arable lands ("field-dying", German: "Ackersterbe"). Conifers on base-rich and compacted ground, and on sites with very variable moisture content suffer more from the disease than those on acidic, more open soils with a more uniform water supply (Butin 1995; Schönhar 1997; Heinsdorf and Heydeck 1998). The inhibition of acidophilic, antagonistic mycorrhizas may play a role. A direct control is difficult, and only preventing measures are used (Schönhar 1990, 2002b). Rooting out and removing the infected stumps as well as isolating the infected sites by ditches are difficult and not always successful (Schönhar 1989). The most effective measure is to perform thinnings during the wintertime, as spore infection decreases during frost (Korhonen and Holdenrieder 2005). In not-yet-infected first plantings, the stumps which are the starting point for a propagation of the fungus via root grafts, have been coated on the fresh surface with carbolineum, which however delays the stump decomposition. Immediate treatment of the fresh surface with a sodium nitrite solution prevented spore germination of *H. annosum*. As chemical, also urea (Schönhar 2002b) and boron compounds are used (Pratt 1996). Originally in the U.K and later in Scandinavia and further European countries, a spore solution of the antagonistic fungus *Phlebiopsis gigantea* is immediately applied to the fresh stump surface of pines (Meredith 1959; Rishbeth 1963; Schwantes et al. 1976; Lipponen 1991; Gibbs et al. 2002) and spruce (Korhonen et al. 1994; Holdenrieder et al. 1997). There are spore preparations, which are specifically suited for spruce, but generally, *P. gigantea* is more suitable for pines. The wood can be automatically inoculated with spores through holes in the saw blade of the harvester (Metzler et al. 2005). The antagonist overgrows the stump cross surface, so that *H. annosum* cannot colonize it by spores. Thus, an infection of neighboring trees over root grafts is prevented. Further antagonists to *H. annosum* are treated by Holdenrieder and Greig (1998) and compiled by Woodward et al. (1998).

Root graft transmission can be reduced by far planting faces and admixture of hardwoods. Lesser sensitive hardwoods as well as fir or larch should be selected for particularly endangered sites instead of spruce and pine. In vitro, mycelial growth was inhibited by stilbenes, flavonoids and lignans (Zycha et al. 1976; Shain and Hillis 1971; Yamada 1992). Breeding attempts with the aim of red-rot resistant tree clones were performed, but did yet not reach a practical use. Recent resistance research mainly deals with the genetic mechanisms of resistance and the physiology of defense reactions (Korhonen and Holdenrieder 2005). Viruses in the root rot fungus, which are morphologically similar to the

Cryphonectria-hypovirus (Chap. 8.1.1.2), only reduced spore germination of the fungus.

8.3.3
Stereum sanguinolentum, Bleeding Stereum, Bleeding Conifer Parchment

Occurrence: conifers, particularly spruce; as saprobe causing red streaking discoloration (see Fig. 6.4a);

Significance: white rot, most important fungus involved in "Wound rot of spruce" (Butin 1995); 2/3 of about 20% of annual harvest of fir wood with fungal damage affected by wound rots, particularly by *S. sanguinolentum* (Schönhar 1989); wounds often due to mechanized wood harvest or bark damage by game; infection of the opened wood body by spores; also transmission of mycelial fragments by woodwasps (*Sirex* spp.); small and superficial wounds often closed by resin excretion; extension of white rot in the outer stem wood with reddish discoloration; fast rot extension (20 cm/year) in the first years after infection; rot spreads more rapidly after injuries at the root collar than after wounding the stem or small roots; injured roots of less than 2 cm in diameter and wounds in more than 1-m distance of the stem foot hardly lead to stem rot.

To prevent wound rot by *S. sanguinolentum*, tree harvest should be done carefully and injuries treated with a wound dressing. *Amylostereum* species may be also involved in wound decay of spruce and other conifers, *A. areolatum* and *A. chailletii*, both also being associated with woodwasps (Vasiliauskas 1999).

8.3.4
Fomes fomentarius, Tinder Fungus, Hoof Fungus

Occurrence: common, circumboreal, south to North Africa, through Asia to eastern North America; mostly hardwoods, common on birches in the north and on beeches in the south, also on oak, lime tree, maple, poplar, and willow, rarely on alder and hornbeam, exceptionally on softwoods (Schwarze 1994, 2001);

Fruit body (Fig. 8.15a): perennial (over 30 years, increase in early summer to autumn), thick, large (to 50 cm in diameter), hard brackets, mostly solitary; often high at the stem; firmly attached to the bark; upper surface: light brown to blackish-grey, bulging-zonate; pore surface: flat, cream-brownish hymenium with white margin; circular pores (4–5/mm); trimitic; soft-tough trama beneath a 1 to 2-mm-thick hard crust; 1–3 new hymenial layers per year; up to 240 million spores per cm^2 hymenium and hour; tetrapolar. In former times (e.g., in Haitabu), the trama was soaked with salpetre for tinder production.

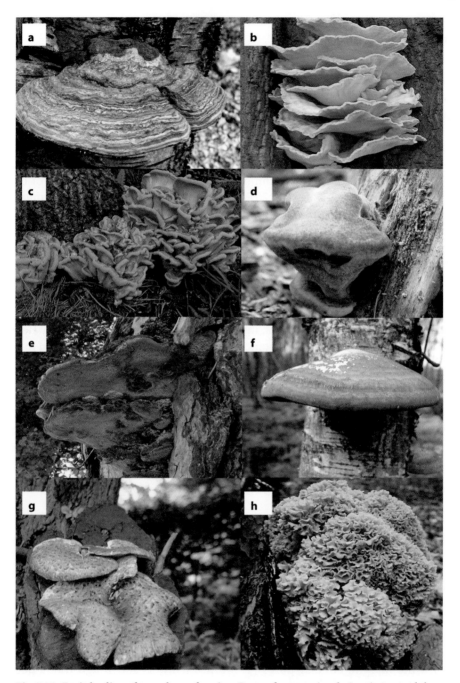

Fig. 8.15. Fruit bodies of tree decay fungi. **a** *Fomes fomentarius*. **b** *Laetiporus sulphureus*.
c *Meripilus giganteus*. **d** *Phaeolus schweinitzii*. **e** *Phellinus pini*. **f** *Piptoporus betulinus*.
g *Polyporus squamosus*. **h** *Sparassis crispa* (photos T. Huckfeldt)

A part of a fruit body was found at the "Ötzi" mummy. Still, around 1890, about 50 t of trama per year were sampled in the Bavarian, Bohemian and Thuringian forests for fire igniting, as styptic, and for the production of hoods, gloves and trousers (Hübsch 1991; Scholian 1996).

Significance: one of the most remarkable "large polypores"; infection of weakened and old trees via bark wounds or branch breakings; natural member in the biocoenosis of birch and beech forests; simultaneous white rot with black demarcation lines; at final stage, danger of windthrow; involved in the final decay of beech bark-diseased trees; saprobe on thrown or felled trees for several years ("Verstocken").

8.3.5
Laetiporus sulphureus, Sulphur Polypore, Giant Sulphur Clump

Occurrence: cosmopolitan, Europe, western North America, northeast Asia; preferentially on hardwoods with colored heartwood, like oak and robinia, also apple, beech, cherry, elm, lime tree, maple, pear, plum, poplar, willow, rarely on conifers; common on park and urban trees (Schwarze 2002);

Fruit body (Fig. 8.15b): annual (summer to autumn), conspicuous (upper surface: sulfur-yellow to reddish) wavy-velvety brackets (15–40 cm); pore surface: sulfur-yellow with angular pores (3–4/mm); single or in clusters; fresh: succulent-soft, later: inflexible, chalk-like, straw-colored to grey; dimitic; eaten in North America;

Significance: infection of the stemwood usually via wounds; brown rot in the heartwood; yellowish mycelium in broad, bind-like strips along the tears and shakes that develop in the wood; sapwood usually not attacked; infected trees alive for many years till broken or thrown by storm; rarely saprobic, e.g., on wooden boats.

8.3.6
Meripilus giganteus, Giant Polypore

Occurrence: circumboreal in the northern hemisphere, but nowhere common; usually hardwoods, particularly horse chestnut, beech, lime and oak; often on park and urban trees (Seehann 1979; Schwarze 2003);

Fruit body (Fig. 8.15c): annual (summer to autumn) on stumps of freshly felled trees and at the basis of standing trees; often apparently growing from the ground, but always in contact to wood; large and pileate with fan-shaped to spatulate pilei from a common base; aggregates to 1 m in diameter and 70 kg fresh weight; upper surface: cream-white to yellow-brown zonate; pore surface: cream to yellow-orange-brown pores (3–5/mm), rapidly blackish when bruised or cut; monomitic; eaten in Japan;

Significance: white rot in damaged roots of usually older trees, weakened due to compressed soil, asphalting, salting, and by wounds due to building operations or road traffic; fruit bodies indicate a heavily destroyed root system leaving only little time to the trees for surviving; stem hardly infected. Tree care in the urban area reduces the damage.

8.3.7
Phaeolus schweinitzii, Dye Polypore, Velvet Top Fungus

Occurrence: circumglobal, in European conifer forests north to 70 °N in Finnmark, Norway, particularly pine, Douglas fir, also spruce and larch, rarely on hardwoods (Ryvarden and Gilbertson 1993);

Fruit body (Fig. 8.15d): annual (late summer), easy-passing; at the stem basis or on the soil on hidden roots; stipitate, short, central, upward more thick, cylindrical to knotty stipe, first with spinning-top-like, later with several tile-like caps (to 40 cm); on the cross cuts of felled trees with lateral stipe; frequently including plant residues or small branches during ripening; upper surface: when young orange, later yellowish-brown, old often black; yellow-brown margin; woolly; pore surface: angular pore (1–2/mm) layer at first orange, later greenish to rusty brown, discolors with pressure red-brownish; monomitic;

Significance: brown rot, major cause of butt rot in the heartwood of old pine and Douglas fir; frequently in conifers forests on former hardwood soils (Schönhar 1989); first on roots and in stem wounds, later in the stem heartwood, less ascending the stem (butt rot); decayed wood and laboratory cultures with turpentine smell; saprobe on dead trees, stumps and logs for several years.

8.3.8
Phellinus pini, Ochre-Orange Hoof Polypore

Occurrence: circumglobal, widespread in northeast Europe on pine, in North America and Asia on other conifers as well (Heydeck 1997; Frommhold and Heydeck 1988);

Fruit body (Fig. 8.15e): perennial (to 50 years), brackets only 5–20 years after infection near branch holes and stubs; often high at the stem of old trees (Naumann 1995), 5–12 cm; upper surface: zonate, rough, cracked, at first rust-brown, hirsute, later dark-brown-blackish, glabrous and encrusted; pore surface: yellow to grey-brown with round to angular/daedaleoid pores (1–3/mm); dimitic, bipolar;

Significance: infection of old (30–50 years) pine and larch at exposed heartwood (branch stubs, wounds); living sapwood usually not penetrated; often high at the stem (Hartig 1874; Liese and Schmid 1966); from deep-reaching

dead branches decay upwards and downwards in the stem; white-pocket rot, preference for latewood of *Pinus* and *Larix* (Liese and Schmid 1966; Blanchette 1980), pockets in some hosts concentrated in the earlywood bands ("laminated rot", ring shake); occurrence of transpressoria and formation of cavity-shaped decay pattern (Liese and Schmid 1966); local bark deepenings, outer sapwood resin-infiltrated (in former times wood used as resinous wood); in spruce, infection also via sapwood; wood still relatively firm at early decay; dying after tree felling.

8.3.9
Piptoporus betulinus, Birch Polypore, Birch Conk Fungus

Occurrence: circumboreal, north to Norwegian North Cape at 71 °N (Ryvarden and Gilbertson 1994); only birch; also in gardens and parks;
 Fruit body (Fig. 8.15f): annual (summer to late autumn), but enduring; solitary and in groups; shell-shaped, fan-like brackets (8–30 cm); pilei pendent, dimidiate, or reniform; often several meters high on the stem; upper surface: dull-smooth, unzonate, young cream-white, later ochre-brown to grey-brown, old usually cracked; pore surface: white to cream-brownish circular to angular pores (3–5/mm); dimitic; some isolates bipolar (Stalpers 1978); fruit body previously used in Fennoscandia as a cushion for knives, which do not rust while standing in the fruit body;
 Significance: weakness-parasite, host-specific on older and weakened (e.g., lack of light) birch; infection via wounds (branch breakage); brown rot; danger of windthrow.

8.3.10
Polyporus squamosus, Scaly Polypore

Occurrence: circumpolar in Europe (north to Finnmark at 70 °N), Australia, Asia, and America; hardwoods such as ash, beech, elm, horse chestnut, lime, maple, planetree, poplar, and willow (Schwarze 2005); frequently on urban and park trees;
 Fruit body (Fig. 8.15g): annual (early summer); solitary or in groups from a branched base; usually laterally stipitate, with circle to fan-like cap (to 80 cm wide and 2 kg fresh weight); upper surface: yellow-ochre with concentrically arranged light to dark-brown, scale-like patches, smooth and sticky; pore surface: cream-yellowish with angular-oval pores (1–2/mm); whitish stipe (up to 10 cm) at the basis dark-brown to black-felty; dimitic; tetrapolar (Stalpers 1978); young edible;
 Significance: white rot in the heartwood of living and dead hardwoods with black demarcation lines after penetration through wounds.

8.3.11
Sparassis crispa

Occurrence: rare in Europe; particularly pine, also Douglas fir, spruce and fir;

Fruit body (Fig. 8.15h): annual (summer to late autumn); solitary at the root area of living pines, lateral and at cross surface of stumps and fallen stems; hemispherical to cushion-shaped; resembling a large (up to 70 cm and 6 kg fresh weight) sponge, cauliflower, or coral (German: "Krause Glucke"); consisting of numerous, wavy, narrow upright-standing branches deriving from a fleshy stalk; frizzy, leaf-like branch-ends partly growing together, similar to Icelandic moss; surface: smooth, cream, later ochre, when old with brown margin, finally completely brown; hymenium on the outside, downward arranged side of the branches; monomitic; when young well edible mushroom (in Germany certified as market fungus) with whitish meat, spicy morel-similar smell and nut-like taste; fruit bodies also on agar cultures; some isolates tetrapolar (Stalpers 1978);

Significance: parasitically in roots of older pines, ascending to 3 m high with brown rot in the stem heartwood; decayed wood with turpentine smell; economically important wood losses in pine and Douglas fir (Heydeck 1994).

8.4
Damage to Stored Wood and Structural Timber Outdoors

After felling or falling of a tree, the living cells die some time later. The active defense systems do not function any longer. Some fungi that are already present in the stem can continue degradation by their now saprobic way of life, e.g., *Fomes fomentarius*. The exposed wood surfaces however rapidly dry, and new ecological conditions develop. Thus, the stem usually provides a new energy-rich substrate for rapid colonization by several saprobic organisms (Zabel and Morrell 1992).

Colonization and discolorations of the stem in the forest occur frequently within short time by bacteria, algae, slime fungi, molds, and blue-stain and red-streaking fungi. After longer exposure wood decays by brown, white and soft-rot fungi develop, which may be summarized as "decay of stored wood", or "colonization of fallen and cut wood" (Rayner and Boddy 1988). Among the Basidiomycetes are e.g., *Armillaria gallica*, *Bjerkandera adusta*, *Chondrostereum purpureum*, *Fomes fomentarius*, *Stereum* spp., *Schizophyllum commune* and *Trametes versicolor*. Several fungi are involved in the decomposition of the stumps remaining in the soil e.g., *Armillaria* spp., *B. adusta*, *C. purpureum*, *Daedalea quercina*, *Fistulina hepatica*, *Ganoderma* spp., *Gloeophyllum* spp., *Grifola frondosa*, *Heterobasidion annosum*, *Meripilus giganteus*, *Phaeolus schweinitzii*, *Phlebiopsis gigantea*, *Pleurotus ostreatus*, *Stereum* spp.,

S. commune and *T. versicolor*. On tree residues remaining in the forest (top, branches) grow e.g., *B. adusta*, *C. purpureum*, *Coniophora puteana*, *Gloeophyllum sepiarium*, *Stereum sanguinolentum* and *T. versicolor*. Forest-litter degrading Basidiomycetes were described by Frankland et al. (1982).

Damages on roundwood (logs, poles) and boards may occur during transport and inappropriate storage e.g., by *C. puteana*, *Fomitopsis pinicola*, *Gloeophyllum trabeum*, *Paxillus panuoides*, *Phlebiopsis gigantea*, *S. sanguinolentum* and *Trichaptum abietinum*. Wood chips are damaged by *B. adusta*, *Gloeophyllum* spp., *Phanerochaete chrysosporium*, *T. versicolor*, and by several Deutero- and Ascomycetes (molds, blue-stain and soft rot fungi). Several bacteria, yeasts, Deuteromycetes and Ascomycetes were found in stored annual plant residues, like sugarcane bagasse (Schmidt and Walter 1978).

Yeasts commonly colonize twigs, leaves, litter, and humus, are however also found on freshly sawn lumber (Mikluscak et al. 2005).

Structural timber that is used outdoors in ground contact, like sleepers, poles, posts, fences, bridges and garden furniture, is attacked by soft-rot fungi if it is insufficiently treated with wood preservatives. Among the Basidiomycetes occur e.g., *Antrodia vaillantii*, *H. annosum*, *Lentinus lepideus*, *Leucogyrophana pinastri*, *Oligoporus placenta*, *Phanerochaete sordaria*, *Phlebiopsis gigantea*, *Serpula himantioides*, *Sistotrema brinkmanni*, *Trametes versicolor* and *Trichaptum abietinum* (e.g., Lombard and Chamuris 1990; Morrell et al. 1996).

Mine timber was decayed by *A. vaillantii* and *C. puteana* as well as by *Armillaria* spp., *G. sepiarium*, *H. annosum*, *L. lepideus*, *L. pinastri*, *O. placenta*, *Paxillus panuoides*, *Schizophyllum commune*, *Serpula lacrymans*, *Stereum* spp. and *T. versicolor* (Eslyn and Lombard 1983). *Earliella scrabosa*, *Loweporus lividus*, *Rigidoporus lineatus*, and *R. vinctus* were isolated from gold mine poles in India (Narayanappa 2005).

Wood in fresh water, like in cooling towers, is often destroyed by soft-rot fungi. Among the Basidiomycetes, e.g., *Donkioporia expansa* and *Physisporinus vitreus* have been isolated from cooling-tower woods (v. Acker and Stevens 1996). The latter fungus degraded pine sapwood samples that showed a final moisture content of up to 320% u (Schmidt et al. 1996). Schwarze and Landmesser (2000) hypothesized that the preferential degradation of tracheidal pit membranes is associated with the adaptation of this fungus to very wet substrates. Wood in salt water below (not permanent) the sea level, as in harbor constructions, is predominantly attacked by Deuteromycetes and Ascomycetes and rarely by Basidiomycetes (Jones et al. 1976; Kohlmeyer 1977; Leightley and Eaton 1980). Basidiomycetes, like *Antrodia xantha*, *Daedalea quercina*, *Gloeophyllum sepiarium*, *Laetiporus sulphureus*, *Lentinus lepideus*, *Phlebiopsis gigantea*, *Schizophyllum commune* and *Xylobolus frustulatus* dominate in wood above the water level, like in docks, stakes or boats (Rayner and Boddy 1988).

Damages on stored and structural timber in outside use can be reduced or even avoided by means of protection measures against fungal activity described

in Chap. 6.4: winter felling, short and adequate storage of the fresh roundwood, wet storage, rapid drying, storage in a gas atmosphere (N_2/CO_2), and storage of cut timber in well-ventilated piles with protection against rain as well as chemical protection.

In the following, some common Basidiomycetes on wood in outside use are described, mostly in note form. For details see also Grosser (1985), Breitenbach and Kränzlin (1986, 1991), Zabel and Morrell (1992), Eaton and Hale (1993), Ryvarden and Gilbertson (1993, 1994), Bech-Andersen (1995), Butin (1995), Kempe (2003), Krieglsteiner (2000), and Weiß et al. (2000).

8.4.1
Daedalea quercina, Maze-Gill, Thick-Maze Oak Polypore

Occurrence: circumglobal and throughout Europe, North America, North and Central Asia, North Africa; in northern Europe only on oaks, in central and southern Europe also on *Acer, Carpinus, Castanea, Chamaecyparis, Corylus, Eucalyptus, Fagus, Fraxinus, Juglans, Juniperus, Populus, Picea, Prunus, Robinia, Sorbus, Tilia,* and *Ulmus* (Ważny and Brodziak 1981);

Fruit body (Fig. 8.16h): perennial, single or fused, broadly sessile, dimidiate, flat or ungulate, sometimes imbricate, sometimes nodular or deformed, large brackets (up to 30 cm wide and 8 cm thick) often high at the stem; hard and corky to woody; upper surface: grooved, uneven, covered with nodes, glabrous or somewhat pubescent, cream, ochraceous grey to brown; pore surface: sinuous, or daedaleoid to labyrinthine, or almost lamellate, pores 1–4 mm wide measured tangentially, walls up to 3 mm thick; monstrous fructification in the dark; trimitic; bipolar;

Significance: brown rot in the durable heartwood of oaks and other hardwoods; on wounded standing trees via exposed heartwood, dead branches, on stumps, fallen stems, on sleepers, poles, stakes, wooden bridges, mine timber; occasionally in buildings on weathered timber, like window sills and half-timbering.

8.4.2
Gloeophyllum Species, Gill Polypores

Three *Gloeophyllum* species are relevant to wood. The fungi have similar fruit bodies and life conditions (Hof 1981a, 1981b, 1981c; Grosser 1985; also Bavendamm 1952a), and are thus usually united as "wood gill polypores". They are widespread in Europe, North America, North Africa, and Asia on conifers and hardwoods. *Gloeophyllum abietinum* is a somewhat southern species, *G. trabeum* a southern species.

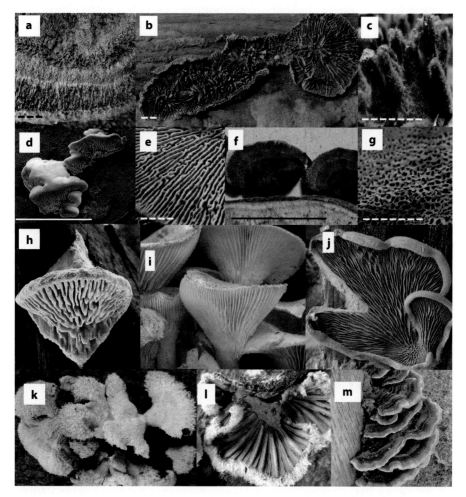

Fig. 8.16. Fruit bodies of decay fungi on stored wood and on timber in outdoor use. *Gloeophyllum abietinum.* **a** Upper side. **b** Lower side. **c** Darkness fruit bodies; *Gloeophyllum sepiarium* **d** Upper side. **e** Lower side; *Gloeophyllum trabeum* **f** Upper side. **g** Lower side. **h** *Daedalea quercina;* **i** *Lentinus lepideus;* **j** *Paxillus panuoides; Schizophyllum commune* **k** Upper side. **l** Lower side. **m** *Trametes versicolor* (photos T. Huckfeldt)

Gloeophyllum abietinum, Fir Gill Polypore

Fruit body (Fig. 8.16a,b): perennial, pileate (2–8 cm wide), broadly attached, often in rows or tile-like, on timber lower side resupinate; upper surface hirsute to velutinate, in age zonate, scrupose to warted or smooth, rusty yellow, reddish-brown to dark grey and black when old, when young whitish-yellow-brown, wavy, sharp margin; hymenophore ochre-grey brown, wavy lamellae (8–13/cm, behind the margin) with anastomosing, serrate, mixed with poroid areas; monstrous fruit bodies in the dark (Fig. 8.16c); trimitic; bipolar;

Strands: only rarely on timber in laboratory culture, cream-ochre-dark brown; fibers to dark brown; no vessels.

Gloeophyllum sepiarium, Yellow-Red Gill Polypore

Fruit body: (Fig. 8.16d, e) annual to perennial, pileate, broadly sessile, dimidiate, rosette shaped, often imbricate in clusters from a common base or fused laterally, to 7 cm wide, 12 cm long and 6–8 mm thick, margin slightly wavy; upper surface when young yellowish brown, then reddish brown and grey to black when old; scrupose, warted to hispid, finally zonate often differently colored; hymenophore with straight lamellae (15–20/cm, behind the margin), edges of lamellae golden brown in active growth, later umber brown, side surface of lamellae ochre-brown; usually mixed with daedaleoid to sinuous pore areas (1–2/mm); monstrous fruit bodies in the dark; trimitic; bipolar;

Strands: only rarely on timber in laboratory culture, white-cream; fibers yellow to brown, no vessels.

Gloeophyllum trabeum, Timber Gill Polypore

Fruit body (Fig. 8.16f, g): annual to perennial, pileate, sessile, imbricate with several basidiomes from a common base or elongated and fused along wood cracks, to 3 cm wide, 8 cm long, 8 mm thick; upper surface soft and smooth, hazelnut to umber brown to grayish when old, weakly zonate to almost azonate, lighter margin; hymenophore semi-lamellate or labyrinthine to partly poroid (2–4/mm), rarely lamellate specimens with up to four lamellae/mm along the margin, ochre to umber brown; monstrous fruit bodies in the dark; dimitic; bipolar;

Strands: only on timber in laboratory culture, white-beige to yellow-orange-grey brown, below 1 mm thick; fibers yellow to brown; no vessels.

Significance: predominantly saprobic, *G. sepiarium* and *G. trabeum* exceptionally on living trees; belonging to the strongest brown-rot fungi of coniferous structural timber; often on stumps; broad moisture optimum (about 40 to 200% u; Table 8.7), on stored timber and on finished timber that is again moistened, like poles, posts, fences, sleepers and mining timber. The fungi are the most important destroyers of conifers windows (cf. Fig. 8.17) that had accumulated moisture due to inappropriate window construction and handling faults by the user (e.g., injuring of the lacquer layer by nails). For example, 3.5 million (7%) of wooden windows were partly or completely destroyed by fungi, predominantly by *G. abietinum*, in Germany between 1955 and 1965 (Seifert 1974). Fungi survive in the sun-warmed and dry window timber due to their heat and dryness resistance [*G. abietinum*: 5–7 years survival in dry timber: Theden (1972)]. Fungi cause (by means of substrate mycelium) decay first only in the wood interior ("interior rot"). The serious brown rot under the varnish layer is often only recognized if fruit bodies develop. Except on

window timber, the gill polypores occur in buildings after moisture damages or incorrect structure on roofing timbers, on façades, outside doors, balconies, and on timber in saunas and mines.

8.4.3
Lentinus lepideus, Scaly Lentinus

Occurrence: temperate zones, common in Europe, North America, former Soviet Union, India; conifers, particularly *Pinus*, also *Abies, Cedrus, Larix, Picea, Pseudotsuga, Tsuga;*

Fruit body (Fig. 8.16i): mainly eccentric, stipe (up to 7 cm long), pileus 5–15 cm wide; fleshy-tough to hard in age, initially convex, later applanate; upper surface: pale to cream or purplish brown, with brownish scales (name!) in radial orientation; lower surface: whitish to yellow-ocher, serrate gills; monstrose, sterile fruit bodies in the dark (Seehann and Liese 1981); dimitic (Kreisel 1969);

Significance: brown rot of heartwood, via wounds and dead branches in standing trees, on stumps, felled logs, serious damage on structural timbers outdoors in ground contact (poles, sleepers, fence posts, stakes, wooden bridges, harbor timbers) (Bavendamm 1952b), on mine timber; particularly dangerous due to resistance to heat, desiccation and coal tar oil (test fungus in EN 113 for tar oil and comparable compounds); degradation of pine heartwood (interior rot) in improperly impregnated (drying shakes developed after treatment) poles and sleepers; rarely in buildings, particularly in the cellar and on damp timber on the ground floor, on joist heads in contact with wet masonry, door posts, roof timber; pleasant smell of the fresh mycelium of Peru balsam.

8.4.4
Paxillus panuoides, Stalkless Paxillus

Occurrence: mostly conifers;

Fruit body (Fig. 8.16j): annual, thin, small (2–12 cm), shell-shaped, bell-shaped, small eccentric stipe or attached, solitary or in groups, also tile-like; upper surface: pale-yellow to olive brown; lower surface: saffron-orange gills; monomitic; normal fructification in the dark (Kreisel 1961);

Significance: slowly growing, but serious brown rot; rarely at the basis of living pines, on stumps, stored wood, structural timber outdoors (sleepers, bridges, balconies), garden furniture, mine timber, rarely in buildings, associated with the *Coniophora* spp., on very moist places in cellars, cow-sheds, greenhouses.

8.4.5
Schizophyllum commune, (Common) Split-Gill

Occurrence: circumglobal, temperate to tropical, very common, predominantly hardwoods like *Fagus, Quercus, Tilia,* fruit woods, bamboos, straw, tea-leaves, coconut fibers;

Fruit body (Fig. 8.16k, l): annual, but durable, thin, small, shell-shaped (1–5 cm), dimidiate; usually in groups, leathery-tough; upper surface: grey-brown to flesh-colored becoming white with dryness, downy-woolly; lower surface: appearing as if gilled, hymenium covering fan-like arranged, at the beginning grey, later violet-brown pseudolamellae, which are lengthwise split and outwardly bent (Fig. 3.3d); hygroscopic movements of the split lamellae by being hard and rolled up in dry weather and being again flexible and sporulating after years of dryness when again moist; monomitic, tetrapolar (Raper and Miles 1958); formerly eaten in Assam, Congo, Peru and Thailand, and used as chewing gum in Hong Kong, Indonesia and Malaysia (Dirol and Fougerousse 1981); fructification also in culture;

Significance: white rot; as wound parasite on living trees after bark fire damage, on stumps, stored stems, frequently on beech as first colonizer; on stored and structural timber outdoors surviving dryness and exposition to sun by dryness resistance; in the tropics serious wood destroyer, fruit bodies often on imported timber; in vitro only little wood decay (Schmidt and Liese 1980).

8.4.6
Trametes versicolor, Many-Zoned Polypore

Occurrence: circumglobal, very common throughout Europe, dead wood of almost all hardwoods, particularly *Fagus,* also *Betula,* no attack of *Quercus, Castanea,* and *Robinia* (Jacquiot 1981), rarely conifers, also fruit woods after pruning;

Fruit body (Fig. 8.16m): annual, often reviviscent, hard-leathery, sessile or effused-reflexed, pilei dimidiate-substipitate, convex or imbricate, rarely resupinate, to 10 cm wide, often in large imbricate clusters, rarely solitary; upper surface: hirsute to tomentose, highly variable in color, with sharply contracted concentric zones of brown, buff, reddish or bluish colors (name!), often green by algae; lower surface: cream-white to ochraceus-yellow, angular to circular pores (4–5/mm); in the dark self-colored fruit bodies with totally white hirsute upper surface; trimitic; tetrapolar;

Significance: white-rot, often with black demarcation lines ("marble rot"); on wounded or dead standing trees, on stored stems, common on 4–6 years old hardwood stumps; rarely on sleepers, fence posts, garden timber; on mine timber; dryness resistance; used after World War II in the former East Germany

for the production of "myco-wood" for pencils, rulers, etc. (Luthardt 1963); test fungus in EN 113 for hardwood samples.

8.5
Damage to Structural Timber Indoors

8.5.1
General and Identification

The indoor wood decay fungi ("house-rot fungi") cause considerable economical damage in buildings. They may be considered to be the most important "wood fungi" as they deteriorate wood at the end of the economical series "forestry" – "timber harvest" – "storage" – "structural timber" – "indoor use". For Britain, it has been estimated that the cost of repairing fungal damage of timber in construction in 1977 amounted to £ 3 million per week (Rayner and Boddy 1988). An estimate for the former East Germany amounts to an avoidable damage in old houses of € 1.5 billion (Huckfeldt 2003). In the northern hemisphere, mainly coniferous wood is used as interior structural timber, in Germany particularly *Picea abies*. The most important wood-degrading fungi within buildings in Europe and North America are therefore fungi that cause brown rot in conifers. White-rot fungi, which preferentially attack hardwoods, are less common in buildings. Depending on the state of knowledge, formerly often only three more well-known species (groups) were called house-rot fungi in Europe: the True dry rot fungus, *Serpula lacrymans*, the cellar fungi *Coniophora* spp. (formerly only *C. puteana*) and the indoor polypores, formerly called "*Poria* group" (probably mainly *Antrodia vaillantii*). These three groups cause about 80% of the fungal wood damages in buildings. Recently, the Oak polypore, *Donkioporia expansa*, has also been accepted as important indoor rot fungus (Kleist and Seehann 1999). The Gill polypores (Falck 1909) may be included to the indoor species as they are common destroyer of painted coniferous window timber (Fig. 8.17) and also occur on damp roofing timber.

There are some evaluations on the frequencies of the various species involved in indoor wood decay. A survey of 1,500 buildings in New York State from 1947 to 1951 showed several fungi and *Hyphodontia spathulata*, *G. sepiarium*, *A. xantha*, and *G. trabeum* as most frequent isolations from decayed wood (Silverborg 1953). An investigation of 3,050 buildings in Poland showed 53.8% *S. lacrymans*, 22.4% *C. puteana* and 11.3% *A. vaillantii* (Ważny and Czajnik 1963). A survey of 1,200 biotic damages in buildings of the former East Germany over 21 years resulted in 34.8% *S. lacrymans*, 14.6% *Coniophora* spp., 13% soft rot and 8.7% "*Poria*" (Schultze-Dewitz 1985). An evaluation of 749 damages in Belgium between 1985 and 1991 revealed 59.4% *S. lacrymans*,

Fig. 8.17. *Gloeophyllum* sp. on window joinery. Fruit body and brown-rotten softwood

10.1% *C. puteana, C. marmorata*, 9.5% *Donkioporia expansa*, 2.3% *Antrodia vaillantii, A. sinuosa, A. xantha* and some further species (Guillitte 1992). An evaluation of a total number of 3,434 decay fungi in Norwegian buildings from 2001 to 2003 found as the most frequent fungi 18.4% *Antrodia* species, 16.3% *C. puteana*, 16.0% *S. lacrymans* and 2.9% *G. sepiarium* (Alfredsen et al. 2005). A recent survey over 4 years in 63 buildings in North Germany yielded 36 basidiomycetous species (Table 8.6). Supplemented by literature research, altogether about 70 different house-rot fungi have been reported (Huckfeldt and Schmidt 2005). However, those literature compilations might be uncertain due to the use of synonyms and the change in fungal nomenclature.

A survey of 5,000 cases of damage in multistorey houses revealed that all timbers without sufficient basic protection are endangered, but that there are different damage centers in a home: "*Poria*" and soft rot in the attic and upper floor, and *S. lacrymans* and *Coniophora* spp. on the ground and in the cellar (Schultze-Dewitz 1990).

Some of the less common indoor Basidiomycetes are listed in Table 8.6. Among them, *Lentinus lepideus* is particularly found in damp cellars, on the ground floor and in beam-ends in contact with wet masonry (Bavendamm 1952b). *Paxillus panuoides* occurs in cellars (Bavendamm 1953). *Daedalea quercina* affects structural oak-wood (windows, half-timbering). Falck (1927) mentioned for cellars *Polyporus squamosus* and Coggins (1980) also *Laetiporus sulphureus, Phlebiopsis gigantea* and *Trametes versicolor*. A description of the Dry rot fungus and other fungi in houses and on timber in exterior use has been compiled by Bech-Andersen (1995). Some of the more rare indoor species normally occur on trees or timber in outdoor use and are described in Chaps. 8.3 and 8.4. Further indoor damages are discolorations of window

Table 8.6. Species and frequency of house-rot fungi and accompanying fungi in buildings in northern Germany (from Huckfeldt and Schmidt 2005)

Species	Frequency
Serpula lacrymans	53
Coniophora puteana	7
Antrodia sp.	6
Antrodia xantha	5
Coprinus spp., three species	5
Donkioporia expansa	5
Asterostroma cervicolor	4
Antrodia sinuosa	3
Antrodia vaillantii	2
Coniophora marmorata	2
Dacrymyces stillatus	2
Diplomitoporus lindbladii [a]	2
Gloeophyllum trabeum	2
Lentinus lepideus	2
Leucogyrophana pinastri	2
Leucogyrophana pulverulenta	2
Paxillus panuoides	2
Trechispora farinacea	2
Asterostroma laxum [a]	1
Cerocorticium confluens [a]	1
Cerinomyces pallidus [a,b]	1
Gloeophyllum abietinum	1
Gloeophyllum sepiarium	1
Gloeophyllum sp.	1
Grifola frondosa [a]	1
Heterobasidion annosum	1
Hyphoderma praetermissum	1
Leucogyrophana mollusca	1
Oligoporus placenta	1
Oligoporus sp.	1
Phellinus contiguus	1
Phellinus pini	1
Pluteus cervinus [a]	1
Stereum rugosum	1
Trametes multicolor	1
Trichaptum abietinum	1
Volvariella bombycina	1
non-decay fungi:	
Peziza repanda	5
Reticularia lycoperdon	3
Cladosporium sp.	2
Fuligo septica	1
Ramariopsis kunzei	1
Scutellinia scutellata [a]	1

[a] For the first time proven to occur in houses
[b] First proof in Germany (Huckfeldt and Hechler 2005)

timber and outside doors by blue-stain fungi and molding in damp rooms (Chap. 6) (Frössel 2003; Hankammer and Lorenz 2003).

The common house-rot fungi are serious wood decayers. Among them, *S. lacrymans* is considered in Europe as most dangerous and most hardly controllable fungus due to its ability to transport nutrients and water. Traditionally, it is also supposed to possess some further specific features, which, however, do not all stand up to laboratory results. Nevertheless, in Germany, *S. lacrymans* has to be clearly differentiated from the other house-rot fungi in view of refurbishment. More far-reaching measures have to be performed in the case of its presence. Thus species identity should be known.

For identification, fruit bodies are preferentially used (Grosser 1985; Breitenbach and Kränzlin 1986; Jahn 1990; Ryvarden and Gilbertson 1993, 1994; Krieglsteiner 2000; Weiß et al. 2000; Kempe 2003; Bravery et al. 2003). A diagnostic key for fungi on structural timbers based on their fruit bodies is available in the internet and is to be completed in time (Huckfeldt 2002).

Some species only rarely fructify in buildings, or after isolation in laboratory culture, or do it never. However, some house-rot fungi form mycelial strands (cords). The classical strand diagnosis from Falck (1912) is old and includes only a few species. A diagnostic key including color photographs based on measurements in infected buildings and on wood samples in laboratory culture comprises several species (Huckfeldt and Schmidt 2004, 2006). An updated version is shown in Appendix 1. A recent textbook comprises photographs and identification keys for fruit bodies and strands of fungi occurring on wood in indoor and exterior use (Huckfeldt and Schmidt 2005).

If neither fruit bodies nor strands, but only vegetative mycelia are present, e.g., if only mycelium is found in buildings, or as it is the case for fungi cultured in the laboratory on agar, there are keys and books for mycelia (Nobles 1965; Stalpers 1978; Lombard and Chamuris 1990). However, some genera among the house-rot fungi are hardly or not at all distinguishable into species, like *Antrodia*, *Coniophora* and *Leucogyrophana*. Thus, molecular methods may be used (Chap. 2.4.2). Among the DNA-based techniques, species-specific ITS-PCR differentiated seven indoor wood-decay Basidiomycetes (Fig. 2.23, Table 2.9; Moreth and Schmidt 2000). The technique is meanwhile used in Germany for commercial identification of house-rot fungi. Sequencing of the internal transcribed spacer (ITS) of the ribosomal DNA (rDNA) and subsequent sequence comparison by BLAST with ITS sequences from correctly identified fungi deposited in the nucleotide databases is to date the best molecular tool for diagnosis (Table 2.8 and Fig. 2.22; Schmidt and Moreth 2002, 2003).

There is a great number of investigations on the physiology of house-rot fungi in text books (e.g., Jennings and Bravery 1991), monographs (e.g., Cockcroft 1981), and publications that may used in support of identification. Among the physiological parameters, growth rate and reaction to wood moisture con-

Table 8.7. Cardinal points of wood moisture content (% u) of some house-rot fungi for colonization and decay of wood (after Huckfeldt and Schmidt 2005)

Species	Minimum for colonization (moisture source 20–30 cm away)	Minimum for decay (mass loss above 2%)	Optimum for decay (mass loss above 10%)	Maximum for decay (mass loss above 2%)
Serpula lacrymans	21	26	45–140	240
Leucogyrophana pinastri	30	37	44–151	184
Coniophora puteana	18	22	36–210	262
Antrodia vaillantii	22	29	52–150	209
Donkioporia expansa	21	26	34–126	256
Gloeophyllum abietinum	20	22	40–208	256
Gloeophyllum sepiarium	28	30	46–207	225
Gloeophyllum trabeum	25	31	46–179	191

tent and temperature are important features. However, some of the older data suffer in so far as they derive from only vague or incorrectly identified fungi. Data that are based on genetically verified fungi are shown in Tables 2.2, 3.8–3.11, and 8.7.

Regarding the most important influence on wood decay, wood moisture, opinion has it that the indoor polypores need moisture above the fiber saturation range, which often occurs only after wetting with water, whereas the *Coniophora* spp. mostly attack wood, which was moisturized by vaporous water or by contact with damp material. The Dry rot fungus is halfway as it germinates on contact-wetted timber, but takes water from wet substrates by capillary mechanism and translocates water in its mycelium to timber for further growth (Schultze-Dewitz 1985).

In piled Scots pine sapwood samples placed on agar in 2-L Erlenmeyer flasks, a continuous wood moisture gradient developed within 6 weeks by diffusion from the agar via the lowest sample, which was water-saturated to the uppermost air-dried sample (Huckfeldt 2003). Table 8.7 shows that all fungi subsequently inoculated on the agar near the bottom wood sample degraded very wet wood. For example, *S. lacrymans* showed more than 2% wood mass loss in a sample of 240% final moisture content. The optimum moisture for decay (mass loss above 10%) varied among the species from 36 to 210% u. The minimum moisture for decay (mass loss above 2%) was slightly below fiber saturation and for *C. puteana* and *G. abietinum* significantly low at 22% u. Minimum moisture for wood colonization was for some fungi around 20% u, whereby the wood sample was 20–30 cm away from the agar as the water source (Huckfeldt and Schmidt 2005).

8.5.2
Lesser Common Basidiomycetes in Buildings

The following species description starts with some lesser common fungi and ends with the most serious European fungus, the True dry rot fungus *Serpula lacrymans*, in order of a transition to the remedial treatments. *Daedalea quercina*, *Gloeophyllum* species, *Lentinus lepideus* and *Paxillus panuoides*, which also occur in buildings, have been already described in Chap. 8.4. The following data are based on observations and measurements in attacked buildings and on genetically verified pure cultures on wood samples in the laboratory (Huckfeldt 2003; Huckfeldt and Schmidt 2005; Huckfeldt et al. 2005; Schmidt and Huckfeldt 2005), and were supplemented mainly from Grosser (1985), Breitenbach and Kränzlin (1986), Ryvarden and Gilbertson (1993, 1994), and Bravery et al. (2003).

8.5.2.1
Diplomitoporus lindbladii

Occurrence: circumpolar in the conifers zone, in Europe throughout the conifer forest regions, but rare in the Mediterranean region, North America, also on hardwoods;

Fruit body (Fig. 8.18a): annual to biannual, resupinate, becoming widely effused (a few decimeters), up to 6 mm thick, biannual basidiomes thicker, frayed margin, easily separable; upper surface white-cream, grey when old; pore surface with 2–4 circular-angular pores/mm, to 3 mm deep; trimitic; allantoid to cylindrical, hyaline spores (5–7 × 1.5–2 µm); bipolar;

Strands (Fig. 8.18b): on timber in laboratory culture, white, yellowing when dry, root-like, iceflower-like, similar to *A. vaillantii*; fibers similar to *A. vaillantii*, but soluble in 5% KOH;

Significance: white rot, indoors.

8.5.2.2
Asterostroma cervicolor and *A. laxum*

Fruit body (Fig. 8.18c): resupinate, sheet-like, thin, whitish to ochre or cinnamon, hardly distinguishable from mycelium; no pores; may be found on masonry; spores warty (*A. cervicolor*), without warts (*A. laxum*); monomitic;

Strands and mycelium (Fig. 8.18d): cream-brown, up to 1-mm-wide strands with a rough appearance, flexible when dry, sometimes across and inside masonry over a long distance, brown strands often present next to fruit body,

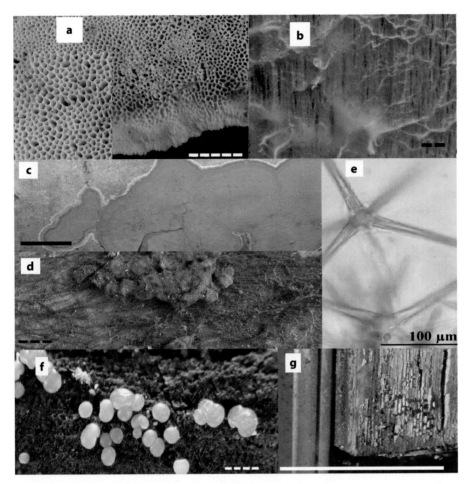

Fig. 8.18. *Diplomitoporus lindbladii* **a** Fruit body and detail. **b** Mycelium and strands on white-rotten wood; *Asterostroma cervicolor* **c** Fruit body on a ground ceiling. **d** Knotty mycelium and strands on a floorboard. **e** Stellar setae; *Dacrymyces stillatus* **f** Young fruit bodies. **g** Old fruit bodies on window joinery (photos T. Huckfeldt) — 5 cm, - - - 5 mm

embedded in white mycelium or in fruit bodies (*A. laxum*); surface mycelium of *A. cervicolor* first white, then brown, partly only small mycelial plugs;

Stellar setae (Fig. 8.18e): within basidiome, mycelium and strand (German: "Sternsetenpilz"); setae dichotomically branched, to 90 µm in diameter and partly rare in *A. laxum*, setae rarely branched and to 190 µm in diameter in *A. cervicolor*;

Significance: white-rot, softwoods, often on joinery, e.g., skirting boards, floor and ceiling boards, windows, fiber and gypsum boards, decay often limited in extent.

8.5.2.3
Dacrymyces stillatus, Orange Jelly

Fruit body (Fig. 8.18f, g): yellow-orange-red, also whitish, dark orange when dry, button-shaped, lenticular to mug- or plate-like, 1 – 15 mm wide, gelatinous-elastic, slimy melting when old, solitary and in groups, often two different forms on the same place, a brighter form with basidiospores and a darker form with arthrospores, often appearing through paint;

Significance: white rot, softwoods and hardwoods, wood darkens, decay commonly patchy with small pockets of rot, often restricted to interior of timber, on window and doorframes, common outdoors on windows, claddings and along the gable board of the roof (Alfredsen et al. 2005).

8.5.3
Common House-Rot Fungi

There is a bulk of knowledge on the common indoor wood decay fungi due to their economic importance. Thus, these species and species groups are described in more detail in the following (also Findlay 1967; Bavendamm 1969; Coggins 1980; Cockcroft 1981; Grosser 1985; Jennings and Bravery 1991; Ryvarden and Gilbertson 1993, 1994; Krieglsteiner 2000; Weiß et al. 2000; Kempe 2003; Sutter 2003; Huckfeldt and Schmidt 2005).

8.5.3.1
Donkioporia expansa, Oak Polypore

This fungus is only recognized since the 1920s as relevant for practice and since about 1985 as important decay fungus in buildings (Kleist and Seehann 1999; Erler 2005). Assumably, the species was often overlooked despite the less common decay type of a white rot in buildings and the large size of its fruit bodies. A reason it was overlooked may be that damage is often restricted to wood interior and not noticed until fruit bodies appear and furthermore that the fruit bodies are inconspicuously embedded in plentiful surface mycelium.

Occurrence: fairly rare, Central Europe, North America, in Germany preferentially in the south, at least in Europe almost exclusively restricted to structural timber, preferably *Quercus*, but also *Castanea, Fraxinus, Populus* and *Prunus*, frequently also on indoor timber of *Picea* and *Pinus*;

Fruit body (Fig. 8.19a, b): perennial, resupinate, first white, then ochre to reddish-tobacco-brown to grey with ageing, to 10 cm thick, becoming widely effused to a few square meters, firmly attached, an walls wavy to stairs-like, often multi-layered, tough-elastic with silvery surface when fresh, hard and brittle when dry, easily separable when old, mainly made up of long tubes, 4 – 5

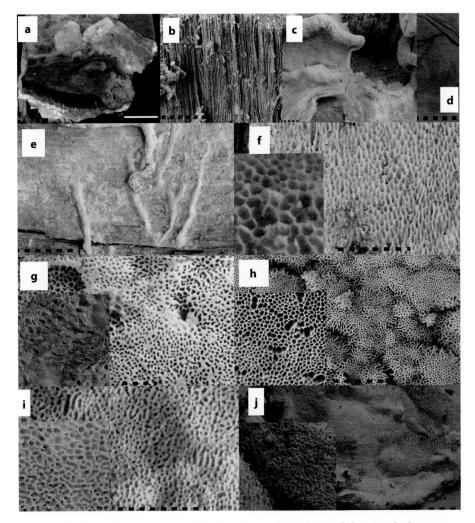

Fig. 8.19. *Donkioporia expansa* **a** Fruit body and mycelium. **b** Detail showing the long pores. **c** Old mycelium. **d** Strand-like structures grown on wood in laboratory culture; *Antrodia vaillantii* **e** Mycelium and strands. **f** Fruit body and detail. **g** *Antrodia sinuosa* fruit body and detail. **h** *Antrodia xantha* fruit body and detail. **i** *Antrodia serialis* fruit body and detail. **j** *Oligoporus placenta* fruit body and detail (photos **b–j**: T. Huckfeldt) — 5 cm, - - - 5 mm

circular to angular pores/mm, often amber guttation drops, which leave behind small black pits when dry; trimitic; ellipsoid spores $4.5-7 \times 3.2-3.7$ µm;

Mycelium (Fig. 8.19a,c): inside wood shakes and cavities, at high air humidity also on free wood surfaces with thin, skin-like mycelial flaps with bizarre seeds, later thick, brownish surface mycelium, guttation as on fruit bodies, black demarcation lines between mycelium and woody substrate;

Strands (Fig. 8.19d): not yet observed in buildings, strand-like structures on wood samples in laboratory culture, rare, cream, yellowish to grey-brown, root-like, hidden under mycelium;

Significance: The Oak polypore inhabits damp areas in kitchens, bathrooms, WC, cellars, cow-sheds, occurs on beams, under floors, in mines, on bridge timber, and cooling tower wood [Azobé, Bangkirai; v. Acker et al. (1995); v. Acker and Stevens (1996)]. It produces a white-rot. Continuous high wood moisture promotes growth (defective sanitary facilities, cooling tower wood). The fungus is often found at beam-ends that are enclosed in damp walls. At initial attack of softwoods, the timber surface remains often nearly intact ("interior rot"). In laboratory culture, minimum wood moisture for wood colonization was 21% u and for wood decay 26%. Greatest wood mass losses occurred between 34 and 126% (Table 8.7). Moisture maximum was 256%. Temperature optimum was 28 °C, and maximum was 34 °C (Table 3.8). The fungus survived for 4 h in dry wood of 95 °C (Huckfeldt 2003). Wood mass losses according to EN 113 were: oak sapwood 45%, oak heartwood 23%, beech 50%, birch 60%, pine sapwood 40% (Kleist and Seehann 1999). Assumably, there is no spread by strands from moist to dry wood and no growth through the masonry because strands were only found in vitro to date. Thus, refurbishment only needs drying and exchange of destroyed timber. In oaks, the fungus is often associated with the death-watch beetle, *Xestobium rufovillosum*.

8.5.3.2
Indoor Polypores: *Antrodia* Species and *Oligoporus placenta*

Four *Antrodia* species and *O. placenta* may be assigned to the indoor polypore fungi.

Occurrence: circumglobal in the coniferous forest zone, mostly on softwoods (Findlay 1967; Domański 1972; Coggins 1980; Lombard and Chamuris 1990; Grosser 1985; Lombard 1990; Ryvarden and Gilbertson 1993, 1994; Krieglsteiner 2000; Sutter 2003);

Antrodia vaillantii occurs circumglobal in the coniferous forest zone and in Europe widely distributed, but rather rare in Fennoscandia. It is the most frequent fungus in British mines (Coggins 1980). *Antrodia sinuosa* is circumpolar in the boreal conifer zone, widespread in Europe, North America, East Asia, North Africa, and Australia (Domański 1972). The species was in Sweden with 1,045 damages between 1978 and 1988 with 13% portion the most common indoor polypore (Viitanen and Ritschkoff 1991a). *Antrodia serialis* attacks logs and piles, causes heart rot in standing trees and occurs widespread, also in Himalaya and Africa (Seehann 1984; Breitenbach and Kränzlin 1986), rarely (1.4%) in buildings (Viitanen and Ritschkoff 1991a; Coggins 1980), within the roof area, in cellars and under corridors (Domański 1972). *Antrodia xan-*

tha (Domański 1972) occurs in Europe and North America on fallen stems, branches, stumps, in greenhouses (Findlay 1967), at windows (Thörnqvist et al. 1987), on timber in swimming pools and in flat roofs (Coggins 1980). *Oligoporus placenta* is rare, but widespread in Europe except for the Mediterranean. In North America, the fungus is the most common wood decayer in ships (Findlay 1967) and was exported to Great Britain (Coggins 1980). In North America, *O. placenta* and *A. serialis* are common on mine timber and poles (Gilbertson and Ryvarden 1986).

Antrodia vaillantii, Mine polypore, Broad-spored white polypore

Fruit body (Fig. 8.19f): annual, resupinate, first white, then light yellow to grey, drying, as corky layer (to 1 cm thick) on the wood underside or above as pad; 2–4 circular-angular pores/mm hymenium, to 12 mm long; dimitic; hyaline spores 5–7 × 3–4 µm;

Strands (Fig. 8.19e): pure white, felty, 0.5–7 mm in diameter, ice flower-like, flexible also if dry; fibers numerous, white, flexible, 2–4 µm thick, unsoluble in 5% KOH; vessels not rare, to 25 µm in diameter, partly with thick walls and reduced lumen, no wall thickenings; vegetative hyphae with clamps, 2–6 µm in diameter, often also thick-walled.

Antrodia sinuosa, White polypore, Small-spored white polypore

Fruit body (Fig. 8.19g): similar to *A. vaillantii*, annual, resupinate, to 5 mm thick; 1–3 circular-sinuous pores/mm, to 3 mm long; dimitic; hyaline spores 4–6 × 1–2 µm;

Strands: similar to *A. vaillantii*.

Antrodia xantha, Yellow polypore

Fruit body (Fig. 8.19h): annual, resupinate, first yellowish, then pale, white-cream, crusty to bracket-shaped, to 10 mm thick, 1 m wide; 3–7 circular-angular pores/mm, to 5 mm long; margin without pores; on vertical substrates small knots, to 8 mm large, partly grown together; dimitic; hyaline spores 4–5 × 1–1.5 µm;

Strands: similar to *A. vaillantii*, but partly yellow discolored, later often pale and then undistinguishable from *A. vaillantii*.

Antrodia serialis, Effused tramete, Row polypore

Fruit body (Fig. 8.19i): annual to biennial, resupinate to pileate, first white to cream-ochre, then pink-spotted, to 6 mm thick, to a few decimeters wide; 2–4 circular, partly slitted pores/mm, to 5 mm long; distinct, wavy margin; also in rows; dimitic; hyaline spores 4–7 × 3–5 µm;

Strands: not yet found.

Oligoporus placenta, (Reddish) Sap polypore

Fruit body (Fig. 8.19j): annual, resupinate, either white to grey-brown (form *monticola*) or later pink to salmon-violet (reddish form *placenta*) (Domański 1972), easily passing, to 1 cm thick; 2–4 circular-angular-slitted pores/mm, to 15 mm long; monomitic; hyaline spores 4–6 × 2–2.5 µm;

Strands: on wood samples in laboratory culture, white, partly yellowing, easily refractable, to 1 mm in diameter; fibers and vessels rare or absent.

Significance: The five "indoor polypores" form a group of brown-rot fungi that are associated with the decay of softwoods in buildings. In Central Europe, these fungi belong after the Dry rot fungus, *Serpula lacrymans*, and together with the *Coniophora* cellar fungi to the most common indoor decay fungi. They accounted for 14% of indoor decay fungi in Denmark (Koch 1985) and Finland (Viitanen and Ritschkoff 1991a). A survey in California ranked *A. vaillantii*, *A. sinuosa*, *A. xantha* and *O. placenta* with 29% occurrence as the main group (Wilcox and Dietz 1997).

The polypores have similar biology and distribution (Lombard and Gilbertson 1965; Donk 1974; Breitenbach and Kränzlin 1986; Lombard and Chamuris 1990; Bech-Andersen 1995; Schmidt and Moreth 1996, 2003). They differ in their fruit body, spore morphology (Jülich 1984; Ryvarden and Gilbertson 1993, 1994) and sexuality. Some species also fruit in laboratory culture, which supports identification of mycelia and tests for sexuality. *Antrodia vaillantii* is tetrapolar heterothallic (Lombard 1990), *A. serialis*, *A. sinuosa* and *O. placenta* are bipolar (Domański 1972; Stalpers 1978). Three *Antrodia* species develop strands (Falck 1912; Stalpers 1978; Jülich 1984), *O. placenta* only in vitro. However, the vegetative mycelium that has been isolated from decayed wood is hardly distinguishable (Nobles 1965). Due to the limited differentiating features, misinterpretations occur.

Furthermore, the nomenclature has a confusing history and is still not always uniform (Cockcroft 1981). Fungi have been variously classified as *Polyporus*, *Poria*, *Amyloporia*, *Fibroporia* (Domański 1972). Misleading synonyms in the older literature such as *Polyporus vaporarius* and *Poria vaporaria* have been used for different species, viz. *A. vaillantii* (Bavendamm 1952c), *A. sinuosa*, and *O. placenta*. According to Ryvarden and Gilbertson (1994), the Reddish sap polypore, formerly *Tyromyces placenta* (Fr.) Ryv., was placed in *Oligoporus*, since the genus *Tyromyces* is restricted to fungi causing a white rot. Older synonyms are *Postia placenta* (Fr.) M.J. Larsen & Lomb., *Poria placenta* (Fr.) Cooke sensu J. Eriksson, *Poria monticola* Murr., and the haploid standard strain *Poria vaporaria* (Pers.) Fr. sensu J. Liese (Domański 1972). *Postia* is a nomen provisorium/nudum in the sense of Fries and illegitimate in the sense of Karsten. Isolate MAD 698 of *Postia placenta* was thoroughly investigated in view of brown-rot decay mechanisms (e.g., Clausen et al. 1993; Highley and Dashek 1998). Difficulties may increase because *O. placenta* separates into the

forms *placenta* with salmon-pink fruit bodies ("Reddish sap polypore") and *monticola,* never with reddish stain (Domański 1972). Monokaryotic isolates of *O. placenta* were used for testing wood preservatives in Germany (*Poria vaporaria* "standard strain II") and are obligatory in the recent European standard EN 113 (see Table 3.9, 3.10, named "*Poria placenta*" FPRL 280). Even literature from 2005 uses the names *Postia placenta* and *Poria placenta.*

For species identification in the case that only vegetative mycelium is present, rDNA-ITS sequencing separates the five species (Schmidt and Moreth 2003; Chap. 2.4.2.2).

For an easier understanding during a practical valuation of a fungal damage, the different fungi are often summarized as "indoor polypores" or as "Vaillantii group", particularly because they differ from the Cellar fungus and Dry rot fungus by their mycelia, strands, and fruit bodies. The polypores, particularly *A. vaillantii,* form a well-developed white and cottony surface mycelium without "inhibition colors", which, thus, can be confused with the young mycelium of the Dry rot fungus. Polypore mycelium spreads ice flower-like over the substrate, that of the Dry rot fungus is converted with ageing into silvery-grey skins, and that of the cellar fungi is dominated by fine black strands. White (*A. vaillantii*), to string-thick, smooth and flexible strands develop within the mycelium and grow over non-woody substrates and also through porous masonry (Grosser 1985), the latter, however, less intensive than by the Dry rot fungus. The white to yellow (*A. xantha*) or red (*O. placenta* f. *placenta*) fruit bodies show pores that are visible with the naked eye (Fig. 8.19). The dry wood shows the typical brown-cubical rot. It is often said that the cubes caused by the polypores and the cellar fungi are smaller than those by the Dry rot fungus. The cube size varies however also as a function of the wood moisture content (Grosser et al. 2003). After advanced decay, the dried substrate of most brown-rot fungi can be ground with the fingers to a brown powder ("lignin").

The polypores attack predominantly coniferous woods in damp new and old buildings, particularly in the upper floor, furthermore mine timber, stored timber as well as timber in outside use, particularly in the soil/air zone, such as poles and sleepers. They also attack trees as wound parasites and live on stumps and fallen trees (Krieglsteiner 2000). *Antrodia serialis* was found in over-mature Sitka spruce trees (Seehann 1984). "Dry" wood should not become infected. In the laboratory, however, wood of 22% moisture content was colonized (Table 8.7). As so-called "wet-rot fungi" (Coggins 1980; Bravery et al. 2003), they need wet wood with moisture contents from 30 to 90% u for a long time. According to literature, the optimum is around 45% (Table 3.6). Laboratory experiments revealed that minimum moisture for wood decay by *A. vaillantii* was 29% and the optimum 52 to 150% (Table 8.7). With timber drying, *Antrodia* species were supposed to die (Bavendamm 1952c; Coggins 1980). However, more convincing seems that they only stop growth (Grosser

1985). In the laboratory, over 11 years were survived by "dryness resistance" (Theden 1972), so that fungi may come to life again. There is also resistance to high temperature: *Antrodia vaillantii, A. sinuosa* and *O. placenta* survived on agar 3 h at 65 °C. *Antrodia vaillantii* and *O. placenta* withstood heat of 80 °C for 4 h in slowly dried wood samples (Huckfeldt 2003), which has to be considered in view of a possible treatment of infected homes with hot air.

Some species destroy timber in soil contact, like poles and palisades, even if it is properly impregnated with chrome-copper salts (Stephan et al. 1996). Especially *A. vaillantii* but also *A. xantha* and *O. placenta* are known for copper tolerance (Da Costa and Kerruish 1964) due to the production of oxalic acid (Rabanus 1939; Da Costa 1959; Sutter et al. 1983, 1984; Jordan et al. 1996). Strain variation occurred (Da Costa and Kerruish 1964; Collett 1992a, 1992b), and monokaryons were more tolerant than their parental strains (Da Costa and Kerruish 1965). In vitro, *A. vaillantii* was the most copper-tolerant fungus among the five species (Table 3.10) and produced most oxalic acid (Table 3.9; Schmidt and Moreth 2003). *Antrodia vaillantii* is also tolerant to arsenic (Göttsche and Borck 1990; Stephan and Peek 1992).

8.5.3.3
Cellar fungi: *Coniophora* species

Occurrence: The genus *Coniophora* comprises about 20 species occurring worldwide with a broad host range primarily on conifers (Ginns 1982). Seven species occur in Europe (Jülich 1984) and five in Western Germany (Krieglsteiner 1991). *Coniophora puteana* is frequently associated with brown-rot decay in European buildings. The fungus was estimated to be twice as common as the Dry rot fungus in the UK (Eaton and Hale 1993). It comprised over 50% of the inquiries at the Danish Technological Institute (Koch 1985), 16.3% in Norway (Alfredsen et al. 2005), and 13% at the Finnish Forest Products Laboratory (Viitanen and Ritschkoff 1991a). The fungus has been used for nearly 70 years as a test fungus for wood preservatives in Europe. It also occurs in the USA, Canada, South America, Africa, India, Japan, Australia, and New Zealand. Further "cellar fungi" that attack indoor timber in Europe are especially *C. marmorata*, and also *C. arida* and *C olivacea* (Fig. 8.20). In Europe, the cellar fungi cause with about 10% frequency the two to third most common fungal indoor wood decay after *S. lacrymans*. In Australia and New Zealand, *C. arida* and *C. olivacea* are common. Some further *Coniophora* species also occur in buildings, mines and glass houses, but predominantly in warm climatic zones (Ginns 1982). The species can be differentiated by their fruit bodies (Jülich and Stalpers 1980; Breitenbach and Kränzlin 1986; Krieglsteiner 2000). However, the species concept within *Coniophora* is difficult because there are only a few, and unstable characteristics, which complicates species identification in infected buildings. With regard to isolates in culture, *Coniophora* cannot

Fig. 8.20. Cellar fungi. *Coniophora puteana* **a** Fruit body. **b** Fruit body margin. **c** Fruit body detail with warts. **d** Strands in a false ceiling. **e** Strands on a steel girder. **f** *Coniophora arida* fruit body. **g** *Coniophora olivacea* fruit body (photos T. Huckfeldt) — 5 cm, - - - 5 mm

be differentiated at the species level by morphological and cultural characteristics (Stalpers 1978). Thus, isolations from buildings were summarized as *C. puteana/ C. marmorata* (Guillitte 1992). Sequencing of the rDNA-ITS separated the species (Schmidt et al. 2002b). Based on fruit-body identification, *C. marmorata* is rather common in southern Germany. The following description is based mainly on Huckfeldt (2003), Huckfeldt and Schmidt (2005) and Schmidt and Huckfeldt (2005).

Coniophora puteana, (Brown) Cellar fungus

Fruit body (Fig. 8.20a–c): annual, resupinate, light to dark brown, first white-yellow, then brownish; indistinct, fibrous margin; to 4 mm thick, to a few decimeters wide, firmly attached, fragile when dry; warty knots up to 5 mm thick; monomitic; yellow-brown spores $9-16 \times 6-9$ μm;

Strands (Fig. 8.20d, e): first white, soon brown-black, to 2 mm thick, root-like, fragile, black wood beneath the strands; fibers brown, 2–5 µm thick, lumina visible; vessels 10–30 µm thick, often deformed, no bars; vegetative hyphae mostly clampless, rarely with multiple clamps, with brown drops (1–5 µm) holding the hyphal net together.

Coniophora marmorata, Marmoreus cellar fungus

Fruit body: annual, resupinate, pale to olive-brown, grey margin, to 0.4 mm thick, to 15 cm wide, separable, felty; dimitic; no picture available because not yet found in buildings in northern Germany;
 Strands: brownish, to 1 mm thick, easily separable, no drops.

Coniophora arida, Arid cellar fungus

Fruit body (Fig. 8.20f): annual, resupinate, white-ochre to yellow-brown, light margin, to 0.3 mm thick, to 10 cm wide, firmly attached, smooth to felty, fine-frayed margin; monomitic;
 Strands: rare, white to brown, 0.1 mm thick.

Coniophora olivacea, Olive cellar fungus

Fruit body (Fig. 8.20g): annual, resupinate, olive-brown, margin lighter, fraying with strands, to 0.6 mm thick, to 6 cm wide, firmly attached, smooth to warty, fibrous-cottony, septate cystidia, monomitic, partly merging fruit bodies;
 Strands: brown, thin.

Significance: The older European literature on occurrence, biology and significance of the cellar fungi summarizes the several fungi to *C. puteana*. This fungus was said to be the most common species in new buildings. It however occurs also in damp old buildings, on stored wood, timber in soil contact like poles, piles, sleepers and on bridge timber as well as rarely on stumps and as wound or a weakness parasite on living trees (Bavendamm 1951a; Grosser 1985; Breitenbach and Kränzlin 1986; Sutter 2003). Of 177 Basidiomycetes on American mine timbers, 83 isolates were *C. puteana* (Eslyn and Lombard 1983). In buildings it does not occur, like the name misleadingly suggests, only in cellars, but it can ascend everywhere on damp timber up to the roof (Schultze-Dewitz 1985, 1990). Beside softwoods, it attacks also several hard-woods (Wälchli 1976). As a so-called wet rot fungus (Bravery et al. 2003) with relatively high requirement for moisture from 30 to about 70% u and the optimum around 50% (Table 3.6), all timber in the area of damp walls (beam ends and wall slats), damp floors and ceilings in kitchens, bathrooms and toilets as well as all timber in areas with water vapor development (swimming pools, launderettes) is endangered. In vitro, minimum moisture of *C. puteana* for wood colonization was 18% u and for decay 22%. The optimum moisture was broad, from 36 to 210% (Table 8.7). Damage by the cellar fungi is quite

comparable with that one of the Dry rot fungus and can even exceed it. A fresh floorboard can be completely destroyed in 1 year, so the danger exists that furniture or persons can fall through. These types of damages occurred in Germany frequently during the building boom in the postwar years, if insufficiently dried wood were used, or the homes had not sufficiently dried before they were moved into and drying was prevented by humidity-impermeable painting, linoleum, or carpet.

The cellar fungi belong to the fast-growing house-rot fungi and reached on agar at 23 °C up to 11 mm radial increase per day (Table 3.11). The optimum temperature (Table 3.8) was between 20 and 27.5 °C, whereby *C. marmorata* preferred the warmer range, and the maximum was between 25 and about 37.5 °C. Isolate Ebw. 1 of *C. puteana* survived 15 min. at 60 °C (Mirič and Willeitner 1984) and 3 h at 55 °C (Table 3.8). In slowly dried wood samples, even 4 h at about 70 °C were withstood (Huckfeldt 2003). The data concerning a possible dryness resistance of the fungus vary: after observations from practice, it dies when drying; up to 7 years were however survived in dry wood in the laboratory (Theden 1972). There was isolate variation with regard to the sensitivity to wood preservatives (Gersonde 1958).

Recognition characteristics (Fig. 8.20): The diagnosis is not always easy, since fruit bodies are rare and colonized wood shows frequently no or only meager surface mycelium (Käärik 1981). The few centimeters to several decimeters wide, resupinate, brownish fruit bodies resemble those of the Dry rot fungus, are however thinner. The species *C. puteana* is easy to recognize of the warty knots on the hymenophore (name: "carrying cones"). Characteristic on agar are double and multiple clamps. The initial stages of the rot are frequently ignored, since hardly infection signs become visible on exposed wood exterior surfaces, e.g., on baseboards, while the wood at the backside is already completely rotten and overgrown by thread-thin, radiate to root-like, brown to black strands (Fig. 8.20d,e). Early signs of rot are often dark discolorations under the paints.

8.5.3.4
Dry-rot fungi: *Serpula* species, *Leucogyrophana* species, *Meruliporia incrassata*

This chapter deals with the brown-rot causing dry-rot fungi, namely *Serpula lacrymans* and *S. himantioides*, and the *Leucogyrophana* species, *L. mollusca*, *L. pinastri* and *L. pulverulenta* (Fig. 8.21). Due to its economic relevance in Europe, emphasis is laid on *S. lacrymans*, however, the American pendant, the American dry rot fungus, *Meruliporia incrassata*, is considered.

The way of spelling of the epithet "lacrimans", which can be attributed to Fries (1821), is linguistically correct, however illegal, since the original spelling by Wulfen in 1781 was with "y" (Pegler 1991).

Occurrence and significance: The True dry rot fungus, *S. lacrymans*, is the most dangerous house-rot fungus in central, eastern, and northern Europe, northwards to the Hebrides. It grows however also in cooler areas of Japan (Doi 1991), Korea, India, Pakistan and Siberia (Krieglsteiner 2000), in New Zealand and southern Australia (Thornton 1991), in Mexico, Canada and in the northern USA (Rayner and Boddy 1988). The data concerning its involvement in fungal indoor damage reach from 16% in Norway (Alfredsen et al. 2005) over 22% in Denmark (Koch 1991), 54% in Poland (Ważny and Czajnik 1963) and North Germany (Schmidt and Huckfeldt 2005) to 59% in Sweden (Viitanen and Ritschkoff 1991a). For example, the annual repair costs of dry rot damage amount to at least 150 million £ in Great Britain (Jennings and Bravery 1991).

Since the fundamental work by Hartig (1885), Mez (1908), Falck (1912: cf. Hüttermann 1991) and Wehmer (1915) *S. lacrymans* belongs to the best-investigated fungi. The older observations and results are described by Liese (1950), Bavendamm (1951b), Cartwright and Findlay (1958), Harmsen (1960), Savory (1964), Wagenführ and Steiger (1966), Findlay (1967), Bavendamm (1969), Coggins (1980) and Segmüller and Wälchli (1981). A literature search from 1988 lists 1200 publications (Seehann and Hegarty 1988). Informative photographs for diagnosis on the basis fruit bodies (Fig. 8.21a, b) are by Grosser (1985) and on the Internet (www.hausschwamminfo.de). Younger reviews and laboratory findings to the biology and physiology are by Jennings and Bravery (1991), Viitanen and Ritschkoff (1991a), Schmidt and Moreth-Kebernik (1991a), Eaton and Hale (1993), Huckfeldt (2003), Schmidt (2003), Huckfeldt and Schmidt (2005), Huckfeldt et al. (2005), Schmidt and Huckfeldt 2005). There is a German instruction leaflet with experiences from the practice on life conditions and refurbishment (Grosser et al. 2003).

As cause of the special danger of the fungus the following features were specified: Its "omnipresent" spores germinate on damp wood or other cellulosic materials (paper, cardboard), and the mycelium can reach wood by growing over and through substrates that do not serve as a nutrient. For initial colonization, it only needs low wood moisture content. The conventional wisdom is that it is the only fungus that can infect so-called "dry" timber (min. 21% u) and masonry (min. 0.6% water content) and widely spread by mycelium (Fig. 8.21c) and its highly developed strands (Fig. 8.21d; name: "small serpent"), thereby growing over and through wood and several other materials, like porous or ruptured masonry or its wall joints, supplying channels for electricity, and water pipes (Coggins 1991; Jennings 1991). However, recent laboratory experiments showed that *S. lacrymans* is not unequalled as is also other indoor fungi colonized dry wood (Table 8.7). Coggins (1980, 1991) stressed that the initial colonization of a substrate, as for example the growth through wall joints, occurs by the youngest hyphae of the vegetative mycelium, in contrast to the infection way of *Armillaria* species that do this by means of rhizomorphs. In contrast, the strands develop as a secondary mycelium behind

Fig. 8.21. Dry-rot fungi. *Serpula lacrymans* **a** Fruit body. **b** Detail. **c** Mycelium. **d** Strands. **e** *Serpula himantioides* fruit body; *Leucogyrophana pinastri* **f** Old fruit body. **g** Detail. **h** Old strands and sclerotia, **i** Mycelium and sclerotia. **j** Young sclerotia. **k** *Leucogyrophana mollusca* fruit body. **l** Hair-like strands and sclerotia. **m** Mycelium and sclerotia; *Leucogyrophana pulverulenta* **n** Old fruit body, **o** Mycelium and strands (photos **b–o**: T. Huckfeldt) — 5 cm, --- 5 mm

the growth front and serve rather to transport nutrients to the hyphal margin. Alkaline materials to pH 10 can be overgrown, and alkalinity is decreased by excretion of liquid (pH 3–4) at the hyphal tip. An acute infection is often for a longer time not recognized due to the "hidden way of life". Spores and still

alive mycelia can lead to re-infections in the case of careless or inappropriate remedial treatments (Bravery et al. 2003). Thick mats of surface mycelium may cover the attacked timber assumably preventing the wood from drying.

Serpula lacrymans occurs predominantly in older buildings and in the cellar and ground floor area (Schultze-Dewitz 1985, 1990; Koch 1990). Uninhabited and poorly ventilated houses and all buildings with high relative air humidity in connection with damages to the structural fabric are particularly endangered. Important causes of dry rot infections are building defects that affect increased wood moisture content (e.g., Paajanen and Viitanen 1989). The mycelium reacts sensitively to draught and humidity removal, generally to climatic changes, so that it often develops in false ceilings and false soil areas under floors and behind wall coverings, from where it spreads. Because of this hidden way of life, often only fruit bodies on masonry, baseboards, doorframes or stairway steps show that the higher floors are already infected. In extreme cases, e.g., during the refurbishment of listed buildings, all timbers as well as large parts of the masonry have to be removed. A survey of houses in northern Germany indicated that old buildings are particularly at risk, which had insulating windows as the only measure of heat insulation. Now, the moisture in the building condenses on other weak spots like empty spaces of the brickwork at the back of heaters (Huckfeldt et al. 2005).

Except in homes, the fungus occurs on mine timber and rarely in the open (poles, sleepers), but in the boreal climate not in the forest. However, according to Pegler (1991), the species occurs outdoors in Central Europe and North America, and according to Bech-Andersen (1995), in the Himalayas in conifers forests. Phylogenetic trees based on the rDNA-ITS sequence showed that the outdoor isolates from the Himalaya and from California belong to the species *S. lacrymans* (Chap. 2.4.2.2). Phylogenetic analyses indicate that the indoor isolates of *S. lacrymans* may have originated from an ancient lineage closely related to the Californian outdoor isolates (Kauserud et al. 2004b).

In the open, the Wild merulius *S. himantioides* (Fig. 8.21e) is common, in Europe frequently on spruce wood, stumps, structural timber in outdoor use, and rarely on living trees. Occasionally, it is also found in buildings (Falck 1927; Harmsen 1978; Grosser 1985; Seehann 1986; Pegler 1991).

As further dry-rot fungi occur three *Leucogyrophana* species (Fig. 8.21f-o) in the forest on fallen stems and branches, and on wood in indoor use: *L. mollusca*, *L. pinastri* (Schulze and Theden 1948; Siepmann 1970) and *L. pulverulenta* (Harmsen 1953). They differ from *Serpula* by smaller spores (Ginns 1978; Pegler 1991; Breitenbach and Kränzlin 1986). *Leucogyrophana pulverulenta* is rather common in Denmark. The three fungi need a higher wood moisture content than *S. lacrymans* (cf. Table 8.7).

Whereas *S. lacrymans* is restricted in North America to the northern parts of the USA and Canada, the American dry rot fungus *Meruliporia incrassata* (first reported in the USA in 1913) occurs particularly in the southern states

and the Pacific northwest of the USA (Verrall 1968; Palmer and Eslyn 1980; Gilbertson and Ryvarden 1987; Burdsall 1991; Zabel and Morrell 1992; Eaton and Hale 1993; Jellison et al. 2004). Being a warm-temperature fungus, two isolates from the USA and Canada grew best between 22.5 and 25 °C and died after 3 weeks of culturing at about 35 °C (Schmidt 2003). Burdsall (1991) named 24–30 °C as the optimal temperature range for growth and above 36 °C as the lethal temperature. Jellison et al. (2004) quoted 28–30 °C as the optimal range for growth, and 3–30 h at 40 °C for lethal. Sapwood and heartwood of many gymnosperms and angiosperms are attacked. It was rarely found on standing trees, infrequently on felled logs and stumps, on structural timber outdoors such as in mills, lumber yards, on shingles, on bridge timber, posts, but is common on moist wood or wood located near a permanent or intermittent water supply if the wood is untreated (Palmer and Eslyn 1980). Some characteristics of wood decay by this fungus are similar to those of *S. lacrymans*, notably its sensitivity to dryness by mostly dying in pure culture tests with southern pine blocks of 30% wood moisture at 90% RH at 27 °C (Palmer and Eslyn 1980), and its ability to transport nutrients and water from a feeding source to the advancing mycelial front spreading over non-wooden mortar and bricks. Pictures of mycelium and strands are by Zabel and Morrell (1992).

The *Serpula* and *Leucogyrophana* species as well as *M. incrassata* can be differentiated by their fruit bodies and strands (Appendix 1). Molecular techniques separate the vegetative mycelia (Chap. 2.4.2). The following description is based on observations and measurements in buildings and on results from wood samples in laboratory tests (Huckfeldt and Schmidt 2005; Schmidt and Huckfeldt 2005) and is supplemented especially for *M. incrassata* from Palmer and Eslyn (1980), Gilbertson and Ryvarden (1987), and Burdsall (1991).

Serpula lacrymans, (True) Dry rot fungus
Fruit body (Fig. 8.21a, b): annual to perenniell, resupinate to effused-reflexed and imbricate, sometimes stalactite-like, rust-brown, old: black; bulging, white-yellowish, sharp margin; fleshy-thick (to 12 mm), to 2 m wide, hymenophore merulioid; first monomitic, later dimitic containing fibers; yellow-brown, thick-walled spores $9-12 \times 4.5-6\,\mu m$; tetrapolar;

Strands (Fig. 8.21d): young: white; old: grey-brown; to 3 cm in diameter, audibly breaking when dry, embedded in flabby mycelium; fibers $3-5\,\mu m$ thick, hardly septate, without buckles, straight, rigidly, refractive; vessels to $60\,\mu m$ thick, with bar-likes or warty wall thickenings, not or rarely branched.

Serpula himantioides, Wild merulius
Fruit body (Fig. 8.21e): annual, resupinate, sometimes membrane-like, rust-brown; white, sharp, not bulging margin, < 2 mm thick, hymenophore smooth to merulioid; yellow-brown, thick-walled spores $9-12 \times 5-6\,\mu m$; tetrapolar;

Strands: white to grey-brown, about 1 mm in diameter, microscopic characteristics similar to *S. lacrymans.*

Leucogyrophana mollusca, Soft dry rot fungus

Fruit body (Fig. 8.21k): resupinate, orange to yellow-brown; old: grey-blackish; white, cottony-frayed margin; 1–2 mm thick, to a few decimeters wide, easily separable; hymenophore merulioid, tooth-like elevations; uneven, brown-violet to grey-black sclerotia (Fig. 8.21m), 1–6 mm, often in groups; yellowish-brown spores 6–7.5 × 4–6 µm;

Strands (Fig. 8.21l): hair-like, first cream-yellow, soon brown-black, below 1 mm thick, separated from mycelium ("barked"), flexible when dry, fragile when old; no fibers; vessels up to 25 µm thick, numerous, in groups, with bar-thickenings.

Leucogyrophana pinastri, Mine dry rot fungus, Yellow-margin dry rot fungus

Fruit body (Fig. 8.21f, g): resupinate, first yellow-orange, then olive-yellow to brown, grey-black when old, to 1 m wide, hymenophore merulioid to irpicoid to hydnoid; round-oval, brown-black sclerotia to 2–3 mm thick; hyaline to yellow spores 5–6 × 3.5–4.5 µm;

Strands: first yellowish, then grey-brown (Fig. 8.21h), hair-thin, separated from mycelium; no fibers; vessels to 15 µm thick, numerous, in groups, with bar-thickenings.

Leucogyrophana pulverulenta, Small dry rot fungus

Fruit body: resupinate, first sulphur-canary yellow, then (Fig. 8.21n) olive-yellow to cinnamon-brown, also grey-black when old, white, indistinct margin, to 20 cm wide; hymenophore smooth to merulioid, no sclerotia; hyaline to yellow, thick-walled spores 5–6 × 3.5–4.5 µm;

Strands (Fig. 8.21o): white, to 2 mm thick, not clearly separated; no fibers; vessels to 20 µm thick, numerous, in groups, bar-thickenings indistinct or absent.

Meruliporia incrassata, American dry rot fungus

Fruit body: similar to *S. lacrymans,* annual, resupinate to effused, 20 cm or more in length, thin, easily separable, whitish to buff margin, grey center, becoming darker as it matures; 1 to 12 mm thick, fleshy, brittle when dried; first appearing as a felted pad of mycelium with formation of pores beginning at the center, subsequent fertile to the margin; hymenophore poroid, occasionally merulioid; whitish to buff or ochre-grey when fresh, grey-brown to black when drying, unequally circular to angular pores, 1–3/mm; monomitic; thick-walled oblong to ellipsoid spores, variable in size, 8–16 × 4–8 µm;

Strands: first as vein-like structures in the mycelium, often extending into soil or masonry, appearing whitish when young, browny-black with age (Eaton and Hale 1993), 0.3–5.1 cm in diameter, length up to 9 m (Palmer and Eslyn 1980).

Recognition characteristics of *S. lacrymans* (Fig. 8.21)

Wood: The relatively large cubes of the brown-cubical rot (Fig. 7.1a) are no reliable characteristic. Painted doorframes or baseboards first show blisters and fine tears in the lacquer and after longer infestation, wavy surfaces.

Fruit body: The brownish, to 12 mm thick and 2 m size, mostly resupinate fruit body growing on wood or masonry (Fig. 8.21a) is conspicuous. From shakes and vertical planes grow pad and bracket-like fruit bodies. The gyroso-reticulate hymenophore is traditionally named "merulioid" (Fig. 8.21b), which derives from the former generic name *Merulius*. The margin is whitish, often bulging and always with a sharply limited front. Particularly at the margin, as also with the mycelium, arise liquid drops of neutral pH value due to guttation, which led to the naming *lacrymans* (watering). Fresh fruit bodies have a pleasant smell like fungi, but putrefy after sporulation and then easily stink (from the ammonia). The old, dry, then black-brown fruit bodies hardly show the merulioid structure. Fruit bodies develop over the whole year, with an amassment in the late summer until winter (Nuß et al. 1991).

Affected areas are often widely covered with brown, elliptical, yellow-brown spores with small, pointed extension at an end and partly with up to five intra-cellular oil droplets (Hegarty and Schmitt 1988; Pegler 1991; Nuß et al. 1991). Falck (1912) calculated the spore release by a 1-m^2 fruit body to 3×10^9 spores per hour.

First, however, inconstant fructification in the laboratory culture was obtained by Falck (1912), Cymorek and Hegarty (1986b) stimulated fructification by 12 °C incubation and by natural temperature change in the open (cool) (Hegarty and Seehann 1987; Hegarty 1991). Fruit bodies relatively often developed in pure cultures, if the mycelium was first incubated for about 4 weeks at 25 °C on malt agar and then at about 20 °C and natural daylight (Schmidt and Moreth-Kebernik 1991b; Fig. 3.1).

Mycelium (Fig. 8.21c) **and biology:** During initial growth, with sufficient humidity and standing air, often a white, woolly thick aerial mycelium develops, which is rapidly interspersed by the typical strands. Yellow to wine-red (also violet) discolorations ("inhibition colors") by restraining influences [light, accumulation of toxic metabolites, increased temperature: Zoberst (1952), Cartwright and Findlay (1958)] are characteristic and led to the former generic name *Merulius*, going back to the yellow beak of the male blackbird *Turdus merula* (Coggins 1980). Older mycelium collapses to removable, dirty grey to silvery skins, in which the branched strand system is embedded. The match-

to pencil-thick, up to 2 to 4-m-long, grey-brown and on their surface fibrously roughened strands (Fig. 8.21d, Table 2.4; Falck 1912) break when being dry with audible cracking. Strands are formed only in aerial mycelium, and there as well by dikaryotic as by monokaryotic mycelium, and not in substrate mycelium and reach (at 20 °C) 5 mm length increase per day (Nuß et al. 1991).

The fungus is tetrapolar heterothallic. Only dikaryons show clamps (Harmsen et al. 1958), while only monokaryons form plentifully arthrospores (Schmidt and Moreth-Kebernik 1991c). Contrary to *Antrodia sinuosa* and *Coniophora puteana*, the clamps are as large as the hyphal diameter (Nuß et al. 1991). Matings between different isolates of *S. lacrymans* revealed physiological differences between the different mycelial types, but also constancy of the characteristics over several generations (Schmidt and Moreth-Kebernik 1989b, 1990, 1991a): The dikaryons (parents and F_1 and F_2 generation) grew significantly faster than the mycelia of the two appropriate monokaryons and the two heterokaryon types (A# B=, A= B#). Regarding wood decay, dikaryons and monokaryons showed greater activity than the heterokaryons (also Elliott et al. 1979). Monokaryons and heterokaryons however tolerated higher temperature than the dikaryons, by growing still at 28 °C. Monokaryons also endured higher protective agent concentrations and this was also proven for *Antrodia vaillantii* and *Gloeophyllum trabeum* (Da Costa and Kerruish 1965). Related to practice, such physiological differences between the different mycelial types could become relevant, since dikaryons can revert under adverse conditions to the monokaryotic stage, as for example *G. trabeum* by arsenic (Kerruish and DaCosta 1963) and *S. lacrymans* by relatively high temperature (Schmidt and Moreth-Kebernik 1990). The more tolerant monokaryons would survive and can mate under again favorable conditions to dikaryons and thus have overcome the adverse environment.

The vegetative hyphae in the aerial mycelium are thicker (about 6 µm) than the hyphae within woody tissue, with about 2 µm. Within wood, medallion clamps also occur. The distance between the two clamps is shorter than in aerial mycelium, and often almost right-angled hyphal branching occurs. Morphologic characteristics of mycelium, fruit body, and spores were described by Nuß et al. (1991).

Conifers are preferred. Hardwoods with dark heart like oak and chestnut are more resistant than light species (Wälchli 1973). Beside wood and masonry, composite woods (chipboards, fiberboards), carpets, and textiles are attacked and insulating materials (Grinda and Kerner-Gang 1982) like mineral wool are through-grown and damaged (Bech-Andersen 1987b).

Because of the relatively low optimal temperature range of 17 to 23 °C, the mycelium grows preferentially in the cooler cellar and ground floor areas. The total span reaches from 0 to 26–27 °C, and growth stops at 27–28 °C, which differentiates the species from the similar *S. himantioides*. The mycelium died on agar at 55 °C for 3 h (Table 3.8, also Mirič and Willeitner 1984). In dried

wood samples, however, only 70 °C for 4 h were lethal (Huckfeldt et al. 2005). The spores were killed after 1 h at 100 °C (Hegarty et al. 1986). Thus, hot-air treatment procedures of attacked buildings (see below), as they are used in Denmark and also proposed for Germany, kill neither the spores nor the hyphae growing within large-dimensioned timbers and masonry.

The minimum wood moisture for initial colonization is 21% u (Huckfeldt 2003). The opinion has it that this infection of wood below the fiber saturation range of about 30% is possible, because the Dry rot fungus is particularly effective to transport nutrients and water by means of mycelium and strands, and here particularly by the vessel hyphae, from a moist nutrient source [wood over fiber saturation or wet masonry: Dickinson (1982)] to the infestation of "dry wood" (Wälchli 1980; Jennings 1987, 1991; Coggins 1991; Savory 1964). Not to stamp out, even in recent publications, is the erroneous opinion that *S. lacrymans* is extraordinary to colonize dry timber by the exclusive water production via its own enzymatic wood decay (Chap. 3.3). Also incorrect is that it takes up the necessary water from the air humidity.

Compared to Cellar fungus and the indoor polypores, the Dry rot fungus was considered to be sensitive to high wood moisture content (Cartwright and Findlay 1958). There is an older reference that it even reduced high wood moistures by guttation in favor of higher air humidity (Miller 1932). The optimal wood moisture for initial decay is about 30–40% u and shifts with longer decomposition rather to 40–60% (Wälchli 1980). The maximum of about 90% (Wälchli 1980) was higher than the 55% moisture content often cited in the older literature. In piled wood samples (Table 8.7), the optimum wood moisture was between 45 and 140%, and even samples with initial values of 240% wood moisture were decayed with wood mass loss over 2% (Huckfeldt and Schmidt 2005), so that the total span reached from 21 to 240%. The common term in English "Dry rot fungus" (Savory 1964; Coggins 1980; Bravery et al. 2003) and in German "Trockenfäule-Erreger" is paradoxical, since the Dry rot fungus also (like all other decay fungi) needs free water in the cell lumina for the enzymatic wood decay and is susceptible to desiccation. By means of mycelium (and strands), the fungus transports beside nutrients and water also minerals, e.g., the wood-decay limiting nitrogen (Watkinson et al. 1981) from the soil under a house to wood decay in the interior (Doi 1989; Doi and Togashi 1989; also Weigl and Ziegler 1960; Jennings 1991). After Savory (1964), the main significance of the strands lies in the nutrient translocation and not in the water transport (also Bravery and Grant 1985). Literature data to the requirements for temperature and humidity are also by Viitanen and Ritschkoff (1991a).

The mycelium of *S. lacrymans* is said to show dryness resistance of many years. However, the few experiments available revealed that it can reach at least under laboratory the dryness resistance only by a slow moisture removal. As-sumably, the mycelium needs time to revert first into the monokaryotic stage

with its resistant arthrospores. Furthermore, the resistance at 20 °C amounted only about 1 year. Only at low temperature (7.5 °C), the fungus survived several years (Theden 1972; also Savory 1964). Nevertheless, the remaining infected areas form a danger potential for new growth. Infected timber parts can exhibit just so much moisture to enable a slight growth and thus a longer survival than by means of dryness resistance (Grosser 1985). Furthermore, the danger of re-infection may derive from the dryness-resistant spores, whose duration of germ ability was said to amount to 20 years. In infected buildings, *S. lacrymans* frequently produces basidiospores, and basidiospores seem to be the main agent of dispersal (Falck 1912; Langendorf 1961; Schultze-Dewitz 1985). Vegetative spread by mycelium and strands seems to be restricted to within buildings or the soil in subfloor space (Doi 1991). However, according to Wälchli (1980) the infection occurs instead by mycelium that is brought in with timber from other remedial treatments and via wooden boxes or shoes.

Beside the requirement for low temperature, the preferential indoor occurrence of *S. lacrymans* was attributed to the intensive synthesis and secretion of oxalic acid (Jennings 1991; cf. Table 3.9), whose excessive production was said to be neutralized as calcium oxalate by calcium from masonry or by chelating with iron from girders (Bech-Andersen 1985, 1987a, 1987b; cf. Palfreyman et al. 1996). Oxalic acid is also implicated in copper tolerance of fungi. Although a single isolate of *S. lacrymans* was only able to grow on agar at a low concentration of copper sulphate (Table 3.10), Haustrup et al. (2005) showed 11 out of 12 isolates to be tolerant against copper citrate. The implication of calcium in oxalate precipitation was also shown for *M. incrassata* (Jellison et al. 2004). Thus, dry rot attack in buildings is often found in the ends of beams, which are not separated from the masonry.

During controversies, e.g., in the context of house buying, frequently the question of the infection date plays a role, for whose determination the daily average mycelial growth is often used. According to Jennings (1991), the linear mycelial extension on wood, masonry and insulants ranges from 0.65 to 9 mm/d. Assuming a 5-mm radial increase per day on malt agar at optimal temperature (Table 2.2), 15 cm follow per month. Due to the changing and not always optimal conditions in buildings and because different isolates of the fungus exhibited considerable differences in growth rate [1.5–7 mm/d: Cymorek and Hegarty (1986a); Seehann and v. Riebesell (1988)], an exact age determination on the basis of the mycelial extension is impossible. Similarly, the decay of pine sapwood samples varied among 25 isolates from 12 to 56% in 6 weeks of cultivation (Cymorek and Hegarty 1986a; Thornton 1991), and different isolates differed likewise in their sensitivity to wood preservatives (Abou Heilah and Hutchinson 1977; Cymorek and Hegarty 1986a; Ważny and Thornton 1989a, 1989b, 1992; Ważny et al. 1992). Important is also the decision if the mycelium in a building is alive or dead. Subculturing on malt agar is possible, but isolations from mycelium are often contaminated by molds. Vital

staining with fluorescein diacetate is suitable (Huckfeldt et al. 2000; also Koch et al. 1989; Bjurman 1994).

The possibilities to identify *S. lacrymans* cover the classical methods of fruit body investigation (Grosser 1985; Pegler 1991), strand diagnosis (Falck 1912; Table 2.4, Appendix 1), and mycelium analysis by identification key (Stalpers 1978). As modern techniques, protein polyacrylamide gel electrophoresis (Schmidt and Kebernik 1989; Vigrow et al. 1989; Palfreyman et al. 1991; Fig. 2.19) and immunological tests (Palfreyman et al. 1988; Vigrow et al. 1991c; Toft 1992, 1993; Glancy and Palfreyman 1993) were tested for suitability. DNA techniques have been established (Schmidt 2000) and are already used commercially. MALDI-TOF mass spectrometry was capable of differentiating the mycelium of the True dry rot fungus and its closest relative the Wild merulius (Schmidt and Kallow 2005; Fig. 2.24). Measurement of microbial volatile organic compounds (MVOCs) may identify wood-decay fungi (Bjurman 1992b). Pinenes, acrolein, and ketones were found in *Serpula lacrymans, Coniophora puteana,* and *Oligoporus placenta* (Korpi et al. 1999). Mono- and sesquiterpenes, aliphatic alcohols, aldehydes and ketones, and some aromatic compounds were emitted by *Fomitopsis pinicola, Piptoporus betulinus,* and further species (Rosecke et al. 2000). Blei et al. (2005) showed that MVOC analysis was able to distinguish pure cultures of *Antrodia sinuosa, C. puteana, Donkioporia expansa, Gloeophyllum sepiarium, S. lacrymans,* and *S. himantioides.* Field experiments, however, were influenced by the distance of sampling from the infested and/or destroyed wood and also by the rates of air changes. To improve the technique of MVOC analysis, Keller et al. (2005) measured volatile compounds in non-infested living and bedrooms as a background reference for infestation. Trained sniffer dogs can also detect *S. lacrymans* (Koch 1991).

If *S. lacrymans* is proven, the fungus is (beside longhorn beetle and termites) the only biological damage causer for which there is the obligation in some German states (Hamburg, Hessen, Sachsen, Thüringen, and Saarland) to become registered. Since costs of refurbishment can be considerable (to €3,000 per m^2 living space), the determination of the extent of the damage and the remedial treatments should be done by a renowned company. In Germany, refurbishment has to follow the standard DIN 68800 part 4. In the case of a lawsuit, §459 of the German Civil Code regarding "regress for material defects" takes effect.

8.5.4
Prevention of Indoor Decay Fungi and Refurbishment of Buildings

All decaying fungi need water for wood decay. Elimination of the source of moisture and drying of wood and masonry after prolonged wetting are the

most important remedial treatments. Since *S. lacrymans* can transport water, it cannot be excluded that sources of dampness are overlooked during repair, and thus more-extensive measures are necessary for its control.

The first remedial treatment of dry rot infestation is described in the Bible in Leviticus 14:33–48. Preventive measures against all house-rot fungi are avoidance of general building defects and of those during refurbishment of old buildings: moisture ascending in the masonry, seeping rain water, insufficient ventilation, installation of wet or infested timber and wet fillers, allside walled beam ends, lack of building drainage, condensation water by wrong thermal insulation and inappropriate vapor barriers, unsatisfactory underside blockage of buildings without cellars, wrong structure of floors, reuse of attacked building debris, leakages in bathrooms and insufficient wood protection.

To the common causes belong also unrepaired building damage: leaky roofs, shattered windowpanes, leaky or sweating water and heater lines, clogged or defective rainwater and drainage facilities as well as water damage caused by burst piping, defective washing machines and dishwasher water pipelines, cellar floodings and fire-fighting water (Thornton 1989a; Paajanen and Viitanen 1989; Bricknell 1991; Doi 1991; Wälchli 1991).

Particularly regarding cellar fungi, flooring in new buildings should not done too early. Damp bulk goods in ceilings shall be avoided.

The danger of infestation exists via spores and by infected timber and wooden boxes, which are stored as firewood in damp cellars, and by mycelium via the shoes of workers.

If a fungus is found, it should be first determined whether it concerns *S. lacrymans* or another fungus, as this decision may require the obligation to register the fungus and influences the extent of remedial treatments. In cases of doubt, laboratory identification should be performed by appropriate institutes, national testing institutions, offices for plant protection or in the laboratories of wood preservative manufacturers. The German standard DIN 68800 demands that if an exact species identification is not possible, then refurbishment is to be proceeded in such a way, as if the True dry rot fungus were present.

Then the extent of the damage has to be established. German guidelines for control measures are listed in Table 8.8 (Grosser et al. 2003).

Table 8.8. German guidelines for control measures during refurbishment

DIN 68800 Part 4: Wood preservation; control measures against wood-destroying fungi and insects, issue 1992

Part 3: Wood preservation; protective chemical wood preservation, issue 1990

Part 2: Wood preservation in building construction; protective structural measures, issue 1984

DIN 52175: Wood preservation; term, fundamentals, issue 1975

Concretization rule for building work (VOB part B)

Refurbishment methods are described by Grosser (1985), Blow (1987), Wälchli (1991), Bech-Andersen (1995), Gründlinger (1997), Sutter (2003), Bravery et al. (2003) and Grosser et al. (2003), briefly: Elimination of the source of moisture, removal of all infected timber 1 m beyond the last evidence of fungus or decay, disposal of the attacked timber and the other infected building materials, physical (heat) and chemical treatment (boron, quaternary ammonium compounds) of infested masonry with certified preservatives for those species that colonize brickwork, use of preservative-treated timbers for replacement following DIN 68800, and providing adequate ventilation.

Eradication in the roof space with hot air as it is used against insects (Paul 1990) is already done or is being considered to fight fungi in some European countries (Koch 1991; Sallmann 2005). However, first these treatments are technically wrong in view of a safe killing of mycelium and spores of house-rot fungi in wood and in masonry, since the necessary heat (Schmidt and Huckfeldt 2005; Huckfeldt et al. 2005; Table 3.8) is not obtained, particularly not in the inside of thick timber. Second, heat treatment is economically doubtful due to the endangerment of the structural fabric and third, from an ecological viewpoint, enormous energy is needed.

Microwaves are also used or being considered as an alternative method. Irradiation tests with microwaves from 1990 to 1992 in Denmark in about 100 cases of fungal infestation killed the mycelium of *S. lacrymans* that previously had been inserted into the brickwork within 10 min (Bech-Andersen and Andersen 1992; Kjerulf-Jensen and Koch 1992). However, microwave treatment is a fire risk if metal fastenings are present in the timber (Bravery et al. 2003) and there are general doubts on the suitability of the technique for buildings (Sallmann 2005).

For registered historical buildings and wood artifacts, the suitability of fumigants was tested mainly for the control of insects, but also to control decay fungi. Against fungi, bromomethane and ethylene oxide have been used (Unger et al. 2001). Fumigants, however, do not provide protection against new infestations. In the laboratory, aminoisobutyric acid, which is analogous to the amino acid alanine, reduced the decay of wood samples by *S. lacrymans* from 22 to 1% (Elliott and Watkinson 1989). An intervention in the trehalose metabolism of *S. lacrymans* was suggested to influence the internal translocation processes (Jennings 1991). The binding of iron by chelating agents inhibited mycelial growth, EDTA prevented decay of pine samples by *Coniophora puteana*, *Gloeophyllum trabeum* and *Oligoporus placenta* (Viikari and Ritschkoff 1992), and tellurium acid wood decay by *C. puteana* (Lloyd and Dickinson 1992). Polyoxin acted as inhibitor of the chitin synthase of several fungi (Johnson and Chen 1983). Particularly the *Trichoderma* species display a wide arsenal of antagonistic mechanisms that make these fungi attractive as biological control agents (Highley and Ricard 1988; Giron and Morrell 1989; Doi and Yamada

1991; Rattray et al. 1996; Bruce 2000). Bacteria decreased wood decay by *O. placenta* (Murmanis et al. 1988; Benko and Highley 1990).

From a biological point of view, there is no reason that all indoor wood decay fungi should be a problem. The biological requirements of the common species are known. Control measures are straightforward. Even once a fungus is established, it is mainly only necessary to change the conditions in the building to a long-term removal of moisture. There was only slight wood decay by some house-rot fungi below the fiber saturation range of about 30% u. The lower limit for decay of pinewood samples (mass loss slightly over 2% within 5 months) was 22% (Table 8.7). This also applies to the feared *S. lacrymans*. This fungus turned out in many laboratory tests on temperature and drying effects to behave rather sensitively when compared to the cellar fungi and the indoor polypores. The only biological specific features of *S. lacrymans* are its more highly developed strand system to transport nutrients from a moist feeding source over considerable distances and to colonize new substrate, its formation of thick surface mycelium that prevents the colonized wood from drying, and its ability to grow through masonry.

The most important measure against all fungi in buildings is to detect and eliminate the cause of the increased moisture content of wood and masonry that is in contact with wood as well to exclude any re-moistening, including through condensation and faults by the home user. If the destroyed timber has been replaced and lasting dryness of the wood can be guaranteed, there is no need for further provision, from the biological view, as there is no fungus known which destroys dry wood (below 22% u), not even *S. lacrymans*. Since practice, however, shows that in many cases a lasting dryness cannot be ensured in buildings, there are specific recommendations (and in Germany regulations) for the case of *S. lacrymans* infestation.

9 Positive Effects of Wood-Inhabiting Microorganisms

Particularly after the OPEC oil embargo of the 1970s, research turned towards the utilization of renewable resources like wood, yearly plants, and lignocellulosic waste from forestry and agriculture instead of oil as raw material for chemical and biological processes ("biotechnology of lignocelluloses") (Eriksson et al. 1990; Dart and Betts 1991).

Among the substantial causes that make the biological conversion of lignocelluloses difficult (Table 4.2), the most serious obstacle is the incrustation of the degradable carbohydrates cellulose and hemicelluloses by the lignin barrier, which is not surmountable by most microorganisms. Table 9.1 groups some bioconversions that have been done in the past or are recently investigated or already performed into those microbial processes, which go well directly with lignocelluloses, and into those, which need a pretreatment of the substrate. Only the wood-degrading white, brown, and soft-rot fungi, and the wood-degrading bacteria can degrade the native woody cell wall without any pretreatment of the substrate. Whereas brown and soft-rot fungi and assum-

Table 9.1. Biotechnological procedures with lignocelluloses without and after substrate pretreatment

conversion without substrate pretreatment
- "myco-wood"
- production of edible mushrooms
- biological pulping

pretreatment of the substrate and subsequent microbial conversion
biological pretreatment
- "palo podrido" and "myco-fodder"
chemical pretreatment
- hydrolysis of wood with acids and use of glucose for yeast production, ethanol fermentation and microbial transformations to amino acids, antibiotics, enzymes, vitamins
- sulphite pulping process and use of hardwood pentoses in the spent liquor for yeast production and of softwood hexoses for ethanol fermentation
- pulping and subsequent use of enzymes for deinking of waste paper
physical pretreatment
- grinding of lignocelluloses to improve accessibility to enzymes
- steam explosion methods to open the wood structure for bioconversions

ably also the wood-degrading bacteria only clear the hurdle of lignification, exclusively the white-rot fungi and their ligninolytic system additionally use the lignin as a carbon source and are therefore predestined for bioconversions (Table 4.3). All other microorganisms as well as their isolated enzymes need first a pretreatment of the substrate wood, which loosens the chemical/physical association of carbohydrates and lignin or reduce the lignin content or improve the physical accessibility of the degrading agents to the substrate. The various possibilities of a pretreatment can be grouped into biological, chemical, and physical methods (Dart and Betts 1991). Saddler and Gregg (1998) distinguished four main pretreatment methods currently being researched and commercialized to make lignocelluloses more easily digestible to hydrolytic enzymes while preserving the yield of the original carbohydrates for bioconversions: organosolv, steam explosion, dilute-acid prehydrolysis, and ammonia fiber explosion. Some of the bioconversions described below like "myco-wood" or "palo podrido" may occur a little strangely to some readers, but are examples that wood bioconversion can work.

9.1
"Myco-Wood"

In Eberswalde, Germany, around 1930, J. Liese started to cultivate edible mushrooms on wood like *Flammulina velutipes*, *Kuehneromyces mutabilis*, *Lentinula edodes* (Fig. 2.17a) and *Pleurotus ostreatus* to improve the food situation of the population (Liese 1934). Due to the import stop of wood from overseas into the German Democratic Republic (GDR) at that time which was needed for pencils etc., his student, W. Luthardt thought about a possible use of the wood substrate remaining after mushroom production to produce pencils and other form-stable products. In 1956, Luthardt got the patent for "myco-wood" for the GDR and in 1957 under license for the Federal Republic of Germany: "Myco-wood is a wood that is loosened through the controlled action of certain wood-inhabiting fungi and which has changed its technological characteristics to a large extent or may obtain defined technical qualities" (Luthardt 1969). For myco-wood production, 50-cm-long stem sections of *Fagus sylvatica* were inoculated on the crosscut surface with a mycelium paste of *Pleurotus ostreatus* or *Trametes versicolor*, respectively, and were incubated in the constant climate of former air-raid shelters for different periods. Through the controlled white rot, a white and porous raw material free from tension was obtained that showed improved carving and sharpening ability to be used for form-constant products like pencils, rulers, and drawing boards. For example, after 3 months of incubation, the wood showed 30% mass loss, was completely colonized by mycelium, and was now suitable for rulers. One of these rulers is still used in our laboratory and looks like newly manufactured.

About 120 million myco-wood pencils were produced in the GDR from 1958 to 1961. The microbially modified wood also showed faster water absorption and desorption and was thus used for wood forms of the glass industry. Due to water-vapor film between wood and glass, it was possible to produce 12,000 goblets using a myco-wood form instead of 800 glasses using normal wood (Luthardt 1963). Attempts to produce myco-wood also took place with tropical woods (Eusebio and Quimio 1975; Arenas et al. 1978) and bamboo (W. Liese, pers. comm.).

9.2
Cultivation of Edible Mushrooms

Although actual data could not be obtained, the worldwide production of edible mushrooms cultivated on straw and wood may be in the range of 2 million t (fresh weight basis) per year (Table 9.2), so that the cultivation of mushrooms represents the economically most important microbial conversion of lignocelluloses (Chang and Hayes 1978).

Without knowledge of the biological background, about 2,000 years ago, the Shii-take, *Lentinula edodes*, (Fig. 2.17a) was already cultivated on wood

Table 9.2. Production of edible mushrooms (after various reports in the journal "Der Champignon")

	Year	(× 1,000 t)	(%)
Mushrooms worldwide	1991	4,273	100
Agarics (*Agaricus* spp.)		1,590	37.2
Oyster mushrooms (*Pleurotus* spp.)		917	21.5
Auricularia spp., *Tremella* spp.		605	14.2
Shii-take (*Lentinula edodes*)		526	12.3
Enoki (*Flammulina velutipes*)		187	4.4
Nameko (*Pholiota nameko*)		40	0.9
Grifola frondosa	2005	35	
Mushrooms worldwide	1997	6,344	100
China		4,000	63.1
Japan, Taiwan, Korea, etc.		1,005	15.8
EU		908	14.3
North America		431	6.8
Shii-take worldwide	1997	1,322	100
China		1,125	85.1
Japan		133	10.0
Taiwan, Korea		44	3.4
EU		0.995	
France		0.450	
Germany		0.150	

in Asia. The name Shii-take means "Pasania-fungus", because the mushroom was grown on the "Shii-tree" (*Castaneopsis* (*Pasania*) *cuspidata,* Japanese chinquapin). For the cultivation of this excellently tasting mushroom (compared to the Shii-take, the commercially produced agarics taste like nothing) as "natural log cultivation", originally in China, and later in Japan, logs and branch sections were exposed to natural, passive inoculation by wind-borne spores and were stacked in the forest for fruit-body formation. About 300 years ago, the Shii-take was cultivated by farmers for extra income to be sold on local markets. The bark surface of logs, particularly from *Quercus serrata* or other fagaceous trees, was broken with an axe to improve the chances of inoculation. Since the 1920s, pure spawn culture was placed ("spawning") into holes drilled into the logs. For the colonization phase of the substrate by mycelium, the inoculated logs were first placed as stacks in the forest or in greenhouses until the mycelium grew out. The colonized woods were then set up individually or stacked crosswise in the forest ("growing yard") or in greenhouses for fruit body formation. Eight to 12 months after inoculation, there is the first flush of mushrooms, and cropping of logs occurs over about 5 years. Since the 1970s in Taiwan, Japan, and China, the Shii-take is produced commercially on chopped wood (chips) and wood waste like sawdust under controlled conditions such as defined substrate composition, temperature, light conditions, relative humidity, and wood moisture content. The big breakthrough for sawdust substrates was the use of plastic bags, in which the substrate can be compressed, sterilized, inoculated, and grown out (Fig. 9.1). The woody substrate is supplemented with amendments (bran, whole meal, urea etc.), watered for a suitable moisture content, and inoculated with special isolates. In this "bag" or "artificial log" culture, the mycelium knits the substrate into a solid block. The methods for Shii-take production have been recently summarized by Miller (1998). In the local experiments (Schmidt and Kebernik 1986; Schmidt 1990), different wood wastes such as chips (Fig. 9.1), sawdust,

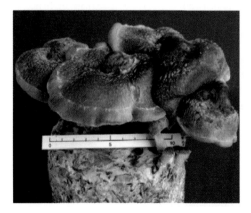

Fig. 9.1. Shii-take (*Lentinula edodes*) fruit-bodies grown on wood waste chips

leaves and needles from some hardwoods and also from spruce and pine were used. A short colonization phase of the substrate was done at about 24–28 °C in closed plastic bags or similar containers. Readiness of the Shii-take to fruiting became visible in the closed bag, when brown-black wet spots occurred between the white mycelial mat along the outer surface of the artificial log and the bag. Then the substrate was a solid block, and the substrate containers were opened or removed for fruiting at lower temperature of about 12–20 °C. After bag removal, the outer mycelial surface becomes brown and leathery. Then the logs were sprayed with water once a day, and natural daylight in a greenhouse was used to stimulate primordia formation. The artificial light–dark cycle requires light in the 3,700 to 4,200-nm range and intensity of 400–500 lux (Miller 1998). Several flushes occur within 1 year. After each cropping, the dry substrate may be re-wetted e.g., by soaking in cold water. This soaking both replaces the water that has been lost by the growth of the fruit bodies and the cold stimulates the development of the next primordia. The yields amounted to about 100% biological efficiency (fungal fresh weight: dry weight wood; Royse 1985). In Taiwan, for example, 516 companies produced about 24,000 t of fresh fungi on chopped substrates in 1985, and a similar quantity was obtained, however, by over 5,000 farmers on wood sections.

The Shii-take was for a long time the most common mushroom cultivated on wood worldwide. Altogether, the fungus was the second most frequent cultivated mushroom with its main production in Japan after the *Agaricus* species, which are traditionally cultivated on wheat straw that is composted with manure or some other nitrogen-rich additive. The Shii-take has been however overhauled through the increased production of *Pleurotus* species particularly in China. Worldwide 526,000 t Shii-take were harvested in 1991 and 1.3 million t in 1997 (Table 9.2). Beside Asia, some Shii-take cultivation is performed in the USA, Canada, and Europe. In Germany, there is a handful of commercial Shii-take growers producing some hundreds of tons. A great part of Chinese and Japanese Shii-take is exported in dry condition to Taiwan, Singapore, USA, Canada, Australia, and Europe. In Germany, 100 g of dry, imported Shii-take cost about € 10. The local market price varies for outdoor-grown fungi due to seasonal influences from € 10 to 40 per kg fresh weight. Because of the slow growth of the Shii-take mycelium during the colonization phase, the cultivation on shopped substrates is endangered by contaminations, partly leading to parasitism, particularly by *Trichoderma* species like *T. hamatum*, *T. harzianum*, *T. parceramosum*, *T. pseudokoningii*, *T. reesei* and *T. viride* (Albert 2003). Thus, the colonization phase is commonly performed with pasteurized (60–100 °C) ore autoclaved substrates in plastic bags (Schmidt 1990).

The fundamentals of Shii-take production are known outside of Asia. The first cultivations in Europe were performed by Mayr (1909) and Liese (1934;

Fig. 2.17a), and research on the biological and physical demands of the fungus were done in the USA (e.g., Leatham 1982; Royse 1985) and in Europe (e.g., Zadražil and Grabbe 1983; Rohrbach 1986; Müller and Schmidt 1990; Lelley 1991; Kalberer 1999). Basically, the procedure consists of four main steps as shown in Fig. 9.2: pre-culture of a certain isolate, propagation of the mycelium for inoculation by growth on sterile grains (spawn production), colonization phase of the sterilized substrate in plastic bags, and fruiting phase on the opened containers.

The reasons why the Japanese and Chinese in particular have been so successful in Shii-take cultivation are not known. Generally, the cultivation of so-called "alternative or exotic mushrooms" has got to have the right feel for it. The Shii-take belongs to "demanding mushrooms" while the Oyster mushroom, *Pleurotus ostreatus*, is easily satisfied through its fast growth ability on several substrates such as lignocellulosic waste (Pettipher 1987) and is thus lesser sensitiveness to contamination. In North America and Europe, particularly in Italy and Hungary, frequently *Pleurotus* species such as *P. ostreatus* are grown on chopped wheat straw, but also stem sections (Fig. 9.3) or chopped waste is used by hobby breeders and commercially. The market price of this lesser-tasting fungus in Germany amounts to €5–10/kg fresh weight. Further fungi that are cultivated on lignocelluloses are e.g., *Agrocybe aegerita*, *Auricularia auricula-judae*, *Flammulina velutipes*, *Grifola frondosa*, *Hericium erinaceus*, *Kuehneromyces mutabilis*, and *Pholiota nameko* (Miller 1998). Research results and practical tips for mushroom culturing occur in the German

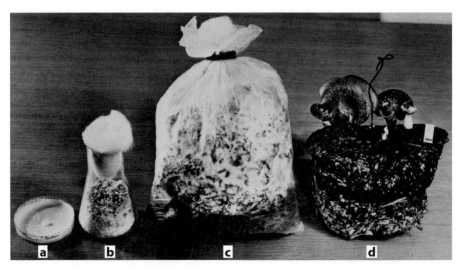

Fig. 9.2. Main steps of Shii-take production: **a** Maintenance of a selected isolate on agar. **b** Mycelial growth on grains for inoculation. **c** Substrate colonization in closed plastic bags. **d** Fruiting phase after removal of plastic bag (from Schmidt 1990)

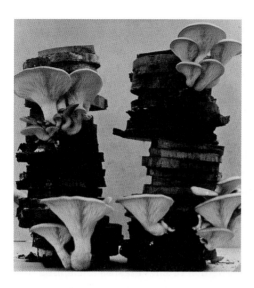

Fig. 9.3. *Pleurotus ostreatus* cultivation on beech wood billets in Germany in 1936 (photo J. Liese)

journal "Der Champignon". The international work is treated at the meetings of the International Mycological Society.

Concerning the nutritional value of fungi, it may be considered that a fresh fruit body contains predominantly water and only about 10% dry matter. For 100 g of fresh Shii-take, 92.6 g water, 4.3 g carbohydrates, 1.9 g protein, 0.3 g lipids, 0.7 g ballast material, and 0.5 g minerals have been measured, corresponding to 109 kJ. Minerals in decreasing order were K, P, chloride, Ca, Mg, Na, Zn, fluoride, Fe, and Cu. The vitamins comprised C, pantothenic acid, nicotine amide, E, B_1, folic acid, and D (Schulz 2002; also Spiegel 2001). Thus, considering the high price of the tasty mushrooms species, their significance as food lies rather in culinary appeal.

For thousands of years, mushrooms have been known as a source of medicine, particularly in Asia. Among these non-culinary mushrooms, e.g., *Ganoderma* species are grown on wood waste to obtain medically active compounds (Miller 1998). For example, he has shown that the methanol extract of the *G. lucidum* fruit body has a strong inhibitory activity of the 5α-reductase that is involved in the benign prostatic hyperplasia of older men (Liu et al. 2005). Those "medicinal mushrooms" are widely sold as a nutritional supplement and are touted as being beneficial to health. Asian people believe that the Shii-take has antivirus, antibactericidal, antitumour (e.g., Mori et al. 1989) and cholesterol-decreasing effects. In view of the possibly increased heavy metal content and radiation load that had been measured in some forest mushrooms, indoor-cultured fungi are harmless, but are usually lesser tasty than outdoor-grown fungi. In Asia, the quality of mushrooms grown in a bag or bottle culture is considered inferior.

9.3
Biological Pulping

Mechanical and chemical processes for pulp and paper production consume energy and chemicals. Their wastes have to be controlled in view of environmental aspects. Biotechnological processes have thus been successfully implemented in the pulp and paper industry during the last decade driven by the objective to reduce manufacturing costs using new delignification processes and by environmental considerations (Messner et al. 2003). The application of white-rot fungi, or their ligninolytic systems, was one option for this. The aim was termed as biological pulping or briefly biopulping. In its strict sense, biopulping was defined as the pretreatment of wood chips with selectively delignifying white-rot fungi prior to mechanical or chemical pulping (Messner 1998). In a broader sense, the term biopulping is also used for any biochemical assistance to the pulping process such as the application of blue-stain fungi for resin reduction or the use of enzymes for bleaching and deinking.

Nilsson had found *Sporotrichum pulverulentum* (first termed *Chrysosporium lignorum*) in chip piles in Sweden, where it caused serious damages (Bergman and Nilsson 1966). In 1972, Henningsson et al. described the fungus as the thermophilic white-rot basidiomycete *Phanerochaete chrysosporium* (teleomorph of *S. pulverulentum*) causing defibration of wood. In the late 1960s, Eriksson in Stockholm had already started research to decrease the lignin content in the wood microbially by treatment of wood chips with white-rot fungi (Eriksson 1985; Eriksson et al. 1990). Mechanical pulp was produced from chips pretreated with *P. chrysosporium* by Ander and Ericksson (1975). Because white-rot fungi of the "selective delignification type" would also attack the carbohydrates sooner or later, cellulase-less mutants such as Cel 44 of *S. pulverulentum* have been produced by UV irradiation of conidia (Ander and Eriksson 1976) and later by crossing of Cel⁻-mutants with monokaryons of high ligninolytic activity (Johnsrud 1988).

Phanerochaete chrysosporium has also been isolated in the USA in the Arizona desert (Burdsall and Eslyn 1974). Also in the late 1960s, Kirk in Madison began research on *P. chrysosporium* with the isolation of lignin peroxidase (Tien and Kirk 1983; see Chap. 4.5), and since the 1980s, biopulping is investigated in the USA (Kirk et al. 1993).

There were masses of investigations and publications on various aspects of biopulping during the past four decades. They report on the successful reduction of chemicals and manufacturing and energy costs as well as on the application of further white-rot fungi such as *Ceriporiopsis subvermispora*, *Dichomitus squalens*, *Merulius tremellosus*, and *Phlebia brevispora*. For example, when biopulped chips are used to produce mechanical pulp, energy for refining was reduced from 25 to 35% and the sheet strength properties are

typically improved 20 to 40% (Hunt et al. 2004). A 20% reduction was obtained in the total pulping time necessary for achieving pulp and paper properties comparable to those from controls (Chen et al. 1999). Körner et al. (2001) showed that non-sterile incubation of wood chips with *Coniophora puteana* yielded energy savings of about 40% during refining of wood chips, a three times higher bending strength and more than half reduced water absorption and swelling of fiber boards. The topic of biological treatment of chips of was reviewed by Messner (1998).

Despite the massive amount of money and work devoted to biopulping, a sweeping success seems however vague. The difficulties involved are mainly microbiological problems: It is generally difficult to scale-up small-sized laboratory experiments with fungal pure cultures via medium-sized rotating fermentors with controlled aeration and temperature to the final aim of obtaining the same result in chip silos or even in large-sized chip piles under natural outdoor conditions. During controlled biopulping, the different white-rot fungi may be grown on wood chips for 10 to 15 days. In a wood chip pile, available nutrients, humidity, and temperature are, however, favorable to contamination by many fungi. Most common are *Trichoderma* species, of which some excrete antibiotics against other fungi. Uneven distribution of the inoculum, unsuitable or uneven oxygen and carbon dioxide amounts, unfavorable or uneven wood moisture content, and increase of the temperature to 50 °C or even to the incineration point are common problems of large-sized outdoor bioconversions in piled substrates. An example with respect to brown-rot fungi is the successful laboratory and pilot-scale experiments by Leithoff (1997) to bio-leach chromium, copper and other elements from treated waste wood by means of *Antrodia vaillantii* (Chap. 7.4) and the failure of the method using larger chip piles under practical conditions. Nevertheless, it has been stated that development of the biopulping process has reached the pilot scale as far as the use of white-rot fungi for mechanical and sulphite pulping is concerned, has already been tested on a commercial scale with *Ophiostoma piliferum* for craft pulping (Messner 1998) and that "biopulping ... is close to mill application" (Messner et al. 2003).

As a "by-product", the biotechnological attempts of using fungi or their enzymes in the pulp and paper industry in processes as biopulping, biobleaching, and fiber modification have spurred the understanding of the mechanisms of wood decay (Chap. 4). It may however be mentioned that the most often investigated fungus with respect to enzyme mechanisms, *P. chrysosporium*, has beside chip piles no relevance for wood, neither for trees nor for constructional timber.

9.4
"Palo Podrido" and "Myco-Fodder"

In the evergreen temperate rainforests of southern Chile, Philippi (1893) found in the heartwood of dying and fallen hardwoods (*Eucryphia cordifolia, Nothofagus* spp. and other trees) a white, spongy-wet wood tissue (Fig. 9.4a, also Fig. 7.2c), which may occupy the entire interior of logs. This white-rotted wood, called "palo podrido" (rotted wood) or "huempe", develops by the action of *Ganoderma* species like *Ganoderma adspersum* (Martínez et al. 1991a, 1991b; Barrasa et al. 1992; Bechtold et al. 1993) and other white-rot Basidiomycetes, associated yeasts and bacteria (González et al. 1986), in the moist forest climate during a long time. Environmental factors such as a lack of desiccation and frost during the year in tropical forests may have reduced the mechanical stress on the wood and maintained conditions that promote delignification (Eriksson et al. 1990). Low nitrogen content of the wood was considered to be a major factor that contributed to this selective delignification (Dill and Kraepelin 1986). Black manganese deposits indicating the correlation to manganese peroxidase have been found in palo podrido by Barrasa et al. (1992) and others. Rodriguez et al. (2003) detected several iron-chelating catechol compounds in palo podrido samples, whose relation to lignin or fungal metabolites remained however unclear.

Palo podrido has been used by rural population as feed for foraging cattle. Healthy wood, even in grinded form, has a very low rumen digestibility. Thus, the development of palo podrido by the action of fungi may be termed as "biological wood pretreatment". Due to the fungal delignification particularly in the area of the middle lamella/primary walls, the woody tissue is loosened and now edible by cattle. Figure 9.4b demonstrates that the Chilean cow prefers the pineapple-like palo podrido (Fig. 9.4a) to the surrounding grass. Mainly through the opening of the wood structure, now the anaerobic rumen bacteria can get access to the digestible wood carbohydrates. The reduction of the lignin content from 22% of healthy *Nothofagus* wood to about 6% in the corresponding palo podrido sample (Dill and Kraepelin 1986) may have promoted bacterial activity, but is probably no premier factor, as it has also been stated for the bacterial degradation of chemically pretreated wood (Chap. 5.2). The rumen bacteria convert the wood carbohydrates in palo podrido to fatty acids like acetic, propionic, and butyric acid. This fermentation is the "biotechnological" part of palo podrido. Last, the cow uses the fatty acids and also the continually dying bacteria to produce meat and milk.

Lignocelluloses which have been specifically treated with fungi to improve the digestibility and protein content for use as ruminant feed have been termed as "myco-fodder" (Heltay 1999; also Eriksson et al. 1990). For example, the digestibility of straw that was treated with *Lentinula edodes* for 2 months showed increased digestibility by 28% (Zadražil 1985; Zadražil and Brunnert

Fig. 9.4. "Palo podrido" caused by *Phlebia chrysocreas* (**a**) and a Chilean cow eating "palo podrido" (**b**) (photos J. Grinbergs)

1980). As a by-product, production of edible mushrooms may increase the economy of fungal straw treatment.

9.5
Wood Saccharification and Sulphite Pulping

Both wood saccharification with acids and sulphite pulping may be termed "chemical wood pretreatment" when the obtained sugars are subsequently used for microbial or enzymatic conversions.

The acid wood saccharification yields monosaccharides from the wood carbohydrates. Hydrolysis of lignocelluloses either with diluted or concentrated acids has been practiced on a large commercial scale for many years. This technique was used in the USA in the 1910s and in Germany and in Switzerland during the Second World War. About 10 million m^3 of wood were saccharified by acid hydrolysis with up to 48% sugar yield of the possible 70% yield in the former Soviet Union around 1983 (Wienhaus and Fischer 1983). The main product is glucose, which is the universal sugar for the majority of organisms. Glucose can by either converted by yeasts, e.g., *Candida utilis*, aerobically to fodder yeast (single cell protein, SCP; Dart and Betts 1991) or for human feed, or glucose is anaerobically fermented to ethanol to be used as chemical feedstock or as petrol substitution (Decker and Lindner 1979). Glucose fermentation to ethanol was one of the first complex biological processes mastered by man and became an important fuel and chemical feedstock in the mid-19th century. However, with the rapid growth of the petroleum and petrochemical industry following World War I, fermentation has been restricted primarily to the brewing and distilling industries (Saddler and Gregg 1998). Ethanol can be also obtained from xylose by the xylose-fermenting yeast *Pachysolen*

tannophilus. Other fungi, e.g., molds, as well as aerobic and/or anaerobic bacteria can produce amino acids, antibiotics, enzymes, organic acids, solvents, and vitamins from glucose or glucose-containing wastes. Technical problems of acid hydrolysis, such as corrosion of the reaction vessels and formation of noxious by-products, led to research on enzymatic hydrolysis processes, which promised, for example, higher sugar yields (Saddler and Gregg 1998).

Spent sulphite liquors contain at about 50% of the employed wood as lignin sulphonic acids and simple sugars from the hemicelluloses. A number of applications for lignosulphonates or the entire spent sulphite liquors have been developed in the past (e.g., Faix 1992). Since the early past century, the hexoses in spent softwood liquors were converted by yeasts to alcohol and the pentoses in hardwood liquors to fodder or feeding yeast, respectively. For example, a mill in Switzerland produced (in 1980) in two tanks (320 m^3) 82,000 hL alcohol and 7,000 t of yeast cells, respectively. In Sweden, 1.2 million hL of alcohol was produced in 33 plants in 1945 (Herrick and Hergert 1977). In the 1980s, the sugars in spent sulphite liquor were converted by means of the soft-rot deuteromycete *Paecilomyces variotii* for use as animal feed in Finland ("Pekilo-process"; Forss et al. 1986). Han et al. (1976) cultured *Aureobasidium pullulans* on straw hydrolysate for production of single cell protein. Ek and Eriksson (1980) used *Sporotrichum pulverulentum* for water purification and protein production. Anaerobic treatment of pulp mill effluents by bacteria was reviewed by Guiot and Frigon (1998).

9.6
Grinding and Steam Explosion

Among the physical pretreatment methods, grinding of lignocelluloses increases the inner surfaces of the wood cell wall and thus improves the accessibility for enzymes to the cell wall components. The particle size must be reduced to 50 µm to maximize the effect. The energy costs become prohibitive at particle sizes of 200 µm (Dart and Betts 1991).

Steam explosion methods saturate the lignocellulose with steam and then allow it to undergo explosive decompression. The treatment releases acids that contribute to the disruption of the cell wall (Dart and Betts 1991). In the steaming-extraction process, chopped wood was treated in watery or alkaline solution for a few minutes at 185–190 °C (1,100–1,200 kPa). Subsequent washing with water or thin sodium hydroxide solution separated the wood into a solid component containing lignin and cellulose and a liquid phase of the hemicelluloses (Dietrichs et al. 1978). In vivo digestibility of wood in a test cow increased from about 5% of natural wood to 80% for steam-treated wood (Puls et al. 1983). The hemicellulose fraction was used to produce *Paecilomyces variotii* mycelium and enzymes (Schmidt et al. 1979).

9.7
Recent Biotechnological Processes and Outlook

Several new applications of enzymes have reached, or are approaching, the stage of commercial use in the pulp and paper industry. These include e.g., enzyme-aided bleaching with xylanases, direct delignification with oxidative enzymes, energy-saving refining with cellulases, pitch removal with lipases, slime control (Klahre et al. 1996) in the paper machine, removing contaminants in the recycle stream, as well as deinking (Kenealy and Jeffries 2003; Messner et al. 2003).

A colorless mutant of the blue-stain fungus *Ophiostoma piliferum* was used to control pitch problems (Blanchette et al. 1992b; Farrell et al. 1993; Brush et al. 1994; also Fischer et al. 1994), and chip treatment with *O. piliferum* decreased energy consumption and increased strength properties in mechanical pulps (Forde Kohler et al. 1997).

Enzymes used in pulping can increase the yield of fiber, decrease further refining energy requirements, or provide specific modifications to the fiber. Cellulases, hemicellulases, and pectinases allowed for better delignification of the pulp and savings in bleaching chemicals without altering the strength of the paper (Kenealy and Jeffries 2003). Laccase and protease reduced energy requirements in mechanical pulping. Cellulases and hemicellulases have been used in the refining of virgin fibers. Agricultural residues like wheat and rice straw have been mechanically pretreated followed by treatment with enzymatic cocktails from *Lentinula edodes* for pulp production (Giovannozzi-Sermanni et al. 1997).

The initial studies on the use of enzymes in bleaching were performed with a goal of imitating the wood-decaying action of fungi in nature (Iimori et al. 1998; Viikari et al. 1998). However, different mixtures of lignin and manganese peroxidases did not consistently delignify unbleached craft pulp. The use of xylanases in bleaching can improve lignin extraction, alter carbohydrate and lignin association, or cleave redeposited xylan. Recently, laccases or manganese peroxidases, either alone or combined with low molecular weight mediators, have been examined. In the laccase-mediator concept, laccase is combined with a low molecular weight redox mediator resulting in generation of a strongly oxidizing co-mediator, which then specifically degrades lignin (Jakob et al. 1999; Sealey et al. 1999). "Novel xylanases" deriving from thermophilic and alkaline sources are of importance due to the prevailing conditions in pulp processing. Progress in the knowledge of the xylanase-encoding DNA sequences and the expression of xylanases in other microorganisms may lead to further development in this area (Kenealy and Jeffries 2003).

Waste paper is the primary raw material of the European paper industry. For Germany, the amount of waste paper for paper production has been forecasted to about 14 million t in 2005. In 1995, the average composition of

waste paper in a deinking plant consisted of 41% newspapers, 39% magazines, 9% wood-free paper, 6% unusable paper and board, 4% other bright papers, and 1% non-paper components (Hager 2003). More than 70% of mixed office waste paper consists of uncoated papers that are printed with copy or laser printer toners, which may be difficult to remove by conventional, alkaline deinking (Kenealy and Jeffries 2003). Fibers may be treated by hydrolyzing enzymes to remove print (deinking). Cellulases are particularly effective in the removal of toners from office waste papers. It was concluded that the primary role of cellulases in deinking involves separating ink-fiber agglomerates and dislodging or separating ink particles and fibrous material in response to mechanical action during disintegration (Kenealy and Jeffries 2003). Few experiments have used oxidative enzymes for deinking. The missing potential for the reduction of specks that derive from residual ink and the observed lignin modification rendered laccase either alone or combined with the mediator 1-hydroybenzotriazole unsuitable for practical ink elimination of wood containing waste paper (Hager et al. 2002). Recycled paper sludge generated during repulping was simultaneously hydrolyzed with fungal cellulase and fermented with the yeast *Kluyveromyces marxianus* to convert cellulose fibers to ethanol (Lark et al. 1997).

Papers made from secondary fibers often show a higher microbial load which is of disadvantage for some applications, e.g., as hygienic papers (Cerny and Betz 1999).

Anaerobic treatment of pulp mill effluents was reviewed by Guiot and Frigon (1998). *Phanerochaete chrysosporium* and *Trametes versicolor* have been used to degrade the chlorolignins in the effluents produced during chlorine bleaching (Eriksson et al. 1990). The ligninolytic systems of white-rot fungi, particularly *P. chrysosporium*, was used to degrade several persistent environmental pollutants such as benzo(a)pyrene, DDT, and dioxin. Bacteria metabolized dibenzo-*p*-dioxin (Wittich et al. 1992). Aerobic bioremediation techniques for the cleanup of creosote and PCP-contaminated soils were reviewed by Borazjani and Diehl (1998) (also Prewitt et al. 2003). Aerobic PCP transformation initially produced small amounts of pentachloroanisole; however more than 75% of both chemicals disappeared in 30 days from the test soil. Under methanogenic conditions, PCP was reductively dechlorinated to tetra-, tri-, and dichlorophenols (D'Angelo and Reddy 2000). Bioremediation of wood treated with preservatives using white-rot fungi was treated by Majcherczyk and Hüttermann (1998). The peroxidases of white-rot fungi unspecifically oxidize aromatic compounds by generating such a high redox-potential that they "burn down" all available aromatics present in the proximity of the mycelia. *Phanerochaete laevis* transformed polycyclic aromatic hydrocarbons (Bogan and Lamar 1996). Tubular bio-filters filled with straw, which were previously colonized with *Pleurotus ostreatus* mycelium was used to filter out ammonia from the waste air of cattle sheds (Majcherczyk et al. 1990). Experiments on the

biodegradability of coal tar oil (creosote) by 16 bacterial species and six fungi using IR-spectra as an indicator for attack have been unsuccessful, assumably due to the complex mixture of some hundred toxic compounds in the tar oil (Schmidt et al. 1991).

Bark extracts of *Acacia* spp. (wattle or mimosa bark extract) and wood extracts of *Schinopsis* spp. (quebracho wood extract) are rich sources of tannins. Tannins are used for a long time in leather tanning and for the production of adhesives (Pizzi 2000; Roffael et al. 2002). Copper tannate was tested as a possible wood preservative (Pizzi 1998). In 1950, worldwide about 300,000 t of tannin extracts were produced (Herrick and Hergert 1977). Main commercial producers are Argentina, South Africa, Brazil, Paraguay, Zimbabwe, Indonesia, Kenya, and Chile. The hot water extract of spruce and larch bark contains a high amount of carbohydrates and was thus unsuitable for adhesives. The soft-rot fungus *Paecilomyces variotii* reduced the carbohydrate content, so that the tannins were suitable as adhesives (Schmidt et al. 1984; Schmidt and Weißmann 1986). Wagenführ (1989) used a commercial pectinolytic enzyme preparation to reduce the carbohydrate content.

Despite the massive amount of money and effort devoted over the past decades to the microbiological or enzymatic conversions/treatments of lignocelluloses, several of the projects started with enthusiasm have suffered success or practical utilization or even loss of interest. Oil has remained the premier raw material for chemicals of all types (Little 1991). However, the foreseeable limitation of oil resources and thus the probable increase in the cost of petroleum-derived feedstock will provide the necessary incentive to further research. But, the development and utilization of alternative processes also depend on political interests and geographical aspects. As an example for the latter, the use of biofuels (rapeseed oil methylester, RME) may be a possible substitute for fossil fuels, which also contribute substantially to the increase in CO_2 in the atmosphere. In Germany, the share of RME on the whole consumption of diesel fuel however is 4.3% and cannot exceed 7% due to the limited arable acreage. In the end, economy and subsidization will decide on future research.

Appendix 1
Identification Key for Strand-Forming House-Rot Fungi
(According to Huckfeldt and Schmidt 2004)

All key points must be considered before a decision. Numbers in parentheses refer to the preceding key point. The question mark points out that only few samples have been investigated.

1	fungus causes (intensive) rot	2
1*	fungus does **not** cause (intensive) rot – possible error: rotten wood is overgrown or infection is in initial stage; no vessel hyphae (if vessels then usually within strands, forward to 3)	34
2(1)	brown-cubical rot; no setae; spores always even (also in oil-immersion)	3
2*	white rot; vessels always less than 15 µm in diameter	24
3(2)	strands clearly recognizable, but often overgrown by mycelium	4
3*	strands indistinct (microscopic investigation necessary; start at (4) if vessels are present)	16
4(3)	strands over 5 mm in diameter, removable from the substrate, frequently surrounded by thick mycelium or hidden in masonry, wood etc.; dry strands break with clearly **audible cracking**; fiber (skeletal) hyphae refractive; vessels with internal wall thickenings (bars), to 60 µm in diameter; vegetative hyphae with clamps see (12) *Serpula lacrymans*	
4*	strands under 5 mm in diameter **or** firmly attached to the substrate	5
5(4,16)	strands hair-like, often branched and clearly defined (with "bark"), **below 0.5 mm** in diameter and often below mycelium, removable; **no fibers; or** strands/mycelium with sclerotia	6
5*	strands **not** hair-like, not clearly defined (without bark); no sclerotia; fibers present or absent	7
6(5)	sclerotia large, to 6 mm in diameter, round, often somewhat irregular, sometimes absent; strands hair-like, with bark, cream to yellow, red-brown to black when old, under 0.5 mm in diameter, somewhat flexible when dry; no fibers; vessels to 25 µm in diameter, numerous, in groups, with bars, cell wall to 1 µm thick; some vegetative hyphae bubble-like swollen to 10–25 µm in diameter and according literature with medallion clamps, always with clamps; strands also in masonry; only on softwoods *Leucogyrophana mollusca*	
6*	sclerotia small and oblong, to 2.5 mm long, brown to grey, sometimes absent; strands hair-like, with bark, yellowish, grey to brown, probably darker when old, covered by lighter mycelium or exposed, under 0.5 mm in diameter, somewhat flexible when dry; no fibers; vessels to 25 µm in diameter, but often partly thickened, numerous, in bundles, with bars;	

vegetative hyphae with clamps, 2.5–4.5 µm in diameter; strands also in masonry; probably only on softwoods ***Leucogyrophana pinastri***

7(5)	strands with vessels (sometimes rare; search; wood fibers may be mistaken for vessels)	8
7*	strands **without** vessels	9
8(7)	strands **without** fibers, however usually with vessels and vegetative hyphae with clamps	10
8*	strands **with** fibers, vessels and vegetative hyphae with clamps	11
9(7)	strands **with** fibers and vegetative hyphae	16
9*	juvenile strands **only** with vegetative hyphae (old strands sometimes with vessels and fibers)	22
10(8)	vessels rare, often narrowed at the septa; fibers absent or indistinct; vegetative hyphae with clamps	15
10*	vessels numerous, to 21 µm in diameter, often in bundles, with septa, bars indistinct or absent, cell wall to 1 µm thick; no fibers; vegetative hyphae with clamps, 1–4 µm in diameter, small hyphae partly with thickened cell wall; strands indistinct, just as embedded as those of *S. lacrymans*, somewhat flexible when dry, white, cream-yellow to grey, always brittle, to 2 mm in diameter, also in masonry ***Leucogyrophana pulverulenta***	
11(8)	vessels with bars (sometimes absent in very young strands), to 60 µm in diameter, fibers straight-lined, not flexible (with aqueous or ethanol preparation, may be flexible in KOH)	12
11*	vessels without bars, but with clearly defined septa, rarely over 30 µm in diameter; mycelium not silver grey (if molds absent), fibers flexible or not	13
12(11)	fibers refractive, (2–) 3–5 (–6.5) µm in diameter, fibers within strands near fruit body to 12 µm in diameter, straight-lined, septa not visible, **no** clamps, thick-walled, lumina often visible; vessels at least partly numerous (in groups), 5–60 µm in diameter, not or rarely branched; with bars, these up to 13 µm high; vegetative hyphae hyaline, partly yellowish, brown when old, with large clamps, 2–4 µm in diameter, near fruit body to 4 µm in diameter; strands white, **silver-grey**, grey to brown, to 3 cm wide, usually with flabby mycelium in between, dry strands breaking with clearly audible cracking (strands contaminated with molds often not cracking any more); aerial mycelium cotton-woolly, soft, white, light-grey to silver-grey, with yellow, orange or violet spots ("inhibition color"), often several square meters on walls, ceilings and floors, in the draught collapsing fast; on hardwoods and softwoods; strands often in masonry; (*S. himantioides* can be excluded, if strands thicker than 2 mm and at least some fibers more than 4.5 µm in diameter) ***Serpula lacrymans***	
12*	see before, but fibers (1.5–) 2–3.5 (–4) µm (sometimes not clearly distinguishable from *S. lacrymans*); strands to 2 mm in diameter, root-like branched and not as surrounded by thick mycelium as *S. lacrymans*; fruit body to 2 mm thick ***Serpula himantioides***	
13(11)	vegetative hyphae partly swelling up to 5–10 (–20) µm, fibers up to 2.5 (–3) µm, vessels up to 40 µm; mycelium white, sometimes going yellow (if vessels swelling up: see 15)	22
13*	vegetative hyphae not swelling, ± regular diameter, at septa sometimes smaller; strands and aerial mycelium predominantly consisting of fibers,	14

these bright to brown; vessels solitary; vegetative hyphae present, however partly rare (search)

14(13) fibers light to dark-brown, flexible or not, older strands not snow-white; 15
on hardwoods and softwoods

14* fibers hyaline or pale yellow, flexible; strands whitish to cream, partly somewhat yellowing or rarely infected by molds, also ice flower-like, **flexible** when dry, up to 7 mm in diameter; fibers numerous, 2–4 µm in diameter (in *Antrodia xantha* partly somewhat yellowish, hyphal tips with tapering ending cell walls), narrow lumina, straight-lined, mostly unbranched, **in**soluble in 3% KOH, [if dissolving, see *Diplomitoporus lindbladii* (31), check rot type, if fibers missing], but in KOH swelling, sometimes with 'blown up' hyphal segments; vessels not rare but in old strands difficult to isolate, up to 25 µm in diameter, **thick-walled with middle lumen**, without bars; vegetative hyphae with few clamps, 2–4 (–7) µm in diameter, sometimes medallion clamps, often somewhat thick-walled; surface mycelium white to cream, thin, aerial mycelium in no-draught or under-floor areas partly some square meters large, white to cream, later also stalactite-like growth from above; strands also in masonry (?); probably only on softwoods; genus *Antrodia* (species not surely distinguishable on the basis of their strands/mycelia)
Antrodia vaillantii, A. sinuosa, A. xantha, A. serialis

15(10,14) vegetative hyphae with clamps; strands first cream to loam-yellow, then brownish to ochre, up to 3 mm wide, root-like branches, similar to those of *Coniophora puteana*, however not becoming black; surface mycelium first dirty-white to yellowish, then loam-yellow, brownish to ochre, near fruit body partly violet; vegetative hyphae refractive, (1.5–) 2.5–3–5 (–5) µm in diameter, partly thickened; fibers indistinct, 1.5–5 µm in diameter (often only in darker strands); vessels hyaline, sometimes with 'blown up' hyphal segments, up to 15 (–25) µm in diameter, without bars, but with septa, with clamps; on and within (?) masonry and wood, often in damp cellars; brown rot *Paxillus panuoides*

15* vegetative hyphae without or rarely with clamps, rarely multiple clamps (more often at margin of fruit body, often indistinct, since branched), 2–6 (–9) µm in diameter; strands first bright, then brown to black, up to 2 mm wide, to 1 mm thick, root-like, hardly removable (not so with *C. marmorata*), when removed usually fragile, partly with brighter center, underlying wood becoming partly black; fibers pale to dark brown, 2–4 (–5) µm in diameter, somewhat thick-walled, however with relatively broad, usually visible lumen, also branched, to be confused with vegetative hyphae; drop-shaped, hyaline to brownish secretions (1–5 µm in diameter) often to be found on hyphae; vessels in strands surrounded and interwoven by fine hyphae (0.5–1.5 µm in diameter), therefore preparation with H_2SO_4 and KOH solution, due to preparation irregularly formed or distorted, up to 30 µm in diameter, thin-walled (or slightly thick-walled with *C. marmorata*), without bars, but with septa; often also in masonry etc., genus *Coniophora* (species not surely distinguishable on the basis of their strands/mycelia) e.g., *Coniophora puteana, C. marmorata*

16(3,9) mycelium on masonry, concrete etc.; vessels possibly not visible or miss- 5
ing, untypical or small; if star-shaped setae present see (25)

16* mycelium not on or in masonry 17
17(16) fibers present; vessels absent; vegetative hyphae with clamps (in older 18
 parts rare); mycelium and strands only on wood
17* fibers missing or very rare; vegetative hyphae present (see (5) if vessels 22
 present, search for vessels, being rare in young strands)
18(17) fibers partly with swelling and partly with regular diameter, 2.5–4.5 μm
 in diameter (in fruit body sometimes larger), **flexible**, lumina small, often
 visible, sometimes punctually larger; vegetative hyphae thin-walled, 1–2
 (–2.5) μm in diameter, with clamps, but no medallions; cystidia possible;
 mycelium cream to corky, firm and tough, often in cavities and shakes in
 wood below fruit body; on oak, half-timbering; brown rot
 Daedalea quercina
18* fibers not swelling, ± regular in diameter; hyphae in wood usually possess 19
 clamps of medallion type
19(18) mycelium rough-velvet; usually two-layered, at least two-colored: white 20
 mycelium close to wood and covered by yellow, reddish to brown aerial
 mycelium; fibers 1.5–5 μm in diameter, discolored at darker mycelial ar-
 eas; vegetative hyphae with clamps; grey mycelia cannot be differentiated;
 often at windows
19* mycelium fine-velvet to silky; not distinctly two-layered; fibers 1.5–2
 (–2.5) μm in diameter, hyaline, straight, rarely branched; vegetative hy-
 phae always with clamps, **1.5–2 μm** in diameter; if hyphae wider see (14);
 mycelium firm and tough, first white, then with yellow, ochre to violet
 spots; covering cavities and shakes in wood, easy to remove; mycelia and
 strands so far only proven for wood; monstrous "dark fruit bodies", some-
 times with little caps; usually on softwoods; brown rot; genus *Lentinus*
 (species not surely distinguishable on the basis of their strands/mycelia)
 e.g., ***Lentinus lepideus***
20(19) fibers up to dark-brown (examine dark areas); aerial mycelium cream,
 ochre to dark-brown, underneath white to cream mycelium (not always
 clearly visible, use pocket-lens); colored fibers 1.5–3 (–4.5) μm in diam-
 eter; vegetative hyphae 2–4.5 μm in diameter, with clamps; strands rare,
 then forming structures of a few centimeters, these first bright, reddish,
 then red-brown to grey; in cavities dark, monstrous tap-, pin-, antlers- or
 cloud-like "dark fruit bodies"; only on softwoods
 Gloeophyllum abietinum
20* colored fibers and surface mycelia not so dark, 2–5 μm in diameter; 21
 sometimes also "dark fruit bodies"
21(20) mycelium white, cream to light brown; rarely short strands of few centime-
 ters of length, these first bright, then yellowish to ochre-brown and usually
 covered by mycelium; colored fibers light to dark yellow, light-brown to
 brown, 2–4.5 μm in diameter (partly broader); vegetative hyphae hyaline,
 2–4 μm in diameter, with clamps; arthrospores rare, 3–4 × 10–15 μm,
 cylindrical; often in shakes; tap-, pin-, antlers- or cloud-like "dark fruit
 bodies"; only on softwoods ***Gloeophyllum sepiarium***
21* mycelium white, beige, yellow-orange to light grey-brown; strands un-
 der 1 mm in diameter and not clearly defined; surface mycelium white-
 yellow to grey and usually covered by mycelium; colored fibers very light
 yellow, gold-yellow to light-brown, 1–4 μm in diameter, septa clearly

recognizable; vegetative hyphae hyaline, 2–4 µm in diameter, thin-walled, with clamps; 'dark fruit bodies' also antlers-shaped, often with brighter tips; often in shakes; only on wood (softwoods and hardwoods)

Gloeophyllum trabeum

22(13,17)	vegetative hyphae **without** clamps	23

22* vegetative hyphae with clamps, partly with swellings, 1–2 µm in diameter; fibers and vessels only in older strands; fibers 0.5–2 (−3) µm, hyaline, straight-lined, thick-walled, septa not visible, no clamps, no reaction in KOH; vessels 6–40 µm in diameter, thin-walled or slightly thick-walled, hyaline, vessels in strands surrounded and interwoven by fine hyphae (0.5–1.5 µm in diameter); mycelium pure white or pink, if being undisturbed lasting so, easily removable, but sensitive; strands often sunk in mycelium; on softwoods, rarely on hardwoods; brown rot; genus *Oligoporus* and similar fungi (species indistinguishable by strands/mycelia)

e.g., **Oligoporus placenta**

23(22) arthrospores thin-walled, cylindrical 1.5–2.5 × 5–12 µm; vegetative hyphae hyaline, thin-walled or slightly thick-walled, 2–3 (−4) µm in diameter, without clamps, but with primordial clamps; vessels indifferent, septa present, thin-walled, to 12 µm in diameter; in older parts sometimes small fibers (compare with 12); mycelium white to yellow, easily removable, but sensitive; strands often sunk in mycelium

monokaryon of **Serpula lacrymans**

23*	arthrospores absent or different	34
24(2)	setae present, simple setae or stellar setae, within white to cream mycelium, partly only very small nests of setae (search)	25
24*	setae absent	28
25(24)	stellar setae present; vegetative hyphae without clamps	27
25*	setae not clearly stellar-shaped or simply branched, partly rooted	26

26(25) simple, dark-brown, to 180 µm long setae within mycelium, strand and fruit body; fibers pale yellow, thin-walled, 2–3 µm in diameter, rarely branched; vegetative hyphae hyaline, 1.5 µm in diameter; mycelium downy, loam-yellow to brown, also white when young; strand-like structures up to 4 mm wide and 0.5 mm thick, firmly attached, often finger-shaped branched; usually on hardwoods (often on framework), very rare on softwoods; so far proven for oak, ash, false acacia, elm, beech, fir and spruce; white rot **Phellinus contiguus**

26* simple, dark-brown setae in fruit bodies and mycelium, under 100 µm; other species of the genus *Phellinus* known to occur in buildings (species not surely distinguishable on the basis of strands/mycelia)

Phellinus nigrolimitatus, P. pini, P. robustus

27(25) stellar setae dichotomously branched, to 90 µm in diameter, in fruit body, mycelium and strand, partly rare; vegetative hyphae with septa, 2–4 µm in diameter; strands cream to red-brown, fibrous surface; partly embedded in white mycelium or fruit body; spores subglobose, smooth; strands on and in masonry; white rot **Asterostroma laxum**

27* stellar setae only rarely branched, up to 190 µm in diameter, in fruit body, mycelium and strand; vegetative hyphae with septa, 1.5–3 µm in diameter; strands cream-brown, up to 1 mm in diameter; surface mycelium

first white, then brown, partly small mycelial plugs; spores subglobose, tuberculate; strands on and in masonry; white rot

Asterostroma cervicolor

28(24) fibers absent (also in aqueous preparation); sometimes strands with ves- 29
 sels

28* fibers present; strands without vessels; mycelium sometimes with vessel- 31
 like hyphae

29(28) crystalline asterocystidia in fruit body and strand, up to 20 µm in di-
 ameter, cystidia stipe to 11 µm long, 2 µm in diameter; vegetative hyphae
 with clamps, 1.5–3 µm; vessels thin-walled, to 15 µm in diameter, without
 bars, but with septa; no fibers; strands snow-white to cream, 0.2–1 mm
 in diameter (?), mostly short und near fruit body; fruit body smooth; to
 date only found on softwood; white rot *Resinicium bicolor*

29* without asterocystidia 30

30(29) vegetative hyphae with clamps, partly with bubble-like swellings, 1–2
 (−4) µm; no fibers (if fibers present, see 31); sometimes with vessels (then
 no swellings), small clamps, 4–9 (?) µm in diameter; strands snow-white
 to cream, 0.2–1(?) mm in diameter, fragile, often only short and near
 fruit body; fruit body resupinate, thin, poroid, grandinioid or smooth,
 fragile; spores warty, translucent and small, $4–5.5\times3–4.5$ µm; so far only
 found directly on damp wood; white rot; genus *Trechispora* (species not
 distinguishable on the basis of strands/mycelia);

 in buildings *Trechispora farinacea, T. mollusca*

30* other characteristics 34

31(28) fibers insoluble in 3% KOH, sometimes slightly swelling, partly under 32
 3 µm in diameter; mycelium partly with brown crust

31* fibers completely soluble in 3% KOH, 2–4.5 (−8?) µm in diameter, thick-
 walled to solid ('filled'), similar to *A. vaillantii* (14); no vessels; vegeta-
 tive hyphae with few clamps, 1–2.5 µm in diameter; surface mycelium
 without crust, usually meager, partly forming compact plates, white to
 light-brown; strands white, partly somewhat yellowing, root-like, richly
 branched, radiate or ice flower-like, fibrous, up to 2 mm in diameter; so
 far mycelium only proven to occur on wood; white rot

 Diplomitoporus lindbladii

32(31) arthrospores often lemon-shaped, hyaline, thick-walled, $5–7\times7–12$ (−?)
 µm, in surface mycelium, which lies close to the wood, and in substrate
 mycelium; in white mycelium: fibers hyaline to brown, to 2 µm in diameter,
 not very thick-walled and hardly separable from vegetative hyphae; vege-
 tative hyphae hyaline with clamps, these often difficult to find, 1–2 µm in
 diameter; vessels not proven; in colored mycelium: fibers light-brown to
 brown, 1.5–3 (−4.5) µm in diameter; vegetative hyphae hyaline to brown,
 thick-walled, rarely clamps, 2–6 (−7) µm in diameter, branched; vessels to
 11 µm in diameter; strands usually absent or short and under mycelium;
 mycelium first white to cream, then yellowish, grey to brown, when old
 often luxuriant, firm and tough, frequently with paper-like, firm, brown
 crust, predominantly in shakes and cavities, usually with amber gutta-
 tion drops or with brown to black spots (remainders of dried guttation),
 in constructions white to cream; surface mycelium partly with distinct

margin; sometimes with poroid fruit bodies within surface mycelium (1–90 mm thick), then also wider hyphae; white rot, preferential sapwood decay, hardwood and softwood, no or only some growth on masonry

Donkioporia expansa

32*	arthrospores, strands or mycelia different	33
33(32)	strands black, very clear, with separate crust layer, often also hollow when old (32), clearly thicker than 1 mm, only on wood with bark rests or in wood in the area of in-growing roots, examine for in-growing roots; hardwood and softwood; white rot rhizomorphs of ***Armillaria*** **spp.**	
33*	strands or mycelia different	34
34(1,23, 30,33)	on masonry, rough-casting etc.; no or slight wood decay: e.g., species of the genera ***Coprinus, Peziza*** (white strands), ***Scutellinia, Pyronema***, molds (e.g., ***Cladosporium***) and slime fungi (***Enteridium, Fuligo, Trichia***)	
34*	further species on wood which so far were rarely found in buildings: e.g., species of the genera ***Daldinia, Fomitopsis, Hyphodontia, Phanerochaete, Phlebiopsis, Pleurotus, Polygaster, Trametes***; see also Table 8.6	

Appendix 2
Fungi Mentioned in this Book

(see also Tables 8.1–8.3; most English names according to Larsen and Rentmeester 1992, Rune and Koch 1992, some names suggested as new by the author)

Scientific name, English name	Significance in this book
Agaricus bisporus (J.E. Lange) Pilát	agaric mushroom
Agrocybe aegerita (Brig.) Singer	edible mushroom on wood
Alternaria alternata (Fr.) Keissl.	toxic mold, blue stain
Amanita caesarea (Scop.: Fr.) Pers.	mycorrhizete
Amanita muscaria (L.: Fr.) Hook.	mycorrhizete
Amylostereum areolatum (Chaill.: Fr.) Boid.	red streaking
Amylostereum chailletii (Pers.: Fr.) Boid.	red streaking
Antrodia serialis (Fr.: Fr.) Donk, Effused tramete	indoor wood
Antrodia sinuosa (Fr.: Fr.) P. Karsten, White polypore	indoor wood
Antrodia vaillantii (DC: Fr.) Ryv., Mine polypore	indoor wood
Antrodia xantha (Fr.: Fr.) Ryv., Yellow polypore	indoor wood
Armillaria borealis Marxm. & K. Korh., Nordic honey fungus	tree parasite
Armillaria cepistipes Velen.	tree parasite
Armillaria gallica Marxm. & Romagn.	tree parasite
Armillaria luteobubalina Watling & Kile	parasite
Armillaria mellea (Vahl: Fr.) Kummer, Honey fungus	tree parasite
Armillaria ostoyae (Romagn.) Herink, Dark honey fungus	tree parasite
Arthrographis cuboides (Sacc. & Ellis) Sigler	pink stain
Aspergillus flavus Link	cancerogenic mold
Aspergillus fumigatus Fres.	cancerogenic indoor mold
Aspergillus niger van Tieghem, Black mold	mold
Aspergillus versicolor (Vuill.) Tiraboschi	mold on poplar wood, indoor mold
Asterostroma cervicolor (Berk. & Curtis) Massee	indoor wood
Asterostroma laxum Bres.	indoor wood
Aureobasidium pullulans (de Bary) Arn.	blue stain
Auricularia auricula-judae (Fr.) Quélet	edible mushroom on wood
Auricularia polytricha (Mont.) Sacc.	protoplasts
Bispora monilioides Corda	black streaking of beech logs
Bjerkandera adusta (Willd: Fr.) P. Karsten, Smokey polypore	tree rot
Boletus edulis Bull.: Fr.	mycorrhizete
Botrytis cinerea Pers.	noble rot of wines, seedling shoot tip disease

Candida utilis (Henneberger) Lodder & Kreger	yeast, glucose conversion
Cantharellus cibarius Fr.	mycorrhizete
Ceratocystis adiposa (E.J. Butler) C. Moreau	blue stain
Ceratocystis coerulescens (Münch.) B.K. Bakshi	blue stain
Ceratocystis fagacearum (Bretz) Hunt	Oak wilt disease
Ceratocystis fimbriata (Ellis & Halstead) Davidson f. *platani* Walter	Plane canker stain disease
Ceratocystis minor (Hedgc.) J. Hunt	blue stain
Ceratocystis pluriannulata (Hedgc.) C. Moreau	blue stain
Cerinomyces pallidus Martin	indoor wood
Ceriporiopsis subvermispora (Pilát) Gilb. & Ryv.	lignin degradation, biopulping
Cerocorticium confluens (Fr.: Fr.) Jül. & Stalp.	indoor wood
Chaetomium globosum Kunze: Fr.	soft rot
Chlorociboria aeruginascens (Nyl.) Kan. Small-spored green wood-cup	'green rot'
Chlorociboria aeruginosa (Pers.: Fr.) Seaver (large-spored)	'green rot'
Chondrostereum purpureum (Pers.: Fr.) Pouzar, Silver-leaf fungus	tree rot, stored and exterior wood
Ciboria batschiana (Zopf) Buchwald	acorn rot
Cladosporium cladosporioides (Fres.) de Vries	blue stain
Cladosporium herbarum (Pers.) Link	mold, blue-stain
Cladosporium sphaerospermum Penz.	blue stain, indoor mold
Climacocystris borealis (Fr.) Kotl & Pouzar	tree rot
Coniophora arida (Fr) P. Karsten, Arid cellar fungus	indoor wood
Coniophora marmorata Desm., Marmoreus cellar fungus	indoor wood
Coniophora olivacea (Fr.) P. Karsten, Olive cellar fungus	indoor wood
Coniophora puteana (Schum.: Fr.) P. Karsten, (Brown) Cellar fungus	indoor wood
Coprinus comatus (O.F. Müller: Fr.) S.F. Gray	light influence
Cryphonectria parasitica (Murr.) Barr	Chestnut blight
Cryptostroma corticale (Ellis & Everh.) P.H. Greg & S. Waller	mold, woodworker's lung
Cylindrocarpon destructans (Zins.) Scholten	oak root parasite
Dacrymyces stillatus Nees: Fr., Orange jelly	indoor wood
Daedalea quercina (L.: Fr.) Fr., Maze-gill	stored and exterior wood
Daedaleopsis confragosa (Bolton: Fr.) J. Schröter	white rot
Dichomitus squalens (P. Karsten) D.A. Reid	successive white rot, biopulping
Diplomitoporus lindbladii (Berk.) Gilb. & Ryv.	indoor white wood
Discula pinicola (Naum.) Petrak	blue stain
Donkioporia expansa (Desm.) Kotl. & Pouzar, Oak polypore	indoor white-wood
Emericella nidulans (Eidam) Vuill.	toxic mold
Earliella scrabosa Gilb. & Ryv.	mine timber
Fistulina hepatica (Schaeffer: Fr.) Fr., Beef-steak fungus	tree rot
Flammulina velutipes (Curtis: Fr.) Singer	edible mushroom on wood
Fomes fomentarius (L.: Fr.) Kickx, Tinder fungus	tree rot
Fomitopsis palustris (Berk. & M.A. Curtis) Gilb. & Ryv.	cellulose degradation
Fomitopsis pinicola (Swartz: Fr.) P. Karsten, Red-belted polypore	brown rot

Fuligo septica Gmelin	indoor wood
Fusarium oxysporum (Schlecht.: Fr.) ssp. *cannabis*	herbicide, oak root parasite
Ganoderma adspersum (Schulzer) Donk	"palo podrido"
Ganoderma applanatum (Pers.) Pat.	white rot
Ganoderma lipsiense (Batsch) G.F. Atk., Artist's conk	white rot
Ganoderma lucidum (Curtis: Fr.) P. Karsten	medicinal mushroom
Gliocladium roseum Bainier	antagonism
Gloeophyllum abietinum (Bull.: Fr.) P. Karsten, Fir gill polypore	stored and exterior wood
Gloeophyllum sepiarium (Wulfen: Fr.) P. Karsten, Yellow-red gill polypore	stored and exterior wood
Gloeophyllum trabeum (Pers.: Fr.) Murr., Timber gill polypore	stored and exterior wood
Grifola frondosa (Dicks.: Fr.) S.F. Gray	white rot, edible mushroom
Hebeloma cylindrosporum Romagn.	mycorrhizete
Hebeloma velutipes Bruchet	mycorrhizete
Helicobasidium brebissonii (Desm.) Donk	seedling smothering
Hericium erinaceus (Bull.: Fr.) Pers.	edible mushroom on wood
Heterobasidion abietinum Niemelä & Korhonen, Fir root rot fungus	tree parasite
Heterobasidion annosum (Fr.: Fr.) Bref. s.s., Pine root rot fungus	tree parasite
Heterobasidion parviporum Niemelä & Korhonen, Spruce root rot fungus	tree parasite
Hormonema dematioides Melin & Nannf.	blue stain
Hyphoderma praetermissum (P. Karsten) J. Eriksson & Strid	indoor wood
Hyphodontia spathulata (Schrader) Parm.	indoor wood
Inonotus dryadeus (Pers.: Fr.) Murrill	white rot
Inonotus dryophilus (Berk.) Murrill	successive white rot
Inonotus hispidus (Bull.: Fr.) P. Karsten	white rot
Kluyveromyces marxianus (E.C. Hansen) Van der Walt	yeast, ethanol production
Kretzschmaria deusta (Hoffman) P.M.D. Martin	white-rot ascomycete
Kuehneromyces mutabilis (Schaeff.: Fr.) Singer & A.H. Sm.	edible mushroom on wood
Laccaria bicolor (Maire) Orton	mycorrhizete
Laetiporus sulphureus (Bull.: Fr.) Murrill, Sulphur polypore	tree rot
Laurelia taxodii (Lentz & H.H. McKay) Pouzar	brown pocket rot
Lecythophora hoffmannii (van Beyma) W. Gams	soft rot
Lecythophora mutabilis (J.F.H. Beyma) W. Gams & McGinnes	soft rot
Lentinula edodes (Berk.) Pegler, Shii-take	edible mushroom on wood
Lentinus lepideus (Fr.: Fr.) Fr., Scaly Lentinus	stored and exterior wood
Leucogyrophana mollusca (Fr.: Fr.) Pouzar, Soft dry rot fungus	indoor wood
Leucogyrophana pinastri (Fr.: Fr.) Ginns & Weresub, Mine dry rot fungus	indoor wood
Leucogyrophana pulverulenta (Sow.: Fr.) Ginns, Small dry rot fungus	indoor wood
Loweporus lividus (Kalchbr.: Cooke) J.E. Wright	mine timber
Macrophomina phaseolina (Tassi) Goid.	conifer seedling parasite
Melanomma sanguinarum (P. Karsten) Sacc.	red spotting of beech wood

Memnoniella echinata (Rivolta) Galloway	toxic mold
Meria laricis Vuill.	Meria needle-cast of larch
Meripilus giganteus (Pers.: Fr.) P. Karsten, Giant polypore	tree rot
Meruliporia incrassata (Berk. & Curtis) Murr., American dry rot fungus	indoor wood
Merulius tremellosus Schrader	successive white rot, biopulping
Monodictys putredinis (Wallr.) Hughes	soft rot
Nectria coccinea var. *faginata* Lohmann, Watson & Ayers	Beech bark disease
Nectria galligena Bres.	Beech bark disease
Nematoloma frowardii (Speg.) E. Horak	lignin degradation
Oligoporus amarus (Hedgc.) Gilb. & Ryv.	brown pocket rot
Oligoporus placenta (Fr.) Gilb. & Ryv., (Reddish) Sap polypore	indoor wood
Oligoporus stipticus (Pers.: Fr.) Kotl. & Pouzar	brown rot
Ophiostoma novo-ulmi Brasier	Dutch elm disease
Ophiostoma piceae (Münch) H. and P. Sydow	blue stain
Ophiostoma piliferum (Fr.) H. and P. Sydow	blue stain
Ophiostoma setosum Uzunovic, Seifert, S.H. Kim & Breuil	blue stain
Ophiostoma ulmi (Buisman) Nannf.	Dutch elm disease
Oudemansiella mucida (Schrad.) Höhn	competition
Pachysolen tannophilus Boidin & Adzet	yeast, xylose fermentation
Paecilomyces variotii Bain.	soft rot
Paxillus involutus (Batsch: Fr.) Fr.	mycorrhizete
Paxillus panuoides (Fr.: Fr.) Fr., Stalkless Paxillus	stored and exterior wood
Penicillium aurantiogriseum Dierckx	indoor mold
Penicillium camemberti Thom	cheese mold
Penicillium brevicompactum Dierckx	indoor mold
Penicillium chrysogenum Thom	indoor mold
Penicillium glabrum (Wehmer) Westling	mold, suberosis
Penicillium implicatum Biourge	mold on poplar wood
Penicillium nalgiovense Laxa	salami-sausages mold
Penicillium roqueforti Thom	cheese mold
Penicillium spinulosum Thom	indoor mold
Peziza repanda Pers.	indoor wood
Phaeolus schweinitzii (Fr.: Fr.) Pat., Dye polypore	tree rot
Phanerochaete chrysosporium Burds.	ligninase, biopulping
Phanerochaete laevis (Fr.) J. Eriksson & Ryv.	detoxification
Phanerochaete sordaria (P. Karsten) J. Eriksson & Ryv.	fatty acid profiles, lignin degradation
Phellinus chrysoloma (Fr.) Donk	white rot
Phellinus contiguus (Pers.) Pat.	indoor white-rot
Phellinus hartigii (Allesch. & Schnabl) Pat.	white rot
Phellinus igniarius (L.: Fr.) Quélet, False tinder fungus	white rot
Phellinus nigrolimitatus (Romell) Bourdot & Galzin, Black-edged polypore	tree rot
Phellinus pini (Brot.: Fr.) A. Ames, Ochre-orange hoof polypore	tree rot
Phellinus pomaceus (Pers.: Fr.) Maire	white rot

Phellinus robustus (P. Karsten) Bourdot & Galzin	white rot
Phellinus tremulae (Bondartsev) Bondartsev & Borrisow	parasite
Phellinus weirii (Murrill) Bilb.	parasite
Phialophora fastigiata (Lagerb. & Melin) Conant	grey stain of poplar
Phlebia brevispora Nakasone	specific PCR, biopulping
Phlebia chrysocreas (Berk. & M.A. Curtis) Burds	"palo podrido"
Phlebia radiata Fr.	lignin degradation
Phlebiopsis gigantea (Fr.) Jül., Conifer parchment	antagonism
Pholiota carbonica A.H. Sm.	competition
Pholiota highlandensis (Peck) Hesler & A.H. Sm.	competition
Pholiota nameko (T. Itô) S. Ito & S. Imai	edible mushroom
Pholiota squarrosa (Pers.: Fr.) Kummer	white rot
Phoma exigua Sacc.	blue stain
Physisporinus vitreus (Pers.: Fr.) P. Karsten, Pole fungus	manganese deposits
Phytophthora cactorum (Lebert & Cohn) Schröter	Beech seedling disease
Phytium debaryanum Hesse	conifer seedling parasite
Piptoporus betulinus (Bull.: Fr.) P. Karsten, Birch polypore	tree rot
Pleurotus ostreatus (Jacq.: Fr.) Kummer, Oyster fungus	edible mushroom on wood
Pleurotus ostreatus ssp. *florida*	edible mushroom on wood
Pluteus cervinus (Schaeffer) Kummer	indoor wood
Polyporus squamosus (Hudson: Fr.) Fr., Scaly polypore	tree rot
Pycnoporus cinnabarinus (Jacq.) Fr.	lignin degradation
Ramariopsis kunzei (Fr.) Corner	indoor wood
Resinicium bicolor (Alb. & Schwein.: Fr.) Parm.	indoor white-rot
Reticularia lycoperdon Bull.	indoor wood
Rhinocladiella atrovirens Nannf.	blue stain
Rhizina undulata Fr.	root-decay ascomycete
Rhizoctonia solani Kühn	beech nut rotting
Rigidoporus lineatus (Pers.) Ryv.	mine timber
Rigidoporus vinctus (Berk.) Ryv.	mine timber
Rosellinia aquila (Fr.) de Not.	seedling smothering
Rosellinia minor (Höhn) Francis	seedling smothering
Rosellinia quercina R. Hartig	oak root parasite
Saccharomyces cerevisiae Meyen: E.C. Hansen	yeast
Schizophyllum commune Fr.: Fr., Split-gill	stored and exterior wood
Sclerophoma pithyophila (Corda) v. Höhn.	blue stain
Scutellinia scutellata Lambotte	indoor wood
Serpula himantioides (Fr.: Fr.) P. Karsten, Wild merulius	indoor wood
Serpula lacrymans (Wulfen: Fr.) Schroeter apud Cohn, (True) Dry rot fungus	indoor wood
Sirococcus conigenus (DC.) P.F. Cannon & Minter	tree parasite
Sirococcus strobilinus Preuss	Sirococcus shoot dieback
Sistotrema brinkmanni (Bres.) J. Eriksson	stored and exterior wood
Sparassis crispa Wulfen: Fr.	tree rot
Sphaeropsis sapinea (Desm.) Dyko & Sutton	Conifer seedling shoot tip disease
Sphaerotheca lanestris Harkn.	virus vector
Stachybotrys chartarum (Ehrenb.) Hughes	toxic mold
Stereum hirsutum (Willd.: Fr.) S.F. Gray, Hairy Stereum	stored and exterior wood

Stereum rugosum (Pers.: Fr.) Fr.	white rot
Stereum sanguinolentum (Alb. & Schwein.: Fr.) Fr., Bleeding Stereum	red streaking, Wound rot of spruce
Strasseria geniculata (Berk. & Broome) Höhn	blue stain, Conifer seedling shot tip disease
Thekopsora areolata (Fr.) Magnus	spruce inflorescence damage
Thelephora terrestris Erh.	seedling smothering
Thielavia terrestris (Apinis) Malloch & Cain.	soft rot
Trametes hirsuta (Wulfen: Fr.) Pilát	white rot
Trametes multicolor (Schaeffer) Jül.	indoor wood
Trametes pubescens (Schum.) Pilát	fatty acid profile
Trametes versicolor (L: Fr.) Pilát, Many-zoned polypore	stored and exterior wood
Trechispora farinacea (Pers.) Liberta	indoor wood
Trechispora mollusca (Pers.) Liberta	indoor wood
Trichaptum abietinum (Dicks.: Fr.) Ryv., Fir Polystictus	red streaking
Trichoderma hamatum (Bonord.) Bainier	mushroom parasite
Trichoderma harzianum Rifai	mushroom parasite
Trichoderma parceramosum Bissett	mushroom parasite
Trichoderma pseudokoningii Oudem.	mushroom parasite
Trichoderma reesei E.G. Simmons	enzymes
Trichoderma viride Pers.: Fr.	mold, antagonism, enzymes
Tyromyces caesius (Schrader: Fr.) Murrill, Blue cheese polypore	brown rot
Tyromyces stipticus (Pers.: Fr.) Kotl. & Pouzar	brown rot
Volvariella bombycina (Schaeffer: Fr.) Singer	indoor wood
Xerocomus pruinatus (Fr.) Quélet	IGS sequence
Xylaria hypoxylon (L.) Grev.	white-rot ascomycete
Xylobolus frustulatus (Pers.: Fr.) Boidin, Ceramic parchment	tree rot

References

Aanen DK, Kuyper TW, Hoekstra RF (2001) A widely distributed ITS polymorphism within a biological species of the ectomycorrhizal fungus *Hebeloma velutipes*. Mycol Res 105:284–290

Abou Heilah AN, Hutchinson SA (1977) Range of wood-decaying ability of different isolates of *Serpula lacrymans*. Trans Br Mycol Soc 68:251–257

Abraham L, Breuil C, Bradshaw DE, Morris PI, Byrne T (1997) Proteinases as potential targets for new generation of anti-sapstain chemicals. Forest Prod J 47:57–62

Abreu HS, Nascimento AM, Maria MA (1999) Lignin structure and wood properties. Wood Fiber Sci 31:426–433

Abu Ali R, Dickinson DJ, Murphy RJ (1997) SEM investigations of the production of extracellular mucilaginous material (ECM) by some wood-inhabiting and wood-decay fungi when grown on wood. IRG/WP/ 10193

Acker van J, Stevens M (1996) Laboratory culturing and decay testing with *Physosporinus vitreus* and *Donkioporia expansa* originating from identical cooling tower environments show major differences. IRG/WP/10184

Acker van J, Stevens M, Carey J, Sierra-Alvarez R, Militz H, Le Bayon I, Kleist G, Peek RD (2003) Biological durability of wood in relation to end-use. Holz Roh-Werkstoff 61:35–455

Acker van J, Stevens M, Rijchaert V (1995) Highly virulent wood-rotting Basidiomycetes in cooling towers. IRG/WP/10125

Adair S, Kim SH, Breuil C (2002) A molecular approach for early monitoring of decay basidiomycetes in wood chips. FEMS Microbiol Lett 211:117–122

Adolf FP (1975) Über eine enzymatische Vorbehandlung von Nadelholz zur Verbesserung der Wegsamkeit. Holzforsch 29:181–186

Adolf P, Gerstetter E, Liese W (1972) Untersuchungen über einige Eigenschaften von Fichtenholz nach dreijähriger Wasserlagerung. Holzforsch 26:18–25

Agerer R, Brand F, Gronbach E (1986) Die exakte Kenntnis der Ectomykorrhizen als Voraussetzung für Feinwurzeluntersuchungen im Zusammenhang mit dem Waldsterben. Allg Forstz 41:497–503

Agustian A, Mohammed C, Guillaumin JJ, Botton B (1994) Discrimination of some African *Armillaria* species by isozyme electrophoretic analysis. New Phytol 128:135–143

Akamatsu Y, Takahashi M, Shimada M (1993a) Cell-free extraction of oxaloacetase from white-rot fungi, including Coriolus versicolor. Wood Res 79:1–6

Akamatsu Y, Takahashi M, Shimada M (1993b) Influences of various factors on oxaloacetase activity of the brown-rot fungus *Tyromyces palustris*. Mokuzai Gakkaishi 39:352–356

Akhter K (2005) Preservative treatment of rubber wood (*Hevea brasiliensis*) to increase its service life. IRG/WP/40320

Albert G (2003) Trichoderma. Konkurrent, Parasit und Nützling. Champignon 431:6–9

Alexopoulus CJ, Mims CW (1979) Introductory mycology, 3rd edn. Wiley, New York

Alfredsen G, Solheim H, Jenssen KM (2005) Evaluation of decay fungi in Norwegian buildings. IRG/WP/10562

Allen MF (1991) The ecology of mycorrhizae. Cambridge Studies in Ecology. Cambridge
 University Press, Cambridge
Altaner C, Saake B, Puls J (2001) Mode of action of acetylesterases associated with endoglu-
 canases towards water-soluble and -insoluble cellulose acetates. Cellulose 8:259–265
Amburgey TL, Schmidt EL, Sanders MG (1996) Trials of three fumigants to prevent enzyme
 stain in lumber cut from water-stored hardwood logs. Forest Prod J 46:54–56
Ammer U (1964) Über den Zusammenhang zwischen Holzfeuchtigkeit und Holzzerstörung
 durch Pilze. Holz Roh-Werkstoff 22:47–51
Anagnost SE (1998) Light microscopic diagnosis of wood decay. IAWA J 19:141–167
Anagnost SE, Smith WB (1997) Hygroscopicity of decayed wood: implications for weight
 loss determinations. Wood Fiber Sci 29:299–305
Anagnost SE, Worrall JJ, Wang CJK (1994) Diffuse cavity formation in soft rot of pine. Wood
 Sci Technol 28:199–208
Ananthapadmanabha HS, Nagaveni HC, Srinivasan VV (1992) Control of wood biodegra-
 dation by fungal metabolites. IRG/WP/1527
Ander P, Eriksson K (1975) Mekanisk massa fran förröttad flis – en inledande undersökning.
 Svensk Papperstidning 18:641–642
Ander P, Eriksson K-E (1976) Degradation of lignin with wildtype and mutant strains of the
 white-rot fungus Sporotrichum pulverulentum. Suppl 3 Mater Org, pp. 129–140
Anderson JB, Korhonen K, Ullrich RC (1980) Relationships between European and North
 American biological species of Armillaria mellea. Exp Mycol 4:87–95
Anderson JB, Ullrich RC (1979) Biological species of Armillaria mellea in North America.
 Mycologia 71:402–414
Andersson H (1997a) Pilzfruchtkörper an 10 gleichaltrigen Fagus sylvatica-Stubben im
 Ölper Holz in Braunschweig. Z Mykol 63:51–62
Andersson H (1997b) Pilze (Basidiomyceten, Ascomyceten) an Fagus sylvatica-Stubben im
 Ölper Holz in Braunschweig (Niedersachsen) im 4. bis 7. Jahr nach dem Einschlag.
 Braunschw naturkdl Schr 5:479–490
Annamali P, Ishii H, Lalithakumari D, Revathi R (1995) Polymerase chain reaction and its
 application in fungal disease diagnosis. Z Pflanzenkrankh Pflanzensch 102:91–104
Anonymous (1992a) Das größte Lebewesen der Welt ist ein Hallimasch-Pilz in den USA.
 Holz-Zbl 118:1227
Anonymous (1992b) Korrektur der Zahl der Pilzarten. Naturwiss Rundschau 45:150–151
Anonymous (1996) Leben im extrem sauren Milieu. Naturwiss Rundschau 49:27–28
Anonymous (1999) Symbiose zwischen Ameisen, Pilzen und Bakterien. Naturw. Rundschau
 52:362
Appel DN, Kurdyla T, Lewis R (1990) Nitidulids as vectors of the oak wilt fungus and other
 Ceratocystis spp. in Texas. Eur J Forest Pathol 20:412–417
Arenas CV, Giron MY, Escolano EU (1978) Microbially modified wood for pencil slats.
 Forpridge Digest 7:73–74
Armstrong JE, Shigo AL, Funk DT, McGinnes EA, Smith DE (1981) A macroscopic and micro-
 scopic study of compartmentalization and wound closure after mechanical wounding
 of black walnut trees. Wood Fiber 13:275–291
Arx von JA (1981) The genera of fungi sporulating in pure culture, 3rd edn. Cramer, Vaduz
Asiegbu F, Daniel G, Johansson M (1993) Studies on the infection of Norway spruce roots
 by Heterobasidion annosum. Can J Bot 71:1552–1561
Aufseß von H (1976) Über die Wirkung verschiedener Antagonisten auf das Mycelwachstum
 von einigen Stammfäulepilzen. Mater Org 11:183–196
Aufseß von H (1986) Lagerverhalten von Stammholz aus gesunden und erkrankten Kiefern,
 Fichten und Buchen. Holz Roh-Werkstoff 44:325

Augusta U, Rapp AO (2003) The natural durability of wood in different use classes. IRG/WP/10457

Augusta U, Rapp AO (2005) Die natürliche Dauerhaftigkeit wichtiger heimischer Holzarten unter bautypischen Bedingungen. 24th Holzschutztagung, Dtsch Ges Holzforsch:71–80

Aziz AY, Foster HA, Fairhurst CP (1993) In vitro interactions between *Trichoderma* spp. and *Ophiostoma ulmi* and their implications for the biological control of Dutch elm disease and other fungal diseases of trees. Arboricult J17:145–157

Babiak M, Kúdela J (1995) A contribution to the definition of the fiber saturation point. Wood Sci Technol 29:217–226

Babuder G, Petrič M, Čadež F, Humar M, Pohleven F (2004) Fungicidal properties of boron containing preservative Borosol 9®. IRG/WP/30348

Bach S, Belgacem MN, Gandini A (2005) Hydrophobisation and densification of wood by different chemical treatments. Holzforsch 59:389–396

Bächle F, Niemz P, Heeb M (2004) Untersuchungen zum Einfluss der Wärmebehandlung auf die Beständigkeit von Fichtenholz gegenüber holzzerstörenden Pilzen. Schweiz Z Forstwes 155:548–554

Backa S, Gierer J, Reitberger T, Nilsson T (1992) Hydroxyl radical activity in brown-rot fungi studied by a new chemiluminescence method. Holzforsch 46:61–67

Bailey PJ, Liese W, Rösch R (1968) Some aspects of cellulose degradation in lignified cell walls. Biodeterioration of Materials. 1st Int Biodetn Symp Southampton. Elsevier, Essex, pp. 546–557

Baines EF, Millbank JW (1976) Nitrogen fixation in wood in ground contact. Suppl 3 Mater Org, pp. 167–173

Balder H (1995) Pflanzenschutzrechtliche Aspekte zur Wundbehandlung. In: Dujesiefken D (ed) Wundbehandlung an Bäumen, Thalacker, Braunschweig, pp. 128–131

Bao A, Cooper PA, Ung T (2005b) Fixation and leaching characteristics of acid copper chromate (ACC) compared to other chromium-based wood preservatives. Forest Prod J 55:72–75

Bao D, Aimi T, Kitamoto Y (2005a) Cladistic relationships among the *Pleurotus ostreatus* complex, the *Pleurotus pulmonarius* complex, and *Pleurotus eryngii* based on the mitochondrial small subunit ribosomal DNA sequence analysis. J Wood Sci 51:77–82

Bao D, Ishihara H, Mori N, Kitamoto Y (2004b) Phylogenetic analysis of oyster mushrooms (*Pleurotus* spp.) based on restriction fragment length polymorphisms of the 5′ portion of 26S rDNA. J Wood Sci 50:169–176

Bao D, Kinugasa S, Kitamoto Y (2004a) The biological species of the oyster mushrooms (*Pleurotus* spp.) from Asia based on mating compatibility tests. J Wood Sci 50:162–168

Bardage SL (1997) Colonization of painted wood by blue stain fungi. Acta Univ Agricult Sueciae Silvestria 49

Barnett HL, Hunter BB (1987) Illustrated genera of imperfect fungi, 4th edn. Macmillan, New York

Barnett JA, Payne RW, Yarrow D (1990) Yeasts: characteristics and identification, 2nd. edn. Cambridge University Press, Cambridge

Barrasa JM, González AE, Martínez AT (1992) Ultrastructural aspects of fungal delignification of Chilean woods by *Ganoderma australe* and *Phlebia chrysocrea*. Holzforsch 46:1–8

Bartholomew K, Dos Santos G, Dumonceaux T, Valeanu L, Charles T, Archibald F (2001) Genetic transformation of *Trametes versicolor* to pleomycin resistance with the dominant selectable marker *shble*. Appl Microbiol Biotechnol 56:201–204

Barton CG, Montagu KD (2004) Detection of tree roots and determination of root diameters by ground penetrating radar under optimal conditions. Tree Physiol 24:1323–1331

Bastawde KB (1992) Xylan structure, microbial xylanases, and their mode of action. World
 J Microbiol Biotechnol 8:353–368
Bauch J (1973) Biologische Eigenschaften des Tannennaßkerns. Mittlg Bundes-
 forschungsanst Forst-Holzwirtsch 93:213–232
Bauch J (1984) Development and characteristics of discolored wood. IAWA Bull ns 5:91–98
Bauch J (1986) Verfärbungen von Rund- und Schnittholz und Möglichkeiten für vorbeu-
 gende Schutzmaßnahmen. Holz-Zbl 112:2217–2218
Bauch J, Höll W, Endeward R (1975) Some aspects of wetwood formation in fir. Holzforsch
 29:198–205
Bauch J, Hundt von H, Weißmann G, Lange W, Kubel H (1991) On the causes of yellow dis-
 colorations of oak heartwood (Quercus Sect. Robur) during drying. Holzforsch 45:79–85
Bauch J, Schmidt O, Yazaki Y, Starck M (1985) Significance of bacteria in the discoloration
 of Ilomba wood (Pycnanthus angolensis Exell). Holzforsch 39:249–252
Bauch J, Seehann G, Fitzner H (1976) Microspectrophotometrical investigations on lignin
 of decayed wood. Suppl 3 Mater Org, pp. 141–152
Baum S (2001) Brandkrustenpilz. AFZ-DerWald 56:932–933
Baum S, Bariska M (2002) Rotstreifigkeit: Vor allem bei Fichte ein Problem. Holz-Zbl
 128:1096
Bavendamm W (1928) Über das Vorkommen und den Nachweis von Oxydasen bei holzzer-
 störenden Pilzen. Z Pflanzenkr Pflanzensch 38:257–276
Bavendamm W (1936) Erkennen, Nachweis und Kultur der holzverfärbenden und holzzer-
 setzenden Pilze. In: Abderhalben E (Hrsg) Handb biol Arbeitsmethod, Div XII, Part
 2/II, Urban & Schwarzenberg, Berlin, 927–1134
Bavendamm W (1951a) Coniophora cerebella (Pers.) Duby. Holz Roh-Werkstoff 9:447–448
Bavendamm W (1951b) Merulius lacrimans (Wulf.) Schum. ex Fries. Holz Roh-Werkstoff
 9:251–252
Bavendamm W (1952a) Lenzites abietina (Bull.) Fr. Holz Roh-Werkstoff 10:261–262
Bavendamm W (1952b) Lentinus lepideus (Buxb.) Fr. Holz Roh-Werkstoff 10:337–338
Bavendamm W (1952c) Poria vaporaria (Pers.) Fr. Holz Roh-Werkstoff 10:39–40
Bavendamm W (1953) Paxillus panuoides Fr. Holz Roh-Werkstoff 11:331–332
Bavendamm W (1969) Der Hausschwamm und andere Bauholzpilze. Fischer, Stuttgart
Bavendamm W (1974) Die Holzschäden und ihre Verhütung. Wissenschaftl Verlagsanst,
 Stuttgart
Bavendamm W, Reichelt H (1938) Die Abhängigkeit des Wachstums holzzersetzender Pilze
 vom Wassergehalt des Nährsubstrates. Arch Mikrobiol 9:486–544
Bech-Andersen J (1985) Alkaline building materials and controlled moisture conditions as
 causes for dry rot Serpula lacrymans growing only in houses. IRG/WP/1272
Bech-Andersen J (1987a) Production, function and neutralization of oxalic acid produced
 by the dry rot fungus and other brown-rot fungi. IRG/WP/1330
Bech-Andersen J (1987b) The influence of the dry rot fungus (Serpula lacrymans) in vivo
 on insulation materials. Mater Org 22:191–202
Bech-Andersen J (1995) The dry rot fungus and other fungi in houses. 2 vol, Hussvamp
 Laboratoriet Forlag, Gl. Holte, Denmark
Bech-Andersen J, Andersen C (1992) Theoretical and practical experiments with eradication
 of the dry rot fungus by means of microwaves. IRG/WP/1577
Bech-Andersen J, Elborne SA, Goldie F, Singh J, Singh S, Walker B (1993) The True dry
 rot fungus (Serpula lacrymans) found in the wild in the forests of the Himalayas.
 IRG/WP/10002
Bechtold R, González AE, Almendros G, Martínez MJ, Martínez AT (1993) Lignin alteration
 by Ganoderma australe and other white-rot fungi after solid-state fermentation of beech
 wood. Holzforsch 47:91–96

Behrendt CJ, Blanchette RA, Farrell RF (1995) An integrated approach, using biological and chemical control, to prevent blue stain in pine logs. Can J Bot 73:613–619v

Beier M, Stähler F, Hammar F (2002) Neue Perspektiven für die DNA-Analyse. Mikroarrays und Chip-Technologien. Naturwiss Rundschau 55:633–637

Benizry E, Durrieu G, Rovane P (1988) Heart rot of spruce (*Picea abies*) in the Auvergne: ecological study. Ann Sci Forestières 45:141–156

Benko R (1989) Biological control of blue stain on wood with *Pseudomonas cepacia* 6253. Laboratory and field test. IRG/WP/1380

Benko R, Highley TL (1990) Selection of media for screening interaction of wood-attacking fungi and antagonistic bacteria. II. Interaction on wood. Mater Org 25:174–180

Bergman O, Nilsson T (1966) On outside storage of pine chips at Lövholmen's paper mill. Roy Coll For Stockholm, Res Note 53

Berndt H, Liese W (1973) Untersuchungen über das Vorkommen von Bakterien in wasserberieselten Buchenholzstämmen. Zbl Bakt II 128:578–594

Bernier R, Desrochers M, Jurasek L (1986) Antagonistic effect between *Bacillus subtilis* and wood staining fungi. J Inst Wood Sci 10:214–216

Björdal C, Nilsson T, Bardage S (2005) Three-dimensional visualisation of bacterial decay in individual tracheids of *Pinus sylvestris*. Holzforsch 59:178–182

Björdal CG, Nilsson T, Daniel G (1999) Microbial decay of waterlogged aerchaeological wood found in Sweden. Int Biodeter Biodegrad 43:63–73

Bjurman J (1992a) ATP assay for the determination of mould activity on wood at different moisture conditions. IRG/WP/2397

Bjurman J (1992b) Analysis of volatile emissions as an aid in the diagnosis of dry rot. IRG/WP/2393

Bjurman J (1994) Determination of microbial activity in moulded wood by the use of Fluorescein diacetate. Mater Org 28:1–16

Bjurman J, Henningsson B, Lundstrom H (1998) Novel non-toxic treatments for sapstain. In: Biology and prevention of sapstain. Forest Prod Soc, Madison, USA, pp. 93–99

Blaich R, Esser K (1975) Function of enzymes in wood destroying fungi. II. Multiple forms of laccase in white-rot fungi. Arch Microbiol 103:271–277

Blanchette RA (1980) Wood decomposition by Phellinus (Fomes) pini: scanning electron microscopy study. Can J Bot 58:1496–1503

Blanchette RA (1983) An unusual decay pattern in brown-rotted wood. Mycologia 75:552–556

Blanchette RA (1984a) Screening wood decayed by white-rot fungi for preferential lignin degradation. Appl Environ Microbiol 48:647–653

Blanchette RA (1984b) Manganese accumulation in wood decayed by white-rot fungi. Ecol Epidemiol 74:725–730

Blanchette RA (1992) Anatomical responses of xylem to injury and invasion by fungi. In: Blanchette RA, Biggs AR (eds) Defense mechanisms of woody plants against fungi, Springer, Berlin Heidelberg New York, pp. 76–95

Blanchette RA (1995) Biodeterioration of archaeological wood. CAB Abstr 9:113–127

Blanchette RA, Abad AR (1992) Immunocytochemistry of fungal infection processes in trees. In: Blanchette RA, Biggs AR (eds) Defense mechanisms of woody plants against fungi, Springer, Berlin Heidelberg New York, pp. 424–444

Blanchette RA, Abad AR, Farrell RL, Leathers TD (1989) Detection of lignin peroxidase and xylanase by immunochemical labeling in wood decayed by basidiomycetes. Appl Environ Microbiol 55:1457–1465

Blanchette RA, Behrendt CJ, Farrell RA (1994) Biological protection of sapstain for the forest products industry. Tappi Proc, pp. 77–80

Blanchette RA, Cease KR, Abad AR, Burnes TA, Obst JR (1991) Ultrastructural characterization of wood from Tertiary fossil forests in the Canadian Artic. Can J Bot 69:560–568

Blanchette RA, Farrell RL, Burnes TA, Wendler PA, Zimmermann W, Brush TS, Snyder RA (1992b) Biological control of pitch in pulp and paper production by Ophiostioma piliferum. Tappi J 75:102–106

Blanchette RA, Nilsson T, Daniel G, Abad AR (1990) Biological degradation of wood. In: Rowell RM, Barbour RJ (eds) Archaeological wood: properties, chemistry and preservation, Adv Chem Series 225, Am Chem Soc, Washington, DC, pp. 141–174

Blanchette RA, Wilmering AM, Baumeister M (1992a) The use of green-stained wood caused by the fungus Chlorociboria in intarsia masterpieces from the 15th century. Holzforsch 46:225–232

Blaschke M, Helfer W (1999) Artenvielfalt bei Pilzen in Naturwaldreservaten. AFZ-DerWald 54:383–385

Blei M, Fiedler K, Rüden H, Schleibinger HW (2005) Differenzierung von Holz zerstörenden Pilzen mittels ihrer mikrobiellen flüchtigen organischen Verbindungen (MVOC). In: Keller R, Senkpiel K, Samson RA, Hoekstra ES (eds) Mikrobielle allergische und toxische Verbindungen. Schriftenr Inst Medizin Mikrobiol Hygiene Univ Lübeck 9:163–178

Blow DP (1987) The biodeterioration of in-service timber in buildings. In: The biodeterioration of constructional materials, Biodetn Soc, Kew, pp. 115–127

Bogan BW, Lamar RT (1996) Polycyclic aromatic hydrocarbon-degrading capabilities of Phanerochaete laevis HHB-1625 and its extracellular ligninolytic system. Appl Environ Microbiol 62:1597–1603

Böhner G, Wagner L, Säcker M (1993) Elektrische Messung hoher Holzfeuchten bei Fichte. Holz Roh-Werkstoff 51:163–166

Booker RE, Sell J (1998) The nanostructure of the cell wall of softwoods and its functions in a living tree. Holz Roh-Werkstoff 56:1–8

Borazjani A, Diehl SV (1998) Bioremediation of soils contaminated with organic wood preservatives. In: Bruce A, Palfreyman JW (eds) Forest products biotechnology. Taylor & Francis, London, pp. 117–127

Borsch-Laaks R (2005) Vorbeugender baulicher Holzschutz. In: Müller J (ed) Holzschutz im Hochbau. Fraunhofer IRB, Stuttgart, pp. 123–168

Bothe H, Hildebrandt U (2003) Im Stress werden Pilze und Pflanzen Partner. Forschung, DFG 2:18–20

Böttcher P (2005) Oberflächenschutz/Wetterschutz. In: Müller J (ed) Holzschutz im Hochbau. Fraunhofer IRB, Stuttgart, pp. 188–233

Bötticher W (1974) Technologie der Pilzverwertung. Ulmer, Stuttgart

Bragaloni M, Anselmi N, Cellerino GP (1997) Identification of European Armillaria species by analysis of isozyme profiles. Eur J Forest Pathol 27:147–157

Braid GH, Line MA (1981) A sensitive assay for the estimation of fungal biomass in hardwoods. Holzforsch 35:10–18

Brandte M, Schraudner M, Büttner C (2002) Viruserkrankungen an Jungpflanzen aus Baumschulen. In: Dujesiefken D, Kockerbeck P (eds) Jahrbuch der Baumpflege. Thalacker, Braunschweig, pp. 196–202

Brasier CM (1999) The genetic system as a fungal taxonomic tool: gene flow, molecular variation and sibling species in the 'Ophiostoma piceae – Ophiostoma ulmi' complex and its taxonomic and ecological significance. In: Wingfield MJ, Seifert KA, Webber JF (eds) Ceratocystis and Ophiostoma, 2nd edn. Am Phytopath Soc Press, St. Paul, Minnesota, pp. 77–92

Brasier CM, Takai S, Nordin JH, Richards WC (1990) Differences in cerato-ulmin production between the EAN, NAN and non-aggressive subgroups of Ophiostoma ulmi. Plant Pathol 39:231–236

Braun HJ (1977) Das Rindensterben der Buche, *Fagus sylvatica* L., verursacht durch die Buchenwollschildlaus *Cryptococcus fagi* Bär. II. Ablauf der Krankheit. Eur J Forest Pathol 7:76–93

Bravery AF (1991) The strategy for eradication of *Serpula lacrymans*. In: Jennings DH, Bravery AF (eds) *Serpula lacrymans*. Wiley, Chichester, pp. 117–130

Bravery AF, Berry RW, Carey JK, Cooper DE (2003) Recognising wood rot and insect damage in buildings, 2nd edn. BRE, Watford

Bravery AF, Grant C (1985) Studies on the growth of *Serpula lacrymans* (Schumacher ex Fr.) Gray. Mater Org 20:171–192

Brefeld O (1889) Untersuchungen aus dem Gesamtgebiete der Mykologie 8. Basidiomyceten III. Arthur Felix, Leipzig

Breitenbach J, Kränzlin F (1981/1986/1991/1995) Pilze der Schweiz. 4 vol, Ascomyceten. Nichtblätterpilze. Röhrlinge und Blätterpilze 1. Blätterpilze 2. Mykologia, Luzern

Bresinsky A, Jarosch M, Fischer M, Schönberger I, Wittmann-Bresinsky B (1999) Phylogenetic relationships within *Paxillus* s.l. (Basidiomycetes, Boletales): separation of a southern hemisphere genus. Plant Biol 1:327–333

Breuil C, Seifert KA (1999) Immunological detection of some ophiostomatoid fungi. In: Wingfield MJ, Seifert, KA, Webber, JF (eds) *Ceratocystis* and *Ophiostoma*, 2 edn. Am Phytopath Soc Press, St. Paul, Minnesota, pp. 127–132

Breuil C, Seifert KA, Yamada J, Rossignol L, Saddler JN (1988) Quantitative estimation of fungal colonization of wood using an enzyme-linked immunosorbent assay. Can J Forest Res 18:374–377

Breyne S, Klaucke R, Wormuth EW (2000) Modifiziertes Wechseldruckverfahren (Hamburger Verfahren); Ergebnisse aus der Praxis mit der Holzart Fichte. 22nd Holzschutztagung, Dtsch Ges Holzforsch, pp. 153–166

Bricknell JM (1991) Surveying to determine the presence and extent of an attack of dry rot within buildings in the United Kingdom. In: Jennings DH, Bravery AF (eds) *Serpula lacrymans*. Wiley, Chichester, pp. 95–115

Bruce A (1992) Biological control of wood decay. IRG/WP/1531

Bruce A (1998) Biological control of wood decay. In: Bruce A, Palfreyman JW (eds) Forest products biotechnology. Taylor & Francis, London, pp. 250–266

Bruce A (2000) Role of VOCs and other antagonistic mechanisms in the biological control of wood deterioration fungi by *Trichoderma* spp. and other antagonists. Polska Akad Nauk, Drewna, Ochrona Drewna 20th Symp, pp. 17–25

Bruce A, Palfreyman JW (eds) (1998) Forest products biotechnology. Taylor & Francis, London

Bruce A, Verrall S, Hackett CA, Wheatley RE (2004) Identification of volatile organic compounds (VOCs) from bacteria and yeast causing inhibition of sapstain. Holzforsch 58:193–198

Bruhn JN, Wetteroff JJ, Mihail JD, Kabrick JM, Pickens JB (2000) Distribution of *Armillaria* species in upland Ozark Mountain forests with respect to site, overstory species composition and oak decline. Eur J Forest Pathol 30:43–60

Brunner I, Ruf M (2003) Tot oder lebendig? Die Biochemie gibt Auskunft. Swiss Fed Res Inst WSL, Birmensdorf, Inf. Forschungsbereich Wald 14:3–4

Bruns TD, Szaro TM, Gardes M, Cullings KW, Pan JJ, Taylor DL, Horton TR, Kretzer A, Garbelotto M, Li Y (1998) A sequence database for the identification of ectomycorrhizal basidiomycetes by phylogenetic analysis. Molec Ecol 7:257–272

Brush TS, Farrell RL, Ho C (1994) Biodegradation of wood extractives from southern yellow pine by *Ophiostoma piliferum*. Tappi J 77:155–159

Buchanan RE, Gibbons NE (eds) (1974) Bergey's manual of determinative bacteriology, 8th edn. Williams & Wilkins, Baltimore

Bucur V (2003) Nondestructive characterization and imaging of wood. Springer, Berlin Heidelberg New York

Bues CT (1993) Qualität von beregnetem Fichtenholz nach Auslagerung und Einschnitt. Part 2. Untersuchungsergebnisse. Holz-Zbl 119:524, 526

Bues C-T, Weber A (1998) Eine neue Methode zur Rundholzlagerung. Forstwiss Cbl 117:231–236

Bull DC (2001) The chemistry of chromated copper arsenate. II. Preservative-wood interactions. Wood Sci Technol 34:459–466

Burdsall HH (1991) *Meruliporia (Poria) incrassata*: Occurrence and significance in the United States as a dry rot fungus. In: Jennings DH, Bravery AF (eds) *Serpula lacrymans*. Wiley, Chichester, pp. 189–191

Burdsall HH, Banik M, Cook ME (1990) Serological differentiation of three species of *Armillaria* and *Lentinula edodes* by enzyme-linked immunosorbent assay using immunized chickens as a source of antibodies. Mycologia 82:415–423

Burdsall HH, Eslyn WE (1974) A new *Phanerochaete* with a *Chrysosporium* imperfect state. Mycotaxon 1:123–133

Burnett JH (1976) Fundamentals of mycology. Arnold, London

Butcher JA (1975) Colonization of wood by soft-rot fungi. In: Liese W (ed) Biological transformation of wood by microorganisms. Springer, Berlin Heidelberg New York, pp. 24–38

Butin H (1995) Tree diseases and disorders. Causes, biology and control in forest and amenity tress. Oxford University Press, Oxford

Butin H, Kowalski T (1989) Schüttepilze der Kiefern. Waldschutz-Merkbl 13. Parey, Hamburg

Butin H, Kowalski T (1992) Die natürliche Astreinigung und ihre biologischen Voraussetzungen. VI. Versuche zum Holzabbau durch Astreiniger-Pilze. Eur J Forest Pathol 22:174–182

Butin H, Nienhaus F, Böhmer B (1992) Farbatlas Gehölzkrankheiten. Ziersträucher und Parkbäume, 3rd edn. Ulmer, Stuttgart

Butin H, Volger C (1982) Untersuchungen über die Entstehung von Stammrissen ("Frostrissen") an Eiche. Forstw Cbl 101:295–303

Calderoni M, Sieber TN, Holdenrieder O (2003) *Stereum sanguinolentum*: Is it an amphithallic basidiomycete? Mycologia 95:232–238

Capretti P, Korhonen K, Mugnai L, Romagnoli C (1990) An intersterility group of *Heterobasidion annosum* specialized to *Abies alba*. Eur J Forest Pathol 20:231–240

Carmichael JW, Kendrick WB, Conners IL, Sigler L (1980) Genera of Hyphomycetes. University of Alberta Press, Edmonton

Carter JC (1945) Wetwood of elms. Ill Natl Hist Surv 23:407–448

Cartwright KStG, Findlay WPK (1958) Decay of timber and its prevention, 2nd edn. His Majesty's Stationery Office, London

Celimene CC, Micales JA, Ferge L, Young RA (1999) Efficacy of pinosylvins against white-rot and brown-rot fungi. Holzforsch 53:491–497

Cerny G, Betz M (1999) Einfluß von Altpapier und Altpapieraufbereitungstechnologien auf die Verkeimungsrate von Sekundärfaserstoffen. Papier 53:V42–V45

Chang ST, Hayes H (1978) The biology and cultivation of edible mushrooms. Academic Press, New York

Chase TE, Ullrich RC (1990) Genetic basis of biological species in *Heterobasidion annosum*: Mendelian determinants. Mycologia 82:67–72

Chatani A, Yoshida S, Honda Y, Watanabe T, Kuwahara M (1998) Reaction of manganese-dependent peoxidase from Bjerkandera adusta in organic solvents. Wood Res 85:71–74

Chen Y-R, Schmidt EL, Olsen KK (1999) A biopulping fungus in compression-balled, non-sterile green pine chips enhancing kraft and refiner pulping. Wood Fiber Sci 31:376–384

Cherfas J (1991) Disappearing mushrooms: another mass extinction? Science 254:1458

Chillali M, Wipf D, Guillaumin J-J, Mohammed C, Botton B (1998) Delineation of the European *Armillaria* species based on the sequences of the internal transcribed spacer (ITS) of ribosomal DNA. New Phytol 138:553–561

Chittenden C, Wakeling R, Kreber B (2003) Growth of two selected sapstain fungi and one mould on chitosan amended nutrient medium. IRG/WP/10466

Christensen IV, Ottosen LM, Melcher E, Schmitt U (2005) Determination of the distribution of copper and chromium in partly remediated CCA-treated pine wood using SEM and EDX analyses. Wood Res 50:11–21

Chung W-Y, Wi S-G, Bae H-J, Park B-D (1999) Microscopic observation of wood-based composites exposed to fungal deterioration. J Wood Sci 45:64–68

Clarke RW, Jennings DH, Coggins RW (1980) Growth of *Serpula lacrymans* in relation to water potential of substrate. Trans Br Mycol Soc 75:271–280

Clausen C (1997a) Immunological detection of wood decay fungi – an overview of techniques developed from 1986 to present. Int Biodeter Biodegrad 39:133–143

Clausen CA (1997b) Enhanced removal of CCA from treated wood by Bacillus licheniformis. IRG/WP/ 50083

Clausen CA (2003) Detecting decay fungi with antibody-based tests and immunoassays. In: Goodell B, Nicholas DB, Schultz TP (eds) Wood deterioration and preservation. ACS Symp Ser 845, Am Chem Soc, Washington, DC, pp. 325–336

Clausen CA, Green F, Highley TL (1991) Early detection of brown-rot decay in southern yellow pine using immunodiagnostic procedures. Wood Sci Technol 26:1–8

Clausen CA, Green F, Highley TL (1993) Characterization of monoclonal antibodies to wood-derived β-1,4-xylanase of *Postia placenta* and their application to detection of incipient decay. Wood Sci Technol 27:219–228

Clausen CA, Kartal SN (2003) Accelerated detection of brown-rot decay: Comparison of soil block test, chemical analysis, mechanical properties, and immunodetection. Forest Prod J 53:90–94

Clerivet A, El Modasfar C (1994) Vascular modifications in Platanus acerifolia seedlings inoculated with *Ceratocystis fimbriata* f. sp. *platani*. Eur J Forest Pathol 24:1–10

Cockcroft R (ed) (1981) Some wood-destroying basidiomycetes, vol. 1 of a collection of monographs. IRG/WP, Boroko, Papua New Guinea

Coetzee MPA, Wingfield BD, Harrington TC, Dalevi D, Coutinho TA, Wingfield MJ (2000) Geographical diversity of *Armillaria mellea* s.s. based on phylogenetic analysis. Mycologia 92:105–113

Coetzee MPA, Wingfield BD, Harrington TC, Steimel J, Coutinho TA, Wingfield MJ (2001) The root rot fungus *Armillaria mellea* introduced into South Africa by early Dutch settlers. Molec Ecol 10:387–396

Coggins CR (1980) Decay of timber in buildings. Dry rot, wet rot and other fungi. Rentokil, East Grinstead

Coggins CR (1991) Growth characteristics in a building. In: Jennings DH, Bravery AF (eds) *Serpula lacrymans*. Wiley, Chichester, pp. 81–93

Collett O (1992a) Comparative tolerance of the brown-rot fungus *Antrodia vaillantii* (DC.:Fr.) Ryv. isolates to copper. Holzforsch 46:293–298

Collett O (1992b) Variation in copper tolerance among isolates of the brown-rot fungi *Postia placenta* (Fr.) M. Lars. & Lomb. and *Antrodia xantha* (Fr.) Ryv. Mater Org 27:263–271

Conedera M, Jermini M, Sassella A, Sieber TN (2004) Ernte, Behandlung und Konservieren von Kastanienfrüchten. Merkbl 38 Eidg Forschungsanst WSL Birmensdorf

Cookson LJ, Watkins JB, Holmes JH, Drysdale J, Waals van der J, Hedley M (1998) Evaluation of the fungicidal effectiveness of water-repellent CCAs. J Inst Wood Sci 14(83):254–261

Cooper JI, Edwards ML (1996) Viruses in forest trees. In: Raychaudhuri SP, Maramorosch K (eds) Forest trees and palms. Science Publishers, Lebanon, NH, USA, pp. 285–307

Cooper PA, Ung YT (1992a) Leaching of CCA-C from jack pine sapwood in compost. Forest Prod J 42:57–59

Cooper PA, Ung YT (1992b) Accelerated fixation of CCA-treated poles. Forest Prod J 42:27–32

Cosenza J, McCreary M, Buck JD, Shigo AL (1970) Bacteria associated with discolored and decayed tissues in beech, birch, and maple. Phytopath 60:167–174

Courtois H (1972) Das Keimverhalten der Konidiosporen von Fomes annosus (Fr.) Cke. bei Einwirkung verschiedener Standortfaktoren. Eur J Forest Pathol 2:152–171

Cowan J, Banerjee S (2005) Leaching studies and fungal resistance of potential new wood preservatives. Forest Prod J 55:66–70

Cowling EB (1961) Comparative biochemistry of the decay of sweetgum sapwood by white-rot and brown-rot fungi. USDA Tech Bull Washington, DC, 1258

Croan SC, Highley TL (1990) Biological control of the blue stain fungus *Ceratocystis coerulescens* with fungal antagonists. Mater Org 25:255–266

Croan SC, Highley TL (1992a) Conditions for carpogenesis and basidiosporogenesis by the brown-rot basidiomycete *Gloeophyllum trabeum*. Mater Org 27:1–9

Croan SC, Highley TL (1992b) Biological control of sapwood-inhabiting fungi by living bacterial cells of *Streptomyces rimosus* as a bioprotectant. IRG/WP/1564

Croan SC, Highley TL (1992c) Synergistic effect of boron on *Streptomyces rimosus* metabolites in preventing conidial germination of sapstain and mold fungi. IRG/WP/1565

Croan SC, Highley TL (1993) Controlling the sapstain fungus *Ceratocystis coerulescens* by metabolites obtained from *Bjerkandera adusta* and Talaromyces flavus. IRG/WP/10024

Cullen D, Kersten PJ (1996) Enzymology and molecular biology of lignin degradation. In: Brambl R, Marzluf GA (eds) The mycota, vol. III, biochemistry and molecular biology. Springer, Berlin Heidelberg New York, pp. 295–312

Curling SF, Clausen CA, Winandy JE (2002) Relationships between mechanical properties, weight loss, and chemical composition of wood during incipient brown-rot decay. Forest Prod J 52:34–39

Cymorek S, Hegarty B (1986a) Differences among growth and decay capacities of 25 old and new strains of the dry rot fungus *Serpula lacrymans* using a special test arrangement. Mater Org 21:237–249

Cymorek S, Hegarty B (1986b) A technique for fructification and basidiospore production by Serpula lacrymans. (Schum. ex Fr.) SF GRAY in artificial culture. IRG/WP/2255

Czaja AT, Pommer EH (1959) Untersuchungen über die Keimungsphysiologie der Sporen holzzerstörender Pilze: Merulius lacrymans und Coniophora cerebella. I. Die Sporenkeimung in vitro. Qualitas Plantarum Materiae Vegetabiles 3:209–267

Da Costa EWB (1959) Abnormal resistance of *Poria vaillantii* (D.C. ex Fr.) Cke. strains to copper-chrome-arsenate wood preservatives. Nature 183:910–911

Da Costa EWB, Kerruish RM (1964) Tolerance of *Poria* species to copper-based wood preservatives. Forest Prod J 14:106–112

Da Costa EWB, Kerruish RM (1965) The comparative wood-destroying ability and preservative tolerance of monokaryotic and dikaryotic mycelia of *Lenzites trabea* (Pers.) Fr. and *Poria vaillantii* (DC ex Fr.) Cke. Ann Bot 29:241–252

Dai Y-C, Korhonen K (1999) *Heterobasidion annosum* group S identified in north-eastern China. Eur J Forest Pathol 29:273–279

D'Angelo EM, Reddy KR (2000) Aerobic and anaerobic transformations of pentachlorophenol in wetland soils. Soil Sci Am J 84:933–943

Daniel G (1994) Use of electron microscopy for aiding our understanding of wood biodegradation. FEMS Microbiol Rev 13:199–233

Daniel G (2003) Microview of wood under degradation by bacteria and fungi. In: Goodell B, Nicholas DB, Schultz TP (eds) Wood deterioration and preservation. ACS Symp Ser 845, Am Chem Soc, Washington, DC, pp. 34–72

Daniel G, Bergman Ö (1997) White rot and manganese deposition in TnBTO-AAC preservative treated pine stakes from field tests. Holz Roh-Werkstoff 55:197–201

Daniel G, Nilsson T (1985) Ultrastructural and T.E.M.-EDAX studies on the degradation of CCA treated radiata pine by tunnelling bacteria. IRG/WP/1260

Daniel G, Nilsson T (1998) Developments in the study of soft rot and bacterial decay. In: Bruce A, Palfreyman JW (eds) Forest products biotechnology. Taylor & Francis, London, pp. 37–62

Daniel G, Nilsson T, Pettersson B (1989) Intra- and extracellular localization of lignin peroxidase during degradation of solid wood and wood fragments by *Phanerochaete chrysosporium* by using transmission electron microscopy and immuno-gold labeling. Appl Environ Microbiol 55:871–881

Daniel G, Pettersson B, Nilsson T, Volc J (1990) Use of immunogold cytochemistry to detect Mn(II)-dependent lignin peroxidases in wood degraded by the white-rot fungi *Phanerochaete chrysosporium* and *Lentinula edodes*. Can J Bot 68:920–933

Daniel G, Volc J, Kubatova E (1994) Pyranose oxidase, a major source of H_2O_2 during wood degradation by *Phanerochaete chrysosporium*, *Trametes versicolor*, and *Oudemansiella mucida*. Appl Environ Microbiol 60:2524–2532

Danko P (1994) Microwave method for the determination of wood moisture content. Drevársky Výskum 39:35–43

Dart RK, Betts WB (1991) Uses and potential of lignocelluloses. In: Betts WB (ed) Biodegradation: natural and synthetic materials. Springer, Berlin, Heidelberg New York, pp. 201–217

Davidson RS, Campbell WA, Blaisdell DJ (1938) Differentiation of wood-decaying fungi by their reactions on gallic or tannic acid medium. J Agric Res 57:683–695

Davidson RS, Campbell WA, Blaisdell Vaughn D (1942) Fungi causing decay of living oaks in the eastern United States and their cultural identification. Tech Bull US Dept Agri Washington, DC, 785 pp

Dawson BSW, Franich RA, Kroese HK, Steward D (1999) Reactivity of radia pine sapwood towards carboxylic acid anhydrides. Holzforsch 53:195–198

Dawson-Andoh BE (2002) Ergosterol content as a measure of biomass of potential biological control fungi in liquid cultures. Holz Roh-Werkstoff 60:115–117

Dawson-Andoh BE, Morrell JJ (1997) Biological protection of freshly sawn sapwood from biological discoloration. In: Prevention of discoloration in hardwoods and softwood logs and lumber. Forest Prod Soc Publ, Madison, pp. 3–9

Decker RFH, Lindner WA (1979) Bioutilization of lignocellulosic waste materials: a review. S Afr J Sci 75:65–71

Delatour C (1991) A very simple method for long-term storage of fungal cultures. Eur J Forest Pathol 21:444–445

Deutsches Institut für Bautechnik (2005) Holzschutzmittelverzeichnis, 53rd edn. Erich Schmidt, Berlin

Dhyani S, Tripathi S, Jain VK (2005) Neem leaves, a potential source for protection of hardwood against wood decaying fungus. IRG/WP/30370

Dickinson DJ (1982) The decay of commercial timbers. In: Frankland JC, Hedger JN, Swift MJ (eds) Decomposer basidiomycetes. Cambridge University Press, Cambridge, pp. 179–190

Dickinson DJ, McCormack PW, Calver B (1992) Incidence of soft rot in creosoted poles. IRG/WP/1554

Dickinson DJ, Sorkhoh NAA, Levy JF (1976) The effect of the microdistribution of wood preservatives on the performance of treated wood. Rec Br Wood Preserv Assoc, pp. 1–16

Diehl SV, McElroy TC, Prewitt ML (2004) Development and implementation of a DNA-RFLP database for wood decay and wood associated fungi. IRG/WP/10527

Diehl SV, Prewitt ML, Moore Shmulsky F (2003) Use of fatty acid profiles to identify white-rot wood decay fungi. In: Goodell B, Nicholas DB, Schultz TP (eds) Wood deterioration and preservation. ACS Symp Ser 845, Am Chem Soc, Washington, DC, pp. 313–324

Dietrichs HH, Sinner M, Puls J (1978) Potential of steaming hardwoods and straw for feed and food production. Holzforsch 32:193–199

Dill I, Kraepelin G (1986) Palo podrido: model for extensive delignification of wood by *Ganoderma applanatum*. Appl Environ Microbiol 52:1305–1312

Dimitri L, Tomiczek C (1998) Germany and Austria. In: Woodward S, Stenlid J, Karjalainen R, Hüttermann A (eds) *Heterobasidion annosum*. CAB Int, Walligford, pp. 355–368

DIN 68800, Part 2 (1984) (1996 under revision) Wood preservation in building construction; protective structural measures. Beuth, Berlin

DIN 68800, Part 3 (1990) (under revision) Wood preservation; protective chemical wood preservation. Beuth, Berlin

DIN 68800, Part 4 (1992) Wood preservation; control measures against wood-destroying fungi and insects. Beuth, Berlin

DIN 68800, Part 5 (1978) Protection of timber used in buildings; preventive chemical protection for wood-based materials. Beuth, Berlin

Dirol D, Fougerousse M (1981) *Schizophyllum commune* Fr. In: Cockcroft R (ed) Some wood-destroying basidiomycetes. IRG/WP, Boroko, Papua New Guinea, pp. 129–139

Dirol D, Vergnaud J-M (1992) Water transfer in wood in relation to fungal attack in buildings – effect of condensation and diffusion. IRG/WP/1543

Dodson P, Evans CS, Harvey PJ, Palmer JH (1987) Production and properties of an extracellular peroxidase from *Coriolus versicolor* which catalyses C_α–C_β cleavage in a lignin model compound. FEMS Microbiol Lett 42:17–22

Doi S (1989) Evaluation of preservative-treated wooden sills using a fungus cellar with *Serpula lacrymans* (Fr.) Gray. Mater Org 24:217–225

Doi S (1991) *Serpula lacrymans* in Japan. In: Jennings DH, Bravery AF (eds) *Serpula lacrymans*. Wiley, Chichester, pp. 173–187

Doi S, Togashi I (1989) Utilization of nitrogenous substance by Serpula lacrymans. IRG/WP/1397

Doi S, Yamada A (1991) Antagonistic effect of *Trichoderma* spp. against *Serpula lacrymans* in the soil treatment test. IRG/WP/1473

Doi S, Yamada A (1992) Preventing wood decay with *Trichoderma* spp. J Hokkaido Forest Prod Res Inst 6:1–5

Domański S (1972) Fungi. Polyporaceae I. Natl Center Sci Econ Inform, Warszawa

Domański S, Orlos H, Skirgiello A (1973) Fungi. Polyporaceae II. Natl Center Sci Econ Inform, Warszawa

Domsch KH, Gams W, Anderson T (1980) Compendium of soil fungi, vol. 2. Academic Press, New York

Donaubauer E (1998) Die Bedeutung von Krankheitserregern beim gegenwärtigen Eichensterben in Europa – eine Literaturübersicht. Eur J Forest Pathol 28:91–98

Donk MA (1974) Check list of European polypores. North-Holland Publ, Amsterdam

Du QP, Geissen A, Noack D (1991a) Die Genauigkeit der elektrischen Holzfeuchtemessung nach dem Widerstandsprinzip. Holz Roh-Werkstoff 49:1–6

Du QP, Geissen A, Noack D (1991b) Widerstandskennlinien einiger Handelshölzer und ihre Meßbarkeit bei der elektrischen Holzfeuchtemessung. Holz Roh-Werkstoff 49:305–311

Duchesne LC, Hubbes M, Jeng RS (1992) Biochemistry and molecular biology of defense reactions in the xylem of angiosperm trees. In: Blanchette RA, Biggs AR (eds) Defense mechanisms of woody plants against fungi. Springer, Berlin, Heidelberg New York, pp. 133–146

Dujesiefken D, Jaskula P, Kowol T, Wohlers A (2005) Baumkontrolle unter Berücksichtigung der Baumart. Thalacker, Braunschweig

Dujesiefken D, Kowol T (1991) Das Plombieren hohler Bäume mit Polyurethan. Forstw Cbl 110:176–184

Dujesiefken D, Peylo A, Liese W (1991) Einfluß der Verletzungszeit auf die Wundreaktionen verschiedener Laubbäume und der Fichte. Forstw Cbl 110:371–380

Dujesiefken D, Seehann G (1995) Zur Desinfektion von Stammwunden. In: Dujesiefken D (ed) Wundbehandlung an Bäumen. Thalacker, Braunschweig, pp. 73–77

Dujesiefken D, Stobbe H (2002) The Hamburg tree pruning system – a framework for pruning individual trees. Urban Forest Urban Green 1:75–82

Dumas MT (1992) Inhibition of Armillaria by bacteria isolated from soils of the Boreal Mixedwood Forest of Ontario. Eur J Forest Pathol 22:11–18

Dumas MT, Boyonoski NW (1992) Scanning electron microscopy of mycoparasitism of Armillaria rhizomorphs by species of Trichoderma. Eur J Forest Pathol 22:379–383

Dworkin MM, Falkow S, Rosenberg E, Schleifer K-H, Stackebrandt E (eds) (2005) The prokaryotes, 3rd edn. Springer, Berlin Heidelberg New York

Dyk van H, Rice RW (2005) An assessment of the feasibility of ultrasound as a defect detector in lumber. Holzforsch 59:441–445

Eaton RA, Hale MDC (1993) Wood: decay, pests and protection. Chapman & Hall, London

Eggert C, LaFayette PR, Temp U, Eriksson K-E, Dean JFD (1998) Molecular analysis of a laccase gene from the white rot fungus Pycnoporus cinnabarinus. Appl Environ Microbiol 64:1766–1772

Eggert C, Temp U, Eriksson K-L (1996) The ligninolytic system of the white rot fungus Pycnoporus cinnabarinus: purification and characterization of the laccase. Appl Environ Microbiol 62:1151–1158

Egli S (2004) Künstliche Mykorrhizaimpfung. AFZ-DerWald 59:1327–1329

Egli S, Brunner I (2002) Mykorrhiza. Merkbl Praxis 35. Swiss Fed Inst For Snow Landscape Res, Birmensdorf

Eguchi F, Higaki M (1992) Production of new species of edible mushrooms by protoplast fusion method. I. Protoplast fusion and fruiting body formation between Pleurotus ostreatus and Agrocybe cylindricea. Mokuzai Gakkaishi 38:403–410

Eikenes M, Alfredsen G, Larnøy E, Militz H, Kreber B, Chittenden C (2005) Chitosan for wood protection – state of the art. IRG/WP/30378

Eikenes M, Hietala A, Alfredsen G, Fossdal CG, Solheim H (2005) Comparison of quantitative real-time PCR, chitin and ergosterol assays for monitoring colonization of Trametes versicolor in birch wood. Holzforsch 59:568–573

Eisenbarth E, Wilhelm GJ, Berens A (2001) Buchen-Komplexkrankheit in der Eifel und den angrenzenden Regionen. AFZ-DerWald 56:1212–1217

Ek M, Eriksson K-E (1980) Utilization of the white-rot fungus Sporotrichum pulverulentum for water purification and protein production on mixed lignocellulosic wastewaters. Biotechnol Bioengin 22:2273–2284

Elliott CG, Abou-Heilah AN, Leake DL, Hutchinson SA (1979) Analysis of wood-decaying ability of monokaryons and dikaryons of Serpula lacrymans. Trans Br Mycol Soc 73:127–133

Elliott ML, Watkinson S (1989) The effect of α-aminoisobutyric acid on wood decay and wood spoilage fungi. Int Biodetn 25:355–371

Ellis EA (1976) British fungi, Part 2. Jarrold & Sons, Norwich

Enoki A, Tanaka H, Fuse G (1988) Degradation of lignin-related compounds, pure cellulose, and wood components by white-rot and brown-rot fungi. Holzforsch 42:85–93

Enoki A, Tanaka H, Itakura S (2003) Physical and chemical characteristics of glycopeptide. In: Goodell B, Nicholas DD, Schulz TP (eds) Wood deterioration and preservation. ACS Symp Series 845. Am Chem Soc, Washington, DC, pp. 149–153

Erb B, Matheis W (1983) Pilzmikroskopie. Präparation und Untersuchung von Pilzen. Franckh, Stuttgart

Eriksson K-E (1985) Potential use of microorganisms in wood bioconversion. Marcus Wallenberg Found, pp. 9–20

Eriksson K-EL (1990) Biotechnology in the pulp and paper industry. Wood Sci Technol 24:79–101

Eriksson K-EL, Blanchette RA, Ander P (1990) Microbial and enzymatic degradation of wood and wood components. Springer, Berlin Heidelberg New York

Erler K (2002) Holz im Außenbereich. Anwendungen, Holzschutz, Schadensvermeidung. Birkhäuser, Basel

Erler K (2005) Der Holz-Schadpilz Ausgebreiteter Hausporling breitet sich aus. 24th Holzschutztagung, Dtsch Ges Holzforsch, pp. 99–102

Ernst E, Kehr R, Müller J, Wulf A (2004) Möglichkeiten zum biologischen Schutz von Nadelholz vor Stamm- und Schnittholzbläue. Nachrichtenbl. Dtsch Pflanzenschutzd 56:169–179

Eslyn E, Lombard FF (1983) Decay in mine timbers. II. Basidiomycetes associated with decay of coal mine timbers. Forest Prod J 33:19–23

Espejo E, Agosin E (1991) Production and degradation of oxalic acid by brown-rot fungi. Appl Environ Microbiol 57:1980–1986

Esser K (1989) Anwendung von Methoden der klassischen und molekularen Genetik bei der Züchtung von Nutzpflanzen. Mushroom Sci XII, vol. I, pp. 1–23

Esser K (ed) (1994 et seq.) The mycota, 12 vol. Springer, Berlin Heidelberg New York

Eusebio MA, Quimio MJ (1975) Microbially modified wooden-pencil slats. Forpridge Digest IV, pp. 11–18

Evans CS (1991) Enzymes of lignin degradation. In: Betts WE (ed) Biodegradation: natural and synthetic compounds. Springer, Berlin Heidelberg New York, pp. 175–184

Evers J, Pampe A (2005) Künstliche Mykorrhizierung von Baumschulpflanzen. Versuche zur Verbesserung des Anwuchserfolges von Buche und Bergahorn in Erstaufforstungen. Forst Holz 60:83–90

Ewert M, Scheiding W (2005) Thermoholz in der Anwendung – Eigenschaften und Möglichkeiten. Holztechnol 46:22–29

Fabritius A-L, Karjalainen R (1993) Variation in *Heterobasidion annosum* detected by Random Amplified Polymorphic DNAs. Eur J Forest Pathol 23:193–200

Faison BD, Kirk TK (1985) Factors involved in the regulation of a ligninase activity in *Phanerochaete chrysosporium*. Appl Environ Microbiol 49:299–304

Faix O (1992) New aspects of lignin utilization in large amounts. Papier 46:733–740

Faix O, Bremer J, Schmidt O, Stevanović J (1991) Monitoring of chemical changes in white-rot degraded beech wood by pyrolysis-gas chromatography and Fourier-transform infrared spectroscopy. J Anal Appl Pyrolysis 21:147–162

Faix O, Meier D, Fortmann I (1990) Thermal degradation products of wood. Gas chromatographic separation and mass spectrometric characterization of monomeric lignin derived products. Holz Roh-Werkstoff 48:281–285

Falck R (1909) Die Lenzites-Fäule des Coniferenholzes. Hausschwammforsch 3:234 S

Falck R (1912) Die Meruliusfäule des Bauholzes. Hausschwammforsch 6:405 S

Falck R (1927) Gutachten über Schwammfragen. Hausschwammforsch 9:12–64

Farrell RL, Blanchette RA, Brush TS, Hadar Y, Iverson S, Krisa K, Wendler PA, Zimmermann W (1993) Cartapip™: a biopulping product for control of pitch and resin acid problems in pulp mills. J Biotechnol 30:115–122

Feicht E, Wittkopf S, Ohrner G, Mühlen zur A, Nowak D (2002) Gefährdung durch Holz-Hackschnitzel analysiert. Holz-Zbl 128:500

Fengel D, Wegener G (1989) Wood: Chemistry, ultrastructure, reactions, 2nd edn. de Gruyter, Berlin

Fenselau C, Demirev PA (2001) Characterization of intact microorganisms by MALDI mass spectrometry. Mass Spectrom Rev 20:157–171

Filip Z, Claus H, Dippell G (1998) Abbau von Huminstoffen durch Bodenmikroorganismen – eine Übersicht. Z Pflanzenernähr Bodenk 161:605–612

Findlay WPK (1967) Timber pests and diseases. Pergamon, Oxford

Findlay WPK (ed) (1985) Preservation of timber in the tropics. Martinus Nijhoff/Dr W Junk Publ, Dordrecht

Findlay WPK, Savory JG (1954) Moderfäule. Die Zersetzung von Holz durch niedere Pilze. Holz Roh-Werkstoff 12:293–296

Fischer J (2005) Umweltaspekte. In: Müller J (ed) Holzschutz im Hochbau. Fraunhofer IRB, Stuttgart, pp. 314–330

Fischer K, Akhtar M, Blanchette RA, Burnes TA, Messner K, Kirk TK (1994) Reduction of resin content in wood chips during experimental biopulping processes. Holzforsch 48:285–290

Fischer M (1995) *Phellinus igniarius* and its closest relatives in Europe. Mycol Res 99:735–744

Fischer M (1996) Molecular and microscopical studies in the *Phellinus pini* group. Mycologia 88:230–238

Fischer M, Wagner T (1999) RFLP analysis as a tool for identification of lignicolous basidiomycetes: European polypores. Eur J Forest Pathol 29:295–304

Fleet C, Breuil C, Uzunovic A (2001) Nutrient consumption and pigmentation of deep and surface colonizing sapstaining fungi in *Pinus contorta*. Holzforsch 55:340–346.

Flick M, Lelley J (1985) Die Rolle der Mykorrhiza in den Waldgesellschaften unter besonderer Berücksichtigung der Baumschäden. Forst-Holzwirt 40:154–162

Florence EJM, Sharma JK (1990) *Botryodiplodia theobromae* associated with blue staining in commercially important timbers of Kerala and its possible biological control. Mater Org 25:193–199

Flournoy DS, Kirk TK, Highley TL (1991) Wood decay by brown-rot fungi: changes in pore structure and cell wall volume. Holzforsch 45:383–388

Fogel JF, Lloyd JD (2002) Mold performance of some construction products with and without borates. Forest Prod J 52:38–43

Fojutowski A (2005) The influence of fungi causing blue-stain on absorptiveness of Scotch pine wood. IRG/WP/10565

Forde Kohler LJ, Dinus RD, Macolm EW, Rudie AW, Farrell RA, Brush TS (1997) Improving softwood mechanical pulp properties with *Ophiostoma piliferum*. Tappi J 80:135–140

Forss K, Jokinen K, Lehtomäki M (1986) Aspects of the pekilo protein process. Paperi ja Puu 11:839–844

Fougerousse M (1985) Protection of logs and sawn timber. In: Findlay WPK (ed) Preservation of timber in the tropics. Martinus Nijhoff/Dr W Junk Publ, Dordrecht, pp. 75–119

Fox RTV (1990) Diagnosis and control of *Armillaria* honey fungus root rot of trees. Profess Horticult 4:121–127

Francke-Grosmann H (1958) Über die Ambrosiazucht holzbrütender Ipiden im Hinblick auf das System. 14th Verhandlungsber Dtsch Ges angew Entomol 1957:139–144

Frankland JC, Hedger JN, Swift MJ (eds) (1982) Decomposer basidiomycetes: their biology and ecology. Cambridge University Press, Cambridge

Frommhold D, Heydeck P (1998) Aktuelles zum Kiefernbaumschwamm im nordost-deutschen Tiefland. AFZ-DerWald 53:1328–1331

Frontz TM, Davis DD, Bunyard BA, Royse D-J (1998) Identification of *Armillaria* species isolated from bigtooth aspen based on rDNA RFLP analysis. Can J Forest Res 28:141–149

Frössel F (2003) Schimmelpilze und andere Innenraumbelastungen. Fraunhofer IRB, Stuttgart

Furono T, Imamura Y (1998) Combination of wood and silicate, Part 6. Biological resistances of wood-mineral composites using water glass-boron compound system. Wood Sci Technol 32:161–170

Garbelotto M, Ratcliff A, Bruns TD, Cobb FW, Otrosina WJ (1996) Use of taxon-specific competitive-priming PCR to study host specifity, hybridization, and intergroup gene flow in intersterility groups of *Heterobasidion annosum*. Phytopath 86:543–551

Gardner DJ, Tascioglu C, Wålinder EP (2003) Wood composites protection. In: Goodell B, Nicholas DD, Schulz TP (eds) Wood deterioration and preservation. ACS Symp Series 845. Am Chem Soc, Washington, DC, pp. 399–419

Garrity GM (ed) (2001 et seq.) Bergey's manual of systematic bacteriology, 2nd edn. Springer, Berlin Heidelberg New York

Gartland KMA, Gartland JS (2004) Biotechnology applied to conservation, insects and diseases. Proc For Biotechnol Latin America, Concepción, Chile, Inst For Biotechnol Raleigh, pp. 109–115

Gasch J, Pekny G, Krapfenbauer A (1991) Mykoplasmen-ähnliche Organismen und Eichen-sterben. MLO in den Siebröhren des Bastes erkrankter Eichen. Allg Forstz 46:500

Gersonde M (1958) Untersuchungen über die Giftempfindlichkeit verschiedener Stämme von Pilzarten der Gattungen *Coniophora, Poria, Merulius* und *Lentinus*. I. *Coniophora cerebella* (Pers.) Duby. Holzforsch 12:73–83

Gibbs JN (1974) Biology of Dutch elm disease. For Comm For Rec 94. Her Maj Stat Off, London

Gibbs JN (1999) The biology of ophiostomatoid fungi causing sapstain in trees and freshly cut logs. In: Wingfield MJ, Seifert, KA, Webber, JF (eds) *Ceratocystis* and *Ophiostoma*, 2nd Am Phytopath Soc Press, St. Paul, Minnesota, pp. 153–160

Gibbs JN, Greig BJW, Pratt JE (2002) Fomes root rot in Thetford Forest, East Anglia: past, present and future. Forestry 75:191–202

Gibbs JN, Liese W, Pinon J (1984) Oak wilt for Europe? Outlook Agricult 13:203–208

Gilbertson RL, Ryvarden L (1986, 1987) North American Polypores, 2 vol. Fungiflora, Oslo

Ginns J (1978) *Leucogyrophana* (Aphyllophorales): identification of species. Can J Bot 56:1953–1973

Ginns J (1982) A monograph of the genus *Coniophora* (Aphyllophorales, Basidiomycetes). Opera Botanica 61:1–61

Giovannozzi-Sermanni G, Cappelletto PL, D'Annibale A, Perani C (1997) Enzymatic pre-treatments of nonwoody plants for pulp and paper production. Tappi J 80:139–144

Giron MY, Morrell JJ (1989) Interactions between microfungi isolated from fumigant-treated Douglas-fir heartwood and *Poria placenta* and *Poria carbonica*. Mater Org 24:39–49

Glancy H, Palfreyman JW (1993) Production of monoclonal antibodies to *Serpula lacrymans* and their application in immunodetection systems. IRG/WP/10004

Glancy H, Palfreyman JW, Button D, Bruce A, King B (1990) Use of an immunological method for the detection of Lentinus edodes in distribution poles. J Inst Wood Sci 12:59–64

Glenn JK, Gold HH (1985) Purification and characterization of an extracellular Mn(II)-dependent peroxidase from the lignin-degrading basidiomycete, *Phanerochaete chrysosporium*. Arch Biochem Biophys 242:329–341

Glenn JK, Morgan MA, Mayfield MB, Kuwahara M, Gold MH (1983) An extracellular H_2O_2-requiring enzyme preparation involved in lignin biodegradation by the white rot basidiomycete *Phanerochaete chrysosporium*. Biochem Biophys Res Commun 114:1077–1083

Göbl F (1993) Mykorrhiza- und Feinwurzeluntersuchungen in Fichtenbeständen des Böhmerwaldes. Österreich Forstztg 2:35–38

Golinski P, Krick TP, Blanchette RA, Mirocha CJ (1995) Chemical characterization of a red pigment (5,8-dihydroxy-2,7-dimethoxy-1,4-naphthalenedione) produced by *Arthrographis cuboidea* in pink stained wood. Holzforsch 49:407–410

Göller K, Rudolph D (2003) The need for unequivocally defined reference fungi – genomic variation in two strains named as *Coniophora puteana* BAM Ebw. 15. Holzforsch 57:456–458

González AE, Grinbergs J, Griva E (1986) Biologische Umwandlung von Holz in Rinderfutter – "Palo podrido". Zentralbl Mikrobiol 141:181–186

Goodell B (2003) Brown-rot fungal degradation of wood. Our evolving view. In: Goodell B, Nicholas DB, Schultz TP (eds) Wood deterioration and preservation. ACS Symp Ser 845, Am Chem Soc, Washington, DC, pp. 97–118

Goodell B, Daniel G, Jellison J, Nilsson T (1988) Immunolocalization of extracellular metabolites from *Postia placenta*. IRG/WP/1361

Goodell B, Jellison J (1998) The role of biological metal chelators in wood degradation and in xenobiotic degradation. In: Bruce A, Palfreyman JW (eds) Forest products biotechnology. Taylor & Francis, London, pp. 235–249

Goodell B, Nicholas DD, Schulz TP (eds) (2003) Wood deterioration and preservation. Advances in our changing world. ACS Symp Series 845. Am Chem Soc, Washington, DC

Göttsche R, Borck HV (1990) Wirksamkeit Kupfer-haltiger Holzschutzmittel gegenüber *Agrocybe aegerita* (Südlicher Schüppling). Mater Org 25:29–46

Göttsche-Kühn H, Frühwald A (1986) Holzeigenschaften von Fichten aus Waldschadensgebieten. Untersuchungen an gelagertem Holz. Holz Roh-Werkstoff 44:313–318

Granata G, Parisi A, Cacciola SO (1992) Electrophoretic protein profiles of strains of Ceratocystis fimbriata f. sp. platani. Eur J Forest Pathol 22:58–62

Gray MW (1996) The third form of life. Nature 383:299

Greaves H, Nilsson T (1982) Soft rot and the microdistribution of water-borne preservatives in three species of hardwoods following field test exposure. Holzforsch 36:207–213

Green F, Clausen CA, Larsen MJ, Highley TL (1991b) Immuno-scanning electron microscopic localization of extracellular polysaccharidases within the fibrillar sheath of the brown-rot fungus *Postia placenta*. IRG/WP/1497

Green F, Hackney JM, Clausen CA, Larsen MJ, Highley TL (1993) The role of oxalic acid in short fiber formation by the brown-rot fungus *Postia placenta*. IRG/WP/10028

Green F, Larsen MJ, Murmanis LL, Highley TL (1989) Proposed model for the penetration and decay of wood by the hyphal sheath of the brown-rot fungus *Postia placenta*. IRG/WP/1391

Green F, Larsen MJ, Winandy JE, Highley TL (1991a) Role of oxalic acid in incipient brown-rot decay. Mater Org 26:191–213

Greig BJW, Gibbs JN, Pratt JE (2001) Experiments on the susceptibility of conifers to *Heterobasidion annosum* in Great Britain. Forest Pathol 31:219–228

Griffin DM (1977) Water potential and wood-decay fungi. Ann Rev Phytopath 15:319–329

Griffith GS, Boddy L (1991) Fungal decomposition of attached angiosperm twigs. III. Effect of water potential and temperature on fungal growth, survival and decay of wood. New Phytol 117:259–269

Grinda M, Kerner-Gang W (1982) Prüfung der Widerstandsfähigkeit von Dämmstoffen gegenüber Schimmelpilzen und holzzerstörenden Basidiomyceten. Mater Org 17:135–156

Grosclaude C, Olivier R, Romiti C, Pizzuto JC (1990) In vitro antagonism of some wood destroying basidiomycetes towards Ceratocystis fimbriata f.sp. platani. Agronomie 10:403–405

Groß M, Mahler G, Rathke K-H (1991) Holzqualität, Auslagerung und Bearbeitung von beregnetem Fichten/Tannen-Stammholz. Holz-Zbl 117:2440–2442

Grosser D (1985) Pflanzliche und tierische Bau- und Werkholzschädlinge. DRW Weinbrenner, Leinfelden-Echterdingen

Grosser D, Flohr E, Eichhhorn M (2003) WTA-Merkblatt E 1-2-03/D. Der Echte Hausschwamm – Erkennen, Lebensbedingungen, vorbeugende Maßnahmen, bekämpfende chemische Maßnahmen, Leistungsverzeichnis. WTA, München

Grotkaas C, Hutter I, Feldmann F (2004) Gütesicherung von Mykorrhizapräparaten. AFZ-DerWald 59:1324–1326

Gründlinger R (1997) Der Echte Hausschwamm – Serpula lacrymans (Schumacher ex Fries) S.F.Gray. Holzforsch Holzverwert 6:115–120

Guidot A, Lumini E, Debaud J-C, Marmeissse R (1999) The nuclear ribosomal DNA intergenic spacer as a target sequence to study intraspecific diversity of the ectomycorrhizal basidiomycete Hebeloma cylindrosporum directly on Pinus root system. Appl Environ Microbiol 65:903–909

Guillaumin J-J, Mohammed C, Anselmi N, Courtecuisse R, Gregory SC, Holdenrieder O, Intini M, Lung B, Marxmüller H, Morrison D, Rishbeth J, Termorshuizen AJ, Tirró A, Dam van B (1993) Geographical distribution and ecology of the Armillaria species in western Europe. Eur J Forest Pathol 23:321–341

Guillitte O (1992) Epidémiologie des attaques. In: La mérule et autres champignons nuisable dans les bâtiments. Jardin Bot Nat Belg, Domaine Bouchout

Guiot SG, Frigon J-C (1998) Anaerobic treatment of pulp mill effluents. In: Bruce A, Palfreyman JW (eds) Forest products biotechnology. Taylor & Francis, London, pp. 99–116

Habermehl A (ed) (1994) Die Computer-Tomographie als diagnostische Methode bei der Untersuchung von Bäumen. Workshop Hess Versuchsanst Hann.-Münden

Habermehl A, Ridder H-W (1993) Anwendung der mobilen Computer-Tomographie zur zerstörungsfreien Untersuchung des Holzkörpers von stehenden Bäumen. Untersuchungen an Allee- und Parkbäumen. Holz Roh-Werkstoff 51:101–106

Haese A, Rothe GM (2003) Characterization and frequencies of the IGS1 alleles of the ribosomal DNA of Xerocomus pruinatus mycorrhizae. Forest Genet 10:103–110

Hager A (2003) Zum Effekt von Laccasen beim Altpapier-Deinking. Doct Thesis, Univ Hamburg

Hager A, Nellessen B, Puls J (2002) Zur Anwendung von Laccase beim Altpapier-Deinking. In: Murr J, Galland G, Hanecker E (eds): 10th PTS-CTP Deinking Symp Rep, PTS, München, 34-1–34-10

Häggman HH, Aronen TS (1996) Agrobacterium mediated diseases and genetic transformation in forest trees. In: Raychaudhuri SP, Maramorosch (eds) Forest trees and palms. Science Publishers, Lebanon, NH, USA, pp. 135–179

Haider K (1988) Der mikrobielle Abbau des Lignins und seine Bedeutung für den Kreislauf des Kohlenstoffs. Forum Mikrobiol 11:477–483

Hajny GJ (1966) Outside storage of pulpwood chips. A review and bibliography. Tappi J 49:97–105

Hallaksela A-M (1984) Causal agents of butt-rot in Norway spruce in southern Finland. Silva Fenn 18:237–243

Haller-Brem S (2001) Bisher rettet ein Virus die Kastanie vor dem Untergang. Holz-Zbl. 127:1470

Halliwell B (2003) Free radical chemistry as related to degradative mechanisms. In: Goodell B, Nicholas DB, Schultz TP (eds) Wood deterioration and preservation. ACS Symp Ser 845, Am Chem Soc, Washington, DC, pp. 10–15

Halmschlager E (1966) Der Kastanienrindenkrebs in Österreich. Österreich Forstztg 7:47–49

Han YW, Cheeke PR, Anderson AW, Lekprayoon C (1976) Growth of *Aureobasidium pullulans* on straw hydrolysate. Appl Environ Microbiol 32:799–802

Hankammer G, Lorenz W (2003) Schimmelpilze und Bakterien in Gebäuden. Erkennen und Beurteilung von Symptomen und Ursachen. Rudolf Müller, Köln

Hanlin RT (1990) Illustrated genera of ascomycetes. Am Phytopath Soc, Minnesota

Hansen EM, Hamelin RC (1999) Population structure of basidiomycetes. In: Worrall JJ (ed) Structure and dynamics of fungal populations. Kluwer Acad Publ, Dordrecht

Hansen K (1988) Bacterial staining of Samba (*Triplochiton scleroxylon*). IRG/WP/1362

Hansen O, Knudsen H, Dissing H, Ahti T, Ulvinen T, Gulden G, Ryvarden L, Persson O, Strid A (1992) Nordic macromycetes, polyporales, boletales, agaricales, russulales, vol. 2. Nordsvamp, Copenhagen

Hansen O, Knudsen H, Dissing H, Ahti T, Ulvinen T, Gulden G, Ryvarden L, Persson O, Strid A (1997) Nordic macromycetes, heterobasidioid, aphyllophoroid and gastromycetoid Basidiomycetes, vol. 3. Nordsvamp, Copenhagen

Hansen O, Knudsen H, Dissing H, Ahti T, Ulvinen T, Gulden G, Ryvarden L, Persson O, Strid A (2000) Nordic macromycetes, ascomycetes, vol. 1. Nordsvamp, Copenhagen

Harmsen L (1953) *Merulius tignicola* Harmsen, eine neue Hausschwamm-Art in Dänemark. Holz Roh- Werkstoff 11:68–69

Harmsen L (1960) Taxonomic and cultural studies on brown spored species of the genus *Merulius*. Friesia 6:233–277

Harmsen L (1978) Draft of a monographic card for *Serpula himantioides* (Fr.) Karst. IRG/WP/174

Harmsen L, Bakshi BK, Choudhury TG (1958) Relationship between *Merulius lacrymans* and *M. himantioides*. Nature 4614:1011

Harrington TC, McNew D, Steimel J, Hofstra D, Farrell R (2001) Phylogeny and taxonomy of the *Ophiostoma piceae* complex and the Dutch elm disease fungi. Mycologia 91:111–136

Harrington TC, Wingfield BD (1995) A PCR-based identification method for species of *Armillaria*. Mycologia 87:280–288

Harris RW, Clark JR, Matheny NP (1999) Arboriculture. Integrated management of landscape trees, shrubs, and vines, 3rd edn. Prentice Hall, Englewood, NJ, USA

Hartford WH (1993) The environmental chemistry of chromium: science vs. U.S. law. IRG/WP/50014

Hartig R (1874) Wichtige Krankheiten der Waldbäume. Beiträge zur Mykologie und Phytopathologie für Botaniker und Forstmänner. Springer, Berlin Heidelberg New York

Hartig R (1878) Die Zersetzungserscheinungen des Holzes der Nadelbäume und der Eiche in forstlicher, botanischer und chemischer Richtung. Springer, Berlin Heidelberg New York

Hartig R (1882) Lehrbuch der Baumkrankheiten. Springer, Berlin Heidelberg New York

Hartig R (1885) Die Zerstörung des Bauholzes durch Pilze. Der ächte Hausschwamm. Springer, Berlin Heidelberg New York

Hartley C, Davidson RW, Crandall BS (1961) Wetwood, bacteria, and increased pH in trees. Forest Prod Lab Madison Rep 2215

Hartmann G, Nienhaus F, Butin H (1988) Farbatlas Waldschäden. Diagnose von Baumkrankheiten. Ulmer, Stuttgart

Haustrup ACS, Green F, Clausen C, Jensen B (2005) *Serpula lacrymans*, the dry rot fungus and tolerance towards copper-based wood preservatives. IRG/WP/10555

Hayashi N, Tokimatsu T, Hattori T, Shimada M (2000) An enzymatic study on an oxalate producing system in relation to the glyoxylate cycle in white-rot fungus *Phanerochaete chrysosporium*. Wood Res 87:15–16

Hedley M, Meder R (1992) Bacterial brown stain on sawn timber cut from water-stored logs. IRG/WP/1532

Hegarty B (1991) Factors affecting the fruiting of the dry rot fungus *Serpula lacrymans*. In: Jennings DH, Bravery AF (eds) *Serpula lacrymans*. Wiley, Chichester, pp. 39–53

Hegarty B, Buchwald G, Cymorek S, Willeitner H (1986) Der Echte Hausschwamm - immer noch ein Problem? Mater Org 21:87–99

Hegarty B, Schmitt U (1988) Basidiospore structure and germination of Serpula lacrymans and *Coniophora puteana*. IRG/WP/1340

Hegarty B, Schmitt U, Liese W (1987) Light and electronmicroscopical investigations on basidiospores of the dry rot fungus *Serpula lacrymans*. Mater Org 22:179–189

Hegarty B, Seehann G (1987) Influence of natural temperature variation on fruitbody formation by *Serpula lacrymans* (Wulfen:Fr.) Schroet. Mater Org 22:81–86

Heijden van der MGA, Sanders IR (eds) (2002) Mycorrhizal ecology. Ecol Stud 157, Springer, Berlin Heidelberg New York

Heiniger U (1999) Der Kastanienrindenkrebs (*Cryphonectria parasitica*). Schadsymptome und Biologie. Merkbl Prax 22, 2nd edn. Swiss Fed Inst For Snow Landscape Res Birmensdorf, Switzerland

Heiniger U (2003) Das Risiko eingeschleppter Krankheiten für die Waldbäume. Schweiz Z Forstwes 154:410–414

Heinsdorf D, Heydeck P (1998) Schäden an Kiefernstangenhölzern auf Kippsubstraten durch den Pilz *Heterobasidion annosum*. AFZ-DerWald 53:695–699

Heltay I (1999) "Mykotap" oder Mykofutter. Rückblick und weitere Entwicklung. Champignon 409:146

Heneen WK, Gustafsson M, Brismar K, Karlsson G (1994b) Interactions between Norway spruce (*Picea abies*) and *Heterobasidion annosum*. II. Infection of woody roots. Can J Bot 72:884–889

Heneen WK, Gustafsson M, Karlsson G, Brismar K (1994a) Interactions between Norway spruce (*Picea abies*) and *Heterobasidion annosum*. I. Infection of nonsuberized and young suberized roots. Can J Bot 72:872–883

Henningsson B (1967) The physiology, inter-relationship and effects on the wood of fungi which attack birch and aspen pulpwood. Swed Univ Agric Sci Dept Forest Prod Res Note 19

Henningsson BH, Henningsson M, Nilsson T (1972) Defibration of wood by a white-rot fungus. Roy Coll For Stockholm, Res Note 78

Henry WP (2003) Non-enzymatic iron, manganese, and copper chemistry of potential importance in wood decay. In: Goodell B, Nicholas DB, Schultz TP (eds) Wood deterioration and preservation. ACS Symp Ser 845, Am Chem Soc, Washington, DC, pp. 175–195

Hernández M, Hernández-Coronado MJ, Pérez MI, Revilla E, Villar JC, Ball AS, Viikari L, Arias ME (2005) Biomechanical pulping of spruce wood chips with *Streptomyces cyaneus* CECT 3335 and handsheet characterization. Holzforsch 59:173–177

Herrick FW, Hergert HL (1977) Utilization of chemicals from wood: retrospect and prospect. In: Loewus FA, Runeckles VC (eds) The structure, biosynthesis and degradation of wood. Plenum, New York, pp. 443–515

Heybroek HM (1982) Der stille Tod der Ulmen. Umschau 82:154–158

Heydeck P (1994) Krause Glucke. Wald 44:25

Heydeck P (1997) Kiefernbaumschwamm. AFZ-DerWald 52:776–777

Heydeck P (2000) Bedeutung des Wurzelschwammes im norddeutschen Tiefland. AFZ-DerWald 55:742–744

Hietela A, Eikenes M, Kvaalen H, Solheim H, Fossdal C (2003) Multiplex real-time PCR for monitoring *Heterobasidion annosum* colonization in Norway spruce clones that differ in disease resistance. Appl Environ Microbiol 69:4413–4420

Highley TL (1988) Cellulolytic activity of brown-rot and white-rot fungi on solid media. Holzforsch 42:211–216

Highley TL, Dashek WV (1998) Biotechnology in the study of brown- and white-rot decay. In: Bruce A, Palfreyman JW (eds) Forest products biotechnology. Taylor & Francis, London, pp. 15–36

Highley TL, Illman BL (1991) Progress in understanding how brown-rot fungi degrade cellulose. Biodet Abstr 5:231–244

Highley TL, Ricard J (1988) Antagonism of *Trichoderma* spp. and *Gliocladium virens* against wood decay fungi. Mater Org 23:157–169

Higuchi T (1990) Lignin biochemistry: Biosynthesis and biodegradation. Wood Sci Technol 24:23–63

Higuchi T (2002) Biochemistry of wood components: Biosynthesis and microbial degradation of lignin. Wood Res 89:43–51

Hilber O, Wüstenhöfer B (1992) Revitalisierung eines Fichtenbestandes durch Mykorrhizapilze. Allg Forstz 47:370–371

Hill CAS, Jones D, Strickland G, Cetin NS (1998) Kinetic and mechanic aspects of the acetylation of wood with acetic anhydride. Holzforsch 52:623–629

Hill CAS, Mastery Farahani MR, Hale MDC (2004) The use of organo alkoxysilane coupling agents for wood preservation. Holzforsch 58:316–325

Hillis WE (1977) Secondary changes in wood. Rec Adv Phytochem 11:247–309

Hintikka V (1982) The colonisation of litter and wood by basidiomycetes in Finnish forests. In: Frankland JC, Hedger JN, Swift MJ (eds) Decomposer basidiomycetes. Cambridge University Press, Cambridge, pp. 227–239

Hirai H, Itoh T, Nishida T (2003) In vitro reduction of manganese dioxide by a ferrireductase system from the white-rot fungus *Phaenerochaete sordida* YK-624. J Wood Sci 49:538–542

Hock B, Bartunek A (1984) Ektomykorrhiza. Naturwiss Rundschau 37:437–444

Hof T (1981a) *Gloeophyllum abietinum* (Bull. ex Fr.) Karst. In: Cockcroft R (ed) Some wood-destroying basidiomycetes. IRG/WP, Boroko, Papua New Guinea, pp. 55–66

Hof T (1981b) *Gloeophyllum sepiarium* (Wulf. ex Fr.) Karst. In: Cockcroft R (ed) Some wood-destroying basidiomycetes. IRG/WP, Boroko, Papua New Guinea, pp. 67–79

Hof T (1981c) *Gloeophyllum trabeum* (Pers. ex Fr) Murrill. In: Cockcroft R (ed) Some wood-destroying basidiomycetes. IRG/WP, Boroko, Papua New Guinea, pp. 81–94

Hoffmann P, Singh A, Kim YS, Wi SG, Kim I-J, Schmitt U (2004) The Bremen Cog of 1380 – An electron microscopic study of the degraded wood before and after stabilization with PEG. Holzforsch 58:211–218

Hofrichter M, Scheibner K, Bublitz F, Schneegaß I, Ziegenhagen D, Martens R, Fritsche W (1999) Depolymerization of straw lignin by manganese peroxidase from *Nematoloma frowardii* is accompanied by release of carbon dioxide. Holzforsch 53:161–166

Högberg N, Holdenrieder O, Stenlid J (1999) Population structure of the wood decay fungus *Fomitopsis pinicola*. Heredity 83:354–360

Högberg N, Land CJ (2004) Identification of *Serpula lacrymans* and other decay fungi in construction timber by sequencing of ribosomal DNA – a practical approach. Holzforsch 58:199–204

Holdenrieder O (1982) Kristallbildung bei Heterobasidion annosum (Fr.) Bref. (Fomes annosus P. Karst.) und anderen holzbewohnenden Pilzen. Eur J Forest Pathol 12:41–58

Holdenrieder O (1984) Untersuchungen zur biologischen Bekämpfung von Heterobasidion annosum an Fichte (Picea abies) mit antagonistischen Pilzen. II. Interaktionstests auf Holz. Eur J Forest Pathol 14:137–153

Holdenrieder O (1989) Heterobasidion annosum und Armillaria mellea s.l.: Aktuelle Forschungsansätze zu zwei alten forstpathologischen Problemem. Schweiz Z Forstwes 140:1055–1067

Holdenrieder O (1996) Der Hallimasch (Armillaria s.l.): Ein Beispiel für die Anwendung des biologischen Artkonzeptes in der Forstpathologie. Mycol Helvetica 8:91–93

Holdenrieder O, Engesser R, Sieber TN (1997) Biological control of Heterobasidion annosum with Phlebiopsis gigantea on Norway spruce in Switzerland. Poster 9th Conf Root Butt Rots, Carcans, France

Holdenrieder O, Greig BJW (1998) Biological methods of control. In: Woodward S, Stenlid J, Karjalainen R, Hüttermann A (eds) Heterobasidion annosum. CAB Int, Walligford, pp. 235–258

Hoog GS, Guarro J (eds) (1995) Atlas of clinical fungi. Centraalbureau Schimmelcultures, Barn

Horisawa S, Sakuma Y, Takata K, Doi S (2004) Detection of intra- and interspecific variation of the dry rot fungus Serpula lacrymans by PCR-RFLP and RAPD analysis. J Wood Sci 50:427–432

Höster HR (1974) Verfärbungen bei Buchenholz nach Wasserlagerung. Holz Roh- Werkstoff 52:270–277

Hübsch P (1991) Abteilung Ständerpilze, Basidiomycota. In: Benedix EH, Casper SJ, Danert S, Hübsch P, Lindner KE, Schmiedeknecht R, Senge W (eds) Urania-Pflanzenreich. Urania, Leipzig, pp. 469–568

Huckfeldt T (2002) Hausfäulepilze – Hausschwamm, Kellerschwamm, Porenschwamm. www.hausschwaminfo.de

Huckfeldt T (2003) Ökologie und Cytologie des Echten Hausschwammes (Serpula lacrymans) und anderer Hausfäulepilze. Doct Thesis, Univ Hamburg and Mittlg Bundesforschungsanst Forst-Holzwirtsch 213

Huckfeldt T, Kleist G, Quader H (2000) Vitalitätsansprache des Hausschwammes (Serpula lacrymans) und anderer holzzerstörender Gebäudepilze. Z Mykol 66:35–44

Huckfeldt T, Schmidt O (2004) Schlüssel für Strang bildende Hausfäulepilze. Z. Mykol 70:85–96

Huckfeldt T, Schmidt O (2005) Hausfäule- und Bauholzpilze. Rudolf Müller, Köln

Huckfeldt T, Schmidt O (2006) Identification key for European strand-forming house-rot fungi. Mycologist (in press)

Huckfeldt T, Schmidt O, Quader H (2005) Ökologische Untersuchungen am Echten Hausschwamm und weiteren Hausfäulepilzen. Holz Roh-Werkstoff 63:209–219

Huckfeldt, T, Hechler J (2005) Cerinomyxes pallidus Martin: Erstfund für Deutschland. Z Mykol 70:97–105

Hulme MA, Shields JK (1975) Antagonistic and synergistic effects for biological control of decay. In: Liese W (ed) Biological transformation of wood by microorganisms. Springer, Berlin Heidelberg New York, pp. 52–63

Humar M, Petrič M, Pohleven F (2001) Changes of the pH value of impregnated wood during exposure to wood-rotting fungi. Holz Roh-Werkstoff 59:288–293

Humar M, Petrič M, Pohleven F, Šentjurc M, Kalan P (2002) Changes in EPR spectra of wood impregnated with copper-based preservatives during exposure to several wood-rotting fungi. Holzforsch 56:229–238

Humar M, Pohleven F, Amartey S, Šentjurc M (2004) Efficacy of CCA and Tanalith E treated pine fence to fungal decay after ten years in service. Wood Res 49:13–20

Humar M, Pohleven F, Šentjurc M, Veber M, Razpotnik P, Pogni R, Petrič M (2003) Performance of waterborne Cu(II) octanoate/ethanolamine wood preservatives. Holzforsch 57:127–134

Humphrey CJ, Siggers PV (1933) Temperature relations of wood-destroying fungi. J Agricult Res 47:997–1008

Hunt C, Kenealy W, Horn E, Houtman C (2004) A biopulping mechanism: creation of acid groups on fiber. Holzforsch 58:434–439

Hunt RS, Ekramoddoullah AKM, Zamani A (1999) Production of a polyclonal antibody to *Phellinus pini* and examination of its potential use in diagnostic assays. Eur J Forest Pathol 29:259–272

Hüttermann A (1991) Richard Falck, his life and work. In: Jennings DH, Bravery AF (eds) *Serpula lacrymans*. Wiley, Chichester, pp. 193–206

Hyde SM, Wood PM (1997) A mechanism for production of hydroxyl radicals by the brown-rot fungus *Coniophora puteana*: Fe(III) reduction by cellobiose dehydrogenase and Fe(II) oxidation at a distance from the hyphae. Microbiol 143:259–266

Iimori T, Miyawaki S, Machida M, Murakami K (1998) Biobleaching of unbleached and oxygen-bleached hardwood kraft pulp by culture filtrate containing manganese peroxidase and lignin peroxidase from *Phanerochaete chrysosporium*. J Wood Sci 44:451–456

Iiyoshi Y, Tsutsumi Y, Nishida T (1998) Polyethylene degradation by lignin-degrading fungi and manganese peroxidase. J Wood Res 44:222–229

Imai T, Sato M, Takaku N, Kawai S, Ohashi H, Nomura M, Kushi M (2005) Characterization of physiological functions of sapwood. IV: Formation and accumulation of lignans in sapwood of *Cryptomeria japonica* (L.f.) D. Don after felling. Holzforsch 59:418–421

Irie T, Honda Y, Ha H-C, Watanabe T, Kuwahara M (2000) Isolation of cDNA and genomic fragments encoding the major manganese peroxidase isozyme from the white rot basidiomycete *Pleurotus ostreatus*. J Wood Sci 46:230–233

Isik F, Li B (2003) Rapid assessment of wood density of live trees using the Resistograph for selection in tree improvement programs. Can J Bot 33:2426–2435

Jacobson KM, Miller OK, Turner BJ (1993) Randomly amplified polymorphic DNA markers are superior to somatic incompatibility tests for discriminating genotypes in natural populations of the ectomycorrhizal fungus *Suillus granulatus*. Proc Nat Acad Sci USA 90:9159–9163

Jacquiot C (1981) Coriolus versicolor (L. ex Fr.) Quél. In: Cockcroft R (ed) Some wood-destroying basidiomycetes. IRG/WP, Boroko, Papua New Guinea, pp. 27–37

Jagadeesh G, Lal R, Ravikumar G, Rao KS (2005) Shockwaves in wood preservation. IRG/WP/40308

Jahn H (1990) Pilze an Bäumen. Patzer, Berlin

Jakob H, Del Grosso M, Küver A, Nimmerfroh N, Süss U (1999) Delignifizierung von Zellstoff mit Laccase und Mediator – ein Konzept mit Zukunft? Papier 2:85–95

Janotta O (1995) 15 Jahre bautechnische Endoskopie – zerstörungsfreie Untersuchung von Holzdecken. Holzforsch Holzverwert 6:110–112

Jarosch M, Besl H (2001) *Leucogyrophana*, a polyphyletic genus of the order Boletales (Basidiomycetes). Plant Biol 3:443–448

Jasalavich CA, Ostrofsky A, Jellison J (1998) Detection of wood decay fungi in wood using a PCR-based assay. IRG/WP/10279

Jeffries TW (1994) Biodegradation of lignin and hemicelluloses. In: Ratledge C (ed) Biochemistry of microbial degradation. Kluwer, Dordrecht, pp. 233–277

Jellison J, Chen Y, Fekete FA (1997) Hyphal sheath and iron-binding compound formation in liquid cultures of wood decay fungi *Gloeophyllum trabeum* and *Postia placenta*. Holzforsch 51:503–510

Jellison J, Goodell B (1988) Immunological detection of decay in wood. Wood Sci Technol 22:293–297

Jellison J, Howell C, Goodell B, Quarles SL (2004) Investigations into the biology of *Meruliporia incrassata*. IRG/WP/10508

Jellison J, Jasalavich C, Ostrofsky A (2003) Detecting and identifying wood decay fungi using DNA analysis. In: Goodell B, Nicholas DB, Schultz TP (eds) Wood deterioration and preservation. ACS Symp Ser 845, Am Chem Soc, Washington, DC, pp. 346–357

Jennings DH (1987) Translocation of solutes in fungi. Biol Rev 62:215–243

Jennings DH (1991) The physiology and biochemistry of the vegetative mycelium. In: Jennings DH, Bravery AF (eds) *Serpula lacrymans*. Wiley, Chichester, pp. 55–79

Jennings DH, Bravery AF (eds) (1991) *Serpula lacrymans*: Fundamental biology and control strategies. Wiley, Chichester

Jennings DH, Lysek G (1999) Fungal biology, 2nd edn. Bios, Oxford

Jensen FK (1969) Oxygen and carbon dioxide concentrations in sound and decaying red oak trees. Forest Sci 59:246–251

Johannesson H, Stenlid J (1998) Molecular identification of wood-inhabiting fungi in an unmanaged *Picea abies* forest in Sweden. Forest Ecol Manage 4525:1–9

Johnson BR, Chen GC (1983) Occurrence and inhibition of chitin in cell walls of wood-decay fungi. Holzforsch 37:255–259

Johnson GC, Thornton JD (1991) An in-ground natural durability field test of Australian timbers and exotic reference species. VII. Incidence of white, brown and soft rot in hardwood stakes after 19 and 21 years' exposure. Mater Org 26:183–190

Johnsrud SC (1988) Selection and screening of white-rot fungi for delignification and upgrading of lignocellulosic materials. In: Zadražil F, Reiniger P (eds) Treatment of lignocellulosics with white-rot fungi. Elsevier Appl Sci, London, pp. 50–55

Jones EBG (1982) Decomposition by basidiomycetes in aquatic environments. In: Frankland JC, Hedger JN, Swift MJ (eds) Decomposer basidiomycetes. Cambridge University Press, Cambridge, pp. 191–212

Jones EBG, Irvine J (1971) The role of fungi in the deterioration of wood in the sea. J Inst Wood Sci 5:31–40

Jones EBG, Turner RD, Furtado SEJ, Kühne H (1976) Marine biodeteriogenic organisms. I. Lignicolous fungi and bacteria, and the wood boring molluscs and crustacea. Int Biodetn Bull 12:120–134

Jones H, Worrall J (1995) Fungal biomass in decayed wood. Mycologia 87:459–466

Jonsson T, Kokalj S, Finlay R, Erland S (1999) Ectomycorrhizal community structure in a limed spruce stand. Mycol Res 103:501–508

Jordan CR, Dashek WW, Highley TL (1996) Detection and quantification of oxalic acid from the brown-rot decay fungus *Postia placenta*. Holzforsch 50:312–318

Jülich W (1984) Basidiomyceten 1. Teil. Die Nichtblätterpilze, Gallertpilze und Bauchpilze (Aphyllophorales, Heterobasidiomycetes, Gastromycetes). In: Gams H (ed) Kleine Kryptogamenflora, vol. 2b/1. Fischer, Stuttgart

Jülich W, Stalpers J (1980) The resupinate non-poroid Aphyllophorales of the temperate northern hemisphere. Verhandl königl niederl Akad Wissensch, North-Holland Publ, Amsterdam

Jung T, Blaschke M (2005) *Phytophthora* an Waldbäumen. AFZ-DerWald 60:394–396

Jüngel P, DeKoning S, Brinkman UAT, Melcher E (2002) Analyses of wood preservative component *N*-cyclohexyl-diazeniumdioxide in impregnated pine sapwood by direct thermal desorption-gas chromatography-mass spectrometry. J Chromatogr A 953:199–205

Jürgens M (2004) MALDI-TOF/TOF-MS: Schlüsseltechnologie für die Proteinanalytik. Bioforum 9:52

Käärik A (1965) The identification of the mycelia of wood-decay fungi by their oxidation reactions with phenolic compounds. Stud Forest Suec 31

Käärik A (1975) Succession of microorganisms during wood decay. In: Liese W (ed) Biological transformation of wood by microorganisms. Springer, Berlin Heidelberg New York, pp. 39–51

Käärik A (1978) Valid names for some common decay fungi, their synonyms and vernacular names. IRG/WP/172

Käärik A (1980) Fungi causing sap stain in wood. Swed Univ Agric Sci Dept Forest Prod 114

Käärik A (1981) *Coniophora puteana* (Schum. ex Fr.) Karst. In: Cockcroft R (ed) Some wood-destroying basidiomycetes. IRG/WP, Boroko, Papua New Guinea, pp. 11–21

Kaestner A, Niemz P (2004) Non-destructive methods to detect decay in trees. Wood Res 49:17–28

Kajita S, Honaga F, Uesugi M, Iimura Y, Masai E, Kawai S, Fukuda M, Morohoshi N, Katayama Y (2004) Generation of transgenic hybrid aspen that express a bacterial gene for feruloyl-CoA hydratase/lyase (*FerB*), which is involved in lignin degradation in *Sphingomonas paucimobilis* SYK-6. J Wood Sci 50:275–280

Kalberer P (1999) Pilzforschung in der Schweiz. Champignon 410:197–199

Kamdem DP, Pizzi A, Triboult MC (2000) Heat-treated timber: potentially toxic byproduct presence and extent of wood cell wall degradation. Holz Roh- Werkstoff 58:253–257

Kamitsuji H, Honda Y, Watanabe T, Kuwahara M (1999) Studies on the production of manganese peroxidase by the white-rot fungus *Pleurotus ostreatus*. Wood Res 86:41–42

Kappen L (1993) Flechten. Algen als Partner oder als Opfer. Naturwiss Rundschau 46:260–267

Karjalainen R (1996) Genetic relatedness among strains of *Heterobasidion annosum* as detected by random amplified polymorphic DNA markers. J Phytopath 144:399–404

Karlsson J-O, Stenlid J (1991) Pectic isozyme profiles of intersterility groups in *Heterobasidion annosum*. Mycol Res 95:531–536

Karnop G (1972a) Morphologie, Physiologie und Schadbild der Nicht-Cellulose-Bakterien aus wasserlagerndem Nadelholz. Mater Org 7:119–132

Karnop G (1972b) Celluloseabbau und Schadbild an einzelnen Holzkomponenten durch Clostridium omelianskii in wasserlagerndem Nadelholz. Mater Org 7:189–203

Karstedt P, Liese W, Willeitner H (1971) Untersuchungen zur Verhütung von Transportschäden bei anfälligen Tropenhölzern. Holz Roh-Werkstoff 29:409–415

Kartal SN, Hwang W-J, Imamura Y (2005b) Preliminary evaluation of new quaternary ammonia compound, dedecyl dimethyl ammonium tetrafluoroborate for preventing fungal decay and termite attack. IRG/WP/30375

Kartal SN, Imamura Y (2003) Chemical and biological remediation of CCA-treated waste wood. Wood Res 90:111–115

Kartal SN, Imamura Y (2005) Remediation of CCA-treated wood by chitin and chitosan. IRG/WP/50229

Kartal SN, Munir E, Kakitani T, Imamura Y (2004) Bioremediation of CCA-treated wood by brown-rot fungi *Fomitopsis palustris*, *Coniophora puteana* and *Laetiporus sulphureus*. J Wood Sci 50:182–188

Kartal SN, Shinoda K, Imamura Y (2005a) Laboratory evaluation of boron-containing quaternary ammonia compound, didecyl dimethyl ammonium tetrafluoroborate (DBF) for inhibition of mold and stain fungi. Holz Roh- Werkstoff 63:73–77

Kasuga T, Mitchelson KR (2000) Intersterility group differentiation in *Heterobasidion annosum* using ribosomal IGS1 region polymorphism. Forest Pathol 30:329–344

Katayama S, Watanabe T, Enoki M, Sato S, Honda Y, Kuwahara M (2000) Mn(III)-dependent breakdown of 13(s)-hydroxy-9Z, 11E-octadecadienoic acid: a key free radical reaction in lipid peroxidation of linoleic acid by manganese peroxidase. Wood Res 87:23–24

Kauserud H (2004) Widespread vegetative compatibility groups in the dry rot fungus *Serpula lacrymans*. Mycologia 96:232–239

Kauserud H, Högberg N, Knudsen H, Elbornes SA, Schumacher T (2004b) Molecular phylogenetics suggest a North American link between the anthropogenic dry rot fungus *Serpula lacrymans* and its wild relative *S. himantioides*. Molec Ecol 13:3137–3146

Kauserud H, Schmidt O, Elfstrand M, Högberg N (2004a) Extremely low AFLP variation in the European dry rot fungus (*Serpula lacrymans*): implications for self/nonself-recognition. Mycol Res 108:1264–1270

Kauserud H, Schumacher T (2002) Population structure of the endangered wood decay fungus *Phellinus nigrolimitatus* (Basidiomycota). Can J Bot 80:597–606

Kauserud H, Schumacher T (2003) Ribosomal DNA variation, recombination and inheritance in the basidiomycete *Trichaptum abietinum*: implications for reticulate evolution. Heredity 91:163–172

Kawchuk LM, Hutchinson LJ, Reid J (1993) Stimulation of growth, sporulation, and potential staining capability in *Ceratocystiopsis falcata*. Eur J Forest Pathol 23:178–181

Kehr RD, Wulf A (1993) Fungi associated with above-ground portions of declining oaks (*Quercus robur*) in Germany. Eur J Forest Pathol 23:18–27

Keilisch G, Bailey P, Liese W (1970) Enzymatic degradation of cellulose, cellulose derivatives and hemicelluloses in relation to the fungal decay of wood. Wood Sci Technol 4:273–283

Keller R (2002) Mikrobielle Sekundärmetabolite aus Schimmelpilzen – Nachweis und Bewertung. In: Keller R, Senkpiel K, Samson RA, Hoekstra ES (eds) Umgebungsanalyse bei gesundheitlichen Beschwerden durch mikrobielle Belastungen in Innenräumen. Schriftenr Inst Medizin Mikrobiol Hygiene Univ Lübeck 6, pp. 193–240

Keller R, Senkpiel K, Butte W (2005) MVOC-Referenzwerte in unbelasteten Wohnungen für einen Beobachtungszeitraum von 12 Monaten. In: Keller R, Senkpiel K, Samson RA, Hoekstra ES (eds) Mikrobielle allergische und toxische Verbindungen. Schriftenr Inst Medizin Mikrobiol Hygiene Univ Lübeck 9, pp. 145–161

Keller R, Senkpiel K, Samson RA, Hoekstra ES (2004) Erfassung biogener und chemischer Schadstoff des Innenraumes und die Bewertung umweltbezogener Gesundheitsrisiken. Schriftenr Inst Medizin Mikrobiol Hygiene Univ Lübeck 8

Kempe K (2003) Holzschädlinge. Vermeiden, Erkennen, Bekämpfen, 3rd edn. DRW, Leinfelden Echterdingen

Kenealy WR, Jeffries TW (2003) Enzyme processes for pulp and paper: a review of recent developments. In: Goodell B, Nicholas DB, Schultz TP (eds) Wood deterioration and preservation. ACS Symp Ser 845, Am Chem Soc, Washington, DC, pp. 210–239

Kern V, Monzer J, Dressel K (1991) Einfluß der Schwerkraft auf die Fruchtkörperentwicklung von Pilzen. Heraeus Instruments 2: 2 pp

Kern VD (1994) Fruchtkörperentwicklung, Gravimorphogenese und Gravitropismus des Basidiomyceten *Flammulina velutipes*. Doct Thesis Techn University München

Kern VD, Hock B (1996) Gravitropismus bei Pilzen. Naturwiss Rundschau 49:174–180

Kerner-Gang W, Nirenberg HI (1980) Isolierung von Pilzen aus beschädigten, langfristig gelagerten Büchern. Mater Org 15:225–233

Kerner-Gang W, Schneider R (1969) Von optischen Gläsern isolierte Schimmelpilze. Mater Org 4:281–296

Kerr AJ, Goring DAI (1975) The ultrastructural arrangement of the wood cell wall. Cellul Chem Technol 9:563–573

Kerruish RM, Da Costa EWB (1963) Monocaryotization of cultures of *Lenzites trabea* (Pers.) Fr. and other wood-destroying basidiomycetes by chemical agents. Ann Bot 27:653–670

Keyserlingk van H (1982) Die Ulmenkrankheit und der Borkenkäfer. Ansatzpunkte zur Schadensminderung. Forschung Mittlg DFG 4:12–14

Kharazipour A, Hüttermann A (1998) Biotechnological production of wood composites. In: Bruce A, Palfreyman JW (eds) Forest products biotechnology. Taylor & Francis, London, pp. 141–150

Kiffer E, Morelet M (2000) The Deuteromycetes. Mitosporic fungi. Classification and generic keys. Science Publ, Enfield, NH, USA

Kile GA, Watling R (1983) Armillaria species from South Eastern Australia. Trans Br Mycol Soc 81:129–140

Kim G-H, Lim YW, Song Y-S, Kim J-J (2005) Decay fungi from playground wood products in service using 28S rDNA sequence analysis. Holzforsch 59:459–466

Kim G-H, Ra J-B, Kong I-G, Song Y-S (2004) Optimization of hydrogen peroxide extraction conditions for CCA removal from treated wood by response surface methodology. Forest Prod J 54:141–144

Kim M-S, Klopfenstein NB, McDonald GI, Arumuganathan K, Vidaver AK (2001) Use of flow cytometry, fluorescence microscopy, and PCR-based techniques to assess intraspecific and interspecific matings of Armillaria species. Mycol Res 105:153–163

Kim YS (1991) Immunolocalization of extracellular fungal metabolites from Tyromyces palustris. IRG/WP/1491

Kim YS, Choi JH, Bae HJ (1992) Ultrastructural localization of extracellular fungal metabolites from Tyromyces palustris using TEM and immunogold labelling. Mokuzai Gakkaishi 38:490–494

Kim YS, Goodell B, Jellison J (1991a) Immuno-electron microscopic localization of extracellular metabolites in spruce wood decayed by brown-rot fungus Postia placenta. Holzforsch 45:389–393

Kim YS, Goodell B, Jellison J (1993) Immunogold labelling of extracellular metabolites from the white-rot fungus Trametes versicolor. Holzforsch 47:25–28

Kim YS, Jellison J, Goodell B, Tracy V, Chandhoke V (1991b) The use of ELISA for the detection of white- and brown-rot fungi. Holzforsch 45:403–406

Kim YS, Singh AP (1999) Micromorphological characteristics of compression wood degradation in waterlogged archaeological pine wood. Holzforsch 53:381–385

Kim YS, Singh AP (2000) Micromorphological characteristics of wood biodegradation in wet environments: a review. IAWA J 2:135–155

Kirisits T, Krumböck S, Konrad H, Pennerstorfer J, Halmschlager E (2001) Untersuchungen über das Auftreten der Erreger der Holländischen Ulmenwelke in Österreich. Forstw Cbl 120:231–241

Kirk TK (1985) The discovery and promise of lignin-degrading enzymes. Symp Proc 2 Marcus Wallenberg Found, pp. 27–42

Kirk TK (1988) Lignin degradation by Phanerochaete chrysosporium. ISI Atlas Sci, Biochem 1:71–76

Kirk TK, Koning JW, Burgess RR, Akhtar M, Blanchette RA, Cameron DC, Cullen D, Kersten PJ, Lightfoot EN, Myers GC, Sachs I, Sykes M, Beth Wall M (1993) Biopulping. A glimpse of the future? USDA Forest Serv Res Pap FPL-RP-523

Kirk TK, Tien M (1986) Lignin degrading activity of Phanerochate chrysosporium Burds.: comparison of cellulose-negative and other strains. Enzyme Microb Technol 8:75–80

Kjerulf-Jensen C, Koch AP (1992) Investigation of microwave heating as a means of eradicating dry rot attack in buildings. IRG/WP/1545

Klahre J, Lustenberger M, Flemming H-C (1996) Mikrobielle Probleme in der Paperfabrikation. Teil1 1: Schäden, Ursachen, Kosten, Grundlagen. Papier 50:47–53

Klein E (1991) Wunden, Naßkern und Baumsterben am Beispiel der Weißtanne (Abies alba Mill.). Holz-Zbl 117:2318–2326

Klein-Gebbinck HW, Blenis PV (1991) Spread of *Armillaria ostoyae* in juvenile lodgepole pine stands in west central Alberta. Can J Forest Res 21:20–24

Kleist G (2001) Rotstreifigkeit im Fichtenholz – ein Pilzschaden und seine Ursachen. Z Mykol 67:213–224

Kleist G (2005) Vorbeugender chemischer Holzschutz. In: Müller J (ed) Holzschutz im Hochbau. Fraunhofer IRB, Stuttgart, pp. 234–264

Kleist G, Schmitt U (2001) Characterization of soft rot-like decay pattern caused by brown-rot fungus *Coniophora puteana* (Schum.) Karst. in Sapelli wood (*Entandrophragma cylindricum* Sprague). Holzforsch 55:573–578

Kleist G, Seehann G (1997) Colonization patterns and topochemical aspects of sap streak in Norway spruce caused by *Stereum sanguinolentum*. Eur J Forest Pathol 27:351–361

Kleist G, Seehann G (1999) Der Eichenporling, *Donkioporia expansa* – ein wenig bekannter Holzzerstörer in Gebäuden. Z Mykol 65:23–32

Klepzig KD, Smalley EB, Raffa KF (1996) Interactions of ecologically similar saprogenic fungi with healthy and abiotically stressed conifers. Forest Ecol Managem 3777: 7 pp

Knigge H (1985) Struktur und Topochemie der Tüpfelmembranen und der Thyllen von Laubhölzern und Möglichkeiten ihrer enzymatischen Veränderung zur Verbesserung der Wegsamkeit. Doct Thesis Univ Hamburg

Knutson DM (1973) The bacteria, wetwood, and heartwood of trembling aspen (*Populus tremuloides*). Can J Bot 51:498–500

Koch AP (1990) Occurrence, prevention and repair of Dry Rot. IRG/WP/1439

Koch AP (1991) The current status of dry rot in Denmark and control strategies. In: Jennings DH, Bravery AF (eds) *Serpula lacrymans*. Wiley, Chichester, pp. 147–154

Koch AP, Kjerulf-Jensen C, Madsen B (1989) New experiments with the dry rot fungus in Danish buildings, heat treatment and viability tests. IRG/WP/1423

Koch G (2004) Biologische und chemische Untersuchungen über die Inhaltsstoffe im Holzgewebe von Buche (*Fagus sylvatica* L.) und Kirschbaum (*Prunus serotina* Borkh.) und deren Bedeutung für Holzverfärbungen. Mittlg Bundesforschungsanst Forst-Holzwirtsch Hamburg 216

Koch G, Bauch J, Puls J, Welling J (2002) Ursachen und wirtschaftliche Bedeutung von Holzverfärbungen. Allg Forstz 57:315–318

Koch G, Kleist G (2001) Application of scanning UV microspectrophotometry to localise lignins and phenolic extractives in plant cell walls. Holzforsch 55:563–567

Koch P (1985) Wood decay in Danish buildings. IRG/WP/1261

Koenigs JW (1974) Hydrogen peroxide and iron: a proposed system for decomposition of wood by brown-rot basidiomycetes. Wood Fiber 6:66–80

Kofugita H, Mastushita A, Ohsaki T, Asada Y, Kuwahara M (1992) Production of phenol oxidizing enzyme in wood-meal medium by white-rot fungi. Mokuzai Gakkaishi 38:950–955

Kohlmeyer J (1959) Neufunde holzbesiedelnder Meerespilze. Nova Hedwigia 1:77–98

Kohlmeyer J (1977) New genera and species of higher fungi from the deep sea (1615–5315 m). Rev Mycol 41:189–206

Kollmann F (1987) Poren und Porigkeit in Hölzern. Holz Roh-Werkstoff 45:1–9

Korhonen K (1978a) Intersterility groups of *Heterobasidion annosum*. Commun Inst Forest Fenn 94

Korhonen K (1978b) Interfertility and clonal size in the *Armillaria mellea* complex. Karstenia 18:31–42

Korhonen K, Bobko I, Hanso S, Piri T, Vasiliaukas A (1992) Intersterility groups of *Heterobasidion annosum* in some spruce and pine stands in Byelorussia, Lithuania and Estonia. Eur J Forest Pathol 22:384–391

Korhonen K, Holdenrieder O (2005) Recent advances in research on the root rot fungus *Heterobasidion annosum* s.l. A literature review. Forst Holz 60:206–211

Körner I, Faix O, Wienhaus O (1992) Versuche zur Bestimmung des Braunfäule-Abbaus von Kiefernholz mit Hilfe der FTIR-Spektroskopie. Holz Roh-Werkstoff 50:363–367

Körner I, Kühne G, Pecina H (2001) Unsterile Fermentation von Hackschnitzeln – eine Holzvorbehandlungsmethode für die Faserplattenherstellung. Holz- Roh Werkstoff 59:334–341

Korotaev AA (1991) Untersuchungen zur künstlichen Mykorrhizabildung der Fichtensämlinge. Forstarch 62:182–184

Korpi A, Pasanen AL, Viitanen H (1999) Volatile metabolites of *Serpula lacrymans, Coniophora puteana, Poria placenta, Stachybotrys chartarum* and *Chaetomium globosum*. Building Environ 34:205–211

Koshijima T, Watanabe T (2003) Association between lignin and carbohydrates in wood and other plant tissues. Springer, Berlin Heidelberg New York

Kottke I, Oberwinkler F (1986) Mycorrhiza of forest trees – structure and function. Trees 1:1–24

Krahmer RL, Morrell JJ, Choi A (1986) Double-staining to improve visualisation of wood decay hyphae in wood sections. IAWA Bull ns 7:165–167

Krajewski KJ, Ważny J (1992a) Airborne algae as wood degradation factor. IRG/WP/1549

Krajewski KJ, Ważny J (1992b) Die Struktur von mit aerophyten Algen infiziertem Holz. Holz Roh-Werkstoff 50:256

Kramer CL (1982) Production, release and dispersal of basidiospores. In: Frankland JC, Hedger JN, Swift MJ (eds) Decomposer basidiomycetes. Cambridge University Press, Cambridge, pp. 33–49

Kreber B, Byrne A (1994) Discolorations of hem-fir wood: a review of the mechanisms. Forest Prod J 44:35–42

Kreber B, Morrell JJ (1993) Ability of selected bacterial and fungal bioprotectants to limit fungal stain in ponderosa pine sapwood. Wood Fiber Sci 25:23–34

Kreisel H (1961) Die phytopathogenen Großpilze Deutschlands. Fischer, Jena

Kreisel H (1969) Grundzüge eines natürlichen Systems der Pilze. Fischer, Jena

Krieglsteiner GJ (1991) Verbreitungsatlas der Großpilze in Deutschland (West), vol. 1A. Ulmer, Stuttgart

Krieglsteiner GJ (2000) Die Großpilze Baden-Württembergs. vol. 1, Ulmer, Stuttgart

Kruså M, Henriksson G, Johansson G, Reitberger T, Lennholm H (2005) Oxidative cellulose degradation by cellobiose dehydrogenase from *Phanerochaete chrysosporium*: a model compound study. Holzforsch 59:263–268

Kruse K, Langensiepen P, Plaschkies K, Scheiding W, Weiß B (2004) Schimmelpilzbeständigkeit von Bau- und Holzwerkstoffen. Holz-Zbl. 130:186

Kučera LJ (1986) Kernspintomographie und elektrische Widerstandsmessung als Diagnosemethoden der Vitalität erkrankter Baume. Schweiz Z Forstwesen 137:673–690

Kučera LJ (1990) Der Naßkern, besonders bei der Weißtanne. Schweiz Z Forstwesen 141:892–908

Kull U (2004) Endophytische Pilze als Schutz vor Pathogenen. Naturwiss Rundschau 57:449

Kutscheidt J (1992) Schutzwirkung von Mykorrhizapilzen gegenüber Hallimaschbefall. Allg Forstz 47:381–383

Kutscheidt J, Dergham Y (1997) Einsatz von Mykorrhizapilzen. Champignon 396:72–75

Lackner R, Srebotnik E, Messner K (1991) Secretion of ligninolytic enzymes by hyphal autolysis of the white rot fungus *Phanerochaete chrysosporium*. IRG/WP/1480

LaFlamme G (1994) Annosus root rot caused by *Heterobasidion annosum*. Nat Res Canada, Can Forest Service Quebec Region, Inform Leafl 27

Laks PE, Park CG, Richter DL (1993) Anti-sapstain efficacy of borates against *Aureobasidium pullulans*. Forest Prod J 43:33–34

Landi L, Staccioli G (1992) Acidity of wood and bark. Holz Roh-Werkstoff 50:238

Langendorf G (1961) Handbuch für den Holzschutz. Fachbuchverl, Leipzig

Lark N, Xia Y, Qin C-G, Gong CS, Tsao GT (1997) Production of ethanol from recycled paper sludge using cellulase and yeast, *Kluyveromyces marxianus*. Biomass Bioenergy 12:135–143

Larsen MJ, Rentmeester RM (1992) Valid names for some common decay fungi and their synonyms. IRG/WP/1522

Larsson B, Bengtsson B, Gustafsson M (2004) Nondestructive detection of decay in living trees. Tree Physiol 24:853–858

Larsson Brelid P, Simonson R, Bergman Ö, Nilsson T (2000) Resistance of acetylated wood to biological degradation. Holz Roh-Werkstoff 58:331–337

Leatham GF (1982) Cultivation of shii-take, the Japanese forest mushroom, on logs: a potential industry for the United States. Forest Prod J 32:329–358

Leatham GF (1983) A chemically defined medium for fruiting of *Lentinus edodes*. Mycologia 75:905–908

Lederer W, Seemüller S (1991) Occurrence of mycoplasma-like organisms in diseased and non-symptomic alder trees (Alnus spp.). Eur J Forest Pathol 21:90–96

Lee J-S, Furukawa I, Tomoyasu S (1993) Preservative effectiveness against *Tyromyces palustris* in wood after pre-treatment with chitosan and impregnation with chromated copper arsenate. Mokuzai Gakkaishi 39:103–108

Lee KH, Wi SG, Singh AP, Kim YS (2004) Micromorphological characteristics of decayed wood and laccase produced by the brown-rot fungus *Coniophora puteana*. J Wood Sci 50:281–284

Lee S, Kim SH, Breuil C (2002) The use of a green fluorescent protein as a biomarker for sapstain fungi. Forest Pathol 32:153–161

Leightley LE, Eaton RA (1980) Micromorphology of wood decay by marine microorganisms. Biodetn Proc 4th Int Symp Berlin 1978. Pitman, London, pp. 83–88

Leiße B (1992) Holzschutzmittel im Einsatz: Bestandteile, Anwendungen und Umweltbelastungen. Bauverlag, Wiesbaden

Leithoff H (1997) Möglichkeiten und Grenzen der Überführung eines biologischen Reinigungsverfahrens für schutzsalzgetränkte Hölzer in den Technikumsmaßstab. Doct Thesis Univ Hamburg

Leithoff H, Peek R-D (1998) Hitzebehandlung – eine Alternative zum chemischen Holzschutz? 21st Holzschutztagung, Dtsch Ges Holzforsch, pp. 97–105

Leithoff H, Stephan I, Lenz MT, Peek R-D (1995) Growth of the copper tolerant brown rot fungus Antrodia vaillantii on different substrates. IRG/WP/10121

Lelley J (1991) Pilzbau. Biotechnologie der Kulturspeisepilze. Ulmer, Stuttgart

Lelley J (1992) Erfahrungen aus der Versuchsanstalt in Krefeld. Problematik und Perspektiven der angewandten Mykorrhizaforschung. Allg Forstz 47:368–369

Lenz O, Oswald K (1971) Über Schäden durch Bohrspanentnahme an Fichte, Tanne und Buche. Mittlg Schweiz Anst Forstl Versuchswes 47

Leonowicz A, Rogalski J, Jaszek M, Luterek J, Wojtas-Wasilewska M, Malarczyk E, Ginalska G, Fink-Boots M, Cho N-S (1999) Cooperation of fungal laccase and glucose 1-oxidase in transformation of Björkman lignin and some phenolic compounds. Holzforsch 53:376–380

Leslie H, Morton G, Eggins HOW (1976) Studies of interactions between wood-inhabiting microfungi. Mater Org 11:197–214

Leslie JF, Leonard TJ (1979) Three independent genetic systems that control initiation of a fungal fruiting body. Molec Gen Genet 171:257–260

Levy JF (1966) The soft-rot fungi and their mode of entry into wood and woody cell walls. Suppl 1 Mater Org, pp. 55–60

Levy JF (1975a) Colonization of wood by fungi. In: Liese W (ed) Biological transformation of wood by microorganisms. Springer, Berlin Heidelberg New York, pp. 16–23

Levy JF (1975b) Bacteria associated with wood in ground contact. In: Liese W (ed) Biological transformation of wood by microorganisms. Springer, Berlin Heidelberg New York, pp. 64–73

Lewis PK (1976) The possible significance of the hemicelluloses in wood decay. Suppl 3 Mater Org, pp. 113–119

Li CY (1981) Phenoloxidase and peroxidase activities in zone lines of *Phellinus weirii*. Mycologia 73:811–821

Li K (2003) The role of enzymes and mediators in white-rot fungal degradation of lignocellulose. In: Goodell B, Nicholas DB, Schultz TP (eds) Wood deterioration and preservation. ACS Symp Ser 845, Am Chem Soc, Washington, DC, pp. 196–209

Li XL, Eriksson LA (2005) Molecular dynamics study of lignin constituents in water. Holzforsch 59:253–262

Liang ZR, Chang ST (1989) A study on intergeneric hybridization between *Pleurotus sajorcaju* and *Schizophyllum commune* by protoplast fusion. Mushroom Sci 12(I):125–137

Liese J (1934) Über die Möglichkeit einer Pilzzucht im Walde. Dtsch Forstbeamte 25, 3 pp

Liese J (1950) Zerstörung des Holzes durch Pilze und Bakterien. In: Mahlke F, Troschel R, Liese J (eds) Handbuch der Holzkonservierung, 3rd edn. Springer, Berlin Heidelberg New York, pp. 44–111

Liese J, Stamer J (1934) Vergleichende Versuche über die Zerstörungsintensität einiger wichtiger holzzerstörender Pilze und die hierdurch verursachte Festigkeitsverminderung des Holzes. Angew Bot 16:363–372

Liese W (1955) On the decomposition of the cell wall by micro-organisms. Rec Br Wood Preserv Assoc, pp. 159–160

Liese W (1959) Die Moderfäule, eine neue Krankheit des Holzes. Naturwiss Rundschau 11:419–425

Liese W (1964) Über den Abbau verholzter Zellwände durch Moderfäulepilze. Holz Roh-Werkstoff 22:289–295

Liese W (1970) Ultrastructural aspects of woody tissue disintegration. Ann Rev Phytopath 8:231–258

Liese W (1986) Biologische Resistenz und Tränkbarkeit von Fichtenholz aus Waldschadensgebieten. Holz Roh-Werkstoff 44:325–326

Liese W (1992) Holzbakterien und Holzschutz. Mater Org 27:191–202

Liese W (2002) Protection of bamboo in service. IAWS Conf Beijing, China, pp. 70–80

Liese W, Adolf P, Gerstetter E (1973) Qualitätsänderungen an Rohmasten während längerer Freiluftlagerung. Holz Roh-Werkstoff 31:480–483

Liese W, Ammer U (1964) Über den Befall von Buchenholz durch Moderfäulepilze in Abhängigkeit von der Holzfeuchtigkeit. Holzforsch 18:97–102

Liese W, Dujesiefken D (1989) Wundreaktionen bei Laubbäumen. 2nd Symp Ausgewählte Probl Gehölzphysiol – Gehölze, Mikroorganismen, Umwelt Tharandt, pp. 75–80

Liese W, Dujesiefken D (1996) Wound reactions of trees. In: Raychaudhuri SP, Maramorosch K (eds) Forest trees and palms. Diseases and control. Science Publishers, Lebanon, NH, USA, pp. 21–35

Liese W, Karnop G (1968) Über den Befall von Nadelholz durch Bakterien. Holz Roh-Werkstoff 26:202–208

Liese W, Knigge H, Rütze M (1981) Fumigation experiments with methyle bromide on oak wood. Mater Org 16:265–280

Liese W, Kumar S (2003) Bamboo preservation compendium. CIBART, ABS, INBAR Techn Rep 1, New Delhi, India

Liese W, Peek R-D (1987) Erfahrungen bei der Lagerung und Vermarktung von Holz im Katastrophenfall. Allg Forstz 42:909–912

Liese W, Peters G-A (1977) Über mögliche Ursachen des Befalls von CCA-imprägniertem Laubholz durch Moderfäulepilze. Mater Org 12:263–270

Liese W, Schmid R (1962) Elektronenmikroskopische Untersuchungen über den Abbau des Holzes durch Pilze. Angew Bot 36:291–298

Liese W, Schmid R (1963) Fibrilläre Strukturen an den Hyphen holzzerstörender Pilze. Naturwissensch 50:102–103

Liese W, Schmid R (1966) Untersuchungen zum Zellwandabbau von Nadelholz durch Trametes pini. Holz Roh-Werkstoff 24:454–460

Liese W, Schmidt O (1975) Zur Giftwirkung einiger Holzschutzmittel gegenüber Bakterien. Holz Roh-Werkstoff 33:62–65

Liese W, Schmidt O (1976) Hemmstoff-Toleranz und Wuchsverhalten einiger holzzerstörender Basidiomyceten im Ringschalentest. Mater Org 11:97–108

Liese W, Schmidt O (1986) Zur möglichen Ausbreitung von Bakterien in saftfrischem Splintholz von Fichte. Holzforsch 40:389–392

Liese W, Walter K (1980) Deterioration of bagasse during storage and its prevention. Proc 4th Int Biodet Symp Berlin 1978. Pitman, London, pp. 247–250

Lilja A, Poteri M, Vuorinen M, Kurkela T, Hantula J (2005) Cultural and PCR-based identification of the two most common fungi from cankers on container-grown Norway spruce seedlings. Can J Forest Res 35:432–439

Lin L, Hse C-Y (2005) Liquefaction of CCA-treated wood and elimination of metals from the solvent by precipitation. Holzforsch 59:285–288

Linars-Hernandez A, Wengert EM (1997) End coating logs to prevent stain and checking. Forest Prod J 47:65–70

Lindberg M (1992) S and P intersterility groups in Heterobasidion annosum: infection frequencies through bark of Picea abies and Pinus sylvestris seedlings and in vitro growth rates at different oxygen levels. Eur J Forest Pathol 22:41–45

Lindberg M, Johansson M (1991) Growth of Heterobasidion annosum through bark of Picea abies. Eur J Forest Pathol 21:377–388

Lindgren RM (1933) Decay of wood and growth of some Hymenomycetes as affected by temperature. Phytopath 23:73–81

Lindner KE (1991) Die Viren, Die Bakterien. In: Benedix EH, Casper SJ, Danert S, Hübsch P, Lindner KE, Schmiedeknecht R, Senge W (eds) Urania-Pflanzenreich. Urania, Leipzig, pp. 28–162

Linn J (1990) Über die Bedeutung von Viren und primitiven Mikroorganismen für das Waldökosystem. Forst Holz 13:378–382

Lipponen K (1991) Stump infection by Heterobasidion annosum and its control in stands at the first thinning stage. Folia Forest Helsinki 770

Little BFP (1991) Commercial aspects of bioconversion technology. In: Betts WE (ed) Biodegradation. Springer, Berlin Heidelberg New York, pp. 219–234

Liu J, Fujita R, Sato M, Shimizu K, Konishi F, Noda K, Kumamoto S, Ueda C, Tajiri H, Kaneko S, Suimi Y, Kondo R (2005) The effect of strain, growth age, and cultivating condition of Ganoderma lucidum on 5α-reductase inhibition. J Wood Sci 51:189–192

Livingston WH (1990) Armillaria ostoyae in young spruce plantations. Can J Forest Res 20:1773–1778

Lloyd JD, Dickinson DJ (1992) Comparison of the effects of borate, germanate and tellurate on fungal growth and wood decay. IRG/WP/1533

Lombard FF (1990) A cultural study of several species of *Antrodia* (Polyporaceae, Aphyllophorales). Mycologia 82:185–191

Lombard FF, Chamuris GP (1990) Basidiomycetes. In: Wang CJK, Zabel RA (eds) Identification manual for fungi from utility poles in the eastern United States. Am Type Culture Collection, Rockville, pp. 21–104

Lombard FF, Gilbertson GP (1965) Studies on some western Porias with negative or weak oxidase reaction. Mycologia 57:43–76

Londsdale D (1999) Principles of tree hazard assessment and management. Forest Comm, London

Lopez SE, Bertoni MD, Cabral D (1990) Fungal decay in creosote-treated Eucalyptus power transmission poles. I. Survey of the flora. Mater Org 25:287–293

Lukowsky D, Büschelberger F, Schmidt O (1999) In situ testing the influence of melamine resins on the enzymatic activity of Basidiomycetes. IRG/WP/30194

Lunderstädt J (1992) Stand der Ursachenforschung zum Buchensterben. Forstarch 63:21–24

Lunderstädt J (2002) Langzeituntersuchung zur Befallsdynamik der Buchenwollschildlaus (Cryptococcus fagisuga LIND.) und der nachfolgenden Nekrosebildung in einem Buchen-Edellaubholz-Mischbestand. Allg Forst-Jagdz. 173:193–201

Luterek J, Gianfreda L, Wojtaś-Wasilewska M, Cho NS, Rogalski J, Jascek M, Malarczyk E, Staszczak M, Fink-Boots M, Leonowicz A (1998) Activity of free and imobilized extracellular *Cerrena unicolor* laccase in water miscible organic solvents. Holzforsch 52:589–595

Luthardt W (1963) Myko-Holz-Herstellung, Eigenschaften und Verwendung, In: Lyr H, Gillwald W (eds) Holzzerstörung durch Pilze. Akademie Verl, Berlin, pp. 83–88

Luthardt W (1969) Holzbewohnende Pilze. Ziemsen, Wittenberg

Lyr H (1958) Über den Nachweis von Oxydasen und Peroxydasen bei höheren Pilzen und die Bedeutung dieser Enzyme für die Bavendamm-Reaktion. Planta 50:359–370

Mabicka A, Dumarçay S, Gelhaye E, Gérardin P (2004) Inhibition of fungel degradation of wood by 2-hydroxy-*N*-oxide. Holzforsch 58:566–568

Magel EA (2000) Biochemistry and physiology of heartwood formation. In: Savidge R, Bernett J, Napier R (eds) Cell and molecular biology of wood formation. BIOS, Oxford, pp. 363–376

Mahler G (1992) Konservierung von Holz durch Schutzgas. Allg Forstz 47:1024–1025

Mahler G, Klebes J, Kessel N (1986) Beobachtungen über außergewöhnliche Holzverfärbungen bei der Rotbuche. Allg Forstz 41:328

Mahoney EM, Milgroom MG, Sinclair WA, Houston DR (1999) Origin, genetic diversity, and population structure of *Nectria coccinea* var. *faginata* in North America. Mycologia 91:583–592

Mai C, Militz H (2004) Modification of wood with silicon compounds. Treatment systems based on organic silicon compounds – a review. Wood Sci Technol 37:453–461

Maier T, Schüler G, Mahler G (1999) Ganzjährig frisches Rundholz aus dem Lager. Eine neue Konservierungsmethode für die Forst- und Holzwirtschaft. Holz-Zbl 125:1092–1094

Majcherczyk A, Braun-Lüllemann A, Hüttermann A (1990) Biofiltration of polluted air by a complex filter based on white-rot fungi growing on lignocellulosic substrates. In: Coughlan MP, Amaral Collaco MT (eds) Advances in biological treatment of lignocellulosic materials. Elsevier Appl Sci, London, pp. 323–329

Majcherczyk A, Hüttermann A (1998) Bioremediation of wood treated with preservatives using white-rot fungi. In: Bruce A, Palfreyman JW (eds) Forest products biotechnology. Taylor & Francis, London, pp. 129–140

Mankowski ME, Ascherl FM, Manning MJ (2005) Durability of wood plastic composites relative to natural weathering and preservative treatment with zinc borate. IRG/WP/40316

Martin F, Delaruelle C, Ivory M (1998) Genetic variability in intergenic spacers of ribosomal DNA in *Pisolithus* isolates associated with pine, eucalyptus and *Afzelia* in lowland Kenyan forests. New Phytol 139:341–352

Martin F, Selosse M-A, Le Tacon F (1999) The nuclear rDNA intergenic spacer of the ectomycorrhizal basidiomycete *Laccaria bicolor*: structural analysis and allelic polymorphism. Microbiol 145:1605–1611

Martínez AT, Barrasa JM, Prieto A, Blanco MN (1991a) Fatty acid composition and taxonomic status of *Ganoderma australe* from southern Chile. Mycol Res 95:782–784

Martínez AT, Gonzáles AE, Valmaseda M, Dale BE, Lambregts MJ, Haw JF (1991b) Solid-state NMR studies of lignin and plant polysaccharide degradation by fungi. Holzforsch 45 Suppl, pp. 49–54

Martinez-Inigo MJ, Kurek B (1997) Oxidative degradation of alkali wheat straw lignin by fungal lignin peroxidase, manganese peroxidase and laccase: a comparative study. Holzforsch 51:543–548

Marutzky R (1990) Entsorgung von mit Holzschutzmitteln behandelten Hölzern. Holz Roh-Werkstoff 48:19–24

Marx DH (1991) The practical significance of ectomycorrhizae in forest establishment. Symp Proc 7 Marcus Wallenberg Found, pp. 54–90

Marxmüller H, Holdenrieder O (2000) Morphologie und Populationsstruktur der beringten Arten von *Armillaria* s.l. Mycol Bavarica 4:9–32

Matsuo N, Mohamed ABB, Meguro S, Kawachi S (1992) The effects of yeast extract on the fruiting of *Lentinus edodes* in a liquid medium. Mokuzai Gakkaishi 38:400–402

May G, Shaw F, Badrane H, Vekemans X (1999) The signature of balancing selection: fungal mating compatibility gene evolution. Proc Nat Acad Sci USA 96:9172–9177

Mayr H (1909) Die Aufzucht eßbarer Pilze im Walde. Naturwiss Z Forst-Landwirtsch 7:274–279

Mazela B, Polus-Ratajczak I, Hoffmann SK, Goslar J (2005) Copper monoethanolamine complexes with quaternary ammonium compounds in wood preservation. Biological testing and EPR study. Wood Res 50:1–17

McCarthy BJ (1983) Bioluminescent assay of microbial contamination on textile materials. Int Biodeterior Bull 19:53–57

McCarthy BJ (1988) Use of rapid methods in early detection and quantification of biodeterioration – Part 1. Biodeterior Abstr 2:189–196

McCarthy BJ (1989) Use of rapid methods in early detection and quantification of biodeterioration – Part 2. Biodeterior Abstr 3:109–116

McDowell HE, Button D, Palfreyman JW (1992) Molecular analysis of the basidiomycete *Coniophora puteana*. IRG/WP/1534

Meier FG, Remphrey WR (1997) Accumulation of mansonones in callus cultures of *Ulmus americana* L. in the absence of a fungal-derived elicitor. Can J Bot 75:513–517

Meister U, Springer M (2004) Mycotoxins in cereals and cereal products – occurrence and changes during processing. J Appl Bot Food Qual 78:168–173

Meredith DS (1959) The infection of pine stumps by *Fomes annosus* and other fungi. Ann Bot 23:445–476

Merrill W, Lambert D, Liese W (1975) Important diseases of forest trees. By Dr. Robert Hartig 1874. Translation and bibliography. Phytopathol Classics 12. Am Phytopath Soc, St. Paul

Messner K (1998) Biopulping. In: Bruce A, Palfreyman JW (eds) Forest products biotechnology. Taylor & Francis, London, pp. 63–82

Messner K, Facker K, Lamaipis P, Gindl W, Srebotnik E, Watanabe T (2003) Overview of white-rot research: where we are today. In: Goodell B, Nicholas DB, Schultz TP (eds)

Wood deterioration and preservation. ACS Symp Ser 845, Am Chem Soc, Washington, DC, pp. 73–96

Messner K, Srebotnik E (1989) Mechanismen des Holzabbaus. 18th Holzschutztagung. Dtsch Ges Holzforsch, pp. 93–106

Messner K, Stachelberger H (1984) Transmission electronmicroscope observations on brown rot caused by *Fomitopsis pinicola* with respect to osmiophilic particles. Trans Br Myco! Soc 83:113–130

Metzler B (1994) Die Luftversorgung des Hallimaschs in nassem Fichtenholz. Nachrichtenbl Dtsch Pflanzensch 46:292–294

Metzler B, Thumm H, Scham J (2005) Stubbenbehandlung vermindert das Stockfäulerisiko an Fichte. AFZ-DerWald 60:52–55

Mez C (1908) Der Hausschwamm und die übrigen holzzerstörenden Pilze der menschlichen Wohnungen. Lincke, Dresden

Micales JA (1992) Oxalic acid metabolism of *Postia placenta*. IRG/WP/1566

Micales JA, Bonde MR, Peterson GL (1992) Isoenzyme analysis in fungal taxonomy and molecular genetics. In: Arora DK, Elander RP, Mukerji KG (eds) Handbook of applied mycology 4. Fungal biotechnology. Marcel Dekker, New York, pp. 57–79

Michaelsen H, Unger A, Fischer C-H (1992) Blaugrüne Färbung an Intarsienhölzern des 16. und 18. Jahrhunderts. Restauro 98:17–25

Mikluscak MR, Dawson-Andoh BE (2004a) Microbial colonizers of freshly sawn yellow-poplar (*Liriodendron tulipifera* L) lumber in two seasons: Part 2. Bacteria. Holzforsch 58:182–188

Mikluscak MR, Dawson-Andoh BE (2004b) Microbial colonizers of freshly sawn yellow-poplar (*Liriodendron tulipifera* L) lumber in two seasons: Part 1. Fungi. Holzforsch 58:173–181

Mikluscak MR, Sawson-Andoh BE (2005) Microbial colonizers of freshly sawn yellow-poplar (*Liriodendron tulipifera* L.) lumber in two seasons. Part 3: Yeasts. Holzforsch 59:364–369

Mikulášová M, Košíková B (2002) Mutagenic/antimutagenic effects of different lignin preparations on bacterial cells. Drevársky Výskum 47:25–31

Militz H (1993) Der Einfluß enzymatischer Behandlungen auf die Tränkbarkeit kleiner Fichtenproben. Holz Roh-Werkstoff 51:135–142

Militz H, Homan WJ (1992) Vorbehandlung von Fichtenholz mit Chemikalien mit dem Ziel der Verbesserung der Imprägnierbarkeit, Literaturbesprechung, Auswahlkriterien und Versuche mit kleinen Holzproben. Holz Roh-Werkstoff 50:485–491

Militz H, Krause A (2003) Neuartige Verfahren der Holzmodifizierung für den Fenster- und Fassadenbau. Rosenheimer Fenstertage, Ift Rosenheim Rep 10

Militz H, Larnoy E, Eikenes M, Alfredsen G (2005) Chitosan als Holzschutzmittel: Ein Naturstoff aus Bioabfällen. 24th Holzschutztagung, Dtsch Ges Holzforsch, pp. 149–156

Miller FC (1998) Production of mushrooms from wood waste substrates. In: Bruce A, Palfreyman JW (eds) Forest products biotechnology. Taylor & Francis, London, pp. 197–297

Miller VV (1932) Points in the biology and diagnosis of house fungi. Rev Appl Mycol 12:257–259; cited from Savory JG (1964) Dry rot – a re-appraisal. Rec Br Wood Preserv Assoc 1964

Milling A, Kehr R, Wulf R, Smalla K (2005) Survival of bacteria on wood and plastic particles: dependence on wood species and environmental conditions. Holzforsch 59:72–81

Mirič M, Willeitner H (1984) Lethal temperature for some wood-destroying fungi with respect to eradication by heat treatment. IRG/WP/1229

Moreth U, Schmidt O (2000) Identification of indoor rot fungi by taxon-specific priming polymerase chain reaction. Holzforsch 54:1–8

Moreth U, Schmidt O (2005) Investigations on ribosomal DNA of indoor wood decay fungi for their characterization and identification. Holzforsch 59:90–93

Mori K, Toyomasu T, Nanba H, Kuroda H (1989) Antitumor action of fruit bodies of edible mushrooms orally administered to mice. Mushroom Sci 12, vol. I. pp. 653–660

Morrell JJ, Acda MN, Zahora AR (2005) Performance of orientated strandboard, medium density fiberboard, plywood, and particleboard treated with tebuconazole in supercritical carbon dioxide. IRG/WP/30364

Morrell JJ, Freitag CM, Smith SM, Corden ME, Graham RD (1996) Basidiomycete colonization in Douglas-fir poles after 3 or 6 month of air-seasoning. Forest Prod J 46:56–63

Morrell JL (1987) A reddish purple stain of red alder by *Ceratocystis picea* and its prevention. Forest Prod J 37:18–20

Morris PI (1992) Available iron promotes brown-rot of treated wood. IRG/WP/5383

Morris PI, Dickinson DJ, Calver B (1992) Biological control of internal decay in Scots pine poles: a seven-year experiment. IRG/WP/1529

Moser M (1983) Kleine Kryptogamenflora. Basidiomyceten, 2nd part. Die Röhrlinge und Blätterpilze (Polyporales, Boletales, Agaricales, Russulales), 5th edn. Fischer, Stuttgart

Möykkynen T (1997) Liberation of Heterobasidion annosum conidia by airflow. Eur J Forest Pathol 27:283–289

Mu K, Hattori T, Shimada M (1996) Occurrence of enzyme systems for production and decomposition of oxalate in a white-rot fungus *Coriolus versicolor* and some characteristics of glyoxylate oxidase. Wood Res 83:23–26

Muheim A, Leisola MSA, Schoemaker HE (1990) Aryl-alcohol oxidase and lignin peroxidase from the white-rot fungus *Bjerkandera adusta*. J Biotechnol 13:159–167

Müller E, Loeffler W (1992) Mykologie, 5th edn. Thieme, Stuttgart

Müller H, Schmidt O (1990) Zucht des Speisepilzes Shii-take auf Holzreststoffen. Naturwiss Rundschau 43:11–15

Müller H, Schmidt O (1995) Biologischer Schutz von Kiefernholz gegen Verblauen. Holz-Zbl 121:2017–2020

Müller J (ed) (2005) Holzschutz im Hochbau. Fraunhofer IRB, Stuttgart

Müller U, Bammer R, Teischinger A (2002) Detection of incipient fungal attack in wood using magnetic resonance parameter mapping. Holzforsch 56:529–534

Mullis KB (1990) Eine Nachtfahrt und die Polymerase-Kettenreaktion. Spektrum Wissensch, pp. 60–67

Munir E, Yoon J-J, Tokimatsu T, Hattori T, Shimada M (2001) New role for glyoxylate cycle enzymes in wood-rotting basidiomycetes in relation to biosynthesis of oxalic acid. J Wood Sci 47:368–373

Murdoch CW, Campana RJ (1983) Bacterial species associated with wetwood of elm. Phytopath 73:1270–1273

Murmanis L, Highley TL, Palmer JG (1987) Cytochemical localization of cellulases in decayed and nondecayed wood. Wood Sci Technol 21:101–109

Murmanis L, Highley TL, Ricard J (1988) Hyphal interaction of *Trichoderma harzianum* and *Trichoderma polysporum* with wood decay fungi. Mater Org 23:271–279

Murphy RJ, Dickinson DJ (1997) Wood preservation research – what have we learnt and where are we going? J Inst Wood Sci 14 (81):147–153

Mwangi LM, Lin D, Hubbes M (1990) Chemical factors in Pinus strobus inhibitory to Armillaria ostoyae. Eur J Forest Pathol 20:8–14

Narayanamurti D, Ananthanarayanan S (1969) Resistance of dethiaminized wood to decay – note on further experiments. Indian Plywood Industries Res Assoc 8; cited from Rayner ADM, Boddy L (1988) Fungal decomposition of wood. Wiley, Chichester, p. 233

Narayanappa P (2005) A comparison of effectiveness of three waterborne preservatives against decay fungi in underground mines – an appraisal. IRG/WP/30366

Naumann A (1995) Zur Ausbreitung des Kiefernbaumschwammes im Stamm. Forst Holz 50:315–318

Neger FW (1911) Die Rötung des frischen Erlenholzes. Z Forst Landwirtsch 9:96–105

Nelson BC, Goñi MA, Hedges JI, Blanchette RA (1995) Soft-rot fungal degradation of lignin in 2700-year-old archaeological woods. Holzforsch 49:1–10

Neubrand H (2004) Schimmelpilzschäden im Holzbau sind vermeidbar. Holz-Zbl 130:858–859

Neumüller A, Brandstätter M (1995) Verblauung von Stammholz. Ursachen – Vorbeugung – Schutzmaßnahmen – eine Literaturübersicht. Holzforsch Holzverwert 4:68–72

Nicholas DD, Crawford D (2003) Concepts in the development of new accelerated test methods for wood decay. In: Goodell, B, Nicholas DD, Schultz TP (eds) Wood deterioration and preservation. ACS Symp Ser 845, Am Chem Soc, Washington, DC, pp. 288–312

Niemelä T, Korhonen K (1998) Taxonomy of the genus *Heterobasidion*. In: Woodward S, Stenlid J, Karjalainen R, Hüttermann A (eds) *Heterobasidion annosum*. CABI, Walligford, pp. 27–33

Niemz P, Bodmer H-C, Kučera LJ, Ridder H-W, Habermehl A, Wyss P, Zürcher E, Holdenrieder O (1998) Eignung verschiedener Diagnosemethoden zur Erkennung von Stammfäulen bei Fichte. Schweiz Z Forstwes 149:615–630

Niemz P, Bues C-T, Herrmann S (2002) Die Eignung von Schallgeschwindigkeit und Bohrwiderstand zur Beurteilung von simulierten Defekten in Fichtenholz. Schweiz Z Forstwes 153: 201–209

Niemz P, Kučera LJ (1999) Eindringtiefe bei verschiedenen Holzarten nach Pilodyn. Holz-Zbl. 125:351

Niemz P, Tenisch W, Kučera LJ (1999) Entwicklungen bei der zerstörungsfreien Prüfung von Holz. Holzforsch Holzverwert 6:101–105

Nienhaus F (1985a) Viren, Mykoplasmen und Rickettsien. Uni-Taschenbuch 1361. Ulmer, Stuttgart

Nienhaus F (1985b) Infectious diseases in forest trees caused by viruses, mycoplasma-like organisms and primitive bacteria. Experientia 41:597–603

Nienhaus F (1989) Laubbaumvirosen. Waldschutz-Merkblatt 14. Parey, Hamburg

Nienhaus F, Castello JD (1989) Viruses in forest trees. Ann Rev Phytopath 27:165–186

Nienhaus F, Kiewnick K (1998) Pflanzenschutz bei Ziergehölzen. Ulmer, Stuttgart

Nierhaus-Wunderwald D (1994) Die Hallimasch-Arten. Biologie und vorbeugende Maßnahmen. Wald Holz 75:8–14

Nierhaus-Wunderwald D, Engesser R (2003) Ulmenwelke. Biologie, Vorbeugung und Gegenmaßnahmen, 2nd edn. Merkbl Prax 20

Niku-Paavola ML, Raaska L, Itävaara M (1990) Detection of white-rot fungi by a non-toxic stain. Mycol Res 94:27–31

Nilsson K, Bjurman J (1990) Estimation of mycelial biomass by determination of ergosterol content of wood decayed by *Coniophora puteana* and *Fomes fomentarius*. Mater Org 25:275–285

Nilsson K, Bjurman J (1998) Chitin as an indicator of the biomass of two wood-decay fungi in relation to temperature, incubation time, and media composition. Can J Microbiol 44:575–581

Nilsson T (1974) Formation of soft rot cavities in various cellulose fibres by Humicola alopallonella Meyers and Moore. Stud Forest Suec 112:1–30

Nilsson T (1976) Soft-rot fungi – decay patterns and enzyme production. Suppl 3 Mater Org, pp. 103–112

Nilsson T, Daniel G (1992) Attempts to isolate tunnelling bacteria through physical separation from other bacteria by the use of cellophane. IRG/WP/1535

Nilsson T, Obst JR, Daniel G (1988) The possible significance of the lignin content and lignin type on the performance of CCA-treated timber in ground contact. IRG/WP/1357

Nilsson T, Singh A, Daniel G (1992) Ultrastructure of the attack of *Eusideroxylon zwageri* wood by tunnelling bacteria. Holzforsch 46:361–367

Nimmann B, Knigge W (1989) Anatomische Holzeigenschaften und Lagerungsverhalten von Kiefern aus immissionsbelasteten Standorten der Norddeutschen Tiefebene. Forstarch 60:78–83

Nimz H (1974) Beech lignin – proposal of a constitutional scheme. Angew Chem 13:313–321

Nobles MK (1965) Identification of cultures of wood-inhabiting Hymenomycetes. Can J Bot 43:1097–1139

Noguchi M, Ishii R, Fujii Y, Imamura Y (1992) Acoustic emission monitoring during partial compression to detect early stages of decay. Wood Sci Technol 26:279–287

Nolard N (2004) Allergy to moulds. BCCM Newsletter 16:1–3

Nsolomo VR, Woodward S (1997) Histological and histochemical detection of defence responses in pine embryos challenged *in vitro* with *Heterobasidion annosum*. Eur J Forest Pathol 27:187–195

Nultsch W (2001) Allgemeine Botanik, 11th edn. Thieme, Stuttgart

Nunes L, Peixoto F, Pedroso MM, Santos JA (1991) Field trials of anti-sapstain products. Part 1. IRG/WP/3675

Nuss I, Jennings DH, Veltkamp CJ (1991) Morphology of *Serpula lacrymans*. In: Jennings DH, Bravery AF (eds) *Serpula lacrymans*. Wiley, Chichester, pp. 9–38

Nutsubidze NN, Prabakaran K, Obraztsova NN, Demin VA, Su JD, Gernet MV, Elisashvili VI, Klesov AA (1990) Preparation of protoplasts from the basidiomycetes *Pleurotus ostreatus*, *Phanerochaete chrysosporium*, and from the deuteromycetes *Trichoderma reesei* and *Trichoderma longibrachiatum*. Appl Biochem Microbiol 26:330–332

Obst JR (1998) Special (secondary) metabolites from wood. In: Bruce A, Palfreyman JW (eds) Forest products biotechnology. Taylor & Francis, London, pp. 151–165

Ogoya R, Peñuelas J (2005) Decreased mushroom production in a holm oak forest in response to an experimental drought. Forestry 78:279–283

Oh SK, Kamdem DP, Keathley DE, Han K-H (2003) Detection and species identification of wood-decaying fungi by hybridization of immobilized sequence-specific oligonucleotide probes with PCR-amplified fungal DNA internal transcribed spacers. Holzforsch 57:346–352

Ohba N, Tsujimoto Y (1996) Soiling of external materials by algae and its prevention. Mokuzai Gakkaishi 42:589–595

Ohkoshi M, Kato A, Suzuki K, Hayashi N, Ishihara M (1999) Characterization of acetylated wood decayed by brown-rot and white-rot fungi. J Wood Sci 45:89–75

Oldham ND, Wilcox WW (1981) Control of brown stain in sugar pine with environmentally acceptable chemicals. Wood Fiber 13:182–191

Oppermann A (1951) Das antibiotische Verhalten einiger holzzersetzender Basidiomyceten zueinander und zu Bakterien. Arch Mikrobiol 16:364–409

Ortega U, Duñabeitia M, Menendez S, Gonzalez-Murua C, Majada J (2004) Effectiveness of mycorrhizal inoculation in the nursery on growth and water relations of *Pinus radiata* in different water regimes. Tree Physiol 24:65–73

Otjen L, Blanchette R, Effland M, Leatham G (1987) Assessment of 30 white rot basidiomycetes for selective lignin degradation. Holzforsch 41:343–349

Otjen L, Blanchette RA (1984) *Xylobolus frustulatus* decay of oak: patterns of selective delignification and subsequent cellulose removal. Appl Environ Microbiol 47:670–676

Otjen L, Blanchette RA (1985) Selective delignification of aspen wood blocks in vitro by three white rot basidiomycetes. Appl Environ Microbiol 50:568–572

Otjen L, Blanchette RA (1986) A discussion of microstructural changes in wood during decomposition by white rot basidiomycetes. Can J Bot 64:905–911

Ouellette GB, Rioux D (1992) Anatomical and physiological aspects of resistance to Dutch elm disease. In: Blanchette RA, Biggs AR (eds) Defense mechanisms of woody plants against fungi. Springer, Berlin Heidelberg New York, pp. 257–307

Paajanen L, Viitanen H (1989) Decay fungi in Finnish houses on the basis of inspected samples from 1978 to 1988. IRG/WP/1401

Paajanen LM (1993) Iron promotes decay capacity of Serpula lacrymans. IRG/WP/10008

Paajanen LM, Ritschkoff A-C (1991) Effect of mineral wools on growth and decay capacities of Serpula lacrymans and some other brown-rot fungi. IRG/WP/1481

Paajanen LM, Ritschkoff A-C (1992) Iron in stone wool – one reason for the increased growth and decay capacity of *Serpula lacrymans*. IRG/WP/1537

Palfreyman JW, Gartland JS, Sturrock CJ, Lester D, White NA, Low GA, Bech-Andersen J, Cooke DEL (2003) The relationship between "wild" and "building" isolates of the dry rot fungus *Serpula lacrymans*. FEMS Microbiol Lett 228:281–286

Palfreyman JW, Glancy H, Button D, Bruce A, Vigrow A, Score A, King B (1988) Use of immunoblotting for the analysis of wood decay basidiomycetes. IRG/WP/2307

Palfreyman JW, Low G (2002) Studies of the domestic dry rot fungus *Serpula lacrymans* with relevance to the management of decay in buildings. Res Rep, Historical Scotland, Edinburgh

Palfreyman JW, Phillips EM, Staines HJ (1996) The effect of calcium ion concentration on the growth and decay capacity of *Serpula lacrymans* (Schumacher ex Fr.) Gray and *Coniophora puteana* (Schumacher ex Fr.) Karst. Holzforsch 50:3–8

Palfreyman JW, Smith GM, Bruce A (1996) Timber preservation: current status and future trends. J Inst Wood Sci 14(79):3–8

Palfreyman JW, Vigrow A, Button D, Hegarty B, King B (1991) The use of molecular methods to identify wood decay organisms. 1. The electrophoretic analysis of *Serpula lacrymans*. Wood Protect 1:15–22

Palli SR, Retnakaran A (1998) Biological control of forest pests: a biotechnological perspective. In: Bruce A, Palfreyman JW (eds) Forest products biotechnology. Taylor & Francis, London, pp. 267–286

Palmer JG, Eslyn WE (1980) Monographic information on Serpula (Poria) incrassata. IRG/WP/160

Panten H, Schnitzler J-P, Steinbrecher R (1996) Wirkung von Ultraviolettstrahlung auf Pflanzen. Naturwiss Rundschau 49:343–346

Papadopoulus AN (2004) Dimensional stability and decay resistance against *Coniophora puteana* of Scots pine sapwood due to reaction with propionic anhydride. J Inst Wood Sci 16:211–214

Parameswaran N, Liese W (1988) Occurrence of rickettsialike organisms and mycoplasma-like organisms in beech trees at forest dieback sites in the Federal Republic of Germany. In: Hiruki C (ed) Tree mycoplasmas and mycoplasma diseases. University of Alberta Press, pp. 109–114

Parker EJ (1974) Beech bark disease. Forest Comm For Rec 96. Her Maj Stat Off, London

Pasanen A-L, Yli-Pietilä K, Pasanen P, Kalliokoski P, Tarhanen J (1999) Ergosterol content in various fungal species and biocontaminated building materials. Appl Environ Microbiol 65:138–142

Paul O (1990) Hausschwammbekämpfung mit Heißluft. Bautenschutz Bausanier 1:12–15

Payne C, Bruce A, Staines H (2000) Yeast and bacteria as biological control agents against fungal discoloration of *Pinus syslvestris* blocks in laboratory-based tests and the role of antifungal volatiles. Holzforsch 54:563–569

Payne C, Petty JA, Woodward S (1999) Fungal staining in Sitka spruce timber in relation to storage conditions in the sawmill yard. Mater Org 33:13–35

Pearce MH (1990) In vitro interactions between *Armillaria luteobubalina* and other wood decay fungi. Mycol Res 94:753–761

Pechmann von H, Aufseß von H, Liese W, Ammer U (1967) Untersuchungen über die Rotstreifigkeit des Fichtenholzes. Suppl 27 Forstw Cbl

Peek R-D, Liese W (1976) Schadwirkung von *Fomes annosus* im Stammholz der Fichte. In: Zycha H, Ahrberg H, Courtois H et al. (eds) Der Wurzelschwamm (Fomes annosus) und die Rotfäule der Fichte (Picea abies). Suppl 36 Forstw Cbl, pp. 39–46

Peek R-D, Liese W (1979) Untersuchungen über die Pilzanfälligkeit und das Tränkverhalten naßgelagerten Kiefernholzes. Forstw Cbl 98:280–288

Peek R-D, Liese W (1987) Braunfärbungen an lagernden Fichtenstämmen durch Gerbstoffe. Holz-Zbl 113:1372

Peek R-D, Liese W, Parameswaran N (1972a) Infektion und Abbau der Wurzelrinde von Fichte durch Fomes annosus. Eur J Forest Pathol 2:104–115

Peek R-D, Liese W, Parameswaran N (1972b) Infektion und Abbau des Wurzelholzes von Fichte durch Fomes annosus. Eur J Forest Pathol 2:237–248

Peek R-D, Willeitner H (1981) Beschleunigte Fixierung chromathaltiger Holzschutzmittel durch Heißdampfbehandlung. Holz Roh-Werkstoff 39:495–502

Peek R-D, Willeitner H (1984) Beschleunigte Fixierung chromathaltiger Holzschutzmittel durch Heißdampfbehandlung. Wirkstoffverteilung, fungizide Wirksamkeit, anwendungstechnische Fragen. Holz Roh-Werkstoff 42:241–244

Peek R-D, Willeitner H, Harm U (1980) Farbindikatoren zur Bestimmung von Pilzbefall im Holz. Holz Roh-Werkstoff 38:225–244

Pegler DN (1991) Taxonomy, identification and recognition of *Serpula lacrymans*. In: Jennings DH, Bravery AF (eds) *Serpula lacrymans*. Wiley, Chichester, pp. 1–7

Pelayo SA, Giron MY, Garcia CM, Cariño FA, San Pablo MR (2000) Effectiveness of cashew (*Anacardium occidentale* L.) nut shell liquid (CNSL) against wood-destroying organisms. FPRDI J 26:28–38

Pentillä M, Saloheimo M (1999) Lignocellulose breakdown and utilization by fungi. In: Oliver RP, Schweizer M (eds) Molecular fungal biology. Cambridge University Press, Cambridge, pp. 272–293

Peredo M, Inzunza L (1990) Einfluß der Lagerzeit auf die mechanischen Eigenschaften des Holzes von Pinus radiata. Mater Org 25:231–239

Perez J, Jeffries TW (1992) Roles of manganese and organic acid chelators in regulating lignin degradation and biosynthesis of peroxidases by *Phanerochaete chrysosporium*. Appl Environ Microbiol 58:2402–2409

Pernak J, Zabielska-Matejuk J, Urbanik E (1998) New quaternary ammonium chlorides – wood preservatives. Holzforsch 52:249–254

Perry TJ (1991) A synopsis of the taxonomic revisions in the genus *Ceratocystis* including a review of blue-staining species associated with *Dendroctonus* bark beetles. Gen Tech Rep SO-86, U.S. Dept Agricult Forest Serv, New Orleans

Peterson RL, Massicotte HB, Melville LH (2004) Mycorrhizas: anatomy and cell biology. CABI, Wallingford

Petrowitz H-J, Kottlors C (1992) Nachweis von Holzschutzmittel-Wirkstoffen im Holz. Holz-Zbl 118:1919–1920

Pettipher GL (1987) Cultivation of the oyster mushroom (*Pleurotus ostreatus*) on lignocellulosic waste. J Sci Food Agric 41:259–265

Peylo A, Willeitner H (1995) The problem of reducing the leachability of boron by water repellents. Holzforsch 49:211–216

Peylo A, Willeitner H (2001) Bewertung von Boraten als Holzschutzmittel. Holz Roh-Werkstoff 58:476–482

Philippi F (1893) Die Pilze Chiles, soweit dieselben als Nahrungsmittel gebraucht werden. Hedwigia 32:115–118

Phillips-Laing EM, Staines HJ, Palfreyman JW (2003) The isolation of specific bio-control agents for the dry rot fungus *Serpula lacrymans*. Holzforsch 57:574–578

Pizzi A (1998) Wood/bark extracts as adhesives and preservatives. In: Bruce A, Palfreyman JW (eds) Forest products biotechnology. Taylor & Francis, London, pp. 167–182

Pizzi A (2000) Tannery row – the story of some natural and synthetic wood adhesives. Wood Sci Technol 34:277–316

Potyralska A, Schmidt O, Moreth U, Łakomy P, Siwecki R (2002) rDNA-ITS sequence of *Armillaria* species and a specific primer for *A. mellea*. Forest Genetics 9:119–123

Powell W, Machray GC, Provan J (1996) Polymorphism revealed by simple sequence repeats. Trends Plant Sci 1:215–222

Pratt JE (1996) Borates for stump protection: a literature review. Forest Comm Tech Pap 15, Forest Comm Edinburgh

Prewitt ML, Borazjani H, Diehl SV (2003) Soil-enhanced microbial degradation of pentachlorophenol-treated wood. Forest Prod J 53:44–50

Prillinger HJ, Molitoris HP (1981) Praktische Bedeutung von Enzymspektren bei Pilzen. Champignon 233:28–34

Prospero S, Rigling D, Holdenrieder O (2003) Population structure of *Armillaria* species in managed Norway spruce stands in the Alps. New Phytol 158:365–373

Puls J (1992) α-Glucuronidases in the hydrolysis of wood xylans. In: Visser J, Beldman G, Kusters-van Someren MA, Voragen AGJ (eds) Xylans and xylanases, Progr Biotechnol 7. Elsevier, Amsterdam, pp. 213–224

Puls J, Ayla C, Dietrichs HH (1983) Chemicals and ruminant feed from lignocelluloses by the steaming-extraction process. J Appl Polymer Sci. Appl Polymer Symp 37:685–695

Puls J, Schmidt O, Granzow C (1987) α-Glucuronidase in two microbial xylanolytic systems. Enzyme Microbiol Technol 9:83–88

Queloz V, Holdenrieder O (2005) Wie gross wird *Heterobasidion annosum s.l.*? – Eine Literaturübersicht. Schweiz Z Forstwes 156:395–398

Quitt H (2005) Die Ausgestaltung der Güteüberwachung von geschütztem Holz aus der Sicht der Bauaufsicht. Holz-Zbl 131:415

Quoreshi AM, Maruyama Y, Koike T (2003) The role of mycorrhiza in forest ecosystems under CO_2-enriched atmosphere. Eurasian J Forest Res 6:171–176

Rabanus A (1939) Über die Säure-Produktion von Pilzen und deren Einfluß auf die Wirkung von Holzschutzmitteln. Mittlg dtsch Forstver 23:77–89

Råberg U, Högberg N, Land CJ (2004) Identification of brown-rot fungi on wood in above ground conditions by PCR, T-RFLP and sequencing. IRG/WP/10512

Raffa KF, Klepzig KD (1992) Tree defense mechanisms against fungi associated with insects. In: Blanchette RA, Biggs AR (eds) Defense mechanisms of woody plants against fungi. Springer, Berlin Heidelberg New York, pp. 354–390

Raper JR (1966) Genetics of sexuality in higher fungi. Ronald, New York

Raper JR, Miles PG (1958) The genetics of Schizophyllum commune. Genetics 43:530–546

Rapp AO (ed) (2001) Review on heat treatments of wood. Proc seminar Antibes, France, 2001, European Communities, Brussels

Rapp AO, Berninghausen C, Bollmus S, Brischke C, Frick T, Haas T, Sailer M, Welzbacher CR (2005) Hydrophobierung von Holz – Erfahrungen nach 7 Jahren Freilandtests. 24th Holzschutztagung, Dtsch Ges Holzforsch, pp. 157–169

Rapp AO, Bestgen H, Adam W, Peek R-D (1999) Electron energy loss spectroscopy (EELS) for quantification of cell-wall penetration of a melamine resin. Holzforsch 53:111–117

Rapp AO, Müller J (2005) Neue Verfahren und Tendenzen. In: Müller J (ed) Holzschutz im Hochbau, Fraunhofer IRG, Suttgart, pp. 331–347

Rapp AO, Peek R-D (1996) Melamine resins as preservatives – results of biological testing. IRG/WP/40061

Rättö M, Ritschkoff A-C, Viikari L (2004) Enzymatically polymerized phenolic compounds as wood preservatives. Holzforsch 58:440–445

Rattray P, McGill G, Clarke DD (1996) Antagonistic effects of a range of fungi to Serpula lacrymans. IRG/WP/10156

Rawat SPS, Khali DP, Hale MD, Breese MC (1998) Studies on the moisture adsorption behaviour of brown rot decayed and undecayed wood blocks of Pinus sylvestris using the Brunauer-Emmett-Teller theory. Holzforsch 52:463–466

Raychaudhuri SP, Maramorosch (eds) (1996) Forest trees and palms. Diseases and control. Science Publishers, Lebanon, NH, USA

Raychaudhuri SP, Mitra DK (1993) Mollicute diseases of plants. Oxford & IBH, New Dehli

Rayner ADM (1993) New avenues for understanding processes of tree decay. Arboricult J 17:171–189

Rayner ADM, Boddy L (1988) Fungal decomposition of wood. Its biology and ecology. Wiley, Chichester

Rayner ADM, Watling R, Frankland JC (1985) Resource relations – an overview. In: Moore D, Casselton LA, Wood DA, Frankland JC (eds) Developmental biology of higher fungi. Cambridge University Press, Cambridge, pp. 1–40

Reading NS, Welch KD, Aust SD (2003) Free radical reactions of wood-degrading fungi. In: Goodell B, Nicholas DB, Schultz TP (eds) Wood deterioration and preservation. ACS Symp Ser 845, Am Chem Soc, Washington, DC, pp. 16–31

Redfern DB, Gregory SC, Macaskill GA (1997) Inoculum concentration and the colonization of Picea sitchensis stumps by basidiospores of Heterobasidion annosum. Scand J Forest Res 12:41–49

Reese ET (1977) Degradation of polymeric carbohydrates by microbial enzymes. In: Loewus FA, Runeckles VC (eds) The structure, biosynthesis and degradation of wood. Plenum, New York, pp. 311–357

Reese ET, Siu RGH, Levinson HS (1950) The biological degradation of soluble cellulose derivatives and its relationship to the mechanism of cellulose hydrolysis. J Bact 59:485–497

Rehm H-J (1980) Industrielle Mikrobiologie, 2nd edn. Springer, Berlin Heidelberg New York

Reifenstein H (2005) Gesundheitliche und umweltbezogene Aspekte bei der Anwendung von Holzschutzmitteln. In: Müller J (ed) Holzschutz im Hochbau. Fraunhofer IRB, Stuttgart, pp. 304–313

Reiß J (1997) Schimmelpilze. Lebensweise, Nutzen, Schaden, Bekämpfung, 2nd edn. Springer, Berlin Heidelberg New York

Remadevi OK, Muthukrishnan R, Nagaveni HC, Sundararaj R, Vijayalakshmi G (2005) Durability of bamboos in India against termites and fungi and chemical treatments for its enhancement. IRG/WP/10553

Reyes-Chilpa R, Gómez-Garibay F, Moreno-Torres G, Jiménez-Estrada M, Quiroz-Vásquez RI (1998) Flavonoids and isoflavonoids with antifungal properties from Platymiscium yucatanum heartwood. Holzforsch 52:459–462

Rhatigan RG, Morrell JJ, Filip GM (1998) Toxicity of methyl bromide to four pathogenic fungi in larch heartwood. Forest Prod J 48:63–67

Richards WC (1994) An enzyme system to liberate spore and mycelial protoplasts from a dimorphic fungal plant pathogen Ophiostoma ulmi (Buism.) Nannf. Physiol Molec Plant Pathol 44:311–319

Rinn F (1994) Bohrwiderstandsmessungen mit Resistograph-Mikrobohrungen. AFZ 49:652–654

Rishbeth J (1950) Observations on the biology of *Fomes annosus*, with particular reference to East Anglian pine plantations. I. The outbreak of the disease and ecological status of the fungus. Ann Bot 14:365–383

Rishbeth J (1951) Observations on the biology of *Fomes annosus*, with particular reference to East Anglian pine plantations. III. Natural and experimental infection of pines and some factors affecting severity of the disease. Ann Bot 58:221–247

Rishbeth J (1963) Stump protection against *Fomes annosus*. III. Inoculation with *Peniophora gigantea*. Ann Appl Biol 52:63–77

Rishbeth J (1985) *Armillaria*: resources and hosts. In: Moore D, Casselton LA, Wood DA, Frankland JC (eds) Developmental biology of higher fungi. Cambridge University Press, Cambridge, pp. 87–101

Rishbeth J (1991) Armillaria in ancient broadleaved woodland. Eur J Forest Pathol 21:239–249

Ritschkoff A-C, Paajanen L, Viikari L (1990) The production of extracellular hydrogen peroxide by some brown-rot fungi. IRG/WP/1446

Ritschkoff A-C, Pere J, Buchert J, Viikari L (1992) The role of oxidation in wood degradation by brown-rot fungi. IRG/WP/1562

Ritschkoff A-C, Viikari L (1991) The production of extracellular hydrogen peroxide by brown-rot fungi. Mater Org 26:157–167

Robene-Soustrade I, Lung-Escarmant B, Bono JJ, Taris B (1992) Identification and partial characterization of an extracellular manganese-dependent peroxidase in *Armillaria ostoyae* and *Armillaria mellea*. Eur J Forest Pathol 22:227–236

Robson G (1999) Hyphal cell biology. In: Oliver RP, Schweizer M (eds) Molecular fungal biology. Cambridge University Press, Cambridge, pp. 164–184

Röder T, Koch G, Sixta H (2004) Application of confocal Raman spectroscopy for the topochemical distribution of lignin and cellulose in plant cell walls of beech wood (*Fagus sylvatica* L.) compared to UV microspectrophotometry. Holzforsch 58:480–482

Rodriguez J, Ferraz A, de Mello MP (2003) Role of metals in wood biodegradation. In: Goodell B, Nicholas DB, Schultz TP (eds) Wood deterioration and preservation. ACS Symp Ser 845, Am Chem Soc, Washington, DC, pp. 154–174

Roffael E, Dix B, Schneider T (2002) Verleimung mit polyphenolischen Extraktstoffen. Holz-Zbl 128:68

Roffael E, Miertzsch H, Schwarz T (1992a) Pufferkapazität und pH-Wert des Splintholzsaftes der Kiefer. Holz Roh-Werkstoff 50:171

Roffael E, Miertzsch H, Schwarz T (1992b) Pufferkapazität und pH-Wert des Splintholzsafts der Fichte. Holz Roh-Werkstoff 50:260

Roffael E, Schäfer M (1998) Die Bedeutung der Extraktstoffe des Holzes in biologischer, chemischer und technologischer Hinsicht. Holz-Zbl 124:1615–1616

Rogers SO, Holdenrieder O, Sieber TN (1999) Intraspecific comparisons of *Laetiporus sulphureus* isolates from broadleaf and coniferous trees in Europe. Mycol Res 103:1245–1251

Rohrbach ML (1986) Biotechnologische Untersuchungen über den Shii-take (Lentinus edodes (Berk.) Sing.) zur Fruchtkörpererzeugung. Mittlg Versuchsanst Pilzbau Landwirtschaftskammer Rheinland, Krefeld, Spec Issue 4

Röhrig E (1991) Totholz im Wald. Forstl Umschau 34:259–270

Röhrig E (1996) Die Ulmen in Europa. Ökologie und epidemische Erkrankung. Forstarchiv 67:179–198

Römmelt R, Kammerbauer H, Hock B (1987) Mykorrhizierung von Fichtenstecklingen. Allg Forstz 42:695–696

Rösch R (1972) Phenoloxidasen-Nachweis mit der Bavendamm-Reaktion im Ringschalen-Test. Zentralbl Bakt II 127:555–563

Rösch R, Liese W (1970) Ringschalen-Test mit holzzerstörenden Pilzen. I. Prüfung von Substraten für den Nachweis von Phenoloxidasen. Arch Mikrobiol 73:281–292

Rosecke J, Pietsch M, Konig WA (2000) Volatile constituents of wood-rotting basidiomycetes. Phytochem 54:747–750

Royer JC, Dewar K, Hubbes M, Horgen PA (1991) Analysis of a high-frequency transformation system for *Ophiostoma ulmi*, the causal agent of Dutch elm disease. Mol Gen Genet 225:168–176

Royse DJ (1985) Effect of spawn run time and substrate nutrition on yield and size of the shii-take mushroom. Mycologia 77:756–762

Ruddick JNR, Kundzewicz AW (1991) Bacterial movement of iron in waterlogged soil and its effect on decay in untreated wood. Mater Org 26:169–181

Rui C, Morrell JJ (1993) Production of fungal protoplasts from selected wood-degrading fungi. Wood Fiber Sci 25:61–65

Rune F, Koch AP (1992) Valid scientific names of wood decaying fungi in construction timber and their vernacular names in England, Germany, France, Sweden, Norway and Denmark. IRG/WP/1546

Rust S (2001) Baumdiagnose ohne Bohren. AFZ-DerWald 56:924–925

Rütze M, Heybroek HM (1987) Ulmensterben. Waldschutzmerkblatt 11. Parey, Hamburg

Rütze M, Liese W (1980) Biologie und Bedeutung der Amerikanischen Eichenwelke. Mittlg Bundesforschungsanst Forst-Holzwirtsch 128

Rütze M, Liese W (1983) Begasungsverfahren für Eichenstammholz mit Methylbromid gegen die amerikanische Eichenwelke. Holz-Zbl 109:1533–1535

Rütze M, Liese W (1985a) Eichenwelke. Waldschutz-Merkblatt 9. Parey, Hamburg

Rütze M, Liese W (1985b) A postfumigation test (TTC) for oak logs. Holzforsch 39:327–330

Rütze M, Parameswaran N (1984) Observations on the colonization of oak wilt mats (Ceratocystis fagacearum) by Pesotum piceae. Eur J Forest Pathol 14:326–333

Rypáček V (1966) Biologie holzzerstörender Pilze. Fischer, Jena

Ryvarden L, Gilbertson RL (1993) European polypores. Part 1. Synopsis Fungorum 6, Fungiflora Oslo

Ryvarden L, Gilbertson RL (1994) European polypores. Part 2. Synopsis Fungorum 7, Fungiflora Oslo

Saake B, Horner S, Kruse T, Puls J, Liebert J, Heinze T (2000) Detailed investigation on the molecular structure of carboxymethyl cellulose with unusual substitution pattern by means of an enzyme-supported analysis. Macromol Chem Phys 201:1996–2002

Saake B, Kruse T, Puls J (2001) Investigations on molar mass, solubility and enzymatic fragmentation of xylans by multi-detected SEC chromatography. Bioresource Technol 80:195–204

Saarela K-E, Harju L, Lill J-O, Rajander J, Lindroos A, Heselius S-J (2002) Thick-target PIXE analysis of trace elements in wood incoming to a pulp mill. Holzforsch 56:380–387

Saddler JN, Gregg DJ (1998) Ethanol production from forest product wastes. In: Bruce A, Palfreyman JW (eds) Forest products biotechnology. Taylor & Francis, London, pp. 183–195

Sailer M (2001) Anwendung von Pflanzenölimprägnierungen zum Schutz von Holz im Außenbereich. Doct Thesis Univ Hamburg

Sailer M, Rapp AO, Leithoff H, Peek R-D (2000) Vergütung von Holz durch Anwendung einer Öl-Hitzebehandlung. Holz Roh-Werkstoff 58:15–22

Sallé A, Monclus R, Yart A, Garcia J, Romary P, Lieutier F (2005) Fungal flora associated with *Ips typographus*: frequency, virulence, and viability to stimulate the host defence reaction in relation to insect population levels. Can J Forest Res 35:365–373

Sallmann U (2005) Bekämpfender Holzschutz. In: Müller J (ed) Holzschutz im Hochbau. Fraunhofer IRB, Stuttgart, pp. 265–303

Samejima M, Igarashi K (2004) Recent advances of research on fungal system of cellulose degradation and related enzymes. Mokuzai Gakkaishi 50:359–367

Samson RA, Hoekstra ES (2004) Toxic moulds in indoor environments – descriptions of important species. In: Keller R, Senkpiel K, Samson RA, Hoekstra ES (eds) Erfassung biogener und chemischer Schadstoffe des Innenraumes und die Bewertung umweltbezogener Gesundheitsrisiken. Schriftenr Inst Medizin Mikrobiol Hygiene Univ Lübeck 8, pp. 409–435

Samson RA, Hoekstra ES, Frisvad JC (2004) Introduction to food- and airborne fungi, 7th edn. Centraalbureau Schimmelcultures, Utrecht

Samuel A, Miha H, Pohleven F (2003) Recycling of CCA/CCB treated wood waste through bioremediation – a review. Wood Res 48:1–11

Sandermann W, Rothkamm M (1959) Über die Bestimmung der pH-Werte von Handelshölzern und deren Bedeutung für die Praxis. Holz Roh-Werkstoff 11:433–440

Saur I, Seehann G, Liese W (1986) Zur Verblauung von Fichtenholz aus Waldschadensgebieten. Holz Roh-Werkstoff 44:329–332

Savory JG (1964) Dry rot – a re-appraisal. Rec Br Wood Preserv Assoc 1964:69–76

Savory JG (1966) Prevention of blue-stain in sawn softwoods. Suppl Timber Trades J 259:31–33

Schales M (1992) Totholz. Ein Refugium für seltene Pilzarten. Allg Forstz 47:1107–1108

Scheffer TC (1986) O_2 requirements for growth and survival of wood-decaying and sapwood-staining fungi. Can J Bot 64:1957–1963

Schink B, Ward JC (1984) Microaerobic and anaerobic bacterial activities involved in formation of wetwood and discoloured wood. IAWA Bull ns 5:105–109

Schink B, Ward JC, Zeikus JG (1981) Microbiology of wetwood: role of anaerobic bacterial populations in living trees. J Gen Microbiol 123:313–322

Schirp A, Farrell RL, Kreber B (2003b) Effects of New Zealand sapstaining fungi on structural integrity of unseasoned radiata pine. Holz Roh- Werkstoff 61:369–376

Schirp A, Farrell RL, Kreber B, Singh AP (2003a) Advances in understanding the ability of sapstaining fungi to produce cell wall-degrading enzymes. Wood Fiber Sci 35:434–444

Schlegel HG (1992) Allgemeine Mikrobiologie, 7th edn. Thieme, Stuttgart

Schmid R, Baldermann E (1967) Elektronenoptischer Nachweis von sauren Mucopolysacchariden bei Pilzhyphen. Naturwissensch 19: 2 pp

Schmid R, Liese W (1964) Über die mikromorphologischen Veränderungen der Zellwandstrukturen von Buchen- und Fichtenholz beim Abbau durch Polyporus versicolor (L.) Fr. Arch Mikrobiol 47:260–276

Schmid R, Liese W (1965) Zur Außenstruktur der Hyphen von Blaupilzen. Phytpath Z 54:275–284

Schmid R, Liese W (1966) Elektronenmikroskopische Beobachtungen an Hyphen von Holzpilzen. Suppl 1 Mater Org, pp. 251–261

Schmid R, Liese W (1970) Feinstruktur der Rhizomorphen von Armillaria mellea. Phytopath Z 68:221–231

Schmidt E (1993) Speisepilzforschung – edible mushroom research. Mittlg Versuchsanst Pilzanbau Landwirtschaftskammer Rheinland, Krefeld 16

Schmidt E, Juzwik J, Schneider B (1997c) Sulfuryl fluoride fumigation of red oak logs eradicates the oak wilt fungus. Holz Roh-Werkstoff 55:315–318

Schmidt EL (1988) An overview of methyl bromide fumigation of oak logs intended for export. Proc Can Wood Preserver's Soc, pp. 22–27

Schmidt EL, Cassens DL, Steen J (1997b) Log fumigation prevents sticker stain and enzyme-mediated sapwood discolorations in maple and hickory lumber. Forest Prod J 47:47–50

Schmidt H (2005) Außenbereich. In: Müller J (ed) Holzschutz im Hochbau. Fraunhofer IRB, Stuttgart, pp. 169–187

Schmidt O (1978) On the bacterial decay of the lignified cell wall. Holzforsch 32:214–215

Schmidt O (1980) Über den bakteriellen Abbau der chemisch behandelten verholzten Zellwand. Mater Org 15:207–224

Schmidt O (1985) Occurrence of microorganisms in the wood of Norway spruce trees from polluted sites. Eur J Forest Pathol 15:2–10

Schmidt O (1986) Investigations on the influence of wood-inhabiting bacteria on the pH value in trees. Eur J Forest Pathol 16:181–189

Schmidt O (1990) Biologie und Anbau des Shii-take. Champignon 350:11–32

Schmidt O (1995a) Characterization of *Poria* indoor brown-rot fungi. IRG/WP/10094

Schmidt O (1995b) Über die Porenhausschwämme. 20th Holzschutztagung, Dtsch Ges Holzforsch pp. 171–196

Schmidt O (2000) Molecular methods for the characterization and identification of the dry rot fungus *Serpula lacrymans*. Holzforsch 54:221–228

Schmidt O (2003) Molekulare und physiologische Charakterisierung von Hausschwamm-Arten. Z Mykol 69:287–298

Schmidt O, Ayla C, Weißmann G (1984) Mikrobiologische Behandlung von Fichtenrinde-Heißwasserextrakten zur Herstellung von Leimharzen. Holz Roh- Werkstoff 42:287–292

Schmidt O, Bauch J (1980) Lignin in woody tissue after chemical pretreatment and bacterial attack. Wood Sci Technol 14:229–239

Schmidt O, Bauch J, Rademacher P, Göttsche-Kühn H (1986) Mikrobiologische Untersuchungen an frischem und gelagertem Holz von Bäumen aus Waldschadensgebieten und Prüfung der Pilzresistenz des frischen Holzes. Holz Roh-Werkstoff 44:319–327

Schmidt O, Butin H, Kehr R, Moreth U (2001) Bakterien in Radialrissen von Stiel-Eiche. Forstw Cbl 120:375–389

Schmidt O, Dietrichs HH (1976) Zur Aktivität von Bakterien gegenüber Holzkomponenten. Suppl 3 Mater Org, pp. 91–102

Schmidt O, Dittberner D, Faix O (1991) Zum Verhalten einiger Bakterien und Pilze gegenüber Steinkohlenteeröl. Mater Org 26:13–30

Schmidt O, Grimm K, Moreth U (2002a) Molekulare und biologische Charakterisierung von *Gloeophyllum*-Arten in Gebäuden. Z Mykol 68:141–152

Schmidt O, Grimm K, Moreth U (2002b) Molecular identity of species and isolates of the *Coniophora* cellar fungi. Holzforsch 56:563–571

Schmidt O, Huckfeldt T (2005) Gebäudepilze. In: Müller J (ed) Holzschutz im Hochbau, Fraunhofer IRG-Verlag, Suttgart, pp. 44–72

Schmidt O, Kallow W (2005) Differentiation of indoor wood decay fungi with MALDI-TOF mass spectrometry. Holzforsch 59:374–377

Schmidt O, Kebernik U (1986) Versuche zum Anbau des Shii-take auf Holzabfällen. Champignon 295:14–18

Schmidt O, Kebernik U (1987) Wuchsansprüche, Enzyme und Holzabbau des auf Holz wachsenden Speisepilzes "Shii-take" (*Lentinus edodes*) sowie einiger seiner Homo- und Dikaryonten. Mater Org 22:237–255

Schmidt O, Kebernik U (1988) A simple assay with dyed substrates to quantify cellulase and hemicellulase activity of fungi. Biotechnol Tech 2:153–158

Schmidt O, Kebernik U (1989) Characterization and identification of the dry rot fungus *Serpula lacrymans* by polyacrylamide gel electrophoresis. Holzforsch 43:195–198

Schmidt O, Liese W (1974) Untersuchungen über die Wirksamkeit von Holzschutzmitteln gegenüber Bakterien. Mater Org 9:213–224

Schmidt O, Liese W (1976) Das Verhalten einiger Bakterien gegenüber Giften. Suppl 3 Mater Org, pp. 197–209

Schmidt O, Liese W (1978) Biological variations within *Schizophyllum commune*. Mater Org 13:169–185

Schmidt O, Liese W (1980) Variability of wood degrading enzymes of *Schizophyllum commune*. Holzforsch 34:67–72

Schmidt O, Liese W (1994) Occurrence and significance of bacteria in wood. Holzforsch 48:271–277

Schmidt O, Liese W, Moreth U (1996) Decay of timber in a water cooling tower by the basidiomycete *Physisporinus vitreus*. Mater Org 30:161–177

Schmidt O, Mehringer H (1989) Bakterien im Stammholz von Buchen aus Waldschadensgebieten und ihre Bedeutung für Holzverfärbungen. Holz Roh- Werkstoff 47:285–290

Schmidt O, Moreth U (1995) Detection and differentiation of *Poria* indoor brown-rot fungi by polyacrylamide gel electrophoresis. Holzforsch 49:11–14

Schmidt O, Moreth U (1996) Biological characterization of *Poria* indoor brown-rot fungi. Holzforsch 50:105–110

Schmidt O, Moreth U (1998) Characterization of indoor rot fungi by RAPD analysis. Holzforsch 52:229–233

Schmidt O, Moreth U (1999) Identification of the dry rot fungus, *Serpula lacrymans*, and the wild merulius, *S. himantioides*, by amplified ribosomal DNA restriction analysis (ARDRA). Holzforsch 53:123–128

Schmidt O, Moreth U (2002/2003) Data bank of rDNA-ITS sequences from building-rot fungi for their identification. Wood Sci Technol 36:429–433, revision in Wood Sci Technol 37:161–163

Schmidt O, Moreth U (2003) Molecular identity of species and isolates of internal pore fungi *Antrodia* spp. and *Oligoporus placenta*. Holzforsch 57:120–126

Schmidt O, Moreth U, Schmitt U (1995) Wood degradation by a bacterial pure culture. Mater Org 29:289–293

Schmidt O, Moreth-Kebernik U (1989a) Abgrenzung des Hausschwammes Serpula lacrymans von anderen holzzerstörenden Pilzen durch Elektrophorese. Holz Roh-Werkstoff 47:336

Schmidt O, Moreth-Kebernik U (1989b) Breeding and toxicant tolerance of the dry rot fungus Serpula lacrymans. Mycol Helvetica 3:303–314

Schmidt O, Moreth-Kebernik U (1990) Biological and toxicant studies with the dry rot fungus *Serpula lacrymans* and new strains obtained by breeding. Holzforsch 44:1–6

Schmidt O, Moreth-Kebernik U (1991a) Old and new facts on the dry rot fungus *Serpula lacrymans*. IRG/WP/1470

Schmidt O, Moreth-Kebernik U (1991b) A simple method for producing basidiomes of *Serpula lacrymans* in culture. Mycol Res 95:375–376

Schmidt O, Moreth-Kebernik U (1991c) Monokaryon pairings of the dry rot fungus *Serpula lacrymans*. Mycol Res 95:1382–1386

Schmidt O, Moreth-Kebernik U (1993) Differenzierung von Porenhausschwämmen und Abgrenzung von anderen Hausfäulepilzen mittels Elektrophorese. Holz Roh- Werkstoff 51:143

Schmidt O, Müller J (1996) Praxisversuche zum biologischen Schutz von Kiefernholz vor Schimmel und Schnittholzbläue. Holzforsch Holzverwert 48:81–84

Schmidt O, Müller J, Moreth U (1995) Potentielle Schutzwirkung von Chitosan gegen Holzpilze. Holz-Zbl 121:2503

Schmidt O, Nagashima Y, Liese W, Schmitt U (1987) Bacterial wood degradation studies under laboratory conditions and in lakes. Holzforsch 41:137–140

Schmidt O, Puls J, Sinner M, Dietrichs HH (1979) Concurrent yield of mycelium and xylanolytic enzymes from extracts of steamed birchwood, oat husks and wheat straw. Holzforsch 33:192–196

Schmidt O, Schmitt U, Moreth U, Potsch T (1997a) Wood decay by the white-rotting basid-iomycete *Physisporinus vitreus* from a cooling tower. Holzforsch 51:193–200

Schmidt O, Wahl G (1987) Vorkommen von Pilzen und Bakterien im Stammholz von geschädigten Fichten nach zweijähriger Berieselung. Holz Roh-Werkstoff 45:441–444

Schmidt O, Walter K (1978) Succession and activity of microorganisms in stored bagasse. Eur J Appl Microbiol Biotechnol 5:69–77

Schmidt O, Weißmann G (1986) Mikrobiologische Behandlung von Lärchenrinden-Extrakten zur Herstellung von Leimharzen. Holz Roh-Werkstoff 44:351–355

Schmidt O, Wolf F, Liese W (1975) On the interaction between bacteria and wood preserva-tives. Int Biodet Bull 11:85–89

Schmiedeknecht M (1991) Die Pilze. In: Benedix EH, Casper SJ, Danert S, Hübsch P, Lind-ner KE, Schmiedeknecht R, Senge W (eds) Urania-Pflanzenreich. Urania, Leipzig, pp. 349–358

Schmitt U, Liese W (1992a) Veränderungen von Parenchym-Tüpfeln bei Wundreaktionen im Xylem der Birke (*Betula pendula* Roth.). Holzforsch 46:25–30

Schmitt U, Liese W (1992b) Seasonal influences on early wound reactions in *Betula* and *Tilia*. Wood Sci Technol 26:405–412

Schmitt U, Liese W (1993) Response of xylem parenchyma by suberization in some hard-woods after mechanical injury. Trees 8:23–30

Schmitt U, Liese W (1994) Wound tyloses in *Robinia pseudoacacia* L. IAWA J 15:157–160

Schmitt U, Singh AP, Thieme H, Friedrich P, Hoffmann P (2005) Electron microscopic characterization of cell wall degradation of the 400,000-year-old wooden Schönigen spears. Holz Roh-Werkstoff 63:118–122

Schmitz D (1991) Untersuchungen über die Einsatzmöglichkeiten leistungsfähiger Mykor-rhizapilze in geschädigtem Forst und über die Mykorrhizaimpfung von Forstpflanzen in Baumschulen. Mittlg Versuchsanst Pilzanbau Landwirtschaftskammer Rheinland, Krefeld 14:35–40

Schmitz D, Willenborg A (1992) Für Waldschadensgebiete und Problemstandorte: Bedeu-tung der Mykorrhiza bei der Aufforstung. Allg Forstz 47:372–373

Schoemaker HE, Tuor U, Muheim A, Schmidt HWH, Leisola MSA (1991) White-rot degrada-tion of lignin and xenobiotics. In: Betts WE (ed) Biodegradation: natural and synthetic compounds. Springer, Berlin Heidelberg New York, pp. 157–174

Schoknecht U, Bergmann H (2000) Eindringtiefenbestimmungen für Holzschutzmittelwirk-stoffe. Holz Roh-Werkstoff 58:380–386

Schoknecht U, Gunschera J, Marx H-N, Marx G, Peylo A, Schwarz G (1998) Holzschutzmit-telanalytik, Daten und Literaturzusammenstellung für Wirkstoffe in geprüften Holzschutzmitteln. Bundesanst Materialforsch –prüfung, Berlin, Rep 225

Scholian U (1996) Der Zunderschwamm (*Fomes fomentarius*) und seine Nutzung. Schweiz Z Forstwes 147:647–665

Schönhar S (1989) Pilze als Schaderreger. In: Schmidt-Vogt H (ed) Die Fichte Bd II/2. Krankheiten, Schäden Fichtensterben. Parey, Hamburg, pp. 3–39

Schönhar S (1990) Ausbreitung und Bekämpfung von *Heterobasidion annosum* in Fichten-beständen auf basenreichen Lehmböden. Allg Forstz 45:911–913

Schönhar S (1992) Feinwurzelschäden und Pilzbefall in Fichtenbeständen. Allg Forstz 47:384–385

Schönhar S (1997) *Heterobasidion annosum* in Fichtenbeständen auf basenreichen Bö-den Südwestdeutschlands – Ergebnisse 30jähriger Untersuchungen. Allg Forst Jagd-Ztg 168:26–30

Schönhar S (2001) Infektionswege der Rotfäule bei Fichte. AFZ-DerWald 56:1323–1324

Schönhar S (2002a) Hallimasch-Rotfäule bei Fichte. AFZ-DerWald 57:862–863

Schönhar S (2002b) Bekämpfung der Rotfäule bei Fichte. AFZ-DerWald 57:98–100

Schröder S, Sterfinger K, Kim SH, Breuil C (2000) Monitoring the potential biological control agent Cartapip™. IRG/WP/10365

Schubert R (1991) Die Flechten (Lichenisierte Pilze). In: Benedix EH, Casper SJ, Danert S, Hübsch P, Lindner KE, Schmiedeknecht R, Senge W (eds) Urania-Pflanzenreich. Urania, Leipzig, pp. 577–606

Schultz TP, Nicholas DD, Henry WP (2005a) Efficacy of copper(II)/oxine copper wood preservative mixture after 69 months of outdoor ground-contact exposure and a proposed mechanism to explain the observed synergism. Holzforsch 59:370–373

Schultz TP, Nicholas DP, Henry WP, Pittman CU, Wipf DO, Goddell B (2005b) Review of laboratory and outdoor exposure efficacy results of organic biocide: antioxidant combinations, and initial economic analysis and discussion of proposed mechanism. Wood Fiber 37:175–184

Schultze-Dewitz G (1985) Holzschädigende Organismen in der Altbausubstanz. Bauztg 39:565–566

Schultze-Dewitz G (1990) Die Holzschädigung in der Altbausubstanz einiger brandenburgischer Kreise. Holz-Zbl 116:1131

Schulz R (2002) Inhaltsstoffe von 100 g frischen Shii-take. Champignon 427:1

Schulze B, Theden G (1948) Zur Kenntnis des Gelbrandigen Hausschwammes Merulius Pinastri (Fries) Burt 1917. Nachrichtenbl dtsch Pflanzenschutzdienst 2:1–5

Schulze S, Bahnweg G (1998) Identification of the genus *Armillaria* (Fr.: Fr.) Staude and *Heterobasidion annosum* (Fr.) Bref. in Norway spruce (*Picea abies* (L) Karst.) and determination of clonal distribution of *A. ostoyae*-genotypes by molecular methods. Forstwiss Cbl 117:98–114

Schulze S, Bahnweg G, Möller EM, Sandermann H (1997) Identification of the genus *Armillaria* by specific amplification of an rDNA-ITS fragment and evaluation of genetic variation within *A. ostoyae* by rDNA-RFLP and RAPD analysis. Eur J Forest Pathol 27:225–239

Schulze S, Bahnweg G, Tesche M, Sandermann H (1995) Identification of European *Armillaria* species by restriction-fragment-length polymorphisms of ribosomal DNA. Eur J Forest Pathol 25:214–223

Schumacher J, Solger A, Leonhard S, Roloff A (2003) Zunehmendes Auftreten von Stamm- und Schnittholzbläue bei der Baumart Gemeine Fichte (*Picea abies* (L) KARST.) im Freistaat Sachsen. Allg Forst-Jagd-Ztg 174:148–156

Schumacher P, Schulz H (1992) Untersuchungen über das zunehmende Auftreten von Innenbläue an Kiefern-Schnittholz. Holz Roh-Werkstoff 50:125–134

Schütt P, Lang KJ (1980) Buchen-Rindennekrose. Waldschutzmerkblatt 1. Parey, Hamburg

Schwanninger M, Hinterstoisser B, Gierlinger N, Wimmer R, Hanger J (2004) Application of Fourier transform near infrared spectroscopy (FT-NIR) to thermally modified wood Holz Roh-Werkstoff 62:483–485

Schwantes HO (1996) Biologie der Pilze. Ulmer, Stuttgart

Schwantes HO, Courtois H, Ahrberg HE (1976) Ökologie und Physiologie von *Fomes annosus*. In: Zycha H, Ahrberg H, Courtois H et al. (eds) Der Wurzelschwamm (*Fomes annosus*) und die Rotfäule der Fichte (*Picea abies*). Suppl 36 Forstw Cbl:14–30

Schwarz WH (2003) Das Cellulosom – Eine Nano-Maschine zum Abbau von Cellulose. Naturwiss Rundsch 56:121–128

Schwarz WH (2004) Cellulose – Struktur ohne Ende. Naturwiss Rundschau 57:443–445

Schwarze F (1994) Wood rotting fungi: Fomes fomentarius (L.: Fr.) Fr. Mycologist 8:32–34

Schwarze FWMR (2001) Der Zunderschwamm. AFZ-DerWald 56:1260–1261

Schwarze FWMR (2002) Der Schwefelporling. AFZ-DerWald 57:268–269

Schwarze FWMR (2003) Der Riesenporling. AFZ-DerWald 58:94–95

Schwarze FWMR (2005) Der Schuppige Porling. AFZ-DerWald 60:182–183

Schwarze FWMR, Baum S, Fink S (2000) Dual modes of degradation by *Fistulina hepatica* in xylem cell walls of *Quercus robur*. Mycol Res 104:846–852.

Schwarze FWMR, Engels J (1998) Cavity formation and the exposure of peculiar structures in the secondary wall (S$_2$) of tracheids and fibres by wood degrading basidiomycetes. Holzforsch 52:117–123

Schwarze FWMR, Engels J, Mattheck C (2004) Fungal strategies of wood decay in trees, 2nd edn. Springer, Berlin Heidelberg New York

Schwarze FWMR, Ferner D (2003) Die Hallimasch-Arten. AFZ-DerWald 58:121–122

Schwarze FWMR, Fink S (1998) Host and cell type affect the mode of degradation by *Meripilus giganteus*. New Phytol 139:721–731

Schwarze FWMR, Fink S (1999) Radial and concentric clefts in the secondary wall (S$_2$) of Norway spruce during incipient stages of decay by *Stereum sanguinolentum* (Alb. & Schw.: Fr.). Mater Org 33:51–64

Schwarze FWMR, Landmesser H (2000) Preferential degradation of pit membranes within tracheids by the basidiomycete *Physisporinus vitreus*. Holzforsch 54:461–462

Schwarze FWMR, Londsdale D, Fink S (1995a) Soft rot and multiple T-branching by the basidiomycete *Inonotus hispidus* in ash and London plane. Mycol Res 99:813–820

Schwarze FWMR, Londsdale D, Fink S (1997) An overview of wood degradation patterns and their implications for tree hazard assessment. Arboricult J 21:1–32

Schwarze FWMR, Londsdale D, Mattheck C (1995b) Detectability of wood decay caused by *Ustulina deusta* in comparison with other tree-decay fungi. Eur J Forest Pathol 25:327–341

Schwarze FWMR, Spycher M (2005) Resistance of thermo-hygro-mechanically densified wood to colonisation and degradation by brown-rot fungi. Holzforsch 59:358–363

Schwerdtfeger F (1981) Die Waldkrankheiten, 4th edn. Parey, Hamburg

Sealey J, Ragauskas AJ, Elder TJ (1999) Investigations into laccase-mediator-delignification of kraft pulps. Holzforsch 53:498–502

Seehann G (1969) Holzschädlingstafel: *Armillaria mellea* (Vahl ex Fr.) Kummer. Holz Roh-Werkstoff 27:319–320

Seehann G (1971) Holzschädlingstafel: Baumporlinge. Holz Roh-Werkstoff 29:241–244

Seehann G (1979) Holzzerstörende Pilze an Straßen- und Parkbäumen in Hamburg. Mittlg Dtsch Dendrol Ges 71:193–221

Seehann G (1984) Monographic card on *Antrodia serialis*. IRG/WP/1145

Seehann G (1986) Butt rot in conifers caused by Serpula himantioides (Fr.) Karst. Eur J Forest Pathol 16:207–217

Seehann G, Hegarty BM (1988) A bibliography of the dry rot fungus, *Serpula lacrymans*. IRG/WP/1337

Seehann G, Liese W (1981) *Lentinus lepideus* (Fr. ex Fr.) Fr. In: Cockcroft R (ed) Some wood-destroying basidiomycetes. IRG/WP, Boroko, Papua New Guinea, pp. 95–109

Seehann G, Liese W, Kess B (1975) List of fungi in soft-rot tests. IRG/WP/105

Seehann G, Riebesell von M (1988) Zur Variation physiologischer und struktureller Merkmale von Hausfäulepilzen. Mater Org 23:241–257

Seeling U (2000) Ausgewählte Eigenschaften des Holzes der Fichte (*Picea abies* (L.) Karst.) in Abhängigkeit vom Zeitpunkt der Fällung. Schweiz Z Forstw 151:451–458

Segmüller J, Wälchli O (1981) Serpula lacrymans (Schum. ex. Fr.) S.F. Gray. In: Cockcroft R (ed) Some wood-destroying basidiomycetes. IRG/WP, Boroko, Papua New Guinea, pp. 141–159

Séguin A, Lapointe G, Charest PJ (1998) Transgenic trees. In: Bruce A, Palfreyman JW (eds) Forest products biotechnology. Taylor & Francis, London, pp. 287–303

Seifert E (1974) Die Ursachen von Schäden an Holzfenstern. Holz Roh- Werkstoff 32:85–89

Seifert KA (1999) Sapstain of commercial lumber by species of *Ophiostoma* and *Ceratocystis*. In: Wingfield MJ, Seifert KA, Webber JF (eds) *Ceratocystis* and *Ophiostoma*. Taxonomy, ecology, and pathogenicity, 2nd edn. Am Phytopath Soc Press, St. Paul, Minnesota, pp. 141–151

Seifert KA, Hamilton WE, Breuil C, Best M (1987) Evaluation of Bacillus subtilis C 186 as a potential biological control of sapstain and mould on unseasoned lumber. Can J Microb 33:1102–1107

Sell J (1968) Untersuchungen über die Besiedelung von unbehandeltem und angestrichenem Holz durch Bläuepilze. Holz Roh-Werkstoff 26:215–222

Sell J, Zimmermann T (1993) Radial fibril agglomerations of the S_2 on transverse-fracture surfaces of tracheids of tension-loaded spruce and white fir. Holz Roh-Werkstoff 51:384

Selosse M-C, Martin F, Le Tacon F (1998) Survival of an introduced ectomycorrhizal *Laccaria bicolor* strain in a European forest plantation monitored by mitochondrial ribosomal DNA analysis. New Phytol 140:753–761

Seufert G, Wöllmer H, Arndt U, Babel U (1986) Das Rhizoskop – eine Möglichkeit zur zerstörungsarmen Beobachtung des Wurzelraumes. Allg Forstz 20:493–496

Shain L, Hillis WE (1971) Phenolic extractives in Norway spruce and their effects on Fomes annosus. Phytopath 61:841–845

Sharpe PR, Dickinson DJ (1992) Blue stain in service on wood surface coatings. 2. The ability of *Aureobasidium pullulans* to penetrate wood surface coatings. IRG/WP/1557

Shaw CG, Kile GA (1991) Armillaria root disease. USDA Forest Serv Agricult Handb 691

Shigo AL (1964) Organism interactions in the beech bark disease. Phytopath 54:250–278

Shigo AL (1967) Successions of organisms in discoloration and decay of wood. Int Rev Forest Res 2:237–299

Shigo AL (1972) Ring and ray shakes associated with wounds in trees. Holzforsch 26:60–62

Shigo AL (1979) Tree decay. An expanded concept. USDA Forest Serv Agric Inf Bull 419

Shigo AL (1984) Compartmentalization: a conceptual framework for understanding how trees grow and defend themselves. Ann Rev Phytopath 22:189–214

Shigo AL (1989) Tree pruning. A world-wide photo guide. Shigo and Trees Assoc, Durham, NH

Shigo AL, Hillis WE (1973) Heartwood, discoloured wood and microorganisms in living trees. Ann Rev Phytopath 11:179–222

Shigo AL, Marx HG (1977) Compartmentalization of decay in trees. USDA Forest Serv Agric Inf Bull 405

Shigo AL, Shortle WC, Ochrymowych J (1977) Detection of active decay at groundline in utility poles. USDA Forest Serv Gen Techn Rep 35

Shimada M (1993) Biochemical mechanisms for the biodegradation of wood. In: Shiraishi N, Kajita H, Norimoto M (eds) Recent research on wood and wood-based materials. Elsevier, Essex, pp. 207–222

Shimada M, Akamatsu Y, Ohta A, Takahashi M (1991) Biochemical relationships between biodegradation of cellulose and formation of oxalic acid in brown-rot wood decay. IRG/WP/1472

Shimada M, Ma D-B, Akamatsu Y, Hattori T (1994) A proposed role of oxalic acid in wood decay systems of wood-rotting basidiomycetes. FEMS Microbiol Rev 13:285–296

Shimokawa T, Nakamura M, Hayashi N, Ishihara M (2004) Production of 2,5-dimethoxyhydroquinone by the brown-rot fungus *Serpula lacrymans* to drive extracellular Fenton reaction. Holzforsch 58:305–310

Shortle WC, Cowling EB (1978) Development of discoloration, decay, and microoraganisms following wounding of sweetgum and yellow poplar trees. Phytopath 68:609–616

Siau JF (1984) Transport processes in wood. Springer, Berlin Heidelberg New York

Siepmann R (1970) Artdiagnose einiger holzzerstörender Hymenomyceten an Hand von Reinkulturen. Nova Hedwigia 20:833–863

Siepmann R (1989) Intersterilitätsgruppen und Klone von Heterobasidion annosum in einem 31jährigen Fichtenbestand. Eur J Forest Pathol 19:251–253

Silverborg SB (1953) Fungi associated with the decay of wooden buildings in New York State. Phytopath 43:20–22

Simonson J, Freitag CM, Silva A, Morrell JF (2004) Wood/plastic ratio: effect of performance of borate biocides against a brown rot fungus. Holzforsch 58:205–208

Sims KP, Sen R, Watling R, Jeffries P (1999) Species and population structures of Pisolithus and Scleroderma identified by combined phenotypic and genomic marker analysis. Mycol Res 103:449–458

Sinclair WA, Iuli RJ, Dyer AT, Marshall PT, Matteoni JA, Hibben CR, Stanosz GR, Burns BS (1990) Ash yellows: geographic range and association with decline of white ash. Plant Dis 74:604–607

Sinclair WA, Lyon HH, Johnson WT (1987) Diseases of trees and shrubs. Comstock, Cornell University Press, Ithaca

Singh AP, Butcher JA (1991) Bacterial degradation of wood cell walls: a review of degradation patterns. J Inst Wood Sci 12:143–157

Singh AP, Hedley ME, Page DR, Han CS, Atisongkroh K (1991) Fungal and bacterial attack of CCA-treated Pinus radiata timbers from a water cowling tower. IRG/WP/1488

Singh AP, Kim YS, Wi SG, Lee KH, Kim I-J (2003) Evidence of the degradation of middle lamella in a waterstored archaeological wood. Holzforsch 57:115–119

Singh AP, Nilsson T, Daniel GF (1992) Resistance of Alstonia scholaris vestures to degradation by tunnelling bacteria. IRG/WP/1547

Singh AP, Wakeling RN (1993) Microscopic characteristics of microbial attacks of CCA-treated radiata pine wood. IRG/WP/10011

Siwecki R, Liese W (eds) (1991) Oak decline in Europe. Proc Int Symp Kornik Poland 1990. Akad Wissenschaften, Inst Dendrol, Kornik

Skaar C (1988) Wood-water relations. Springer, Berlin Heidelberg New York

Smalley EB, Raffa KF, Proctor RH, Klepzig KD (1999) Tree responses to infection by species of Ophiostoma and Ceratocystis. In: Wingfield, MJ, Seifert, KA, Webber, JF (eds) Ceratocystis and Ophiostoma, 2nd edn. Am Phytopath Soc Press, St. Paul, pp. 207–217

Smith KT, Shortle WC (1991) Decay fungi increase the moisture content of dried wood. In: Rossmoore HW (ed) Biodeterioration and biodegradation 8. Elsevier, Essex, pp. 138–146

Smith ML, Bruhn JN, Anderson JB (1992) The fungus Armillaria bulbosa is among the largest and oldest living organisms. Nature 256:428–431

Smith RS (1975) Deterioration of pulpwood by fungi and its control. Trans Techn Sect Can Pulp Paper Assoc 2:33–37

Smith S, Read D (1997) Mycorrhizal symbiosis, 2nd edn. Academic Press, San Diego

Solheim H (1992) Fungal succession in sapwood of Norway spruce infested by the bark beetle Ips typographus. Eur J Forest Pathol 22:136–148

Solheim H (1999) Ecological aspects of fungi associated with the spruce bark beetle Ips typographus in Norway. In: Wingfield MJ, Seifert, KA, Webber, JF (eds) Ceratocystis and Ophiostoma, 2nd edn. Am Phytopath Soc Press, St. Paul, pp. 235–242

Solla A, Tomlinson F, Woodward S (2002) Penetration of Picea sitchensis root bark by Armillaria mellea, Armillaria ostoyae and Heterobasidion annosum. Forest Pathol 32:55–70

Spiegel C (2001) Inwieweit können Pilze Fleisch ersetzen. Champignon 423:19–23

Sprey B (1988) Cellular and extracellular localization of endocellulase in Trichoderma reesei. FEMS Microbiol Lett 55:283–294

Srebotnik E, Messner K (1990) Immunogold labeling of size marker proteins in brown-rot degraded wood. IRG/WP/1428

Srebotnik E, Messner K, Foisner R (1988b) Penetrability of white rot-degraded pine wood by the lignin peroxidase of *Phanerochaete chrysosporium*. Appl Environ Microbiol 54:2608–2614

Srebotnik E, Messner K, Foisner R, Pettersson B (1988a) Ultrastructural localization of ligninase of Phanerochaete chrysosporium by immunogold labeling. Curr Microbiol 16:221–227

Stahl U, Esser K (1976) Genetics of fruitbody production in higher basidiomycetes. Mol Gen Genet 148:183–197

Stalpers JA (1978) Identification of wood-inhabiting Aphyllophorales in pure culture. Stud Mycol 16. Centraalbureau Schimmelcultures, Baarn

Stenlid J, Karlsson JO (1991) Partial intersterility in *Heterobasidion annosum*. Mycol Res 95:1153–1159

Stenlid J, Redfern D (1998) Spread within the tree and stand. In: Woodward S, Stenlid J, Karjalainen R, Hüttermann A (eds) *Heterobasidion annosum*. CABI, Walligford, pp. 125–141

Stephan BR (1981) Douglasienschütte. Waldschutz-Merkblatt 4. Parey, Hamburg

Stephan BR, Osorio M, Lang KJ (1991) Nadelpilze der Fichte. Waldschutz-Merkblatt 17. Parey, Hamburg

Stephan I, Leithoff H, Peek R-D (1996) Microbial conversion of wood treated with salt preservatives. Mater Org 30:179–199

Stephan I, Peek R-D (1992) Biological detoxification of wood treated with salt preservatives. IRG/WP/3717

Stobbe H, Dujesiefken D, Eckstein D, Schmitt U (2002b) Behandlungsmöglichkeiten von frischen Anfahrschäden an Alleebäumen. In: Dujesiefken D, Kockerbeck P (eds) Jahrbuch der Baumpflege, Thalacker, Braunschweig, pp. 43–55

Stobbe H, Schmitt U, Eckstein D, Dujesiefken D (2002a) Developmental stages and fine structure of surface callus formed after debarking of living lime trees (Tilia sp.) Ann Bot 89:773–782

Stone JK, Sherwood MA, Carroll GC (1996) Canopy microfungi: function and diversity. Northwest Sci 70, Spec Iss, pp. 37–45

Strobel NE, Sinclair WA (1992) Role of mycorrhizal fungi in tree defense against fungal pathogens of roots. In: Blanchette RA, Biggs AR (eds) Defense mechanisms of woody plants against fungi. Springer, Berlin, Heidelberg New York, pp. 321–353

Strohmeyer M (1992) Züchterische Bearbeitung von Paxillus involutus. Mykorrhiza schützt Forstgehölze vor schädlichen Umwelteinflüssen. Allg Forstz 47:378–380

Suberkropp K (1997) Annual production of leaf-decaying fungi in a woodland stream. Freshwater Biol 38:169–178

Suhara H, Maekawa N, Kubayashi T, Kondo R (2005) Specific detection of a basidiomycete, *Phlebia brevispora* associated with butt rot of *Chamaecyparis obtusa*, by PCR-based analysis. J Wood Sci 51:83–88

Sulaiman O, Murphy R (1992) The development of soft rot decay in bamboo fibres. IRG/WP/1572

Sunagawa M, Miura K, Ohmasa M, Yokota S, Yoshizawa N, Idei MJ (1992) Intraspecific heterokaryon formation by protoplast fusion of auxotrophic mutants of *Auricularia polytricha*. Mokuzai Gakkaishi 38:386–392

Sunagawa M, Neda H, Miyazaki K (1995) Application of random amplified polymorphic DNA (RAPD) markers. II. Rapid identification of *Lentinula edodes*. Mokuzai Gakkaishi 41:949–951

Sutter H-P (2003) Holzschädlinge an Kulturgütern erkennen und bekämpfen, 4th edn. Haupt, Bern

Sutter H-P, Jones EBG, Wälchli O (1983) The mechanism of copper tolerance in *Poria placenta* (Fr.) Cke. and *Poria vaillantii* (Pers.) Fr. Mater Org 18:241–262

Sutter H-P, Jones EBG, Wälchli O (1984) Occurrence of crystalline hyphal sheaths in *Poria placenta* (FR.) CKE. J Inst Wood Sci 10:19–25

Suttie ED, Hill CAS, Jones D, Orsler RJ (1999) Chemically modified solid wood. I. Resistance to fungal attack. Mater Org 32:159–182

Suzuki K, Sugai Y, Ryugo K, Watanabe D (1996) Seasonal effects of the field evaluation on wood preservatives against mold fungi. IRG/WP/20087

Swift MJ (1982) Basidiomycetes as components of forest ecosystems. In: Frankland JC, Hedger JN, Swift MJ (eds) Decomposer basidiomycetes. Cambridge University Press, Cambridge, pp. 307–337

Takahashi M (1978) Studies on the wood decay by the soft rot fungus, *Chaetomium globosum* Kunze. Wood Res 63:11–64

Takahashi R, Mizumoto K, Tajika K, Takano R (1992) Production of oligosaccharides from hemicellulose of woody biomass by enzymatic hydrolysis. I. A simple method for isolating β-D-mannanase-producing microorganisms. Mokuzai Gakkaishi 38:1126–1135

Takemura T, Taniguchi T (2004) Method to estimate the internal stresses due to moisture in wood using transmission properties of microwaves. J Wood Sci 50:15–21

Tamai J, Miura K (1991) Characterization of strains of basidiomycetes with Bavendamm's reaction. Mokuzai Gakkaishi 37:656–660

Tamminen P (1985) Butt-rot in Norway spruce in southern Finland. Commun Inst Forest Fenn 127

Tanaka H, Hirano T, Fuse G, Enoki A (1992) Extracellular substance from the white-rot Basidiomycete *Irpex lacteus* involved in wood degradation. IRG/WP/1571

Tanaka H, Itakura S, Enoki A (1999) Hydroxyl radical generation by an extracellular low-molecular-weight substance and phenol oxidase activity during wood degradation by the white-rot basidiomycete *Phanerochaete chrysosporium*. Holzforsch 53:21–28

Tanaka H, Itakura S, Enoki A (2000) Phenol oxidase activity and one-electron oxidation activity in wood degradation by soft-rot deuteromycetes. Holzforsch 54:463–468

Tattar TA (1978) Diseases of shade trees. Academic Press, New York

Taylor AM, Gartner BL, Morrell JL (2002) Heartwood formation and natural durability – a review. Wood Fiber Sci 34:587–611

Taylor JL, Cooper PA (2005) Effect of climatic variables on chromated copper arsenate (CCA) leaching during above-ground exposure. Holzforsch 59:467–472

Teischinger A, Müller U, Korte H (2005) Holz-Kunststoff-Verbundstoffe (WPC) – Leistungsvergleich für eine neue Werkstoffgeneration mit vielfältigem Profil. Holztechnol 46:30–34

Temp U, Eggert C (1999) Novel interaction between laccase and cellobiose dehydrogenase during pigment synthesis in the white rot fungus *Pycnoporus cinnabarinus*. Appl Environ Microbiol 65:389–395

Teranishi H, Honda Y, Kuwahara M, Watanabe T (2003) Suppression of the Fenton reaction by ceriporic acids produced by a selective lignin-degrading fungus, *Ceriporiopsis subvermispora*. Wood Res 90:13–14

Terashima K, Cha JY, Yajima T, Igarashi T, Miura K (1998b) Phylogenetic analysis of Japanese *Armillaria* based on the intergenic spacer (IGS) sequences of their ribosomal DNA. Eur J Forest Pathol 28:11–19

Terashima K, Kawashima Y, Cha JY, Miura K (1998a) Identification of *Armillaria* species from Hokkaido by analysis of the intergenic spacer (IGS) region of ribosomal DNA using PCR-RFLP. Mycosci 39:179–183

Terziev N, Nilsson T (1999) Effect of soluble nutrient content in wood on its susceptibility to soft rot and bacterial attack in ground contact. Holzforsch 53:575–579

Theden G (1972) Das Absterben holzzerstörender Pilze in trockenem Holz. Mater Org 7:1–10

Theodore ML, Stevenson TW, Johnson GC, Thornton JD, Lawrie AC (1995) Comparison of *Serpula lacrymans* isolates using RAPD PCR. Mycol Res 99:447–450

Thevenon M-F, Pizzi A, Haluk J-P (1998) Protein borates as non-toxic, long-term, wide-spectrum, ground-contact wood preservatives. Holzforsch 52:241–248

Thörnqvist T, Kärenlampi P, Lundström H, Milberg P, Tamminen Z (1987) Vedegenskaper och mikrobiella angrepp i och på byggnadsvirke. Swed Univ Agric Sci Uppsala 10

Thornton JD (1991) Australian scientific research on *Serpula lacrymans*. In: Jennings DH, Bravery AF (eds) *Serpula lacrymans*. Wiley, Chichester, pp. 155–171

Thwaites JM, Farrell RL, Hata K, Carter P, Lausberg M (2004) Sapstain fungi on *Pinus radiata* logs – from New Zealand Forest to export in Japan. J Wood Sci 50:459–465

Tiedemann G, Bauch J, Bock E (1977) Occurrence and significance of bacteria in living trees of *Populus nigra* L. Eur J Forest Pathol 7:364–374

Tien M, Kirk TK (1983) Lignin-degrading enzyme from the hymenomycete *Phanerochaete chrysosporium* Burds. Science 221:661–663

Timell TE (1967) Recent progress in the chemistry of wood hemicelluloses. Wood Sci Technol 1:45–70

Tippett JT, Shigo AL (1981) Barriers to decay in conifer roots. Eur J Forest Pathol 11:51–59

Tjeerdsma BF, Boonstra M, Pizzi A, Tekely P, Militz H (1998) Characterisation of thermally modified wood: molecular reasons for wood performance improvement. Holz Roh-Werkstoff 56:149–153

Toft L (1992) Immuno-fluorescence detection of basidiomycetes in wood. Mater Org 27:11–17

Toft L (1993) Immunological identification in vitro of the dry rot fungus *Serpula lacrymans*. Mycol Res 97:290–292

Tokimoto K, Fukuda M, Matsumoto T, Fukumasa-Nakai Y (1998) Variation of fruit body production in protoplast fusants between compatible monokaryons of *Lentinula edodes*. J Wood Sci 44:469–472

Tommerup IC, Barton JE, O'Brien PA (1995) Reliability of RAPD fingerprinting of the three basidiomycete fungi, *Laccaria*, *Hydnangium* and *Rhizoctonia*. Mycol Res 99:179–186

Torr KM, Chittenden C, Franich RA, Kreber B (2005) Advances in understanding bioactivity of chitosan and chitosan oligomers against selected wood-inhabiting fungi. Holzforsch 59:559–567

Toyomasu T, Mori K-I (1989) Characteristics of the fusion products obtained by intra- and interspecific protoplast fusion between *Pleurotus* species. Mushroom Sci 12(I):151–159

Trockenbrodt M, Liese W (1991) Untersuchungen zur Wundreaktion in der Rinde von *Populus tremula* L. und *Platanus* x *acerifolia* (Ait.) Willd. Angew Bot 65:279–287

Trojanowski J, Hüttermann A (1984) Demonstration of the ligninolytic activities of pro-toplasts liberated from the mycelium of the lignin degrading fungus *Fomes annosus*. Microbios Lett 25:63–65

Troya MT, Navarette A (1991) Laboratory screening to determine the preventive effectiveness against blue stain fungi and molds. IRG/WP/3677

Troya MT, Navarette A, Escorial MC (1991) Wood decay of *Pinus sylvestris* L. and *Fagus sylvatica* L. by marine fungi (part II). IRG/WP/1471

Uçar G, Meier D, Faix O, Wegener G (2005) Analytical pyrolysis and FTIR spectroscopy of fossil *Sequoiadendron giganteum* (Lindl) wood and MWLs isolated hereof. Holz Roh-Werkstoff 63:57–63

Uemura S, Ishihara M, Shimizu K (1992) Exo-ß-glucanases in the extracellular enzyme system of the white-rot fungus, *Phanerochaete chrysosporium*. Mokuzai Gakkaishi 38:466–474

Umezawa T (1988) Mechanisms for chemical reactions involved in lignin biodegradation by *Phanerochaete chrysosporium*. Wood Res 75:21–79

Unger A, Schniewind AP, Unger W (2001) Conservation of wood artifacts. Springer, Berlin Heidelberg New York

Uno I, Ishikawa T (1973) Purification and identification of the fruiting inducing substances in *Coprinus macrorhizus*. J Bact 113:1240–1248

Upadhyay HP (1981) A monograph of the genus *Ceratocystis* and *Ceratocystiopsis*. University Georgia Press, Athens

Urzúa U, Kersten PJ, Vicuña R (1998) Manganese peroxidase-dependent oxidation of glyoxylic and oxalic acids synthesized by *Ceriporiopsis subvermispora* produces extracellular hydrogen peroxide. Appl Environ Microbiol 64:68–73

Usta I (2005) A review of the configuration of bordered pits to stimulate the fluid flow. IRG/WP/40315

Uzunović A, Webber JF (1998) Comparison of bluestain fungi grown in vitro and in freshly cut pine billets. Eur J Forest Pathol 28:323–334

Vainio EJ, Hantula J (2000) Direct analysis of wood-inhabiting fungi using denaturing gradient gel electrophoresis of amplified ribosomal DNA. Mycol Res 104:927–936

Vanhoutte LT, Huys G, Cranenbrouck IS (2005) Exploring microbial ecosystems with denaturing gradient gel electrophoresis (DGGE). Belgian Co-ordinated Collect Microorganisms Newsl 17:2–4

Varma A, Hock B (eds) (1999) Mycorrhiza, 2nd edn. Springer, Berlin Heidelberg New York

Vasiliauskas R (1999) Spread of *Amylostereum areolatum* and *A. challetii* in living stems of *Picea abies*. Forestry 72:95–102

Vasiliauskas R, Stenlid J (1998) Spread of S and P group isolates of *Heterobasidion annosum* within and among *Picea abies* trees in central Lithuania. Can J Forest Res 28:961–966

Venmalar D, Nagaveni HC (2005) Evaluation of copperised cashew nut shell liquid and neem oil as wood preservatives. IRG/WP/30368

Verma P, Mai C, Krause A, Militz H (2005) Studies on the resistance of DMDHEU treated wood against white-rot and brown-rot fungi. IRG/WP/10566

Vermaas HF (1996) Wood-water interaction and methods of measuring wood moisture content. Holzforsch Holzverwert 2:30–33

Verrall AF (1968) *Poria incrassata* rot: prevention and control in buildings. USDA Forest Serv Tech Bull 1385

Vicuña R (1988) Bacterial degradation of lignin. Enzyme Microbiol Technol 10:646–654

Vignon C, Plassard C, Mousain D, Salsac L (1986) Assay of fungal chitin and estimation of mycorrhizal infection. Physiolog Végétale 24:201–207

Vigrow A, Button D, Palfreyman JW, King B, Hegarty B (1989) Molecular studies on isolates of *Serpula lacrymans*. IRG/WP/1421

Vigrow A, Glancy H, Palfreyman JW, King B (1991b) The antigenic nature of *Serpula lacrymans*. IRG/WP/1492

Vigrow A, King B, Palfreyman JW (1991c) Studies of *Serpula lacrymans* mycelial antigens by Western blotting techniques. Mycol Res 95:1423–1428

Vigrow A, Palfreyman JW, King B (1991a) On the identity of certain isolates of *Serpula lacrymans*. Holzforsch 45:153–154

Viikari L, Buchert J, Suurnäkki A (1998) Enzymes in pulping bleaching. In: Bruce A, Palfreyman JW (eds) Forest products biotechnology. Taylor & Francis, London, pp. 83–97

Viikari L, Ritschkoff A-C (1992) Prevention of brown-rot decay by chelators. IRG/WP/1540

Viitanen H, Ritschkoff A-C (1991a) Brown rot decay in wooden constructions. Effect of temperature, humidity and moisture. Swed Univ Agric Sci Dept Forest Prod 222

Viitanen H, Ritschkoff A-C (1991b) Mould growth in pine and spruce sapwood in relation to air humidity and temperature. Swed Univ Agric Sci Dept Forest Prod 221

Vlosky RP, Shupe TF (2004) An exploratory study of home builder, new-home homeowner, and real estate agent perceptions and attitudes about mold. Forest Prod J 54:289–295

Volkmann-Kohlmeyer B, Kohlmeyer J (1993) Biographic observations on Pacific marine fungi. Mycologia 85:337–346

Vos P, Hogers R, Bleeker M, Reijans M, van de Lee T, Hornes M, Frijters A, Pot J, Peleman J, Kuiper M, Zabeua M (1995) AFLP: a new technique for DNA fingerprinting. Nucleic acids Res 23:4407–4414

Voß A, Willeitner H (1992) Charakteristik schutzsalzbehandelter Althölzer im Hinblick auf ihre Entsorgung. 19th Holzschutztagung, Dtsch Ges Holzforsch pp. 257–266

Wadenbäck J, Clapham D, Gellerstedt G, v. Arnold S (2004) Variation in content and composition of lignin in young wood of Norway spruce. Holzforsch 58:107–115

Wagenführ A (1989) Enzymatische Rindenmodifikation zur Phenolharzsubstitution. Holztechnol 30:177–178

Wagenführ R, Steiger A (1966) Pilze auf Bauholz. Ziemsen, Wittenberg

Wahlström KT, Johansson M (1992) Structural responses in bark to mechanical wounding and Armillaria ostoyae infection in seedlings of Pinus sylvestris. Eur J Forest Pathol 22:65–76

Wakeling RN, Maynard NP, Narayan RD (1993) A study of the efficacy of antisapstain formulations containing triazole fungicides. IRG/WP/93-30021

Wälchli O (1973) Die Widerstandsfähigkeit verschiedener Holzarten gegen Angriffe durch den echten Hausschwamm (Merulius lacrimans (Wulf.) Fr.). Holz Roh-Werkstoff 31:96–102

Wälchli O (1976) Die Widerstandsfähigkeit verschiedener Holzarten gegen Angriffe durch Coniophora puteana (Schum. ex Fr.) Karst. (Kellerschwamm) und Gloeophyllum trabeum (Pers. ex. Fr.) Murrill (Balkenblättling). Holz Roh- Werkstoff 34:335–338

Wälchli O (1977) Der Temperatureinfluß auf die Holzzerstörung durch Pilze. Holz Roh-Werkstoff 35:96–102

Wälchli O (1980) Der echte Hausschwamm – Erfahrungen über Ursachen und Wirkungen seines Auftretens. Holz Roh-Werkstoff 38:169–174

Wälchli O (1982) Möglichkeiten einer biologischen Bekämpfung von Insekten und Pilzen im Holzschutz. Holz-Zbl 108:1946, 1948

Wälchli O (1991) Occurrence and control of Serpula lacrymans in Switzerland. In: Jennings DH, Bravery AF (eds) Serpula lacrymans. Wiley, Chichester, pp. 131–145

Wallace RJ, Eaton RA, Carter MA, Williams GR (1992) The identification and preservative tolerance of species aggregates of Trichoderma isolated from freshly felled timber. IRG/WP/1553

Walter M (1993) Der pH-Wert und das Vorkommen niedermolekularer Fettsäuren im Naßkern der Buche (Fagus sylvatica L.). Eur J Forest Pathol 23:1–10

Wang CJK (1990) Microfungi. In: Wang CJK, Zabel RA (eds) Identification manual for fungi from utility poles in the eastern United States. Am Type Culture Collect, Rockville, pp. 105–352

Wang CJK, Zabel RA (eds) (1990) Identification manual for fungi from utility poles in the eastern United States. Am Type Culture Collect, Rockville

Ward JC, Pong WY (1980) Wetwood in trees: a timber resource problem. USDA Forest Serv Pacif Northw Forest Range Exp Stn 112

Ward JC, Zeikus JG (1980) Bacteriological, chemical and physical properties of wetwood in trees. Mitt Bundesforschungsanst Forst-Holzwirtsch 131:133–166

Watanabe T, Sabrina T, Hattori T, Shimada M (2003) A role of formate dehydrogenase in the oxalate metabolism in the wood-destroying basidiomycete *Ceriporiopsis subvermispora*. Wood Res 90:7–8

Watkinson SC, Davison EM, Bramah J (1981) The effect of nitrogen availability on growth and cellulolysis by *Serpula lacrimans*. New Phytol 89:295–305

Ważny H, Czajnik M (1963) Zum Auftreten holzzerstörender Pilze in Gebäuden in Polen (Polish). Fol Forest Polonica 5:5–17

Ważny H, Ważny J (1964) Über das Auftreten von Spurenelementen im Holz. Holz Roh-Werkstoff 22:299–304

Ważny J, Brodziak L (1981) *Daedalea quercina* (L.) ex Fr. In: Cockcroft R (ed) Some wood-destroying basidiomycetes. IRG/WP, Boroko, Papua New Guinea, pp. 47–53

Ważny J, Krajewski KJ (1984) Jahreszeitliche Änderungen der Dauerhaftigkeit von Kiefern-holz gegenüber holzzerstörenden Pilzen. Holz Roh-Werkstoff 42:55–58

Ważny J, Krajewski KJ, Thornton JD (1992) Comparative laboratory testing of strains of the dry rot fungus *Serpula lacrymans* (Schum. ex Fr.) S.F. Gray. VI. Toxic value of CCA and NaPCP preservatives by statistical estimation. Holzforsch 46:171–174

Ważny J, Thornton JD (1989a) Comparative laboratory testing of strains of the dry rot fungus *Serpula lacrymans* (Schum. ex Fr.) S.F. Gray. V. Effect on compression strength of untreated and treated wood. Holzforsch 43:351–354

Ważny J, Thornton JD (1989b) Comparative laboratory testing of strains of the dry rot fungus *Serpula lacrymans* (Schum. ex Fr.) S.F. Gray. IV. The action of CCA and NaPCP in an agar-block test. Holzforsch 43:231–233

Ważny J, Thornton JD (1992) Computer-assisted numerical clustering analysis of various strains of Serpula lacrymans. IRG/WP/5383

Wehmer C (1915) Experimentelle Hausschwammstudien. Beitr Kenntn einheim Pilze 3, Fischer, Jena

Weigl J, Ziegler H (1960) Wassergehalt und Stoffleitung bei *Merulius lacrimans* (Wulf.) Fr. Arch Mikrobiol 37:124–133

Weindling R (1934) Studies on a lethal principle effective in the parasitic action of *Tricho-derma lignorum* on *Rhizoctonia solani* and other soil fungi. Phytopath 24:1153–1179

Weiß B, Wagenführ A, Kruse K (2000) Beschreibung und Bestimmung von Bauholzpilzen. DRW Weinbrenner, Leinfelden-Echterdingen

Welker M, Bruhnke M, Preussel K, Lippert K, v. Döhren H (2004) Diversity and distribution of *Microcystis* (Cyanobacteria) oligopeptide chemotypes from natural communities studied by single-colony mass spectrometry. Microbiol 150:1785–1796

Welzbacher C, Rapp AO (2005) Durability of different heat treated materials from industrial processes in ground contact. IRG/WP/40312

Werner D (1987) Pflanzliche und mikrobielle Symbiosen. Thieme, Stuttgart

White EE, Dubetz CP, Cruickshank MG, Morrison D (1998) DNA diagnostic for *Armillaria* species in British Columbia: within and between species variation in the IGS-1 and IGS-2 regions. Mycologia 90:125–131

White NA, Dehal PK, Duncan JM, Williams NA, Gartland JS, Palfreyman JW, Cooke DEL (2001) Molecular analysis of intraspecific variation between building and "wild" isolates of the dry rot fungus *Serpula lacrymans* and their relatedness to *S. himantioides*. Mycol Res 105:447–452

White TJ, Bruns T, Lee S, Taylor J (1990) Amplification and direct sequencing of fungal ribosomal genes for phylogenetics. In: Innis MA, Gelfand DH, Sninisky JJ, White TJ (eds) PCR protocols. Academic Press, San Diego, pp. 315–322

White-McDougall WJ, Blanchette RA, Farrell RL (1998) Biological control of blue stain fungi on *Populus tremuloides* using selected *Ophiostoma* isolates. Holzforsch 52:234–240

Whittaker RH (1969) New concepts of kingdoms of organisms. Science 163:150–160

Wiehlmann L, Siebert B, Tümmler B, Wagner G, Slickers G, Müller E (2004) Geno- und Pathotypisierung von *Pseudomonas aeruginosa*. Bioforum 6:48–49

Wienhaus O, Fischer F (1983) Stand und Entwicklungstendenzen der chemischen Holzverwertung. Holztechnol 24:102–110

Wilcox WW (1978) Review of literature on the effects of early stages of decay on wood strength. Wood Fiber 9:252–257

Wilcox WW, Dietz M (1997) Fungi causing above-ground wood decay in structures in California. Wood Fiber Sci 29:291–298

Wilcox WW, Oldham ND (1972) Bacterium associated with wetwood of white fir. Phytopath 62:384–385

Willeitner H (1971) Anstrichschäden infolge Überaufnahmefähigkeit des Holzes. Holz-Zbl 97:2291–2292

Willeitner H (1973) Probleme des Umweltschutzes bei der Holzimprägnierung. Holzschwelle 68:3–20

Willeitner H (2000) Holz erfolgreich schützen ohne und mit Chemie. Holz-Zbl 126:1671, 1674

Willeitner H (2003) Holzschutz und Ökologie – eine Herausforderung. Holz-Zbl 129:298–299

Willeitner H (2005a) Natürliche Dauerhaftigkeit. In: Müller J (ed) Holzschutz im Hochbau. Fraunhofer IRB, Stuttgart, pp. 24–28

Willeitner H (2005b) Normen, Gesetze, Vorschriften. In: Müller J (ed) Holzschutz im Hochbau. Fraunhofer IRB, Stuttgart, pp. 101–122

Willeitner H, Illner HM, Liese W (1986) Vorkommen von Bläueschutzwirkstoffen in importierten Schnitthölzern unter besonderer Berücksichtigung von PCP. Holz Roh-Werkstoff 44:1–5

Willeitner H, Klipp H, Brandt K (1991) Praxisbeobachtungen zur Auswaschung von Chrom, Kupfer und Bor aus Fichten-Halbrundhölzern einer Lärmschutzwand. Holz Roh-Werkstoff 49:140

Willeitner H, Liese W (1992) Wood protection in tropical countries: a manual on the know-how. Schriftenr Dtsch Ges Techn Zusammenarb 227, Eschborn

Willeitner H, Richter HG, Brandt K (1982) Farbreagenz zur Unterscheidung von Weiß- und Roteichenholz. Holz Roh-Werkstoff 40:327–332

Willeitner H, Schmidt O, Wollenberg E (1977) Orientierende Versuche zur bakteriellen Detoxifikation von Holzschutzmitteln. Mater Org 12:279–286

Willeitner H, Schwab E (eds) (1981) Holz – Außenverwendung im Hochbau. Koch, Stuttgart

Willenborg A (1990) Die Bedeutung der Ektomykorrhiza für die Waldbäume. Forst Holz 1:11–14

Williams END, Todd NK, Rayner ADM (1981) Spatial development of populations of *Coriolus versicolor*. New Phytol 89:307–319

Willig J, Schlechte GB (1995) Pilzsukzession an Holz nach Windwurf in einem Buchennaturwaldreservat. AFZ-DerWald 50:814–818

Willoughby GA, Leightley LE (1984) Patterns of bacterial decay in preservative treated eucalypt power transmission poles. IRG/WP/1223

Wingfield MJ, Seifert KA, Webber JF (eds) (1999) *Ceratocystis* and *Ophiostoma*. Taxonomy, ecology, and pathogenicity, 2nd edn. Am Phytopath Soc Press, St. Paul

Winter S, Nienhaus F (1989) Identification of viruses from European beech (*Fagus sylvatica* L.) of declining forests in Northrhine-Westfalia (FRG). Eur J Forest Pathol 19:111–118

Wittig R-M, Wilkes H, Sinnwell V, Francke W, Fortnagel P (1992) Metabolism of dibenzo-*p*-dioxin by *Sphingomonas* sp. strain RW1. Appl Environ Microbiol 58:1005–1010

Woese CR, Fox GE (1977) Phylogenetic structure of the prokaryotic domain: the primary kingdoms. Proc Nat Acad Sci USA 74:5088–5090

Wohlers A, Kowol T, Dujesiefken D (2001) Pilze bei der Baumkontrolle. Thalacker, Braunschweig

Wolf F, Liese W (1977) Zur Bedeutung von Schimmelpilzen für die Holzqualität. Holz Roh-Werkstoff 35:53–57

Wong AHH, Pearce RB, Watkinson SC (1992) Fungi associated with groundline soft rot decay in copper-chrome-arsenic treated heartwood utility poles of Malaysian hardwoods. IRG/WP/1567

Woodward S (1992a) Responses of gymnosperm bark tissues to fungal infections. In: Blanchette RA, Biggs AR (eds) Defense mechanisms of woody plants against fungi. Springer, Berlin Heidelberg New York, pp. 62–75

Woodward S (1992b) Mechanism of defense in gymnosperm roots to fungal invasion. In: Blanchette RS, Biggs AR (eds) Defense mechanisms of woody plants against fungi. Springer, Berlin Heidelberg New York, pp. 165–180

Woodward S, Stenlid J, Karjalainen R, Hüttermann A (eds) (1998) *Heterobasidion annosum –* biology, ecology, impact and control. CABI, Wallingford

Wörner U (2005) Englische Ulme ist römischer Klon. Naturwiss Rundschau 58:154

Worrall JJ (1997) Somatic incompatibility in basidiomycetes. Mycologia 89:24–36

Wudtke L (1991) Beobachtungen in einem Versuchsbestand. Buchenrindensterben. Allg Forstz 46:504–507

Wulf A (1995) Gefährdung der Platane durch zunehmende Ausbreitung des Krebserregers *Ceratocystis fimbriata*. Gesunde Pflanzen 47:12–15

Wulf A (2004) Krankheiten und Schädlinge an fremdländischen Baumarten. AFZ-DerWald 59:1113–1115

Wüstenhöfer B, Wegen HW, Metzner W (1993) Triazole – eine neue Fungizidgeneration für Holzschutzmittel. Holz-Zbl 119:984, 988

www.chem.qmul.ac.uk/iubmb/enzyme: Enzyme nomenclature

www.ddbj.nig.ac.jp: DNA Data Bank of Japan DDBJ

www.dsmz.de/species/abbrev.htm: German Collection of Microorganisms and Cell Cultures

www.ebi.ac.uk/embl: European Molecular Biology Laboratory EMBL

www.eccosite.org: European Culture Collections' Organization (ECCO)

www.holzfragen.de/seiten/hsm_reagenzien.html: Detection and penetration measures of wood preservatives by colour reactions

www.indexfungorum.org/names/names.asp: Index Fungorum

www.ncbi.nlm.nih.gov/blast/blast.cgi: Basic local alignment search tool BLAST

www.ncbi.nlm.nih.gov/genbank: American GenBank

www.wfcc.info/index.html: World Federation of Culture Collections (WFCC)

Xiao Y, Morrell JJ (2004) Production of protoplasts from cultures of *Ophiostoma piceae*. J Wood Sci 50:445–449

Xie Y, Bjurman J, Wadsö L (1997) Microcalorimetric characterization of the recovery of a brown-rot fungus after exposures to high and low temperature, oxygen depletion, and drying. Holzforsch 51:201–206

Xu Z, Leininger TD, Lee AWC, Tainter FH (2001) Physical, mechanical, and drying properties associated with bacterial wetwood in red oaks. Forest Prod J 51:79–84

Yamada T (1992) Biochemistry of gymnosperm xylem responses to fungal invasion. In: Blanchette RA, Biggs AR (eds) Defense mechanisms of woody plants against fungi. Springer, Berlin Heidelberg New York, pp. 147–164

Yamamoto K, Uesugi S, Kawakami K (2005) Effect of felling time related to lunar calendar on the durability of wood and bamboo – fungal degradation during above ground exposure test for 2 years. IRG/WP/20311

Yang D-Q (1999) Staining ability of various sapstaining fungi on agar plates and on wood wafers. Forest Prod J 49:78–90

Yang D-Q (2004) Isolation of staining fungi from jack pine trees. Forest Prod J 54:245–249

Yang D-Q, Beauregard R (2001) Sapstain development on jack pine logs in Eastern Canada. Wood Fiber Sci 33:412–424

Yang D-Q, Gignac M, Bisson M-C (2004a) Sawmill evaluation of a bioprotectant against moulds, stain, and decay of green lumber. Forest Prod J 54:63–66

Yang D-Q, Wang X-M, Shen J, Wan H (2004b) A rapid method for evaluating antifungal properties of various barks. Forest Prod J 54:37–39

Yao Y-J, Pegler DN, Chase MW (1999) Application of ITS (nrDNA) sequences in the phylogenetic study of *Tyromyces s.l.* Mycol Res 103:219–229

Yoshida S (1997) Degradation and synthesis of lignin and its related compounds by fungal ligninolytic enzymes. Wood Res 84:76–125

Zabel RA, Morrell JJ (1992) Wood microbiology. Decay and its prevention. Academic Press, San Diego

Zabel RA, Wang CJK, Anagnost SE (1991) Soft-rot capabilities of the major microfungi, isolated from Douglas-fir poles in the North-East. Wood Fiber Sci 23:220–237

Zabielska-Matejuk J, Urbanik E, Pernak J (2004) New bis-quaternary and bis-imidazolium chloride wood preservatives. Holzforsch 58:292–299

Zadražil F (1985) Screening of fungi for lignin decomposition and conversion of straw into feed. Angew Bot 59:433–452

Zadražil F, Brunnert H (1980) The influence of ammonium nitrate supplementation on degradation and in vitro digestibility of straw colonized by higher fungi. Eur J Microbiol Biotechnol 9:37–44

Zadražil F, Grabbe K (1983) Edible mushrooms. In: Rehm H-J, Reed G (eds) Biomass, vol. 3. Biotechnology. Chemie, Weinheim, pp. 145–187

Zainal AS (1976) The soft-rot fungi: the effect of lignin. Suppl 3 Mater Org, pp. 121–127

Zaremski A, Ducousso M, Prin Y, Fouquet D (1999) Molecular characterization of wood-decaying fungi. Bois Forêts Tropiques 1999, Spec Issue, pp. 76–81

Zimmermann MH (1983) Xylem structure and the ascent of sap. Springer, Berlin Heidelberg New York

Zink P, Fengel D (1989) Studies on the coloring matter of blue-stain fungi. Holzforsch 43:371–374

Zoberst W (1952) Die physiologischen Bedingungen der Pigmentbildung von *Merulius lacrymans domesticus* Falck. Arch Mikrobiol 18:1–31

Zujest G (2003) Holzschutzleitfaden für die Praxis. Grundlagen, Maßnahmen, Sicherheit. Bauwesen, Berlin

Zycha H (1964) Stand unserer Kenntnisse von der *Fomes annosus*-Rotfäule. Forstarch 35:1–4

Zycha H, Ahrberg H, Courtois H, Dimitri L, Liese W, Peek R-D, Rehfuess KE, Schlenker G, Schmidt-Vogt H, Schnurbein von U, Schwantes HO (1976) Der Wurzelschwamm (Fomes annosus) und die Rotfäule der Fichte (Picea abies). Suppl 36 Forstw Cbl

Zycha H, Knopf H (1963) Pilzinfektion und Lagerschäden an Holz. Schweiz Z Forstwesen 9:531–537

Subject Index